Lady in the Dark

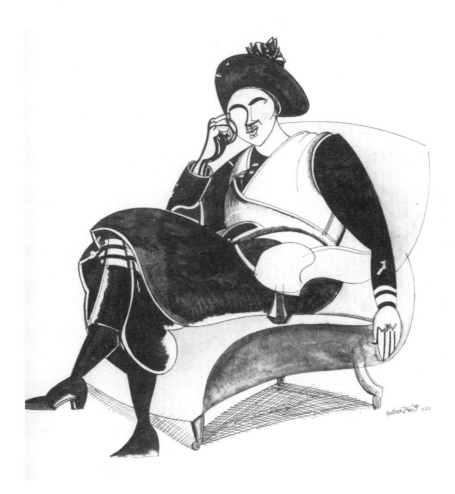

Wyndham Lewis, *Iris Barry Seated in an Armchair* (1921).

Lady in the Dark

IRIS BARRY AND THE ART OF FILM

ROBERT SITTON

Columbia University Press *New York*

Columbia University Press

Publishers Since 1893

New York Chichester, West Sussex

cup.columbia.edu

Copyright © 2014 Robert Sitton

Library of Congress Cataloging-in-Publication Data

Sitton, Robert.

Lady in the dark : Iris Barry and the art of film / Robert Sitton.

pages cm

Includes bibliographical references and index.

ISBN 978-0-231-16578-5 (cloth : alk. paper) — ISBN 978-0-231-53714-8 (ebook)

1. Barry, Iris, 1895–1969. 2. Museum of Modern Art (New York, N.Y.).
Film Library—Biography. 3. Archivists—United States—Biography.
4. Film critics—England—Biography. 5. Motion picture film—Preservation—
United States—History. 6. Motion picture film collections—United States—
Archival resources. I. Title.

PN1998.3.B3738S58 2014

791.43092—dc23

[B]

2013044123

Columbia University Press books are printed on permanent
and durable acid-free paper.

This book is printed on paper with recycled content.
Printed in the United States of America

c 10 9 8 7 6 5 4 3 2 1

Cover images: (*front cover*) IBP, MoMA Dept. of Film Archives, NY;
(*front flap*) Wyndham Lewis, *Praxitella* (1921), a portrait of Iris Barry /
Leeds Museums and Galleries (Leeds Art Gallery) UK /
© The Wyndham Lewis Memorial Trust / Bridgeman Art Library
Cover and book design: Lisa Hamm

FOR PAT

◉ ◉ ◉

CONTENTS

ILLUSTRATIONS

TO IRIS BARRY (1895–1969)

S HE WAS A brassy little girl in Birmingham, England, who shocked her grandmother by spending every spare hour at the movies, when the movies were a thin cut above the poolroom. She shocked the rest of the family when, having spent the First World War in a succession of unladylike jobs (shipping telephone poles for the Post Office, ordering machine guns for the Ministry of Munitions), she made a profession of her vice and became the first woman film critic in England.

In the heyday of the Flapper she was one of the most beguiling of the breed: a small trig brunette with an Eton crop, a pair of skeptical violet eyes and a belly laugh that responded like a Geiger counter to the presence of a stuffed shirt. She was always long on mockery and short on tact, and when she demanded more money and a trip to Hollywood from the *Daily Mail* she was, as she put it later, "severed rather forcefully." She decided, on her own, to get to the waystation of New York and for a time she practiced the pathetic routine of a genteel English girl on a casual visit to America who, in fact, was down to the one-room walk-up or whatever snacks the escort can pay for.

But she always landed on her own or somebody else's feet and first she ran into a patron in Philip Johnson, a sponsor in Alfred Barr and a husband in John E. Abbott of Wall Street. These three complemented her vague but grand design, which was somehow to have a private film collection and yet be on hobnobbing terms with the Warner Brothers and the gods and goddesses they employed. Johnson moved her into a 53rd Street brownstone, then masquerading as the young Museum of Modern Art, and set her cadging books from the libraries of bankrupt tycoons which she sold for books on painting. Barr recalled she had been a founder member of the London Film Society and thought she would be "better employed doing something about a film collection," a rather grandiose promise given by the Museum in its original manifesto about which nothing

had yet been done. Out of the blue, or a cocktail acquaintanceship, came John Hay Whitney, who put up the money for a preliminary study of what a film collection might be. By now she was married to John Abbott and the two of them first wrangled a fat grant from the Rockefeller Foundation and then, with Whitney's entree, whisked off to Hollywood and for a year or more explored the tedious mysteries of projectors, staff, storage vaults, raw film stock, copyright, and pierced the more formidable barrier of Hollywood's indifference to its stockpile of old movies and its suspicion of the non-commercial showing of any of them.

There were interminable battles with corporations, banks, and all the other keepers of the cash register who awoke with a bang to what was then the pleasing new concept of "residuals."

This was the way the Museum of Modern Art Film Library (now Department) began. Iris Barry was its inventor, crusader, first curator and subsequently its director. Very few of the fans who drop by to catch the early Fairbanks or *The Birth of a Nation* have ever heard of Iris Barry or, I am sure, give a passing thought to the Laocoon coils of stock holdings, proprietorship and dumb greed through which she had to slash her way toward her vision of a regular parade of the motion picture's past for you and me on a gray afternoon. But there is it. She died in France three weeks ago, full of years and unquenchable humor. It is a good time to recall her pluck and cunning and energy. For all the hundreds of thousands who now accept the Museum Film Department as an inevitable amenity of New York City, she was their pioneer public servant. She would have laughed herself sick at the thought.

<div style="text-align:right">

Alistair Cooke
New York Times
January 18, 1970*

</div>

*Permission granted by the Estate of Alistair Cooke C Cooke Americas, RLLP.

CREDITS

WRITING THIS BOOK, the first on the life and work of Iris Barry, involved a good deal of patient and persistent investigation. Although she became known after 1930 as the first curator of film in a major museum in the United States, Barry was also part of the Bloomsbury demimonde in London and was known as a poet, novelist, biographer, and pioneering film critic before she arrived in the United States. Few people she befriended in America knew of her early life. Barry never published an autobiography. Although she made a variety of autobiographical notes, the documentation that remained after her death comprises a bewildering mélange of letters, notebooks, datebooks, and memorabilia scattered among numerous archives.

I am indebted to several people who made these disparate materials available. The critical mass of Barry materials can be found in the Iris Barry Papers at the Museum of Modern Art Film Archives. I am grateful to Ron Magliozzi of the Museum's Film Study Center for making these papers accessible, and to Mary Corliss and Katie Trainor for providing many of the photographs in this book. Amy Fitch of the Rockefeller Archive Center helped me bring into focus the vital role Nelson Rockefeller played in the history of the Film Library. The Robin Barry Collection, an assemblage of documents given me by Iris Barry's son, proved invaluable as a resource on his parents' relationship, as did the extensive Wyndham Lewis/Iris Barry correspondence in the Carl A. Kroch Library at Cornell University. Paul Thiessen surprised me one day with a shipment of photocopies from Cornell. Much of the narrative about Iris Barry's senior years comes from the Edmund Schiddel Collection at Boston University's Mugar Library, as well as the A. E. Austin Papers housed at the Wadsworth Atheneum in Hartford. The avatar of A. E. "Chick" Austin, Wadsworth Curator Eugene Gaddis, has proven an unfailing friend and ally. For Iris Barry's

relationship with the poet Ezra Pound, extensive correspondence between the two can be found at the Lockwood Memorial Library at the State University of New York at Buffalo. Iris's first years in New York are chronicled in the John Widdicombe correspondence at the Harry Ransom Center at the University of Texas. Thanks to Cathy Henderson of the Ransom Center for opening that amazing trove to me. Thanks also to Dean Rogers of Vassar College Library, who supplied information about and a photo of Alan Porter.

All this material would be meaningless without contextualization, however, and for that I would like to thank the many scholars quoted in this book. Paul O'Keefe, Brett Gary, and many others provided intellectual and historic grounding for the record of a mercurial life, as did the friends and colleagues of Iris Barry who generously granted me interviews. All were candid, articulate, and helpful, including David Austin, Margaret Scolari Barr, Robin Barry, Eileen Bowser, Mary Ellen Bute, Frank Capra, Shirley Clarke, John Houseman, Philip Johnson, Arthur Kleiner, Arthur Knight, Henri Langlois, Adrienne Mancia, Jonas Mekas, Caroline Moorehead, Dorothy Miller, Maisie Wyndham Neil, Marius Rochemaure, Roberto Rossellini, Nellie Soby, Virgil Thomson, Willard Van Dyke, Amos Vogel, and Monroe Wheeler.

Principal research for this book was conducted at the Henry Suzzalo Library of the University of Washington in Seattle, whose staff proved unstintingly helpful. Additional research was carried out at the British Library, British Film Institute, Cinémathèque Française, Archives of the Legion d'Honneur, Library of Congress, Archives of American Art, and the Academy of Motion Picture Arts and Sciences. The European research was made possible by a travel grant from the Oregon Committee for the Humanities.

Many of my present and former colleagues have tolerated my monologues about this project. I thank them for their patience and insightful comments. They include Doris Chase, Constantine and Koren Christofides, Bikram Day, Norman Dorn, Leo Dratfield, Margie and Arthur Erickson, Pietro Ferrua, Susan Fillin-Yeh, C. J. Fox, Robert Haller, Charles Hobson, Frank Jewett, Robert Mirandon, Brian O'Doherty, Jerome Silbergeld, John Stevenson, and Duane Zaloudek.

I am grateful to the estates of Wyndham Lewis and the late Alistair Cooke for permission to publish materials from them.

I would also like to express my admiration for the writers who have also tried to find Iris Barry. I am but one among several, including Mary Lee Bandy, Missy Daniel, Raymond Haberski, Leslie Hankins, Bruce Henson, Doug Herrick,

Jeffrey Meyers, Jolene Slonim, and Haidee Wasson. We have attempted the impossible, as this book may well attest.

Finally, my literary agent, Sam Fleishman, a former professor of cinema at Hunter College, recognized upon reading this book's manuscript that the project required excellent editorial hands, and accordingly steered me to Jennifer Crewe, Associate Director and Editorial Director at Columbia University Press. Her assistant Kathryn Schell, copyeditor Roy Thomas, designer Lisa Hamm, and associate publicist Derek Warker all brought their particular talents to the project. Most of all, I would like to thank my wife, Patricia Failing, whose intelligence and good humor have made this work delightful.

Lady in the Dark

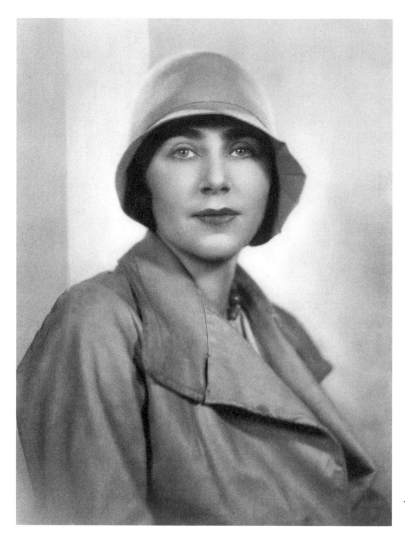

Portrait of Iris Barry by Sasha (1929).

PREVIEWS

On the first of August 1935, Iris Barry addressed a glittering crowd assembled at Pickfair, the Hollywood mansion of cinema megastars Mary Pickford and Douglas Fairbanks, inviting their involvement in establishing a film library at the Museum of Modern Art. Pickford had been a movie star even before her name appeared in credits, when the plucky, curl-topped character she portrayed was known simply as "Little Mary." Fairbanks was the handsome, kinetic star of the original *Robin Hood* and *Thief of Baghdad* movies. They accepted an offer to host a dinner party on behalf of John Hay Whitney, board chairman of the new film library and the man who introduced Technicolor to Hollywood. The guest list included illustrious figures from in front of and behind the camera, among them Charlie Chaplin, whose Little Tramp character was known the world over; Mack Sennett, creator of slapstick comedies that set an industry standard for zaniness; Lewis Milestone, director of *All Quiet on the Western Front*; Walter Wanger, the producer whose films had launched the careers of the Marx Brothers and Greta Garbo; and the cartoonist Walt Disney.

After dinner Whitney introduced the new director of the film library, 27-year-old John E. Abbott, Iris Barry's husband. Abbott was a meticulous man whose Wall Street brokerage experience impressed the founders of the Museum of Modern Art. He looked the part of the Wall Street banker, tall and tuxedoed with slicked-back hair and wire-rimmed glasses. He spoke briefly about the drawbacks of leaving film preservation up to the producing companies. Why not turn your valued images over to a museum equipped to take care of them? he asked. Why not circulate your films to new audiences at colleges and universities? To those in attendance whose reputations had been made in more mundane circumstances—often in the flea-pit cinemas of the urban poor—the Museum of Modern Art seemed a step up indeed.

When Abbott turned the podium over to his wife, the film library's new curator, few in the crowd could have known that the speaker was an established writer whose poems had appeared in the pages of *Poetry* and other prestigious magazines, attracting the attention of Ezra Pound and luminaries of the post–World War I British avant-garde. They did not know she had lived in Bloomsbury among artists and writers such as T. S. Eliot, William Butler Yeats, Wyndham Lewis, and Ford Madox Ford, or that she was the mother of two children born out of wedlock with the eccentric Mr. Lewis. They did not know of her pioneering work as a film critic for the *Spectator*, or that she cofounded the influential London Film Society in 1925.

The crowd at Pickfair did not know these things because polite society did not inquire about them. Women were not expected to be powerful or to lead influential professional lives, and matters of maternity were considered strictly personal. Barry was skilled at keeping her past to herself and minding her appearance. With her clipped British accent and sensible attire, she easily could have passed for an Oxford graduate from the upper social echelons. Who would have guessed she was a convent-school dropout born in a farming outpost of Birmingham, daughter of the noted Madame Pandora, gypsy seer from the Isle of Man?

Looking splendid in paisley silk, her dark eyebrows arched and brown hair neatly coiffed and fashionably short, Barry won over most of the stars and studio moguls that night. She appealed to their desire for immortality, telling them how regrettable it would be if future generations knew nothing of their cinematic achievements. She was prepared to rescue them from this fate, if only they would lend her their films.

Walt Disney eagerly offered to cooperate, although he was skeptical about museums and wondered if Pablo Picasso was an artist. Harold Lloyd offered his films. Charlie Chaplin played coy for a while, but eventually allowed his works to be deposited at the Museum. Pickford, who produced and owned her own films, offered some titles but decided to hold tightly to others, even if she would miss out on future audiences. Walter Wanger and other producers made agreements with the Museum to circulate their films and store preservation negatives for future safekeeping.

After Pickfair, Barry and Abbott traveled to the archives of Europe and the Soviet Union, convincing their leaders to exchange films with the Museum. As a result, cinema students before there were university film departments began to study and appreciate films. For this effort Iris Barry was named Lifetime

President of the International Federation of Film Archives, an organization she cofounded in 1938.

As the Museum of Modern Art's first Curator of Film, Barry was essentially an architect. Her vision went beyond expressing points of view about particular films to the deeper infrastructure of a world she was engaged in building. This complex of museum film programs, film societies, preservation archives, specialized film theaters, independent film distributors, and degree programs in film is now familiar to us. Iris Barry, who was born when the movies were born and worked to legitimize film as an art form throughout the first half of the twentieth century, was a central player in this construction. She was not alone, of course, nor was she necessarily the first to do what she did. She was not always consistent in her vision. But where she may not have been the first, she was steadily the most consequential. In 1915, American writer Vachel Lindsay published one of the earliest books making the case that film was an art. Iris Barry followed in 1925 with her more comprehensive *Let's Go to the Pictures* and cofounded a flagship film society as well. C. J. Lejune preceded her as a female writer on film in the London popular press, but Barry wrote for journals that artists and intellectuals looked up to, making a persuasive argument that film should be taken seriously.

What Iris Barry achieved was to lay down an infrastructure for the film component of what philosopher Arthur Danto has termed an "art world." Weighing in on the controversy about how to define the limits of "art," Danto approached the question by positing that art might be anything an "art world"—the world of artists, curators, critics, collectors, and patrons of art—recognizes it to be. Barry was an architect of the film component of the art world, and this is the core of her contribution.

When she began to study film in London in the 1920s, the motion picture was regarded as lower-class entertainment. From cold-water flats in ethnic neighborhoods, viewers flocked to cinemas to laugh at the foibles of Charlie Chaplin, Buster Keaton, and Harold Lloyd. Iris spent many hours in these dark pits, sometime accompanied by Wyndham Lewis or sent there by him to get her out of the way while he saw other women. Iris first met Lewis in 1917 through their mutual friend, Ezra Pound, who had corresponded with and mentored Iris as a poet, passing on to her the philosophy of writing he would later publish as *The ABC of Reading* and *Guide to Kulchur*. While living with Lewis, in discussions with him and through her own observations, she began to formulate a view that cinema could be a significant medium of artistic expression. As she plied her

early career as a film critic at the *Spectator* and the *Daily Mail*, it became her responsibility to make the case that films—especially British films—were not to be taken as a mere amusement but instead bore marks of a new and influential art form.

This phase of her career coincided with a dawning awareness that the medium she was dealing with was vulnerable. The cellulose nitrate film stock invented by George Eastman was physically flexible enough to pass through the curving spools of a projector, but from the day it left the factory it began to deteriorate. Oxidation commenced immediately and accelerated with age until the film stock became volatile. Movies stored in metal cases and left in the sunlight at the back doors of theaters were sometimes known to explode. Early attempts at archiving films led to major fires. Exit lights became mandatory in film theaters and fire marshals were called upon to certify theaters as safe. Barry would soon lead a campaign to raise industry awareness that ephemeral motion pictures were deserving of protection and should be kept for posterity.

Barry became concerned with preserving this new artistic medium in the mid-1920s, just as exemplars of the new art form were cultivating their first audiences. In America the ever-ambitious D. W. Griffith had earlier gained notoriety for implementing narrative and dramatic effects of scores of techniques such as the close-up, flashback, flash-forward, parallel editing, screen masking, tinting, musical accompaniment, and the myriad applications of the mobile camera. Griffith had shown that film distribution itself could be an art, accompanying his films with posters, lobby cards, previews, fan magazines, and contracts facilitating state-by-state distribution to reach the largest audience. Barry saw Griffith's work in its infancy, and watched as it blended with the innovations of German and Russian filmmakers such as Friedrich Murnau, G. W. Pabst, Sergei Eisenstein, and V. I. Pudovkin. Before there was a canon of great films, she studied the gliding camerawork and minimal intertitles of Murnau's *The Last Laugh* and the incandescent achievement of Charlie Chaplin in *The Gold Rush*. Between 1924 and 1930, in numerous magazine and newspaper articles and in her 1926 book, *Let's Go to the Pictures*, she looked with fresh eyes and saw that what these filmmakers were doing was an art.

Barry faced a further challenge as the twenties came to a close. Motion pictures learned to talk. Much of what she and others had learned to think about film had been identified with the silent cinema: the empathetic subjectivity of events viewed through a character's eyes—the longing for respect of Emil Jannings as an imperious doorman reduced to the status of washroom attendant in *The Last Laugh*, for example; the ubiquity of a mobile camera floating across

a set identifying significant objects; the immediacy of music played without dialogue, giving a direct sense of mood or wish or dream; the visual clash of montage in Soviet cinema. All this seemed threatened by sound. Characters whose inner states revealed themselves easily in images could be reduced to mere verbalizers of emotion. The floating cameras of German film might have to be anchored to one place, encased in a soundproof box to serve the needs of the microphone.

Barry took these changes in stride. She kept her eye on her central goal, to find audiences for good films, however they might be made. She had come to appreciate some of the foundational needs for the new art form—that film must be understood through study and comment, preserved for posterity, and presented to the public in quality programming with informative program notes. In short, she began to envision filmgoing as an institution, moving beyond small cine-clubs and into museums.

The opportunity to cofound the London Film Society in 1925 gave Iris Barry the chance to place innovative films before a new audience. Her experience there formed the basis of her later programming style at the Museum of Modern Art. She and her London colleagues, Ivor Montagu, the naturalist-turned-filmmaker, and Sidney Bernstein, who owned a circuit of theaters in England, hoped the model established by the London Stage Society could be transferred to their organization. The Stage Society was founded to introduce Londoners to recent and challenging dramas. As a private subscription group exempt from censorship by the Lord Chamberlain's office, the Stage Society could be adventurous. The Film Society founders expected their program to be similarly protected, allowing them to bring controversial films into the country and exhibit them free of interference. Although this did not always prove to be the case, the London Film Society was wildly successful and became the prototype for the later British Film Institute and film societies throughout Europe and the United States.

Iris Barry was "sacked," as she put it, by the mighty *Daily Mail* in 1929. It seems she failed to appreciate the cinematic charms of an actress her boss, Lord Rothermere, had treated to dinner the night before and assured of a favorable review. Additionally, Rothermere felt she was not playing her assigned role of championing British films over their American competitors. Barry decided to move to the United States, bringing along her first husband, the Oxford poet Alan Porter, literary editor of the *Spectator*. Barry and Porter struggled in Depression-era New York for the better part of five years, the wolf never far from the door. She published occasional articles about America for readers

back home (a role later taken up by her friend, Alistair Cooke), edited a book on Afghanistan, and ghostwrote a directory of dreams under the pseudonym "Jonathan Westerfield." Porter taught English at the New School for Social Research. In the early thirties he joined the English department at Vassar College, remaining there after his divorce from Iris in 1934.

Also in the early thirties Barry was taken in by a circle of emerging modernists in New York. Bright young men and women from Ivy League schools such as Harvard's dance-minded Lincoln Kirstein and the young architect Philip Johnson; the Princeton-educated Alfred Barr, Jr., Director of the new Museum of Modern Art; the composers Paul Bowles and Virgil Thomson; the theatrical producer John Houseman; and the Vassar art historian Agnes Rindge all regularly attended a Sunday salon held at the home of Kirk and Constance Askew. Kirk Askew was the New York representative of London's Durlacher Brothers, leading art dealers at the time. Iris had heard of the Askews through her friends, the actors Charles Laughton and Elsa Lanchester, who would be invited to the Askews when in town. As she was introduced to the salon, Iris was befriended by Philip Johnson, who bought her a new dress and found her a job, without pay at first, at the fledgling modern museum. She was to be its first Librarian. Although she had no library training, she once had worked as a secretary to Arthur Waley, who developed a library at London's School of Oriental Studies. Iris promised to take some library classes. Johnson helped out with a small stipend.

The friendships she formed at the Askews, begun in the casual banter of cocktails in Depression-era New York, sustained Iris Barry throughout a life lived before the era of government safety nets and Facebook pages. They led to a long skein of lively correspondence and some surprising acts of kindness.

At the Museum of Modern Art, Iris Barry flourished. At first she "set her cap," as curator Dorothy Miller put it, for Alfred Barr, the Museum's director. Barr, however, was notoriously abstemious and already married to the art historian, Margaret Scolari. Iris settled for John E. "Dick" Abbott, then working on Wall Street and living with a roommate in the apartment above hers in the neighborhood of the Museum. Abbott liked film and was discontent with Wall Street life. With Abbott, Barry began to lobby for a film department at the Museum, a function already envisioned by Alfred Barr. Together they researched its feasibility through a grant from the Rockefeller Foundation, and in 1935 a new film activity grew out of Iris's library work, the Museum of Modern Art Film Library. Abbott was made Director and Iris its first Curator.

The new library brought with it the possibility of adding film preservation to Iris's list of structural requirements for sustaining film as an art. She realized

that now she might combine film preservation with distribution, especially if she could convince the holders of copyrights to allow her to keep preservation materials and make copies to be circulated to college campuses. This goal is what brought her to Pickfair in 1935. She subsequently launched a study program at the Museum and an exhibition program in a theater built especially for film. With Abbott she developed a film study course at Columbia University that served as a model for future academic programs.

Thus began the most productive years of Iris Barry's life. The Film Library was established as a separate corporation with its stock wholly owned by the Museum, and though the two were legally separate, they were never truly independent. Throughout the late thirties Abbott curried favor among influential trustees and became part of a network of aspirants for the power vested in Alfred Barr at the Museum. Eventually Abbott assumed most of the administrative power Barr originally possessed. The powerful role Abbott played in the Museum's operations and development in the early 1940s is a little-known chapter in the history of the Museum.

It is widely assumed that Alfred Barr was "fired" in 1943 by Museum board president Stephen C. Clark, heir to the Coats and Clark and Singer Sewing Machine fortunes. Looking at Barr's tenure from the vantage point of the Film Library, however, we can see that Barr's troubles began much earlier—that he sustained numerous coup attempts, both known and unknown to him, and that the crown never rested securely on his head.

Several historians have analyzed the "politicization" of the Museum as a Cold War phenomenon, when Alfred Barr helped to provide a theoretical framework for understanding American Abstract Expressionism as related to Western democracy. But following Barry's career reveals that the politicization of the Museum began much earlier and was centered in the Film Library. From his first days at the Museum until his death at the age of 43 in 1952, John "Dick" Abbott enjoyed the support of Nelson Rockefeller, son of Abby Aldrich Rockefeller, a cofounder of the Museum. Abbott did Rockefeller's bidding and provided the link between Rockefeller's political agenda and the Museum's programming. Through Rockefeller's Office of the Coordinator of Inter-American Affairs, Iris Barry and her Film Library staff spent the years before and during World War II in service to the U.S. Government. They led a propaganda campaign against Nazism in Latin America and worked closely with the Office of Strategic Services, precursor to the Central Intelligence Agency. Barry and her staff facilitated the *Why We Fight* documentary series, which was responsible for the recruitment of thousands of soldiers near the end of the war.

After the war the Film Library led the effort to build a national film collection at the Library of Congress. Ironically, the Film Library at MoMA was constantly under threat from right-wing detractors who saw Iris and her staff as a cadre of Bolsheviks. Among the snipers were the film historians Seymour Stern and Terry Ramsaye and the film director Iris immortalized in her 1940 book, *D. W. Griffith: American Film Master*. Their attacks damaged the careers of her longtime staff members, Theodore Huff and Jay Leyda, as well as the celebrated filmmaker Luis Buñuel, whom Iris had hired to translate propaganda films for Latin American audiences.

At the war's end Barry faced a time of ambivalence at the Museum. Her marriage to Abbott, long the source of tension between Iris and others on the staff, fell apart. Abbott gradually was replaced in influence by Rene d'Harnoncourt, who brought tact and diplomacy to his role as the Museum's new director. Iris found herself waylaid by medical problems and was diagnosed with cancer in 1949. She disappeared from New York in 1950, abandoning the small apartment she had been lent by Constance Askew after her marriage to Abbott collapsed. She later was seen at Cannes on the French Riviera, where at a dance club she attended with a French olive oil smuggler named Pierre Kerroux, she was abducted at gunpoint by a Corsican gangster and whizzed in a sports car on the curvy roads above Antibes. With Kerroux, she spent all but the last year of her life in the small French village of Fayence, living in a tumbledown seventeenth-century townhouse owned by Wadsworth Atheneum Director A. E. "Chick" Austin, whom she had met at the Askew salon.

Many who knew Barry thought that she severed her relations with the Museum in 1950. On the contrary, she retained a position with the Museum until her death in Marseilles in 1969. Her ties to MoMA, and especially to its cofounder's son, Nelson Rockefeller, sustained her through years of struggle for survival and brushes with the government over politics and passports. Iris never really left the Museum.

Iris Barry is buried in an ordinary grave in the cemetery on a hill above Fayence. A marble slab states simply "Iris Barry—1895–1969." There is no mention of her accomplishments. But the film world she helped to construct remains her enduring legacy. When the Film Society of Lincoln Center opened in 1962, it honored Iris Barry as a founder not only of the London Film Society but also of the Film Department of the Museum of Modern Art, cosponsor of the festival. When the American Film Institute was created in 1967, it derived its structure from a Stanford Research Institute report recommending that AFI undertake

the same preservation, exhibition, education, and distribution functions Iris pioneered. In a sense this world, the world of film, is Iris Barry's monument. For her part she accepted credit for only one achievement. If there was a single thing she was proud of, she said toward the end of her life, it is that films are "*dated*, like wine."

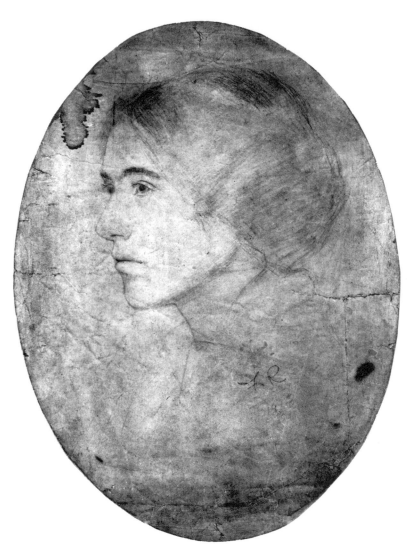

Portrait of Iris Barry as a teenager, artist unknown.

(IBP, MoMA Dept. of Film, NY)

1

EARLY YEARS

IRIS BARRY WAS born Iris Sylvia Symes in Washwood Heath, a farming outpost of Birmingham, England, on March 25, 1895.[1] Her father, Alfred Charles Crump, was a brass founder whom her mother, Anne Symes, also known as "Acie," divorced in the first case in English law in which a wife complained of having contracted a venereal disease from her husband.[2] Being divorced left her mother, Iris later recalled, "in a most ambiguous position, like or worse than that of a 'fallen woman.'" Her mother nonetheless "vigorously rode a bicycle and went incessantly to weddings and picnics with a horde of young people her age, a gay but circumspect divorcee very welcome among them because she was a sublime cook of such things as a lady *could* cook . . . the lightest pastry, the most delicious cakes. I think my mother was, at that time, a lady and kept some trace of it no matter what circumstances befell her later."[3]

Her parents' marriage ended two years before Iris was born. Although this chronology may raise some doubts about Iris's paternity, and his name is not listed on her birth certificate, it was nevertheless the custom in her family to acknowledge Mr. Crump as her father.

Following her divorce, Iris recalled that her mother "went to work for the local squire, who had gone into the then-quite-new business of manufacturing motor cars; the mark, I think, was Woolsely. She was sort of manageress and head-typist of his firm. That must have been around 1905." After having "passed rather lightly through a Roman Catholic phase," her mother "took up with mysticism, cartomancy, etc. She gave five hundred pounds to an Arab from Cardiff to teach her astrology" and "sold nasty, tired underwear and garments to the too-hopeful wives of distressed curates," an activity that immensely depressed Iris and caused her to hope her schoolmates would not hear of it.[4]

Iris owed whatever stability she knew as a child to her maternal grandparents, Henry Symes and Anne Barry Wharton, the source of her surname, who lived placidly on the dairy farm where she was born. In Iris's estimation it was a "middle-big farm" and the family was not always poor. Her grandparents met while performing charitable works such as teaching reading and writing in the evening to children otherwise employed in Dickensian workshops during the day. "Eventually by hard work and Christian endeavor etc.," she recalled, they became fairly prosperous and took control of the farm, part of which they owned and part they leased from a local lord. They tended as best they could to the education of their granddaughter and coped with the ostracism their daughter suffered due to her divorce.[5]

At age five Iris was sent to a village school run by an elderly Danish woman with silver corkscrew curls. Iris was expelled because she said the lady smelled bad, an episode from which she later claimed to have "learned then, and known ever since, how unfair the world is."[6] There followed three years of staying at home and doing lessons, assisted by her grandmother and her great aunt Agnes, a schoolteacher and devout reader of the Bible. At the age of eight Iris was sent to King Edward VI Grammar School in Birmingham and finally, at age eleven at her grandparents' expense, to the Institut de St. Anges, an Ursuline Convent in Verviers, Belgium, where she was one of thirty boarders.

Iris chaffed at convent life. She disagreed with its "customary rigours and disciplines, unremitting surveillance in bath with concealing chemise, in bed with drawn curtain and hands neatly crossed well outside the sheet." She disliked its smell of floor polish and thought overbearing the nuns who skated on pads to shine the floors. She did not like the convent's "outdoor privies with heart-shaped holes cut in the door where every gesture, posture, whisper were observed and weighed towards the all-important mark for comportment given at the term's end." To her it seemed odd that "obedience and tidiness were held as important as marks for lessons."[7]

"Needless to say," she recalled, "there were no movies in convents: not even books were allowed except of course *From Metternich to Bismarck* and Fleury's *French Grammar* and so forth, though for some reason I was permitted to retain a copy of *Imitation of Christ* and, more remarkably, *The Poems of Sir Walter Scott*—a prize awarded, perhaps?" Otherwise her convent years transformed into memories of "the particular delights of the month of May in the flowery convent garden (how the pebbles hurt one's knees, praying before the Virgin's garish statue) or those of frenziedly picking wild strawberries on the roadside hedgerows when we were allowed to 'break' the Sunday crocodile walk on a summer

afternoon."[8] Despite her discontent, convent life provided the closest to a formal education Iris would ever know.

In 1911, Iris's friend Ivor Montagu later recalled, "when Iris was getting on for 17, a party of girls, escorted by a nun, came over from Belgium to sit for Responsions [entrance exams] at Oxford. Iris passed, and all seemed set fair. But now occurred one of the series of ups and downs of which she met not a few in her life, and overcame. At that time, and indeed later also, Oxford colleges did not favour intake at so young an age. Iris was to wait two years, and it was arranged for her to spend this time in a flower shop in France, supposedly 'learning the language.' This turned out to mean, as one might have guessed, working as an apprentice shopgirl. The 1914 war intervened, Iris had already come back from France, but the war had hit her grandparents so that Oxford seemed impossible, and the budding literary student studied typing and shorthand instead and obtained a temporary wartime post in a Birmingham post office."[9]

Iris had left the convent by mutual agreement with the head nun, who found illicit books belonging to another girl under Iris's pillow. The Mother Superior threw them into the fireplace. Iris refused to snitch on her friend, and that was the end of her formal education. She later said she "wasn't being noble, I was just damned well fed up. I was eighteen and I had already missed so many things going on in the world I was afraid I'd be too old to enjoy them by the time I finished school."[10]

Back at home with her grandparents, Iris was moody and disconsolate and longed to get away. She began to write poetry, which eventually led to her first publication. A poem entitled "Double" appeared in the July 1916 issue of *Poetry*, the Chicago magazine founded in 1912 by Harriet Monroe.

Through the day, meekly,
I am my mother's child

Through the night riotously
I ride great horses.

In ranks we gallop, gallop,
Thundering on
Through the night
With the wind.

But in the pale day I sit, quiet.[11]

In the same issue another of her compositions appeared:

The Fledgling

The fire is nearly out,
The lamp is nearly out,
The room is untidy after the long day.
I am here, unhappy,
Longing to leave the hearth,
Longing to escape from the home.
The others are asleep,
But I am here, unhappy.
The fire is nearly out,
The lamp is nearly out.

Iris also amused herself with books, "endless books." She read Voltaire and took to heart his skepticism of religion. Nietzsche and Yeats comprised the bookends of a wide spectrum of youthful reading, but it was in the cinema and music hall that she found the purest pleasure. Every Monday her mother would take her into Birmingham to a matinee.

"This she seemed to regard as educational," Iris recalled, "and so it was if not in the conventional sense. For here one saw Vesta Tilley and Sarah Bernhardt and Anna Pavlova and Chinese jugglers and others. One gleaned from the audience's laughter as much as from the patter of George Robey a whole harvest of glorious gross sexy humor. As this was my only instruction as to the facts of life except that gained from books . . . this was clearly invaluable. And moreover at the end of each performance there were movies—newsreels and quite a lot of them—before God Save the King."

In the glow of music hall films Iris received lasting impressions of "passionate snake-tressed ladies rolling tragic eyeballs (Italian), dressy young persons in boudoir caps making their way upwards in society (American) and deliriously funny trick films (French). There must have been British films too, but of the sheep-and-water or Dickensian sort. The overwhelming experience, however, the really eye-opening, heart-compelling one was the appearance in Birmingham of a feature-length French version of *Les Miserables*. This *was* a film, and although I have not seen it since there are images of it as vivid as ever. When I saw this film I had really had it and henceforth nothing stood higher or pleased more than film."[12]

Also during summers at home in her self-schooling years Iris experienced the love and loss typical of adolescence. As much as she enjoyed the romances of her childhood, she also learned very early "the sting of farewells." Many young men were going away, after 1914, to war. "They had been nobility and graciousness itself," Iris later recalled. "They had set me to ride on the wide backs of horses, explained the nature and management of the good-smelling fodder, seemed to enjoy kittens . . . and come to say good-bye. Long after they had gone I believed in their promises—promises to grow rich, to write to us. They never wrote."[13]

Young men she knew seemed to vanish as mercurially as the subject of a poem she titled "Lost":

When the boy knocked on our door, looking in,
We remember now that we spoke to him timidly,
Kept him waiting on the porch,
While we busied ourselves within over a fitting reception

When we called to him,
We found the porch empty.
Hop-vines and ivy trembled there,
A frame lacking its picture.
Nor can any tell us
whether he ran along the road or the field path.[14]

Iris was beginning to sense that men in her life could not be relied upon. Her father had abandoned her, and did not support her or her mother, and her mother increasingly ceded parental responsibility to her own parents. Iris's grandfather seemed passive, and her grandmother an embarrassingly rough and rural figure. Iris felt left to her own devices. She began to wonder what else the war might bring.

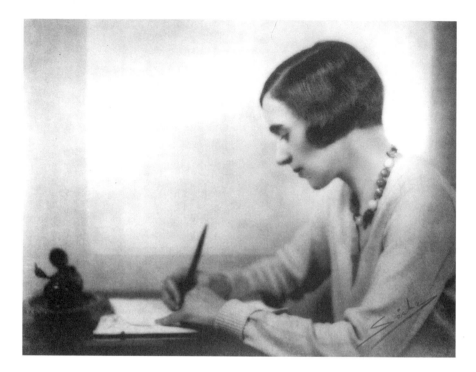

Iris Barry as a young writer (c. 1917).

2

"WE ENJOYED THE WAR"

WHEN WAR BROKE out in 1914, Iris took a job as a typist at ten shillings a week in a dismal pen factory, from which she was summarily fired. She then answered an advertisement proclaiming "intelligent girls wanted for government service." The upshot was employment at the General Post Office, a tiresome clerical job having to do with telephone poles. "Everyone," she later told her friend, the novelist Edmund Schiddel,[1] "had pimples and talked smut." Having heard more money was to be earned there, Iris transferred to the Ministry of Munitions, "typing endless huge sheets of figures" that "went up every night to Winston Churchill personally," so there was "no mistake possible." On her own time Iris continued to write poetry, and when she received a check for fourteen pounds for poems published in *Poetry* magazine, her grandparents, who had hoped she might follow her Aunt Agnes's example and become a schoolteacher, decided that they might as well let the child have her way.[2]

Meanwhile, Iris was becoming aware of the domestic effects of World War I. "The actual declaration of war gave everyone a moment's pause," she recalled in 1934,[3] "but what comes back to me most vividly was the indignation of my family when gold coin was called in. My grandfather kept a boxwood bowl three-parts full of gold sovereigns in a cupboard in the small parlor. From this he paid out weekly the wages of his farm laborers, and tradesman's bills. Small daily expenses were met by my grandmother out of a majolica mug full of silver. There was a protracted family brawl when my mother insisted on paying a draper's bill in gold, and I remember in rather a confused way bursting into tears myself in the middle of the argument, because I thought we would not have any more money. Money was gold. But we soon grew accustomed to the new paper bills—the first I had ever seen except for occasional birthday gifts of a five-pound note. And as a matter of fact the paper bills began to be rather plentiful.

"My grandfather was a farmer and farmers have never hated war. The price of wheat and hay went up: pigs fetched a good price and so did butter. The sons of many farmers we knew were sent abroad almost at once, since they all belonged to the Yeomanry. If you were a soldier, you took part in cavalry action and got killed, probably very gloriously. The many reproductions of battle-paintings that hung in all our homes had firmly implanted this idea in us since early infancy. And sure enough, by the winter of 1914 most of the farmer-boys were dead somewhere far away in the East, including a fifteen-year-old bugler called Alf, with whom I had recently been playing games. No one was surprised and there were no demonstrations of grief. The bereaved families became more and more prosperous, and this class in England is well accustomed to losing sons on the battlefield. They had lost many in the Boer war, several on the Indian frontiers since; and farmers have large families" (280).

So although the eligible men in her life were dying on the battlefield, Iris nonetheless recalled that "the majority of my countrymen and women experienced nothing of the kind. We enjoyed the war" (279).

"It was not clear at first whether we had to expect a short decisive series of skirmishes, or a real war like the Napoleonic," she remembered. "By the autumn it began to look like the latter. Young men were enlisting 'for three years or the duration,' which delighted everyone with its air of British thoroughness. The rest were quite content to pursue 'business as usual.' The city of Birmingham, beyond whose suburbs we lived, raised three volunteer battalions, maintained, equipped, and trained at the city's expense. The uniform was a nice navy piped with red. All of the young men had been well grounded in the idea that being a soldier was a fine thing, like being a clergyman or an explorer—and preferable to going into an office.

"All this enlisting and flourishing of bayonets seemed the most natural thing in the world. . . . My uncle was a soldier, my great-grandfather had been a soldier, elderly colonels had patted me on the head, given me candy, and helped me to steal apples. . . . I would have chosen to be a soldier myself had I not unfortunately turned out to be a girl: the scarlet coats were so dashing, and at that age the idea of a short life and a gay one seems particularly attractive. Who would not rather have been with the Light Brigade than have become a successful grocer?" (280).

Iris recalled the summer of 1915 as "most agreeable. There was much activity and excitement. Factories were humming, new factories were being built. Belgian refugees, whom without exception we all detested personally, were, as necessary allies, boarded out in the neighborhood and provided us with an

inexhaustible topic of conversation. We were too polite to ask them outright if they had been raped or if their babies had been crucified. Girls older than myself were breaking away from home in the most alluringly novel manner, joining organizations called the Women's Volunteer Reserve which had its own uniform, training as nurses, getting curiously well-paid government jobs" (280).

"By the fall of 1915," she recalled, "all the biggest boys from the High School who, of course, had all been in the Officer Training Corps, were in process of becoming real officers and growing little moustaches. We others became very critical of the cut of the British warm, as the topcoat was called, and very facetious about the sword, which each officer had to purchase. In the evenings groups of them with schoolgirl friends used to invade a certain cafe in the city that sold good chocolate éclairs and after filling up with sandwiches, cookies, and cups of tea, repaired to the movies next door. Nothing could have been more remote than the actual war. I was learning Russian, instead of the German I would have taken but for the hostilities. All of us were full of enthusiasm for Russia, sang the Russian national anthem at every opportunity, read *The Brothers Karamazov* and had utter confidence in the Russian 'steam roller.' The immense carnage of Tannenberg the previous year, the loss of two army corps and almost a hundred thousand prisoners had been quite disregarded by every one. Thousands of Russians had been killed ('such things must be, after a famous victory') but there were hundreds of thousands more loyal moujiks who would continue to roll forward in an endless wave until Germany had been nipped between them and us. Everybody knew that Russian troops en route for France (who, of course, were wholly mythical) had passed through England in railroad coaches with every shade drawn down. How thrilling it all was! And then there were the Zeppelins, too. By combining what we saw in the papers with rumor, we judged that quite a few people had been killed in the south and along the eastern seacoast. We proudly believed that the Zeps were really aiming at us, because of our many munitions works, rifle factories, and so on. A Zep did actually pass over us once, groping its way through the dark night on its way home from London: but nothing happened." The zeppelins "were just a part of the 'frightfulness' we had been taught to expect of 'the Huns,' they were comic and nasty like a sausage or a dachshund and when they did drop bombs, they always killed little babies. And we on our side kicked and chivvied any dachshund we saw on the streets" (280).

The war was filled with horrors in its front lines, but tales to that effect took time to reach the home front. Meanwhile the same war that introduced a new and terrible mechanization also called for troops and horses to be fed

and billeted. As a result, Iris wrote, "we were all getting rich, or richer. The unemployed of pre-war days who used to parade in gaunt bands had now disappeared: they were all in the army and their wives and children instead of starving were getting allowances from the government and finding employment for themselves. Wages were rising steadily. This was the time when silk stockings, hitherto worn at parties only, came in for daytime wear—and flesh-colored ones at that. Underwear ceased to have sleeves, corsets went out, the habit of spending and of living for the moment came in. Our mothers had gone boating, but we took a phonograph along as well.

"All the schoolboy friends had gone to France, so that the casualty lists in the newspapers took on a new color of reality. We used to send pork-pies and cigarettes to them; they also sent gifts back. The first pair of silk pyjamas I ever saw was sent as a gift from the front, and I myself even received a present of three pairs of woolen bedsocks from a soldier, because in the winter of 1916 he had heard of the coal shortage at home. But when the same young men came home on leave, bearing used shell-cases and German helmets, we were so glad to see them, they were so eager to go to the theater and get up dances and go for picnics that there never seemed time to talk about the war. We did not believe what we read in the papers, because obviously if we had as many victories as the press claimed we would have been in Berlin by then. I don't remember how it was I gathered it must be pretty awful in the trenches. When Mrs. Taylor's boy came home, she hung his khaki out in the garden to air and it was suddenly alive with lice that hatched out in the sunshine. Another time when we were going off early canoeing on the Avon, I called a friend who was staying in the house during his leave. He leapt out of bed the moment I touched his shoulder, gripped me by the neck, and was trying to choke me before he realized where he was. That gave one ideas" (281).

Iris's recollections of the First World War, though fraught with her growing dread that the cause might be vainglorious, reflect a nascent feminist sensibility, both irreverent and perceptive. She appreciated the gains women made during the war, and from her writing we can infer that many of the changes in dress, employment, and public behavior typically associated with the 1920s' Jazz Age began much earlier. Left to her own devices in a small rural community, however, Iris harbored a desire to get out of town. An unexpected opportunity soon presented itself. Her writing attracted the attention of an artist who would come to play a pivotal role in her life. Ezra Pound, ever vigilant for promising young authors, noticed her work in *Poetry* magazine. In 1916, an eventful year in Iris's personal life, Pound decided to offer his services as mentor.

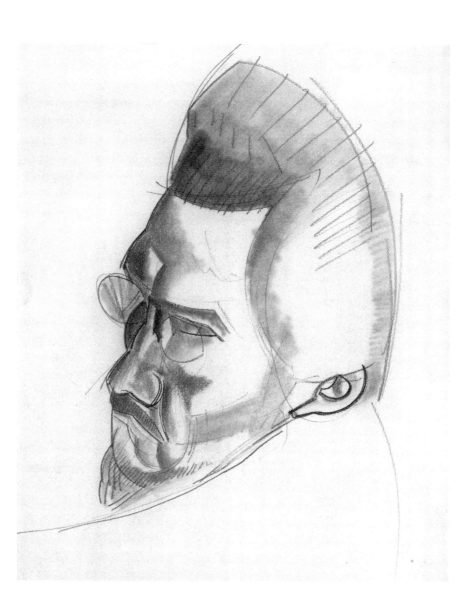

Wyndham Lewis, *Ezra Pound, Esquire* (1919).

3

"DEAR MISS BARRY"

IRIS'S GRANDMOTHER DIED in 1916. Iris recalled that "the saddest thing for me, apart from the selfish regret at her absence, was that she had never seen a Charlie Chaplin film. It is true that she had not been outside the house for years, and had always refused to ride in an automobile or to be photographed, but there were so many other things that she *had* enjoyed—lavender and hedgehogs, Bunyan and Handel (she sang Handel in a vigorous soprano while pottering around the resonant tiled dairy) that it seemed especially necessary that she should also at least once enjoy the best of all new things, the incomparable Charlie.

"Though the best of him was yet to come—*The Pawnshop, Shoulder Arms, The Pilgrim* and *Monsieur Verdoux*—young people everywhere had fallen upon his brief comedies in their local cinemas and taken the little Englishman to their hearts, singing blithely 'The moon shines bright on Charlie Chaplin.' Subtle and divinely vulgar, timing to a hair's breadth, Charlie had utterly enchanted us: and alas Grandma had not seen him."[1]

Iris's grandparents were among her few assets as a child. They not only provided some measure of financial stability, but were also the source of the only reliable home and family she knew. Iris's mother had remarried, "was off on a thousand money-making projects," and generally remained distant. For her concept of her father Iris depended upon her mother's recollections. "My mother said 'your father never did anything for you, though you had a little money-box like a red letter-box and he often gave you a three-penny piece to put in it,'"[2] she recalled near the end of her life. The idea of having pennies forced into a box as a sign of recognition left her, she said, with "a sense of disappointment" and a "desire for money without much hope for it." This remembrance is bound up with another dreamlike image in which she could "dimly remember a drawing-room with an immense standard lamp with a rose

pleated silk shade and my mother lying on a sofa there and being afraid because the door was opening and she said, 'Here comes your father.'" This was a fearful thought to Iris, "though of what I could not know or say." She "grew up to hate" her father for having done "nothing for one except sometimes contributing (pushing) three-penny bits into my little money box." Her mother disliked him too, especially, according to Iris, "walking abroad with him because he could not resist looking back over his shoulder at every woman they crossed."[3]

It is clear that by the time she was twenty, Iris had come of age with little but contempt for her father and at best an intermittent relationship with her mother. These youthful experiences undoubtedly affected her personal relationships later in life, and also presage another aspect of her sensibility: a persistent nostalgia for the farm. Absent her parents, she became attached to her grandparents, especially her grandmother, about whom in 1924 she sketched an affectionate verbal portrait in the *Adelphi* magazine. The portrait indicates that Iris was more deeply impressed by her rural background than her later and more urbane lifestyle suggests.[4] A recurring stress in Iris's life was her ambivalence toward urbanity: she needed the city to ply her chosen profession, but she longed for the simplicity of country life. More than once she would occupy a farm and eagerly attempt a return to nature.

"Grandmother's skirt was full and long," she wrote, "bunched over four or five petticoats, and a white apron buttoned at the waist fell over it. She made her own clothes, half a dozen skirts at a time, from the same roll of print with bodices to match. The set I remember, and so I suppose liked best, had a buff ground covered densely with small sprigs of fuscia roses, yellowrattle, and flowering currant. Gradually those bright flowers faded in the wash-tub. Then she made another six that had a black ground with tufts of yellow and mauve lilac clustered all over.

"My earliest memories lay in the folds of Grandma's skirt. Perhaps because it was on the level of my eye then, I remember best how she used to stand at the kitchen hearth, with her lame foot up on the steel fender and the skirt swaying as she stirred food in saucepans. And when she sat, always in the same place, bolt upright in the Windsor chair at the head of the kitchen table before the fire, her skirt made a great tent of refuge. When she shelled peas she let me eat the ones that tumbled down and hid under her hem. Once a mouse ran under her skirt: she caught it and threw it into the fire. The cats took refuge round her when Grandpa came into the house.

"All the life of the house was concentrated in the kitchen, a large irregular-shaped room, with a tiled floor. Five doors opened into it: the thick oaken

door, the only way into the house, leading from the yard: a door into the par-
lour in which my mother and aunt sat to sew or play the piano or entertain
their friends: one leading down the dairy steps, one leading up into Grandma's
[room], and one into the little parlour where the harmonium and the barom-
eter and the bookshelves and the china cupboard and the carriage lamps were
kept. Grandpa and grandma lived and ate in the kitchen, under the hams and
bunches of drying herbs hung from the rafters; the churning and ironing and
the kneading of dough and the cooking were done there, and there, of course,
I always managed to be too, to watch what went on. But at meal-times I went
away to eat with my aunt in the parlour, because the cowmen and the serving-
girl ate with my grandparents. . . .

"Then one day my mother said: 'Grandma won't get up again.' Her Windsor
chair stayed in the same place, but she never came to sit in it and no one else
ever sat there. I used to go every evening into her little white room looking on
to the garden, to say goodnight. The bedclothes lay flat as though no one were
there, she was so thin; her long big hands were folded on the sheet, her blue eyes
burnt, small and piercing still, from the hollow, greyish face under the pale hair.
Her lips moved constantly, for she repeated prayers and hymns to herself all
the day and most of the night. We could just hear the low murmur going on and
on. A great iron bell hung over her bed for her to ring in case she needed help.

"Later on a nurse began to come every day to wash grandma and dress her
bedsores, and grannie used to shriek and call to the Lord God to have mercy
and take her. It was very frightening and made us not want to eat. Then one
Sunday in June my mother told me to go to the chemist's to get a jar of honey
because grandma's lips were dry and cracked, and honey would be good to
moisten them with. The chemist's was two miles away. When I got back grandpa
was sitting in the armchair by the settee with his head hanging down and a
handkerchief on his knee. Mother came out of grandma's room and said: 'Your
grandmother died quite peacefully while you were gone.' So I went up to my
room and looked out through the iron bars of the window, wondering why I
didn't begin to cry. I could only think how much I wished I had asked grandma
to tell me far more about when she was young. . . .

"The funeral was three days later. Mother said grandfather would be hurt if I
didn't go in and see grandma before they put her in her coffin, so I went in alone
and stood at the foot of the bed. The face had a proud look, the lips were curled
down. They had tied a white bonnet on her head, and her rigid fingers, which
had not changed like the face, seemed to be just going to unstiffen and come to
life again. The room felt cold, and I was very much afraid.

"About noon relatives in black came, and when the men carried the oak coffin out and turned it round the corner where she used to sit, grandpa made a dreadful choking noise. Mother said: 'There, father, you know mother wouldn't have liked us to make a fuss,' and led him out to the carriage. I stayed home all alone.

"The honey I had bought from the chemist's we none of us ate. It stayed in the kitchen until it dried up and was thrown away."[5]

Her grandmother's death further loosened the ties Iris felt with Birmingham. She continued to work as a secretary and attend films in a squire's house that had been converted to a cinema, "a pleasant square Georgian affair that had first become the stronghold of a rag and bone merchant but afterwards emerged as a cinema," she recalled. "This for a long time was forbidden territory believed to be the haunt of fleas."[6] Delightful though it was, the cinema could only play counterpoint to the rigors of clerical work. Even before her grandmother's death Iris had begun to despair that she might go through life as a secretary. It was while working as a shorthand typist, however, that she received an inquiry about her poetry from the American writer, Ezra Pound, then living in London.

Pound, the obstreperous American poet, had moved to London and become tenuously associated with "imagist" poets attempting to break with Victorian tradition. He retained some contacts with American publications for which he served as an editorial advisor. Pound noticed some of Iris's poems in the British publication *Poetry and Drama* and wrote to her on April 2, 1916, in care of the Poetry Book Shop, which forwarded his letter:

Dear Madam,

Have you any poems unpublished. It is one of my functions to gather up verses for an American publication called Poetry. *They have even been known to print and decently to pay for what I select and send in to them, although they are not always prompt in this matter. At any rate I should be glad to see some of your stuff. I think some of it might be 'available'.*

very truly yours,
Ezra Pound[7]

Iris responded enthusiastically, sending along a "suitcaseful"[8] of poems and a request for criticism. Thus began a tutorial by correspondence, which proved

to be the genesis of later works by Pound—the essay, "How to Read" (1931), and the books, *The ABC of Reading* (1934) and *Guide to Kulchur* (1952).

In reply, Pound wrote on April 17, 1916:

Dear Miss Barry,

It is rather difficult to respond to your request for criticism of your stuff. I am not quite satisfied with the things you have sent in, still many of them seem to have been done more or less in accordance with the general suggestions of imagisme, wherewith I am too much associated. The main difficulty seems to me that you have not yet made up your mind what you want to do or how you want to do it. I have introduced a number of young writers (too many, one can't be infallible). Before I start I try to get some sense of their dynamics and to discern if possible which way they are going.

With the method of question and answer: Are you very much in earnest, have you very much intention of 'going on with it,' mastering the medium, etc? Or are you doing vers libre *because it is a new and attractive fashion and anyone can write a few things in* vers libre? *There's no use my beating about the bush with these inquiries. I get editorial notes from odd quarters blaming me that I have set off too many people.*[9]

Despite his bluster, Pound offered to "send on your stuff to Chicago as it is, if you like," although he noted he "should prefer to see more of it first, if that is convenient," preferably a great mass, for if there weren't sufficient output available or wasn't going to be, he'd rather not bother the editor. Pound went on to make specific suggestions regarding phrasing and meter, noting that "some of the things seem to me are 'just imagistic,' neither better nor worse than a lot of other imagistic stuff that gets into print." In some of her poems, he complained, she fell "too flatly into the 'whakty whakty whakty whak' of the old pentameter" while others bore signs of passion and originality.[10]

Iris must have suggested in her reply that written correspondence might not be as convenient as a personal meeting for conducting a tutorial. Pound responded on April 24: "You are quite right, it is much easier to go at such points in talk than by letter."[11] Eventually they would meet, but not until Pound had given her a thorough orientation to what he called his "Ezuversity."

Pound urged Iris to teach herself Greek and Latin. "Greek seems to me a storehouse of wonderful rhythms," he proclaimed. "If you don't read it and if you can't read Latin translations of it, it can't be helped. Most English

translations are hopeless. The best are in prose. . . . Wharton's *Sappho* is the classic achievement. . . . I am mailing you MacKail's *Latin Literature*.

"Catullus, Propertius, Horace and Ovid are the people who matter. Catullus most. Martial somewhat. Propertius for beautiful cadence though he uses only one metre. Horace you will not want for a long time. I doubt if he is of any use save to the Latin scholar. I will explain sometime *viva voce*.

"Virgil is a second-rater, a Tennysonianized version of Homer. Catullus has the intensity, and Ovid might teach one many things. To the best of my knowledge there is no history of greek poetry that is worth ANYthing. They all go on gassing about the 'deathless voice' and the 'Theban Eagle' as if Pindar wasn't the prize wind-bag of all ages."[12]

Above all Pound urged upon Iris the need for simplicity and lack of ornament:

> *The whole art is divided into:*
>
> *a. concision, or style, or saying what you mean in the fewest and clearest words.*
>
> *b. the actual necessity for creating or constructing something; of presenting an image, or enough images of concrete things arranged to stir the reader.*
>
> *Beyond these concrete objects named, one can make simple emotional statements of fact, such as 'I am tired,' or simple credos like 'After death there comes no other calamity.'*
>
> *I think there must be more, predominately more, objects than statements. . . . Also one must have emotion or one's cadence and rhythms will be vapid and without any interest.*
>
> *It is as simple as the sculptor's direction: 'Take a chisel and cut away all the stone you don't want.'??? No, it is a little better than that.*[13]

As with others with whom he corresponded (Pound once attempted to diagnose James Joyce's astigmatism via letter), Pound was liberal with personal advice to Iris. He urged her to get out of Birmingham, to leave the farm, not to marry as she said she might, even to write her autobiography, which she did, despite her youth. He invited her to send along some plays she had written, promising to show them to a Mr. Knoblauch ("I hear he is the Gawd of the British theatre"), noting that "if your stuff is any good at all I can probably get it looked at."[14] Iris's autobiography was later lost and no plays by her are known to have been produced, but she did have her meeting with Pound. The meeting marked the beginning of a new phase in her life.

Pound wrote Iris from London on July 13, 1916:

Dear Miss Barry,

I believe the Underground runs from here to Wimbledon. At least I have a map with black lines on it, moving in that direction, and I think it implies some form of conveyance. I will enquire with due diligence. Also as to time consumed in transit. Place of arrival, whether two or six stations in Wimbledon, etc.

As to marks of identification in case there be two males loose on the platform??? Do you wish any, or will you trust purely to instinct? And I? . . .

It would be a shame to pass in silence for want of a boutonniere. Perhaps a perfectly plain ebony staff, entirely out of keeping with the rest of the costume will serve. Perfectly plain, straight, without any tin bands, etc. at the top of it. Emphatically not a country weapon.

And what am I to look for?

There is no record of Iris's reply, but as she wrote to Charles Norman in 1959, she did not recall having had any "distinguishing signs" when the two met the following Sunday. "I was just a young person in a black hat with flowers, which had cost my family a lot of money: it was up to me to recognize Pound, not he me." Iris described herself at the time as having had "middle-brown hair which was done up then in two long plaits coiled over the ears, very tidy and circumspect: emphatic black eyebrows: medium size: serious as all get out and fairly fresh out of a convent: an only child and a solitary one, very romantic." She also noted that she "was not—as I pretended—22 but not quite 17 [she was 21 at the time]. I think I slept at the Euston Hotel as it was the nearest to the station where one arrives from Birmingham and I was afraid of London."[15]

"Walking across Wimbledon Common," Iris recounted in a 1931 article, Pound gave her "what was undoubtedly an illuminating and comprehensive account—a sort of bird's eye view for a provincial just arrived in the metropolis—of the state of literature and the arts in England in that year 1916." He rattled on about T. E. Hulme and the Imagistes, but Iris "heard barely a word—no more than a few names of what was certainly an invaluable and highly personal (as it was visibly a most dramatic) dissertation. But the wind was blowing hard. It hurled the words away from Pound's lips as they issued, across the landscape. Also, Pound talks like no one else. His is almost a wholly original accent, the base of American mingled with a dozen assorted 'English society' and Cockney accents inserted in mockery, French, Spanish and Greek exclamations, strange cries

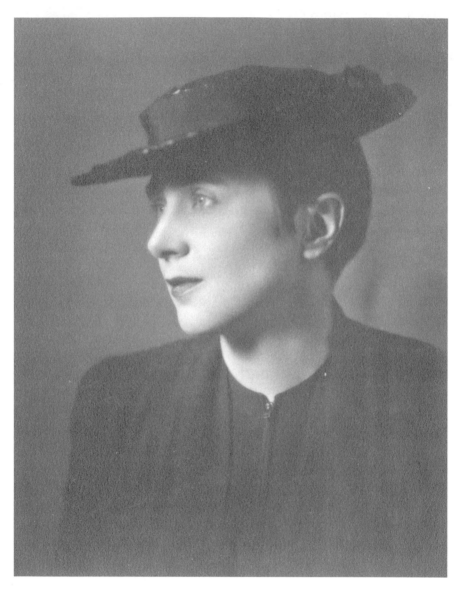

Iris Barry in London (c. 1919).

and catcalls, the whole very oddly inflected, with dramatic pauses and diminuendos. It takes time to get used to it, especially as the lively and audacious mind of Pound packs his speech—as well as his writing—with undertones and allusions. I knew as little as a dog he might have been taking for a walk of even the sort of thing he was talking about: and, in addition, was too agitated to grasp much, now that I found myself striding along with the Spirit of Revolt itself."[16]

The Spirit of Revolt must have paused a time or two to listen to Iris, for he acknowledged in a letter to her on the 27th of July: "Of course I might have known that you had most of [Francois] Villon by heart. . . . You have read Villon, Ford Madox Hueffer, the anthology *Des Imagistes*, nine verses by me, Omar Kayamm, forty-five vols. on dissection of plants and animals, Zola, . . . enough of this. So long as you don't adore Milton and Francis Thompson, it don't matter." He told her that "Flaubert's *Trois Contes*, especially 'Coer Simple,' contain all that anybody knows about writing. Certainly one ought to read the opening of the *Chartreuse de Parme*, and the first half or more than half of the *Rouge et Noir*." He prescribed that "someday, certainly, you must have the soufflé of contemporary French poets" and suggested that "sometime before that I think you shall try a huge mass of Voltaire." Almost as an afterthought he urged her to "read all of the *Dictionaire Philosophique*. Presumably no other living woman will have done so. One should always find a few things which no other living person has done, a few vast territories of print that you can have to yourself and a few friends. They are a great defense against fools and against the half-educated, and against dons of all sorts (open and disguised)."[17]

Of English poetry Pound had only contempt: "Ugh. Perhaps one shouldn't read it at all. Chaucer has in him all that has ever got into English." Wordsworth was "a dull sheep," Byron's technique "rotten"; of Browning "the hell is that one catches (his) manner and mannerisms. At least I've suffered the disease." Among English writers he could recommend with enthusiasm Walter Savage Landor, particularly his essays on politics and orthography ("He is the best mind in English literature. Don't hand this on to the mob yet"). There is nothing in Spanish literature, however, and in Italian just Leopardi, "the only author since Dante who need trouble you, but not essential as a tool."[18]

When Iris wrote and asked if he liked music, he replied, now addressing her as "Dear Iris," that "Je connus the London mondo musicale, at least the concert-hall, recital part of it." He sent her a copy of his *Lustra*, in limited edition, and when she remarked favorably upon the portrait it contained, he replied that "the portrait is there to make junior typists clasp their hands ecstatically. Or, as Yeats says: 'That'll sell the book.'" Pound's landlady had exclaimed upon

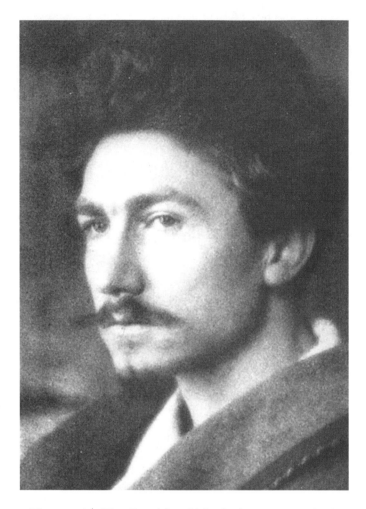

The portrait of Ezra Pound from his book of poems, *Lustra* (1916).

(Photograph by Alvin Langdon Coburn, 1913)

seeing the portrait, "Oh—the first that ever did you justice," and added "Eh, I hope you won't be offended, sir, but eh, It-is-like-the-good-man-of-Nazareth, isn't-it, sir?" When Iris urged him to receive a poet friend of hers whose "heart's desire" had been to meet him, Pound replied, "Chere Iris: I believe in everyone's having their heart's desire at the earliest possible opportunity.... Still, you might have told me his name was Reginald."[19]

Iris converted Pound's allusion to the junior typist into a poem, "At the Ministry" which she published under Pound's auspices in *The Little Review* in

August 1917. Pound was by then a fixture at the American magazine, which had been rescued from economic hard times by John Quinn, whose support was tied to publisher Margaret Anderson's taking on Pound as an editor. Pound must have enjoyed seeing himself in Iris's poem:

> Having received the last volume of a great poet
> I look out of the office window –
> Coloured shirts: green, blue, red, grey:
> Men in coloured shirts moving heavy things with deliberation
> Out there in the sun.
> The junior typist cries ecstatically
> On seeing the costly photogravure of the author,
> Clasping her hands and flushing.
> But I sit and look out at the irregular wandering shirts,
> At the men unloading projectiles
> And storing them in the dark sheds.

Overall, this was a period of considerable uncertainty for Iris. She was out of school and holding down a typing job. Addressing her as "Beautiful Evelyn Hope," Pound encouraged her to complete her autobiography as a series of letters sent to him, "under seal." This he felt would be "much easier than trying to write it all at a sitting, and it will keep the style simple and prevent your getting literary or attempting to make phrases or paragraphs."[20] Iris must have again mentioned getting married and settling down to life on a farm, for on September 22, 1916, Pound wrote her a letter that would prove fateful:

Dear Iris: On the whole, it is all rubbish your going to a farm. The soul is more than flesh, etc. You had much better come up to London. I am writing to my treasured and unique ex-landlady to see if she has a room ... unless you have some better place to stay. I shall be back Wednesday. You can come to tea, and be took out to see someone or other some evening, and come in to meet someone else. God knows who is in London at the moment and divers circles are non-extant from war. Still you can put in your spare time somehow.

The cheapest restaurant with a real cook is Belotti's, Ristorante Italiano (not Restaurant D'Italie). I will send you Mrs. Langley's address if I find she has a room.
Directions: for life in the capital. NOT to use the competent and defensive air. (In really Lofty circles an amiable imbecility is the current form ... That you won't need in the monde d'art. A naive and placid receptivity should suffice.)

Gin-crawls, illegitimate infants, etc., to be kept out of conversation. EVEN with confidants . . . not that you are likely to fall a prey to new friends in four days, but this is set down for always. Half London has a 'past.' Luridity will shock some and merely bore others.

I believe being a barmaid would be no obstacle. BUT one would be obliged to conceal the fact.

As for 'competent bearing and defence'; it is no use. People here haven't the time. And anyone would be perfectly willing to be friendly. Simply the capital is 'intime,' instantly 'intime,' scarcely ever familiar.

One talks aesthetics, literature, scandal about others, political intrigue (war, for the present, though no stranger should introduce this last topic).

All this is very bald, but am in a hurry.

General instructions:
Ask questions: Every one likes to be asked questions.
Super-strategy:
Ask questions showing knowledge of or sane interest in something of interest to the interlocutor.

All of which you know quite well already.
yours,
Polonius"[21]

Iris considered throughout her life that Pound's advice about being "intimate but scarcely ever familiar" was the best she ever received.

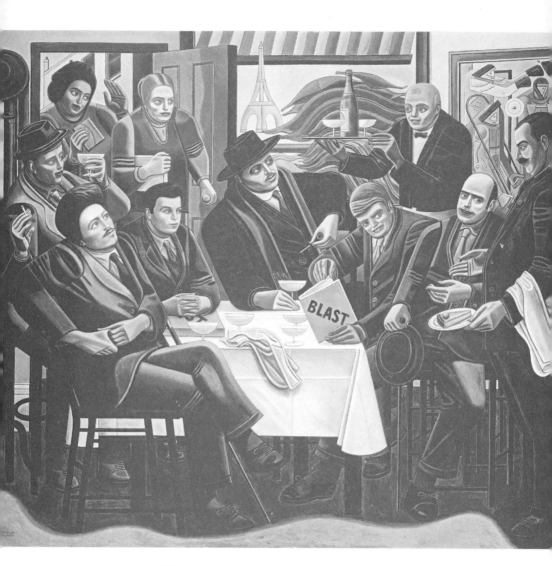

William Roberts, *Vorticists at the Restaurant de la Tour Eifel, 1915*
(*left to right:* Culberth Hamilton, Ezra Pound, William Roberts, Wyndham Lewis, Frederick Etchells, and Edward Wadsworth. Standing in the doorway are Jessica Dismorr and Helen Saunders; on the right are Joe the waiter and Rudolph Stulik, the proprietor).

4

THE OTHER BLOOMSBURY

"L ONDON, DEAH OLD London, is the place for poesy," Pound wrote to his friend William Carlos Williams in 1909, announcing trium- phantly, "I have weathered the storm, I have beaten out my exile".[1] Behind his exuberance was an emerging trail of disappointments, beginning with his dismissal from his first professorial job in the United States and leading eventually to his departure from England in 1920. Although Pound was, as Iris told Charles Norman in the late fifties, "everybody's schoolmaster and more,"[2] he was also a difficult person and one to follow at some peril.

When Iris took Pound's advice and moved to London in 1917, she found her- self under the wing of a man ostensibly at the center of an intellectual *haut monde*, although not the more well-known coterie associated with Clive Bell, Virginia Woolf, and their Bloomsbury friends. Having served for two winters as a secretary to William Butler Yeats and gained sufficient status to be able to "correct" his poetry, Pound had become an adjunct of Yeats, marshaling aspi- rants to evenings with the great man and holding forth in various restaurants patronized by the avant-garde. Pound cut quite a figure. The shipping heiress and poet Nancy Cunard remembered him vividly: "That appearance of his in 1915!" she wrote. "He was of middle stature, with green, lynx-like eyes, a head of thick, waving red hair and a pointed red beard. He was dressed at that time in black and white check trousers, black velvet jacket, with a large-brimmed black felt hat. He wore a sweeping black cape and carried yellow chamois leather gloves and a cane." Cunard thought he should be called "Rodolfo."[3]

Ford Madox Ford provides another contemporary description of Pound: "His Philadelphian accent was comprehensible if disconcerting; his beard and flowing locks were auburn and luxuriant; he was astonishingly meagre and agile. He threw himself alarmingly into frail chairs, devoured enormous quantities of your pastry, fixed his pince-nez firmly on his nose, drew out a manuscript

from his pocket, threw his head back, closed his eyes to the point of invisibility and looking down his nose would chuckle like Mephistopheles and read you a translation from [the Occitan troubadour] Arnaut Daniel."[4]

Pound had been booted unceremoniously from the faculty of Wabash College in Crawfordsville, Indiana, in 1908, precipitating his departure from America and his descent upon London via Italy in the same year. In what Pound's biographer J. J. Wilhelm refers to as "the Crawfordsville incident,"[5] Pound found himself on the wrong side of an accusation that he had taken a traveling actress in for the night in his boarding house room. "If it has any value at all," Wilhelm concluded, "one must remember that Pound, to the very end, proclaimed his innocence, even when the issue was long dead. He said in a [1955] letter . . . that it was not until he got to England, when men were scarce in the war, that he passed beyond the innocent caresses of the early 1900s."[6] Pound had also suffered an aborted engagement to the young Hilda Doolittle and was thrown over for another man by Marianne Moore.

Pound facilitated Iris's move to London, and quite possibly there they became lovers, however fitfully, despite the fact that he was married.[7] "A few weeks ago I found a studio with bath, for I think £40 per year," he wrote her on January 25, 1917, "but naturally unfurnished would have to take it for three years, and probably it is already gobbled." He counseled that "wisdom consists in getting a room cheap and having spare cash to embellish it, add gas conveniences etc which are paid once and for all and not a constant drain. . . . I had better get you a furnished room at 8 (eight) shillings a week, in the center of the part of Chelsea where you will probably find what you want (very possibly unfurnished)."[8] Pound suggested she could live on £2 per week, since he himself had lived on that amount "or rather less for a considerable period," and assured her that "in any case you won't be turned out onto the street." If necessary, he offered, "I suppose Dorothy [Mrs. Pound] and I might be persuaded to lend you ten shillings."[9]

Finding she was able to transfer her job with the Ministry of Munitions to London, Iris settled on a furnished room at 20 Glebe Place renting for ten shillings a week. Pound assured her the room had "a bawth with a penny in the geyser slot." The room was clean, he reported, and the proprietors "are accustomed to the ways of literature," since writers had lived there before, and "won't suspect you of fornication if you choose to put a shawl over the small bed and call it a couch and use the place to serve tea of a Saturday or Sawbath afternoon."[10] Were she to arrive on a Sunday, he told her, "your Sunday afternoon is engaged and you are forbid to dispose of it."[11] He proposed that he and

T. S. Eliot would escort her to a tea party and on Monday evening, "unless you are dead with fatigue," she would be included in his group at the New China Restaurant and later repair to the regular Monday soiree at the residence of William Butler Yeats. She would also be included in his Thursday literary dinners at Belotti's restaurant.

By mid-February 1917, when Iris arrived in London, her mentor—ten years her senior—long had been a married man. Pound married Dorothy Shakespeare, whose mother Olivia was a former mistress of Yeats, in 1914.[12] Dorothy Pound became his lifelong supporter and often accompanied her husband to his weekly literary dinners in Regent Street during World War I. Iris recalled that "into the restaurant with his clothes always seeming to fly round him, letting his ebony stick clatter to the floor, came Pound himself with his exuberant hair, pale cat-like face with greenish cat-eyes, clearing his throat, making strange sounds and cries in his talking, but otherwise always quite formal and extremely polite. With him came Mrs. Pound, carrying herself delicately with the air, always, of a young Victorian lady out skating, and a profile as clear and lovely as that of a porcelain Kuan-yin."[13]

Pound's fellow diners comprised a Who's Who of London literati. Iris described them in her later recollection of "The Ezra Pound Period":

Semi-monstrous, bulging out of his uniform, china-blue eyes peering from an expanse of pink face, pendulous lower lip drooping under sandy moustache as he boomed through endless anecdotes of Great Victorians, Great Pre-Raphaelites, Henry James, and somebody no one else had ever heard of and hardly believed in even then, was Ford Madox Hueffer [Ford Madox Ford]—of particular interest to some of us when we realized that he had once been the little William Tell boy in the Rossetti painting.[14] A small lady almost always dressed in raspberry pink, with acute dark eyes and a crisp way of speech and sharpness of phrase that, somehow, one would not have expected from her at first sight, was May Sinclair.[15] Tall, lean and hollow cheeked, dressed in the formal manner appropriate to his daytime occupation in Lloyd's Bank—that was T. S. Eliot, generally silent but with a smile that was as shy as it was friendly, and rather passionately but mutely adored by the three or four young females who had been allowed in because of some crumb of promise in painting or verse. Chattering with a sublime disregard for practically everything, distraught golden hair, obviously a beauty of the Edwardian era, Violet Hunt often proved disconcerting to some of these same young women, for the way she pounced on them and

asked questions and was at once good-natured and sharp-tongued. The bust of Ezra Pound by Gaudier-Brzeska stood in her garden.[16] We used to go and peep at it through the fence. Miss Hunt herself at those dinners was always mingling her complaints about the behaviour of a family of blue Persian cats that ruled her household with slightly distracted but amusing accounts of how often she had to go out and pick snails off this bust, how it weighed a ton and no one else would keep it, how the scarlet blinds in her drawing room were a mistake because they killed the red in the paintings Wyndham Lewis had done for her, and equally inconsequent fragments about Ruskin and old Lord Somebody and how absurd Mrs. So-and-So had looked at her coming-out ball twenty years before.[17] The young man in uniform who looked like a farmer was Richard Aldington, home on leave from France. Taller and more silent even than Mrs. Pound and looking, somehow, haunted, was his wife, the poetess H.D. [Hilda Doolittle]. A dark young man in Italian uniform who appeared once or twice must have been a Mr. del Re who afterwards went on to Tokyo and the other dark young man in the Artillery with highly polished leggings who talked too forcibly was Anthony Ludovici. I forget now why they used to come; the connection is vague, and I never knew what drew Edgar Jepson to the group either, except that both Pound and his close friend Edmond Dulac (a regular member of the group) were both passionately fond of jade, and Jepson collected it. He used to pass pieces of it around the table: Pound would finger each piece long and lovingly. Another regular diner was Mary Butts, with her long white Rossetti throat and vermilion-red hair strikingly like her ancestor, Henry VIII's tutor, and just married to John Rodker at the other end of the table. Arthur Waley,[18] pale and scholarly in appearance, with almost inaudible, clipped speech and incredible erudition, was there almost weekly—he had just begun those fine translations from the Chinese and Japanese that show the influence of Pound so clearly. Someone else from the Russian ballet. Next to him the young woman who married and went to live in a ruined castle abroad; and with her the other young woman who (like Victoria Cross from the days of *The Yellow Book*)[19] afterwards descended to popular journalism. And who was the lady sitting up so very straight with her severe hat and nervous air—she might have been a bishop's daughter, perhaps? That was the lion-hearted Miss Harriet Weaver who printed Joyce when nobody else would and who, indeed, I believe made it possible for Joyce to enjoy sufficient leisure to write *Ulysses* at all, though she had never even seen him; who printed T. S. Eliot and Wyndham Lewis and Amy Lowell when nobody else did . . . and published *A Portrait of the Artist* and *Tarr* and

Prufrock and [portions of] *Ulysses* until prevented by the law. Save under extreme pressure or when business and nothing else made it essential and then only in the lowest tones and with unutterable detachment, she was never known to speak either of herself or of anything to do with that very remarkable publishing activity.

Now and then other figures appeared—Lewis, back from the Front, ghastly pale under his black hair and after silences that seemed, at least, to denote some suspicion of his fellow creatures, proving full of inimitable conversation, riotous song, and an unequalled play of humour. Now and then Yeats appeared with his famous lock falling into his eyes. He was devoted to Pound, who had once been his disciple and with whom now he had just finished reading the entire [Walter Savage] Landor. Arthur Symons, very frail and elegant, just out of a sanitarium, came once or twice. Round the table went the story of Miss Lowell's amazing descent upon London, of the opening of London's first night club by Madame Strindberg with her troop of little monkeys, of what young [painter C. R. W.] Nevinson had said to annoy in the Cafe Royal, of Saint Augustine and his mother's death, of Rihaku and Catullus, of Keats and *The Edinburgh Review,* of the big munitions works, which (so rumour had it every month or so) had been blown up by Zeppelin bombs overnight. Mixed in would be someone's account (Pound's, I think) of a row of houses discovered intact in Earl's Court outside the front door of each of which was a pair of stone dogs, large as life and no pair alike or even of the same species. There would be news of a restaurant where you could get more meat than the ration cards properly allowed. There was mourning for the theft of the Dulac dog. To the accompaniment of air-raids, we younger ones heard for the first time of Proust and the Baroness Elsa von Freytag Loringhoven, of Negro music and Chinese poetry, of the Oedipus complex and Rousseau the Douanier and Gertrude Stein.

The effect, all too little realized at the time, was as though something that mattered very much had somehow and rather miraculously been preserved round that table when so much else was being scattered, smashed up, killed, imprisoned or forgotten. It was as though someone kept reminding us that the war was not perpetual (as it certainly seemed by then) and that it was in the long run more important that there should be new music and new and fresh writing and creative desire and passionate execution than that one should believe angels descended at Mons or that the population of Germany had from inherent vileness taken to consuming margarine decocted from boiled corpses. It was, for the long hours the gathering lasted, less important that

so many were being killed and more that something lived: possible to recall that for every [battle of] Blenheim there is a Voltaire and that the things that endure are not stupidity or fear.[20]

The coterie surrounding Pound represented an emerging generation of artists and writers intent upon replacing the era of Thomas Hardy, Henry James, Arnold Bennett, and others with new ways of making art. Ford Madox Ford, whose calls for lack of ornament in writing prefigured their ideals, christened these new artists "les jeunes." Their innovations would constitute some of the major "isms" of modernity: Imagism, Vorticism, and the free-form literature of James Joyce, among other influences-to-be.

Pound had introduced the term "Imagism" in 1912[21] to call for the proliferation of poetry that relied upon concrete, simply described images. The seeds of the new movement lay in T. E. Hulme's revolt against Sir Edmund Gosse's conservative Poets' Club, which cultural historian Steven Watson identifies as "the reigning circle of established English poets."[22] Hulme attended the club's somewhat stultifying gatherings until an article by F. S. Flint appeared entitled, "The Poets' Club is Death," at which point, beginning on March 25, 1909, Hulme convened a splinter group more inclined to follow the lead of Paul Verlaine. On Thursday nights the new group met at the Tour Eiffel restaurant in Soho, and although their membership, which included writers Florence Farr, F. S. Flint, Edward Storer, and F. W. Tancred, is little remembered now, their attitude toward writing made a difference. Hulme wrote that "the great aim is accurate, precise and definite description,"[23] much as Pound would urge upon Iris later when he called for modeling modern poetry on the Japanese tanka and haiku. Pound attended these meetings and, in Flint's view, "He took away the whole doctrine of what he later called Imagisme" (59).

"Imagisme's appeal is strikingly evident in [Boston poet] Amy Lowell's reaction to it," according to Watson. "She had been writing undistinguished Keatsian verse when, one January evening in 1913, she read 'Hermes of the Ways'— H.D.'s [Hilda Doolittle's] poem that Pound so admired. . . . Lowell paused at the signature, 'H.D., Imagiste,' then set down her *Poetry* magazine and declared, 'Why, I, too, am an Imagiste!' After a decade of writing verse alone at night in her library, she was thrilled to declare herself a member of a group. By the time her first poems (which were not identifiably Imagiste) appeared in the July 1913 issue of *Poetry*, she had sailed for London, armed with a letter of introduction to Ezra Pound from [*Poetry* publisher] Harriet Monroe" (195).

Watson continues, "In early July 1914 Lowell's claret-colored Pierce-Arrow eased out of the SS Laconia onto a Liverpool dock, and a chauffeur, dressed in matching claret livery, piloted Lowell and her companion Ada Russell to London's Berkeley Hotel, where Lowell booked an entire floor." At the time, "London was in a state of frenzied gaiety, the crescendo at the end of an epoch. Champagne corks of the newly rich popped nightly in the Ritz ballroom; the Futurist Fillipo Tommaso Marinetti howled and made machine-gun noises, only to be clangorously disrupted by the Vorticists; six-inch sans-serif type screamed *BLAST* across a shocking pink cover; Wyndham Lewis shrieked that he would kill T. E. Hulme for stealing his mistress. And charging the air was the threat of international explosion following Archduke Ferdinand's assassination, which had taken place during Lowell's transatlantic crossing" (200).

There followed the infamous Imagist dinner wars, in which Lowell and Pound faced off and divided the loyalties of poets in the movement into two camps. Lowell moved to lure away Richard Aldington, H.D., and D. H. Lawrence and formed her own school of Imagists, which Pound derisively labeled the Amygists.[24]

If this was a time of intellectual ferment and conflict, however seriocomic, the intensity of the period also became overshadowed by the horrors of the Great War. Hundreds of thousands of young Englishmen crossed the English Channel to face death and numbing boredom in the trenches of Belgium and France. Many were killed with weapons that were both impersonal and indiscriminate: poison gas, machine guns, airplanes with their rain of explosives, enormous guns capable of lobbing shells behind the lines of defense. Among those of the Pound circle whose careers were cut short by the war were the sculptor Henri Gaudier-Brzeska and writer T. E. Hulme. They died in a war characterized by gangrene and dismemberment, in which injuries were treated by a simple bandage without benefit of penicillin or sulfa drugs. Nevertheless, as she had found in Birmingham earlier, being in London during the war years brought Iris Barry a particular kind of excitement.

"The city was a sea of uniforms," she recalled, "every other girl and most middle-aged people were in some government job or other. Theaters, restaurants, hotels were doing a roaring trade. It was possible to tell by the number of stretchers carried into Charing Cross Hospital from the daily ambulance train from France when there had been real activity at the front. Life was punctuated with the arrival of friends from France or wounded men leaving hospital, with consequent parties.

"One sunny Saturday morning German airplanes, like a string of wild ducks, came flying over London. They glittered in the sunshine. There were some rather loud explosions and suddenly we realized that hard bits of metal were falling on our heads as we stood out in the square, looking up at them. This was shrapnel from our own anti-aircraft guns in Hyde Park, for which we had a hearty contempt. They were obviously no good, like the machine-gun which had been mounted on a roof of a neighboring public-house. Reluctantly we went indoors. Somebody's housekeeper in the basement was having fits and shrieking—just what one would expect of the lower classes: no self-control. Yet we all felt rather sick when ambulances came tearing by, said to be filled with dead people from a railroad depot on which a bomb had fallen.

"The air-raids became quite a feature of 1917. Every moonlit night we expected them, and usually they came. First there would be the warning, a 'maroon'[25] which went off with a loud bang. Then gathering silence. Everyone off the streets. Generally we would be sitting in dressing-gowns round a gas-fire (gas-fires had almost entirely supplanted coal) and being intensely normal and serene. But we had no light in the room and every now and then someone would go to the window and look out from behind the dark shades at the immense moonlit sky. The city was still, save for the rumble of a belated omnibus rushing to its garage, or a child crying in a dark room. We toasted marshmallows by the fire. Someone would motion carelessly toward the window and go on talking— we had all heard the sound. It was the Germans coming over, that steady drone on a high note. The little whining hum that followed it must be one of our own fighters maneuvering to get above them. That we were all pretty frightened showed itself in the set smiles we maintained, in the fact that we had to swallow frequently, and by the necessity for frequent trips from the room. . . .

"When there was a loud explosion and especially when it seemed nearer than the previous ones, we stopped talking and just listened. I remember hoping that if 'anything happened' I should remember to behave well. The fear of behaving badly in an emergency was, or so it seems to me now, at least equal to the fear of a bomb, which might have caused one to behave badly. Then more silence. It is quite an uncanny thing to hear a city of millions of people holding its breath. Finally, the silence was shattered by the sound of bugles, as boy scouts and special constables bicycled along the streets sounding the 'All Clear.' A blessed sound. Yet I had a friend at that time who regretted the end of an air-raid. When one began she used to take down her long hair, put on cloth slippers, and go out to the deserted embankment, where she ran madly up and down in a state of crazy exaltation. . . .

"Looking back, I must admit that I enjoyed the raids in a peculiar way. I am not speaking of the exhilaration of danger, or the keen relief that came with the bugle call of 'All Clear'—that was indescribably intense. But there was another pleasure, the feeling 'I am in it now, too,' as though it allied one somehow to the people in the trenches whom we understood so little because their lives were unknown to us. Also a feeling of rage against older people who had permitted and indeed encouraged these things to happen, and yet who seemed far more grave and alarmed about the raids than we did. We had begun to blame them for the war. When the men came back from the front, when the war was over, the 'grown-ups' would find things changed. It would be the day for young people: we would rule then, not the old ones. Dimly I felt that. And at the same time there was a vivid gregariousness about those air-raid parties. . . .

"Naturally enough, the air-force was incomparably more glorious than any other arm. It was novel, the uniform was far more dashing, the pay higher, the expectation of life shorter, the whole attitude to life more reckless. My impression is that they drank nothing but champagne. Certainly, young ladies would jilt even a major in the artillery for a second lieutenant in the air-force. To be an airman's widow was the greatest height a female could attain. The pension was proportionate to the glory. And how often did I hear girls little older than myself and their mothers regret that they had not married poor so-and-so before he was killed! It was like throwing money out of the window."[26]

Ultimately, however, knowledge of the character of the war crept in, and Iris, like many others, realized her generation had been deceived about the war's realities. "War as we had been taught to think of it," she recalled, "according to paintings by Lady Butler [Elizabeth Thompson, the Victorian war scenes artist] and poems by Tennyson, had proved a myth. It was a matter of crouching in holes in the earth. Courage and vague heroism, though they still remained the decent thing, were obvious folly in a war being fought not by men but by machines. It was tanks and high explosive and airplanes that really counted, not the brave brandishing of a sword or a gallant death.

"Nevertheless the summer of 1918 was gay. No more air-raids and a great deal of wining and dining. People came home on leave in shoals, we all went to the theater continually and saw movies galore. Everyone kept getting engaged to be married (often to several soldiers at once, since the chances of two of them turning up in London at the same time was remote). Marriages took place by special license every day: profitable widowhood was achieved by hundreds. And what civilian had not his little nest-egg of war bonds by then? Poverty had almost been abolished and every civilian worker could become a small plutocrat.

"Meantime there was summer—women selling lavender as ever on the streets with their strange wailing song, and honey for breakfast because there was no sugar or jam, and August bank-holiday with the customary round-abouts and swings and brilliant yellow lemonade and ice-cream cones at Hampstead Heath.

"We were by no means convinced on November 10th that peace would be signed the next day—there had been rumors of peace before. On the morning of November 11th I was walking through Soho when the maroons went off to announce the signing of the Armistice. People stood up on tops of buses and cheered, factory girls came running out of a large building, there was much hurrahing. Yet somehow everyone seemed rather stunned, many were crying hysterically. As I walked on after a little, I remember thinking: 'What now?' I felt a distinct let-down. The future suddenly looked blank and a little alarming. I had known nothing but the war and now it was over.

"All day there was cheering and yelling. The streets were full of people waving flags, careering about in taxis, yelling and blowing tin trumpets. In the evening I was to join a party of six or so in Piccadilly Circus: some one had engaged a table in a window on the second floor that gave a good view of the crowds below. By the time we sat down to dinner, the Circus was a mass of milling revelers, blowing whistles, dancing round in a clumsy way, yelling and embracing each other, shrieking from the tops of buses, the tops of taxis. The noise that came up was extraordinary, not particularly gay. Dinner itself was gay on the surface but not particularly a success. The restaurant was too full, the waiters almost frantic. And one of the men in our party was in the navy, another a gunner.[27] They both seemed rather moody and taciturn. They would be demobilized now, rank and pay gone, no one to salute them. Of course, nobody mentioned this, but I remember also thinking that now so many men would be coming back and the quite excellent jobs which any fairly proficient girl could get for the asking would be less plentiful. Indeed most of the jobs would cease to exist.

"It was midnight and we decided to go home. Getting out of that restaurant was a nightmare. Wandering guests and frenzied waiters all seemed quite mad, or drunk. It took forever to push one's way down the stairs because all about the landing and down the stairs women, most of them young and in evening dress, were lying unconscious with nurses in uniform bending over them, slapping their faces and trying to bring them round. Even in the heyday of the post-war years not even a country club dance has ever seen anything like that, and at the time I had never seen women drunk. I lost the rest of my party in the crowd and

was pretty frightened. I could hear one of the men hiccoughing but could not get to him and anyway one drunk person was about as alarming as another to me in those days. Though the crowds were good-natured and even hilariously friendly, it all seemed sinister, worse than the air-raids, rather like the end of the world. I got home on foot as best I could—every taxi, every truck in town was still laden to the scuppers with people singing and shaking rattles—and cried a little as I went because I was alone and frightened and felt for the first time in my life really terrified and in some sort of danger. It was tomorrow and the days after I was frightened of. The war had been nice and exciting and had taken care of us all, given us a sense of importance and lots of money to spend and a zest for life. What would we be without it? I was sure I would not like it so well."[28]

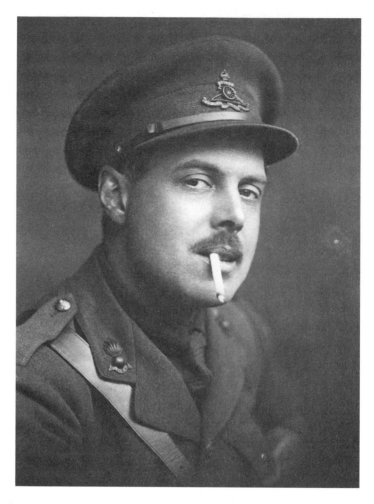

Wyndham Lewis (World War I).

5

LIFE WITH LEWIS

A volcanic and disordered mind like Wyndham Lewis' is of great value,
especially in a dead, and for the most part rotted, milieu.

—Ezra Pound, *Guide to Kulchur* (1952)[1]

I'm not too careful with a drop of scotch.
I'm not particular about a blotch.
I'm not alert to spy out a blackhead.
I'm not the man that minds a dirty bed.
I'm not the man to ban a friend because
He breasts the brine in lousy bathing-drawers.
I'm not the guy to balk at a low smell.
I'm not the man to insist on asphodel.
This sounds like a He-fellow don't you think?
It sounds like that. I belch. I bawl. I drink.

—Wyndham Lewis, *One-Way Song* (1933)

For iris the war's end brought with it the beginning of a consequential
liaison with the painter and novelist Wyndham Lewis.

Percy Wyndham Lewis was born in Nova Scotia, the son of a n'er-do-
well American traveling man who lived on his family's wealth and an English
girl he married at half his age of 32. She later left him because of his constant
infidelity. Born in 1882 and named for an English soldier of fortune who volun-
teered to serve on the Union side in the Civil War along with Lewis's father,[2]
Lewis described himself as "an only child of a selfish, vigorous little mother."[3]
He was reared in genteel poverty in England and sent to Rugby School, which

he despised, and after two years transferred to the Slade School of Art. There he excelled as a draftsman under the influence of Augustus John, whose prolific sexual appetites he sought to emulate. Lewis's father was more than once bigamous and fathered several children out of wedlock.[4] The first of Lewis's own illegitimate children, all of whom he disowned, was born to a German mistress in 1909.[5]

Pound and Lewis had been introduced at London's Vienna Cafe in that same year, but they were not immediately friendly. Lewis recalled of Pound that "the impression he made, socially, was not a good one."[6] Lewis viewed his fellow immigrant to British society as "a drop of oil in a glass of water. The trouble was, I believe, that he had no wish to mix: He just wanted to impress. The British in question were not of the impressionable kind—hated above all things being impressed and people who wished to impress them. I may add they also disapproved of Americans.

"Pound approached these strangers as one might a panther, or any other dangerous quadruped," Lewis recalled, "tense and wary, without speaking or smiling: showing one is not afraid of it, inwardly awaiting hostile action." In Lewis's view Pound "did not desire to prove to the people he had come among that he was superior in physical strength, but that he was superior to all other intellectuals in intellect, and all poets in prosodic prowess." So even though Pound "socially was a little too much like the 'singing cowboy,'" Lewis felt "his gaucherie was quite unnecessary. I have met young men from Idaho—or just as bad—with no money, who had the manners of a juvenile Henry Adams. However, he had rushed with all the raw solemnity of the classic Middle West into a sophisticated post-Nineties society dreaming of the XVIIIth Century, discussing the quality of the respective cellars of the Oxford Colleges, calling their relatives' country palaces 'places,' still droppin' their g's from time to time, for whom the spectacle of American 'strenuousness'—the Bull Moose tradition—was something that hardly any longer deserved a smile. They looked at it with a stony stare of infinite boredom. Above all, these people were unready to be lectured to: to have their shortcomings, as to literary taste, dissected, to have their chronic amateurism exposed" (137).

The tradition of amateurism figured heavily in the ambivalent relationship both Lewis and Pound developed toward British high culture. The two were united by a belief that poetry and the other arts should be viewed as professions, worthy of respect, and not as diversions or sporting events for the well-to-do. By contrast, many educated Britons held the somewhat moralistic view that the arts should remain unspoiled by the concerns of professionalism.

To Lewis, and to no lesser extent to Pound, "a huge middle-class rentier army of the intellectual or the artistic emerged, like a cloud of locusts from the Victorian Age and it covered the landscape, to the dismay of the authentic artist. They drifted dreamily about, paint-brush in hand, or with the novelist's notebook tucked away in their overcoat pocket, choking professional talent— drawing all the applause to themselves . . . because they were such awfully nice people (and the critics were not looking for artistic perfection, needless to say, but for social niceness). This lifeless host of niceness eyed Pound, very naturally, askance. A professional! Hum! But that, of course, was what was the matter with the Americans! They take their sports too seriously" (139).

Lewis was extremely allergic to what he perceived to be upper-class pretensions. Rather than attend an evening event for wealthy customers and patrons, Lewis biographer William Wees wrote that Lewis would "choose, unhesitatingly, an afternoon in a little flea-pit cinema at the bottom of Charlotte Street, where children sat for tuppence to see, among other things, Charlie Chaplin one-reelers. This was before anyone talked about Chaplin, but Lewis discovered him there. 'Come and see a clown,' he said to [his model and friend] Helen Rowe one day, and took her to sit among the children and marvel at an actor who understood that mannerisms not only disguise, but have the power to take on lives of their own. One of Lewis' favorite Chaplin characters was the artist, whose every movement was programmed according to the stereotype of the nineteenth century *artiste.* Real and fictional equivalents of that character became butts of Lewis' own satiric jokes."[7] It was this penchant for the popular cinema that Lewis later shared with Iris Barry.

After circling warily around one another in cafe society for a time, Lewis and Pound joined forces with accompanying fanfare in 1914. With the financial backing of painter and patron Kate Lechmere, Lewis formed the Rebel Art Center, from which he hoped to launch a movement in the arts alternative to the more effete inclinations of the Bloomsbury Group. Lewis had feuded with Roger Fry and Clive Bell over the installation of his work in their art gallery, and overall he felt that the Fry–Bell contingent, with its sacred formalism, lacked the robust engagement with the world a truly virile art required. Lewis conscripted Pound, whom he called the "Trotsky of literature," and together they dreamed up their own aesthetic ideology, a noisy variant of the Italian Futurist movement they dubbed "Vorticism." In a letter to (arts patron) John Quinn signaling the vagueness of their new "-ism," Pound compared Vorticism to "every kind of geyser from jism bursting up white as ivory, to hate or a storm at sea. Spermatozoon, enough to repopulate the island with active and vigorous

animals. Wit, satire, tragedy." The movement would "sweep out the past century as surely as Attila swept across Europe." To note the coming Renaissance, Pound hung a banner in front of the Rebel Art Center proclaiming the "End of the Christian Era." As E. Fuller Torrey remarked in his study of the British avant-garde, "Anglican England took startled notice."[8]

A rough but revealing definition of Vorticism might be found in the remark made by Lewis years later when London's Tate Gallery mounted a show on the movement: "Vorticism," he proclaimed in the catalogue, oblivious to his comrades, "in fact, was what I, personally, did, and said, at a certain period."[9] Lewis's hyperbole aside, artists such as Edward Wadsworth, Jacob Epstein, Henri Gaudier-Brzeska, C. R. W. Nevinson, and William Roberts are routinely included within the Vorticist circle.

Armed with their flexible ideology, Lewis and Pound were intent upon elbowing aside rival cliques such as the formalists Roger Fry and Clive Bell, the Cubists, and their closest rivals, the Futurists. They sought a more muscular form of modernity, one that not only allocated to the rubbish heap all of Victorian culture and its residual amateurism but also looked at the twentieth century with a more stoically detached eye. They rejected both "pedantic Realism" and the studio-bound aesthetic of the Cubists. They would embrace the machine age with all the gusto of the Futurists, yet would remain essentially aloof, depicting the force of the machine through dynamic lines and angles suggestive of, but not slavishly representative of, their true nature. As Richard Cork put it in the catalogue of a retrospective of Lewis's work mounted by the City of Manchester Art Galleries in 1980,

Where the Futurists were unashamedly romantic and rhapsodized about industrial society, expressing their enthusiasm in blurred, multiple imagery, Vorticism was far more coolly appraising about the ambivalent character of twentieth-century change and always affirmed the integrity of the defined, single object. In this respect, the English movement was closer to Cubism's severe monumentality and planar austerity. But Vorticism could never forgive Picasso and his friends for retaining the old studio motifs in their paintings. Guitars, posed models, and still life on a table-top belonged to the quietist, domesticated art which Vorticism was at pains to reject; and besides, the Cubists combined their preference for traditional, interior subjects with a static sobriety incapable of satisfying the English vanguard's appetite for venomous color and explosive aggression. The Vorticist's ideal was an independent synthesis of Futurism and Cubism, the romantic and the classical, and its desire

to control wars with its dynamism so fiercely that a wholly distinctive tension results. The typically diagonal forms of a Vorticist picture thrust outwards, as if the artist is straining to burst the bounds of the picture-frame; but they are contained, even so, by an insistence on precise contours and a solidity of construction which is often sculptural in its implications. Time and again the Vorticist appears to fragment his or her picture-surface to the point of total dispersal, and then recant by locking all its forms together into an inevitable, thoroughly immovable structure.[10]

To cook up all this mischief, Lewis and Pound utilized Ford Madox Ford's estate, South Lodge, for what Ford's biographer Arthur Mizener called a "bewildering series of demonstrations by which (they) undertook to blast the establishment from the seat of power." This included the founding of the journal *Blast*, which contained submissions by the Lewis–Pound coterie along with lists of things and individuals they either blessed or heartily despised.

By the time Iris Barry entered Wyndham Lewis's life, much of the loudest clatter of his disordered world was subsiding. Gone were the visits of the Italian Futurist F. T. Marinetti, who appeared in London no less than ten times in 1913 and 1914. Publisher Douglas Goldring recalled Marinetti, on one of his visits, as "a flamboyant personage adorned with diamond rings, gold chains and hundreds of flashing white teeth. In addition to readings of his works accompanied by the banging of drums and loud noises from a band of 'cacophonists' and 'gluglutineurs,' he organized a show of Futurist Painting which . . . was surprisingly good."[11] In August 1910, Goldring reprinted the founding Futurist Manifesto, which first appeared in *Le Figaro* in February of 1909, in his journal *The Tramp*. Marinetti promised to replace somnolent literature of the period with "the feverish insomnia, running, the perilous leap, the cuff and the blow." Showing a disdain for the art establishment that presaged Lewis and the Vorticists, he claimed that his followers would "destroy museums, libraries, and fight against moralism, feminism and all utilitarian cowardice." To his home country he pledged to "free Italy from her numberless museums which cover her with countless cemeteries. We intend to glorify the love of danger, the custom of energy, the strength of daring. The essential elements of our poetry will be courage, audacity and revolt."[12]

It was in the wake of this blaring Futurist parade that Vorticism made itself felt, if by but few. In the Rebel Art Center on Great Ormand Street, Goldring recalled, "the Great English Vortex came into being. Here, at the cost of an annual subscription of a guinea, the young could meet and rebel to their hearts'

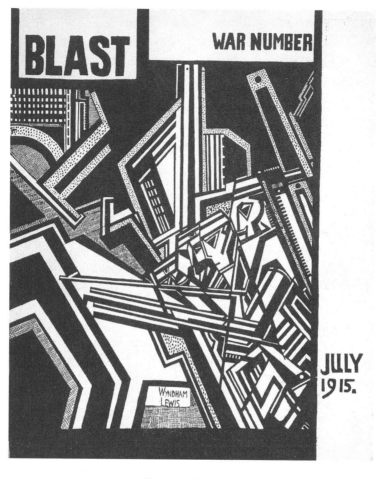

Blast cover (July 1915).

content, while the old were graciously permitted to warm both hands before the fire of their exuberance. The meaning of the Vortex and Vorticism as propounded by Lewis, was simplicity itself. 'You think at once of a whirlpool,' he explained. 'At the heart of the whirlpool is a great silent place where all the energy is concentrated. And there, at the point of concentration, is the Vorticist.'"[13]

The mural decorations on Great Ormond Street suggested a butcher's shop full of prime cuts, or so they were described to Goldring by Violet Hunt. Like

Hunt's study at South Lodge, the Center's rooms seemed to him as "noisy as red paint could make them and highpitched manifestoes erupted almost daily. Nevinson quarreled with Lewis on some doctrinal issue, and seceded, amid rolls of stage thunder. Ford, although Lewis had explained, with more violence than tact, that he was a back number—'Finished! Exploded! Done for!'—and that his Impressionism was dead, was at least permitted to take a benevolent interest in his supplanters and become an honorary vorticist."[14]

Alas, the great Vorticist Rebel Art Center proved a bust. "Initially, the Centre had high aspirations," according to William Wees in his study of Vorticism. "Its prospectus made the Rebel Art Centre sound like a mixture of Omega, Kensington Town Hall, the Slade, Saturday afternoons at 19 Fitzroy Street, and the recently closed Cave of the Golden Calf.[15] There were to be lectures by Marinetti, Pound, 'some great innovator in music, Schoenburg or Scriabin,' and others. Some 'short plays or Ombres Chinoise,' dances, and other 'social entertainments' were promised, along with special exhibitions and 'Saturday afternoon meetings of artists from 4 to 6 p.m.' There was also to be 'a *Blast* evening, or meeting to celebrate the foundation and appearance of the Review in that name,' and at that event, said the prospectus, 'a manifesto of Rebel Art will be read and an address given, to the sound of carefully chosen trumpets.' An ambitious art school was to open on 26 April 1914, offering not only drawing and painting, but 'instruction in various forms of applied art, such as painting of screens, fans, lampshades, scarves. Mr. Wyndham Lewis will visit the studio, as professor, five days a week.'

"A few of the promised activities took place," Wees recounts. "Marinetti appeared, Pound talked on Vorticism (and published a version of the talk in the *Fortnightly Review* in September 1914), and Ford Madox Ford lectured, only to have his peroration interrupted by Lewis' large *Plan of War*, which suddenly fell off the wall and on to Ford, knocking the canvas loose and trapping Ford inside the frame. Some 'workshop' items were made and displayed at the Allied Artists' exhibition in June 1914. But the Centre's major project, its art school, never materialized, and Lewis did not get to try out the role of professor of art. Only two applicants turned up, according to Kate Lechmere, 'a man who wished to improve the design of gas-brackets and a lady pornographer.' "[16]

The entire world would forget Vorticism, at least temporarily, when war broke out in the same year the Vorticist journal *Blast#1* was published, leaving only a short while for the movement to take hold. As Iris later described it, the "magenta-covered *Blast*, with its manifestoes and frenetic illustrations, dropped like a delayed fuse-bomb into London drawing-rooms,"[17] but even

with all this artillery it could not compete with the start of the war. A second issue was published in 1915. Unable to recover their costs of publication, Lewis, Ford, Gaudier-Brzeska, and others went off to battle, to ponder the static lines of trench warfare and wonder how different the world might be if the conflict would ever end. Pound volunteered but, like nearly half of those who did, was deemed unfit for service. The war inevitably forced modifications in the Vorticist aesthetic. "Sickened by the realization that the machines which had once inspired them could cause untold human misery, the former rebels turned their backs on radicalism and in their various ways returned to a more representational style," wrote Richard Cork. "Lewis made a half-hearted attempt to rally them again for a third issue of *Blast* in 1919, but it was doomed to remain unpublished: the whole heady context of pre-war London, which provided such an ideal environment for the fermentation of experimental ideas, had vanished forever."[18]

The postwar lacunae also spelled an end to Pound's protracted but ultimately unsuccessful siege of London. By 1919 Pound had suffered almost universal rejection and indifference. By then, according to biographer Doris Eder, Pound's "financial mainstay was A. R. Orage's *New Age*, for which he wrote literary, musical, and art criticism and economic articles. Biographers affirm that by 1919 Pound had antagonized all London editors except Orage. Pound said so himself. He was either fired by the other journals or severed himself from them in disgust at their editorial policies. Orage wrote, in the issue of *The New Age* in which Pound published his 'last will and testament' on leaving London, that despite all Pound had done for English letters, he had made many more enemies than friends. 'Much of the press has deliberately closed by cabal to him; his books have for some time been ignored or written down; and he himself has been compelled to live on much less than would support a navvy.' In Pound's poetic 'last will and testament' to London, *Hugh Selwyn Mauberley*, he alienated most of his English readers beyond recall. Pound would have had to be superhuman not to be embittered by his difficulties in an unremitting struggle to publish the best work, but it is plain that he was his own worst enemy and that, having once been victimized, he continued to victimize himself."[19]

At this point, at war's end and during Pound's declining influence, Iris became involved with Lewis. One might imagine him appearing to her as he did to Ford Madox Ford, who described Lewis in the persona of George Heimann in his novel *The Marsden Case* in 1922: "A face . . . alabaster white and aquiline; intent under a slouch hat. . . . The foreignness of his aspect, his high-crowned hat, his coat, black and buttoned-up round his neck, like a uniform—always a startling

Wyndham Lewis, *Self-Portrait as a Tyro* (1920–21).

effect, his immense black Inverness cloak, his young beard and his long black hair drooping over his ears, all these things were the products of a sojourn in Bohemia, not of foreign birth."[20]

It is unlikely that Lewis ever paid solicitous attention to Iris, and no one seems to recall their relationship as particularly romantic. Lewis, in fact, was not predisposed to like protégés of his friend Pound. In retrospect he described himself at the time as "prejudiced ... against all that that great 'fan,' Ezra Pound, gathered successively under his wing, with so often a truly maternal absence of judgment." Pound, he said, "warmed, with an alarming readiness, to almost everything that was immature, in the development and evolution of which he might masterfully intervene."[21]

Although they cohabited erratically between 1919 and 1922, during which time Iris often posed as a model for Lewis to draw or paint, Lewis, motivated by jealousy or perhaps a desire to be left alone with other sitters in his studio, as often as eight times a week would send Iris off to the movies, which she studied intently. Lewis at times would join Iris "on old school forms" watching the flickering images.[22] Iris shared Lewis's fascination with Chaplin. He also quizzed her about films he would send her to, so intently that, as Iris later recalled, "in self-defense . . . I had to keep my eyes glued to every damned frame in the film. I could quote sub-titles word for word. And before I knew it I was a hopelessly confirmed addict."[23] Despite his rude behavior, Lewis remained, by Iris's own account, consistently "the one person who never bored her"[24] and, as her notebooks confirm, despite their discords, he was the love of her life.[25]

No record seems to exist of the progress of their affair. A search of the autobiographical fiction Lewis produced so prolifically at the time, however, reveals a number of passages suggestive of a Lewis-Barry liaison.

A plausible depiction of amorous relations with Iris might be found in a section of a story Lewis wrote in 1918 and titled "The War Baby." It begins with a couple in a café. The Lewis-like character is called Richard Beresin. The two dine and drink, go to a risqué vaudeville show or film, make love in a taxi, spend the night together and conceive a child:

> He had to make her drink. He looked with leisurely satisfaction at her brown curls, brown eyes, brownish dress, white flower, white teeth, white gloves, and hard, bloodless face. Her beauty was as formal as a playing card, as neat and clean as a fish. Her red lips stuck out in a pulpy abstraction. She drew herself up from time to time free of her stays and sighed.

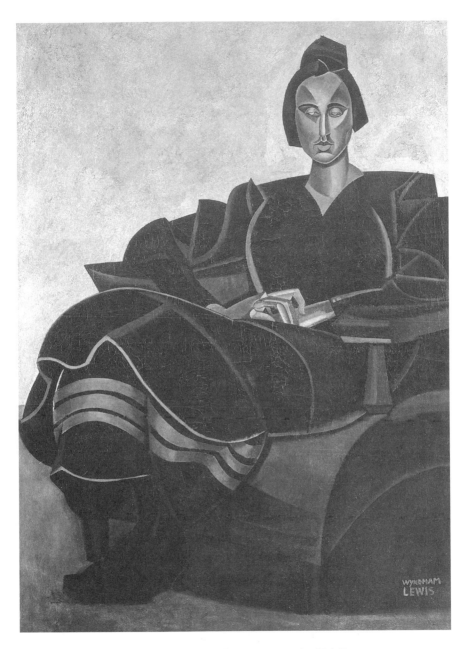

Wyndham Lewis, *Praxitella* (1921), a portrait of Iris Barry.

They both guzzled. Bronx and Beaune, the war-wine that appears on tap, brought the right weighty cheer into their hearts.

Their kisses in the taxi on the way to the Alhambra partook of the disordinate character of the orchestra in its last bout. She arrived there in physical disarray, her eyebrows raised, eyes staring, lips in reminiscent uncontrol. She wept with laughter at the Bing Boys. Robey, with his primitive genius, flattered the mood of the evening. She did not deny the Bacchanalia its culmination. As they drove through the black streets afterwards they lay in each other's arms and sealed their unwisdom with the ultimate convulsions of love. The eating up of the pennies and the yards on the taximeter was an intense and palpable symbol of time.

The next morning Beresin found a warm mass beside him in bed, and realized, as he would have done at the presence of a pool of blood or a dead body, that the preceding evening had been marked by a human event. The lass stirred, and a cumbrous bestial scented arm passed round his body. In the middle of a thick primitive gush of hair, he found the lips with their thoughtful pathetic spasm. He looked with curiosity and uneasiness at what he found so near to him.

The corpses of the battlefield had perhaps cheapened flesh? Anyway, realities were infectious; and all women seemed to feel that they should have their luxurious battles, too; only they were playing at dying, and their war was fruitful.

'Willie, do you love me a little bit?'

What should he say? He loved her as much as he loved a luscious meadow full of sheep, or the side of a tall house illuminated by a sunset, or any peasant sight or sound that he might meet. But this is not what women mean by 'do you love me?' He understood that. They mean, 'Do you think that perpetual intercourse with me for the rest of your life would be a nice thing?' That was hardly a question to put to a sentimental theorist of nobility, a dealer in hardness. Was the mink to inquire of the panther whether he would always kiss so nicely, while he was giving the mink a preliminary lick before devouring his prey?"[26]

Beresin, like Lewis, declined to marry his pregnant mistresses.

Some sense of what Lewis was like at the time might also be gained from a recollection by Edith Sitwell, although at the time Iris may not have shared Sitwell's unflattering view of Lewis.[27] Sitwell and her brothers, Osbert and Sacheverell, who may have been the targets of Iris's satire in *Splashing into*

Society (1923), became friendly with Lewis sometime in 1921. They had admired him as early as 1913, when Sacheverell, at age 16, had attended Marinetti's Futurist performances and struck up a correspondence with Marinetti.[28] The Sitwells took to Lewis, despite his eccentricities, but found themselves unexpectedly reviled by him in *The Apes of God* (1932), an excoriation Edith attributed, perhaps in mocking retaliation, to Lewis's embarrassment at having misplaced his collar while a guest at Osbert's house.

"Mr. Lewis visited us at Renishaw," she wrote in her autobiography, "but this visit, alas, was not entirely happy, for he mislaid his collar on the morning of his arrival, and could not come down to luncheon until he found it. But eventually Robins, Osbert's delightful ex-soldier servant (by this time butler at Renishaw), tracked it down, and it flapped back on to Lewis' neck, much as a weary and rather dilapidated blackbird might return to its nest.

"This temporary parting of the ways in Osbert's house caused Mr. Lewis, after three years' brooding on the subject, to believe that Osbert, Sacheverell, and I are evil symbols of the decay of civilization, and to denounce us in a book called *The Apes of God*—God being, in this case, Lewis, although the only resemblance between that gentleman and his creator lay in both having brooded over chaos.

"Before the collar calamity I sat to Lewis for the portrait of me that is in the Tate Gallery, and also for several drawings. But, in the end, his manner became so threatening that I ceased to sit for him, and his portrait of me, consequently, has no hands."[29]

Sitwell did not share as well the more heroic descriptions of Lewis registered by Pound or Ford. "His complexion," she wrote, "always dark, was at moments darker than others; and this pigmentation was due to no freak of nature or chance, but to habits and choice. His clothes seemed as much a refuge as a covering, and when fully equipped to face the world and the weather, he presented much the same appearance as that which we are privileged to see in photographs of certain brave men at the very moment of their rescue after six months spent among the polar wastes and the blubber.

"His outward personality, his shield against the world, changed from day to day—one might almost say from hour to hour. When he grinned, one felt one were looking at a lantern slide . . . a click, a fade-out, and another slide, totally unconnected with it, and equally unreal, had taken its place. . . . For this remarkable man had a habit of appearing in various roles, partly as a disguise (for caution was part of his professional equipment) and partly in order to defy his own loneliness. For in this way so many different characters inhabited his studio

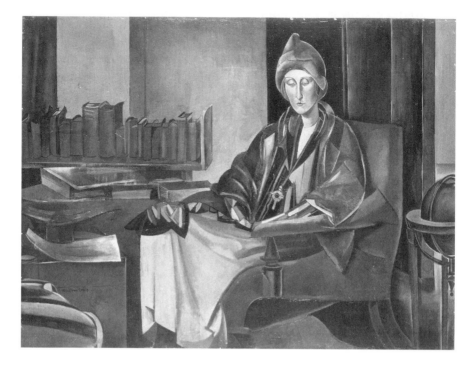

Wyndham Lewis, *Portrait of Edith Sitwell* (1923–35).

(all enclosed in his own body, so that they had no opportunity of contradicting him or paying him insufficient attention and homage) that he had scarcely any need of outside companionship."[30]

It is clear by her own admission, however, that Sitwell, at least in the early days, admired Lewis, responding especially to his "Spanish" guise, in which "he would assume a gay, if sinister manner, very masculine and gallant, and deeply impressive to a feminine observer."[31] But such guises may be for the "pretty dears" she referred to elsewhere, who go for Lewis's "Cave-man stuff. For it is not often that they meet a real He-man."[32]

Lewis and Sitwell ultimately became lifelong enemies. She and her brothers bothered him with silly postcards and telegrams. "When I feel cross, which is often, I tease Wyndham Lewis,"[33] Sitwell told her secretary Elizabeth Salter, whereas Lewis referred to Sitwell as "one of my most hoary, tried, and reliable enemies. We are two good old enemies, Edith and I, inseparables, in fact. I do not think I should be exaggerating if I described myself as Miss Edith Sitwell's favourite enemy."[34]

The last word, perhaps, belongs to Sitwell: "Mr. Lewis's pictures appeared, as a very great painter said to me, to have been painted by a mailed fist in a cotton glove. . . . Poor man! The only real fault in him was an unconquerable suspicion of everyone who admired his great potential gifts, seeing in that admiration a plot to gain his confidence and then hand him over to his real or imagined enemies. He longed, I think, to be liked, and would have been by everybody; but he simply did not know how to receive affection."[35]

Iris would no doubt have agreed that Lewis could be paranoid. Of his many enemies, she once said she thought Lewis might have chosen them "at random."[36] Nevertheless, by this eccentric, troublesome man Iris twice became pregnant.

Maisie Wyndham Lewis as a baby.

6

CHILDREN

WITH WYNDHAM LEWIS Iris Barry bore two children, a boy, Robin Lewis Barry, born June 3, 1919, and a girl, Maisie[1] Wyndham Lewis, born September 1, 1920. Lewis had already sired three children out of wedlock: in addition to the child born to his German mistress in 1909, Lewis fathered a boy and girl with Olive Johnson before the war.[2] Lewis biographer Jeffrey Meyers says that upon returning from the hospital with their second child, Iris was kept waiting in the cold on the doorstep of his studio while Lewis finished having sex with socialite Nancy Cunard.[3]

Iris repaired to nursing facilities to give birth to both children, and in neither case did Lewis much participate. The correspondence that survives their relationship suggests that Lewis was preoccupied with his career while Barry plaintively vied for his attention. Ill with tonsillitis at one point, she wrote to him complaining of "four sleepless nights, much pain, and long slow days—Will you come to see me? I shall not be infectious now, and you can gargle—or are you still so angry? I am better now, and tomorrow hope to be feeling gay again—I want so much to see you. Please telephone me in the morning or any time and give message to nurse who will answer."[4]

Lewis biographer Paul O'Keefe speculates that it was during a trip with Iris to Liverpool or Blackpool in late August 1918 that Lewis impregnated Iris with her first child.[5] By the end of that year Lewis had moved out of his Great Titchfield Street flat and, according to O'Keefe, "for the first half of 1919, had no settled address of his own in London" (209). Iris thus was on her own during her first pregnancy and by the eighth month was back with her mother in Birmingham. Lewis, meanwhile, fell victim to the great influenza pandemic of 1918–19 and spent from the middle of February to about March 20 in Endsleigh Palace Hospital (212).

Lewis had run a dangerously high fever for some weeks and the flu turned to double pneumonia. Despite being rude to his nurses, Lewis recovered

sufficiently to be moved to a convalescent home in Torquay, and thence "from one seaside place to another," according to O'Keefe, who relates that Lewis's "route between these resorts took him to Birmingham, where Iris Barry, nearly eight months pregnant, was staying. Her mother lived in the suburb of Washwood Heath and Lewis wrote inviting her to visit them one afternoon. Presumably anxious to avoid establishing too frank and close a relationship with Mrs. Crump, he adopted one of Iris's pseudonyms for the occasion and signed the letter 'Percy Bark.'

"By the middle of May he had continued his journey and was staying at 'The White Lion,' Aldeburgh-on-Sea. He sent Iris two nightdresses and £8, promising to send more in a day or two. For her part, probably some time towards the end of that month, Iris moved into a nursing home in Edgbaston where, on 3 June, she gave birth to a son.

"It can be safely assumed that Lewis was not present for this event," O'Keefe surmises, since "the following day he was attending an Officer's Dispersal Unit in London and having his Demobilisation ration Book stamped. . . . Iris called her son Robin. She registered the birth without divulging his father's name and, accordingly, no entry appeared in that category on the child's birth certificate."[6]

Lewis was eager to energize his career after the war and let it be known that he was reviving his journal, *Blast*. He took tenancy of a flat and studio on the lower level of a house in Campden Gardens, near Notting Hill Gate. It was probably here, having left her child in the care of her mother, that Iris spent the longest period under the same roof with Lewis, a time she later would remember for its suffering. She was expected to serve and not be seen, to flatter Lewis and disappear to the movies when he wanted privacy. Nonetheless, Iris cared enough for Lewis to have a second child by him.

Meanwhile Lewis thundered along on what he believed to be his revived career path. He began to work on a long overdue painting with a war theme for the Ministry of Information; he sketched prolifically (often using Iris as a subject), made energetic but futile attempts to revive *Blast*, and participated fitfully in the London art scene.

The immediate postwar years were marked also by Lewis's loss of both parents. His mother, who doted on him despite his occasional sniping at her, died of pneumonia at home in Hanwell, England, on February 7, 1920. She was preceded in death by fifteen months by Lewis's estranged father in America. An aunt of Mrs. Lewis, Frances Prickett, at the age of 78, took custody of Lewis's two children by Olive Johnson—Peter, aged eight, and Betty, aged six.

For eight months while he was living with Iris in 1920–21, Lewis was preoccupied with settling his mother's estate. Lewis was her executor, but he found it impossible to dispose of her laundry business at a reasonable price. He nonetheless managed to finagle Mrs. Prickett out of the £100 promised her in her niece's will. "Six years later," O'Keefe relates, "Lewis drew up a declaration and had her sign it: This is to say that since your mother's death you have supported me: and therefore the sum of money mentioned in your mother's will to be paid to me in the event of your otherwise not assisting me has long ago been cancelled" (218).

It was during this period of distraction that Lewis filed in the Leicester Square Post Office at 3:35 in the afternoon of June 1 a telegram to Iris addressed to their residence at the time, 83 Lansdowne Road, near Notting Hill:

PLEASE PREPARE CHOP EIGHT—LEWIS

O'Keefe writes that on the back of this telegram Iris wrote a shopping list:

> butter 1/4.5d
> potatoes 2/7.5d
> onions 4d
> steak 2/9.5d

She was doing her best to make him comfortable, and with some sacrifice. " 'I have led a singular kind of life all the last year to try and fit in with your life,' she told him two months later. 'I have no friends and no acquaintance and nothing at all either hobby or career or whatnot to live for except to get on with you' " (218).

Iris may not have known that during this time Lewis was also being stalked by a former mistress, Helen Saunders, whom another of Lewis's lovers, Sybil Hart-Davis, dubbed "the wild dandelion," because of her splaying golden hair and erratic behavior. Helen pestered Lewis with unannounced visits, telegrams, and letters. "The habit of secrecy with which he surrounded every successive dwelling-place and bolthole over the next two decades may have been established," according to O'Keefe, "at least partly, by this campaign of emotional persecution he felt himself to be a victim of in the first six months of 1920."

Helen pleaded, "You don't know what you are doing. You are killing me by mistake. . . . If I have driven you away it is my death as a human soul because it is not possible for me to love anybody else. . . . I beg you not to drive me away from the discipline of your mind on my mind and body. . . . I'm not fit to be

alive just now. . . . If it hadn't been for my mother I should have killed myself last week. . . . Please hear me this time—It is as if someone were beating me just over the heart." Helen complained that because Lewis "did not believe in my affection something went wrong in the very centre of my life" (219).

Lewis eventually convinced Helen's mother to restrain her, but not until Lewis claimed she had "persecuted" him "for a year or more" (220). This was the year Iris lived with Lewis. Helen's campaign did not preclude, however, the complication of another pregnancy.

"As she prepared Lewis' steak and onions for 8 o'clock in the evening of 1 June 1920," O'Keefe writes, "Iris Barry was about six months into her second pregnancy. This time her condition seems to have been at Lewis' suggestion. 'I must remind you that last year you spoke of my having another child – yours – as proof of good will and all that.' It appears that he had harboured suspicions regarding the paternity of Robin, now being cared for by Mrs. Crump in Washwood Heath, suspicions not entirely allayed by Iris herself.[7] On this occasion, however, she could assure him: 'I'm having another and most indubitably yours whatever stupidities you commit by conjuring up impossibilities to the contrary.'

"By early August Iris was installed in the Nursing Institute at Mitcham in South London to await delivery. She spent the first part of her stay knitting Lewis brown woolen socks and sending him meticulous timetable details. There were trains from Victoria at 3 and 4 o'clock, then 4:30, 5:22, 6:15 and 6:58. If catching the train from Clapham Junction, two or three minutes were to be added to these times and the journey took less than half an hour.

"Lewis visited her when his hunt for a new studio allowed him time," O'Keefe records, "but going six miles into the southern suburbs remained tiresome."[8]

Iris was in the care of a "Nurse Thompson" in the Nursing Institute. Lewis wrote to Iris there on August 5, addressing his correspondence to "Mrs. Lewis":

My dear Eyerish, I am going to try to get down tomorrow (laterish, I expect). How are you getting on? I am sorry that I cannot come and see you more often. It can't be helped. The distance is very great, and you are awkward to get at. I returned the other night via Croydon. This is probably the last week. I am writing you this about 8:30, after which I go to dinner. . . .

Yours, with much love, WL[9]

Iris tried to remain optimistic. She wrote that she had plans for their future life together. Knitting Lewis's socks had given her ideas for a thriving little business. "I should . . . teach knitting," she wrote him, "and try to arrange with

some firm of manufacturers making woolen underwear to be an agent for them, selling women's and children's vests, etc. on commission. As I got more orders I should employ more knitters, and aim eventually at doing nothing but sell." The business could be run from home, she told him, "if we had two furnished rooms near where you have your next studio." The enterprise was, she added, dependent on one factor. "Naturally all this is supposing we continue to see each other—which I certainly wish."[10]

Iris did not hear from Lewis for several days. She became preoccupied with the disposition of the expected child. In Sudbury, near Harrow, she wrote Lewis, there was a "Home for Infants and Children of Gentlepeople," where they would take the child off their hands for 27/a week. O'Keefe relates that Iris admitted to Lewis that this was "a lot but then you don't have to buy a pram." She added that she badly needed Lewis's advice and support, and said of the baby that "some place has to be found for it when I leave here, and I don't suppose you want to try and find anywhere even if you had time. What shall I do?"

"His intermittent visits, and now the prolonged absence of a 'husband' from her bedside, was becoming a depressing embarrassment," O'Keefe surmised, quoting a letter from Iris to Lewis begging that he "Only do communicate with me. I feel so very deserted when I don't know where you are, and it is so beastly being unmarried and nosey old crabs of women will come and be rude and horrid to me, I do dread all that."[11]

Iris felt abandoned. Unknown to her, Lewis had departed for a two-week vacation in France with T. S. Eliot.[12] Writing from the Loire on August 21, he addressed his correspondence again to "Mrs. Lewis":

Darling,

I have not written you before, because up to the present I have been engaged in an incessant trek. I have risen at six in the morning, have stood for 3 hours on end, 6 hours at one time, in corridors of crawling trains. I have crossed gulfs, stopping at innumerable islets, lain in the sun above beautiful estuaries, driven in dusty carriages through the most divine villages (architects, here is your Vortex!) and have finally settled for a couple of days at Saumur. . . .

Eliot is coming up to Paris with me tomorrow (or on Monday). I will probably see Joyce again then. Paris was en fête, the people were amusing themselves. The Bois very lovely and nice. England is most certainly a slip of Nature's, a nasty little slip at that. I will communicate again in a day or two.

But love, WL[13]

Lewis's trip took place at a time during which Iris continued to fret about the disposition of their imminent offspring. In a letter sent, *poste restant,* to Lewis in Vannes in Brittany, Iris pleaded for Lewis to help in her dilemma. According to O'Keefe, she had become worried that the Home for the Infants and Children of Gentlefolk in Sudbury might find out she was unmarried and refuse to accept the child. "Ought I tell them before or what?" she asked Lewis.[14]

Seemingly oblivious to Iris's troubles and preoccupied with his own affairs, on August 28 Lewis wrote her from the Hotel du Quai Voltaire in Paris:

Dear IB,

I have been here for a day or so now: waiting for money from the Bank. In my last day at Saumur a little accident befell me. I hired a bicycle along with Eliot, in the intention of riding to Chinon. After pedaling for 200 yards the chain flew off. That fixed up, at the end of another 200–300 yards, going at a brisk turn, the forked bar over the front wheel broke. I was violently precipitated on the pavement. I have a medium-sized surface gash in my knee and hand. The recurring daily discomforts are rather a bore. Still more is the fact that I lost what would have been a most useful day's work. I don't know what day I shall return or by what route: but soon, in a few days.

I would not confide in Thomp. (Nurse). As soon as I am back I will straighten that out. Should you want anything urgently, wire me Cooks (Av. de l'Opera). . . .

Keep well and patienter. I don't suppose you will void your foetus for several weeks yet. . . . Tell Nurse I will attend to her present arrangements or mysteries. I have sought to be able to come down and see you. But that will soon be a geological possibility again now.

But love: yrs, WL[15]

Lewis attempted, however enigmatically, to address the concerns of Nurse Thompson the same day via a telegram sent to

LEWIS NURSE THOMPSON NURSING INSTITUTE LONDON ROAD MITCHAM LONDON: BACK TOMORROW DON'T WORRY WILL ARRANGE IMMEDIATELY MUCH LOVE WRITTEN—LEWIS[16]

A letter from Iris awaited Lewis upon his return to England: "This is just a note to greet you when you get back. . . . I'm sorry I've not gone to bed yet but I can't help it. . . . I shall surely take to my bed this coming week, and we will spring into an autumn offensive of Little Men, Art, and knitting."[17]

Indeed there was little waiting time. Their second child was born on September 1, 1920. "If Iris was expecting a second son she was disappointed," wrote O'Keefe. She invited Lewis to give the child a name. "I want you to name the child . . . she's a nice little female and may possibly transmit a few traits of intelligence into a cow-like world so you could take a little interest. I know you don't like females but this one is bound to 'favour' you more than a male, and she'll like you better too: she won't like me! Is AUDREY too Shakespearean a name? Invent one, then."

O'Keefe writes that the birth certificate of Maisie Wyndham included the names of both parents: "Percy Wyndham Lewis, 'journalist,' and Iris Crump, of 'no occupation.'"[18]

Despite all this Lewis found it difficult to get to the nursing facility. "Dear I.B.," he wrote on September 4, "I intended coming down this evening. But . . . as I was kept longer than I expected in my studio hunt, I could not manage it. I will come sometime tomorrow however. I can't say exactly when. Better early afternoon or evening, I expect.

"I hope all going well. Much love. Yrs, W.L."[19]

On September 9, Lewis made passing mention of their newest child in a letter:

Dear I.B.,

I am going to try and get down tomorrow somewhere about one or two. I am contemplating a little arrangement, which I will tell you about tomorrow, which I think will be more convenient than the present economic system. I am sending a book: all I could lay my hands on. What meets the eye in the shelves in the bookshop is unbelievably mournful and repellent. It's high time some new books were written. I hope you and Maisey (sic) are well and not too spotty.[20]

After Maisie was born, Iris retreated to a priory in Sussex. In a letter from there she wrote to Lewis: "I cannot believe that you are in the land of the living, and I have some horrible idea that you are also at Liverpool, or New Haven, or Stockholm—

"I am now convalescing and will be out by Christmas. I hope nevertheless if you have time do come here to see me tomorrow or Friday—why not have dinner with me here tomorrow about 7—we would be alone and if you came earlier in the evening people might come and be boring—or for lunch?—dinner better? Please telephone tomorrow. I may be able to speak to you—or perhaps you

are angry—or bored with the thought of me—very good—I feel so well now—
and sleep soundly—and eat cream—my life is luxurious or rather disgusting
in bed—grapefruits, champagne, medicine, red, red nurses, soup-sipping,
flowers—Well, in case I do not see you tomorrow I wish you a merry Xmas and
a bright new year—Iris"[21]

On New Year's Eve Iris wrote Lewis that despite the facility's comforts ("there
is a nice fire in my room") she "felt very tired and rather remote. . . . I hope you
didn't harden your heart against me last night—I had been wanting so much
to see you all the evening and was rude to everyone else and exasperated with
myself and the world in general—so that when at last I saw you I was too far gone
in bitterness to be my 'own sweet self'—One feels so wretched at times—and
one's high tone of reason deserts and leaves one to rummage among the garbage
for some worm-eaten grievance—That is all bad and spoils things—You will
have to scold me a little when I come back—In the mean time I shall walk about
in the rain here, eat long meals, sleep long, I hope, and come back refreshed to
please you occasionally when you wish it—I hope you are doing fine work, and
I will of course drink your health at midnight and wish you many things—We
perhaps return Wednesday—might we not dine on Thursday?—Yours, Iris"[22]

How Iris would have been drawn to, and tolerant of, such a strange and
indifferent man is interesting. The powerful men with whom she was to have
significant relationships all had strikingly different personalities, and although
she may have later married for convenience, she is not known ever to have
married for love. Nonetheless, Lewis was, and remained, the central figure in
her life. He seems to have earned her affections the moment she first laid eyes
on him.

Everybody knows [she wrote toward the end of her life in recounting their
time together],[23] that I had to do with a rather famous English painter-
polemicist. I thought that he was the great man of whom I dreamed.

Que j'aimerais
Dit la fille a par soi
Etre la maitresse d'un roi

[What I would like, said the girl at home, is to be the mistress of a king]
and surely in 1918 Lewis was considered the greatest—a warrior, whereas
Pound and Eliot were not.[24] Was he the most talented? They seemed to
think so. He appeared on one of the Thursday evenings I spoke of before—
a soldier, an officer, back from the Front, uniform and hat and rather pale,
moustache . . . a hero.

Destiny drew the picture. I was trotting along Tottenham Court Road (or was it Shaftesbury Avenue?) the following Saturday and there was Lewis, who saluted me with his stick; yes, he had a stick—something between an officer and a Whistler—and said, 'Come and have a drink.' I believe I had never entered a pub before. I would have followed him anywhere. The others—Pound, Eliot, Ford—had shown they thought he was the best. Of course I followed him.

Four years followed.[25] I was very happy but suffered a lot. I was a prisoner. He suffered a lot and felt persecuted. He wore a hat at home[26] because he thought that someone was peering through holes in the ceiling, only there was no upper story.[27] It was all very dramatic and dreadful. The daytimes were painful except when he was working. The evenings were better. We went always to dine at Kettner's or Verrey's, but only occasionally at [La Tour Eifel]. On the first floor there was a private dining room decorated by Lewis. We did go there sometimes, which is how I saw Iris Tree and Nancy Cunard and no doubt other celebrated people.[28] As I was dressed like a necessitous mouse and felt like one, I was tolerated. Later Lewis suddenly bought me a heavenly dress—navy blue with a tunic over an underskirt looking crazily naval, and a most elegant hat.[29] I felt better in myself. But as I say we lived in simplicity but dined out always rather sumptuously.

My function was to be quiet all day[30] and droll in the evening, to flatter, to listen and to stimulate . . . hence, the Tyro. Lewis had painted on the wall itself a grimacing head, so to say something, since a part of my function was to be gay and mocking, I said, 'Oh, you have made the portrait of the veriest tyro,' an unknown creature of whom people spoke a lot at that time when discussing art.[31] Lewis was greatly taken by my suggestion, and said, 'Yes, exactly, that, it is his very portrait.' I suppose this same nomenclature was that of his publication[32] but I don't know because one sunny day in June I suddenly felt free (shackles fallen?) and went out, out. The charm no doubt from both sides was broken. Anyway I myself went away."[33]

Since her birth Maisie had been cared for in the children's home in Sudbury. After struggling with Lewis for over a year following Maisie's birth, Iris decided to strike out on her own. "An advertisement in the newspaper asked for a young lady speaking French," she recalled, "so I went there, to a smallish affair in upper Bond Street where I was interviewed by an obviously inferior type and hired immediately. The staff consisted of this sort of Moroccan and a dusty old fellow and me. Bales of sweaters came in from France, but on the whole none

of them corresponded to another: it was poor stuff. The old fellow, feeling them with his withered hands, said 'Rough as a badger's backside.' As the goods were not good they were for sale at almost any price. I understood eventually: [the owners] Bertry and Samuel took their pounds sterling on a *marche noir* and were earning good money on the exchange.

"And then we had Kitty, a lovely fairly tall blonde, supposed to be a sales lady. She said, 'Can I have a half-hour off? I would like to go and have tea.' As her presence was not necessary I said yes: such a sweet tall lovely innocent girl—until the day that she broke down and sobbed and told me that she was perhaps pregnant . . . and that the twenty-minute tea times actually represented a jump to a nearby flat of some South American. Moreover, she said that the old man who adored her would pay for her abortion. It was not difficult in London at that time to be aborted. One only needed money and the right address. I myself between 1925 and 1928 arranged to have several abortions, including one which I shall never forget, as I came back to my flat the same evening to give a snack to the fellow (was he a journalist?, I can't remember) and so did though not feeling very good. Heaven help us, how content men are of themselves ('the lady is tired or not feeling so well') . . . at least that man never knew that I had been butchered that same day. How I really <u>hate</u> men."[34]

During the period after her break with Lewis in which she worked at several odd jobs, including the Bond Street sweater shop, Iris lived in a room at 8 Stanhope Terrace in Regents Park. From there she wrote Lewis often, usually asking for money. "How are things," one such letter gaily began. "I'm getting a little restive once more—not having heard from you. But you know you will owe me £3 on Saturday, don't you? And I really don't know how I can manage any longer without at least a good portion of this: you know yourself how near a thing it is for me even with your help: and I've absolutely got to get some shoes, now the sole of those you bought me last summer separated from the top!" She reported that she had several employment prospects, although

good jobs aren't as common as leaves on the trees: however, I'm to meet Mrs. Hoster who seems to be the person through whom one gets nice jobs, and perhaps I shall be lucky. In the meantime things are rather upside down in Bond St. and I've asked for a rise, but they're putting me off on the score that as soon as the company is formed (they are forming a Company with some other people) they will do. Still I am still here, and feeling rather more competent than I did last summer—I'm practicing shorthand in the evenings—and as soon as ever I can afford it I intend to learn another language, but I can't decide whether Russian, Spanish or German is the most profitable. I've got some

idea of book-keeping now, thank heaven—there are jobs that make my mouth water,
jobs at £500 a year as secretary to grand lords—and the most awful horrid people have
them—jobs to political agents, etc. etc. Anyway, I'm getting in touch with this woman
who is most likely to help me.

I sent The Dial *a story and passionately hoped they would take it: but they wrote a*
letter saying they were compelled to 'buy nothing from abroad'—and asked me to send
something else later on, etc. etc. story had impressed them, etc. etc. All very disappoint-
ing. Still, perhaps in the end I shall manage to storm this position, which I set so much
store by—a place in The Dial.

I've not heard from Maisie for ten days—hope all is well.

Write me a cheery discursive letter some time—and try and send me a little money
this week or on Monday without fail, will you not? . . . Tell me about the Life of the
Tyro . . . when you write?

Freda[35]

Iris's friendly overtures notwithstanding, Lewis continued to keep Iris at arm's
length, forcing her to communicate with him through his bank. "Shall be glad
to have an address to write you at," she replied to him from Stanhope Terrace,
"as I don't much like writing to the bank. I don't quite know why.

"Please do your best to send regularly, as it is easier I think to send the 15/-a
week, and it saves me having to borrow and getting tangled up and worried. I
do hope to be able to write a book sometime, it is certainly the only way I can
ever do the trick, but at present I've not been doing much—I think I shall have
to get another room as I've got no fire in my present one and it's rather like sit-
ting in an ice box. . . .

"Acie's [her mother] affairs are rather muddled too, but I hope to have Maisie
sent to Birmingham sometime in the new year and then I won't be quite so agitated.

"Anyway, thank you again for sending, Iris"[36]

In the spring of 1921 the value of the franc was diminishing against the Eng-
lish pound and Iris found herself out of work at the sweater shop. Through
the publisher, Harriet Weaver, whom she had met at the dinners with Pound
and Lewis, she landed an assignment to travel to Paris to help with the dis-
tribution of the second edition of James Joyce's *Ulysses*, which Weaver was
publishing despite opposition from the British censors. According to Lewis,
Weaver had been "sold" the idea of publishing Joyce's novel by Ezra Pound.[37]
Weaver had inquired of Iris whether she knew anyone who spoke French and
Iris volunteered. For eight weeks at the Hotel de Mainz Iris bundled and

mailed copies of the novel, only to find later that all had been seized by the authorities.[38] She then wrote Lewis from 70 Rue Notre Dame des Champs, which Lewis's biographer Victor Cassidy identifies as Ezra Pound's address in Paris, that "It was sad not seeing you in Paris, you might have spared me five quick minutes for one quick drink" while Lewis was visiting Paris to promote his work.[39] In the same letter she offered to help him find a Paris studio, complained that he "did not leave a *Tyro* [Lewis's new magazine] for me," and sought the return of two or three poems she had left with him, "as they are the only copies—or perhaps they have gone the way of all trash?" She assured him she was "still writing" and said it "will be nice to see you again—we must have a long meal and a long bottle together when you come [back] to Paris." Although she claimed that she liked Paris "and do not intend return to England yet though I may go to Germany or Geneva sometime this spring," she soon was back in London.

Upon her return to England, Iris took a room at 6 Carrington Street in Shepherd's Market where the landlady was the head charwoman to the Duchess of Norfolk and whose sons were valets at local gentlemen's clubs. Iris got the royal treatment ("how much hot water they carried up!" she told Edmund Schiddel)[40] and at the same time she found a job as a secretary with the Bank of Romania. The bank manager, a man named Lukasevitch, kept offering to "show her his etchings." But this time Iris determined that she would tend to her own career and immerse herself in readying for publication a parody of Daisy Ashford's novel, *The Young Visiters*, which originally had been intended as a special edition of *Blast*.[41]

Following her separation from Lewis, Iris frequently appealed to him by letter for attention and money, expressing remarkable affection and regrets about their being apart. Writing from his friend Augustus John's country house in Dorset, she lamented that "we have never had any peace of mind, ripe, tasty hours together, Lewis, except those stolen from my domestic cupboard, leaving a skeleton there. . . . If I say that the country is nice you will answer that I have been hypnotized by John's peasants, pubs and gypsies—J. himself is absent, and there is an endless but very comfortable family here, indulgent, hip-swinging decorative people. . . . I have swum twice in the sea—ridden a pony, and lain for many hours in a pleasing walled-in garden—the evenings are less agreeable and I should like a sprightly mind like yours to keep my own from sagging. . . . It was a pity we could not talk the other night at Stulik's[42]—I was rather tight and oppressed by the octopus motions of Colonel Barron's eyes and plump white

fingers. Will you be nice and write to me? My letter is dull because I fear the comical lift of your eyebrows when you read it. Write quick and say you miss me and that you are well and your plans thriving."[43]

Lewis, however, remained aloof. Iris had placed Robin in the care of her mother, Acie, and Maisie remained in the home in Sudbury. Iris's mother promised to take Maisie as well by the spring of 1921, but "for the present," Iris wrote to Lewis at his bank, "I can see nothing better than to continue with Sudbury as they have been very considerate. Maisie appears to be training for a prize. I had a new photo of her this week. She looks extremely well and very properly intelligent. I would send you a photo if I were sure you would like it, but it is not convenient to send to the bank. . . .

"As regards my job, I simply feel that it is preferable to work for an established firm as I am unable to face the prospect of being without work. I have no definite information with regard to the present situation, except that it is a new firm and business is not too good. My work is pleasant but hard. I do typing, salesmanship, errands, correspondence and accounts, etc. etc. There is no immediate danger but if I could get something safer I should. I hope you are getting on with *Tyro*, which I am looking forward to reading. I think under the circumstances I have to congratulate myself on having <u>any</u> kind of job with so many out of work. I do not want to fuss you about myself, and since I can depend on you to assist me for the present, I think perhaps even now we shall win in the end. I am hopeful of becoming a writer someday anyhow."[44]

The eventual publication of her first book, *Splashing into Society*, in 1923 gave Iris hope that she might succeed as a writer. She was pleased one day to see her name on an advertisement on the side of a passing autobus. The book's reception, however, was not encouraging. Today *Splashing into Society* holds interest as an autobiographical fantasy, but at the time it was accepted indifferently, if politely, as an attempted parody of a more popular book, Daisy Ashford's *The Young Visiters*.[45] Iris's friend Ivor Montagu later recalled that Iris had "managed to get a first book published" but it was "not very good, it had one or two welcoming reviews. But what was important: it brought in fifty pounds. When Iris got the cheque she had a job in a Bond Street wool shop and splashed some on herself taking a taxi to work every day for a week."[46]

The book received a few favorable reviews. Far from the London literary scene Iris sought to satirize, the *New York Times* in an unsigned review opined that "the author of this little book *Splashing into Society* has apparently tried to combine a satire on literary London with a burlesque of Daisy Ashford." After

snipping a quote or two from the text, the reviewer noted, "No doubt many people will think this little book amusing."[47]

In the dark period after separation from Lewis, Iris tried earnestly to find portrait work for him so he might in turn keep his financial commitments to her.[48] She referred stockbrokers and models, bankers and landed aristocrats to him whenever she could, writing that she was "sure we can rake in a pound or two this way."[49] Even after 1923 and the publication of her first novel, Iris wrote Lewis that she had to "sell outright: copyright, American and serial rights" to her publisher and she needed to "borrow a few shillings as I have only 8 £/2s and I haven't paid for Maisie." She said she hoped to "meet one or two people with a view to getting a job to write a weekly prosy page in some paper like the *Tattler* or *Eve.* I thought you might assist."[50]

Lewis's support was at best erratic, and at worst demeaning. Iris resorted to confronting him at his studio, unwittingly risking recalling for Lewis the stalking tactics of Helen Saunders. ("I popped round on Monday night but the gate was locked. . . . I am inclined to set up a further howl as to the necessity of having a penny or two from you—really most urgent—but I am sure you will do what you can. As a matter of fact a dinner would be handy as I am quite penniless this week");[51] still, she attempted to exchange favors with Lewis despite his indifference. Upon publication of *Splashing into Society* she asked him to "put in a good word for it where you can." In the same letter she told him she was "just over half-way through a novel the plot of which I once discussed with you, as to what people may feel like if death ceased to occur for a period. I think it will be a seller." She told Lewis there would be a photo of her in the *Sketch* and possibly the *Evening Standard* and asked that he notify anyone who might be helpful. "I don't think you need fear mentioning me as I appear to be 'swallowed' all right," she assured him, "at any rate the Sitwells were very pleasant to me (all three of them) and I rather think that's a sort of test. . . . I've also just, today, got my first job of reviewing for *The Spectator*. I'm having a shot at their 'material reviews': i.e. criticisms of cretonnes, lampshades, pottery, etc. I wanted to ask you to please let me come and borrow a few books I know you have which might me useful to me." She reported that she had "chucked the Bank" and was doing secretarial work, part-time, for St. Loe Strachey of the *Spectator*. She hoped Lewis might have some "power" to get her on with Middleton Murray at *Adelphi* and possibly help her get publicity for *Splashing into Society*. She concluded by asking, "If you can stand an interview, which would probably be the simplest, drop me a line. I'm free till 1:30 mornings, and of course evenings after 6."[52]

There is no record of Lewis's reply. Iris, in turn, wrote him back, "I wish I owed you (as I do Selfridge [the department store]), then perhaps you would write to me as often as they do. Maisie is here; your chum Mr. E. Pound has written a poem to her. I have got another cold, my leg hurts me, my mind is as empty as most people's larders are today, with a bleak wind blowing through it—I am neither very warm nor very happy—farewell."[53]

Iris made her separation from Lewis final by requesting her things. "At 8:30 one evening in mid-August," Paul O'Keefe relates, "Lewis made a delivery to a house on the eastern edge of Regent's Park. He left a note: 'I . . . paid a call, but found you out. Left last parcel of effects asked for.'" He told her he wanted to see her, but "that will not be possible now, as I shall be off tomorrow or the following day. . . . I will try to send £2 during the ensuing week."[54]

Lewis was off to Germany, where he hoped to find a market for his work. Iris interpreted this as a "short holiday," and hinted that it might be an extravagance under the circumstances. Lewis retorted that "the fare, 2nd class, via Ostend, to Berlin is £4.7.6, about the same as it in to Cornwall."[55] He argued that difference in the rate of exchange made his relocation a thrifty move.[56]

Iris had pleaded with Lewis for support since 1921, with diminishing results. By the end of 1923 she had come to the conclusion that Lewis "evidently [did] not care," acknowledging that she had "made a mistake" and there was "absolutely no relying on" him. She demanded that he "instruct your lawyer to make me a regular weekly payment of 15s—to arrive on Monday morning, and at the same time either send me yourself or cause him to send me the three weeks money due last Monday the 28th, immediately. I am sorry to have to come down to a business footing, but you make everything else a sort of slow suicide. Please let me have some sort of reply to this letter. Iris Barry."[57] This formal signature differed markedly from the "yours, Iris" farewells of earlier letters, or even the "Frieda" signature she sometimes used in deference to a pet name for her used by Lewis.

Lewis had promised Iris earlier, in the summer of 1921, that despite the possibility of bankruptcy,[58] he would send her two pounds a month, "until you get a good job." He also attached the condition that "you must then keep your word, and keep your child. I suggest therefore either 1. you advertise and try and find it [the child] a better home or more settled home than you are likely to be able to give it, or 2. get her and place her more cheaply in a more distant spot. The further you get from London the cheaper these things should be. Something might be found in Wales."[59] This letter was followed by several from Lewis pleading poverty ("I have no money," "I literally have no money," etc.)

and saying that he was "very, very busy," the latter being signed "Yrs, WL." Or: "You must absolutely cease to regard me as a portion of Providence, or ask more of me than you do of other people. In the autumn if I have any luck, I will help you along for a few months, until you secure a better position, with Maisie. But it came to my notice (through an accident) that you contemplate in a week or two a large addition to your wardrobe. I suggest that if you have such money to spend you should first spend it in meeting the expenses for Sudbury. There is nothing, then, to be gained at present either from interviews or letters. It is as impossible for me to give you ten pounds as I assume it is for you to give *me* such a sum. Note: I had hoped against appearance that it might be possible to remain on friendly terms with you when you resumed your captivating struggle with the world. Expect two pounds in a day or so. I'll do what I can. Yrs, WL."

These abjurations, delivered in a time when Lewis claimed he had "struck bottom," contained criticisms of Iris. Lewis accused her of a propensity to "indulge in little pseudo-scientific parables . . . which are not devoid of a desire to imitate [presumably a critique of her novel in progress about a town in which death temporarily ceases]. You cannot control your tongue—or mind," he complained, and denied that it was a "sign of ill will" that he did not want to see her. "I have got all the invitations I want at the present moment. Later on perhaps that might be adjusted."[60]

The injury of this dismissal was compounded when Lewis tried to cut Iris off from any acquaintance with his powerful friends. "In the course of our unfortunate intimacy you became acquainted with a half dozen people whom I regard as my small circle of friends," he wrote her. "It is a very small circle: an avoidance of which by you could not embarrass you or hamper you in any practical manoeuvres you may have to engage in.

"When you ask me 'if I mind,' you know it is not my business what friends you or anybody else has. But it is certainly under the circumstances a question that need not have arisen, and there is no sense in asking. I want to forget a certain episode in my life completely. It is an absurdity to talk of 'friendly' relations, when you don't keep your word as regards the money for your child, and when at the most unbelievably difficult time for me I am expected to help you much more than I can afford to. But if you wish the person who temporarily is forced to send you money that he has not got to consider you with anything but intense dislike, you will let him alone, and not indulge in actions calculated to make the obliteration of yourself less satisfactorily complete. . . . I am not going

to write any more letters to you, and I hope you will write as few letters to me as possible. I will send you 2 pounds and the *Tyro* Monday, and 15s a week after that, until you are better off. Will that, or will it not, exempt me from further appeals that at present I <u>cannot</u> satisfy? Let me know, W.L."[61]

With relations with Lewis at their lowest ebb,[62] with two children to worry about and no job security, this period passed as a dismal one for Iris. Despairing of alternatives, she answered an ad in a newspaper and placed her daughter with a childless couple in Manchester.

Alan Porter in 1938.

7

ALAN PORTER

IN 1923, AS Iris recalled in interviews conducted by her novelist friend Edmund Schiddel in 1942–43, "suddenly Oxford was spewing forth a vast congregation of young men."[1] On the eighth of October 1923, she married one of them, Alan Porter, a 24-year-old American poet just out of Oxford who was writing for the *Spectator*.[2] Through her association with Porter, Iris published a poem, "A City Song," in the July 14, 1923, issue of the magazine. Also during their courtship the *Spectator* published one of the few favorable reviews of Iris's book, *Splashing into Society*.[3] As Iris told her friend Yvonne Kapp, she always went for "the most important man in the group."[4] Important or not, the bridegroom was curiously absent on his wedding night. Iris spent the nuptial eve in their basement residence on Guilford Street with the kitten she had received as a wedding present.[5]

Porter was born in Indianapolis, Indiana, of English parents, who returned with him to England when he was two years old. He distinguished himself in philosophy and English literature at Oxford, graduating with honors in 1921. In 1922 he coedited with Edmund Blunden a book on the poems of John Clare.[6] He was assistant literary editor of the *Spectator* when Iris married him, and became Literary Editor in 1924, the same year Iris became a regular film columnist at the magazine. Porter held this position for the duration of Iris's tenure as the *Spectator*'s film critic.

It was through Porter and his Oxford friends that Iris was introduced to St. Loe Strachey, proprietor of the *Spectator*. Strachey's son, John, a film enthusiast, thought that the magazine should take notice of films. In the early twenties Porter's Oxford friend, Bertram Higgins, was doing short reviews of motion pictures, but decided he could not continue and turned the job over to Iris, who had been doing occasional criticism for the publication.[7]

There was a geopolitical dimension to Iris's hiring that would become important to her career. In the autobiographical notebook she jotted in while living in France in the 1960s, she wrote that in the early twenties "the English press and even the English government had suddenly become aware of the near-demise of the British film industry, not inconsiderable before the war of 1914. . . . With more than a little jingoism, this lack had recently been privately and publicly deplored as prejudicial to the health of the nation, more and more of whose subjects (and notably its younger ones) were thus being subject to the influence of foreign—which is to say American—ideas and ideologies. There was of course also the loss of prestige to deplore, not to mention the loss of 'devises.' Hollywood was mopping up the money."

It was in this atmosphere, Iris recounted, that "the then-proprietor and owner of the influential weekly *The Spectator*, Mr. St. Loe Strachey, had at a directorial meeting touched upon this very topic. I should perhaps recall that up to that time the press collectively more or less ignored the existence of the cinema. But Mr. Strachey with his customary dash and foresight felt that 'something should be done' by his *Spectator*. His son, recently graduated from Oxford and now a member of the staff, said in his immutable drawl 'There *is* a woman whom I have met who <u>seems</u> to know quite a little about the subject. I <u>think</u> we might try her.' No sooner said than done. The woman was myself. I had had the pleasure of dining with the Strachey son and his roommate E. Sackville West not so long before and evidently I must have talked a lot about the movies. So I was now interviewed, I think by the fils Strachey for I seem to recall a sofa in his office with a surprising number of very bright cushions piled on it."[8]

Thus began Iris's long and consequential association with film and film criticism. She became what Ivor Montagu later called the "first film critic on a serious British journal," meaning the first to criticize rather than merely to promote, motion pictures. Montagu felt that the new role, "to treat the cinema as yet another art—needed an all-sided person" and Iris was the perfect choice. "Aside from her literary catholicity," he recalled, "she had an eye for painting. Also she had a deep appreciation of music. None but her most intimate friends knew that she also had an excellent contralto voice. Later, when she could afford it, she would never be without a piano or, for that matter, without a cat."[9]

For Iris's part, she took her new job with unaccustomed seriousness. "I tried hard to think through what my job really meant," she later recalled. "On the *Spectator* I was seeing about a dozen or more pictures a week, and actually being paid to see them. It was a bit bewildering at first and not a little frightening for at that time I was, I suppose, a horrid little egoist—as jejune as they come: I took my responsibilities as weightily as the late Mr. Ghandi and I firmly believed

that my slightest qualifying adjective might raise grave doubts amongst count-less thousands as to whether they should invest their shillings at the Strand Palace or forget it all with a pint of bitters at the Elephant and Crown."[10]

Iris could not have failed to recognize that going to work for the Stracheys placed her squarely in the enemy camp as far as Wyndham Lewis was con-cerned. The Stracheys, especially St. Loe's son Lytton, the noted biographer, were associated with the Bloomsbury Group, whose members Lewis vehe-mently despised. Lewis satirized Lytton both in *The Apes of God* (1932) and later in his novel, *Self-Condemned* (1954), and in the former book took it upon himself to characterize the relationship between the effeminate Strachey and his boyish female admirer, Dora Carrington, as one hopelessly enmeshed in father-daughter love. Strachey returned Lewis's contempt, though more kindly, mentioning to Ottoline Morrel that "living in the company of such a person would certainly have a deleterious influence on one's moral being."[11] By the time she took her new job, of course, Lewis was officially out of Iris's life.

Porter and Barry lived frugally in a basement flat, where Porter frequently spent days writing. When he finally published a volume of poems, *The Signature of Pain*, in 1930,[12] the book was prefaced by poems in his honor by friends. Most alluded to the book's long gestation, as did W. Force Stead of Worcester Col-lege, Oxford, in a poem called "The Hour Glass," subtitled "To Alan Porter, on His Delay in Printing":

> Friend Alan, we have waited long
> To welcome your first Book of Song;
> What sands have run since first I knew,
> Liked and admired and envied you!
> Envied your flash of wit,
> Admired your tightly knit
> Philosophic thinking,
> Liked to abuse
> Your muse
> For coy excuse,
> From the public shrinking.
> Welcome, now you bestow it
> In print, elusive poet!
> Thrice welcome, for your gifts are three,
> Wit, Music, and Philosophy.
> Now 'mid the grains of Time's glass will hold
> One less of sand, three more of gold. (9)

The poetry in *The Signature of Pain* reveals a sensitive personality, though one affected by sadness and self-doubt. These characteristics place Porter in sharp contrast to the other men in Iris's life, known for their self-confidence and hauteur. On the other hand, Porter provided Iris with entrée into the inner circles of Bloomsbury, a culture Wyndham Lewis loathed. With remarkable agility, Iris joined the enemy camp.

She lived with Porter as a liberated woman, taking lovers and undergoing several abortions. The possibility that Porter's life with Iris may not have been altogether tranquil is suggested in a line from his poem, "A Sophistry of Love," in which he wrote:

There's yet some hate between us, or some devil.
We keep reserve, as any country girl
With a too civil stranger; thrust and parry
And long most bitterly to throw down arms. (17)

In keeping with their Bloomsbury aspirations, another poem in the collection, "The Cosmopolitan," is dedicated to Edith Sitwell ("You, Edith, my interpreter, reveal the lost unfabled isles") and in another there is a trace of the old Imagism on a subject often associated with Iris:

The White Cat

The fire whispered to the old white cat:
"I shall grow fat.
Out in the night I'll jump, and there
Swallow up the air.
I shall take trees and mountain-tops for tinder
Till the whole world's a cinder."

Still dozing by the fireside sat
The old white cat. (48)

In the early 1920s Porter had expanded upon his interests in philosophy and psychology as well as literature. His restless inquiry at times led him to blend a newfound religious faith with a personal form of communism. In 1921 he wrote his friend W. Force Stead, "I've been a communist too long to be unaware that many delightful persons consider communists the devil's agents, inhuman

villains if they know what they're about, disastrous fools if they are ignorant."
To Porter "communism—as every other political faith—derives a meaning and
a direction only from the characters of men who profess it. If men of amiable
and kindly character profess it—and I have never met an English communist of
any other character—then their communism must in all events differ from the
travesties of the *Morning Post*." [13]

On November 25, 1923, he announced his marriage to Iris to Stead: "I am
seriously, strictly, and civilly married," he wrote. "I should never carry a practi-
cal joke so far; and I don't make many at my own expense, anyhow. Thank you
for your congratulations: I deserve them. And I beg your pardon if I gave you
the news in riddles. That was only because I didn't want the people who see
me every day to hit me heartily on the back beforehand, or to make superior
and kindly and derisive remarks."[14] As Stead had apparently informed William
Butler Yeats that Porter had married, Porter admonished: "I suppose you didn't
tell Yeats who I'd married. He would have been really surprised, I think. My wife,
you know, once lived for some years with Isolde Gonne, to whom the old fellow
proposed. All she could find to say, as Yeats magnificently offered himself, was
'Oh, Willie!' There are many stories of Yeats that my wife tells me; and as they
knew each other before he was quite too famous or quite so sure of himself, they
present a man quite different from the venerable poet of our acquaintance."[15]

One might imagine that a person as sensitive as Porter could be challeng-
ing to live with. Iris remained married to him, however, until 1934. Of their life
together there is little record. As late as 1978 a friend, the writer and editor Peter
Quennell, wrote to Wyndham Lewis's biographer Jeffrey Meyers that he was
"astonished to learn that she [Iris] had two children—by her second husband,
I suppose. She certainly was childless in my day (about 1922–23), and married
to a young poet named Alan Porter, said to be highly talented, tho' not pro-
ductive, who seemed to spend most of his time abed, while Iris supported the
household as a film-critic. They lived in a run-down 19th-century street, which
has now vanished, somewhere off Theobald's Road, and shared a basement flat.
I remember a strong smell of cats in the passage and a Gaudier-Brzeska print
on the sitting-room wall."[16]

Four years into her marriage with Porter, Iris made one of her periodic
attempts at mothering. She snatched Maisie away from the people who were
caring for her. Iris had placed Maisie with the Spencers, a financially comfort-
able but somewhat straight-laced couple living in Manchester. The Spencers
were childless and actually would have preferred to take in a boy, but Iris
assured them she had only a female to offer. Maisie lived with the Spencers,

assuming their name without benefit of legal adoption, until her teenage years. At the age of seven, however, she was confronted, without forewarning, by Iris, who brusquely took her to London to live with her and Alan Porter.

In 1988 Maisie recalled that what little childhood life she had known with Iris was fraught with confusion and loneliness. Iris would appear unexpectedly, uprooting her from wherever she was settled in an awkward attempt at mothering. "I think she thought I reminded her of Lewis," she recalled. "He wounded her pride a great deal. Mainly she felt snubbed by him. She was fascinated at first. She once showed me a letter containing a lock of his hair. But I believe she was a social climber and thought him to be useful. She used people. She knew what she needed in life. But very soon he appeared less than useful and they began to clash.

"She told me that they separated because after I was born he would tell her to go tend to the baby and she would say the same to him when both of them were busy writing. He, of course, didn't stop. He was the man and that was Iris' job. With that she left the house, taking Robin [Maisie's brother] off to her mother's. She said she left me behind because it would teach Lewis a lesson. But she heard through mutual friends that he rather enjoyed caring for me. It soothed his nerves. Far from being a distraction, it made him quite agreeable. So when Iris saw this was having the opposite effect she took me away as well."[17]

Of her reunion with Iris, Maisie recalled: "I remember this lady in black, described as my mother, and the next thing I knew I was on a train to London. I went with her to Guilford Street and stayed with her for about a year. I hardly saw her. I'd be in this big house all day. There was this disagreeable cook-housekeeper in the basement, who had to care for the whole empty house. There were fashion dolls all over the house, on the beds and chairs. I didn't like them because I wasn't allowed to touch them. They were rather big, not as large as me, but with realistic faces. I was alone with them. Alan was in his study trying to write. I would wander down the stairs and up would come the housekeeper, 'Out out out,' she'd say, 'I've more than enough to do without being bothered with you,' and I would be driven up the stairs again to sit alone with the dolls."[18]

What little human contact Maisie had during these days came in occasional exchanges with Porter who, as she put it, "took me under his wing. Actually my mother told me later that Alan hadn't earned any money, that he had ceased to write from the time they were married. He was sort of lolling round the house in the study. A very nice man. I liked him. He gave me his fountain pen.

We lent over the balcony on Guilford Street in Bloomsbury near the Museum. I remember him standing on the balcony, a sad man but pleasant. Iris was supporting them both. I know I didn't like her very well, because she was always talking French to her friends when they came to see her—very rapid French so I couldn't understand. Sometimes she would look at me as if to say, 'Oh, dear, what shall we do with *her*?'"[19]

What Iris did was put Maisie in a boarding school with Robin, while neglecting to inform either of their relationship to one another. To Robin Iris was merely a lady called "Auntie." Robin thought perhaps Iris's mother was his own. Maisie had no idea who Robin was. "I remember Iris coming to visit and being very cross with Robin," she recalled in 1988. "Robin was sitting under a tree speaking to no one. I always thought of him as the boy who spoke to no one. Iris went over to him and said, 'Why are you sitting by that tree? Oh . . . you are so dirty!' It was a 'free expression' school, but Robin was completely silent. We were playing cricket that day, I recall. It was very pleasant. I was happy there. One could play in the forest.

"The next thing I knew I was back in Manchester, not knowing how I got there. Back with the Spencers, where my normal life resumed and I forgot Iris completely, forgot the whole thing, because I was always rather busy and on the go. Iris then would annoy my mother [Mrs. Spencer] by writing and saying 'I do hope you let Maisie read *Vogue* magazine, it's very important the girl should have a good dress-sense.' Of course, the Manchester people are not into clothes, it's not what they're bothered about. The Spencers were very annoyed, because they thought that I was their child and they were wealthy and used to telling other people what to do. They were not accustomed to getting orders from people. They'd throw the letters in the fire. My mother used to read them and get disgusted but my father would say 'Don't open them, just throw them in the fire.' My mother had a bad heart. It was terribly disturbing to get these letters."[20]

The episodes with Maisie reveal a life of conflict for Iris. She badly wanted to get on as a writer, but could not altogether sever ties with her children. Nevertheless, she managed to keep her maternity hidden from them and their own status as siblings obscure. At the same time, she saw herself as the breadwinner in her marriage to Porter, and so struck out with renewed effort to forge a career.

Maisie later became a fashion columnist.

Mary Pickford.

8

THE SPECTATOR

I N H E R W R I T I N G S for the *Spectator*, Iris began to develop an aesthetic for the emerging art of film. She did this at a time when motion pictures were finding a grammar and syntax to differentiate the medium from theater and the other arts. Iris saw many of the seminal films of the period with fresh eyes, not knowing which, if any, eventually would take their place among the canons of a new art form. Her writing and analysis is sophisticated, substantial, and surprising for a self-taught critic who seems to have derived great benefit from her informal contacts and conversations with the important British modernists she knew.

The prevailing attitude toward film viewed it at best as an amusement, neither worthy of respect as an art nor in any way as potentially valuable as literature. Few seemed willing to consider film to be a variety of visual art, and the documentary function of film was regarded as a mere recording mechanism. As she began her career as a film critic, Iris faced two formidable challenges: how to define film as an art form and distinguish it from the other arts, and how to acknowledge foreign superiority in filmmaking in the face of rising British nationalism.

Even in her first column in February 1924, Iris touched upon an issue holding hidden thorns for her. Businessmen, government officials, and moralists of the period were suspicious of American dominance of British screens. Iris faced the dilemma of what to say about Hollywood. Objective opinion might hold that British films were rather stagy, that the edge for entertainment and legitimacy as a serious art lay with the Americans, especially with D. W. Griffith and the studios newly resident in California. If not, then the Germans had a claim, with F. W. Murnau, G. W. Pabst, and others finding an expressiveness that gave films an aesthetic aura.

The first column Iris published in the *Spectator* came during British Film Weeks, a period during which the nation's theaters devoted their programming exclusively to British films in the hope of convincing the public to support them. Iris dealt politely with this mix of commerce and aesthetics, noting that

> a traditional British vein has long been worked by the Hepworth company who contribute *Comin' Thro' the Rye* to the programme. This film, in common with all those from the Hepworth studios, is distinguished by a slowness of tempo very different from the speed in which America has specialized since the days when she exported those first flickering little films of rushing express trains. The *moeurs* of the Victorian novelist have never been better crystallized than in this pretty crinoline piece: excellent use has been made of the intimate hedge-row landscapes of Southern England as a background. Both *Comin' Thro' the Rye* and *Borden's Boy*, from the same studio, are remarkable for their care of detail. A different traditional British spirit is caught in *Squibbs M.P.*, a rollicking picture about a flower-girl (acted with spirit by Miss Betty Balfour). Here the English humour of character, the Dickens humour, is exploited, and the film goes at a good pace. A third, and at the moment the commonest kind of British production is typified by *Bonnie Prince Charlie*, in which Miss Gladys Cooper and Mr. Ivor Novello combine their personal beauty; but here the producer has allowed both romantic and dramatic situations to slip past. The chief characters stand about in picturesque attitudes, but the story flags—even our sympathy for the Pretender is never roused. In *Mary Queen of Scots* something much better in period plays has been achieved, and Miss Fay Compton proves herself a talented actress in emotional parts. In *Becket* great care has been given to period details, and Sir Frank Benson, though rather stagy, makes something of the title role. But an audience accustomed to the vivacity of Mr. Douglas Fairbanks will nod through the piece. It is an excellent thing that these plays should be produced in England, in the right atmosphere with the right scenery. But scenery and atmosphere are not everything, and on the whole the British producer still proves himself unable to re-create emotion and is weak in suspense. These films are all gentle, well mannered, but decidedly quiet and sometimes dull.[1]

The inferior state of British production would present a political thicket for Iris for as long as she remained in England. Indiscreetly, perhaps, she routinely championed American over British films. "Take away American films and you

close the cinemas," she declared in one of her *Spectator* columns.[2] She delighted in films depicting an America she imagined to be "hard-working and prosperous, where mechanics possess cars, and one concludes that such a country is inventive, enterprising and very rich."[3]

In developing a film aesthetic, the first step Iris took to argue the legitimacy of cinematic art was to differentiate film from its closest rival, theater. In a column titled "A Comparison of Arts" appearing in the May 3, 1924, issue of the *Spectator,* she noted that

some glib fraud long ago invented the detestable phrase 'the silent stage,' as though the cinema were nothing more than the theater docked of its words. This dishonest and unintelligent view is strangely persistent. Yet partisan comparisons between the cinema and the stage are actually rather unfair to the stage, because the cinema has so much wider a scope. It alone can handle natural history, anthropology and travel. It can more fully develop parable, fairy-story, pageant, romance and character-study. But since both theater and cinema do express farce, comedy, tragedy and melodrama there is a common ground on which they may properly be compared, although they are different art forms in different mediums.

In presenting drama, the theater has certain advantages. The actors are present in the flesh. Everyone who saw Sarah Bernhardt in *Queen Elizabeth*, a 1913 film, felt the loss involved in her physical absence. Her acting was Bernhardt's acting. But it was not merely her voice that lacked: it was an emanation of personality. Then, the very concentration and confinement of the actors on the stage gives an adventitious and enviable intensity to all they do. The atmosphere is one so gem-like and fierce that the audience feels itself included in that brilliant cube behind the footlights, and is given a lasting impression of light and activity. They forget that the theater is as dark as the picture-palace, and the acting static compared with film-acting. The third advantage, which I believe not really to be an advantage, is the use of the spoken word. Certainly, in the most exalted form of the drama, the language has a peculiar literary beauty. But since there are excellent plays in which the speeches cannot be judged as literature, this quality is not essential. And even if it were, then, ideally, the visual beauty of a film should be the alternative to the stage's poetry. I can conceive of films throughout which pictures of ineffable loveliness should continually melt into each other. There will be such films yet.[4]

In the mid-1920s Iris was writing as the new art form defined itself. Among the examples of definitive achievement in film was Ernst Lubitsch's *The Marriage Circle*, which Iris reviewed in the May 17, 1924, issue of the *Spectator*.

"*The Marriage Circle*," she wrote, "may well silence those who claim that the film cannot compare as a dramatic form with the stageplay. For this is at once perfect cinematography and perfect conventional drama. Lubitsch, the producer of this delicious piece, has shown, not told, the story. Everything is visualized, all the comedy is in what the characters are seen or imagined to be thinking or feeling, in the interplay, never expressed in words, of wills and personalities. There is a minimum of subtitling, and the progress of the plot is not dependent on the letterpress. Gestures and situations, so lucidly presented that one is perfectly aware from the 'pictures' alone of what is happening, give rise to other gestures and other situations which—because of the permanence of visual memory—one recognizes as the logical result of what has occurred before. There is a peculiar mental delight in watching a plot develop so. And with curious boldness Lubitsch has drawn on the minimum of the cinema's technical resources. Here are no magnificent halls, no costly crowds, no multiplicity of scene, no great bridgings of time or space. This deliberate limitation gives the film perfect unity. Lubitsch uses only one focus, brings the five characters up to us a little magnified and intimate and, keeping them at that constant range, sets the action going simply, precisely, without hesitation."[5]

Despite her awareness of the visual nature of film, and her appreciation of directors such as Lubitsch and Chaplin who exploited it imaginatively, Iris was not resistant to the possibility of sound being fruitfully added to film. In the first year of her career as a film critic she encountered the earliest viable attempt to marry sight and sound: the Phonofilms of Lee De Forest.

"I have just been to a demonstration of what are generally called 'talking films,'" she wrote in the June 7, 1924, issue of the *Spectator*,

> though a more exact word, 'Phonofilms,' has been coined by Dr. Lee De Forest, the inventor of this particular device. Vague rumours of fresh inventions for talking films have always disturbed me, for I fancied I saw in them a menace to the proper development of cinematography, and the evolution of a proper technique of film acting. We have been afflicted with many densely titled and badly acted films: I was afraid that if these same titles came to be spoken mechanically instead of written, bad acting would be encouraged and bad producers confirmed in their evil ways of making films as though they were stage productions.

But I have seen and heard some half-dozen Phonofilms, and my prejudices and misconceptions about talking films have been transformed into enthusiasm and interest, for it is obvious at the very first sight and hearing that these sound-pictures have functions and applications, that they contain elements for delight and instruction foreign to my favorite 'movies.'

Others had tried in vain to synchronize recorded sounds with separately projected film images, but De Forest solved the problem by printing the sound directly on the film. As Iris described it, "a Phonofilm is an ordinary film of standard size on which is printed a photographic record of the sound accompanying the picture. A tiny band of horizontal stripes of many widths runs down one margin of the film: the stripes are the equivalents of sound vibrations. When the film is projected, the intensity of an infinitesimal beam of light is varied as it falls on a photo-electric cell by the passage before it of the 'stripes,' and the variations produce currents which are magnified, then amplified, and are finally thrown out as an exact reproduction of the original sound by loud-speakers; the quality of the sound is that of the most perfect transmission of wireless music. The human voice particularly is as clear as anything gramophone records have yet produced. The question of sound and picture does not really arise since the sound is *part* of the film."

In imagining "applications" of this technology, Iris did not immediately foresee what we now consider a "talking picture." As others before her who felt the motion picture essentially to be a kind of recording device, Iris at first considered the kinds of documentary function sound film might portend.

The recording of the artistry of our best comedians, singers, dancers and so forth is the most obvious and first use to which this new device should be put. It is not merely a question of recording them for posterity (yet how gladly to-day we would welcome such ghosts of Jenny Lind or of Caruso or Dan Leno!). Many of the great exponents of particular arts appear perhaps only once a year for one or two performances in the capital of any given country. Now Phonofilms could, for instance, have carried the great voice and equally admirable presence of [the Russian opera singer] Chaliapine to every little town and village in the country, whereas actually he has only been heard once this year in one spot. But it is not only artists who could be broadcasted visibly as well as audibly: the great disadvantage under which politicians have laboured through being unable to be in two places at once will be removed.... Then, the application of this new process to the bi-weekly

News Gazettes which form so constant a feature of all cinema programmes might be a considerable improvement. . . . The scope of educational films can also be valuably extended by the use of the voice: the moving pictures which are already doing so much good in assisting children to retain what they are taught would gain enormously in effect if accompanied by a carefully prepared lecture by an eminent authority on the subject. And finally, it seems an obvious economy and simplification to issue ordinary film-dramas in future with a suitable musical accompaniment printed on them, thus relieving at once the agonies of cinema proprietors in trying to get an insufficiently-rehearsed orchestra to synchronize both the rhythm and the nature of the music they play with the action of the film-story, and the agonies of the audience when the orchestra fails to do so, and goes on playing a dirge when a wedding march might be more appropriate.

All these applications of sound-pictures have, of course, nothing to do with art: no one would claim, for instance, that wireless recording was 'art.' It and Phonofilms and the new gazettes are mere reproduction. But I might suggest a use for these sound-films which might be half reproduction and half art: that is a Phonofilmed opera.[6]

Initially, then, sound film did not strike Iris as containing within its technology substantial aesthetic potential. This is understandable, for it would be many years before Howard Hawks and Frank Capra would discover the peculiar capacity of sound film to present, for example, overlapping dialogue. In Hawks's *His Girl Friday* (1940) as well as in Capra's earlier and equally zany farce, *It Happened One Night* (1934), actors speaking simultaneously were found to be easily understood. No matter how fast the actors spoke during the filming process, when played back their dialogue seemed slowed to a comprehensible speed. The possibility of "jump-cutting" and the clipped dialogue so characteristic of early gangster pictures lay ahead for Iris. She was understandably led to conclude that "personally I do not see how Phonofilm plays can ever be anything but another kind of stage play, for the very use of dialogue in drama tends to hold the actors in one place, and therefore destroys the freedom of movement, so like that of the ballet, which distinguishes the 'silent' films and gives them their peculiar aesthetic." Nevertheless, she declared, "I salute these enjoyable talking films as I saluted broadcast plays and wireless concerts, because something is being added to our capacity for enjoyment and experience, and no one is a button the worse off."[7]

In assessing Iris's view, it should be said that De Forest's Phonofilms suffered from the stasis of all early synchronized sound techniques. Early sound films often involved concealed microphones near the speaking actors, who could not move without risk to being heard. It would not be until the Western Electric system was adapted by Warner Bros. in the thirties that microphones on booms were utilized and sound could be recorded while actors moved about. Early synchronized sound films, as Iris described them, looked like recorded musical or dramatic events with actors positioned for the convenience of an on-set microphone. Given such stasis in an art form already distinguished by its fluidity and movement by the artists of Germany and the United States, it is not surprising that in 1924 Iris Barry could not have anticipated the full cinematic potential of sound and that many others might lament the introduction of sound when it finally arrived in the late twenties.

In her writings on film during this time, Iris continued to construct an aesthetic of the motion picture, citing one characteristic or another that differentiated film from the other arts. She noted that "apart altogether from dramatic and visual values, the cinema . . . acts as a storehouse of information wherein the individual may become familiar with the manifold habit of his, and, indeed, also of past, times—a function which has probably gained more adherents to the picture-screen even than the pleasure-giving or cathartic quality of its plays."[8] She remarked upon the decline of D. W. Griffith who, despite having been responsible for "the two finest American films produced in ten years,"[9] seemed intent upon boring his audience. In November, however, she encountered a film that merited high praise, American Arthur Robison's 1923 German Expressionist film, *Warning Shadows*. Noting that "people are always challenging me to direct them to one matchless film which will convert them to a belief as fierce as my own in the absolute, inherent values of the cinema," she alerted her readers to a showing of the film, declaring: "I would boldly urge all unbelievers to see it."[10]

There are no sub-titles in *Warning Shadows*, the characters are introduced and named; after that the story unfolds itself in pictures only. The action takes place during one night at a townhouse sometime in the early nineteenth century. The host and hostess are entertaining three fops and a picturesque youth at dinner. There is something odd about the house, impossible to say what; the visitors whisper, candlelight is reflected in mirrors too coldly; the husband, one feels immediately, is very jealous. He fancies the guests try to

fondle his wife, or did only their shadows fall greedily across hers? Dinner is served, there is music, but one is increasingly conscious of a menace such as I have only felt elsewhere in *Scheherezade*. A strolling player comes to amuse this uneasy party, and as they watch his performance—one is prepared by now for anything—he filches their shadows away from them, and projects their consciousness into another kind of awareness as they sit bewitched. The vision which he conjures up develops naturally from the vexed atmosphere brooding in the room, the action is not broken by his sorcery. The husband's volcanic jealousy, already almost uncontrollable, bursts out now in bitter frenzy when he sees his wife in the handsome youth's arms and culminates in a murder so fantastic, so expressive of his psychological agony that it chills one with horror. Then the strolling player slides them back their shadows, they stir uneasily, glance apprehensively at each other, and give a constrained attention to the original entertainment which is still in progress. When it is ended, the guests hurry away embarrassed, curtains are drawn back, and the atmosphere of horror vanishes permanently as daylight strikes into the room.

Such, baldly, is the scheme of a film to which I would send everyone who doubts the cinema's power to deal with tragedy, with real emotion, or in terms of art. It is, of course, a German picture. It is serious, large, terrible and unforgettable. The acting is bold and true, glances and movements of the hand have real significance. And naturally, no short verbal description can indicate the richness and intensity with which the action moves. Peculiarly cinematographic, the very inanimate objects speak undeniably; emotional situations succeed each other with a convincing dreadfulness; and one draws breath when all is over as though a real, not a fictitious, calamity had been averted.[11]

As 1924 drew to a close Iris had seen enough pictures to begin to categorize them by genre. "The travel picture and the farce are at opposite ends of the range of the cinema," she wrote, "they are the purest things in it, the most plainly socially valuable. In between them exists a mixed and sometimes frightful world of domestic comedy, cowboy and crook films of action, melodrama, costume and historical pageantry, ill-adapted novels, and so on. There is great capacity for beauty and aesthetic passion in this middle ground and an equally great achievement of vulgarity and dirtiness."[12] By this Iris meant that she was "complaining more of the furtive flirtations with sexual problems than of the relatively unimportant salaciousness both of many film titles and themes when I speak of dirtiness, for the trouble here is a nasty-minded timidity, not, alas!

a grossness. A film, like any other medium, can, if its maker be great enough, handle frankly and with beauty any moral subject without offense save to hypocrites: *Warning Shadows* was a purge, and the frank nudity of savage tribes does not concern the film censor. The dirtiness of which I speak is the confusion of spirit which allows too many of those who make pictures again and again to offer us films telling a pseudo-moral story, showing sub-normal types aping what is imagined to be the behaviour of the demi-monde. If these films were immoral, not non-moral, the public would react against them, but as it is the public is confused and poisoned by this ridiculous imitation of vice with a moral text pinned to its skirt. And not only morals, but economics, politics, patriotism, too, are muddied on the screen. Confusion of spirit is the devil of art."[13]

Thus Iris began to develop a typology of film production and to recognize film's value as partly aesthetic and partly social. With regard to the latter, she wrote of "the undeniable calmative value of the motion picture as a relaxation for nerve-wracked humanity. We are all of us, today, more or less nerve-wracked; and I suggest that the cinema, and therefore American films in particular, do far more social good than they do harm."[14]

In the *Spectator* Iris acknowledged that movies were beginning to matter. "At the very lowest," she observed, "the moving picture brings every week both happiness and a definite nervous and mental relaxation to many millions of jaded human units in our less than ideal industrial civilizations. Its social value is great: the cinema plays no small part in broadening the common horizon; its ubiquitous *Pathe Gazette* and travel films alone deserve credit for supplying a vicarious experience of contemporary events and foreign places which quite certainly is evolving, gradually, countless men and women who are 'citizens of the world.' But, beyond all this, though the moving picture has affinities with the respectable muses, it is a substitute for none of them, but one of the phenomena for which our age will be remembered: a new art born painfully and ingloriously, as no doubt the other arts too were born in unremembered days—a new art more than we realize for though it tells a story it is not a literary form; though it is a pictorial medium it is also a dramatic one; yet its concerns are not those of the theatre and its problems the very opposite of those that confront painters."[15]

To further illustrate the achievements of film as an emerging art form and, coincidentally, prefiguring much-later *auteur* theory, Iris cited the recent exhibition of Chaplin's *The Woman of Paris* (1923): "The valiant Charlie Chaplin rendered the cinema a great service—the great comic actor had rendered it many others—when he nearly made a superb film out of *The Woman of Paris*," she declared, "and showed his confreres not only that film-acting could be

made highly significant but that a melodrama, in pictures, might be a rich and dignified thing. It is to him and to Ernst Lubitsch that we owe the growing realization that if a film, of no matter what type, is to be worth while, it must be entirely dominated by the will of one man and one man only—the director. A film is made up of so many ingredients, prepared over so large an area and so long a space of time that it must be controlled by that one man as absolutely as an orchestra is by the man with the baton. And film stars, instead of attempting to allure the public, must subordinate their own personalities to the parts they play. Indeed, it would be ideal if they could remain as anonymous as are the violins and cellos, the drums and horns in even the best orchestras. Failing that, we certainly expect them to give us more than chocolate-box beauty and manly strength."[16]

Iris's view of the actor as an instrument of the director—a view later taken up by Alfred Hitchcock—made her skeptical of "movie stars," a phenomenon promoted by D. W. Griffith, who broke with the tradition of anonymity for actors by listing their names in the credits of his films. In 1925 Iris could not have known that in a few years she would be appearing before an audience of film stars at the home of Mary Pickford to seek support for the formation of a film department at the Museum of Modern Art. In her appreciation of the uniqueness of Emil Jannings in *The Last Laugh*, in a 1925 *Spectator* review, she made a somewhat invidious comparison of Jannings and Pickford:

The best-known, the most successful personage in the film world—for she is still that—once made a significant remark: 'I play only one role: Mary Pickford.' She realizes that she is not an actress but a celebrity. Five-eights of the famous stars are in the same case without realizing it.

Among the few real actors the screen has so far thrown up, Emil Jannings has slowly become famous in spite of the fact that he has never acted the role of Emil Jannings in any picture, and has never bewitched his audience with details either of his private life or his wardrobe. In *Peter the Great* he was an ardent, statesmanlike soldier: In *Passion* an elegant and stately Louis XV: In *Anne Boleyn* an immense and thunderous Henry VIII. His gait and his gestures, his facial and psychological make-up varied immensely with each part: he created the characters he played—as he does too in impersonating an old commissionaire in *The Last Laugh*—and none of his roles has any likeness to the cultured, innocent-looking man he really is. He sets, in fact, a fine and modest example to the too numerous egotists who style themselves actors and are, in fact, nothing but public favorites.

The Last Laugh is a slight story of the commissionaire of a metropolitan hotel whose uniform fills him with pride, dazzles his plainer neighbors and strikes a degree of awe even among his fellow-workers. But because he is old a younger man takes his place and he is given a light but humble task as attendant in the gentlemen's cloakroom, stripped of his splendid gold-braided coat and cap. No one respects him any longer: his bulky body shrinks, his degradation crushes him.

As there are no sub-titles in this film, not only Jannings as the old man but the places which he frequents have to be very expressive pictorially. The eye of the camera treats the swinging doors of the hotel, the porcelain basins and mirrors of the cloakroom lovingly, sees them—I would say—freshly and intelligently. We know that hotel, take part in its subtler moods. It is almost the villain of the piece. There are other fine things about *The Last Laugh*. It is, without being arty, agreeable to the eye: beauty is dragged forth from the unbeautiful, expensive glass and mahogany and marble of the hotel, and from the tomb-like facade of the commissionaire's tenement home. Its motive is simple, sincere and human. The story is not more improbable than life, even though, afraid of denying us a happy conclusion, it twists a delightful one on at the end.

Yet, excellent as it is, I would not call it a *great* piece of cinematography for two reasons. The story is too meagre, and the drawing of the minor characters careless. Jannings is a delight: but one does not quite believe in the too-suddenly malicious neighbors, nor in the too-hilarious guests in the final dining-room scenes. Here and there the action lags.

But *The Last Laugh* is a progress: it is not parasitic on any novel or play, does not resemble any literary form at all. It contains one of the finest pieces of sustained character acting yet seen and while it has all the merits we now expect from the best continental films, it has not their former macabre touch. It would be a misfortune not to see this unusually civilized entertainment.[17]

Another opportunity to encourage a higher seriousness in film came the same month in 1925 when Iris found herself in the audience for the first showings of Erich von Stroheim's epic, *Greed*. She noted that "nothing could have been sweeter to the cinema enthusiast's ear than the mingled noise of hissing and clapping which greeted the new film, *Greed*, on its first night at the Tivoli, Strand. The sheep and the goats were expressing their different points of view at last. There were those present who genuinely disliked it: those—no doubt the majority—who frankly prefer the usual type of film, with its hero and heroine

suffused with meaningless virtue, its scenes of gilded boudoirs and ballrooms, its false but flattering psychology, and its soothing 'happy endings.' Such people need not be alarmed, there will always be plenty of what they like. But among the millions of people who every night of the year frequent picture palaces are reckoned a good many hundred thousands who appreciate a degree of realism, of imagination, or of wit. Like Strindberg, they wish for a theatre (though it be a motion picture theatre), *where there is room for everything but incompetence, hypocrisy and stupidity . . . where we can be shocked by what is horrible, where we can laugh at what is grotesque, where we can see life without shrinking back in terror. . . .* There were many such people witnessing *Greed* on the first night; there are very many more who will wish to see it when it appears generally up and down the country in July. It is a magnificent piece of realism, and nothing like it has been seen before.

"The film is based on Frank Norris's novel *McTeague,* a bitter study of life among the respectable poor. The story must be well known already—a quack dentist's wife wins five thousand dollars in a lottery and becomes a miser. An envious friend deprives the husband of his living: from a pathetic brute the dentist becomes a savage one and eventually murders his wife for the money, to die of thirst in a scorching desert with the gold spilt at his feet. It is not a pretty story, but then neither is the undying tale of *Punch and Judy,* nor *Lear.* The producer, Erich von Stroheim, has wrung every ounce of dramatic intensity from the actors (Gibson Gowland and Zasu Pitts give remarkable performances) and their motives; their pathetic ambitions and pleasures, but also from the very streets where they herd together, from the shabby furniture of their homes. His interpretation of the slow-witted dentist is more interesting and more human than that given by the author of the original novel—a coarse creature reared among ugliness, but able, when he has a moment's happiness, to snatch in his own way at beauty by playing the accordion, by wooing a neat little wife, by tending pet canaries. Stroheim's treatment lifts the story from squalor though it always remains grim.

"There are minor faults in the film. Throughout, a not very pleasing yellow tinge is smudged on all brass, gilded and gold objects, and here and there unnecessary symbolism—large cat-faces, grasping hands and bars of metal—jars. But the producer of *Greed* must be reckoned with the few men who are really contributing to the development of the motion picture (they are now eight in number).[18] On behalf of the minority of film-goers who will, however even though they may be shocked by his fierce realism, perceive that he has made here a masterpiece in quite a new manner, one feels inclined to thank him. He has, at any rate, dispelled the idea that sound tragedy is impossible to the cinema."[19]

As her reviews attest, steadily throughout her first two years with the *Spectator* Iris tried to promote film to a readership more inclined to recognize poetry or dramatic literature as legitimate art forms. Conceding that film "still smells overmuch of the sawdust and beer-fumes of the circuses and low music-halls whence it has drawn so much of its very vital inspiration and talent," she admitted that cinema "is an art of the people" which, to her, "is a merit, but one cannot deny that the cinema lacks *chic*. It is true that wealthy, well-born and intelligent people go to the pictures, but their attendance is not noted by the Press as it is when the same people go to the theater."[20] Barry's sensitivity to the need to transform the cinema's image from beer hall diversion to something of interest to the social register became one of the motivating factors behind the founding of the London Film Society in the summer and fall of 1925.

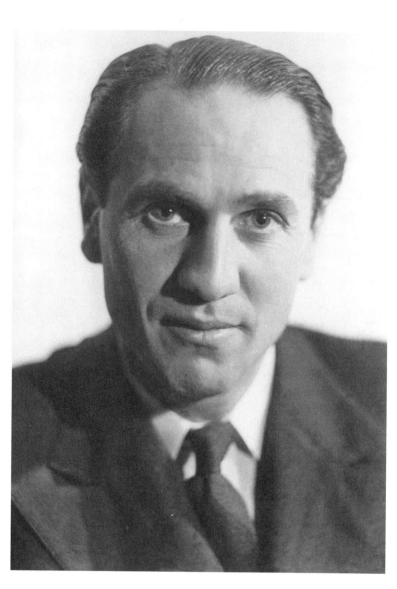

Sidney Bernstein in 1934.

9

SPLASHING INTO FILM SOCIETY

T HE LONDON FILM Society was founded by members of a postwar generation alive with new ideas. "We were the brave new world," Iris recalled, "but authority was senior to us, not only all-powerful but conservative. Now it so happened that at that moment many of the most interesting films were being made in Germany (thus 'Boche') or in the USSR (thus 'Red'). They were in any case not films calculated to delight the general public in England at that time. They remained unseen, or crept furtively out much truncated in shabby little cinemas where they were viewed unenthusiastically. The censor had his hand in this Semi-ban. Yet these were the films that we wanted to see. Forbidden fruit? Something new, something that grandfather disapproved?"[1]

Perhaps if serious films could be seen in a proper venue before a knowledgeable and appreciative audience, and if somehow the study of film could find its way into the halls of academe, it might then be possible to undermine the conservatism of the old guard. In an article in the September 5, 1925, issue of the *Spectator*, Iris noted that a Mr. Kane, an American producer, had proposed the creation of a Chair of Cinematography in one of the large American universities. The study of film was relatively unknown at the time, but Iris saw the proposal as an opportunity for students to concentrate on the rare and unusual motion pictures that escape mere economic categorization. In contrast to the popular filmmakers of the time, directors such as Lubitsch and Griffith were attempting to augment their commercial achievements with contributions to the emerging art of film. It would be toward the work of these directors that a Chair of Cinematography could address itself. To Iris, "its chief functions should be:

To instruct intelligent, enthusiastic and likely people in the craft of film-direction in its manifold aspects.

To teach and disseminate as widely as possible a sound theory of aesthetics both in general and in particular regard to cinematography.

To encourage, by lectures and other means, a curious attitude towards the nature of the moving picture viewed ideally. There is much work to be done here; there is as yet no critical standard, no recognition of the diverse tendencies and schools of production, no analysis of the forces at work within the film itself. Research must be encouraged, and practical experiment made possible."[2]

At the same time, she called for the setting aside of some of the profits from films of the commercial sort for the making of noncommercial films, a scheme already in place in Germany and then being considered in Britain. In this way Iris foresaw the need for an alternative economic model to support motion pictures made for aesthetic as well as commercial purposes and appreciated by an audience outside the usual venues. This new audience might take the form of a film society, a development she announced in the same article:

"Meanwhile," she continued, "on the public as apart from the professional side, another movement is in progress with the foundation of The Film Society in London. This new Society has for its immediate object the showing of both new and old films of unusual interest to a limited membership on Sunday afternoons during the winter seasons, in the same way as plays are given for the Phoenix and Stage Societies on Sunday evenings. The first season, which begins on Sunday, October 25th [1925], will consist of eight performances which, it is hoped, will be given at the Tivoli, Strand. The subscription is conveniently low, since the Society is precluded from making any profit from its operations, and lest possible members should fear to find themselves in unknown company, I should add that among the Society's original members and kindest supporters are Lord Ashfield, Mr. Roger Fry, Mr. Bernard Shaw, Mr. St. Loe Strachey, Dame Ellen Terry and Mr. H. G. Wells. The number of members will necessarily be limited to the capacity of the theater in which the performances are given, and seats will be allotted strictly in order of application. The Secretary, Miss Harvey, of 56 Manchester Street, London, W1, will gladly supply details." The hope, Iris concluded, is for the new audience the Society provides to become a model for similar societies elsewhere, in Britain and throughout the world, to serve those who "want to see the best films of all kinds without having to suffer twenty inanities in order to enjoy one good picture. If these people can be drawn together, it should be possible in time to establish a network of picture houses open daily, one to each large town, in which the best films of all

kinds, from weekly pictorials and scientific films to farces and tragedies, can find an audience."[3]

A central figure both in the founding of the London Film Society and in most of Iris's adult life was Sidney Bernstein, scion of the family who owned Granada Theaters and, later, the founder and owner of Granada Television. "Now how on earth did I know him," Iris wrote in one of her notebooks, "very simply: a boy I knew from Shropshire . . . had sent me some little while before [the founding of the Film Society] a letter of introduction to this same young Moghul who, it seemed, was looking out for and seeking to hire some person who could review and report on new and available movies for his theaters. The young Moghul had inherited from his father and was managing for the family a chain of movie houses, suburban and extensive: he wanted really up-to-date, lucid info about the new films available. So he saw me and I went off eagerly to provide him with a sample dozen of reports on forthcoming films.

"Goodness how I toiled. I had written and toiled over endless poems before this but never had I so weighed phrases and words nor so worked over them in draft form as now I did with these reports—only, when finished and perfected and delivered they proved to be exactly what Mr. B did not want.

"Presumably, I was analysing samples of a new art form: clearly I was not helping a movie magnate discern what would 'go' in his movie houses. However, the contract between us had been made: there were lunches, he invited me to his Mother's house for a fabulous Saturday luncheon, my husband and he seemed to get along most agreeably and he seemed to like our friends. To whom else then at this nascent stage of the Film Society would one have recourse but to him?"[4]

Iris brought Sidney Bernstein into the circle of the Film Society and through him not only secured access to the New Gallery Cinema in the West End but also to its orchestra and conductor. Iris served as guide to the artistic demi-monde for Bernstein, dragging him to early performances of Edith Sitwell's "Façade," in which the author declaimed in stentorian tones via megaphone through a hole in a sheet. Iris invited him to meet her friends, writing him that "a small party here on the evening of the 8th would be vastly improved by your presence—and if you can bring a lovely young woman so much the better. I seem rather short of them. 10 pm and after. There is a dim hope that [playwright John] Galsworthy might come but I doubt it. [Writer] Rebecca West, Vyvyan [Holland, son of Oscar Wilde], [actors] Elsa (Lanchester) and perhaps C. (Laughton), [and mutual friends] the Lavers, perhaps the Cochrans perhaps not, and so forth. Do come my angel. Yours, Iris."[5]

Regarding the formation of the London Film Society, Iris later recalled that Bernstein intuitively understood the challenges the idea presented, chief among them the problem of legitimizing film as an art. "Don't forget," she recalled, "that at approximately the same time the Theatre Guild was in the process of formation and independently hit upon the identical methods. While by 1925 virtually everyone went to the movies regularly, the better-educated strata were inclined to acknowledge the matter deprecatingly, if at all. That was a matter, you might say, which never confronted the Guild."[6]

Sidney's counter was to "get the right people to sponsor it [the Film Society]." In this connection he asked, "who's the one person of importance who most vociferously denounced films, who derides them at any and all opportunities, who ridicules them when he can't think of anything else to come up with?" The answer was George Bernard Shaw. "'Get him,' said Bernstein firmly," Iris recalled, "'After that you'll have to fight the others off!'"

Shaw was a friend of Ivor Montagu's father, Lord Swaythling, and Shaw, according to Iris, "really had a great spot in his heart for the young, was so amused at our brazen effrontery that he readily accepted."[7]

The idea for the Film Society originated with Ivor Montagu, who at 21 and recently out of Cambridge was at something of a loss to put his life together as a zoologist. Having tried unsuccessfully to book as a scientist aboard the *Discovery*, the ship Robert Falcon Scott had taken to the Antarctic, Montagu had traveled to Berlin to look over the German film industry for a newspaper article he contracted to write for the London *Times*. On the train back from Germany he ran into Hugh Miller, an actor returning from the shooting of an Anglo-German production in Munich. "Hugh Miller and I got into talk and before we reached Charing Cross decided that what London needed was a Film Society," Montagu wrote in his autobiography, noting that the purpose of the organization would be "to show pictures which were worth while for one or another reason but could not get commercial showing, just as the Stage Society did plays."[8]

The Stage Society set the pattern for subsequent film societies with its dedication to the appreciation of challenging and out-of-the-way theater. "The principles of the Stage Society and its function were well established," Montagu recalled.

> The whole theatre world understood this Society as, of its nature and purpose, interested only in such plays as could obtain no other showing, either for reasons of censorship or novel and esoteric character, and a try-out at

the cost of the society could only benefit everyone in every branch of the profession: the actors could widen their experience with fat parts otherwise unavailable, the authors see living on the stage works that would otherwise gather dust rotting on their desks, the managements find out the potentialities of new material without risking their money; only the critics might lose a week-end or two and they would be paid by their editors. This meant the actors, authors and managers mucked in; only theatre-hire, costumes and sets needed to be covered by the members' subscriptions to the Society.

We should have to operate the same way. We meant to show the films in no hole-and-corner fashion. We must have the best West End cinema for the purpose, the best orchestra and the best music. Remember—these were in the days of silent films and a special score well played was an intrinsic part of the impression that could make or kill a film. We—that is the group that eventually got together to do the job—could (and did) talk our heads off about benefiting film art by enabling interested persons to study the potentialities of cinema and introducing, to the cinema, circles and personalities who had never hitherto been attracted to it. But there is no doubt that—just as with my friends and I when we got *Caligari* to Cambridge— our real motive, unavowed perhaps even to ourselves, was that we liked pictures, and that without the subscriptions of the like-minded enthusiasts who joined the society, we should ourselves never have been able to afford to see them with a big audience and the right music—both essentials for proper appreciation—or maybe even entice their owners to send them to England at all." (*The Youngest Son*, 272–73)

As to programming, Montagu recalled that "our policy was to concern ourselves not only with 'art' but with every use of film that did not reach the commercial screen in Britain at that time. Science concerned us—eventually we showed a film called *The Equation $x + x = o$* and right at the beginning Shaw sent me with an introduction to the Institut Marey in Paris for photographs of fast motion slowed down; this institute was named after E. J. Marey, the biologist whose contribution to the eventual principle of recording and reproducing motion pictures was basic, and whom G.B.S. described as 'my old friend who used to drop cats upside down out of the window and photograph them as they landed on all four feet.' Technique concerned us—we showed early films of making films. Antiquity—if we found primitives that had been forgotten. Even what might be run-of-the-mill commercials in remote regions—if their exoticism kept them from the market for the British screen. In dedication to this task

we were not internationally speaking, quite pioneers but seconds. First of all in the field was the Theatre du Vieux Colombier in Paris, which had already gone over from the stage not to the 'society' idea, but to concern itself with regular showings of similar film material to small public audiences. We needed its experience and its contacts, which were liberally available" (273–74). In this manner the founders of the Film Society sought to lift film art from its cine-club origins, where small groups of fans gathered to talk among themselves, to a level in which it could be supported by a broader audience.

An early recruit to the Film Society effort was Adrian Brunel, who then worked as an independent film editor. "I was standing at the back of the dress circle at the London Pavilion—I think sometime in the spring of 1925," Brunel recalled, "when my friend, Hugh Miller, approached me with a tall and dark stranger who smiled at me friendlily and waved his hand in greeting. This was because Hugh Miller had been talking about me, and the stranger, feeling that I was a comrade, thought he might as well establish this *before* we were introduced. And then I heard it was Ivor Montagu. All I knew then of the man who was destined to become my partner was that he was a brilliant zoologist, and authority on football and table tennis, that he was very interested in films, and that he and Hugh had some plan about them. Before I knew where I was, I had become a promoter of the film society, an organization for showing to its members films which they would not otherwise have much chance of seeing elsewhere."[9]

As to the official founding of the Film Society, Montagu recalls that "this was done at Iris Barry's. . . . At this time she was married to the poet Alan Porter; she was dark, slender, capable and calm with extremely well-shaped features and a crop as tight as Beatrice Lillie's or a Dutch doll's. Iris had a gypsy mother and also two children who were not living with her. She and Alan had a small house in Guilford Street, which is just within the Bloomsbury ambiance. Here she threw a party where the first plans were made."[10]

"It began with a telephone call from an unknown person," Iris later recalled,

a man who said that his name was Ivor Montagu, that he had been lunching with Hugh Miller the actor and that they both wanted to come and talk to me. About the cinema. About something to do with the cinema. And as the cinema was one of the things that interested me most at the time, to a degree which most of my friends regarded as eccentricity or mania, I said that they had both better come round at once to have tea with me so that we could

talk. Curiosity to see these unknown persons and to hear what they had to say understandably played its part in my invitation.

At that time . . . I was living in the romantic but rather sordid ground floor and basement of an 18th century house in Bloomsbury just off Theobalds Road. The hall smelt strongly of tomcats and though the proportions of the rooms were charming, the paintwork was dismal and the furniture, mostly books, rather sketchy. I remember chiefly an old oak coaching chest of my grandfather's which was painted scarlet and served as an additional seat. There was a typewriter on a cheap desk, three Chippendale chairs and a similar but heavily rustic armchair which I had formerly found in the family cowshed, a 'good' dining-room table, masses of books and a portable typewriter. It was in fact a set-up almost too typical of the dwelling-place of a young intellectual couple of the period.

Whatever the characteristics or deficiencies of the place, it was clear that when Mr. Montagu and Mr. Miller arrived that neither had the least interest or importance for them, this tall bespectacled young man with the black curly hair got right down to the subject at once. His senior, elegantly handsome Mr. Miller, spoke less but was clearly in accord with him.

When Montagu proposed the founding of a Film Society to be modeled after the London Stage Society, Iris recalled, "my agreement was immediate and enthusiastic and we got out pencils and paper at once to sketch a program of action."[11]

The result of their deliberations was a statement of purpose for the Film Society, which Adrian Brunel reprinted in his autobiographical book, *Nice Work*, as a "preliminary manifesto" of the Film Society:

> The Film Society has been founded in the belief that there are in this country a large number of people who regard the cinema with the liveliest interest, and who would welcome the opportunity seldom afforded the general public of witnessing films of intrinsic merit, whether new or old. . . .
>
> It is felt to be of the utmost importance that films of the type proposed should be available to the Press, and to the film trade itself, including present and (what is more important) future British film producers, editors, cameramen, titling experts and actors. For, although such intelligent films as *Nju* or *The Last Laugh* may not be what is desired by the greatest number of people, yet there can be no question but that they embody certain improvements in

technique that are as essential to commercial as they are to experimental cinematography.

It is important that films of this type should not only be shown under the best conditions to the most actively minded people both inside and outside the film world, but that they should, from time to time, be revived. This will be done. In this way standards of taste and of executive ability may be raised and a critical tradition established. This cannot but affect future production, by founding a clearing-house for all films having pretensions to sincerity.[12]

Montagu recalls that the "originals" of the Film Society "included—besides Iris, Hugh Miller, Adrian (Brunel) and myself—Sidney Bernstein, Frank Dobson, and W. C. Mycroft, this last the film critic of *The Evening Standard*. All these except Adrian are listed as members of the original Council. With us were also McKnight Kauffer—almost begetter of the modern poster of the twenties—and his equally tall and handsome wife Marion Dorn, as original in carpet design; Edmund Dulac—the delicate illustrator of fine editions—and his novelist wife Helen Beauclerk; Sidney's friend Jack Isaacs—don in English at King's, London—and [aspiring filmmaker] Anthony Asquith."[13]

Later the group was joined by the documentary filmmaker and film theorist Thorold Dickinson. There was also Robert Herring of *Close-Up*, then a budding film magazine, filmmaker Basil Wright and Elsie Cohen, whom Montagu describes as "the first person in Britain to try to emulate Le Vieux Columbier with a public cinema for such programmes as ours. She started the Academy Cinema on Oxford Street and handed over to George Hollering when ill-health made her retire." It is notable that given diverse talents such as these, according to Montagu, "we never had a single quarrel or disagreement about anything and there were no jealousies." But when it came to work, "the real indispensables were Iris, Sidney and Walter Mycroft."[14] Of the night they all first met to form the Society, Montagu later recalled, "what I do remember clearly is Iris and her husband standing on the pavement with the light of their open door behind them as Sidney and I went off together in the rain."[15]

To Montagu, "it was a stroke of luck that Sidney's imagination was struck that night in Guilford Street. He was the only one of us on the real inside of films, as well as, probably, the only person in the industry of those days who shared our enthusiasm for 'the arts.' As second son of his father—the eldest died at Gallipoli—he had inherited the direction of, and much expanded, a small family business selling theatre equipment and a small chain of cinemas, by then—I think—numbering some dozen or so. In this later role, he was active

as an independent in the politics of the C.E.A.—the Cinematograph Exhibitors' Association—the organisation (largely ineffective due to internecine wars) through which the then 'unchained' cinema owners strove to protect their interests in the perpetual battle against the 'renters,' those who distributed the films the exhibitors were bound to book to keep their cinemas open. It was not that in those days he was particularly rich. Like those whose capital is 'working' he rarely carried ready money because credit was usually available when needed; Hell [Mrs. Montagu] and I have been out with him in a Soho restaurant when all three of us were exposed as penniless, each having depended on the other, and he had to leave his watch to cover the bill. But he did have something, independence and booking power—trivial though the latter would be counted nowadays when the giant circuits rule (eventually he partly linked his small chain to the largest)—which the bigwigs both feared and wanted, and this made them deferential to anything he was known to be interested in and smoothed our way."[16]

Montagu remembered Bernstein as a "slim, tall, elegant handsome creature, with humorous eyes and a boxer's nose, liberal and enterprising in his ideas, catholic, comfortable, and choosy in his surroundings, generous and loyal to friends and family, an unpredictable and nerve-wracking adventure to work for—or I should guess—to live with. . . . I do not know where the Film Society could have got without him. Anyway, through him it got the use of the Regent Street New Gallery Cinema on Sunday afternoons for a start."[17]

Iris recalled that E. McKnight Kauffer had designed a "strikingly effective and modern 'trade mark' to use alike on our letter heads, main titles, and programs—for each performance there were to be printed programs with brief critical notes and full documentation to each film shown."[18] In Montagu's estimation the film critic Walter Mycroft "was invaluable because he knew the minds and ways of his fellow film critics, and what had to be done to get newspaper space."[19] As secretary of the society, "really purser," he noted, "we took on Miss J. M. Harvey, who ran a concert agency in Manchester Street. I don't know who suggested her, but she was perfect. For a minimal fee she took on all the paper work, the distribution of tickets, the keeping of files. It was a wonderful thing to have an expert so good that the rest of us could forget all this and just have fun with the films. . . .

"As shareholders, technically 'guarantors,' at £1 apiece, we enlisted all the most prominent V.I.P.s of our acquaintance. These were to bring us publicity, respectability, credit. I brought in G.B.S. and H. G. (Wells), Julian Huxley and [geneticist J. B. S.] Haldane, [John Maynard] Keynes, Roger Fry, H. F. Rubinstein

(whom I had met through the Stage Society) and Anthony Asquith, who was just beginning to show a film interest. Also Angus and Edith Craig, who used to lunch in Soho at the table next to ours, and she brought in her sister [the actress] Ellen Terry. Father came in and brought Lord Ashfield, who was the most useful name as at that time he ran the Underground. I don't remember others so well, although I do recall Iris brought in J. St. Loe Strachey of *The Spectator*. The only hitch was with H. G. Wells who wanted the draft of our articles altered where we had him down as 'writer'; he said he should be listed as 'man of letters.' Now all was ready for a lunch at 28 Kensington Court for the critics and a press conference in the library to tell the world and start collecting members" (278–79).

"Iris and I did our best at the press conference," Montagu continues. "We were ably supported not only by Mycroft but by other sympathisers among the pros: I count Pat Mannock of the *Daily Herald* and Ernest Betts as among the most decent and interested, and also Jympson Harman of the *Evening News*. The two trade papers, the *Cinema* and the *Daily Film Renter*, led by the latter's editor, Ernest Fredman, were cautious from the start. They seemed to regard our exploration of any other criterion of film judgment than box-office as an intrusion not only dangerous to their readers' interests but even immoral. C. J. Lejune, bless her, disappointed us sadly. One of the first serious, non-gossip-monger film writers—she wrote then for the *Manchester Guardian*—we had hoped for her backing. But after we had explained that the society, even if a small and private body, would at least give a few of those interested a chance to see work that would otherwise be hidden entirely, she declared with red-hot obstinacy that nothing could be of any use that was not open to the public. In a sense she was not wrong, of course; that had to be the target and when the [repertory film house] Academy Cinema was eventually opened and imitated, and the 'film society' movement itself spread in the provinces, we were able to wind up with a sigh of relief and a sense of public taste and opportunity broadened and a job of work well done. But at the time was that possible? Is it ever right to make the better the enemy of good? However, the ship was now launched, and the organizing donkey-work and circularisation for the first voyage could be left to Miss Harvey and her aides" (280–81).

Although the Film Society was founded in part to provide safe harbor for films from censorship of performances open to the public, there was at the time little precedent to go on, and the inaugural exhibition of the Society ran aground on this issue. "The Stage Society was the oldest and most respected of

the private societies fulfilling this function," Montagu recalls. "We had assumed that any enterprising public-spirited characters would be free to fulfill the same role for films. We were wrong. The law turned out to be quite different. There was, in fact, no law at all of film censorship. The British Board of Film Censors, which exercised the function, was simply a group appointed and paid by certain trade interests to exercise self-censorship, and was tolerated by the authorities as a convenience" (319–20).

Rushing naively into this void, Montagu recalls that "to our surprise we discovered that the Cinematograph Films Act, 1909, exempted not private performance, as did the theatre laws, but only performance in private houses," which, in effect, "completely removed from the realm of cinema the freedom that such a body as the Stage Society enjoyed for enabling study of new work for the stage" (321). So instead of being subject to the Lord Chamberlain's rule, which permitted one person of some sophistication to exempt for private viewing a work putatively of "artistic" value, the Film Society appeared to fall under the aegis of the British Board of Censors, a trade organization.

Montagu recounts that "the Board of those days was unwise enough to make available a printed list of exceptions that would disqualify a film: miscegenation—*Othello*, for example, would have been precluded; no doctor, clergyman, schoolmaster, police official (there followed a long list of equally sanctified professions) might be represented in any role that might hold him up to derision or discredit—*The Doctor's Dilemma* or *The Private Secretary* would have been definitely out. 'Notorious crimes' came under another ban ... *The Great Train Robbery* of recent times would have been out of the question. Two persons of the opposite sex, even if married and long past any imaginable age of effective performance, might not be represented together in one bed; unless—in obedience to what feat of mental gymnastics can hardly be imagined—one partner had at least one foot at all times on the floor" (321–22). In these restrictions the British censors were not unlike the Breen Office administering the Production Code in the United States, which was set up by the Motion Picture Association of America (MPAA) in 1934 to protect commercial film interests.

The specter of censorship presented a daunting prospect for Film Society supporters. "We of the Film Society expected to be welcomed by all," Montagu recalls. "Were we not bringing the industry new prestige, opportunities of research into novel methods of expression, a try-out ground, all at our own effort and expense? On the contrary, during the summer [of 1925] the industry had time to think. We were condemned and hindered...."

"It was not that our opponents were anti-art. They just did not think 'art' had any place in their occupation. The secretary of the Board, Brooke Wilkinson, told me roundly that he had never known a film the making of which had not been determined in every respect and in every detail by money-making, and when I instanced *The Cabinet of Dr. Caligari*, suggesting that the stylisation of sets might have represented a sincere effort by its makers to find novel graphic forms for the portrayal of a strained and anguished mind, he pooh-poohed the conjecture as impossible. He explained to me that the Board had a rule forbidding the representation of lunatics in films because any audience was liable to contain people with relatives in lunatic asylums, and a film like *Caligari*, for example, might distress these by making them think that was how their patient-relations were actually confined" (322–23).

The obstacles facing the Film Society were evident at its very first showing. One of the films was Paul Leni's *Waxworks*, featuring three established actors—Emil Jannings, Conrad Veidt, and Werner Krauss—in a trilogy film, one episode of which involved a portrayal by Krauss of Jack the Ripper. "Jack the Ripper as a character could not be allowed," Montagu says the Board of Censors determined, "his crimes were real, and this came up against the list of bans. 'Why not call him Springheeled Jack?' Brooke Wilkinson suggested helpfully, although admittedly the character never springs and you could not possibly see his heels.

"We saw that compromise would mark a fatal precedent, and fought the issue, with every stop out, and pulling every string we knew, by a special appeal to the L.C.C. [the Lord Chamberlain's Commission]. This was the authority for London; we took advantage of the judgment relating to appeals to ask it to license to the New Gallery all programmes shown under our auspices and under bona-fide 'private society' conditions of annual membership for eight performances, sight unseen and without benefit of censor. With so many sacred cows among our sponsors we won, but it was a close-run squeeze. According to my recollection the margin at the crunch was some 50 odd to 40 odd. Neither trade nor censor forgave us. Instead of being glad of getting rid of an embarrassment, they clearly resented our privilege" (323–24).

The way now cleared, Iris recalls the excitement of the Society's opening day:

> The first programme of the Film Society was given on a Sunday. Our amiable sponsors had arranged to give lunch parties and were to bring their guests [to the screening]. I lunched at the Cafe Royal[20] with a friend, Yvonne Kapp,

and tried to be calm. A little before [the showing] we crossed over Regent Street towards the New Gallery and, goodness, in what normally was the desert of a Sunday afternoon, people were gathering or going in, taxis were drawing up, there were even limousines, really quite a procession of Daimlers and Bentleys and Rolls exuding their contents. The venture was a hit.

Inside the theatre that indescribable bustle and hum, programs distributed efficiently and being glanced at all at once, discrete greetings exchanged, people and more and more people taking their places, the lights dimming, the proscenium curtain sliding back, the tap of the conductor's baton and—at last—on the screen, 'The Film Society Presents'. The idea had worked![21]

Adrian Brunel recalled that for the first performance "the house was packed with an audience that became typical and consisted mainly of the *beau monde* of Bohemia, including some of the more adventurous members of society and official circles. Chelseaites and Bloomsburians were in evidence—young men with beards and young women in homespun cloaks. Since they were numerous and noticeable, they were a good angle for the Press men, and certain film trade columnists seized on these people as a target for their venom, which developed into a regular vendetta against the Film Society. They prophesied that after the first season, the membership would drop and the Society would no doubt cease to exist after its second season.

"The attackers of the Film Society were wrong. It grew in numbers, strength and in its influence. There was a growing prestige attached to a film being exhibited by the Society, and British film technicians flocked eagerly to these Sunday shows."[22]

The Society's birth, nevertheless, was uneasy. Sidney Bernstein recalls that when he tried a film-as-art argument on one of the censors, the man retorted, "Don't talk to me about art, young man; I knew Ruskin!"[23] Montagu recalls that he and his colleagues were

no sooner over this pickle [about censorship] than we fell at once into another. The *Daily Express* anticipated our premiere by suddenly publishing on its eve a red-baiting article. The article was written and signed by its regular film critic, G. A. Atkinson. A group of prominent society figures, writers, artists, etc. had got together to communise the country by showing Soviet films, it alleged. Under the banner of art these persons—listed in the article—had secured exemptions from censorship and were going to introduce riot and revolution. Ivor Montagu had just returned from Russia. What had he been

up to there? It was known he had a diplomatic passport—had he brought the films to Britain in the diplomatic bag? How many of those concerned were Communists? All must share responsibility for the plot.

There were many odd things about the article. I had no diplomatic passport. None of us was a Communist—at that time not even I [Montagu later joined the British Communist Party]. I had brought back no films from Russia, and I had no access at all to any diplomatic bag. There has never been any difficulty in importing any film into Britain, or so far as I know from anywhere. There is no law under which any can be excluded, unless it is obscene. It is quite true that I had tried to get hold of Soviet films for the Film Society but . . . I had failed; and indeed it was not until several years later that we were to succeed in convincing the Soviet authorities that it would be sensible to let us show any.

But the interesting thing is that I had been earnestly advised that I *must* at all costs get hold of Soviet films for our programme. This had been in the course of a conversation I had had with somebody in the *Express* building itself shortly before my departure on the B.M expedition [Montagu had gone on a zoological expedition for the British Museum the year before]. The somebody was G. A. Atkinson who had, indeed, accepted the invitation himself to be one of the Film Society's one-pound-shareholder guarantors. His very words to me were: 'It is no good you people starting off the Film Society with French and German Films. We've seen those before. You simply must succeed in getting Soviet pictures. Otherwise there'll be no interest and the papers will have nothing to write about.'[24]

Sidney Bernstein, Iris Barry, Frank Dobson, Walter Mycroft and others were upset. Except for Mycroft—who could hardly do so since, being on the *Evening Standard*, he was employed by the same group of newspapers—they issued a writ. Sidney's solicitor took us to consult D. N. Pritt as counsel. . . . I refused to join in the writ. My own solicitor, my cousin Walter Hart, told me that, as I was the most seriously libeled, I should certainly collect the heaviest damages. But I explained that it was impossible for me to sue; although it was untrue to say I was a Communist (at that time) or had engaged in surreptitious import of subversive pictures, I could not consider myself damaged by the former allegation and would, if I considered it in the interest of the country, have no hesitation anyway in importing anything. Therefore I would not claim to be libeled.

This was fortunate in a way, because not being a party to the case enabled me to see [Lord] Beaverbrook [publisher of the *Daily Express*] and discuss a

settlement. I got in touch with Beverly Baxter [a reporter friend] and told him the facts. Within a few days I was invited to Beaverbrook's office. It was a curious scene. In the corridor outside his office Atkinson came up to me and whispered, before we went in, that if what I really wanted was to have his job on the *Express* he was ready to give it up to me. I do not know what he had been put through in the building for this extraordinary idea to come into his head, but of course I took no notice of it. We entered and he stayed standing at the edge of the room during what followed, never speaking except once or twice answering 'yes, sir' or 'no, sir.' Beaverbrook was sitting on the very edge of a low arm-chair, leaning forward. I do not recall, if ever I knew, exactly who were the several others present, but the room was crowded and I think I remember Lord Castlerosse and his cigar. Beaverbrook was short and to the point. The *Express* had consulted its lawyers, he said, looking to the others for confirmation, whereupon they nodded. The opinion was definite: the *Express* would lose the case, but the costs and any possible damages would be well worth it in view of the increased publicity and sales which would be sure to result from the public interest aroused. But he, Beaverbrook, did not want to make money that way. (Here a glance at the unfortunate Atkinson.) He would like to settle. Would my friends agree? As my colleagues did not want damages but only costs and a withdrawal, and we had agreed on this beforehand, this was easy to answer. A full retraction duly appeared.[25]

In this stormy manner, the London Film Society was born. It would flourish until most of its original founders had moved along, and it survives today as part of the London Film School. In its first season the Society presented thirty-nine films, including twenty screened for the first time in England. The Society enjoyed its privileged position, taking advantage of it to show a wide variety of films, including the notorious *L'Age d'Or* (1930), by Luis Buñuel and Salvador Dali, which Sidney Bernstein invited Nancy Cunard to import from France in her hatbox. Bernstein had arranged for the showing through Buñuel, who complained that the film had been greeted by rotten eggs in Paris. To this Sidney inquired, "Well, wasn't that what you wanted?" "Exactly," was Buñuel's reply.[26]

Association with the Film Society brought Iris Barry her moment in the limelight of the British social scene and a new job as well. "The word of mouth publicity which had almost automatically started [with the Film Society] now led to circumstances which were enormously to my own advantage," she recalled, "but eventually left me less time than I would have wished to give to the nascent Film Society. The artist Edmund Kapp [husband of her friend,

Yvonne] did a delicious and flattering caricature of me that appeared in a fashionable weekly. A sprightly paragraph in a society column linked my name with those of the Hon. Anthony Asquith. . . . Bernard Shaw and a Maharajah, and brought in the forthcoming Film Society. At the same moment *The Spectator* commissioned and published quite a long article by me on the dire state of English film production and the steps which might or should be taken by parliament to combat the 'stranglehold' which the American film—that is 'Hollywood'—had taken on British cinemas and British minds.

"When I received a letter from the managing editor of the *Daily Mail* asking me to come and see him, I was delighted and also quite sure that he wanted to be informed about the Film Society. In I popped then to the fortress on Fleet Street at the appointed hour, dressed in my tidy and efficient best (well-groomed and modest). My interviewer was a Scot, evidently a big shot, with an accent and speech almost entirely incomprehensible to me until I did hear him say 'How much a week will you want?' No time for reflection, I named at once as big a sum as I had ever dreamed of—15 pounds—and some remote inspiration made me add 'and expenses.' So there I was, a real journalist starting a new and unknown career the very next day and charged with the really rather alarming duty of helping strongly to put the British film back on the map.

"There were two odd circumstances, apparently: my very serious article in *The Spectator* had caught the eye of [*Daily Mail* publisher] Lord Rothermere, and it had been signed. As he whom one knows now as John Strachey at that time signed Evelyn S., as Sir Evelyn Wrench, another contributor and later editor, had the same forename, I have always suspected that Rothermere and/or his henchman had supposed that the author of my sober and patriotic piece on the cinema in the same weekly to be also a gentleman rather than a lady. The fact is that I became the only female special writer on the *Daily Mail* staff, apart of course from the (invisible) fashion editress, until my friend Evelyn Irons came to work for the same journal.

"Frankly, I was overjoyed by my new real job although of course it was not very *chic* to write for a daily journal, especially not for the *Daily Mail*,[27] but it was slightly envied, much better people/writers than I did it, and the money seemed divine. The job proved to be more than a full-time one. Quite apart from seeing some twelve films per week, it meant my covering each and every major event concerning cinema every day—I recall one Monday having eight separate pieces in that day's paper, including long signed ones such as a comment on all the films due in local cinemas that week and in stop-press the fact that the Prince of Wales had attended a long African travel film at the Capitol

on Sunday and had or had not wanted to sit on the steps of the balcony because by the time he got there no seats were available (Oh, modest, film-loving prince!)."[28]

It is significant that the basis of Barry's hiring at the *Spectator* and the *Daily Mail* was political and economic. Her employers in both cases viewed her as an advocate for British film. She, however, viewed herself in a role then only emerging in British journalism, that of film critic. The clash between these two agendas would prove consequential.

England at the time was fully engaged in its love-hate relationship with American culture. The rise in wealth and ostentation across the Atlantic seemed threatening to the more subdued lifestyle at home. The cinema had often been identified as the source of this threat. "At a time when the population stood at 45 million people," notes historian Mark Glancy, "[film] admissions reached the rate of 20 million per week," and in those theaters "Hollywood films outnumbered British films by a ratio of 17 to 1."[29] Taking their cue from the slogan, "Trade Follows the Film," a self-promotional vacuity of the Motion Picture Producers and Distributors of America (before it became the MPAA), British leaders often subscribed to the fantasy that images of wealth in American films were leading to buying trends injurious to domestic products. There seemed to be what Glancy calls a "zero sum" game on culture, with any addition of American influences leading to an immediate subtraction of those domestically grown. This was the atmosphere present among large-volume publications in London at the time, with the two most popular newspapers in town also being the most stridently anti-American.

For Iris, troubles with anti-Americanism lay ahead. Meanwhile, she was enjoying her celebrity in the clique surrounding the Film Society. The group congregated in a new restaurant, the Alexis on Lisle Street. "We all became regular patrons," Brunel recalled, "with our wives and friends joining us. Harold Warrender and Elsa Lanchester [both actors] were with us most days; Iris Barry and Yvonne Kapp were constant customers; Charles Laughton, John Gielgud and other rising stage celebrities became regulars, too. Soon it was established that two or three tables placed together should be set aside as our table and at times we overflowed to other tables. The Alexis became a miniature Ivy [another upscale restaurant], and it was not long before people began to come along to see the lions feed; the focus of attention was our table and we were the pivot of the business."[30]

Although many of the original founders of the Film Society later drifted into careers related to film, they remained friends for years and took pride in

their joint endeavor. The Society continued fiscally solvent, often carrying a small yearly surplus. It played a pioneering role in the promotion of film as art in England, spawned similar organizations in Australia and the United States, coordinated the formation of an International League of Independent Film, and financed experimentation in filmmaking. Public lectures and demonstrations by Sergei Eisenstein, V. I. Pudovkin, and others contributed greatly to the growing appreciation of cinematic art. The Society's example also paved the way for the founding of the British Film Institute and its network of regional film theaters throughout England. Its programming called attention to directors deserving of international regard, while also fostering an appreciation of short and experimental films, documentaries, and films by women and filmmakers from many ethnic and regional cultures. No organization of its time was more vital to the furtherance of the appreciation of the art of film in England.[31]

10

CINEMA PARAGONS, HOLLYWOOD, AND LADY MARY

W HILE FILING HER reports for the *Daily Mail*, Iris continued con-
tributing more in-depth articles to the *Spectator*. There she had the
latitude to work out her responses to some of the achievements
of early film. In her writings we see an astute mind at work, free from the
assumptions that would later color standard assessments of great figures in film
history. Iris saw things afresh. It was only later, in part due to the recognition
she accorded them, that the pantheon figures of filmdom took on their preter-
natural glow.

Coincident with the founding of the Film Society in September of 1925, Iris
saw Charlie Chaplin's *The Gold Rush* for the first time and published her analysis
in the *Spectator*. Iris considered herself too fond of Chaplin's films to be critical.

> A mother would find it hard to say at what stages of their development
> she loved her children most, and though spring comes every year, who can
> decide whether the woods and hedgerows were better dressed in 1910 or in
> 1925? In between Chaplin's pictures we grow a little critical, say how good
> Buster Keaton is becoming and how much new comic genius Harold Lloyd
> has developed in his last piece, *College Days*. But when, as on Monday night,
> a new example of this master's art comes to the screen it is quite clear again
> that Chaplin is king of them all. If anyone doubts it, let him only listen for
> a moment, as I did during the first showing of *The Gold Rush*, to the lovely
> soprano laughter of some children who were there. It was, as the programme
> reminds us, the children who first discovered Charlie, and while he has their
> clear music wherever he goes—ours too, and all of it laughter of the most
> celestial kind, pure laughter of joy—his supremacy is unchallenged.
>
> In *The Gold Rush* the old familiar Charlie—with the little stick, emblem
> of his citizenship, and that most expressive, all-courteous bowler—trots

across the harsh white landscape of Alaska and through the dreary dance-halls of mining-camps whose garish gaiety has bored us in many a false and unworthy film. Charlie's presence makes the old unreal cave-men, the tawdry, impossible dance-girls step from the realms of cinemaese into reality. His courageous and slightly mischievous figure gives them that same kind of depth and beauty that a great writer's hand gives to the figures in his stories. . . . The story of *The Gold Rush* I need not tell, or even record that its very improbabilities are carefully calculated to give just that finest twist of pure farce to the piece. But let no one fail to appreciate those small details of his perfectly timed and quite exquisite acting, as when he has most kindly boiled one of his famous boots for a starving miner-pal, and serves it up after due testing with a fork. His friend does not seem much to appreciate the upper, but Charlie himself is most endearingly delighted with the sole. If the flower of the aristocracy did choose to eat boiled boot-sole, and if it were the business of an epicure to extract an exquisite enjoyment from the small portions and flavorings adhering to the nails, then one is quite convinced that the aristocracy and the epicures would dine exactly as Charlie does, and with just that nice appearance of ritual.[1]

Iris pointed out in a 1925 article in Edgell Rickwood and Douglas Garman's *Calendar of Modern Letters* what made *The Gold Rush* distinctive among Chaplin's films. She found it "the most Chaplinesque, and most likable piece he has made. . . . Chaplin the director has for the first time fully realized the potentialities of Chaplin the comedian, has given him a new kind of world to move in and deepened his meaning vastly. In all the other comedies the little figure has moved in a comic world of villains, policemen, mothers-in-law, naughty children and curates. The custard pie was imminent in the atmosphere, except here and there in his other masterpiece *The Kid*. But in *The Gold Rush* Chaplin acts in a non-comic world, the ordinary world of Alaskan film-drama with its fur-coated miners, flash houris, mining camps and snow. The subsidiary characters are ordinary characters out of cinedrama, not out of low comedy. And against this familiar background Chaplin's brave, battered little figure takes on its real meaning. He is the individual trying to come to terms with society: this is true of his impish as well as his pathetic moments."[2]

Iris not only appreciated Chaplin's mimetic skills and his ability to place them in a noncomedic context, she also thought of him as a model for the quintessential filmmaker, the artist who combined the ability to handle a camera with the facility to create and film a story. In calling for England's better

writers to work for motion picture studios, she sensed quite early a need for the *auteur*, the independent filmmaker fully in control of the film process. "There is a prejudice among most men of letters," she wrote in the *Spectator*, "usually unconscious, against the film as an art-form. They have the most ineradicable conviction that it is necessary to write, and to think, *down* to it."[3] But exceptional films do not deserve such derision. "Now a good film—and one expects men of letters to create good films—is not an irrational, foolish or unlikely affair at all. It can deal with few characters, though crowds small or large may appear in it as social background. The motive for every action must be implicit if not explicit, and must also be true to some accepted order of behaviour, romantic or realistic. The action may be set in a great many different scenes, though the fewer the better, but they must cohere within the geography of the world where the action takes place. A good film is not a disorganized sequence of events at all. It has its canons every bit as much as a play, and it needs to be much more closely dovetailed, consistent, fool-proof. Though it may resemble in content an infinitely expansive short story or an infinitely simple novel, it is ruled by absolutely other conventions, and conventions which are unknown outside studios, and only lately being discovered there."[4] This "new form of artistic expression," the writing of "scenarios," she felt, should be combined in the single person of the director.[5]

While she advocated centrality for the film director, and identified herself as among those capable of being enchanted by motion pictures as a recreative amusement, Barry also called for realism where realism was appropriate, especially in the war film. Despite her positive feelings about being liberated in her professional and private life during the First World War, she knew that the war was a turning point for those who survived it and a tragic end for those who did not. Later in her career at the Museum of Modern Art she would be surrounded by a full-scale civilian mobilization involving the Museum and the film department of which she was curator, in a major effort to support American involvement in World War II. In 1927, nearly ten years after the end of the First World War, Iris drew different conclusions about war films.

"We ought to have guessed when we saw the first film made with a nice romantic love-story set against a background more or less representing the period 1914–1918," she wrote, "that it would be followed by scores of others like it. . . . People from time to time have alleged that these films are excellent anti-war propaganda. Nothing more ridiculous has ever been suggested. On the screen war has no horrors; it does not show men engulfed alive in mud, blown to bits with explosives, choking to death with gas. It only shows the hero being

incredibly brave in the most unsoldierly way, or, as in *The Big Parade* and *What Price Glory?* permits him to utter one or two literary phrases against the evils of war, while continuing to display him, nevertheless, as the conventional hero, returning to the arms of his loved and admiring ones later on. As a matter of fact one would judge that these war films are about as good propaganda for war as peace-time has ever known."[6]

Lest her readers get the impression that she supported only high-mindedness in cinema, Iris also showed a lighter side in articles such as "Lesser Glories," which appeared in the March 6, 1926, *Spectator*, observing that "the more intelligent cinemagoers seem to be divided into two: those who go seldom and only when they can be sure of seeing an exceptionally good picture, and those who go frequently to take the bad with the good." Iris sided with the latter, calling them "naturally the best informed," and unreservedly expressed her admiration for "programmers" such as newsreels, cartoons, and rough-and-ready westerns. Felix the Cat she found "a joy" and she longed to see again some of the slow-motion nature photography the Film Society would screen, which she called "marvels of patience," especially one titled *The Life of a Plant*, in which "a nasturtium germinated, grew up, flowered, was cross fertilized, languished, shot its seeds off and died in five minutes." She even had a good word for the action films of Tom Mix, which she found to be "a tonic." She appreciated "the rapidity of action in all his films" and found him to be "the absolute hero" who "outwits his enemies and triumphs over the most impossible odds with all the ease of dream life. You can tell by the roars and moans of appreciation which the small boys in the cheap front seats emit that he is appreciated by them as nothing else is. For I recommend the smaller and obscurer of the picture houses to the film lover's attention. They have a way of springing surprisingly good and little advertised pictures on one, and they also teach one how incredibly bad the worst films can be."[7]

These early writings presage the wide-ranging curatorial aesthetic of Barry's later career. Throughout her life, she remained so genuinely devoted to a variety of filmic achievements that she never developed a rigid sense of what a good film must be.

Iris's early eclecticism betrayed a tolerance for American films that eventually would get her into trouble with Lord Rothermere at the *Daily Mail*. After all, she had been hired because of her patriotic call for support of British films in her *Spectator* column. In September of 1927 she convinced the *Mail* to send her to Hollywood for the first time. There she quickly satisfied her curiosity about Americans and looked without success for films for the Film Society.

Writing Sidney Bernstein from the Hotel and Bungalows at Beverly Hills, she complained that she was

> *most frantically disenjoying Hollywood, and it was like a breath of civilization to hear from you. How right you were not to come out here: there is nothing at all but exactly what you see on the screen—a lot of good workmanship and a lot of abysmal stupidity. And of course the people—the society—the conversation—all is unimaginably awful. You know what chorus girls are like, or don't you? Let's argue that you do, and it's just like that. The men are worse than the women.*
>
> *California itself is fun—I spent a day at a lake up in the mountains—enjoyed every second, even motoring home at night along the most hairpin of serpentine roads you ever imagined—and Hollywood and the other more residential places are delicious holiday resorts for the idle rich and the invalid, with their sunshine and lawns and sea bathing and shooting and so on. It's only the film community which is so vile, so deadly boring, and so exhausting. They never talk of anything but films and not at all intelligently, and all of them, good and bad, are most bloody self-important.*
>
> *I fancy I am not, by the way, very popular as it is a strain being insincere all the time. I forget myself now and then and say something candid and they look like cows disturbed at pasture. . . .*
>
> *New York of course I adored . . . and the train journey and the warmth here during the daytime—and the real Americans.*
>
> *But Sidney my dear if you knew how I wish I were sitting on your big Chesterfield this minute, with you, and far from the most madding of crowds—you would be confused! You must make much of me when I return, for I shall be almighty glad to see you. . . .*
>
> *My love and a most spontaneous and cordial hug.*
> *Iris*[8]

From the Algonquin Hotel in New York on November 1, Iris wrote to "Darling Sidney":

> *Here I am on the way home: shall be back (rather regretfully) towards the end of November. It's glorious to be out of Hollywood back into the everywhere and New York is grand, isn't it? You can't think what an amusing time I'm having. I don't mean on the film side, but otherwise. Even the film people are all right here and I keep meeting the oddest people . . . Roxy [Samuel Rothafel, noted for lavish presentations of silent films] I'm to see one night soon and [the chief Hollywood censor] Will Hays*

(yes I have things to say to him) and Symon Gould [an early art house exhibitor] and find out about a film made privately here of Tom Jones. There was nothing I could find in Hollywood, not that we could get. I tried to get the real version as Stroheim finished it of The Wedding March but they won't, being angry about it: and you can't do anything with Chaplin either: and the amateur films there are too awful. . . . Dudley Murphy [co-director with Fernand Leger of Ballet mécanique], on the other hand, will give us something: and O'Flaherty's [sic] wife [Mrs. Robert Flaherty, also a documentarian] is off now in the desert making two short films for some govt. department at Washington, of the Indians which also we can have in god's good time. Here I am looking around.

They don't know any more about films than we do, as you know, though as you also know there are more intelligent people in the film trade here than there. . . . I dread the sea voyage . . . last time coming over I had to keep drinking brandy all the while and that is such a bore, I wasn't wholly sober (nor quite drunk for that matter) for a knot of the passage. Perhaps it won't be so bad returning, tho' it may be worse. I won 24 dollars on the horse game though and danced every night and was made much of—you should have seen it! You know, young American men like Arrow collars, from Boston: so manageable and so polite and so danceable and so little else: not forgetting the officers, or the really charming elderly ladies from Connecticut who liked me very much indeed and discussed the anti-American feeling in Europe quite intelligently. . . .

This is a nice hotel, by the way, the bedrooms are infinitely shabby and squalid, so much nicer than the awful place I stayed in before, full of butter-and-egg men and too large and glittering and common for words.[9]

In her letter Iris also mentioned that a manuscript she delivered to publishers in New York had been well received. The manuscript was her biography of Lady Mary Montague.

Iris's *Portrait of Lady Mary* (1928) is a novelistic re-creation of the life of Lady Mary Wortley Montague, the self-taught writer and courtesan of the late seventeenth and early eighteenth century who was noted for having introduced an early form of smallpox vaccination to England. Writing with the blend of fictive technique and historical research popularized by Lytton Strachey in his *Eminent Victorians*, Iris drew a vivid portrait of Lady Mary, complete with a deathbed speech of her own invention ("It has all been very interesting"). The speech is one Iris claimed to have devised for herself, but it took on a life of its own as it came to be repeated.[10]

Critical reception to the book was mixed, with some appreciating its liveliness and others excoriating its alleged inaccuracies. Comparing it with an authoritative work such as Robert Halsband's book on Lady Mary[11] does not make its historical shortcomings clear, but it is impossible to determine if the dialogue or thoughts attributed to Lady Mary by Iris are authentic.

The fact that she chose this particular person to write about, however, seems surprisingly prophetic. In several ways Iris Barry's life and that of Lady Mary ran parallel. Both rose from rural anonymity to fame within the context of the English gentility of their times, both had unsatisfactory liaisons with the fathers of their children. Both ended their lives in voluntary exile in southern Europe, Lady Mary resettling in Italy with a disreputable Italian count and Iris taking up with a smuggler of olive oil in southern France.

Iris's husband, Alan Porter, also sensed these affinities in his assessment of the book. "It is very late," he wrote her, "too late really to write but a whole day and night full of thoughts of you need something to prevent them from turning into sentimental formless longings. I have been reading your book as well and in reading it see you more clearly hiding behind your Lady Mary. But you should not write books like that about dead people. You are at your best in analysis of actual life. You observe, you feel too much in the present to be a good historian. The past lives in you only to make you see refracted your present life. It is the actuality of the past that strikes you. You cannot get that effect from the pseudo-past of the history book or the biography. If dead men have lost their tongues, not all the art of the biographer will do better by them than a modest raising of their spirits. The biographer's art is the jeweler's, to build a setting for the words that remain. But you have been caught in the Strachey tradition."[12]

The *Times Literary Supplement* gave the book perhaps its most balanced appreciation:

Miss Iris Barry is keenly interested in the background and the detail of her portrait of Lady Mary Wortley Montague, as well as in her central figure, and she has very successfully sketched in the notabilities of a brilliant age. We may disagree with her conclusion that all former biographies of Lady Mary 'concern a corpse'; but that is not to deny that there is room for this new study of a remarkable personality and that within its limitations it is very well done. But with all her ability to write good English she is often careless: she is fond of schoolgirl's verbs and writes that [Alexander] Pope was 'thrilled' to meet Lady Mary, and that she was 'intrigued' by something else; that Queen Anne was

'worried to death,' and that the Duke of Kingston's mind 'fussed indefinitely with the cause of his present passion.'[13]

Perhaps the energetic format of *Splashing into Society* carried over too literally in the *Portrait of Lady Mary*. It remains, nonetheless, a lively and readable book about a remarkable historical figure, whom Iris recognized as "the first New Woman." For Iris, the book added luster to her role as a significant force in postwar British culture.

II

LET'S GO TO THE PICTURES

B
Y 1926 IRIS had been a filmgoer for twenty years, excepting time served
in convent school. With the founding of the Film Society and the grow-
ing awareness that film could be more than popular entertainment, Iris
decided to concentrate her ideas about film into a book. *Let's Go to the Pictures*[1]
brings together observations and theoretical concerns present in more fragmen-
tary form in her *Spectator* articles. Writing the book provided an opportunity to
summarize what she had learned about film at the time.

Although the book ostensibly attempts to differentiate film from the more
established arts and lend respectability to the appreciation of film, it succeeds
most thoroughly as a report on the nature and rewards of filmgoing. In its com-
ments on national film movements, directors, actors, and the mechanics of film
distribution, the text astutely chronicles the achievements of filmmakers; but
most affectingly captures the allure of film-as-experienced, telling us a great
deal about why viewers are drawn to pictures in motion.

"One by one we slip away into the dark, soporiferous cinema," Iris wrote
in her introduction. "Why? Because it shows us the object behaving. Because
without ever telling the unnecessary and mutable truth it is always saying
something which is relatively exact under given circumstances. Because it is
personal experience."[2]

Iris was comfortable with contradictions and incompleteness, perhaps
because that was how she lived. She could write that "it is the accumulated
succession of diverse images which gives aesthetic delight" in filmgoing, while
appreciating that "even in the crudest films something is provided for the imag-
ination, and emotion is stirred by the simplest things—moonlight playing in a
bare room, the flicker of a hand against a window" (vii–ix). A film to her was
more than the summation of its parts, and she could see that the medium was
still evolving as an art form. She, perhaps more than other influential critics

who followed (with the possible exception of James Agee), was happy to let film be whatever it wished to be. She could agree with Tolstoy that "art should be comprehensible to the simplest people," declaring that "this the cinema certainly is, besides being as universal as music," and, at the same time, disdainful of the hoi poloi: "I do not however foresee a time when the public will 'support' the cinema. The monster public can safely be left alone with its chief amusement: pterodactyl does not support mammoth" (ix–x).

The divisions between "high" and "low" in the emergence of film art run as a leitmotif in Iris's writings. She remembered fondly her childhood days in lowly cinemas, while remaining impressed with the Dusenbergs that rolled up in front of the Film Society's showings, signaling acceptance of film among the well-to-do. She was equally comfortable with lowbrow B westerns as with the historically faithful films of John Ford.

First and foremost Iris wanted people to go to the cinema and respond enthusiastically. "Let's Go to the Pictures," as she titled her first chapter, symbolically ushers us into the darkness among "the little boys who eat oranges and smell of machinery" (3). She recognized that "the cinema is almost as standardized as a church service or a daily newspaper. You know roughly what to expect." We appreciate the regularity. "You do ask for *pictures*: you do not consciously ask for uplift, or to be made to laugh or cry. You only ask that something shall take place on the screen: it is restful and dark and you can talk or not as you like (at least while the music is on) and it is cheap" (5).

Iris felt the escapist allure of the cinema had a stabilizing effect upon society. Ordinary life, especially for women, she thought limited and boring. The cinema, on the other hand, "is *something*: whereas making the beds and shopping, or taking shorthand, or covering jam-pots is, by repetition, less than nothing. So there the girl sits in the cinema and feels that life after all is not so dreary: even if nothing happens to her, it happens to other people" (8–9).

It is pure vicariousness that matters. "The thing to remember," she says of her imaginary moviegoer, typically a female, "is that she doesn't much mind what happens, although she may prefer Mae Murray's writhings to Mae Marsh's candour, or like Charlie's inferiority complex better than Buster Keaton's stoical indifference. But when she has a good cry, it is because the hero and the heroine have been in some moving and pitiable state. Did you ever see anyone cry because the villain came to grief? No, the weeping cinema-goer is himself or herself (men weep copiously in the cinema of course) the heroine and the little child lost, and the ill-treated dog: his or her tears are a curious sort of self-pity" (9).

The key to understanding cinemagoing, to Iris, lay in the simple fact of ego-centricity. We willingly pay the small price of admission to get something in return. It would indeed seem absurd to pay to give something away. But what, besides purgation through the vicarious experience of heroes and heroines, do we receive? This, in Iris's estimation, varies with the *kind* of picture it is. Travel films, for example, "do give something, a kind of realistic something, which no book of travel, not even the best books of all like *The Voyage of the Beagle* and *Arabia Deserta*, can give. The visual impact is directer than the literary one with its complicated acts of comprehension." These films make the "stay-at-home citizen a man of the world" (13). There is an intrinsic reality effect in the cinema, at least to the extent that, no matter how fantastic the subject matter, photography in motion lends credibility.

There is always something informative about the content of a film. To Iris, "even the silliest photoplay may contain information—information about the physical conformation of Devonshire or California, or the technique of whale-fishing, information about standards of morality and conduct," such that "watching even the most foolish film makes one a student of human nature" (13–14).

In Barry's estimation the motion picture is the quintessential postindustrial art form. It flourishes in centers of population, where work is concentrated, and especially during the early years of the twentieth century, appealed to those "smelling of machinery" or who kept homes in working-class housing. For the small price of admission, denizens of these environs could forget the strictures society placed on them. Preindustrial society, which slowly faded as the nineteenth century progressed, encouraged self-sufficiency. "There was a time," she observed, "when every man and woman knew what baking was: but now it is carried on in secret, by routine craftsmen in inaccessible works. So it is with all the processes, like weaving, turnery, agriculture and so forth. The cinema, by showing how these things are done, tends to counteract the horrid effects of specialization, which makes most of us use words and entertain concepts of all sorts of movements and objects we never see or handle. The cinema helps us to live complete lives, in imagination if not in fact. And I cannot help thinking that knowing is the same thing as sympathizing. This is why I think the educative ingredients of this immense entertainment are subterraneously inculcating a shadow of sympathy among the many peoples, the many castes, in the world" (16). Moviegoing, then, provides not only selfish relief to the individual trapped in workaday reality but a subtle kind of social cohesion that comes from passing on information that encourages empathy. Movies soothe, but they also teach.

Although the theater derives impact from the presence of live actors artic-ulating language in the confines of a relatively constricted space, it is from literature that theater derives its essence. "The most beautiful plays are good to listen to," Iris argued, "the most beautiful films are good to look at" (25). It is in the power of images that the strength of cinema lies. "Visual imagery, less primitive and more sophisticated than auditory imagery, is also sharper, more rapidly apprehended, though not richer in association, and more permanent. The eye, that is, can take in more and more definite impressions in a given time, and can associate ideas more quickly than can the ear." So while the theatrical actor may give the audience more to think about, the film actor is more likely to reveal internal thoughts. The personal presence of the actors, so critical to theater, is "compensated by the cinema's increased intimacy, by the possibil-ity of seeing the actor's very thoughts as well as his eloquent gestures and his changes of expression" (25–26).

"The world of the screen," Iris wrote, reshaping an earlier view from the *Spectator*, "is also a much wider world than that of the stage: it is not spatially confined, it has, besides an infinite variety of scenes, endless angles of vision and of focuses: you can look down on the action, or up to it, from behind or before. It also includes as part of itself all the riches of landscape or architec-ture, which are not, as they are in the theatre, mere conventionalized hints. The landscape and the architecture play a definite role on the screen: they can even be the chief characters. And the camera brings out an enormous and dramatic significance in natural objects. Chairs and tables, collar-studs, kitchenware and flowers take on a function which they have lost, save for young children, since we abandoned animism in the accumulating sophistications of civilization."[3]

Putting the contrast between theater and film quite directly: "The stage dolls live in a box. The front slides up and there they strut in their nice toyhouse, which has an exaggeratedly high ceiling to allow the human beings in the gal-lery to get an oblique look down into the scene.... Nothing is real: the audience doesn't think it is real."[4] If one of the actors had a heart attack while onstage we would have to interrupt our suspended state of disbelief to comprehend it.

Representing space is problematical in theater, but in film, "space as a limita-tion is banished: it becomes not a convention but a factor. Time as a limitation is destroyed too. In a flash we can be seven thousand years back, a century forward, in a thousand ages and areas. And all the while there is something to look at. It moves."[5] In the theater, "our minds project themselves into the light, leaving the body behind in its seat.... The stage of the cinema is in the mind of its spectators. There is no such sense of separation as the theatre-goers

experience. To go to the pictures is to purchase a dream. To go to the theatre is to buy an experience, and between experience and dream there is a vast difference. That is why when we leave the theatre, we are galvanized into a strange temporary vigour, why so many people run home and act and strut in their own rooms before the wardrobe mirror. But we come out of the pictures soothed and drugged like sleepers wakened, having half-forgotten our own existence, hardly knowing our own names. The theatre is a tonic, the cinema a sedative. The cinema is a liberation of the ego, the theatre an enrichment of it. And that is why, after the feverish activity of a day of modern life, the screen calls to us more strongly than the footlights."[6]

The artistry of film lies in the intrinsic value of viewing photographs in motion and it differs markedly, Iris points out, from drawing or painting. "That which moves is looked at," she argued, since vision is our way of guarding against intrusion. But watching motion also has its aesthetic rewards. "I enjoy seeing for its own sake," she wrote, and when we look at cinema we also look at pictures "for their own pleasure-giving qualities apart from their story-telling value or symbolism. . . .

"A draughtsman's talent really lies not so much in his ability to represent nature accurately, that is, not merely in his technical ability, as in giving an appearance of life to a non-living representation of life. He is also concerned with form and volume, with the use of light and shade to give an appearance of three dimensions to that which is in fact flat. The moving picture has light and shade and looks three-dimensional. But in giving an appearance of life, the moving picture and the artist are on equal terms. The artist has eternally to arrest movement in such a way that the action which has gone before and that which will succeed the actual moment depicted are both somehow suggested. The film, on the other hand, uses motion as one of its mediums, very unlike the artist who can only suggest the life-quality by convention. So that, in this sense, the film approximates very much more to the ballet or dance-drama. Take away the story-telling quality of the ballet, and what is it? It is a harmonious succession of moments of free, not arrested, motion in which the line of beauty follows the passage of matter in space and in which pleasure is given by the spectacle of lively units harmoniously changing their relative positions to each other and to the whole composition; also in the various rhythms of speed. This is exactly the case with a film, though less noticeably, because attention is drawn primarily to the dramatic element" (37–39).

The representation of spatial depth in film takes on a quality different from that of postmedieval painting. The two-dimensional, flat surface of the film

screen, like a painting's canvas, is the occasion for presenting the illusion of depth. The painter utilizes the elements of perspective, among them sizing and placing objects as they would appear in nature, working toward a vanishing point. The makers of films, however, have a built-in technological advantage to work with. As Iris put it, "the film is much more stereoscopic than the still photograph" since "another description of the third dimension, impossible to painting, enters: this is the delineation of planes by the free movement of the objects in the picture. The objects, seen in the round in a sense, move not only on their own axes but also in a free orbit, and the line of their motion describes the depth of the scene. It may be objected that the objects are not seen in the round because the screen is flat. But in order to assure oneself that the *Venus de Milo* is not hollow behind, it is not necessary to walk round her. It is sufficient if she is revolved for us. And this is what happens on the screen; the objects are revolved for us."[7]

Iris was skeptical about the aesthetic utility of color ("I am not yet convinced that there is any reason why colour should ever be utilized generally") since it is the tone of film that enhances its appearance of depth and texture, and even with color tone determines its appeal. To Iris, "color without tone has no aesthetic value at all, any more than noise without music has" (44). She therefore deemed it fruitless to try to "decode" colors for any intrinsic aesthetic value they might have.[8]

These uniquely filmic capabilities, in her view, should be put to coherent use. Despite the "unruliness" of film, despite "its power to soar beyond all limits of possibility, to depict the passage of years, to step over oceans and mountain ranges, to double back on itself and show what happened before the action commences, to interpolate dreams and fantastic sequences," ultimately a film must be coherent. "And on the whole the more successfully a film does cohere, the better," as Iris put the organicist argument. "In other words, a film should have form" (46–47). What that form amounts to seemed a matter of indifference to her, although she tended to favor narrative over, say, visual coherence. This flexibility, however, allowed her to be open both to traditional "story" films and those more focused on visual concerns.

Iris's preference for narrative over other forms of coherence is apparent in her early expression of disdain for *Entr'acte*, the 1924 avant-garde film created by René Clair and Francis Picabia for *Relâche*, a Dadaist soiree. The film's structure includes an intermittent narrative and compiles a succession of intentionally illogical images. "Amusing," is what Iris called it, and she grouped it along with other attempts at "experimental" cinema as aesthetic failures; for "original as

they are, I am confident that there is no future whatsoever for films of this kind. That is to say, for films which merely aim at a rhythmical succession of either static objects or of objects in motion. It is true that the eye is forced to look at what moves, but unless something is going to happen through the motion, unless in fact there is a story value, the eye very quickly tires" (244–45). This proclivity would later put Iris in contrast to influential film programmers in New York such as Amos Vogel and Jonas Mekas, who, in part in reaction to the tradition of her programming at the Museum of Modern Art, started organizations such as Cinema 16 and the Filmmakers Cinematheque in support of nonnarrative film.[9]

Not all narrative coherence is equal, she adds, since "the worst possible unity is a common one: a false emotional crisis or conflict such as one gets in the innumerable American pictures with heroines who have pasts, or are played some rough trick by circumstances and are too spiritless to fight it. The real *raison d'être* of these pictures is that they give a female star plenty of opportunity for appearing on the screen, or whether she is taking the place of her fallen twin sister, or engaged in secret business which enrages her husband, but is in reality innocence itself, or does unaccountable things to bring happiness to her little daughter, the picture sags and oozes beyond anything that can be called true form." Ultimately, then, the best films result when directors competent in the craft of filmmaking utilize its unique capabilities in the service of a substantial humanistic narrative. "It is when film producers start being arty that the worst happens," Iris concluded, chiding that "the less the magnates of film talk of art the better; the critics hold a brief to do all the art-talk necessary about the cinema" (48–49).

In sum, at this point Iris endorsed the escapist functions of film and regarded the medium as inherently entertaining. Film entertains by taking us empathetically and passively along on a waking dream, showing us people and places we take pleasure in seeing. And contrary to those who seek so diligently a higher ground for cinema, hoping to secure for it a place in the pantheon of traditional arts, Iris saw the motion picture as a particularly narcotic diversion, one that so blended technology with artistry as to be both art and craft. "This is the great strength of the cinema," she wrote," that it caters for daydreams—surface sentiment, riches, travel, splendour and wild excitement—more thoroughly, more generously, more convincingly than any other known form of entertainment, and offers it in the most effortless way, under the best circumstances, to music, in a twilight solitude, with no mental effort demanded of those for whom it caters." To this she added a final suggestion: "ask for slightly better dreams."[10]

Iris's *Let's Go to the Pictures* in 1926, therefore, offered a different analysis of film than one finds in Vachel Lindsay's pioneering 1915 *The Art of the Moving Picture.* Lindsay, who distinguished himself as a poet, began his career as a student at the Chicago Art Institute and New York's Metropolitan Museum of Art. His book attempted to define the genres of film, and he identified many of the medium's singular capabilities. In the end, however, he thought of film as an art form at best derivative of the other arts. Lindsay called on filmmakers to emulate painters, and to fashion their dialogue after the best dramatic artists. Iris went beyond such comparisons to find what film alone can do, and hailed it as a new art of the twentieth century. Although she recognized high seriousness in the achievements of many filmmakers, she always returned to the notion of the film as a soothing and collective dream.

Iris welcomed technological advancements in film, but she was not satisfied by the most noteworthy film to date on the subject of technological utopianism, Fritz Lang's *Metropolis*. "If *Metropolis* fails to be a great film," she wrote upon its British premier in March 1927,

> the fault lies, not with its brilliant German producers, nor with its subject matter, nor with the actual treatment of this picture-parable of life next century. It fails because the cinema as yet fails to be quite adequate as a means of expression.
>
> Here on the screen is a concrete picture of a great city of the future, with its soaring skyscrapers, its aerial traffic-bridges, its clouds of little aeroplanes buzzing about like gnats, its smokeless air, its labour-saving dwellings, its intricate electrical devices and its dependence on machinery. The imagination of Fritz Lang, the director, and of the studio-architects and designers who have brought this vision to 'life' proved adequate enough here. The film shows us the making of an artificial human being: shows us television. We can accept these miracles. It shows us, grimly, the standardized mankind which a future civilization keeps buried deep in the bowels of the earth, and uses only as machine-fodder, mere slaves to the machinery on which—we can quite believe—everything depends. These too we can believe in, for we know and recognize and accept these manual workers with their weary backs, heavy hands and dull, hopeless eyes. We can feel with them and for them, when they rebel and destroy the machinery that enslaves them.
>
> But I fear that the intelligent part of the audiences that see *Metropolis* will find it very difficult to admire the peacock-strewn pleasure gardens of the future, in which the free and gilded inhabitants of the skyscrapers of the

future disport themselves, heedless of the tragic workmen deep below. It is sad, too, to find that men of the future dress just as hideously as do those of today. But the costume is not very convincing, anyhow, in *Metropolis*: and though part of the film is conceived in an expressionist mood, and part of it quite naturalistically, some of it is mere picture-postcard. The expressionist parts are far and away the best, and the workmen turn out better than their masters.

The weaknesses of the cinema are most apparent in the story. It is pure melodrama on the D. W. Griffith plan, and frankly treated as such. So grandiose a theme as that which *Metropolis* attempts to develop demanded, of course, something on the epic scale. The cinema, even here at its best, and full as it is of invention and thrill, is still only at the mental age of seventeen. It is still—quite rightly—far more concerned with its medium than with what its medium may most magnificently express. We cannot delude ourselves about this: for it is a fact.[11]

As the decade of the 1920s neared its close, the dreamlike qualities of the silent film Iris so admired faced a new challenge. By the spring of 1929 the phenomenon of talking pictures was being popularized by Warner Bros. and its release of *The Jazz Singer*, starring Al Jolson. What earlier was seen as an experimental novelty threatened to become an integral component of the new art. Iris noted in the *Spectator* that this historic transition was not brought about solely by the film industry. "The film industry itself," she wrote, "powerful and wealthy though it be, and deeply affected as it is by the introduction of sound into cinematography, was not responsible for talking pictures. Dialogue and sound with films were forced on them by inventions perfected by the great electrical companies. It is the Western Electric and Radio Corporation across the Atlantic, Siemens and the General Electric in Europe who are bringing the innovation about. The film industry was compelled to harness this new factor, or find itself in competition as purveyors of mechanically reproduced entertainment with the electrical wizardry of two continents."[12]

Despite recognizing *The Jazz Singer* as "a picture which will go down to history," Iris still did not see broad aesthetic implications for sound film. Her view was to see talking films as a way of spreading the influence of England and the English language. "It is impossible not to speculate already on the possibility of English becoming a world-language through the screen," she wrote. "It would be absurd to overlook the opportunity which this new type of entertainment offers our English film makers. If it is seized, at the very least picture theaters

throughout the English-speaking world, and quite possibly further afield still, may enjoy, and pay to enjoy, a composite form of entertainment emanating from London and uniting some of the qualities of the best silent films with those of the theatre, the operatic stage and of wireless: not revenue alone will accrue, but that prestige for England of which all well-wishers to the British film revival dream."[13]

The medium of silent cinema faced a seismic technical shift. Iris was watching the medium she cared about change irrevocably. *Metropolis* contained minimal elements of sound, such as the tweet of a foreman's whistle, but after 1929 the silent cinema that had formed the basis of Iris's aesthetic would gradually be displaced. Possibly her fondness for silent films, combined with her ambivalence about promoting the ever-struggling British film industry, contributed to her severance from the *Mail* just as sound film gained dominance in 1930.

12

VICTORY AND DEFEAT

As a matter of survival, their standards shift with the times.

—Rudolf Arnheim on critics in *Film as Art* (1957)[1]

AFTER HER MARRIAGE to Alan Porter, feeling the pinch of earning the family income, Iris decided to write more profitable books. In this endeavor she hoped her old liaison with Lewis might prove useful. In July of 1928, some years after drifting into the periphery of the enemy Bloomsbury camp at the *Spectator*, she wrote to him:

Dearest Lewis,

Sorry to bother you, but I didn't ever give you the agreement I made with the people up in Manchester who have Maisie, did I? I simply cannot recollect what I did with the copy I had, signed by them. I have to go up there on Wednesday, and if I can't trace it, have no fear of being able to bounce them into giving me a duplicate. But just in case you did have it—though I don't know any reason why you really should—I wish you'd send it to me.

As I think I told you they consider her 'naughty' and I have to go up and see what it is all about—nothing I take seriously anyhow. One does the best one can. I mean, to be more clear, that it is quite my affair, not otherwise.

I haven't forgotten the very interesting points we discussed relative to your books. I've done a little, perhaps not useful at the moment, talking. But couldn't you give me a list of exactly what there is to dispose of, and what you want? One hears of things, things turn up, one meets people—I know several of the American publishers quite well etc. I would like to have details, as to what books you have already actually placed with whom, and which not placed and what you are asking as advances. I'll do anything I can. . . .

As to myself I have happily persuaded Gollancz and the American publishers to take a novel from me instead of another biography. I imagine it will be much easier, though I only have 3 months to do it in. As I say, one does the best one can. I see even D. H. Lawrence writes for the Evening News . . .

I really regret bothering you about that cursed agreement, but I think maybe you'll forgive me.[2]

There is no record of a reply.

The book Iris mentioned, *Here Is Thy Victory* (1930), her second novel, considers the meaning of death by imagining what the world would be like if mortality were suspended for a fortnight. It is an example of the kind of work, like Frank Capra's film *It's a Wonderful Life*, that makes its argument by considering a hypothetical negative. Just as Jimmy Stewart's character comes to understand his significance to his community by having played out for him all that might have happened had he committed suicide at a young age, so Iris shows how, ironically, death can be seen to be good by pondering the consequences of its absence. Her argument convinces only indirectly. The reader is led to see, perhaps, that death in general has certain benefits without at the same time developing a desire for it.

The story concerns the residents of a village accessible by train from London. The daily routines of people's lives are depicted with period detail. The women wash on Mondays, visit and gossip early Saturday evenings, their men gather at the local pub on Saturday nights to carouse. Mr. Griffiths, the kindly local registrar of deaths and marriages, has begun to notice that no one is dying. His observation is confirmed at the pub by a registrar from a neighboring area, and slowly the realization spreads that people throughout the south of England, including London, are not dying. This forces a consideration of the need for death, and brings on unrest and a religious revival when people realize that matters such as the availability of work and food, economic stability, pension plans, and so on depend upon the orderly progress of generations.

Iris's argument is strained. She adopts an unaccustomed seriousness toward religion and then, as quickly, casts her conclusion in equivocally humanistic terms. The absence of death brings an increase in suicides and murders, "an epidemic of throat cuttings with safety-razor blades purloined or secreted, of Lysol drunk and poison pilfered," which she relates with unflinching grimness. Tuberculosis and cancer sufferers and "hopelessly mutilated war-wrecks hidden away in county hospitals" fling themselves out of windows. Of a maimed man who crawled out on a sill she says, "it must have taken him a good hour."

Suffering nevertheless brings about a renewed appreciation of the goodness of creation and the realization that death is the door to an afterlife with loved ones. "Give us back the gift of death," the local vicar prays. In the end the registrar surmises that the world is "good; not of itself, but made so by some power, were it the mind of man or the will of God he did not care."

Perhaps most curious about this book is the way the story resolves itself. After experiencing the frightful inconveniences of immortality, the return of death is signaled by, of all things, a skywriting airplane announcing a first decease. The departed, it turns out, is the likable but illegitimate offspring of a liaison between the village doctor and the local midwife. The child becomes a martyr to the cause of death and proof that all can be well if only people continue dying.

Here Is Thy Victory, strange as it is, may have been somewhat cathartic for Iris at the time. She was in her mid-thirties, married to a poet with uncertain prospects, having suffered through a torrid relationship with an unstable man with whom she bore two children, and struggling to find her footing as a novelist. At this time she conceived a story based on the fantasy that a woman, much like herself, after maturely setting her good-for-nothing boyfriend back to think about their relationship, could find happiness with him through the death of a child secretly born out of wedlock—a child martyred to the resumption of plague-like death and the possibility of the demise of a grandparent, which brings with it permission for the woman to marry.

Whatever this fantasy might signify, in reality things did not go well for Iris. As the date of publication for the novel neared, she lost her job at the *Mail*. Hoping to salvage something of the novel venture, Iris contacted Lewis for his support. On March 19, 1930, from her flat with Porter on Guilford Street, she wrote:

My dear Lewis,

I wish I knew certainly whether you were to be found directly at the address to which I sent this letter—it is rather a long time since you gave it to me.

I want to send you an advanced copy of a novel of mine which Elkin Mathews and Marrot are bringing out early in April: wondering if you would glance at it: and begging you if there was anything you could say in its favour, that you would say it. It would help me tremendously.

The publishers wish too, that they had a drawing or painting of me by somebody of the first water. Really, I feel it so difficult, and yet there cannot be much harm in my asking you if you would or could feel disposed to do anything about it—they tell me you

don't do drawings any longer, but this is harder to believe than that you would dislike doing one of me.

Frankly, I do want what help I can get. I've had the sack from the Daily Mail. *It's a good thing for my soul but damnably difficult, and if this novel could be done something about it would make a terrific difference. The indications are that it just might 'go'. If it did it would at once make my chance of making a living by writing what I can where I can get a great deal easier.*

And so I feel I can at least ask you. I've been at least negatively friendly on my side for a long time, which is what I think you would esteem most. Can you possibly feel like a positive friendly gesture on your side? It is a bitter world and why you should do anything to temper it for me I don't really know. But I ask.[3]

Lewis's reply must have included an address at which he could be reached, a "friendly gesture" for him given his past inaccessibility. Iris replied that "the novel is being sent today, now that I know it will reach you. Perhaps you'll ring me up if you feel you can do anything—a drawing would of course be the greatest help if you could consider it, and of course a paper that used it would pay for it, too. Anyway, do your best: as I said before I really need help."[4]

Lewis's response was surprisingly harsh:

Dear Barry,

I have received your further letter. The endearments that you think fit to employ I confess disgust me, and I cannot at all make out what causes you suddenly to indulge in them. The lapse of so many years may have effaced from your memory the fact, but it has not effaced it from mine, that my acquaintance with you was of a most unpleasant nature. Why then in heaven's name these epistles?

Your book is not, as you may guess, of any interest to me, and I am returning it to you.

Yours etc.
W. Lewis[5]

The letter carries the note, written in Lewis's crabbed scrawl, that it was "Sent, by registered post, with book on 11th April—W.L."

Possibly Lewis scanned the book and saw that it was unsupportable.[6] Lewis's irritable reply, however, only added to Iris's growing despair. She could not have known, however, that at this time Lewis was caught in a private drama of his own. Lewis's son by Olive Johnson, Peter, had been arrested for burglary and was facing trial. On February 18, 1930, at the age of 18, Peter "London," as

the boy gave his name to police, was caught with two others in a gasoline station break-in. He was denied bail because he refused to give his address to the police. His fingerprints were taken forcibly because he would not give them willingly. Lewis's biographer Paul O'Keefe relates that the fingerprints "were found to match those at scenes of over a dozen other recent burglaries" and that in Mrs. Prickett's coal shed (she still cared for the boy) were found "2 or 3 motorcycles, 2 or 3 pedal cycles, boxes of spare parts and accessories, many of them still in their wrappings, several gallons of petrol, a typewriter and a bunch of about 30 keys."[7]

Lewis, asked to "come forward" by the boy's mother, offered only to pay for his defense. He refused to guarantee the youngster shelter and, after seven weeks in the "Boy's Section" of Wormwood Scrubs, Peter Lewis was released in the custody of his stepfather, William Elstow, on the understanding that Lewis "would not have anything whatever to do with the matter of the boy's future, financially or otherwise."[8]

As Iris's friend Ivor Montagu later put it, "now came a down. Her marriage broke up. Alan continued to write her sad and beautiful love poems but was less perfect as an office wizard. And Iris too fell foul of her editor or owner. Separation from Alan, the sack from the *Mail.* All was to start anew. She went to America."[9]

The falling afoul of her editor involved a review Iris published in the *Daily Mail* critiquing *Knowing Men*, Eleanor Glyn's first and last British picture. This occurred, Iris recalled, while "another of the spasmotic attempts to give the ailing British film industry a shot of adrenaline was being made by government and press."[10] Her boss, Lord Rothermere, "had laid down a policy: British pictures were to be praised wherever possible and blame, if it must be meted out, was to be constructive and point to a rosy future."[11] Although Iris agreed with this "in theory, but not without some mental reservations," she found the Glyn film to have been made on what she called an "abysmally low level" and felt like crouching as she walked out in the middle of it. The day after her review was published she received a check for the balance of her unpaid contract, which had six months to run. As Iris put it, "No questions. No excuses. No job."[12]

Some months afterward Iris learned that Lord Rothermere had dined with Mme Glyn the night before the preview and had told her, "Dear Lady, rest assured the full power of my paper is at your disposal: you may be certain we shall do the right thing."[13]

Although the pan of the Glyn film was the proximate cause of Iris's dismissal, she no doubt disappointed her boss on the issue of British protectionism.

In contrast with her rival critic at the *Express*, G. A. Atkinson, who was stridently anti-American[14] unless he was paid by American producers to be the opposite, Iris took a more nuanced view of American influence. "It is true," as she put it, that "we are much more familiar with the American temperament and social habit because of the all-prevalent American films than we should be without it. But I am sure that we do not love or respect the Americans more on that account. To know is not necessarily to admire."[15] Iris's sensible view notwithstanding, she was out of a job and British protectionism prevailed. Since 1927 the British government had had in place a quota system regulating the ratio of imported films to home-grown product.

Iris again chose to join the enemy. She decided to move to America, Alan Porter in tow. Although their marriage was unstable it had not yet broken up. Before their departure Iris was treated to some medical care paid for by Sidney Bernstein and his mother. Iris wrote Sidney she thought that it was

> *kind of you, and kind of your Mother, to have me overhauled by Dr. Young. Do let me say how very, very sincerely I appreciate your thought and consideration.*
>
> *You will be glad to hear he says there is nothing 'wrong' with me, only a few feeble bugs in the interior parts such as most people have, which probably arose originally first from bad wisdom teeth now extracted, and give rise to weariness and 'that tired feeling.' Otherwise it is smoking too much and darting about too rapidly only. So I have to reform.*
>
> *It isn't as though I weren't sufficiently in your debt already: no one could have been so kind, though you must sometimes think I show my gratitude very badly. But you know Alan and I are very attached to you: and I haven't changed in any way from my past fondness for you. So don't think it. I may cut up rough but its only on the surface.*[16]

At the same time Iris was packing to leave the country, on October 9, 1930, Wyndham Lewis married Gladys Hoskins, a woman he had known for as long as he had known Iris. She would remain with him until his death in 1957.

The haste of Iris's departure from England is evident in her note to Sidney Bernstein saying that although she had "not heard yet about how I can get across to America . . . I shall have to scrape up another 20 odd pounds and go anyhow. Go I clearly must."[17]

With thirty pounds borrowed from friends, Iris told Sidney she was "taking my boy down to Bognor [Bognor Regis, her mother's hometown] next week, trying to get him into Chichester High School which is only £15 a year and good; if not he goes to a private school in Bognor. I must leave him and my

mother at least £40. There are several people I haven't asked yet for money who will probably help . . . I suppose you could say I was making progress. The flat I still have to arrange about. . . .

"You said to tell you how things were and that's how they are. Don't scold me any more. I know fully well how much it is all my fault."[18]

Iris later recalled that she "arrived in New York City late in 1930, a ridiculously optimistic immigrant visitor who had just been severed rather violently from the then powerful London paper for which I had been correspondent for five years with the special mission of combating the influences of the all-pervasive American film which was supposed to be corrupting our youth, speech, morals, and concurrently to succor and support the then frightfully struggling British film—almost moribund in 1925."[19]

She landed in New York with few resources other than a unique resume. In addition to her poetry, a biography, a novel, and a major book on film, Iris had produced over forty articles for the *Spectator* and over sixty columns for the *Daily Mail*. Nearly all the magazine and newspaper articles addressed film or topics related to film, including five essays for British *Vogue*, in which she promoted film as a cultural asset for the modern woman.[20] Despite these accomplishments in her home country, Iris could not have known that within the next decade she would become the architect of an organization that would place America at the center of film art exhibition and preservation.

13

AMERICA

SOON AFTER HER arrival in New York in 1930, Iris looked back and worried about the disarray she had left behind. Again, she turned to Sidney Bernstein. "I am forced to have recourse to you because I don't know what else to do," she wrote him on September 16, "I am awfully worried about Guilford Street. You know I thought I had arranged everything beautifully, [I] sold some things to people and left everything to Olga [a friend, Olga Cooke] to dispatch. She knew just where everything was to go, she had a little money for sending them off, and herself had offered to sell what remained for the best she could get."

With no word from Olga, Iris asked Sidney to check on her apartment, which "passes into other hands on the 29th of September, hence my haste now," and do what he could to "prevent all the things from being thrown into the street." She worried that "maybe someone stepped in and seized what was left for a debt . . . but they can't do that because Alan is technically responsible for my debts and all the things at the flat were my own and my mother's. Oh dear!" There followed a list of the contents of the Guilford Street flat and a request that Sidney not reveal her New York address, for fear that "there are one or two summonses in the offing and all that."[1]

Summonses did follow. Iris wrote Sidney that she had "just had a nasty letter from the bank who tell me they have been after you too . . . damn them. You know the *Woman's Journal* decided to get rid of me when they heard I was over here: they cut off the ten pounds a month which would, otherwise, have paid off that bloody overdraft already. Alas there is still fifty-seven pounds owing. I am sorry they have been at you: they insist it must be paid off by Feb 12th and it looks to me there is little hope of that happening. When I deliver the etiquette book to Elkin Matthews there will be another thirty pounds less 10%

commission to go towards it . . . but as it is not payable until final proofs are corrected and returned I doubt if that will be in time for Feb 12th. My novel didn't produce anything at all. I had the statement the other day. It sold nearly three thousand copies but there is no money for me out of it.

"I am applying for a job on the *World* here which I certainly shan't get. . . . I'm also rewriting a novel for a Chicago society woman for which I shall get three hundred dollars: half of that I shall have to send to my mother again (I did pay her Christmas allowance all right out of the translation I did) and the other half I shall positively need unless something strange happens.

"You may wonder how we live or if we live why we can't pay you: you know I got a little furniture, the last installment on which I hope to be able to pay when it is due end of this month, as I am doing some reviewing for the *Herald Tribune.* The rent is sixty dollars a month, which we have just managed to pay, out of Alan's customers. We eat all our meals in, and I do the housework and most of the washing. We generally have from three to fifteen dollars in our possession. Once we had forty-five cents. You see, it is not very possible to pay off debts then. As for the extravagances like having one's hair washed or clothes cleaned, I know them no longer."[2]

In desperation Iris begged Sidney to send her a letter of introduction to the movie mogul Walter Wanger, telling him "how important I am, how brilliant, how many books I've written – and let me meet him. I don't expect any results but it's going to be a long row to hoe and I need all the connections I can get."[3]

Iris's first five years in New York, before the founding of the Film Library of the Museum of Modern Art in 1935, were desperate, hand-to-mouth years. Burdened by debts left behind, the obligation to send money to her mother and son, fitful income from freelance work, and a husband she viewed as lethargic and unconcerned about money, Iris scrambled as best she could and wondered if she had done the right thing by leaving England. "My dear," she wrote Sidney, "what can I do? I do all the work I can get, and it just keeps my mother and that absurd boy and myself alive." She had expected that "in this land of plenty I'd pay off all my debts in a year," but was coming to the conclusion that "it's going to be more like two."[4]

Iris considered it "odd that two really, in a way, quite talented people like A. and me don't seem to do better. A. is so pathetic and so <u>good</u>. But you know he never knew how to make money. . . . At least I've found in a small way how to make myself work again. Every day I think I'll find the secret for A. too."[5]

Of her friends back in England, Iris told Sidney she supposed "they all think I am dead, or feel it might be an advantage if I were. But just wait and see if I am. After all I shall certainly live to be sixty: so I have another life in front of me yet. And something tells me even yet that I shall die solvent.

"What am I writing about? Dreams, my sweet. A book on dreams. Having finished the idiotic novel about love in the arctic for the lady in Chicago, I write about dreams. And Ezra Pound. That's something else.

"What do I do? Go to the pictures when taken, eat out when invited, type a great deal, talk when I can find anyone to talk to, ride on the elevated railway, read the newspapers . . . and perhaps wish I were in England."[6]

By February 1931 Iris was able to write Sidney that she and Alan "have both managed to get a hold on the edge of things here, are both reviewing for two decent papers, being 'heard of' and suddenly becoming in a very humble way solvent." She thanked him "enormously for putting the bank and the overdraft right" and promised that "little by little" her debts in England would "vanish away to naught."[7] During this time Alan Porter also lectured on sociology and psychology at the New School for Social Research, substituted as a lecturer in psychology for Dr. Alfred Adler at Columbia University, edited Adler's *What Life Should Mean to You* and two books by Dr. Olga Knopf, *The Art of Being a Woman* and *Women on Their Own*.[8]

With their new solvency, she reported to Sidney, "I grow to like it here very much. We find a nice lot of decent, serious people: simple and interested in their jobs. The better business people and the less arty and smart writers and artists are really excellent—far better than one judges the town to hold at first glance. And there are so many odd things that it is homely and not like home. Strawberries heaped in the windows just now, for instance."[9]

Aside from the erratic flow of cash from writing and teaching, Alan Porter's psychological counseling work provided the closest to a steady income the couple knew. Iris told Sidney that Alan, whose writing efforts she thought list-less, nonetheless had "a patient who comes three times a week and pays our rent. He might stop coming of course. He's rather impotent apparently. If he cheers up and does the deed then I suppose he won't come. He is alarmingly better already. Then there is the group of people with small troubles who come on Wednesday nights, who pay very little. Then there is the clinic, which doesn't pay at all but seems a good thing to do. Of course in the autumn we trust it will be better. Everyone goes away so much here in the summer, even the so-called working classes. No shops or offices are open on Saturday at all

in the summer, for instance. Rich patients are out of the question, while we live where we do.

"The curious thing here, which nobody seems to know so it might interest you, is that while there is this 'depression,' actually the rich people are much richer than ever they were and there are lots of new rich. The middle classes and the poor are much poorer. But there are more luxury yachts and sailing boats and motor boats being built and sold than ever before. Dressmakers for the very rich are doing better than they ever have. Odd, isn't it? So I suppose it is getting more like England used to be. This aspect of things over here is never mentioned in the press, of course."[10]

Iris's reports to the public back in England were more optimistic. Assuming a role later taken on by Alistair Cooke and his "Letter from America" radio series for the BBC, in a 1931 article titled "New York Housekeeping" for the *Spectator*, she described life for women in the city:

> This metropolis might be an idle woman's paradise: she could recline forever on a daybed with the telephone by her side. Even if, long after dinner, she decided to give a midnight supper-party, she need only ring up the nearest of twenty delicatessen shops in her immediate neighborhood, and her bootlegger. Within half an hour, a cheerful youth will arrive from the former with mineral water, salads of every sort, cold meats, tinned soups, bread and butter. From the other purveyor (who apparently never sleeps) will come a somewhat graver messenger with bottles.
>
> Nor need she move after her guests arrive, since in the often servant-less and always labour-saving American home, the kitchen is no forbidden fortress. It is a glittering, white Tom Tiddler's ground where many parties begin, almost all end. A hostess may well resign herself to guests making their own sandwiches and mixing their own drinks. Moreover, it is the custom here for men, not women, to do the waiting, fetching and carrying. They seem to like it—as who might not, where one machine squeezes the oranges, another throws out its own toast when duly brown, and almost the only hard work is agitating the cocktail shaker?

Iris seemed particularly fascinated by the convenience of the telephone, which seemed to her to "rule all." It amused her that "suave gentlemen call up out of the blue and fascinate you—momentarily—into decisions to purchase electric refrigerators, or have your photograph taken. The merest dialing and

medicine is sent, an air-trip to Mexico arranged or dry cleaning fetched – not when the tradesman wishes it, but when the housewife does."

Iris marveled at sea creatures called blue fish and found "exotic charm in buying squashes, Swiss chard, or being offered buttermilk (a popular beverage) or turtle fins. As summer comes, the variety of fruits and vegetables is overwhelming. There are more kinds of melon than are seemly—from cantaloupe for a few pence, and honeydew with its pale skin and melting green flesh, to the humble water-melons like high explosives painted deep green. Peaches and pineapples are no luxury, though less good than our hothouse kind. Cucumbers are thick, short and full of large, woody seeds; tomatoes lack flavour. Fresh sweet corn, sweet potatoes and the little Concord grapes that taste like raisins make up for that."

American women seemed to Iris to be liberated by domestic technology enabling them to "have interests outside their own horizon which do not cease after marriage—as too often in England—and far from old age having any terrors for them, after sixty they are at their most active, bright and endearing." Indeed, she seemed to have found freedom from the British society she had grown tired of. "Everyone here is, indeed, your equal," she reported, and "servility is unknown." Although skilled workmen may be hard to find and may be indifferent to one's complaints, Iris was nonetheless moved to "ask myself how, when I come home again, I shall bear our chilly bedrooms in winter." She was content to remain in her new home, where her "American friends . . . do not value their friendships or regulate their likes and dislikes the slightest degree in terms of dollars."[11]

In the more liberated atmosphere of New York, Iris also went in for spectator sports. Addressing a topic that must have seemed outré among the magazine's female contributors, she reported enthusiastically about the American style of wrestling to *Spectator* readers. "Though the news-reels sometimes show us a glimpse of American wrestlers at grips," she reported,

> I had no idea until I arrived in New York how popular a sport wrestling had become in the States. The general belief here seems to be that boxing is seldom 'on the level.' There are rumours of this and that boxer being 'run' by gunmen. At any rate, the sport-loving public is tending to desert the 'ring' for the 'mat.' Thirty-five thousand people tried to get into Madison Square Garden one spring night to see Londos, the world champion, meet ex-footballer McMillen. Most of the 22,000 who succeeded were plainly well-informed

amateurs of the sport. 'That hoits the noives here, see?' a man on my left kept demonstrating to a friend. The excitement was so intense that we really needed the iced orangeade or coca-cola in paper cups and the hot dogs, which white-coated attendants sold briskly during the intervals.

As a spectacle, a wrestling bout seems to me more satisfactory than boxing. For one thing, there are no pauses. The contestants fight to a finish or for a set period, without gongs or seconds. Even the uninitiated can follow what is happening. That night every bout, including the big event of the evening, which lasted fifty-seven minutes, went to a finish. No holds were barred; I had a rare opportunity, for a novice, of seeing not only what it really means to 'put the half-nelson' on a man but of seeing a full-nelson, too, and no lack of head-locks, flying mares, scissors and toe holds. The men are magnificent creatures, each fleeting pose is sculpturally beautiful, and though there are those who condemn wrestling as brutal it struck me as strangely satisfying to see skill overcome brute force, as we did twice that evening.

Iris particularly enjoyed a bout that lasted only three minutes.

Steinborn, one of the strong men in the world and a professional weightlifter (described in the programme as 'the German Hercules') met a lithe Hungarian called Szabo, 'the Adonis of the Mat.' Adonis, with his patent-leather hair and slender legs in ankle-long red tights, looked like something Hercules could sling over one shoulder. Hercules did so, several times, slamming him to the floor with a noise as though someone had hit an empty barrel with a wooden mallet. Quick as an eel, Adonis rose each time. After a twist or two and a fall, he had a scissors on Hercules' head. The idea is that you get your legs on either side of your opponent's face, cross your ankles and treat the head like a nut between crackers. Hercules got out of this, but, when he was on his feet again, Adonis took him by the neck and heaved him (an apparently immovable body) to the ground with a noise like ten mallets hitting ten tubs. Each time Hercules rose, Adonis threw him again, once with a 'flying mare,' until the last time found Hercules on his back, two shoulders flat on the ground for the requisite three seconds. Adonis rose and took his bow, the winner."[12]

Although there were amusing outings such as this, Iris's first years in New York were trying. Toward the end of 1931 she found herself in Canada, her temporary visa to the United States expired, and Alan not at her side. Iris turned to Lewis:

My dear Lewis,

I wonder if after all this time I might ask something of you? I wouldn't unless it were really quite desperate.

Here I am, of necessity temporarily exiled in Canada, as my temporary visa to the United States expired and so I have to sit here and await the good graces of the US consul to let me back, which I trust will be some time next week. I hadn't the fare back to England, so this seemed the only thing.

I feel great hesitation about venturing to write to you—please understand. What I wondered was whether you could possibly scrape up a few pounds and send them to my mother. It took every penny I had in the world to come here and I can't see how I can get more in time to give her what she needs by the end of November. You know how it is, trying to live by one's wits or a pen. I've just kept going and sent her what she needs since I came over here fifteen months ago, but this trip, though imperative, has just queered everything.

Of course I know I've no claim on you at all—but I thought maybe if you happened to be able to put your hands on ten pounds you might just this once help me over a rather bad patch. It is only half what she has to have, but I think I can scrape the rest together. The whole of it I know I can't at this time, and she is quite destitute save for what I send her.

Naturally, you may not be able to do anything. I only ask you if by any means you possibly can, to do me this very great charity at the moment when circumstances make it for the moment impossible to go on managing. You perhaps know I lost my job on that newspaper. Coming over here at all was a mistake and I am still being badgered about an overdraft I raised to get here . . . but here I am, sort of swimming back.

If I make my plea so simply, it is perhaps because I hope that now, at this late date, I may have earned your confidence. I don't know. I hope so.

There is no need to reply to my letter but if you cared to I should be very happy indeed. It would be best to write to me c/o Curtis Brown Ltd., 130 West 42nd Street, New York as I don't know where I may be living when I return—that is, if you should feel you wish to. But please do not write to me angrily.

Help me, please, if it is in your power. I really do need it. I would ask you to send me what you could direct, but there is not time for an exchange of letters if my mother is to be kept going in time. I hate having to worry you, but I am truly in difficulties.

My mother's address is: Mrs. Crump, "Up Top", York Road, Bognor Regis, Sussex, England. There would be no need to say who the money was from: if you could send her some and prefer not to make it known from where it comes, just put in a typed note, asking her to acknowledge it to me.

With many, many regrets of many kinds, but very sincerely,

Iris Barry[13]

There is no record of a reply. Ironically, Iris's call for help was sent from Canada, the scene of Lewis's later exile. Iris had no choice but to continue struggling for survival in her new environment. Her efforts eventually led her to the center of the emerging modernist movement.

14

THE ASKEW SALON

A FTER STINTS AT ghostwriting and freelancing and her brief sojourn in Canada, Iris escaped to California to stay in the garage apartment of her British friends, Charles Laughton and Elsa Lanchester. Iris hoped she might find work in the film industry. Laughton biographer Charles Higham wrote that Iris helped make Elsa Lanchester "feel a little more comfortable in Hollywood," and to Elsa "she was a pleasant companion and a fine conversationalist. Elsa at least felt she had someone to talk and walk with; they would stroll down Hollywood Boulevard, Elsa taking photographs."[1] As for job prospects, this "hegira to Hollywood," as Iris later termed it, was "foredoomed to failure. . . . The royal preserves were no longer abounding in game. Producers were down to their last cloth-of-gold crying towels and for the most part avoided Diana like so many startled rabbits. After a few months given over to tenuous promises and elaborate runarounds," Iris took stock of her situation, concluded she needed a change, and headed back East.[2]

Iris later recalled, "[I] lost my one hat on the train—almost my last earthly possession. Somehow that decided me: I said to hell with all this false pride and I went to a friend who was in a position to be helpful [the architect Philip Johnson]. Right off I told him, 'I haven't got a cent and I haven't any prospect of earning one. Also I haven't a hat and I'm going to a cocktail party. Lend me a thousand dollars. God knows if you'll ever see it again.' He sat down and wrote a check, just like that. Right then I knew that things were going to be different. . . . At the party that night I met Alfred Barr, which was what should have happened when I came to the States."[3]

Johnson recalled taking an instant liking to Iris. He thought her witty and conversational and felt she might do well in the circles he frequented, including the Askew salon. The connection with Museum of Modern Art director Alfred Barr came through the Askews. Kirk Askew was a Harvard graduate

who worked for the New York office of Durlacher Brothers, a major European art dealership. His wife Constance was much admired as a hostess and became Iris's lifelong friend. The Askew salon comprised a petrie dish of modernism, in which movers and doers in all the arts met to exchange ideas. In his *Memoir of an Art Gallery*, art dealer Julien Levy recalls that "the best and most culturally fertile salon I was to know in the thirties grew from little Sunday gatherings at Kirk and Constance Askew's, where many of my Harvard and New York friends gathered. Kirk's system of invisible manipulation kept the evening both sparkling and under control [and] combined the hidden rigidity of as carefully combed a guest list as any straight and proper social arbiter might arrange, with the frothy addition of the uninhibited of Upper Bohemia, plus, one at a time, to avoid jealousy and sulks, a single real lion. Two were asked together only if they expressed a desire to meet or already knew and liked each other and admired each other's work. There developed and was maintained a colorful variety of conversations, many fruitful contacts, some light flirting, some sex, and a little matchmaking, with an occasional feud for spice. A small group of regulars came every week and provided the dependably witty core of the parties, so that on rainy or otherwise off nights there still would be no risk of boredom.

"By the time we arrived each Sunday, perhaps Henry-Russell Hitchcock, an impressive authority on architecture and my old Harvard tutor, would be in town for the weekend, and ensconced behind a demitasse and a snifter of brandy, sipping from each and talking in measured, uninterrupted, and interminable tones to Agnes Rindge, who, down from Vassar where she taught art history, would be a patient listener until Allen Porter arrived [not to be confused with Iris's husband, this Allen Porter was Levy's gallery assistant and later joined the administration of the Museum of Modern Art]. She would leave Russell abruptly to chatter with Allen. By that time Russell might not even notice, for there were enough new arrivals to form a shifting audience for him the rest of the evening.

"In another corner of the drawing room would be [the writer] Esther Murphy, another indefatigable monologist, knowledgeably opinionating on current politics. If [composer] Virgil Thomson was there, and he was more often than not, he would need the third corner, as he too liked to preempt an audience. The fourth corner belonged to Constance Askew. There she, at least early in the evening, could receive. Since there were but four corners, the rest of us would circulate. Near Constance would be guests who had come earlier to dinner, always one or two couples besides the out-of-towners: Russell, Agnes, and occasionally Chick Austin [director of Hartford's Wadsworth Atheneum], who

would be staying the weekend. The dinner guests were alternately young New England couples of old family, museum curators, or critics. Not the newspaper critics; these were considered rather too lowbrow for the Askew Sundays, Henry McBride of the *Sun* excepted. Such authors of books of criticism as Richard Offner, Erwin Panofsky, or Etienne Gilson (who were really more aestheticians than critics, or as Kirk would most properly call them, 'art historians'), would be in attendance.

"The Barrs came often in those days. Liela Wittler of Knoedler's would turn up, so would Nellie and Adam Paff, Kirk's partner in the American branch of Durlacher Brothers. There were also [actress] Fania and Carl Van Vechten, the elegant author; [composer] Max Ewing; lively and convivial [photographer] Tom Howard; Philip Johnson and his sister Theodate; and Amanda and Gilbert Seldes [the writer]. Muriel Draper, mother of the dancer Paul, might appear with [dance impresario] Lincoln Kirstein in tow. Muriel had her own salon, too. Lorna Linsly (who in the world was she?) was always there. Composer Paul Bowles and his wife Janie with one or another of the 'serious ladies' about whom she was to write in her rather strange and interesting book, *Two Serious Ladies*. The Stettheimer sisters sometimes appeared: Carrie, Ettie and Florine, the painter who was Duchamp's special friend. These and many others came in and out with a dependable regularity that gave one a sense of belonging to an entertaining inside group."[4]

Although many members of the Askew salon were homosexual, the rules of conduct of the period discouraged overt activity. As Steven Watson, author of *Strange Bedfellows*, a study of the sexuality of modernist culture put it, "once a man made a pass at another man, the butler brought him his coat. The rule was, *we do not camp in public*."[5]

A second salon Iris sometimes attended, hosted by Muriel Draper, took on a more political tone and had rules of conduct more permissive than the Askews. Muriel Draper had entertained artists in a London salon between 1911 and 1915,[6] and since her return to New York carried on a successful interior design business among the well-to-do. Her leftist leanings later got her into trouble with the House Committee on Un-American Activities (HUAC). Despite her association with left-wing organizations in the 1930s, however, she was apparently not a Communist Party member. Esther Murphy, Paul and Jane Bowles, and others in the Draper salon flirted with communism, but political or, for that matter, sexual orientation, made no difference at the Drapers.[7] Virgil Thomson, a frequenter of both salons, referred to the group as "the Little People," since many there, like Thomson himself, were of short stature.[8]

Of the two salons, even the Bowleses preferred the Askews'. Paul Bowles' biographer, Gena Dagel Caponi, noted that "despite living separately, Jane and Paul were very much a couple when they socialized. They regularly attended gatherings at the [Askews], who held what Paul called 'the only regular salon in New York worthy of the name.' There Paul played the piano and sang his own songs, while Jane visited, sitting first on one man's lap and then in another's. Composers Virgil Thomson, Aaron Copland, Elliot Carter, and Marc Blitzstein could be counted on to be there, as could Lincoln Kirstein and George Balanchine and their dancers. Several connected with the Museum of Modern Art attended. . . . Poet E. E. Cummings and John Houseman were often there as well. As Europe headed towards war, artists immigrated to New York and to the Askew salon. Among them were surrealists—Marcel Duchamp, Yves Tanguy, and Salvador Dali—who dominated the intellectual tone of the Askew salon from 1940 on; Paul felt at home with them, but Jane did not."[9]

At the Askews Iris sized up Alfred Barr as "a kindred soul . . . a youngish Wellesley College art professor who was a simple, direct Harvard aesthete whose wanderings about the museums of Europe and the salons of Paris had led him to envision the Museum of Modern Art. If he was a visionary, he was so in the best sense of being an intensely practical one." Possessed of influential friends, Barr "could think on his feet with the best of them and was, to boot, an elegant parlor orator, attributes which beautifully accompanied his deep and abiding sincerity."[10]

Iris found that she and Barr "entertained a similar outlook on the motion picture as falling within the Museum's proper scope of activity." She promoted herself to Barr as the one to develop a film component of the Museum. "No time was lost in pointing out to him that the only noteworthy attempt to make the motion picture known as a living art rather than ephemeral entertainment had come from the Film Society in London," which had been handicapped "by the lack of any central repository from which important films of the past could be booked at will. The inference was plain; the Museum, by its avowed purpose and very nature as an institution for the study of contemporary art, should logically become that central repository.

"With this thesis Barr had no fault to find, but he regretfully elaborated his predicament: the financial set-up was simply insufficient to adequately support even the painting, sculpture and architectural departments of the Museum, much less found new ones at the present time. Indeed, the miracle was they had actually been able to get as far as they had, nor would they have in all likelihood had not the majority of sponsors made their grants prior to the great market

crash. For example, at that very moment a librarian was desperately needed, yet there were no funds for the salary." Iris jumped at the job. Adjusting her new hat, "a fetching trifle from Hattie Carnegie's," she told Barr she had been a librarian at London's School of Oriental Studies, working with Arthur Waley, and would gladly take the job without pay. This provided her with "a toe inside the door" of the Museum. Among the chores she was charged with was the publication of the Museum's monthly bulletin, in which she "inaugurated a policy of including thumbnail reviews of current films."[11]

Iris became a favorite of the Askews. She wrote Sidney Bernstein that she had "been in and out of their house like an iceman these many moons" and esteemed them as "the sort of people who make America worth living in."[12] It isn't clear exactly how Iris made her way into the Askew salon. One scenario has it that she carried a letter of introduction from the Laughtons. Museum of Modern Art historian Russell Lynes, who credits the Laughtons with stirring Iris into the "artistic compote" of the Askew salon, says that Iris met Philip Johnson "at a cocktail party at Joseph Brewer's" and that Johnson, impressed with Iris's "wit, agility and knowledge . . . told her she simply had to work at the Museum, that he would pay her salary and she would be the Librarian."[13]

Reflecting on these events some years later, Johnson recalled that he "first met Iris Barry at one of the salons at the Askews [or possibly Joseph Brewer's] in 1930. We at once felt a friendship. I realized that she was hungry, so I gave her some food and bought her a dress. We went to Saks and bought one of the most unattractive dresses imaginable, but she had nothing to wear. She said she was in films and needed a job, any job. I asked Alfred Barr if there were any jobs at the Museum. He said, 'No, but we are trying to found a library.' So she was made the librarian. She knew nothing about libraries, so she was sent to library school at Columbia, which she hated. I paid her living for a while. She sat in the penthouse of the house at 11 West 53rd Street. I gave my library of architecture books."[14] It would be some time, however, before a film library would emerge from the book library of the Museum of Modern Art.

The most likely scenario linking Iris and the Askews might be that, as Russell Lynes put it, she met Philip Johnson at a party at Joseph Brewer's and was later ushered by Johnson into the Askew salon. Iris and Alan Porter had camped out at Brewer's East 48th Street apartment during their first year in New York in 1930.[15] Joseph Brewer was a classmate of John Strachey's at Oxford and had been with him both on the *Oxford Fortnightly Review* and in Paris in 1922.[16] Strachey, who was responsible for giving Iris her job at the *Spectator*, had visited the United States in 1928, encouraged by his mother to meet people

who would divert him from his socialist friends in England and from marrying a vicar's daughter she disapproved of. In America, Strachey was diverted briefly into marrying Esther Murphy, the Irish-American Catholic daughter of the owner of the Mark Cross leather goods fortune, Patrick Murphy. Esther's brother, Gerald, is now regarded as a precursor of pop painters such as Andy Warhol and provided F. Scott Fitzgerald with the model for the character of Dick Diver in *Tender Is the Night*.[17] Herself a lively member of the New York and London bohemian set, Esther was known as a nonstop talker, heavy drinker, and out-of-the-closet lesbian. "She was for years working on a life of Madame de Maintenon," historian Hugh Thomas noted, "but her mind was quite undisciplined."[18] Esther and Iris became friends, and it is likely that at Brewer's in 1931 Iris met Esther along with Philip Johnson, both of whom were regulars at the Askews.

At the same time Iris became a guest at the Askews, and before she began working at MoMA, she became involved in a move to clone the London Film Society in New York. Iris's brief foray into the nascent New York Film Society also came through the Askews. Julien Levy led an attempt to develop a nonprofit film organization out of his for-profit art gallery. The reasons behind the venture—to show films which were "too avant-garde for the public or too censorable" or to import films from Europe without paying duty since their showing would be not-for-profit—repeated the ambitions of the London founders.[19] But the New Yorkers were a less cohesive group than the British. Among their number were the writer and journalist Raul de Roussy de Sales and the crusading lawyer, Morris Ernst, who was interested in the anticensorship aspects of the society. Levy recalled that

> the original promoter of the group, [writer] Critchel Remington, knew Raoul and brought the matter up in the course of an accidental conversation, and Raoul sent him on to me. . . .
>
> We were originally eight directors and conducted our meetings with all the ritual of parliamentary law. Weekly, then almost daily as difficulties accumulated, we met, usually at my house. Joella [Levy's wife] threw green baize over the dining room table, and as chairman I held the gavel. The walls of the room were deep red. An elaborate brass chandelier overhung the table, on which were stacks of pencils, a box of cigarettes, and ashtrays at each place. The ceremonial niceties only appeared as so much nonsense when the thread of accomplishment was lost, then broken, in a tangle of discussion, when each man seemed to use his privilege to ask recognition from the chair only to call

attention to himself and his persuasive, or rather, I should say, self-persuasive, words. One, Harry Allan Potomkin, very vehemently urged that we show Communist films, and Communist films only. In this he was seconded by a fellow who had come uninvited to the meeting, who claimed some connection with the importation of Russian films. Later he proved unable to secure a single one for us. One director prepared endless lists of films he personally had enjoyed during the course of his life, on the theory that, being of average intelligence, he was a good guinea pig for an average audience. At moments of most acrid debate, the tallest director, Dwight Macdonald, would stand and clear his throat. He stammered earnestly and cleared his throat often but up to the day he collapsed in frustration and resigned, we never discovered what he wished to propose. Several available films were considered and rejected, and one unavailable film was unanimously approved.

Meanwhile we had no theater, and no films, but we did have some money and an audience. While the directors argued, Joella and Reine, Raoul's wife, pursued the social efforts of a membership drive, and my secretary at the gallery, Allen Porter, designed and ordered announcements. So, unofficially, this much had been accomplished; in fact the date scheduled for the first performance was almost upon us. Raoul commenced a strenuous course of diplomacy.

"In a miniature way this is only another example of the advantages of dictatorship, if you must act, and have not infinite leisure for parliamentary law," said Raoul. "Almost all the members have been enlisted from our personal friends, yours and mine and Joella's and Reine's and Allen's. I feel more responsibility toward them than toward these impractical, pigheaded, argumentative directors. We at least have a film in mind that we think is interesting and that we know is available. But I will make one more effort to persuade each director separately that this film is his own bright particular suggestion."

The film was George Pabst's *Opera de quatr' sous*, and this was the film we finally presented, but not before additional conflict. The little Communist director was not for a minute to be fooled by Raoul's diplomatic tact. He organized an opposing bloc. He mentioned that by corporate law we could not override the directors' deadlock without risking criminal procedure. Raoul's face is sardonic at best, but now his eyes gleamed. He delivered an angry review of his activities toward establishing the film society, said that he would not think of overriding a vote, but that if an opposition director did not resign, he himself would, and take with him whatever members he originally

had enlisted. As Remington and I joined Raoul, our following embraced all the paid membership. The tall director cleared his throat and sourly resigned, so did two others. We replaced them with our own candidates: Iris Barry, who had managed the London Film Society; [architect] Louis Simon; and [dance critic] Lincoln Kirstein. But our troubles were not over.

We were officers now of a little schooner and, having caulked a leak, and overcome mutiny, were soon to find ourselves scuttled by a Leviathan. I never did quite fathom the nature of the forces frustrating us. Instead of cooperation from the Museum of Modern Art, Lincoln was censured by that institution because of his association with us. We were rivals then? I had not so imagined. This was only the first of many indications that we were out of our depth. Was navigating in the waters of the film industry dangerous for even so peaceable and small a craft? On we sailed. . . .

If our initial performance succeeded, we thought we could be sure of an established advantage. A brilliant audience filled the large hall, but something was amiss. Joella pressed my hand. Friends were greeting me. The moment came when I concluded a short speech to our supporters, and indicated that the lights should be lowered and the film begin. There was confusion at the back of the hall, and I spoke additional words to fill the interval. The projector exploded. It was repaired. A fuse blew. The hastily repaired projector was inadequate. The image wavered, the film broke three times, and a fuse blew again. Joella could not stay to watch. She was sick in the washroom and went home with Reine de Roussy de Sales. Half the audience had left when we finally overcame the major difficulties and staggered through the program. But of course we never recovered our lost prestige. We completed our promised schedule and then quietly collapsed.[20]

Iris came late to the New York Film Society effort and she probably lacked enthusiasm for the idea. She knew Alfred Barr had plans for a film component at the new museum, and her fellow Askew salon companion Lincoln Kirstein was receiving instructions from the museum not to cooperate. Iris may well have judged her future to lie with the museum and decided to moderate her support. In any event the effort did not succeed and she endured the lifelong contempt of another Film Society director, critic James Agee.

Iris's ascent within modernist circles coincided with the further decline of her marriage to Alan Porter. Porter had taken a teaching position in English at Vassar College up the Hudson at Poughkeepsie. In the spring of 1933, Iris wrote Sidney Bernstein:

As you know I toil daily, which is so, so good for me that I am almost myself again, at this place the Museum of Modern Art which isn't really a museum at all but a place for showing things in and getting people excited, which I must admit they do. Formerly it was modern architecture, or one thing and another, just now it is a largish exhibition of Mayan and Aztec stuff collected from all over and very very handsome and nice. People like Matisse and Aldous Huxley come in and go wild about it. I up in my little nest in the penthouse don't see much activity but am very busy making a library on modern art out of thin air, which seems to work rather well. Odd how misfortunes often turn to blessings later, like knowing about films because Lewis was jealous and poked me into cinemas when he went out, and I suppose I partly owe this to him too, or maybe it is Ezra Pound, no matter. Anyway I do extremely like the job. . . .

Alan has been away all the winter and spring. I have hardly seen him. He is very happy indeed at Vassar, teaching the young ladies, and they seem to like him very much though I hear now I've got to tell him to try and have something done about his deafness. If it's fixed up I guess he can stay at Vassar for the rest of his life if he likes, which seems to suit him perfectly. He reads in the library and plays bridge with professors when he is not actually teaching, and also has been lecturing in New York every week very ably if not very profitably, but then of course he doesn't want money.

I suppose you will be sorry to hear, or not, I don't know—but anyway we seem to have drifted rather completely apart. I mean we don't get on badly now as we used to, we just don't see each other really, and haven't anything to say when we do except I feel rather nervous and inclined to depart.

Alan more or less suggested we separate with a definite view to divorce, as he thinks he might marry again (I don't know if he has anything definite in mind) or at least doesn't want to have affairs with people unless he can marry them, which sounds a bit complex. However, I don't just see what we can do about divorce. I would gladly go to Reno, which I imagine is delightful for six weeks, but I doubt if that would please him, as I don't think then a re-marriage is legal in English eyes. We shall probably talk it over this summer, but I have gone very American and am not at all going to do anything about it myself—as I was prepared to before—and he will have to pay for it all, so god knows when that will be. However, here I am single as ever. I think I was never really married: but what a silly thing to do, to marry; it is too difficult to undo. The Russians are right.[21]

Alan Porter became a popular teacher at Vassar. He was sought after by aspiring writers for his astute and empathetic criticism of their work. He contributed verse to the *New Republic*, the *Nation*, and other periodicals and in 1935 completed an unfinished play by Ben Jonson, *The Sad Shepherd*. Occasionally he

made speeches for leftist organizations in Duchess County in which he offered an economic analysis of the causes of war. He remained unmarried and died of a long illness at the age of 43 in 1942.[22]

Possibly hoping he might accept her invitation, Iris suggested to Sidney Bernstein that he move to America with her. "I've just been for a weekend up in the mountains," she told him eagerly, "about an hour and a half by train up the Hudson or you can go by boat which is spectacular but slow. Sidney, America is really the place, I mean just for people. You go to the country or the week-end to the beach, and it is just people, there are no Lords who have preserved places."[23]

Bernstein was indulgent but unresponsive. It is clear Iris longed for Sidney and probably loved him. He, however, did not reciprocate and undoubtedly recognized that Iris would be difficult as a romantic partner.

Meanwhile, Iris cast her lot with the Museum. Although a small salary as Librarian began to replace the subsidy from Philip Johnson, she still scraped along. While attending Columbia University "twice a week to study library work," she wrote Sidney, an effort she described as "a vast bore but a bit of politics toward getting more salary,"[24] she labored in the penthouse at 11 West 53rd Street that was the first permanent home of the Museum. Between 1929 and 1931 the Museum had been housed in the Heckscher Building on the corner of Fifth Avenue and 57th Street. To escape the confining spaces of the single floor of the building it occupied, the Museum was moved to a brownstone abutting the back of the Rockefeller family home on West 54th Street, a building also owned by the Rockefellers. The family leased the building to the Museum's trustees for a fraction of the cost of renting the Heckscher Building.[25] This 11 West 53rd Street address persisted after the original brownstone was razed to make way for the new Museum building in 1939.

Iris decided she needed to live near the Museum. Her decision proved fateful. She took an apartment at 403 East 52nd Street underneath one occupied by a Wall Street broker named John Abbott. Also known as Dick, Abbott was a tall, handsome man fourteen years her junior from an established Delaware family. His neat appearance, slicked-back hair, and rimless glasses gave him an air of respectability, and when he confessed to Iris that he preferred art and films to stocks, the statement undoubtedly piqued her interest. She was, after all, on her own, if still married. The first thing she did with Dick Abbott was to borrow a painting from his apartment. "It really looks what they call 'darling,'" she wrote Bernstein of her new apartment, "especially as there's a 'real' painting by Eugene Berman over the sitting room fireplace which comes from upstairs but looks better in my room, lends tone no end."[26] Iris may also

have decided that Abbott might lend the kind of "tone" that fit in with the Museum. The two began to date, attending films and art openings until they became associated as a couple in social circles. Iris even took Abbott to the Askews, and he apparently went over well enough, although no one seems to have remembered him.

At the same time, without a secure job and possibly as a way of bringing together her past and present literary connections, Iris toyed with the idea of starting a literary magazine along the lines of the *Little Review*. Virgil Thomson offered to do a column on his life in Paris, focusing on the literary-artistic circle surrounding Gertrude Stein. Iris wrote to Ezra Pound, who had settled into Rapallo, Italy, seeking his involvement. Pound replied enthusiastically ("There hasn't been a real *Little Review* for 12 years," he exuded, "it is TIME my krrruist it IS time for a real monthly mag/") and offered to serve as her European editor in exchange for "5 bucks per two pages . . . IF given a free hand, or at any rate a section where I wdn't have stuff shoved in, that I cdnt. approve."[27]

Pound also sought from Iris a guarantee that she would run "the best seller I ever wrote," a manuscript entitled "Jefferson and/or Mussolini." He asked for a "definite section in which I have EXCLUSIVE right to nomination" of other contributors, reserving veto power for Iris "save in the case of the Jeff/Muss which is the basis of this agreement." As for other writers, Pound had qualified praise for the idea of using poetry from Eliot and Yeats, so long as one avoided their prose, and he claimed that he did not "know anyone but Bill Williams [writer William Carlos Williams] who can write a short story of INTEREST, I mean NOW 1933/34."[28]

Pound reserved his most virulent disapproval for Virgil Thomson, whom he called in his November letter "yr/ low limit and not a ROOF." Pound claimed that Thomson "was never admitted in Paris" in the twenties, and that "his view of anybody solid wd / be merely the real man AS SEEN FROM the terrace at the Cafe du Dome." He dismissed Thomson's connection to Gertrude Stein as superficial: "That Virgie was let into Gertie's means nothing more than that anybody who chooses to flatter that second Miss Lowell can be fairly welcome." Amy Lowell, in turn, he again dismissed as "that tub of guts Amy."[29]

Despite this garrulous welcome, or perhaps because of it, the new magazine was never published. Iris had no time. She had events to attend and was becoming more involved in the new museum.

During the spring of 1934, again through contacts made at the Askews, Iris attended the premier of Virgil Thomson's innovative operetta, *Four Saints in Three Acts*, at the Wadsworth Atheneum in Hartford. Thomson's work was

presented by his Askew salon associate, A. Everett "Chick" Austin, director of the Atheneum. Reporting to Bernstein that

I suppose the event of the season has been the production of an opera by Virgil Thompson to words by Gertrude Stein, with which Freddy Ashton (great buddy of the Askews) had to do. It was very diverting and quite unimportant except in so far as it has put Gertrude Stein on the map here (didn't we all put her off the map long ago?) It was all very smart and clever, the negro cast sang divinely, the cellophane background was pretty and the music an agreeable hotchpotch of scales, popular tunes, Mozart and Auric. That's the kind of thing they would like here. But far more interesting is They Shall Not Die, *a more or less exact photographic play about the Scottsboro case. It is quite unbelievable though an exact replica of what really happened, and everyone who knows says it is not an exaggeration of life in the South. It makes a staggering play. Oddly enough what comes out of it is not merely a plea for the Scottsboro boys or even for the negroes, but a whole accusation of the social structure. The plight of the poor whites appears as ghastly as that of the negroes.*[30]

Iris knew the Scottsboro case might interest Sidney. Politically, Bernstein could be labeled, as many volunteers of the Abraham Lincoln Brigade had been for their early support of the Republican cause during the Spanish Civil War, a "premature anti-Fascist." Both he and Ivor Montagu were members of the Committee for the Victims of German Fascism, which ran a counter-trial in London to the show-trial staged by Hitler in Germany to justify the Nazi burning of the Reichstag in 1933. It is well known that members of the Comintern were behind the London event. Later Sidney visited the United States to "carry the campaign against fascism to America," according to his biographer Caroline Moorehead. He eschewed the comforts of the train from Chicago to Los Angeles to drive with Alan Porter's younger brother Edward to Alabama to visit the Scottsboro Boys, black teenagers awaiting execution on a trumped-up charge of raping two white girls. Their cause drew strong support from British and American Communists, Nancy Cunard among them, although the NAACP considered the subject too divisive for their involvement.[31]

Iris's mention of the Scottsboro case is emblematic of her lifelong political ambivalence. She understood and appreciated that such matters were of concern to her friends, and she was not indifferent herself, but she was so constantly confronted with personal challenges that she had little time for politics. She needed work and she now saw cultivating her position at the Museum as her path to stability.

Chick Austin as a Magician (1944).

15

MUSEUM MEN

THE TWO MEN most influential in Iris's life after 1932, in addition to John Abbott, were Chick Austin, director of the Wadsworth Atheneum in Hartford, and Alfred Barr. Alfred H. Barr, Jr. was born January 28, 1902, in Detroit, Michigan, the son of a Presbyterian minister who received his undergraduate and Bachelor of Divinity degrees from Princeton University, and Annie Elizabeth Wilson Barr, who attended Vassar College. The younger Barr excelled at Princeton, where he studied classical languages and mathematics until switching to the study of art under professors Charles Rufus Morey, George Elerkin, and Frank Jewett Mather. After receiving his MA in Art and Archaeology from Princeton, he taught for a year at Vassar and then entered Harvard University Graduate School as a Thayer Fellow and an assistant in the art department. While teaching art history at Wellesley in 1926, he shared an apartment in Cambridge with Jere Abbott, who joined him in taking Paul Sachs's influential museum course at Harvard's Fogg Museum and later worked with him at the Museum of Modern Art. In Sachs's class he met A. Everett ("Chick") Austin, who was hired as director of the Wadsworth Atheneum in 1927; Henry Russell Hitchcock, who became prominent as an architectural historian; James Rorimer, who went on to become director of the Metropolitan Museum of Art; and Kirk Askew, the future art dealer.[1]

During a year traveling abroad with Jere Abbott in 1927, Barr called on Wyndham Lewis and other figures in the London art world before moving on to Germany and Russia. In Moscow they attended a showing of *Potemkin* and met the film's director, Sergei Eisenstein. Drawing upon his experiences there, Barr wrote an article, "The Documentary versus the Abstract Film" for the Moscow journal, *Sovetskoe Kino* (14–15). It was during this period that Barr formed his conviction that film should be accorded a place among the fine arts.

Back at Harvard, other efforts to recognize contemporary art forms were afoot. In December of 1928 the Harvard Society for Contemporary Art was formed at a dinner at Paul Sachs's house. The Society was set up to exhibit contemporary art in various media, and at its head were Lincoln Kirstein, editor of the literary magazine *Hound and Horn*, who later became instrumental in bringing ballet master George Ballanchine to America; Edward M. M. ("Eddie") Warburg who, along with Kirstein, became a trustee of the Museum of Modern Art; and John Walker, later the director of the National Gallery of Art in Washington, D.C. (17).

In June of 1929 Paul Sachs was asked for advice on the selection of a person suitable to lead the Museum of Modern Art, then in its conceptual stages in New York. Sachs approached Barr on the subject, found him receptive, and Barr subsequently was invited to the home of Mrs. John D. (Abby Aldrich) Rockefeller, Jr. in Seal Harbor, Maine. On July 9 Barr cabled his father, "Position as director informally accepted. Now dining with Mrs. Rockefeller. Breathe not a word" (18).

Probably at Barr's suggestion, Mrs. Rockefeller telephoned Jere Abbott, asking that he join them at Seal Harbor. "At Seal I learned that a museum of modern art was being opened in the autumn," Abbott wrote. "Alfred was to be Director and I was proposed as Associate. I was excited, I can tell you" (19). Barr was to be paid $10,000 a year, plus $2,500 for travel expenses.

Barr set about writing a prospectus for the new museum. Its first draft included provisions for a multidepartmental institution, including architecture, design, photography, and film, in addition to painting, drawing, and sculpture. The Museum of Modern Art officially opened in the Heckscher Building, 730 Fifth Avenue, New York, on November 7, 1929, with an exhibition titled "Cezanne, Gauguin, Seurat and van Gogh." In attendance and signing the guest book was Margaret Scolari, the future Mrs. Barr, then a graduate student in the arts at New York University.

The first years of work on the Museum of Modern Art were hectic and exhilarating. They included the appointment of Barr's friend, Philip Johnson, as head of the new Department of Architecture in February 1932. Johnson had lived abroad for several years, indulging his interest in new architectural styles, and lingered at Harvard well beyond his youth, receiving his bachelor's degree in architecture in 1943. In the spring of 1932, Jere Abbott left the Museum to become director of the Smith College Museum of Art, and Barr began a year's leave of absence recommended by Mrs. Rockefeller's physician as therapy for exhaustion. In his absence, A. Holger Cahill, who for ten years had been director

of the Newark Museum, was asked to serve as Acting Director. During this time Philip Johnson met Iris Barry and ushered her into the Museum as a volunteer.

Iris was, nevertheless, in a kind of interim position at the Museum. As Barr's biographer Alice Goldfarb Marquis put it, "Barr frequently 'parked' talented people to run the MoMA library while he patiently pushed a new museum department toward reality. Barry's replacement at the library, for instance, was Beaumont Newhall, who would head the department of photography when Barr had wrangled it out of the trustees."[2]

Barr's interest in film had to be prioritized with the needs of a new museum founded at the dawn of the Depression. In June of 1932, he formulated his thoughts on the subject:

The part of the American public which could appreciate good films and support them has never been given a chance to crystallize. People who are acquainted with modern painting or literature or the theatre are amazingly ignorant of modern films. The work of and even the names of such masters as [Abel] Gance, [Mauritz] Stiller, [René] Clair, [E. A.] Dupont, [V. I.] Pudovkin, [Jacques] Feyder, [Charles] Chaplin (as a director), [Sergei] Eisenstein and other great directors are, one can hazard, practically unknown to the Museum's Board of Trustees, most of whom are interested and very well informed in other modern arts. But many of those who have made the effort to study and see the best films are convinced that the foremost living directors are as great artists as the leading painters, architects, novelists and playwrights. It may be said without exaggeration that the only great art peculiar to the twentieth century is practically unknown to the American public most capable of appreciating it.[3]

Although an advocate of film as a component of the new museum, at first Barr devoted his considerable energy to the acquisition and exhibition of painting and sculpture. When the Film Library was finally created in 1935, it became a separate corporation grafted onto the side of the museum, with the museum's trustees ultimately in control of its assets. Nevertheless, Barr served as the mentor and model for leaders of the museum's divisions, and the way he conducted himself set the pattern for the museum's curatorial practice.

Barr was scholarly, austere, exacting, and utterly dedicated to the institution he was building. To some he could appear humorless, but his dedication to causes of art and justice revealed a passionate character and expansive mind. Iris was freeing herself from Porter and, despite her liaison with Abbott, was

attracted to Barr, at least in the view of Barr's colleague, Dorothy Miller. "First she set her cap for Alfred," Miller recalled, "And how! But when she saw he was true to Marga [Barr's wife] she knew it was no use."[4]

Barr's personality contrasted with that of his friend, A. Everett "Chick" Austin, of the Wadsworth Atheneum. Austin was as outgoing as Barr was reserved. He was adventuresome with his museum's funds and risked alienating his trustees in ways Barr would never have attempted. Austin would stroll the Atheneum galleries performing magic tricks for visitors and was the instigator of the infamous Paper Ball at his museum, for which artists, among them Alexander Calder and Pavel Tchelitchew, made patrons outrageous paper costumes to wear. Although his showmanship may have served his institution well, it was not appreciated by his board.

"With Chick, business and friendship were outrageously, happily, and rewardingly mixed," Julien Levy wrote in his *Memoir*.

> It was part of his particular genius for putting pleasure into work. And quite contrary to what one might think, this was all in favor of the Atheneum. Chick and I felt we were associates in two branches of the same business, together advancing the horizons of art. We, in our separate functions, could either be at odds with each other, as was true to some extent of Alfred Barr at the Museum of Modern Art, who seemingly had a suspicion of dealers—or the dealer and museum director could cooperate as Chick and I were able to do over the years.
>
> Alfred did not see this need for cooperation. First of all, he resented a gallery that had more mobility than his museum, that could move faster in making finds and decisions. . . . In addition to his desire to excel in the field of new discoveries, he also placed great importance on his obligation to his trustees' interests in the matter of price, no matter how it affected a dealer like me. For a museum to ask for a further reduction beyond the museum discount of 10 percent seemed to me a form of pressure, for the artist and dealer are all too aware that not having museum representation works to the detriment of the artist. . . . Furthermore, it was made clear to me by implication that it was to the benefit of my artist and my gallery to make a present of the picture to the museum, and so enhance the artist's reputation and the value of his other work. No doubt a good case can be made for Alfred's position, and the argument can be indulged in at greater length. Chick, however, did not try to drive my prices down. When he wanted a picture he knew the right price, about how much he was willing to pay for it, and he didn't haggle,

nor did he defer to his trustees. Perhaps this assumption of authority was to be one of the factors that finally cost him his job.[5]

Austin's charm and imagination endeared him to many in the art world. Levy remembered fondly Christmas of 1931 when "Chick had only recently been made director of the Wadsworth Atheneum" and "the Christmas tree Joseph Cornell helped us decorate, and the Magic and Prestidigitation show Chick Austin staged on New Year's day for our children . . . the tree looked heavenly even when daylight was on, and the rabbits from Chick's hat were quite real and hid in the apartment, not to be coaxed out until a later day."[6]

Barr represented all that was responsible and upright about curatorship and would set a standard for others to live by. Chances are that Iris as a curator never thought of herself in terms of those standards and preferred instead the unconventionality of Chick Austin. It was for Chick and the Atheneum that she would present her first film program in the United States. At Chick's invitation and to test the waters for museum film exhibition, Iris put together a retrospective of films under the title, "The Motion Picture (1914–1934)." It offered lighter fare such as Charlie Chaplin's *Easy* Street (1917) and Walt Disney's *The Three Little* Pigs (1933), but also acknowledged the achievement of D. W. Griffith's *Way Down* East (1920), and European milestones such as Fritz Lang's *Sigfried's Tod* (1924) and F. W. Murnau and Robert Flaherty's *Tabu* (1924). The programs, presented between October 28 and December 30, 1934, were a huge success and led to requests for showings from universities and museums throughout the country It marked the beginning of the film art movement in the United States and was the first collaboration between Iris and Chick Austin, a man who would become integral to Iris's survival during the last twenty years of her life.

16

REMARRIAGE

For one so unenthusiastic about matrimony, Iris moved with surprising alacrity from her first to second husband. She decried "love stuff" in the movies, and although agreeing in *Let's Go to the Pictures* that love-interest is "useful and necessary in seven-eights of all films," she rejected what she called "this cheap business of just getting oneself married . . . this insistence on the feminine power of attracting a man till he finds her bed and board till the end of her days without her making one effort to deserve it."[1] She noted also that "we have all liked Jane Austen for ridiculing this 'getting married' business. But women in those days really had some excuse for feeling so urgent about matrimony. It was the only career open to them. Today, thank heaven, we're crawling out of that bog! There are a good many things women can do, including the making of good wives, the kind of wives who are more than food-dispensers and child-rearers, who are individuals with some individuality of their own as well"[2]

Iris did not make the move between husbands without consulting Sidney Bernstein. Before announcing her intention to agree to divorce Alan Porter and wed the stockbroker Dick Abbott, she tried again to lure Sidney to America with what can only be described as a fantasy. Motivated, as she periodically was, by nostalgia for the land, she asked if Sidney might join her and Abbott in the Southwest United States. "Now if London becomes too objectionable," she wrote him, "I hope it won't but you indicated it might—you come over here and give up business altogether and join us. We are planning on going to New Mexico for good next year. The government may give one land, and with a little money you put in water and fix a house (usually an old Spanish one) and make a swimming pool (which is necessary, really) and then you go ahead and grow all your food and as much extra as you can barter or sell in the neighborhood. Pigeons, hens, and so on. Mexicans (only you mustn't call them that, they are

Hispano-Americans) work for you if you want them for $1.50 a day or they will go shares with you raising a pig etc. etc. Dick thinks he wants to go into politics, gradually, out there. We really are going, next year probably, maybe spring, maybe fall [1935]. Dick's roommate is going too. All very communal. You come too. Horses are only $15 each. Saddles of course much more. It is such a lovely country: and as for hunting, at least you can't starve there, the Mexicans don't. It is a question of can you live comfortably or not. But we feel we don't much care, we would like to work hard and see something for it instead of like here, all nervous and nasty and nothing to show. This is more or less confidential as we don't want to talk about it beforehand and have people laughing at us, as we are very much in earnest. Even if you don't come to farm with us, you will have to come to visit. It is a place definitely to be sampled, better than Ireland. So be prepared."[3]

At the same time, Iris expressed a fleeting nostalgia for England, telling Bernstein, "I so wish in so many ways I were back there and ask myself what I am supposed to be doing here. Nothing could have been less successful. I begin to see why. It's rather illuminating."[4] One must make a "name" for oneself in America, she explained. "It isn't a question of whether I can write a good article or not" she reported, referring to an *American Mercury* editor's willingness to take an interest in her work only after some of her book reviews for the *New York Herald Tribune* began to be quoted in advertisements ("Now isn't this very discouraging?").

> I've been struggling for months to get a longish piece done for the New Yorker, the only paper apparently that doesn't care if you have a name or not but does exact a very special sort of writing. If I can get it in the New Yorker then I think I can undoubtedly get it in the Mercury and thence rise to any heights—even if I have nothing to say!
>
> I do like America immensely. It's a grand country, but I'm often not sure I like Americans and am more and more convinced that they don't know what I'm talking about, or I them. . . .
>
> All of which sounds possibly rather dismal. You can imagine how one feels after endless and frightful cold which withers you up and alternately sheets of ice and ponds of slush underfoot! Dick's mother was here recently. We 'did' New York together, and it was 17 below zero and your nostrils went all stiff as you went out and tears ran down the cheeks etc. etc. Furthest north and all that kind of thing. And so one gets (after weeks of this, plus rain and oh my dear the streets, bruised tomatoes and garbage of every kind right under one's very windows and everywhere) tired, very very tired. And horribly homesick.

As for Alan Porter, Iris told Bernstein that

> *the present arrangement is for him to go to Reno this summer as I can't get the time off or pay the fare out! This is the way things are done here. You divorce for cruelty in Reno, not for adultery in New York (which is the alternative). It is such a pity I could never get on with him, perhaps I never tried, as I admire much of him greatly . . . but he makes me unspeakably miserable, so there you are.*[5]

Bernstein remained in London. Unknown to Iris he was two years into a relationship with Zoe Farmer, who in 1936 became his wife. Zoe, fourteen years Bernstein's junior, is described by his biographer, Caroline Moorehead, as "funny and beautiful and she had great style, with an oval face and high cheek bones and a look that was at once rather knowing and slightly amused. She rarely wore the bulky trousers then in fashion, preferring tailored suits and high-necked silk blouses."[6] She and Sidney met in the summer of 1932 while he was renting Long Barn, a summer home belonging to Harold and Vita (Sackville-West) Nicolson. Moorehead, describes Long Barn as "a fifteenth-century, L-shaped, barn-like house with mullioned windows and a tiled roof" where Sackville-West had spent the twenties writing about gardening. When Sidney offered to buy Long Barn, Harold Nicolson warned him that he was making "a big mistake," since "it's cold and miserable here."[7]

Bernstein thoroughly enjoyed Long Barn. According to Moorehead, he held cordial weekend parties there for "the Huxleys, Sean O'Casey, the [Ivor] Montagus. . . . Charles Laughton came when he could, and so did the American actress Sally Eilers, as well as Oliver Messel, the young designer." Bernstein "took great pleasure in providing excellent food and wine," she recounts. Zoe Farmer assumed a role in Sidney Bernstein's life unique among his women friends. He had had "many close women friends," according to Moorehead, "like Iris Barry and [the British film actress] Lydia Sherwood, but they remained precisely that."[8]

Having received no assurance from Bernstein that he would abandon this life and join her and Abbott in the Southwest, on August 2, 1934, she wrote "Dearest lovely Sidney," saying, "Well, I just had a postcard from Alan in Reno to say that I am a divorced woman. He sounded very gay and I think he will be pleased about it. It had dragged on too long and it is a good thing it is over. I feel quite well-disposed and even affectionate towards him now, and it was a very funny postcard he sent."[9]

Her next "piece of news" announced that she was, in effect, giving up on bohemia in favor of bourgeois comfort and stability. She revealed that she and

Abbott were "getting married during the next few weeks, haven't quite decided date yet because difficult to get away for both of us as he's just joined new firm and I'm rather tied up at Museum last two weeks in August. Probably beginning of September. Now isn't that nice? I am very happy about it, and it will be rather the sort of marriage I'm not used to, with proper furniture and silver and life insurance and all those things, though we won't be very well off, but hoping to be better off, and at least cozy and wolf not at the door." Iris asked that Bernstein "write and give me your blessing and so forth," and closed by saying that she thought she'd "be a better woman for it."[10]

Just over two weeks later Iris repeated her announcement that she hoped "in fact to get married again on probably the 30th (of September), as I warned you before." She and Abbott had apparently abandoned their plans to move to the Southwest, since

we are remaining at the same address [403 East 52nd Street] as both Dick and I have tramped the city looking for better flats at perhaps a little more money but they don't exist, only worse ones for the same money or marvelous ones at rather more than twice as much, which is too much as we haven't marvelous enough furniture for a sumptuous place, so will stay in what was Dick's apartment for another year and hope to blossom forth next year. So it's the same old address (my apartment was underneath his and his roommate's, roommate now disposed of) as before. We're not having any sorts of shines for a wedding. Dick's mother will be there. I wish you and Elsa [Lanchester] would, and maybe my boss and his wife who are very very nice and two other people. And we're going (in a shattered 1928 two-seater Ford) to a small seaside place near where Dick's people live for the two weeks. We haven't told anybody except my boss and his wife and one man and you and the Laughtons. I suppose I shall have to tell Alan. I had lunch with him the other day and felt quite differently towards him now we are no longer man and wife, not constrained and embarrassed and vaguely uneasy as I used to. He is very well and seems to have enjoyed Reno. The papers they gave him when the divorce was over were all done up with seals and blue ribbon. He was told the ribbons would have been pink if he had been a lady.

I am of course staying at the Museum. It will be funny living in a rather orderly way for a change: Dick has the quaintest ideas about budgeting and keeping accounts such as I never met before, am sure it is quite right but novel to me. All of which sounds perhaps as if I were sober about the whole thing which of course I am not. I think it is the nicest thing that ever happened to me and am very very glad: perhaps today rather careworn and weary and obsessed with many things to be done and hence have a rather tired tone. You have no idea how wearying this town can be in summer.

But we're hoping to get away again during the winter for two weeks if possible. The awkward part is being a stockbroker one really can never go away unless clamped to a long-distance wire all the time. Especially at the moment when no one knows what the morrow may bring except that mercifully Dick insisted some while back that commodities were safer than stocks so most of his customers and he are in commodities and those seem to be going up in rather a tooth-edged way, down and up but more up. It's all very alarming to me. I don't understand anything about it really.[11]

Iris's view of her marriage to Abbott is also suggested in a letter she wrote Abbott's mother just days before the two were married. She told Annie Gow Abbott, whom she called Mother Nan, that she and Dick were "trying to plan things for the future so that we can really have a sound as well as happy life together."[12] Dick was discontentedly working on Wall Street, and Iris was freelancing between volunteer stints at the Museum. "I had the good fortune to sell an article to *Scribner's* a fortnight ago," she told Mother Nan, "and also to do a job of editing a weird book on Afghanistan for a publisher: so I shall be able to buy a trousseau! The idea of course is that I should make a lot of extra money by writing and I greatly hope I do. It certainly won't be Dick's fault if I don't. He is so pleased about the *Scribner's* article that he threatens to become a slave-driver."[13]

Iris gave a similar impression of Abbott to her prospective sister-in-law, Teresa, then affianced to Dick's brother, Charles. "I only regret that I probably gave T. a quite wrong impression of Dick as a sort of old-time Southern overseer," she wrote to Charles after she and Abbott were married. "That's the caricature, but the real picture justifies my being able to assure her that the Abbotts make perfect and unbelievable husbands."[14]

Iris and Dick Abbott were married in City Hall, New York, on August 31, 1934, the decree of her divorce from Alan Porter having been issued in Reno, Nevada, on July 27.[15] The marriage certificate understates Iris's age by five years. She was then 39, Abbott 26. Thus the discontented young Wall Street broker took up with the older English lady with a curious background. Together they briefly shared notions of new lives in the Southwest, but both saw more promising horizons at the Museum of Modern Art.

Abbott had been previously married. His first wife, an art dealer from Duluth, had died at a young age of a blood disease. "Somebody discovered the cure for whatever it was very shortly after she died," Iris recalled. On Iris and Dick's wedding day Dick received a letter from the dead girl's parents. It wished him well but demanded the return of "all the silver." Upset, Dick told

his mother, who had arrived for the wedding. She in turn called Dick's father, then ailing with a heart condition, who told her to tell Dick to "send back all the silver," and tell Iris that he would "replace every piece, or better."

"We did not send anything back," Iris recalled. "We kept it all ... but I had a new feeling, that people would back me up, that I belonged."[16]

Iris took to Abbott's parents eagerly. She liked them and his brother, Charles, and found in them a sense of family she was drawn to, in part for their exoticism. "Indeed that was one of the few pure contacts I had with the real, the normal and good life of honest people," she wrote in a notebook she kept later in France.[17]

Iris remembered Dick Abbott's father as "a smallish stalwart blond man of English Quaker descent from Virginia," while his wife was "a bonier, taller, darker Welschwoman and purely Delaware fisherfolk at origin but of a family at least as long established in America as his. She hardly ever drank, or had a sip only at table for pure politeness, whereas I enjoyed many a good glass before and during meals with Dad, who liked best to drink standing up with his back to the fireplace, glass in hand, his eyes lively behind his spectacles talking away. It was from him I learned much about America, American ideas, local politics, and scraps of family history and peregrinations.

"I remember especially his indignation upon the second Roosevelt election— it must have been in 1938. The results were already in when we went down to Delaware for the weekend. Dad took up his usual stance, back to the fireplace, glass in hand.

" 'No liberty left!' he exploded. My husband asked what was wrong. 'No liberty left, boy!,' he said sententiously.

" 'You know how it was: we always gave a marked voting slip to the niggers, good fellows, and they put that slip of paper in the box and when they brought us back the blank paper they hadn't used, well, naturally each of them got ten bucks. But this time, as I say, there's no liberty left. They came to see us as always and took their marked paper and—Goddammit—went right ahead and voted for that bastard in the White House the way they wanted to! No honesty left, son. Let me replenish your glass.' "

When Abbott later announced to his father that he had received a grant from the Rockefeller Foundation to help start a film library at the Museum of Modern Art, which followed his brother Charles's receipt of Carnegie Endowment money to begin the Poetry Collection at the Lockwood Memorial Library at the State University of New York at Buffalo, Mr. Abbott, again during what Iris called a "pro-prandial libation ... rocked back on his heels and remarked dryly, 'Both sons on charity now, eh?' "[18]

Racist, anti-Roosevelt leanings aside, Mr. Abbott and his wife provided Iris with her first sustained impressions of domestic life in America. She liked what she saw. She was particularly impressed by the way her new family celebrated Christmas.

We left New York to go down to be with the Delaware folks, bringing various packages and gifts. They forbade us to go into the spare bedroom. The next day, early in the afternoon, Dad with Dick dragged a largish tub into the living room and put stones and coal into it. Towards evening they brought in a young pine or spruce tree, which was then set up and stayed with as much coal and stone ballast as necessary. This one was supposed not to notice, although at about that time my mother-in-law was told to 'go and get the ornaments.'

From the attic she tugged down an old box, whereupon Dad went off (evidently in his car since like all but the poorest and richest Americans he had forgotten any other means of locomotion) to the one and only Five and Dime, which we were not supposed to know either. Now it was Christmas Eve. We all dressed up, and at six p.m. gathered in the living room where, mysteriously, a pine tree had reared up to the ceiling with its root veiled in red crinkled paper. Drinks were served. It was the moment to dress the tree. Out of new parcels Dad had brought in, we threw long silvery-sparkling 'icicles' here and there on the tree's branches. Then clipped on tiny colored electric bulbs here and there. Then, with glasses renewed, came the moment to place the ornaments here and there, but to the best advantage those ornaments brought down from the attic which, having surpassed time, linked us and the tree to the past.

First, it was essential to place the Swan at the apex of the tree. The Swan probably came to America from Germany about 1890. It was furnished with a clip behind it, which, properly employed, established it magically at the top of it all. Dad, tottering on a small stepladder, placed the Swan not without difficulty exactly there. Some few other hereditary ornaments from the attic box—to the cries of 'I remember that!'—were placed advantageously on the tree.

A renewed glass in hand, we all stepped back from time to time to judge or admire the effect. A few adjustments were made, and Dad threw some sparkling new Woolworth ribbons here and there, and at the risk, I suppose, of upsetting the entire electric lighting system of the house, drew out and draped here and there over the little branches of the tree what I think are called 'fairy lights,' a sort of chain of tiny electric bulbs of red, blue, and yellow.

But this is only the rehearsal, and we must eat, which we did and royally: oysters lightly sautéed in butter with parsley and served with quarters of lemon to squeeze on them. So many things. . . .

Everyone was then supposed to go to bed, and seemed to do so, the only trouble being that everyone was creeping up and down the staircase, secretly placing Christmas presents under the tree. It was all very touching and everyone was so polite, pretending not to see the others trotting up and down the stairs with all their mysterious parcels. . . .

So . . . night fell.

Odour of coffee. Slight bustling below as the maid cleaned up as best she could and summoned us all to breakfast. . . . There was a lovely moment when we all had come downstairs and rushed at the tree. We were astonished and overjoyed by the presents we found under it. My father-in-law was shocked but pleased by an elephant, a quite small but very lively one, carved in dark green jade. He was a Republican and a collector of elephants. He had never had one in jade before. I think he was a little suspicious of its elegance.

Meanwhile, I had leapt upon a rather bulky parcel, saying—politely, I hope—'Is this for me!?' Stripping off the paper, I found a quilted dressing gown with matching bedroom slippers. My mother-in-law told me Dad had gone especially to the big store in Philadelphia and had asked there for a mannequin my size, one with dark hair.

I must say that upon hearing this, I wept a bit. That American kindness, so unimaginable, so tender, so impersonal. But . . . it was not always Christmas.[19]

Iris's impression of Abbott as an overseer would prove prescient.

"A memory that enchants me more," Iris also recalled, "is of crabbing with Dad. Occasionally on a fine day he and I would go to the village butcher and obtain a few good gobbets of slightly overripe meat and then set off for the little cove nearby where a sound if slightly tottering jetty ran out into shallow water. There we sat, lowering our smelly meat tied on strings into the water. Each of us had a net in the right hand: meat dangling on its long string on the left. Sky. Salt water lapping. Time to spare. And then gently creeping towards the bait, a crab, then a larger one . . . up with the first into the basket we had brought along. A time to wait until the sand and mud had settled. Again, a good-sized crab after the meat. Up into the basket. Hours passed, the crabs in the basket scrabbled and fussed. I think this happened always on maid's night out, because Dad and I would bring the basket in through the kitchen door. Ma had brought from somewhere an oval footbath. The crabs were put into it with several pints

of cream, and a good deal of dry mustard, and briefly stewed. With napkins tied under our chins, we all sat to table there in the kitchen and as Ma put thick slices of bread at our disposal, she ladled out crabs and sauce into soup plates and we devoured them in a particularly inelegant chomping and sucking manner. Nothing tastier."[20]

This newfound sense of belonging proved an antidote to the instability of Iris's early years in America. She had never been part of a family in which the mother, father, and children remained close. This she found attractive, even though the family in question would have dismayed her more liberal friends.

Having achieved a degree of domestic tranquility for the first time and made the acquaintance of some powerful figures in the museum world, Iris launched upon one of the busiest years of her life.

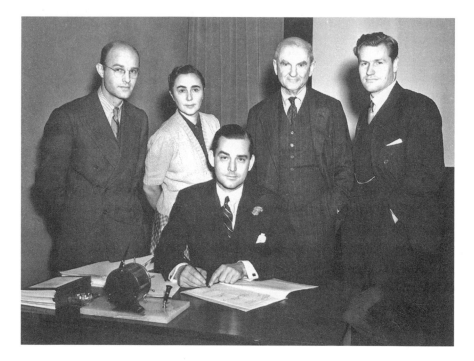

John Abbott, Iris Barry, Jock Whitney (*seated*), Conger Goodyear, and Nelson Rockefeller on the signing of incorporation papers for the Film Library in 1935.

(IBP, MoMA Dept. of Film Archives, NY)

17

SETTLING IN

BY 1935, HER fifth year in America, Iris came to be committed to her new situation. Her longings for Sidney and others in her London circle gave way to an open embrace of the United States. She preferred American matter-of-factness to the rigorous class system that had circumscribed her life in London. She did not dwell on the exceptions to this rule—the ingrained racism, grinding poverty, and pseudoscientific oddities of the period such as the eugenics movement, for example. In an unpublished article intended for the *New Yorker*, she recorded her first impressions as well as her expectations of her new country:

> There are two questions which almost all Americans have asked me. One is, 'How do you like it here?' When the reply is critical, they seem nettled but satisfied. Unfortunately, I am apt to burst into rhapsodies. Whether I praise American candour, or scenery, or antiques they seem both suspicious and offended. They adduce infinite reasons for not liking America. At a later stage comes the second question: 'But why do you want to live over here?' and without waiting for an answer to this they continue: 'Of course, I can quite see from the point of view of work, there are opportunities, but . . .' That anyone from England could actually like living in the States, actually prefer it to living in England, is apparently something so unexpected that it provokes hostility.
>
> Frankly, this is rather uncomfortable. I have discussed the problem with other English friends who all find much the same thing—that we are not expected and hardly even permitted to like the United States or any part of them, and that the only thing expected of us is a 'reserved' or patronising manner and a great deal of harsh criticism. Also, I have seldom met an American who had a good word to say about his own country. Perhaps I should qualify that by saying that most of them enjoy praising its defects. 'Well, we certainly

have some fine citizens,' they say with glee when a public figure comes unattractively into the limelight. There is a recurrent phrase: 'This is still a very new country.' To hear them, one would think that from coast to coast it was one vast mining camp or perhaps impenetrable forest mixed with deadly desert, dotted only with a few Boston wigwams inhabited by cutthroats.

The impression that the English visitor gets is, of course, entirely contrary. It seems the most intensely civilized place in the world, almost overcivilized in parts, presenting at every turn all those amenities our contemporaries most highly cherish. I doubt if there is a handful of people in England who would not consider even a flying trip to the United States, however it strained their resources, as the most exciting of possibilities. It gives one a distinct cachet to have been to America, improves one's standing. More than Egypt or Italy, it is undoubtedly the place English folks today long to see. It is consequently a little disconcerting to find that practically no American can believe that one of us might want—apart from material considerations—to live here.

To begin with, we hear too much about America to feel indifferent to it. It is not only the prominent place the nation holds in world affairs that has this effect. In childhood, all the most exciting bits of our history primers point this way. Half our storybooks for children, from Fenimore Cooper and Susan Coolidge to Thomas Seton were set here. Nearly all the movies we see come from here. English common speech and everyday habits are continually affected from across the Atlantic. The English eat grapefruit for breakfast, diet, buy cars and gramophones on the installment plan, say 'Oh, yeah?' and have adopted the costume as well as the term for hiking in the last few years. Our very era (or so the younger English think) finds its most peculiar and intense expression here. Also we have never thought of it as a foreign country, and not only because many relatives of our grandfathers and great-grandfathers lie in the quiet cemeteries of a dozen different states. We are incurably romantic about America's past, and excited by its present.

Of course . . . there is a good deal over here to which we are not used and which in a superficial way we criticize. Let me instance the custom of tying up a lot of dust and twigs in muslin that is stiff with dressing, then pouring hot water over it and pretending that the resulting fluid is tea. Now suppose the visitor comments on this, or on the heat in living-rooms in winter, no one will like him any the better for it. It is, however, in the right tradition: it is the sort of remark that is expected. The English are believed to be like that, therefore everyone waits for them to start complaining. It is when the visitor speaks unguardedly of the lovely proportions of colonial architecture that his host makes him feel uncomfortable, as if an error in taste had been

committed. Once upon a time I used to voice admiration for the dawns of Colorado—the sharp green of sky, hills suddenly capped with rose, the magic minute of breathless and cool waiting for the sun to strike its first metallic blow to earth. In this I had imagined citizens would concur, as subjects at home would about the Welsh hills or yellow fields of mustard in Essex. I soon learned better. They merely looked irritable. Once when I said that anybody who went to Egypt before they had been to New Mexico must be crazy, I was snubbed flat. Nowadays it is only in letters home that I venture the opinion that Connecticut alone seems to me to have more beautiful small towns than all England, or that Maine with white sails off its pine-fringed coast and the smell of bay underfoot is a better place to spend August than Scotland. . . .

One of the things that strikes one most about life here is its curious combination of the new and the traditional. You may visit an apartment on the sixteenth floor equipped with every modern device: but the little daughter of the house will curtsey to you as if the eighteenth century were still here. Conversation between acquaintances of the opposite sex will be as stilted, the company tend to gather in a circle and remain formal and lacking intimacy just as if Dr. Johnson were still with us. The attitude of many men towards women, as they half-lift you across the street, shoot to their feet every time you stir and insist, socially at least, on the myth that women are helpless and rather sacred beings strikes me as definitely nineteenth century. . . .

What is more, the average American is as pedigree-conscious as a kennel-master. Strangers tell you ten minutes after meeting that their 'folks came over in 1670.' Expressions like 'a very good old family,' 'his mother was a Byrd,' 'one of the first families' are ridiculously common. I am amazed to find everyone here so fully aware of what their forebears were doing in 1670 or 1750: I fear that the average person in England neither knows nor cares who his great-grandmother was. . . .

There have been times when I was homesick, though there are things I do not like about England—such as gamekeepers, decaying but cumbersome relics of the caste system, chilly bedrooms, the brainless snobbery of the middle-class and the apathetic endurance of the urban poor. Yet I should like to hear 'time, gentlemen, please' yelled as the public houses close for the night, to see the guards by St. James again. The strange excitement of those June nights when the automobiles are creeping up the Mall to the Palace, the very different tone of ordinary friendly social intercourse, the gentleness and smallness of the landscape, the kinder hypocrisy of friends one misses suddenly at times with a violent nostalgia. But I shall never go back to live there, only to visit.[1]

Iris sought instead to find her way in the United States. Thus the founding of a film department at the Museum of Modern Art became her consuming interest after 1935. In a draft of an article submitted to the *Delineator* (intended for the issue of October 1936), she described the origins of the Film Library:

> The Film Library really materialized one afternoon in February, 1935, in the drawing room of a remarkably wise and generous patron of the Museum of Modern Art who usually cloaks her good works in anonymity. It is no secret in this case, however, that it was the active interest of Mrs. John D. Rockefeller, Jr. that the Film Library owes this initial impetus on which everything else depended. It was she who brought together then Mr. John Hay Whitney,[2] one of the Museum of Modern Art's trustees and himself actively a participant of the film industry, with the director of the Museum, Mr. Alfred Barr who cannot be offended if we call him a passionate as well as a learned film fan. With him came also John E. Abbott, who in Wall Street had acquired a special sort of knowledge about the cinema. The conversations turned naturally to the films, and the suggestion was made that a practical outline or plan of operation for a department of films at the Museum might be usefully drawn up at once. Mr. Abbott seemed to think he could do this in collaboration with the writer of this article, the then librarian of the MoMA and—in private life—the wife of Mr. Abbott. This proved a singularly convenient arrangement, since the two of us could work together every evening (and often far into the night), and while one of us would grasp the highly technical and financial machinery necessary for such a scheme, the other (that is to say myself) had had the good fortune to be associated since 1925 with the Film Society in London, and thus had acquired already a certain amount of rather special knowledge about the aesthetic and history of the film.[3]

In the winter of 1934–35, at the same time she presented her historic program at the Wadsworth Atheneum, Iris and Abbott conducted a survey of educators to gauge their interest in having films to show on their campuses. Over 80 percent of about two hundred replies to the survey expressed a desire to exhibit film programs.[4] This information was combined with arguments for needs in preserving and exhibiting films to convince the Rockefeller Foundation to offer its support. The positive responses were included in the founding document for the Film Library, Barry and Abbott's "An Outline for Founding the Film Library of the Museum of Modern Art." The library was ultimately funded not by the Museum itself but by John Hay Whitney, who had inherited $175 million

from his father, Payne, and the Rockefeller Foundation. Together they funded the start-up of the Film Library in June 1935.[5]

Barry and Abbott argued that "a comprehensive film library or any library of films at all must become invaluable historically," and "of major importance in raising both the level of production and appreciation," adding that "unless the better films of the past are preserved no standards are possible." The fact that the project was to "trace, catalog, assemble, preserve, exhibit and circulate . . . all types of films" made it universal.[6]

On April 17, 1935, Abbott and Barry turned in their final report, which resulted in a $100,000 grant from the Rockefeller Foundation the next month. Whitney threw in most of an additional $60,000 in private funds to get things started. Rockefeller and Whitney had long and close associations. Their families were among the small group of families heading up the Standard Oil Trust, the entity controlling the largest energy company in world history.[7] Together the two set up the Film Library as a separate corporation, with its stock wholly owned by the Museum. Whitney became the corporation's president, Abbott its director, and Barry was named curator.[8]

"As there was no room at 11 West 53rd Street," historian Russell Lynes later recalled, "office space was rented at 485 Madison Avenue, and the Abbotts moved in with five employees to help them in what turned out to be a massive job of hunting, accumulation, sifting, cajoling, cataloguing, and distribution."[9] The *New York Times* described the new offices as a "fifteenth-floor suite with blue plushy carpets and walls of either ultramarine or vigorous pink, depending on what room one is in. The pink walled library proper contains a nucleus of all sorts of movie books." Visitors are "not officially welcomed until things are a bit settled."[10]

Iris Barry once again had a steady job.

The Rockefeller Report indicated on its front page that it was prepared by Abbott as "Secretary, Motion Picture Department" and Barry as "Librarian." It shows approval by Alfred H. Barr, Jr. as "Director" and Thomas Mabry as "Executive Director" of the Museum. The report "embodies a project for the making possible for the first time a comprehensive study of the film as a living art." It recognizes "a widespread demand on the part of colleges and museums for the means and material for such study, which are now lacking" and identifies the Museum of Modern Art as the institution best suited to meet this need. Quoting the Museum's Charter that it is "established and maintained for the purpose of encouraging and developing a study of modern art and the application of such art to manufacture and practical life, and furnishing popular

instruction," the report argues, in underline for emphasis, that "<u>modern art is not confined to painting and sculpture</u>." Since "the Trustees and the Director of the Museum of Modern Art have planned, since the foundation of the institution in 1928, to develop a department of motion pictures,"[11] Barry and Abbott provided evidence that the time was right to do so.

The Rockefeller Report committed the Museum of Modern Art to becoming a national film organization designed to serve educational and nonprofit institutions through film programming and distribution, development of a comprehensive card catalog of major films, research and advisory publications, equipment loan, archival preservation, oral and other history-taking, and the development of both print and stills libraries. No similar institution had previously existed and no institution subsequently created on this model has completely succeeded in all these areas, perhaps not even the Museum itself.

The day after finishing the report, on April 18, 1935, Iris wrote Mother Nan that she and Dick "were just in the final stages of preparing an application to the Rockefeller Foundation for a sum of money for the Museum.... It was a big job that kept us both at work most days till near midnight, and was only finished finally yesterday. The last few weeks we have seen no one and done nothing but work and fall into bed, though we both enjoyed it and Dick especially. It was a great change for him to have a little activity after the long deadness in Wall St."[12]

On the same day Iris wrote Charles Abbott that "our ordinary mortal life has been totally suspended, we have seen no one and know nothing, save that Charles Laughton flashed through here and we took a brief while off to commune with him and—incidentally—[Albert] Barnes.[13] Charles took a great fancy to the old man, not knowing who he was, and was swept down to Merion and overwhelmed with Renoirs and altogether was given the works by Barnes."[14]

After completing the report and even before Rockefeller made a decision about funding the Film Library, Iris and Abbott worked to promote the project. Iris described Abbott to his brother Charles as being "in his element" as a promoter. "He is amazingly good, quite astonishing—I mean really so ... such energy and sense and so good at getting information out to people. He is rather too energetic for me. I collapsed into bed several times when he gaily continued. The whole thing has made him very happy as he was obviously bored to death by the inactivity in Wall Street: so for the last two months he has spent only the afternoon as a broker and the rest of the day as a movie fan. I hope very much this thing comes off, as he is passionately anxious to be given the running of it and I am sure they would never get anybody better or half as good, and he would be much more content with his lot than he has been the last few months."[15]

At this point Iris appears to have been more interested in her husband's welfare than in assuming control of the Film Library herself. She was grateful for his interest in budgets and finances, leaving the curatorial work to her. She took to it with an air of insouciance. "But what an undertaking," she wrote her brother-in-law, "pathetic little old men who worked with Edison, coming in with reels of old film (including *The Great Train Robbery* in pristine condition): frightful educationists who talk about 'electrifying education' and draw huge salaries and don't know a thing."[16]

In presenting to the public its new film activity, the Museum's publicity department was especially sensitive to the potential fears of the commercial film industry. "All the activities of the Film Library will be strictly non-commercial," the Museum's press release stressed. "There will be no charge for many of its services and the fee for its circulating exhibitions of films will be less than the cost of assembling and distributing the programs for the colleges and museums. It will in no way compete with the film industry."[17]

Many publications joined in welcoming the new museum activity. After attending a preview of the program of films the library intended to distribute to educational institutions nationwide, William Troy of the *Nation*, for example, wrote that

> the Film Library has made an excellent beginning in its attempt to provide a sanctuary against time for what is, in a quite literal sense, the most perishable of the arts. Future Ph.D.'s, making a study of the early twentieth-century cinema from the standpoint either of its technical evolution or of its sometimes bewildering reflection of our culture, will be grateful for the spirit of devoted foresight which has prompted its founding. It is certain also that the existence of such an institution will have the immediate effect of increasing the prestige of the films in those quarters which still consider a serious interest in them a sign either of affectation or of intellectual decay. It endows them with a kind of respectability which may be only academic but which tends to place them on an equal footing with the other arts.[18]

Once launched, however, the new library needed films. It remained to be seen whether milestones of the cinema could be coaxed from their owners, and if so, on what terms. To address these issues, Barry and Abbott went West.

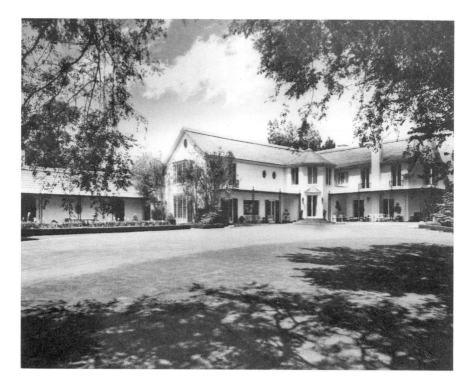

Exterior of Pickfair Mansion.

(Los Angeles Public Library Photo Collection)

18

CRACKING HOLLYWOOD

I T WAS ONE thing to found a film library, quite another to have films to put in it. The expense, copyright protections, and peculiarities of producing and marketing a product whose purpose is to be shown to the public for a profit made collecting and exhibiting films for study purposes initially seem irrelevant to leaders of the film industry. Education and public benevolence were not primary motives in Hollywood, and although there might be those who could sympathize with their objectives, Barry and Abbott faced a formidable task.

In August of 1935 they set up shop at the Garden of Allah Hotel and Villas in Hollywood, to try and convince the luminaries of the film industry they should lend their films to the new effort. Iris had been to Hollywood twice before, but neither visit had left her impressed with California culture. This time around, despite her new status as a representative of the Museum of Modern Art, she again felt out of place.

We were invited one evening by [director] Walter Wanger and [actress] Joan Bennett to go with them to see an open air performance of *Jedermann*, which was being given in a vast natural amphitheater in the hills behind Hollywood. On arriving at Walter's somewhat sumptuous office for a brief but quite regal snack of caviar and champagne, we found there also a Professor from Dartmouth and his wife. Night was falling as we left, Walter and Joan in the first chauffeured limousine and the other four of us in the second one—all in our best evening togs. This was a relatively important cultural manifestation, and also of course movie stars like J.B. are necessarily always 'en grand revue' on public occasions. As we neared the amphitheater we were accosted with a veritable dazzle of spotlights playing over the hills, sweeping across the entrance where, dimly, a great mob of fans surged in the

intermittent light. Photographers' flashbulbs punctuated this dark heaving mass of semi-invisible people as the automobiles delivering celebrities drew into the entrance. We from behind saw the crowd of onlookers bear down on and seethe towards the limousine in front of us in which Wanger, assisted by uniformed ushers, extricated J.B. with difficulty from the autograph-seeking and squealing mob fighting to get at her.

Now in turn our limousine drew to the entrance. There was a quick expectant surge of the mob towards us in turn, until the foremost cried, in sharply falling disappointed accents, 'It's Nobody!,' and turned quick and disgusted from us to rush away and seek better prey elsewhere. We four stepped out of the limousine, made our way like lepers to the entrance, while voices further and further away took up the refrain, 'It's Nobody!,' until, small and distant, it sounded against the topmost hillcrests . . . 'It's Nobody!' . . . and vanished into the empyrean.

At least we knew how we rated.[1]

Having left England disgusted with the class system, and embracing America as a country relatively free of such distinctions, Iris felt ill at ease in Hollywood. In this incongruous setting, her thoughts turned to the children she had left behind in England. From Hollywood she wrote Sidney Bernstein to see if he might help provide some diversion for her son, telling him that

that boy of mine, Robin, seems to be doing all right—he is sixteen now—is still at school but has taken it into his head to work in a garage all summer, which seems sensible. I should like somehow to arrange for him however to take a holiday, a week or so, but do not know how to do it, as I don't know what one could possibly do with a solitary boy. It seemed to me that if I came over this summer I might arrange something, but now it seems we shan't be there in time.

If by any possible chance you can think of anybody nice where there are other young people who would have him for a week, but not just anybody where they'd be nosey about who he was and so forth, I wondered if you could think about it and see if it couldn't be arranged for him to go along.

I daresay it isn't feasible, but I thought I'd mention it. He seems a sensible but rather difficult person, not, at least I think, a bore. He is used to being more or less alone as I don't think my mother has any friends in Bognor. But I would like to have him get away once in awhile.

I should add in case there should be any prospect of his doing so that of course he is officially (and from his own point of view) an orphan whom my mother adopted.

Next year we are going to try to arrange for him to come over here and go to camp—all that sort of thing is so well arranged here—but this year I can't quite think what to do.

Elsa [Lanchester] I think would not at all like the idea of asking him to Stapledown, else I would have suggested that. I don't know what you would feel about asking him to your country mansion if I say Ivor and Hell [Montagu] and 'nice' friendly folk were there. I'm not asking you to do that, because I can see it could be quite a problem or a nuisance, but if there is anything that can be done will you consider it? ... The boy lives with my mother Mrs. Crump at 4 York Terrace, Bognor Regis and his name is Robin Barry—I personally want very much to have him change it to Robin Lewis because it would be so much less awkward and as that is his sister's name anyhow—only that he doesn't know that he has a sister. It is really as involved as an early Elizabethan drama. Ah, well ...

Gracious me, how I've run on. Now I shall go out in the garden and think what on earth I am to say when I have to make a speech at this Pickford dinner.[2]

Once more Iris received a faithful response from Bernstein. He promptly invited Robin to visit his country home. It was the first of many such visits and one on which Robin would meet his future wife, Zoe, before she became Mrs. Sidney Bernstein.

The dinner Iris alluded to was a party arranged by Mary Pickford at Pickfair, the estate she shared with her husband, Douglas Fairbanks, Sr. The party was paid for by Jock Whitney and was intended to give Iris and Abbott an opportunity to explain why leaders of the film industry should cooperate with the new library effort.

Iris had already formed an opinion of Mary Pickford as an actress. She thought of her as the virtuous side of an ambivalent view of women. "Mary is the perpetual Cinderella," she had written in *Let's Go to the Pictures*, "the little girl in rags who in the end resides in a glittering castle with h. and c. in every bedroom, men-servants and real fur rugs. In so far as she is Everywoman: that is her strength, because she is Everywoman much more wholeheartedly than her lesser rivals. In so far she is above criticism. She is not an actress but an incarnate idea, the flame round which every woman's desire circles moth-like. Indeed her only rivals are the Bad Women—I mean Nita Naldi and Pola Negri. For every single woman on earth is, in her dreams, always and forever, a blonde thing of eighteen, ripe for kisses, pure as the driven snow, and so forth, but maddening to all mankind, and at the same time an experienced woman of thirty-forty with sleek tresses, dinner gowns with fish-tail trains and too much

knowledge of 'life,' given to ruining Man as lightly as one would kill a midge. But the golden-curled eighteen is the dearest of these two dreams, as it is the more respectable."[3]

Now Iris stood in need of the golden-curled's assistance. She found herself impressed by the regal glitter of Mary's milieu.

The Pickfair party was set for a night of tropical warmth. Everyone knows that Pickfair is a 'great' house, but it can seldom have looked lovelier than that night, with dinner for seventy set on small tables on the immense verandah running round the white house, overlooking a wide lawn so floodlit that, as guests strolled across it, their feet were bathed in moonlight and diamonds until the womenfolk looked like goddesses floating over the meadows of heaven. Like immortals too, they seem all of them to retain their youth eternally. . . .

It seemed strange to us that, as the party assembled, famous person after famous person met with cries of 'My dear, I haven't seen you in five years.' Indeed, some of those present had never met before, and others had never previously visited Pickfair. That, of course, is typical of Hollywood. They work long hours during films, go out little and once the film is finished they rush away for a holiday. That evening, at any rate, quickly proved to be one charged with emotion for everyone present, partly because so many old friends and new acquaintances were meeting each other in a mood quite novel to film people – meeting to look back over the intense and romantic forty years since their incredible art-industry had its birth.

There was Walt Disney, a veritable babe in the business, talking to old Colonel Selig who made Hollywood's first film a quarter of a century ago. There was Mrs. Thomas Ince talking to her hostess, both of them every whit as lovely as when the late Thomas Ince, at the very beginning of his career, directed little Mary Pickford in pictures made in Cuba before the war. Harold Lloyd, unrecognizable as ever without his glasses, Mack Sennett and Walter Wanger, keen-faced Otterson of Paramount, Sam Goldwyn with his wife, the former Frances Howard, Jesse Lasky who first entered the business with Sam in 1913, and other executives whose names, though little known to the public, dominate absolutely the careers of present-day favorites of the screen—all of whom for that one night called a halt and looked back at what they achieved.[4]

After dinner Abbott and Iris screened the famous May Irwin–John C. Rice *Kiss* of 1896, and D. W. Griffith's *The New York Hat*, written by Anita Loos, also

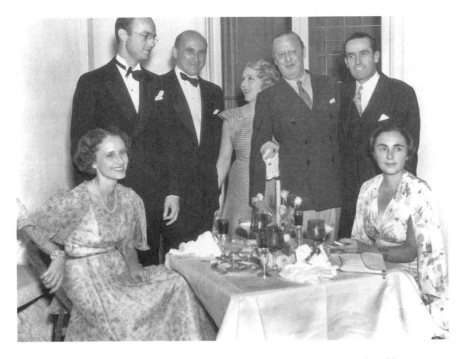

Pickfair guests (*left to right*): Frances Goldwyn, John Abbott, Samuel Goldwyn, Mary Pickford, Jesse Lasky, Harold Lloyd, Iris Barry.

(IBP, MoMA Dept. of Film Archives, NY)

present, starring Mary Pickford and Lionel Barrymore in a supporting role in his first film. Chaplin lent the sequence from *The Gold Rush* in which he does a dance with dinner rolls on forks. *All Quiet on the Western Front*, Lewis Milestone's powerful 1930 lament about World War I, was shown in part along with a *Silly Symphony* by Walt Disney called *Pluto's Nightmare.*

"I cannot describe how tensely fraught with feeling the atmosphere became," Iris recalled, "There were tears on many faces in the darkness of the drawing room. Many present saw friends long dead reappear before their eyes. Many saw themselves of long ago."[5]

That evening Abbott made a brief speech addressing the industry's misgivings about an archive of film. "You will be thinking here," he said, "'but films have been preserved, we have them in our vaults.' True, but are they remembered as they deserve [to be], and what do they mean to the rising generation who have never seen them?" Drawing on Iris's populist views, Abbott argued that people who felt that films had no place in a museum "seem to believe that

art is something apart from life, already consecrated in museums and—above all—something which the common man cannot enjoy." But the polling he and Iris had done of schools and institutions proved that hundreds of potential venues existed for the "masters of film." And although Hollywood may view itself as merely an industry, there was a new generation of students ready to proclaim it a source of new art. "Let us save the outstanding films of past and present," he implored, "from turning, in the end, as they must unless something is done, into a handful of dust—and memories."[6]

Abbott's speech warmed the audience for Iris.

"A rather awkward and even dangerous task has been given me," she began somewhat tentatively,

> for I have been asked to say something of what we mean by 'the art of the motion picture.' How exactly can we arrange for people to study the films seriously? What are these mysterious programs we speak of arranging? What are we, in heaven's name, going to do with the films you give us?
>
> I know that many of you have felt a reluctance about presenting your older films to be seen again, because they represented only stages toward your present achievement. Miss Pickford herself had planned to have all her old films destroyed: but such a cry of protest arose from people all over the world that she was convinced, to use her own words, that she did not really have the right to destroy them. And that is true for all of you. There is a sort of obligation to see that at least the outstanding films are preserved for posterity, permanently and in good shape. But again, many of you feel that if those older films are shown again, people will laugh at them. Now I myself am among you here not only in connection with the Museum of Modern Art, but also as one of the oldest fans in existence. I can therefore speak perhaps of the love and affection which the fans bear you and your films. It is an affection which is sometimes critical and often expressed in surprising ways, but it is an affection which stretches back along the years and includes the old as well as the new films. If there is laughter when the old films are shown as we plan to show them, it is and will be affectionate and understanding laughter, not derision—and indeed we here tonight have laughed and chuckled in affection.
>
> One point: there will be no clipping and butchering of films at our hands. Nobody would cut a painting in half and hang only a piece of it in an art gallery because it was painted in a now outmoded convention. That would very rightly be regarded as vandalism. And so it would be with the motion picture, I feel. We shall preserve the films whole, as originally issued; we shall show

new perfect prints with original subtitles, and therefore they will be run at the right tempo, not hurried and jerked across the screen. If a film is worth considering seriously at all, it is worthy of the respect we would accord to a painting or a book: if it is not worthy of respect, then it has no place in the library's collection. Of course we did show portions of three films tonight, but as Mr. Abbott said earlier, this is an audience of the converted and anyway you have none of you been registered—or at least not yet—for a three semester course of study on the art and appreciation of the motion picture!

I do want to repeat, however, that the films we acquire will be respected, presented and preserved intelligently. I should really like to give you, because it may convey some concrete idea of just what we plan to do, a few of the main headings under which we are trying to assemble our library, and under which the films will be distributed for study:

Primitives: Early Edison films
 The works of Georges Melies
 The Great Train Robbery
The Development of Narrative and Epic
 D. W. Griffith 1909 to *Broken Blossoms*
 Ince and the Western
 Serials
 Early imports and superfilms: *Quo Vadis,*
 Queen Elizabeth, The Coming of Columbus
The Rise of Comedy
 Mack Sennett and the development of slapstick
 Lonesome Luke and Harold Lloyd
 Chaplin: Early, middle and late
Newsreel and Documentary
Outstanding Directors and Actors of the Silent Era
 The Squaw Man
 A Fool There Was
 Carmen
 A Romance of the Redwoods
 Salome
 Mickey
 The Marriage Circle
 The Unholy Three
 The Black Pirate
and so on down to the time of *Stella Dallas, Sunrise,* and *The Political Flapper.*

Remember, the films are not to be shown as entertainment, but strictly as classroom or extracurricular courses under the auspices of universities, colleges and museums. They will be presented seriously, as part of the regular education in the history and appreciation of art. That surely no one could doubt as fitting and proper.

Let this be done: for none of you in the industry will ever esteem your own best films, old or new, more highly than the eager and loyal students of the motion picture. Those of us at the Museum of Modern Art who have been working on this scheme have learnt far more than any books or lectures, however brilliant, could have taught us, while we looked again at some of the older films, whether they were of 1903 or 1930. We have seen the earlier work in its proper perspective, watched the many and varied experiments in their proper sequence, and our enthusiasm for the film as a great, a living art yesterday, today and tomorrow has now in consequence of this progressed beyond its original bounds, far beyond. We envy the experience that lies before the students of films to whom, with your cooperation, we hope to send our programs.

And now, at last, consider when we are all of us gone, both those of you who launched this museum enterprise, and those of you who have created the motion picture—when all of us are gone, the Museum's Film Library will still be there, the films that you give us will still be there to constitute, in so far as anything in this world can be lasting, a lasting memorial to the art of the motion picture, to the men and women who laid its foundations and carried it to its present power.[7]

Iris thus assured the industry's leaders that their films would be respected, projected whole and in an educational context. Above all she offered them immortality, the promise that their films would outlive them and guarantee them a place in history. Iris later recalled that "this glimpse of the birth and growth of an art which was peculiarly their own both surprised and moved this unique audience."[8] Some seemed particularly touched by images of Lewis Wohlheim, star of *All Quiet on the Western Front*, who had recently died, putting those in attendance, perhaps, in mind of their own vulnerability. The Abbotts promised a new kind of immortality. Their appeal resulted in pledges of films from Mary Pickford, Harold Lloyd, Samuel Goldwyn, Walter Wanger, and Walt Disney.

The American film industry had been brought onboard.

It had been a long and difficult visit. Iris wrote Chick Austin,

we are shattered from Hollywood, six weeks of the most incredible coping with the industry which I am happy to relate has had good effect and films will be had by all though not I fear ready for circulation till next January—we don't want to rush out a poor program.

Of course just as one would expect the Disneys were the easiest to deal with and the nicest. Walt said 'Who is this guy Picasso you just mentioned? Is he a real artist?' We were motored across Hollywood from their place by a young man in a sweat-shirt who said he was 'the quack of Donald Duck' and also made the bird sounds in the Silly Symphonies....

But aside from all that we really had a romp with the movie folk, culminating in a small dinner for about 70 given for us by Miss Pickford. Did you know by the way that two of her long curls repose on a red velvet cushion in the Los Angeles museum? I'd love to have them here and also a genuine Keystone Kop's helmet in a glass case. Ah, box office! I think we shall have to borrow both of these and see if they really stand up to Whistler's mother.[9]

The Pickfair visit also resulted in the basic legal agreements upon which the Film Library would operate. As Iris later recalled, "terms were finally approved by the legal departments of Paramount, Lowe's, Twentieth Century-Fox, Warner's and Universal so that early in 1936 the Film Library actually began to rent out its first series of programs to colleges, museums and other non-profit organizations, which were thus able for the first time to institute a study of the growth, technique, aesthetics and sociological content of the most popular of the arts."[10]

After Hollywood, Iris thought again of her son. She wrote to Sidney Bernstein at Christmastime thanking him for hosting Robin during the summer.

I just had a long letter from him with copious detail about his stay at Long Barn, which must have been a great event in his life: he said to tell you that they were the happiest days he ever spent. The horse seems to have made a great impression, also the two 'friendly' dogs. How good of you it was to have him. I can't say how thankful I am.

I do hope next summer that we can get him fixed up for the future somehow. He wants to go into radio if possible. He is a funny boy and perhaps not wholly a nice character, but he is trying hard to be sensible and good—I admired him for taking a job in a garage for the summer, which is largely why I ventured to ask you to invite him, as a reward. Or have I gone American?...

We are having a great time with the film business (as usual). It is like the Film Society all over again but on a larger scale and rocks loom ahead every day. We go to

the tape on Jan. 7th with our first film show here, and fourteen more that same month elsewhere. Dick has just been offered a magnificent job elsewhere but I don't think he will take it or give this up, it is too amusing and too new; also I think he eventually wants to ease himself out into the film business proper.[11]

Having primed the pump in Hollywood, and sold many educational institutions on the idea of a film library, it remained for Iris and Abbott to determine the criteria by which films would be included in the library. Their decisions would set a pattern for curatorial practice in nontheatrical film.

19

ART HIGH AND LOW

P UTTING LOWBROW POPULAR entertainment into a highbrow museum
was going to be a delicate maneuver. New York in the mid-thirties was
quite a different milieu than London in the twenties. While Iris and oth-
ers were bringing elite audiences in London together with emerging European
film masters, America felt its way toward an appreciation of film in a more bot-
tom-up manner. Motion pictures quickly caught on with American audiences,
especially those in the cities, whose large immigrant populations especially
appreciated the visual communication of slapstick comedy. Chaplin's character
of the Little Tramp gave foreign-born factory workers a figure to identify with.
The Tramp's confusions in the face of modern society, his clever, nonconfron-
tational run-ins and bare escapes from authority, and his longings for love in a
vast and confusing new world resonated with new Americans. At the same time,
these immigrants and their tastes were perceived as a threat by many. Crime
waves, both real and imagined, were often thought to be the outcome of too
many people from "hot-blooded" cultures in southern Europe crowding into
cities. Such people were also believed to be the bearers of foreign ideologies, of
Bolshevism and anarchism and syndicalism of various kinds. To combat these
influences the Attorney General of the United States, A. Mitchell Palmer, had
conducted his infamous deportation raids of 1919 and 1920.

While new Americans were flocking to nickelodeons and fleabag theaters in
the early years of the new century, middle-class Americans were finally accept-
ing theater as a legitimate cultural institution. But while the art form long
regarded as the "wicked stage" was gaining acceptance, the growing popularity
of motion pictures also had to be contended with. Many feared that theater,
having struggled for respectability throughout the nineteenth century, might
lose its audience to the cheaper and more reproducible films. Theaters built for
stage productions containing over two thousand seats were being converted for

the exhibition of motion pictures. The large touring companies, who through-out the nineteenth century brought spectacular productions to the Pantages, Orpheum, and other theater circuits all over the United States, were giving way to a more small-scale genre of theater. At the same time, many large legitimate theaters were being adapted for movie use.

Throughout the 1920s the New York Theatre Guild promoted the cause of so-called "Little Theaters" in New York, and clones of the Guild spread the message elsewhere that small theatrical operations dedicated to new and origi-nal productions could survive outside the mainstream theaters that were trying to compete with films. The National Board of Review undertook an analogous mission for film, touting the idea of small cine-clubs and "art house" theaters that would facilitate the matching of better films to more discerning audiences.[1]

Here an analogy with the London Film Society becomes apparent. There as well the Stage Society provided the model for developing a Film Society, the purpose of which was to bring to educated audiences motion pictures of supe-rior quality. The less class-conscious American audience, however, provided a significantly different precondition. It was unlikely that precisely the same idea would be welcomed in America, where class distinctions were less defined and the embrace of some form of democratic values had already worked its way through the economic echelons.

By the time Iris Barry and John Abbott found financing for the Film Library of the Museum of Modern Art, anti-immigrant sentiment in the United States had been tempered by the injustices of the Sacco-Vanzetti trial and the rise of sympathy for the poor brought on by the Great Depression. People in high culture were becoming somewhat more comfortable with the low. In a tight economy many citizens appreciated the inexpensive escapism of the movies. Indeed, Hollywood was being viewed as Depression-proof. The time seemed auspicious for legitimizing this popular art form.

Iris brought her past experience to bear. She had worked for more than ten years to convince the British upper classes that film was a proper object of study. As film scholar Raymond Haberski put it, "her enthusiasm for movies reflected a belief in their inherent virtues as a popular art form and as a medium that had challenged the distinctions between highbrow and lowbrow culture." As Barry emphasized in *Let's Go to the Pictures*, "Going to the pictures is nothing to be ashamed of."[2]

Iris's view that movies provided a legitimate dream-escape for people from otherwise oppressive lives, and that their content reflects cultural issues and trends worth studying, was nonthreatening to the entertainment side of the

American film scene represented by Hollywood. Her regard for seminal film-makers, and her historian's bent to preserve and study their works, on the other hand, gave her efforts the air of legitimacy sophisticated museum work required. The result was a movement, largely set in motion by her efforts and carried forward by others over the years, which turned traditional aesthetic evolution on its head. Instead of lifting motion pictures upward to fit aesthetic standards derived for other and preexisting art forms, she focused critical attention downward to find in the vibrant new art form its own inherent validation. Ultimately, this populist dynamic set in motion an approach to film criticism later practiced by critics such as James Agee and Pauline Kael.

On the other hand, the populism of Iris Barry's approach contrasts with the canonical view of modernism usually associated with the Museum of Modern Art and its founding director, Alfred Barr. Barr thought American films to be tainted, as he put it, by the "usual commercial manipulation—of super slapstick and the too-eternal triangle," while European films he saw as buoyed by "the extraordinary standards of a public trained in a progressive theatrical tradition."[3] According to Haberski, Barry's work synchronized with Barr's modernism in that both contributed to the "revitalization of American arts," which to Haberski was a "remarkable feature of the modernist movement." Barry's role, to champion motion pictures as the newest and quintessentially American art, was nevertheless accomplished by defying "an idea central to the modernist definition of art: that art shared nothing in common with mass culture. By suggesting that aspects of mass culture such as movies could be art, Barry introduced the notion that popular taste could help shape artistic standards. Such a notion also further eroded the cultural authority that had been used to dismiss and condemn the cultural significance of movies. Moreover, Barry did all this in a museum founded with money from New York City's ruling elite and under the guidance of Barr, one of Manhattan's most important modernists."[4]

In attempting to compare the aesthetic and programming choices Iris made as Curator of the Film Library at the Museum with those of Barr at the Museum itself, it should be remembered that the library functioned as a separate corporation attached to the Museum under the auspices of the Rockefeller Foundation and with the oversight of Museum trustees such as Jock Whitney and Nelson Rockefeller. Barr liked and was supportive of Iris. He could have discouraged her involvement with the Museum's development. But his own open-mindedness made him unlikely to interfere with Iris's programming decisions. Barr's thinking had been shaped by his travels in Europe and the Soviet Union, during which

he saw not only the vitality of Futurism, Cubism, Russian Constructivism, and other artistic movements but also firsthand the repressiveness of the Stalinist regime toward abstract art. He identified abstraction and personal expressiveness in art with the democratic tradition from which he came. And although he sympathized with the formalism of Clive Bell and Roger Fry, and respected the "plastic values" championed by the scholar-collector Albert Barnes, he maintained a personal openness about artistic developments. As art historian Irving Sandler put it in his 1986 introduction to Barr's writings about art, "very early in his career Barr rejected the vanguardist notion that art was progressing in one direction. . . . For avant-gardism, Barr substituted the conception of the history of art as a vast storehouse of ideas that living artists could use for new departures, depending on their vision, energy, and independence. Barr responded to the pull both of tradition and of modern innovation, which seemed to subvert it: he was attracted to masterpieces with art-historical pedigrees and to lively new works with none, and even to movies, snapshots, and mass-produced artifacts, whose very status as art was questionable." In short, to Sandler, "Barr questioned every definition of what makes art modern."[5]

Barr's open-mindedness may have stemmed from his innovative role as head of a new kind of museum, one which combined the practices of the *kunsthalle*, with its attention to the works of living artists, and the *kunstmuseum*, given to the collection, preservation, and exhibition of more traditional works.[6] By keeping his options open, Barr also could range widely in his curatorial decisions, leading the public into unexpected territory. In Sandler's view, "Barr's reluctance to define modern art stemmed in part from his recognition that preconceptions would curb receptivity to new experiences. Moreover, implicit in any definition was a restriction of the artist's freedom of creation or what it was permissible for a 'modern' artist to create. Any such limitation or even its suggestion was intolerable to Barr. Only free artists could determine what art would be: curators, critics, viewers had to remain perpetually open to the new visions of artists."[7]

Iris, on the other hand, was not known for her receptivity to artistic experimentation. She respected the proven innovator—the D. W. Griffith or F. W. Murnau—who blazed new paths in film history, but she seldom sponsored unknown talent. In this regard she might have been a somewhat stronger curator had she been more attuned to the convictions of Alfred Barr.

Iris and Abbott as a team promoted their own brand of cinematic populism. Addressing the annual luncheon of the National Board of Review in late 1935, for example, Abbott echoed Barry's view that "neither the public at large nor the leaders of opinion have been accustomed to take the film really seriously."

Abbott suggested that the Film Library might "lend the authority which is now lacking, to the work of the great film makers." In doing so, however, he was comfortable with film being considered a popular art. "That the motion picture is a popular art is one of its greatest assets," he told those in attendance, adding that "it lacks authority, but it is living and lively, it is of our time, it speaks in terms we can all understand."[8]

At the Albright Gallery in Buffalo in April 1936, Iris sounded a similar note, asking her audience not to overlook "an extremely important function which it [film] fulfills—that of holding up, all consciously, a mirror to contemporary life." She argued that "while it is possible for us today to get a glimmering of the mentality, of the profound human nature of the unknown artists of the Middle Ages . . . it is possible, in exactly the same way, to see in the motion pictures of our own era a searching and profound reflection of the mentality, of the soul of our own time."[9]

Given Barr's eclectic openness, even a populist view such as Iris's found sanctuary in his temple of the modern. But since Barr was not the only power at the Museum, the Film Library ultimately stood among contrasting and often contradictory forces. Looking back at the evolution of the Film Library, film historian Haidee Wasson concluded that "the library staff was faced with a daunting project: selling the value of film's history to numerous and strikingly different communities of interest. To the trustees of the museum, film needed to be continuously legitimated as a medium deserving the prestige and investment of museum resources. As such it was often aligned with other high-cultural forms and the need to develop a critical and responsive public. To the industry, film history was first and foremost constructed as an honorable and non-profit venture, lending to the prestige of film generally. To the public, film history was sold as a collection of popular memories, fashion's oddities, bygone youth and American ingenuity. Each constituency was essential to the success of the Film Library: the trustees pulled the strings and opened doors; the industry owned copyrights and marshaled vast resources; celebrities brought glamour and public endorsements. Approval of the public was also needed to ensure the civic legitimation the Film Library's continued survival depended upon."[10]

Taking into account the conflicting forces impinging upon the Film Library, and Iris's verbal facility, it should come as no surprise that, as Wasson observed, "throughout the literature generated by the Film Library, there are notably vague uses of powerful concepts such as art, influence and history. For instance, at times the influence of film was linked to popularity, at others, to its impact on higher, cultural concerns. Precise definitions for 'film art' are never offered.

Barry and the library staff carried these seeming contradictions through many of their public relations endeavors. The tension residing in the idea that the same film-object might be both a high and popular art-object was simply not addressed in the great bulk of Film Library publications. The tension is, however, implicit in their early programming, film notes and other publications which collectively presented films that had set popular fashions and caused moral panics alongside films it considered markers of aesthetic development. What kind of art was film? This was posed as an open question within which answers to the question of film's history would be constructed."[11]

The new Film Library, therefore, was developed amid a maelstrom of agendas. Iris's wit and verbal agility served her well in navigating these conflicts. She found ways to appeal to many factions, and if in doing so she seemed to lack coherent vision, she nonetheless served as an articulate spokesperson for an exciting new art form, however it might be defined. In retrospect, she nurtured the new art form by providing the adaptability it needed to survive.

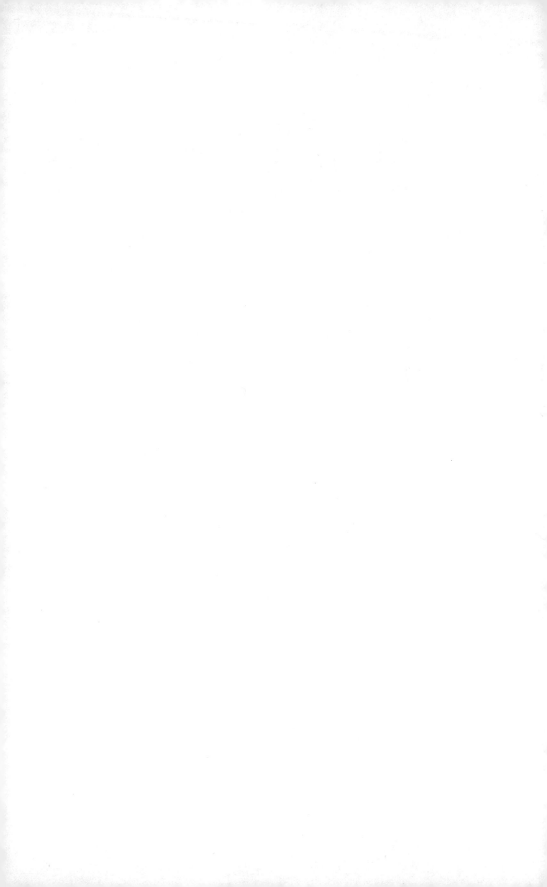

John Abbott and Iris Barry in Luxembourg (1936).

(IBP, MoMA Dept. of Film Archives, NY)

20

ON TO EUROPE

B Y 1936, ATTEMPTS to collect and archive films in public institutions were already under way in Europe, despite the threat of war. It was apparent to Iris that her work in New York could benefit from mutual accords struck with film archive efforts elsewhere. Of equal importance, however, was a less obvious and little-known agenda: Iris's interest, as she put it, in getting her hands on any film which "might become politically or militarily useful to the United States in the event of our entry into the conflict" of World War II. With this objective in mind she approached the State Department and was gratified to learn that her purposes "met with unofficial but complete approbation, with Secretary [Cordell] Hull extending every facility of the various embassies" to smooth her path should she need official help.[1]

In this way Iris Barry, who typically eschewed politics, took on a political role in light of the threat posed by Hitler's Germany. Iris had every reason to be concerned about the possibility of another war. Her native country was vulnerable, and many of her leftist friends in England were alert to the rise of fascism. Germany's government had fallen to Hitler, who now occupied the Rhineland. Setting out on a not-altogether-aesthetic mission, in May of 1936 Barry and Abbott sailed for Europe. They visited London, Paris, Hanover, Berlin, Warsaw, Moscow, Leningrad, Helsingfors, and Stockholm, for the most part finding welcome among archivists. It was no doubt helpful that they were armed with letters from the State Department to American ambassadors at London, Paris, Berlin, and Moscow, and the American minister at Stockholm.[2] Five years before America's entry into the war, as these documents indicate, the Film Library was already conducting its work in close cooperation with the U.S. government.

In a report on their trip to the Rockefeller Foundation, Abbott noted that "film collections have been formed by the British Film Institute in London,

the Cinémathèque Nationale and the Cinémathèque Française in Paris, the Reichsfilmarchiv in Berlin and the Scientific Research Institute (NIS) in Moscow. It must be observed, however, that none of these institutions seems to have attacked the problem actually of preserving (as apart from collecting) film, that some of these collections are very scrappy and others composed of sadly worn or fragmentary material. All of them displayed a keen interest in obtaining material from the Film Library."[3]

Despite the fact that Lenin was reputed to have placed the highest priority on the uses of film in the new state, the visit to the USSR proved "somewhat disappointing," the report continued. Here "the main difficulty seemed to be that the nature of the Museum of Modern Art, not being a state-financed institution but one supported by private capital, was difficult for the Soviets to grasp. The Soviet film directors and artists were markedly friendly, and the State Film School professors and students were very anxious to obtain films and information from the Film Library and therefore to contribute to its collection. The officials finally promised twelve films, only one of which has so far been sent." Nevertheless, Abbott and Barry came away with "a valued collection of unique photographs, original drawings and manuscript scenarios from Sergei Eisenstein."[4]

Eisenstein's assistant, the American film scholar Jay Leyda, facilitated the gift of the Eisenstein material. He joined the Film Library staff in 1936 as an assistant to Iris, paid by a grant of $2,500 from the Rockefeller Foundation to complete a comparative study of how film materials in the United States and Europe might be organized for nonprofessional service to colleges and museums. Thus far, more than seventy-five institutions had booked film programs organized by the Museum.

Barry and Abbott noted an unexpected decline in the status of film in the Soviet Union. Iris reported that "it seems that the film industry is now no longer regarded (from the point of view of the external world's seeing Russian films) as of so much importance: they are no longer trying particularly to make films to impress the non-Soviet world. Instead they are trying to make a large number of relatively mediocre films for home consumption, to build and equip cinemas and to develop a color system. In any case the film business is only 47th in importance among the industries: they are still short of film stock, though they now manufacture it, and our request was unprecedented, and not easy to understand."[5]

In London Barry and Abbott met with Iris's Film Society colleagues, Sidney Bernstein and Ivor Montagu, who assisted in making contacts both in England

and abroad. They met with British film director Alexander Korda, who promised his cooperation. They also received help from John Grierson, head of the GPO Film Unit (an unusual venture in which avant-garde filmmakers made information films for the General Post Office). Grierson later went on to found the National Film Board of Canada. He introduced the two to Len Lye, who donated his handmade film, *Colour Box*.

Good relations were also established elsewhere, with the "fullest cooperation" coming from Germany, where, "after consultation with Dr. Leinich of the Ministerium fur Volksaufklärung und Propaganda, the Reichsfilmkammer placed its staff, its projection room and all the films in its collection at the disposal of the Film Library. Instructions also seem to have been given to the Germans producing films to accede to the Film Library's request for films. All the twenty-nine German films selected have already been delivered in excellent condition together with important collateral material, such as still photographs, posters and printed matter."[6] Among the films were productions by directors G. W. Pabst (*Beggar's Opera*, *The Joyless Street*) and Dimitri Kirsanov (*Menilmontant*). Lotte Reiniger donated two of her much-admired silhouette films.

The otherwise cooperative response the two found in Germany was blunted by one refusal, for Josef von Sternberg's *The Blue Angel*, in which a cross-dressing Marlene Dietrich vamps a stodgy professor played by Emil Jannings. "This was refused on the ground that it was a pornographic film," Iris wrote, "showing Germany and Germans in a very unpleasant light and therefore they did not wish it to be shown again abroad."[7]

While in Germany, Barry and Abbott visited a technical motion picture exhibit organized by the producing firm, Ufa. The two were "especially impressed" by the exhibit, which they found "mounted in the best German manner, exceptionally lucid and attractively displayed . . . to which a large library of books and periodicals is attached, displaying the technique of film production in all its phases in admirable fashion—in many cases with practical miniature models, and all of them intelligently and clearly labeled. It is greatly to be desired that some such Museum be established, presumably in New York, possibly at the Museum of Science and Industry. . . . Presumably there would be no room for it in the new MMA building, and in any case such an exhibition would be more suitably associated with a technical Museum such as the M of S and I: but it would be of great benefit to students and of undoubted interest to the general public."[8]

Also in Germany, Iris found that "the Reichsfilmarchiv contained *Potemkin*, most famous of the Russian propaganda films, the original negative of which

Goebbels had purchased in 1933 as a model for Nazi propagandists to emulate."
Since in the German film archive she saw an institution whose "sole cause for
existence was to serve the Nazi state," she quickly drew the implication that
"if war came, the film would be used as a military as well as political weapon."[9]
This realization proved consequential for the Film Library.

Taking the isolationism of her adopted country into account, Iris concluded
that "the government and the people of the United States, with their ingrained
distaste for both war and propaganda, could not be persuaded to conduct an
official investigation of film's war potential until war itself was so imminent
that much of the crucial material could no longer be obtained. But could the
Museum, a private institution philanthropically supported and without official
status—could the Museum presume to take upon itself a course of action from
which the government itself would almost certainly recoil if it were suggested?
Well—why not?"[10]

So it appears that Iris, who had been urged by Secretary of State Cordell
Hull to consider what she called "the necessity for reticence and the desirability
of keeping her self-imposed task to herself," developed "a growing conviction
that the motion picture might one day be vital to national defense." She will-
ingly took on the role of government agent. Consequently, along with the silent
films she was acquiring from the Reichsfilmarchiv, she added "a small list of pic-
tures made under Nazi direction. These included *Hitlerjunge Quex* [*Hitler Youth,
Quex*—the nickname of Herbert Norkus, a Hitler Youth member martyred by
Communists in 1932], the first important propaganda film and an eye-opener in
its self-revealing brutishness; *Triumph of the Will*, the vast, impressive record of
the 1934 party conference in Nuremberg widely recognized as the most illu-
minating propaganda film ever made anywhere, and a series of films of the
style and purpose of the propagandist-documentary, *Flieger, Funker, Kanoniere*
[*Pilots, Radio Operators, Gunners*] which gave the world a preview of [German]
dive-bombing."[11]

Leni Riefenstahl supported Iris in her request for acquisitions from the
Reichsfilmarchiv, and later when she and Ernst Hensell, head of the German
archive, arrived with an entourage in New York expecting reciprocal cordiality,
Iris and Abbott suppressed their reservations and entertained "each of the visit-
ing Nazis at dinners from which our friends were conspicuously absent."[12] The
acquisition of Nazi films went unannounced by the Museum, but staff leaks
about it may have been the cause of grumbling among film aficionados that the
Film Library was pro-Nazi.

In Paris, Iris recalled, "producers and government officials alike had not forgotten that in the years of the first World War far too much historic French film had been junked to provide explosives—celluloid and nitroglycerine possessing a common family kinship." Evidencing the "warmest understanding," the Cinémathèque Française bade her to help herself. Working closely with Henri Langlois, Iris was able to obtain film that would have fallen into the hands of the Nazis during the occupation. Indeed, "the Cinémathèque after the war had to turn to . . . the Film Library for new prints and dupe negatives of some of the most important films in the history of the French industry," Iris recalled.[13] This prescience was reflected in Barry's election as Chevalier of the Legion d'Honneur in 1949.

After stops in Moscow, Helsinki, Stockholm, and Warsaw, and finding many archivists interested in foreign productions but unable to obtain the films, Iris began to envision a united organization of film archives. Custom duties, taxes, and other obstacles confronted each of the archivists in ways that made it appealing to consolidate their efforts. "Stopping in Paris on the way back to New York," Iris says she "called a meeting of the various officials she had met with the purpose of forming the International Federation of Film Archives."[14] The United States, France, Britain, Germany, Russia, and Sweden were the first members. The "bold purpose of the new organization," she recalled, "was to persuade the governments involved to recognize motion pictures, when used for non-commercial purposes to be cultural objects like paintings, sculptures, and rare books, to permit their international circulation free of duty or taxation."[15] This plan was delayed somewhat by the spreading world war. The federation would not be officially founded until 1938.

Prior to an official declaration of war, Iris's hopes that the United States would stand beside her native country had to remain muted. "Because of her nativity," as she put it, writing of herself in the third person, "it was obvious where her sympathies must lie," but she also recognized that she "was an official of a public institution in a country still officially neutral and still largely isolationist." Yet she felt "impelled to inform, and if need be to warn, official Washington of what she had learned of the formidable power of Nazi propaganda, to the extent that it was planned and organized, and the need, sooner or later, to combat it effectively."[16]

Iris had earlier met Siegfried Kracauer, the former film critic of the *Frankfurter Zeitung*, and admired his social perspective on film. Kracauer had predicted that Germany would not go Communist and would, instead, support

Hitler. He based his belief on an analysis of popular German films. This study became the thesis of his landmark book, *From Caligari to Hitler* (1947), which he wrote while serving as a member of Iris's staff.

During her visit in 1936, Kracauer was imprisoned in a French concentration camp on the grounds that he was a suspicious German. Despite the fact that "it was certain that Goebbels would like to get his hands on him," Iris recalled, "the undercover emissaries of the Rockefeller Foundation and the Friends Service Committee in unoccupied France discovered that his incarceration in the French camp had saved him: he had remained there in anonymity under the noses of the Nazis. . . . To get him safely out of the country the collaboration of Vichy was necessary—and it was forthcoming! Years before, he had written a book about [Jacques] Offenbach [published in the United States as *Orpheus in Paris*] which had charmed the French with its enchanting picture of Parisian life under the Second Empire. Even the timorous Vichyites remembered and were grateful; they connived with agents of the Museum to sneak him out of the country and in the spring of 1941 he arrived in New York" and was soon hired by the Film Library.[17]

With these political as well as aesthetic agendas, the Film Library of the Museum of Modern Art was expanded during this European trip. While traveling abroad Iris stopped twice at Bognor Regis to dine with her mother and see her son.[18] Throughout these visits she never acknowledged to Robin that she was his mother. Afterwards she went to London, where she waited while Abbott finalized arrangements for shipping films from Germany. Upon flying in from Germany, Iris recalls that her husband "fell foul of English friends of mine with whom I had been awaiting his return in London. He told us how, that same morning, before leaving he had been taken on a tour of inspection of an air field and shown a goodly concentration of what were evidently fighter and bomber planes; he had indeed walked under them. This my friends and particularly Sidney Bernstein vehemently denied, on the grounds that there were not and could not be any such planes in Germany. As Abbott did not much like being given the direct lie, and moreover as the argument soon embraced varied and heated references to the Spanish Republican conflict and bombings there, a quite angry quarrel developed which ended as so often in no conclusion, very bad feeling and our abrupt departure for Paris. This incident was tactfully or forgetfully never referred to subsequently, though we continued to see the same friends later in America during the actual war years and later. But the word 'unpreparedness' always recalled this incident to me."[19]

Iris Barry and John Abbott examining film from their European trip (c. 1937).

(IBP, MoMA Dept. of Film Archives, NY)

Abbott's testiness in London may have been exacerbated by the difficulties of locating some of the films he and Iris were seeking. In an attempt to convey some of the challenges he faced, Abbott posed a question in an article for the *New York Times*: "Just suppose somebody in Paris told you you might locate a rare French film in Berlin. You begin the search by writing letters and making phone calls to Berlin, and invariably receive encouraging replies. You rush there only to discover that a reel or so of the film is missing. Then you are informed that there is a complete print in London.

"Yes. London has the film. Arriving there you find that a portion of the film has been deleted by the censors for some reason or other. Then you are off for Sweden, where the London attendant is quite certain you will find a print of the original film. That is just one illustration of what we had to go through to get one film."[20] Nevertheless, by the end of September 1936, the first shipment of foreign films—twenty-nine German films including Murnau's *The Last Laugh*, Wiene's *The Cabinet of Dr. Caligari*, and Fritz Lang's *Metropolis*—arrived for deposit at the Museum of Modern Art.[21]

Now Europe was onboard. The Film Library had been stocked.

In an attempt to tie up the loose ends in her family life as a wider war threatened, Iris wrote to friends and acquaintances in England about her son. Robin and his grandmother did not get along, and the boy, as Iris had done at his age, yearned to be on his own. Sidney Bernstein again stepped forward, finding Robin a job with an architectural firm and paying them to employ him.[22] He had his secretary locate a room for the boy to rent. The situation for Robin improved steadily, so that by February of 1937 Iris was able to write Sidney that she had "had several letters from Robin who sounds as though he were far happier in his new abode and not too displeased with the office—I am continually so glad that he did burst away (or get pushed, as I suspect) and had the sense to telephone you. It is all so much better: and he is, for the first time, a lucky boy."

She reported that she and Dick "have both been deeply immersed in work, getting out five new programs on 'The Film in Germany and in France.' Dick has taken to lecturing, so have I, it is a bore but a necessity here. And we have to see people, all the time, professors and such. On the other hand we also manage to have our fun, but not with the professors!"[23]

With her son somewhat settled, and films from abroad coming into the library, Iris ended her first year as a film curator.

21

GOING PUBLIC

OLLECTING AND PRESERVATION, to Iris the critical functions of the Film Library, had been going well after a year of operation. The exhibition program, however, suffered a slight misstep in its first encounter with the public. Just as the Hollywood people had expressed their fears that "old" pictures might be laughed at, the first film exhibitions at the Museum of Modern Art found the public unprepared.

Headlining the first public program of the nascent Film Library in January of 1936 was *Queen Elizabeth*, a filmed staging of the play featuring the famed actress Sarah Bernhardt. The film has come to be regarded as an unfortunate subjugation of film to theater, but at the time its exhibition could easily be justified for the glimpse it afforded of the divine Sarah. Under a heading reading "Bernhardt Movie Shown by Museum," which carried a subheading: "Other Old Pictures Seen," an anonymous *New York Times* reviewer noted that

Sarah Bernhardt scored another triumph last night when her motion picture, *Queen Elizabeth*, made in 1911, was shown at the Museum of Modern Art in a program of six early films illustrating the development of the cinema.

Archaic as is Mme. Bernhardt's picture and overwrought as is much of the acting, something shone through the years that affected last night's audience. Often more wiltingly Parisian than regally British, Mme. Bernhardt portrayed Queen Elizabeth in the tragic episode ending in the execution of Essex.

Enough of the poignance of Elizabeth's grief survived in the film to justify Sarah Bernhardt's remark when first asked to act for the screen, "This is my one chance at immortality."

What was calculated, however, to summon tears a generation ago aroused the opposite emotion last night. What should have been the climax of tragedy brought only laughter.

The distraught Elizabeth chose to die in the film by falling forward flat on her face into a large pile of pillows. In a flash the audience changed from hushed emotion to laughter, so suggestive was the incident of awkward comedy.

This was one of six early movies gathered by the Museum of Modern Art Film Library and arranged as its first program illustrating the development of the motion picture. Last night's program launched the public activities of the library, which was established last May by a grant from the Rockefeller Foundation.

It illustrates the history of film art from 1893–94 to 1911. The earliest picture shown was a fifty-foot reel depicting *The Execution of Mary Queen of Scots.* This historic episode also produced laughter, for the headsman's axe fell too obviously not on a regal neck but on a dummy's.

The reviewer remarked that in another short reel entitled *Wash Day Troubles,* "nothing more comic happened . . . than the overturning by a mischievous boy of a wash tub at which presided an overdressed laundress with leg-of-mutton sleeves." Noting that *A Trip to the Moon* had "trick camera effects" and *The Great Train Robbery* was "presented as the 1903 version of the modern gangster-G Men cycle," the reviewer concluded that the 1905 *Faust* had "proved more inadvertently comic than poetic" and that the Bernhardt film alone had "aroused emotion."[1]

Having failed utterly to bring the audience and the *Times* reviewer to an appreciation of film art, the Film Library turned away from public exhibition and concentrated on developing programs for colleges and museums.

Iris clearly had learned from this experience when, almost three years later, she first tested a program of filmed scenes of famous actresses at the Dalton School in New York before sending it out on tour. Of her program, which featured scenes of Sarah Bernhardt and Eleanora Duse, among others, she wrote: "What is presented on the screen is not the inimitable Bernhardt, the incomparable Duse, but the thin shadow of a stage celebrity. Yet since this is all that remains to be studied of the great actresses of the past, affection and curiosity unite to demand the preservation of their films."[2] Having suffered opprobrium on her first outing, Iris thereafter always presented her films with balanced critical notes.

The films the library was collecting comprised a unique resource for film study. An opportunity to demonstrate this came when Iris and Abbott were invited by the Extension Division of Columbia University to teach a course on

the "history and aesthetics of the motion picture," utilizing the Film Library collection as its base.[3] As they were preparing the course, to begin in the fall of 1937, a fire struck their film vaults. James Card, curator of the film collection at George Eastman House in Rochester, New York, and no friend to Iris, claimed that the 1937 "disastrous nitrate fire" went "publicly unreported" and "all but wiped out the Museum's entire 35mm collection, and Iris Barry was forced to go to foreign film archives to replace most of the museum's basic holdings."[4] Card also relates that "Dick Griffith, then Iris Barry's assistant, tells of going into her office, where he could usually expect to find her in a frenzy of activity, but now she just stood looking out the window, staring down onto West Fifty-third Street.[5] Amazed, he asked, 'What are you doing, Iris?' 'I'm waiting for the next disaster to happen,' she answered."[6]

The facts of the fire are somewhat different. On September 23, 1937, Abbott reported to John Marshall of the Rockefeller Foundation that on the night of July 8 "an explosion and fire of unknown origin [destroyed] in all 380,417 feet of negative and 282,571 feet of positive film" located in the film storage vaults in Little Ferry, New Jersey. Fortunately, according to Abbott, there was "a very small loss of material which it is impossible to replace," since separate vaults were used to store negatives, on the one hand, and master negative or duping positives, on the other, of each film, and sufficient material of either kind remained untouched to recover the loss. However, "the necessity to replace the material, at a cost of approximately $63,000, was a very serious blow to the Film Library." The loss was made up by donations of film stock from the Eastman Kodak Company and processing by DeLuxe Laboratories. Additionally, the Rockefeller Foundation authorized a grant of $20,000 to replace material acquired from foreign archives. Subsequently, the Museum reversed its policy of not insuring the film vaults.[7]

In spite of this disaster, the first meeting of the class on film as an art form was held on September 28, 1937, in the reading room of the Film Library at 485 Madison Avenue. After apologizing to the forty-odd participants for the cramped conditions in the room,[8] and promising that the projection room, where the space was equal to taking care of everyone, would be the site of all future classes, Abbott confessed that he was not

> exactly aware of why we are all here. It is a very peculiar situation. I think the result of the talks that I have had with each one of you makes me feel extremely optimistic. This course, so far as we know, is the first definite effort to pursue the field of material in the film, with the opportunity, at the same time,

of looking at the films, themselves. It will be a course in which we will check theory, fact, practice. None of us who is doing the teaching has any knowledge, whatsoever, of how to teach. We are simply depending on the fact that we are all either very much interested in the subject or we wouldn't be here. Members of the class, practically everyone here, has a specific knowledge on some subject. Each one of you has practical experience in writing or working in the film, is interested in some by-line, which has led you to go into an endeavor to find out about the film. It is very curious that suddenly some spirit arises out of general interest—I am certain I don't know what—but almost simultaneously England, France and America have had the formation of film libraries, whereby people could go back and check, and look over again at the material that they had been seeing and becoming accustomed to seeing, and go back and look at it again from the critical point of view.

What we are going to try to do is to give some general, basic idea of the technique of the film, and proceed from that into consideration of the theory and aesthetic of the film.

He then introduced "Miss Iris Barry, who is Curator of the Museum of Modern Art Film Library, who will give you a few words on the film in general."[9]

Iris's initial address to the students remains significant not only for its deft summarization of her point of view on film but also as a model, still valid, for how film can be taught in universities. It is worth considering at length.

As Mr. Abbott has already said, this is a rather odd course, in a way, since so many members of the class who have come to take the course already are, themselves, working practically in the film, or several of them are experienced writers on film or, at any rate, are closely concerned with the film in some way for a long period of time. I think that is going to make the course very much more interesting for all of us, because so many of the students in the course will have a good deal to contribute from their practical experience, in one way or another. It also ought to make it a very cooperative and friendly sort of course. We hope that those who don't agree with what is said here will say so, and if they want to contribute information or opinion, will do so.

In the last part of each session, when the thing is really organized, we shall each week see films. I think you know, roughly, it is supposed to run more or less this way: that the first hour will be a talk or lecture or instruction; the next hour and a half the seeing of films, and the last half a period of discussion.

It seems to me that this first evening that it might be wise, before we begin to think about the film, to dispose of any confusion there may be in any of our minds about art and the film, or the art of the film, or the film as an art. This probably wouldn't be necessary except for the fact that the word 'art' has been so variously understood and defined in the past, and used in so variously and contradictory sort of ways today. . . .

Now, photography and the film have only very recently been designed as arts, or recognized or accepted as arts. There is a sort of vague feeling in many quarters—I think many of us have been guilty of it—that a film which is artistic is one in which the eye sees something which looks like a painting; that an artistic film has little popular appeal but ought to be admired because the person who made it was patiently trying to produce something that would look like a work of art. That, of course, is absolutely not the case at all. In fact, the contrary is entirely true. The film—and this is all elementary but it has to be said before we can start in actually attacking the film—the film is a popular art. This may be confusing, but an artistic film is often or may be a film about which there is something a little wrong.

During these classes and meetings of ours, we shall see in the films themselves, how very popular the essential ingredients of the film were right at the beginning. Dr. [Erwin] Panofsky[10] has defined them extremely well in an article I would like to bring to your attention later—that is to say, the essential ingredients of the film. We shall be able to consider the conditions under which films used to be made and still are made, how films were received by people in the past and how we receive them today. While doing all this it would be impossible, I imagine, not to realize very, very sharply, indeed, while examining the films, themselves, and reconsidering their history and the story of their development, that to live in the world of today without the fullest possible knowledge of the motion picture, is rather to limit oneself in the same way as a person would have done in the Fifteenth Century had he or she willfully or carelessly ignored the existence of the printed book. They had then, we have now, a new means of communication. The film is the one which is perhaps most typical and characteristic of our age, which explains again why so many of us are here tonight, drawn by all sorts of different interests in the film; why we should come together and wish to re-examine this popular entertainment, as it is often called.

There can hardly be anybody here or living who hasn't seen a piece of film. I mean a strip of film. It might be useful, for a moment, to consider exactly what a piece of film is. It resembles an ordinary roll of film which you

put into your camera to take snaps with. It has holes on one or both sides with or without photographic recordings of sound alongside, 16 divisions to a foot of the film, called frames, and each of them bearing a still picture. The still pictures when projected, create an illusion of movement. In one sense, that is all there is to it. The only other thing is what sort of pictures are on the film, and in what sort of combination. It is quite obvious that all the pictures, the images on a strip of film, must either be a series of images photographed continuously without a break, or photographed discontinuously and joined together. In other words, if you want to film a man on horseback coming close to the camera, you can grind away until he comes up to the camera, or economize by photographing him at a distance, and then, half-way along, then get him quite close, and join those together, by doing which you not merely economize, but may give a less boring and equally accurate impression of a man approaching on horseback. All of this being exceedingly elementary, it is sometimes useful to recall once more.

Then again, the subject matter of a film can only be one of two things: something which is real, actually existing in the world at the time it was taken, or something imagined. We might extend 'imagined' to include the recollected or reconstructed. The Marx Brothers, in *A Day at the Races* is obviously an imagined thing; the *Zola* film which is current now is reconstructed. *The Birth of a Nation* had a good deal of imagined material as well as some reconstruction, and a newsreel is something actual. At times it is difficult to tell, however, whether you are seeing an actual record of something that happened or a reconstruction of it, as, for instance, in *The March of Time* or in *The Bitter Tea of General Yen*, which appeared to open with a newsreel of the bombing of Shanghai in 1932. Actually, there was a newsreel of this made in '32, but the beginning of *The Bitter Tea of General Yen* was studio-made.

In either method, however, the creative element is bound to enter. One man making a newsreel of the burning of the Hindenberg will not make quite the same film as another man, and even the same film handled by two different firms might be different. Then again, the identical film as seen by different people communicates, at times, a quite different idea. A man, in making a film, can do one of four things: he can choose, as a subject, something which may be taken to be of interest, and he can make that film effectively or not; he may choose a subject which is not commonly thought to be of interest, and he can film that well or not. That is a very useful thing to remember when looking at a film and judging a whole or a part of it.

Throughout the . . . meetings and discussions that we shall have, there will be a good deal of opportunity to consider the different kinds of film, not merely the narrative or dramatic film, whichever you prefer to call it, but all the many different kinds there are. From the absolutely straightforward record of something taken for a scientific purpose, such as the film of a surgical operation, where the camera is used to assist or extend normal vision; –the educational film, which is intended to impart information; –the newsreel or travel film, which is meant to please, and also extends individual or collective experience; –the documentary film, in which, as a rule, a statement is made or implied about something actual. There is a distinctive difference, obviously, between the travel film . . . where the intention is clearly to show you something which you can't, perhaps, readily see, yourselves, and a documentary film, such as the English *Song of Ceylon*, in which it is possible to detect that the person making the film did not merely desire to show you something, but wished to make you form an opinion or come to certain conclusions about something. Then, there are the many varieties of fictional films that are like plays and novels, like illustrations of novels, etc. Then, the animated cartoon, the abstract film which, when purely abstract, presents no image of any recognizable object and, as a consequence, is called non-representational. They are rather few and far between. In Western or Cowboy films, there is something of the travel films, too. *A Day at the Races* contains some newsreels, a purely scientific film may strike many as aesthetically pleasing. In almost all films there is an advantageous quality which is not apparent at the time the film is made. Every film conveys some information about the era in which it was made, the people who made it, the race who made it, and certain conditions under which it was made. This becomes visible as the film becomes older. Almost any film which you see twenty years after it was made has something which the makers never intended to put there. We have, for instance, the last three reels of a four-reel film of Sarah Bernhardt in *Camille*. It is not merely interesting to most people who see it because it shows Sarah Bernhardt, is a record of a performance of a dead, famous personality, nor is it merely interesting because it catches and records a glimpse of a vanished style of acting, of a theatre which no longer exists, but because it also, rather oddly—and certainly the person who made the film did not intend—tells one something about what people were like before the war that they are not like now.

Iris concluded with an eloquent plea for aesthetic tolerance:

> I would very much like to suggest that since we have the opportunity for re-examining the film right from the beginning all the way through, it would be perhaps the most practical method if, as far as it is humanly possible, instructors and students, too, would drop all their preconceived ideas and even, in a sense, their knowledge, certainly their theories, and then, in order to approach the subject as objectively as possible, in order to get as much out of it as possible, look at the film, to begin with, as though one had never seen one before, or never read a book about the film before. This will have several results, of which I think one of the best ought to be that it will help us in the very difficult task of avoiding doing one thing, which is not to force on this medium, on the film, any one of the traditions, peculiarities, virtues, necessities that hold good as regards the other arts.[11]

Film historian and critic Arthur Knight, who got his start working for Iris, recalled that among his fellow students in the Columbia class were Irving Reis, who worked at CBS; Felicia Lamport, who became a novelist; and Janet Graves and Ezra Goodman, who also became film critics.

"The whole point," Knight recalled, "is that the very existence of this class . . . not only touched, but changed our lives. We who loved the movies suddenly found that they had the cachet of the Museum of Modern Art, that what we loved was not merely a popular entertainment, but a powerful and pervasive art form. And we were in the vanguard of those who appreciated this. For many of us, the goal became to spread this appreciation, to proselytize for better films, better audiences, and more and better film schools." He added that his own popular Thursday night class at the University of Southern California was "patterned precisely after those long-ago Tuesdays with Iris Barry."

Knight also recalled "that day early in 1939 when I ran up to 485 Madison to do some research on my lunch hour. Iris was on the floor of the reading room, leafing her way through the *Encyclopedia Britannica.* She looked up at me through her glasses and said, 'Arthur, you're here so much of the time anyway. How would you like to get paid for it?' How would I like to get paid for it! If I could have afforded it in those Depression-ridden days, I'd have cheerfully done it for nothing."

Knight took over Iris's old job as Librarian. "The pay was $30 a week," he recalled, "and a 12-hour day (or longer) was not exceptional. But nobody told me to do it, nobody *asked* me to do it. I was working with books that I knew and

loved, and arranging them for shelving and cataloguing in categories that had never existed before."[12]

Iris's allusion to an essay by art historian Erwin Panofsky may trace back to the Askew Salon. Iris Barry approached Panofsky of the Institute for Advanced Study at Princeton in 1934, possibly at the Askews, seeking his support for her plans to create the Film Library. After the library was established, she lent him films for his innovative lecture at the Metropolitan Museum on November 16, 1936, entitled, "The Motion Picture as Art." The sold-out lecture provoked a headline in that day's *New York Herald Tribune* announcing, "Films Are Treated as a Real Art by Lecturer at Metropolitan." In the words of Princeton scholar Thomas Levin, "Panofsky gave an intellectual (art historical) and cultural (continental) imprimatur to MoMA's pioneering move to establish a serious archival and scholarly center for the study, preservation and dissemination of the history of cinema."[13]

Panofsky's affinities with Barry involve matters both of style and substance. Like Barry he was, by his own admission, "a constant movie-goer since 1905."[14] Hence, he did not shy away from admitting his affections for a popular medium. More substantially, Panofsky shared Barry's methodology for defining cinema. Both sought to define film art not by identifying its commonalities with established arts, as Vachel Lindsay had done, but by articulating what made cinema different from and unique among the arts. Both Barry and Panofsky focused upon the plasticity of space and time in the new medium as its distinguishing characteristic. Plasticity of space took precedence. A film can range widely into visual space, circling around its objects, positioning and repositioning them with a facility not found in the other arts. Theater, by contrast, is confined to the real-time movements of actors in a proscenium box; cinema can take us anywhere. The movies also rearrange time with ease, flashing back and forward in time with all the malleability of dreaming. Both Barry and Panofsky recognized the dreamlike quality of the cinema, and both would have urged film audiences to "ask for better dreams."

The dreamlike nature of the cinema also had a cultural and iconographic dimension both for Panofsky and Barry. Not only does the audience apply its own iconographic vocabulary to the cinema, dividing it roughly into genres distinguished by recognizable types—the cowboy hero, the gumshoe, the vamp, etc.—the motion picture, by its very nature as a popular medium, reflects to its audience larger cultural and historical concerns, making possible the kind of analysis exemplified by Siegfried Kracauer in *From Caligari to Hitler* and the later works of Stanley Cavell and Robert Sklar. For these reasons Iris Barry found a

kindred soul in Panofsky, and she kept him on her film advisory committee at MoMA for most of her tenure there.

As another outreach effort in the fall of 1937, the Film Library decided to produce a film about the art of filmmaking. It was to be coordinated by Paul Rotha, the British documentary producer who arrived in late September to begin work. "The idea is just an idea," Abbott told Bosley Crowther of the *New York Times*. "But we feel if we can reproduce visually the component parts which go into the final make-up of an emotional film, we will have established a dictionary—a set of values—for the art."[15]

Rotha intended the film to address two sets of issues: the nomenclature having to do with film technique ("cut," "pan," "dissolve," etc.) and the broader issues of filmmaking style and approach. He and Abbott agreed that their focus should not be on the director alone, but also include the contributions of camera operators and others on the set. "You see," Abbott told Crowther, "we are approaching the field on this basis: that the film cannot possibly be an individual effort. It must be communal. Even the smallest picture must be a communal job."[16] Rotha and Abbott felt that matters such as these were too difficult to explain verbally and could best be illustrated through the film medium itself.

When completed in December, the film was included in an exhibition titled "The Making of a Contemporary Film," described by the *Times* as "the first major exhibition organized by the Museum of Modern Art Film Library." The *Times* noted that "the motion picture thus illustrated, from original script to make-up, costumes and 'sneak preview,' is the David O. Selznick technicolor filming of *The Adventures of Tom Sawyer*, not yet released."[17] Selznick, not coincidentally, was a partner with MoMA trustee John Hay Whitney in developing the Technicolor process. His involvement suggested a potential symbiosis between motion picture production and the Museum's new Film Library. In this manner the Film Library closed out 1937, the second year of its existence. It was becoming a force to be reckoned with.

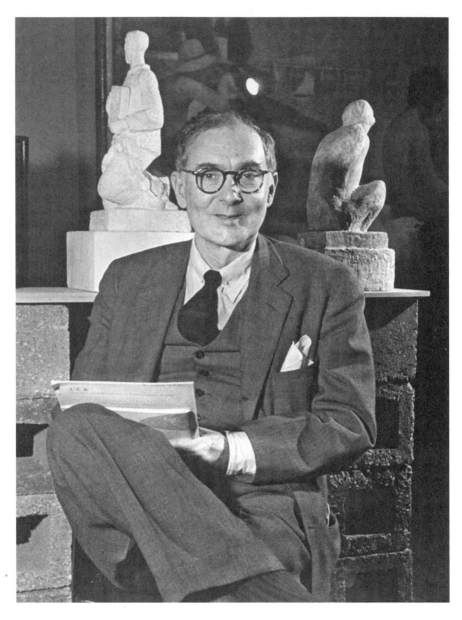

Alfred Barr, Jr. (Photograph by Carl Mydans)

22

THE SLOW MARTYRDOM
OF ALFRED BARR

THE SUPPORT OF Alfred Barr, as we have seen, was critical in securing a place for film in the Museum of Modern Art. Barr's position as director of the Museum, however, was never totally secure. Although most accounts of his professional difficulties focus on the year 1943, his troubles began much earlier. John Abbott played a major role in Barr's undoing.

The focus on 1943 seems to derive from the account of Barr's "firing" in Russell Lynes's canonical study of the Museum, *Good Old Modern* (1973). Other writers, among them Serge Guilbaut and Alice Marquis, have followed Lynes in attributing Barr's demotion to his decisions to exhibit naïve American art works such as the work of Morris Hirshfield and, in 1942, the infamous shoeshine stand decorated by its owner, Joe Milone.[1] Documents uncovered in the course of this research, however, reveal that Alfred Barr's position at the Museum was internally unstable as early as 1937, and that authorities such as the Museum's president Conger Goodyear and its founder Abby Aldrich Rockefeller, whom the Barrs regarded as allies, were less than totally supportive. Thomas Mabry, who held the title of Secretary and Executive Director of the Museum, a position Abbott would later assume, wrote in confidence to Goodyear as early as June of 1937 that, although he did not "want in any way to seem disloyal to Alfred as Director of the Museum . . . nevertheless I have recently had such a difficult time with him that I am writing confidentially to ask you, if you should happen to talk with him about the matter, to try to persuade him that the new interest that has been shown in enlarging the Department of Industrial Design does not 'threaten' the Department of Architecture."[2]

Barr apparently feared that initiatives to the Museum board regarding the field of industrial design being made by Monroe Wheeler and others threatened the hegemony of the Museum's Department of Architecture over matters having to do with industrial design and imperiled the continued funding of

that department, headed by his friend, John McAndrew. Wheeler was head of the publishing company Harweal, Inc. in New York and had not yet begun his long association with the Museum as head of publications. Talk of reorganizing the Museum was in the air in 1937, and Wheeler stood ready to write a plan that would launch a new Department of Industrial Design. Barr resisted Wheeler's effort, refusing to endorse it and subjecting him to various inquisitions.

"For some weeks Alfred was so opposed to Wheeler," Mabry wrote in a cover letter to a copy of his letter to Goodyear sent to trustee Nelson Rockefeller, "that, frankly, if I had not taken a hand in the matter, I don't think Wheeler would have felt there was any use in trying to go ahead. And now I should think he may not want to undertake what will result in an enormous job, when Alfred has so repeatedly given him to understand that he is to work always under the direction of John McAndrew, Curator of the Department of Architecture."[3] Mabry then sought authority to control Barr, complaining to Rockefeller that "what I feel I must have is the authority to encourage and endorse the various plans that are put before Alfred, if I am convinced that they deserve the Museum's consideration." Mabry was, however, "sorry to say that I have found that Alfred antagonized many people to the extent that they are reluctant to give us their support, and it seems to me imperative at this moment when so many irons are in the fire, that I take a firmer tone with Alfred. He has my deepest affection, and as I wrote to Mr. Goodyear, no one could have served the Museum so well. But I cannot any longer stand by and see the future of the Museum jeopardized by Alfred's disinclination to make up his mind, and by his purism."[4]

Barr's "purism," Mabry explained in his letter to Goodyear, was leading to administrative inactivity. "At the times when he ought to be using the talents and energies of others, he is critically judging the purity of their tastes. On the one hand, his inability to make up his own mind, and on the other, his disinclination to depute responsibility, result often in a kind of stale-mate which, although I have grown accustomed to [it], I feel is often interpreted to our disadvantage by people outside the Museum." Mabry told Goodyear that if he would "care to discuss what I have written with Nelson or Mrs. Rockefeller I would be grateful."[5] By sending a copy of the Goodyear letter to Nelson Rockefeller, Mabry guaranteed that both would get involved.

Mabry's machinations against Barr clearly were not just self-initiated. He was aware of ambivalence toward Barr in parts of the board leadership, and he sought to solidify his maneuvering with blessings from above. Nelson Rockefeller and Conger Goodyear already were considering restructuring the

Museum. Mabry mentioned the formation of restructuring plans in May of 1938, when he wrote to Rockefeller of "your plan to place the artistic end of the Museum under the guidance of Mr. Clark [trustee Stephen Clark] and the executive end under your own supervision."[6] Mabry "heartily" endorsed such a plan and fawningly expressed his allegiance to Rockefeller by volunteering: "I may as well say this too: I should very much like to see you as President of the Museum in the immediate future. I have long deplored the fact that our present President [Goodyear] assumes no responsibility of any serious nature and that his motivations are often influenced by superficialities."[7]

In the spring of 1938 Iris and Dick Abbott joined the Barrs in Paris, where the Museum of Modern Art was invited to present an exhibition at the Jeu de Paume museum focusing on American accomplishments over three centuries in painting, sculpture, literature, architecture, photography, film, and technological inventiveness. A project of MoMA's board chairman Goodyear and a French friend of Mrs. Rockefeller's, Eustache de Lorey, the exhibition proved a mixed success, with most visitors interested principally in the films projected daily by the Film Library. The French preference for the film component of the exhibition may have been tinged with a certain disdain for American painting at the time, but this early triumph of the Film Library resonated with Goodyear and strengthened the profile of film within the Museum.

Although Margaret Barr, even many years later in her eighties, regarded Conger Goodyear as an ally of her husband, research reveals that Barr's support in 1938 was eroding on several fronts. While the Barrs were in Paris, Nelson Rockefeller as incoming president of the board was seeking new leadership for the Museum. Rockefeller had received from Goodyear a letter indicating that he had been visited by Joseph Hudnut, dean of the Graduate School of Design at Harvard University, "to discuss the suggestion that he become the head of our Museum staff." Goodyear told him that, "for the time being at least, we had decided that we would not adopt the plan of having a salaried President, . . . if he came with us we would expect him to take charge as executive head of the Museum to whom all department heads would report," effectively replacing Barr seven years before the date Russell Lynes gives in *Good Old Modern* for Barr's "firing."[8]

Goodyear offered Hudnut a salary of $15,000 a year, a contract for five years, and reported to Nelson Rockefeller that "Mrs. Rockefeller had talked with President Conant [of Harvard] about the possibility of his [Hudnut's] coming with us and that President Conant said that, while he was reluctant to part with him, he would not stand in the way of Mr. Hudnut's making the change if he

decided that he wished to do so."[9] Hudnut told Goodyear that Walter Gropius could serve as his successor "and in general [he] seemed very much interested in the possibility of coming with us."[10]

In the end Hudnut demurred. He cited inexperience in Museum work, and pressing obligations in Cambridge, in declining the position on June 20, 1938.[11] Not content to give up on replacing Barr, however, Goodyear wrote on September 23, 1938, to trustees Stephen Clark and Nelson Rockefeller that "we might consider employing Holger Cahill" in a new position having to do with "nationalizing" the Museum. Cahill, Goodyear suggested, could be made co-equal with Barr and Mabry, leaving them "with a staff from which we might ultimately develop someone to be made the President of the Museum."[12] Cahill, who had distinguished himself as an exhibitor of contemporary and folk art at the Newark Museum, had briefly substituted for Barr in 1932–33 when Barr was on leave. He also headed the successful Federal Arts Project during the Depression.

It is clear, then, that despite Margaret Barr's impression that Goodyear was supportive, Nelson Rockefeller disruptive, and Stephen Clark the ultimate nemesis of her husband, and despite her long-standing appreciation of Abby Aldrich Rockefeller, these people, and others as well, were undermining Barr's leadership as early as 1937.

Goodyear, however, appeared to be a stalwart supporter and friend to Alfred Barr (Mrs. Barr called him "a man of considerable museum experience"),[13] and it was only after he was replaced as board chairman by 30-year-old Nelson Rockefeller that Barr's position of power within the Museum truly began to wane. On the occasion of his succession on May 8, 1939, Rockefeller insulted Goodyear by presenting him with a trompe l'oeil painting of a dollar bill by William Harnett.[14] Goodyear was a collector of modern European paintings and easily understood the insult young Rockefeller was giving him, though he did not show it. According to his nephew, Tom Goodyear, he was quietly furious and afterwards, upon approaching his waiting limousine in front of the Museum, smashed his hand through one of its windows.[15]

In this stormy manner the inheritor of the patent for vulcanizing rubber, a process indispensable for manufacturing automobile tires, ceded control of the Museum to the scion of the largest oil company in the world. Rockefeller set about reshaping the Museum in his own image, commissioning what the staff viewed derisively as "efficiency experts" to analyze the workings of the Museum and seeking to put the institution on a "businesslike" footing. In Margaret Barr's view the experts "could not make out what its [the Museum's] purpose was, nor

how it went about its business."[16] To her "they were bad news," but Alfred did not foresee "the consequences of their reports" and the fact that Rockefeller had bypassed "Alfred's authority as director of the museum" and "played havoc with its central nervous system."[17]

In early summer of 1939 while again in Paris making preparations for a Pablo Picasso exhibition due to open November 15, Alfred Barr received a cablegram from photography curator Beaumont Newhall and key members of the Museum staff informing him of the dismissal of Frances Collins, director of publications, and of the Executive Director of the Museum, Thomas Mabry. Margaret Barr said she and Alfred were "stunned" by this. Collins had been a friend of Margaret Barr's since Vassar and had produced "single-handed some of the museum's most admired catalogues" and now was being "thrown out on the streets with no warning, no separation pay." Mabry, whom Mrs. Barr called "very suitable for his job," was "suddenly unemployed."[18] Although he didn't realize it at the time, this was also the end of Alfred Barr's primacy as leader of the Museum.

In a move that it would have been difficult to predict, ascending to Mabry's position as Executive Director of MoMA was the head of its Film Library, Dick Abbott, a man admired both by Rockefeller and Clark as a no-nonsense money manager and faithful factotum. At the same time, Monroe Wheeler was appointed director of publications.[19] The Nelson Rockefeller years at MoMA were beginning to take shape.

After Nelson Rockefeller assumed the board chairmanship and presidency of the Museum, Margaret Barr recalls that "Mrs. Rockefeller consciously diminishes her involvement so as not to interfere with her son's newly acquired position."[20] Alfred Barr "sees her less often."[21] In January of 1940, Dick Abbott, Monroe Wheeler, and Alfred Barr were jointly appointed to the Board of Trustees. Barr had been reassigned, in effect, as an employee of Executive Director Dick Abbott.

By the fall of 1940, Nelson Rockefeller was increasingly involved in government work, focusing on how the Roosevelt administration might deal with the Nazi threat in Latin America and protect his own family's interests there. Meanwhile, shifts in the power dynamics were continuing at the Museum, further undermining Barr's authority and leaving the institution increasingly without coherent leadership. The new board chairman, Stephen Clark, with Mrs. Rockefeller's approval, relieved Barr of his responsibility for Museum exhibitions by appointing Monroe Wheeler, director of exhibitions as well as publications head.[22] The ostensible reason was to give Barr more time to write.

In Margaret Barr's words, they were "intent on making him [Alfred] produce a book on modern art."[23] Drawn away by his government work, in January of 1941 Nelson Rockefeller resigned as president of the Museum and was succeeded by Jock Whitney, a principal supporter of the Film Library since its inception. To Barr's dismay, on his way out Rockefeller saw to it that Barr's friend John McAndrew would be terminated within six months as director of the Museum's Department of Architecture.[24] McAndrew was remembered by Stanton Catlin, who served as Abbott's chief assistant on Rockefeller's emerging Latin American art projects, as "a very articulate, buoyant scholar of strong likes and dislikes . . . that just didn't fit in with Nelson's way."[25] These shifts made it easier for other staff members, Executive Director Abbott principal among them, to increase their influence over the day-to-day operations of the Museum. By 1940 Alfred Barr had lost control of his position at the institution he had created.

As a result, according to Margaret Barr, the "morale of the museum gradually eroded by the practice of hiring and firing by the trustees without consultation with Alfred as director. Factionalism sets in. Iris Barry alludes to A. [Alfred] as the 'eminence grise.' She likes the expression so much that she uses it inadvertently even while speaking to M. [Margaret]. Late after dinner one evening John Abbott swears at A. using the standard four-letter word. Iris giggles. A. ignores."[26]

Enter Stephen Clark, thread and sewing machine magnate and usually regarded as the Evil One by Alfred Barr admirers. In the fall of 1942, just after Pearl Harbor and the United States' entry into World War II, Clark took over both as president of the Museum and chairman of its board, relieving Whitney, who had been commissioned an officer in the Army Air Corps. Whitney wound up in the Office of Strategic Services, General Donovan's intelligence agency, precursor to the Central Intelligence Agency.

With Clark's backing, Abbott's control over the Museum was secured. Abbott, who shared Clark's love of baseball,[27] emerged as the conduit through which decision-making at the Museum ran. Over lunch at the University Club on December 15, 1942, Clark, according to Margaret Barr's chronology, "informs A. that unless he resumes his literary activities his usefulness to the museum will end."[28] Clark proposed replacing Barr with Barr's assistant, James Thrall Soby, giving Soby control over "artistic matters" of the Museum.

The "firing" of Alfred Barr is a legendary event in the U.S. museum world. Yet to be understood, however, is the relationship of his demotion to the rise of the Film Library and the fortunes of John Abbott and Iris Barry. The exhibition in 1942 of Joe Milone's shoeshine stand did outrage the trustees. However,

their discontent only added support to Clark's ongoing attempt to get rid of Barr. Clark, whom curator Dorothy Miller claimed to be jealous of Barr for his superior knowledge of art,[29] decided to take action.

Throughout 1943 Barr's role at the Museum remained ambiguous. Ostensibly, he was at work on the book Clark and Mrs. Rockefeller required of him. In September *What Is Modern Painting?* (nicknamed WIMP by the staff) was published, but this brief survey did not satisfy Clark. On October 16, "a gray Saturday," according to Margaret Barr, Alfred seemed "listless." She prevailed on him to go to an afternoon movie. On the way home he informed her that a letter had arrived from Mr. Clark

asking him to resign. The letter is three pages long, single-spaced. The main grievance is that A. has not produced the book on modern art that Mr. Clark and Mrs. Rockefeller have ordered him to write:

The amount of time you are able to devote to unimportant matters and to philosophical discussions in the course of a presumably busy day has been a constant source of wonderment to me. . . . In these difficult times the relatively unimportant work you are doing does not justify a salary of $12,000 a year. . . . In the interest of the Museum you should assume the position of Advisory Director at a salary of $6,000 a year . . . this letter has been written with the approval of a group of our more active and influential Trustees, but without the knowledge of any member of the staff.

The effect on A. is one of nausea and contempt for the obtuseness of Clark, who obviously has no understanding of the scope or purpose of the museum. M. is torn between shock and outrage at this heartless dismissal. Fearful for the future, she consults an indigent friend and asks, "How does one live more cheaply?" The friend advises, "You take a Madison Avenue bus, not the Fifth." In the house there is a sense of nightmare. A. won't go out. He won't dress. He won't eat. He sits at his desk formulating answers to Stephen Clark.[30]

Dorothy Miller recalled that Alfred "called me and asked to have lunch and we chose a place nobody would be likely to meet him, near Central Park which he adored and knew everything about. We'd meet and walk in the park until he had to go home. For a while I was the only person in the Museum who saw him. He was annihilated, but he was a strong man. He pulled himself out of that tragedy."[31]

Ultimately, Barr gave in. He composed his own resignation letter and read it to the staff on October 27. In it he conceded that he had "not been able to give enough attention to the book on modern art which I have been planning and which the Trustees have long wanted me to write," and said that "in order to find time and peace of mind for writing, it seems best that I should take the position of Advisory Director" in which he would "no longer be involved in administrative or curatorial responsibilities, and shall work as much as possible outside the Museum."[32]

In alliance with Clark, Abbott was manipulating these events. As Miller put it, "Abbott called a meeting of department heads and made Alfred announce that he was resigning from the ship. We were totally stunned. We knew Alfred never would have done that on his own."[33]

Work outside the Museum he had conceived of and created? Even though Barr appealed to the staff that "though these changes may come to you as a surprise I would like to ask you as my friends and loyal members of the staff to accept them and go on with your work,"[34] and despite the further heartache of a letter from Mrs. Rockefeller telling him that the demotion was "for his own good," in the end it was Abbott who dealt Barr the cruelest blow. On November 12, Barr, as Margaret Barr put it, became "conscious of Abbott's ill will."[35] Abbott put Barr out of his old office and refused to designate a space anywhere in the Museum for him to occupy. To Dorothy Miller the situation was unambiguous: "Dick Abbott engineered with Clark to fire Alfred Barr so he could replace him."[36]

Several key staff members also held the view that Abbott was the point man in the firing of Alfred Barr. James Thrall Soby concurred with Miller's view that Abbott lobbied against Barr with Clark. As Barr's assistant director, Soby tried to spare Barr the pain of being fired. "I've always thought it was a great mistake to have Alfred step down from a job he'd held since the Museum was founded and in which he could easily have served with great distinction for another twenty years," Soby wrote in retrospect. "I remember vividly an afternoon in his apartment when Marga Barr and I tried to persuade him to resign and let me resign along with him. . . . I told him two leading staff members, on the executive rather than the curatorial side, had been undermining him for years with Stephen Clark, the Chairman of the Museum's Board of Trustees. Alfred refused to believe me, though I had plenty of first-hand evidence. He liked one of the two very much personally, and thought the other an able staff member and that was that: his loyalty to them was unshakable and to the Museum absolute, to the point of self-immolation."[37]

A footnote to Soby's remark indicates that in a letter dated March 7, 1971, to Russell Lynes, at that time at work on his history of the Museum, *Good Old Modern*, Soby revealed that "Since Dick [John Abbott] is now dead, I can tell you that he and [his assistant] Frances Hawkins [Secretary of the Museum]—a very bright and terribly neurotic woman—were in great part responsible for Alfred's temporary downfall. Yet Alfred would never hear a word against Dick, though he must have known that Dick and Hawkins were constantly bombarding him to Clark: I heard them do it a number of times and bawled them out for it."[38]

Alfred Barr's demotion was noted in small type in a back page of the Museum of Modern Art's *Bulletin* of February–March 1944. Above an ad reading "Wanted: Objects for Industrial Design Exhibition" and under a heading reading "Staff Appointments," notice was given that "Mr. Clark has also announced that Alfred H. Barr, Jr. has retired as Director of the Museum in order to devote his full time to writing the works on modern art which he has had in preparation and which his heavy directorial duties have made impossible for him to undertake. Mr. Barr, however, will continue to serve as Advisory Director. Mr. Barr's curatorial duties have been taken over by James Thrall Soby, who was elected a Trustee in April 1942 and appointed Assistant Director of the Museum in January 1943."[39]

The public perception of Alfred Barr's firing, on the other hand, differed significantly from the views of the Barrs themselves or those of the Museum staff. Barr had long been taking criticism from the art world press about his collection and exhibition practices and about his perceived lack of support for U.S. artists. According to Emily Genauer, art editor of the *New York World-Telegram*, writing in *Harper's*, Barr was perceived by the art world's cognoscenti as out of touch with the cutting edge of American art. She cited a Summer 1943 article in *Art Digest*, which claimed that "Art to these amiable folk [MoMA officials and trustees] is something to make fashionable conversation, finding cultural intoxication as they whiff the fragrant chi-chi flower. . . . While serious professional artists fight for recognition that means life to them, the Modern fiddles away its resources, building a precious cult around amateurism."[40]

Another controversy accompanied the Museum's exhibition of "outsider" artist Morris Hirshfield's paintings in 1943, a show assembled by the art dealer Sidney Janis and endorsed by Barr. Hirshfield's human figures were distinguished by the possession of two left feet. This exhibition, coincident with the transfer of leadership at the Museum from Goodyear to Rockefeller to Stephen Clark, drew more opprobrium from the outgoing "supportive" Goodyear than the Barrs later cared to remember. Genauer quotes a letter from Goodyear to

Clark sent in July of 1943 saying that "it seems to me that this exhibition is very silly, perhaps the silliest we have ever had, and that I think is saying a good deal. . . . I have acquiesced in this exhibition, but I certainly am not going to do so in the future. . . . Really I think we must put a stop to it. It would be far better to have no exhibitions at all than things of this sort. . . . I think that together we can stop the present tendency."[41]

Thus Hirshfield, a retired Brooklyn shoe manufacturer whom Genauer described as "a quiet-spoken man who had meant only to occupy himself in his declining years by harmless puttering with paint and canvas," inadvertently became another catalyst in the decline of Alfred Barr. It was, Genauer recounts, only two months after the Hirshfield exhibition that Barr made the "bombshell announcement" that he was "retiring."[42]

According to Genauer, "the art world was galvanized by the announcement." Nevertheless, few outside or inside the Museum knew of the history and consequences of Barr's demotion within the power structure of the Museum. While Barr was derided both for real and imagined inadequacies of leadership, a vacuum was created that left the decision-making process open to manipulation by employees cozying up to trustees. Into this void stepped Dick Abbott, whom Genauer cited as among the more dubious assets of the Museum. Abbott, whom she reported "had been working as—to use his own words—an 'office boy, messenger boy, mail sorter, and bookkeeper' in one of the more conservative Wall Street houses became at the age of twenty-six the Director of the Museum's Film Library, in 1939 became executive vice president of the Museum and since Barr's retirement has been the top administrator of the institution." Hiring people like Abbott, who enter the Museum through personal connections, namely his marriage to Iris, seemed to Genauer "an unreliable method of recruitment."[43]

The frigid atmosphere at the Museum during the winter of 1943 came at a time when Rockefeller and Whitney were engaged in war work. Other long-term trustees such as Eddie Warburg and Philip Johnson were in the army, and Paul Sachs, Frank Crowninshield, and Duncan Phillips, who had long institutional memories of the Museum, were honorary trustees with no voting capacity. As Barr's biographer Alice Goldfarb Marquis put it,

> the board fell into the grip of conservative, elderly trustees led by President Stephen Clark, the severe, humorless, black-clad heir to the Singer sewing machine and Clark thread fortunes. During the twenties, he had accumulated some of the choicest modern works of the previous decades, but he

was frankly dubious about the more recent art which intrigued Barr. . . . He had also resisted the museum's involvement with films, photography, and industrial design and served still as a trustee of the Metropolitan Museum, where the MoMA's lively publicity and innovative exhibitions were viewed as unseemly pandering to the mob.

Some of Clark's notions about proper displays of art must have struck Barr as distinctly tacky. In the late 1920s Clark had remodeled a gym on the top floor of his gray Gothic mansion on Seventieth Street between Madison and Park avenues as a Matisse room, with blue curtains, red-checked table-cloths, polka-dot pillows, and crockery imitating the paintings on the walls. When Clark proudly displayed this room to the artist in 1930, Matisse had been appalled.[44]

Abbott's growing status as a pariah among the staff tended to isolate Iris from her colleagues at the Museum. When, as Dorothy Miller put it, "executive control over the Museum was taken away from Barr and handed over to Abbott, the staff threatened to resign. Iris had already in general lost the friendship of the staff. She married Abbott purely for her own advancement. In that time one needed a man. There was no love lost between them. The staff in general, after having been fascinated with Iris, then learned to distrust her."[45]

To Mrs. Barr, however, the rise of Abbott and the decline of her husband did not immediately redound to Abbott's disfavor. Dick Abbott's "line of action in late '43 and early '44," she claims, did not "undermine his tenure." On the contrary, "Abbott continued on his way under the protection of Stephen Clark and Iris proceeded happily and ambitiously and Alfred went into his cubbyhole."[46]

Alfred Barr did not cease to play an important role at the Museum. His influence found sustenance in the person of James Thrall Soby, whom Clark had chosen to replace Barr as head of the Department of Painting and Sculpture. Soby was a wealthy industrialist from Hartford, Connecticut, and a friend of Chick Austin's. Margaret Barr recalled that Soby could speak "man to man" with Clark, and helped to make him "understand the value of A. [Alfred] to the Museum, although he cannot make him understand what the museum is all about."[47] Barr was soon rehired as Director of Collections. Because of his wealth, Soby was able to guarantee Barr the funds to purchase paintings for the Museum he otherwise might not be able to convince Clark and the trustees to buy. Meanwhile, Clark continued to pressure Barr by keeping his salary low and decided to raise funds for the Museum by cashing in on the sale of works of art. On May 11 he held a sale at the Parke-Bernet Galleries billed as "Notable

Modern Paintings and Sculptures that Are the Property of the Museum [of Modern Art], With Additions from Members of the Board of Trustees and Advisory Committee."[48] Barr's precious paintings were put up for sale.

The Museum of Modern Art remained without a true director until October 1949, when the appointment of Rene d'Harnoncourt coincided with the end of the Abbott era. Recalling Abbott's regime, Soby's widow, Nellie, said of him: "Abbott, now there was a flat tire, wasn't he?"[49] In Abbott Iris had made another fateful choice in a man. It was not, as Dorothy Miller put it, "the only mistake she ever made."[50] Abbott had proven useful in founding the Film Library. He liked film, was good with numbers, and convinced the trustees that his Wall Street background, such as it may have been, qualified him for an executive position. He eagerly promoted the Film Library. According to Iris he was good at doing so, and she may have believed his elevation as Executive Director of the entire Museum might make the status of the Film Library even more stable. In retrospect, Abbott proved to be a miserable manager of people, and his years of influence at the Museum coincided with the decline of Iris's standing among her MoMA peers.

23

MEANWHILE, BACK AT THE LIBRARY

D URING THIS PERIOD of Barr's slow martyrdom in the late thirties and early forties, Iris continued to build the Film Library and its infrastructure, removed, as women typically were, from the high-level politics of the Museum. In 1937 the Academy of Motion Picture Arts and Sciences voted to present a special award for distinctive achievement to the Film Library "for its significant work in collecting films dating from 1895 to the present, and for the first time making available to the public the means of studying the historical and aesthetic development of the motion picture as one of the major arts."[1] The award was presented on March 10, 1938, at the Academy Awards dinner in Los Angeles.

Earlier in January, the Museum announced plans for constructing its own building in the space on 53rd Street donated to it by the Rockefeller family. The architects, Philip L. Goodwin and Edward Durrell Stone, chosen with only a cursory consultation with Alfred Barr, would do the design, a fittingly modern home for the new museum. The building's design, with its lack of a traditional cornerstone, a façade of gleaming metal and glass, and adjustable walls to accommodate a variety of exhibitions, exemplified the museum's mission of modernity. A 500-seat theater would be situated below street level, and on the fourth floor of the five-story building (plus penthouse), there would be ample room for administrative offices including the Film Library and a small screening room.[2]

A week after the Academy Award ceremony Abbott announced the receipt of a large deposit of films and documents from D. W. Griffith, "an enormous quantity of material," according to the *Times*, "including more than 250,000 feet of early film, correspondence, business papers and pressbooks, representing a record of his career as a producer from 1913 to 1924," a contribution which "has been presented by David Wark Griffith to the Museum of Modern Art

Film Library." The gift, the *Times* noted, "is regarded as one of the most valuable single acquisitions that the film library has received, since it is expected to reveal many interesting details of Griffith's work during the years of his greatest creativeness."[3] The gift included "historically invaluable negatives of such Griffith epics as *Judith of Bethulia*, his first feature-length picture made in 1913; *Intolerance, Hearts of the World, Broken Blossoms, Orphans of the Storm*, and *America*." Adding this material to the Griffith work already held by the Film Library, which included the 1912 *New York Hat* and *The Birth of a Nation* (1915), the *Times* concluded that "this material will round out an almost complete record of the work of one of the pioneers of the cinema."[4]

On October 28, 1938, the *Times* announced that

> a plan for cooperation and exchange of film materials among the Museum of Modern Art Film Library and similar non-commercial groups in England, France and Germany went into effect yesterday with the signing of the articles of federation here by John Hay Whitney, president of the American organization. The purpose of the quadrilateral entente, which will be known as the International Federation of Film Archives [FIAF], is to permit a clear collaboration among the four members in the collection and use of historical, educational and artistic films and data, thus increasing the value of results obtained individually. The other members of the federation [in addition to the British Film Institute] are the Cinémathèque Française of Paris and the Reichsfilmarchiv of Berlin. The formation of the federation was promoted by John E. Abbott, director of the Museum of Modern Art Film Library, during a visit abroad last summer. The ceremony of signing yesterday took place in the projection room of the Film Library at 125 East Forty-sixth Street, and was witnessed by A. Conger Goodyear and Nelson A. Rockefeller, trustees of the Film Library; Iris Barry, curator, and Mr. Abbott."[5]

Iris Barry had done the work to bring the archivists of FIAF together, but now John Abbott was credited for initiating the project. In retrospect, this error is not surprising. Iris Barry was the lone woman in a profession of male leaders of film archives. As library historian Gemma Waterston has noted, "she was an anomaly of her time, a woman holding a position of power within the library, archive and collecting industries. . . . No woman had achieved similar success in the field prior to her efforts."[6]

FIAF, and its member archives, set about the important work of preserving an art form imbedded in vulnerable material. Nitrate film, which remained the

standard print material for motion pictures until the introduction of tri-acetate film stock in 1952, had a life expectancy of less than thirty years. By removing original negatives from circulation and preserving them in cold storage vaults, FIAF members contributed greatly to the preservation of film art. Iris added to the international dialogue by completing and publishing her English translation of Bardeche and Brasillach's *History of Motion Pictures*, the main text used in France, to coincide with the founding of FIAF.[7]

As 1939 began, John Hay Whitney announced in the *New York Times* the publication of a three-volume bibliography compiled by WPA writers working under Iris's supervision, intended to be what Whitney called "the world's most comprehensive guide to the literature of the motion picture." According to Whitney, "the bibliography was conceived as a means of bringing order to the chaotic state of the motion picture's vast literature." Although it would encompass "comprehensive references to the European film, its total effect is to reveal the extent of America's contribution to this art and to establish continuity in the recorded history of the American film." This was *The Film in America*, the Film Library's first major contribution to film research, which in its first volume cited "9,000 book and magazine references grouped under five general headings, with 500 sub-classifications" dealing with 3,500 films.[8]

The Film in America, which the *Times* described as "the first of its kind ever made available on the American cinema" had been "accumulating ever since May, 1936 when a handful of Federal writers were first set loose upon it. Since that time a varying corps of diligent research workers has been burrowing through the shelves of the New York Public Library, the Library of Congress and other collections," seeking comprehensive references to writings on films.[9] The first volume, to be titled *The Film as Art*, in January 1939, was, according to the *Times*, "in its final stage—the Federal writers have turned it over to the film library for checking and sponsorial approval—and will probably be published and for sale within the next few months. The remaining two volumes on *The Film as Industry* and *The Film in Society*, both included in one binding, will not be ready for some time—perhaps another year or two."[10] The *Times* noted that "some 19,000 references have been amassed by the research workers on this project for inclusion in the three volumes," although newspapers were excluded from the project's purview as were references to the technology of films, since the latter subject had been covered in publications of the Society of Motion Picture Engineers.

Augmenting the publications and collecting activity, a signal change occurred in the way the Museum of Modern Art Film Library related to its

public during the hubbub provoked by the 1939 New York World's Fair. Since the disaster with the Bernhardt film, the library had shown films from its collection only to members of the Museum, scholars visiting its offices, or by renting prints to colleges and other nontheatrical venues throughout the country. But on May 11, 1939, the day after the formal opening of the new museum building, in the 500-seat theater in the Museum's basement, Film Library exhibitions were first opened to general admission by the public. This the *New York Times* called an example of the Film Library's "planning to open its own world's fair of movie fare," since on "each day for thirty consecutive days it will present a new program of pictures; then the 30-day cycle will begin all over again. So it will go for five or six months, or until everyone who is interested will have had an opportunity to back-track over the history of the movies from 1895 to the present."[11]

The programs, the *Times* noted,

> are about the same, or exactly the same, as the museum has been sending out these last four years to study groups all over the country—but there will be a difference in their presentation. This time they will be open to the general public, instead of being restricted to members of a university or museum study group. To attend, the visitor need not subscribe to the entire series. Admission to the museum includes admission to the 500-seat lecture hall beneath the street level. Program notes will be distributed, an occasional lecturer may take the stand; the films probably will be screened continuously through the afternoon and evening. In sum, the Film Library—which has been criticized for withholding its programs from John Q. Citizen—now is indicating a willingness to meet him more than half-way, not simply financially (for the museum, queer thing, is forbidden to profit from these showings) but by removing the attendance restrictions. And this, of course, is eminently desirable.[12]

In this manner the Film Library transformed itself from a collection with a circulating film library into an exhibition facility.

Iris's first program comprised the film component of the "Art in Our Time" exhibition Alfred Barr had planned for the opening of the new museum building. The exhibition and the Museum's opening, Barr said, was planned "especially for the visitors to the New York World's Fair," and in focusing on many aspects of painting, sculpture, graphic art, photography, architecture, industrial art, and film, Barr hoped to "give some idea of the different kinds of art with which the museum is concerned and some of the various ways of exhibiting them."[13]

So it was in concert with the exhibition of other arts in the Museum that Iris began her exhibition program in earnest, broadening the focus of the Film Library to add exhibition to its collecting and circulating programs. Unlike the casual experience of the average moviegoer, those attending her programs would find excellent prints of noteworthy films exhibited in context with one another—sorted, for example, by genre or period and accompanied by notes explaining their historical and aesthetic significance. Often those who made or participated in the making of the film would meet with the audience, thus aiding the impression that film is being taken seriously. The standards set by these MoMA film programs were subsequently emulated by museum and nontheatrical film programs throughout the world.

Along with the larger profile taken on by the Film Library's exhibition program, the library increased its output of program notes for use with its circulating film programs. Having learned that films can receive mixed reactions from the public, it was taken as a rule by the Film Library staff that program notes must be balanced and not function merely as promotional material. This policy of critical objectivity tended to lend credibility to the notes, and they grew to assume a significant role in the formation of film-historical understanding in the American academic community. In retrospect, some film historians rue this fact, claiming that the Museum's influence is responsible for many misunderstandings. Sorting these misunderstandings out, however, is not easy. The notes were not the sole province of Iris Barry. They were penned by numerous members of her staff, by assistants such as Arthur Knight, Jay Leyda, Richard Griffith, and Siegfried Kracauer. It is not easy to separate the influence of Iris Barry from others of her staff in this regard. Suffice it to say the notes were influential, and they remain available for study in the *Bulletins* of the Museum in which they were occasionally collated as well as in a volume published by curator Eileen Bowser of MoMA's Department of Film in 1964.[14]

The newly designed Museum of Modern Art opened to the public on May 11, 1939, following a preview and formal opening for members and invited guests. The preview featured remarks by Mayor Fiorello LaGuardia; Museum trustees Edsel Ford and Nelson Rockefeller; Robert Hutchins, president of the University of Chicago; Walt Disney, speaking from Hollywood; and a special address broadcast from the White House by President Franklin D. Roosevelt.[15] In his address Roosevelt noted the dependence of the arts upon peace. "We are dedicating this building to the cause of peace and to the pursuits of peace," he stated. "The arts that ennoble and refine life flourish only in the atmosphere of peace."[16] Moreover, he said, "the conditions for democracy and for art are one

and the same. What we call liberty in politics results in freedom in the arts. There can be no vitality in the works gathered in a museum unless there exists the right of spontaneous life in the society in which the arts are nourished."[17] In its eclectic concern for so many art forms, the Museum of Modern Art seemed to Roosevelt a promising source of art education for the general public. But to fulfill this promise the Museum must reach out to the country as a whole. "It is most important," he concluded, "that the museum make these travelling exhibits an essential part of its work. By this means the gap between the artists and American industry, and the great American public, can be bridged."[18]

Roosevelt's words signaled a new role for MoMA. To carry the Museum into its second decade, major changes were being made to its leadership. Central to this change would be Dick Abbott, a man of proven loyalties. Nelson Rockefeller thought that Abbott would exact new efficiencies, push the Museum's departments toward self-sufficiency, and carry out the wishes of his superiors. Rockefeller soon moved to Washington to play a major role in the Roosevelt administration, but in many ways he took the Museum along with him.

Abbott's ascendancy under Rockefeller and Clark came as the Film Library played to capacity houses in its first months of operation in the new museum. In August the *New York Times* proclaimed the Film Library's showings to be "the hit show of the Summer."[19] The cycle of films made between 1895 and 1935 "has played to near capacity audiences daily since the programs started ninety-odd days ago," the paper announced, and Abbott surmised that by the program's end upwards of 42,000 patrons had pressed into the Museum's new basement theater.

Abbott, distracted by his newfound responsibilities at the Museum, left the teaching of the repeat round of the Columbia film course entirely to Iris. The course, produced in cooperation with the Department of Fine Arts at Columbia University, took place at the Museum on Wednesday evenings between February 14 and May 22, 1940.[20]

As summer turned to fall, the popularity of the film programs put pressure on the Museum's gallery schedule. Barr was still nominally director of the Museum at the time, although his influence was on the wane. In October the *New York Times* announced that "the question of keeping art museums open weekday evenings for the benefit of those employed all day has been raised here by Alfred Barr, Jr., director of the Museum of Modern Art." As Barr put it, "many requests have come to the museum to arrange an evening program of its history and development of the motion picture for the benefit of those whose daily occupations have prevented them from seeing the regular 4 o'clock

program. As a consequence the museum will begin on Oct. 8 two afternoon motion picture programs, one at 3 o'clock and a second at 5:30 o'clock. The museum has considered the possibility of remaining open one or more evenings a week, and the 5:30 o'clock motion picture program is a step in that direction."[21]

Endorsing the idea of museums remaining open at night, Barr offered as justification an argument borrowed from Roosevelt's speech given at the opening of the new MoMA building: "It is something of an anomaly that museums, which are places of recreation as well as study, should ordinarily be closed at night," Barr told the *Times*. "During the day business prevents many people from finding the mental refreshment and mental stimulation they want and need from art. This is particularly true at present when the principal news of the day is of war and destruction. It is therefore only logical that every agency devoted to the peaceful arts should open its doors wide to the public and keep them open for more hours of the day."[22] With this justification, echoing Roosevelt's expressed view, Barr acknowledged the increasing role of the Film Library in the mission of the Museum.

As 1939 came to an end, the rising importance of the Film Library to public perception of the Museum became clear. Bosley Crowther in the *New York Times* declared that "it is obvious that many persons visit the museum solely to attend the daily film showings. Since the opening of the museum in May (and to the first of this year), it is estimated that some 240,000 persons have visited it. Of this number, 131,708 have attended the programs of the Film Library in the theatre."[23]

The new emphasis on numbers in the press, not notably a feature of Alfred Barr's previous leadership, was no doubt due to the fact that a good numbers man with Wall Street and Film Library connections was in control at the Museum.

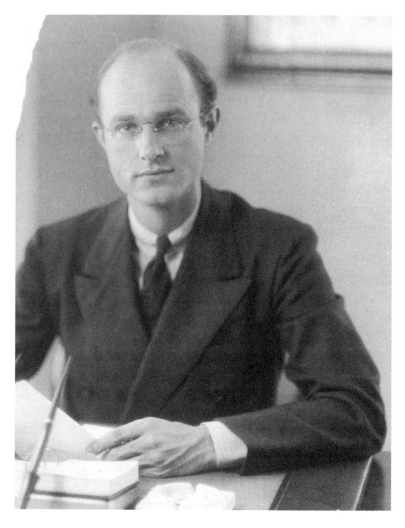

John Abbott at work (1940s)

(IBP, MoMA Dept. of Film Archives, NY)

24

NEW WORK, OLD ACQUAINTANCES

PERHAPS NO ONE captured the vitality of the young Film Library better than Jimmy Ernst, the son of surrealist painter Max Ernst. Young Ernst had been sent as a teenager to America in the summer of 1938 to escape deportation to Germany from occupied France. After traveling throughout the United States and holding numerous menial jobs in New York, he was referred to Iris by the surrealist gallery owner Julien Levy. Ernst was interviewed by Abbott at the Film Library's temporary headquarters at 485 Madison Avenue, one month before the move into the newly constructed Museum at 11 West 53rd Street. Ernst remembered Abbott as "a lanky, ascetic-looking man, with small eyes behind rimless glasses" who "questioned me in a very businesslike manner. He seemed to take pains in giving the appearance of being a banker or a judge rather than the director of an institution concerned with the aesthetics and history of moving pictures."[1] Abbott "listened impassively to my resume of 'experience,' in which I foolishly also included the writing of surrealist poetry and my background of immersion in culture. He allowed what seemed like a full minute of silence, which had the desired effect of heightening my embarrassment," then informed Ernst that he was hired not, as he had hoped, as a film critic but as a mail boy, earning fifteen dollars a week. In this capacity Ernst developed a worm's-eye view of the Film Library's operations.

Ernst regarded Iris as "the soul of the Film Library." To him she was "attractive, small and given to gentle irony," and was "listened to without her ever needing to raise her voice. She also treated me as something more than a lowly employee," was "concerned enough to find out how and where I was living," and then secured Ernst a room in the tenement of the Barrs' Irish cleaning woman near the Museum (160). Ernst found in the Film Library in 1938 "an atmosphere of friendly cooperation," which he attributed to "the diversity of individuals assembled by Iris Barry for the project," resulting in "a minimum of

office politics." Each employee of the Film Library, he recalled, "instinctively accepted the concept that his or her respective knowledge was a mosaic detail of a larger picture."

The Film Library, Ernst affirmed, "did not operate under the pressure of the profit motive." He felt "comfortable in this environment of considerate and sensitive human beings, most of whom did not consider my khaki office jacket a barrier to a kind word or a friendly gesture. I remember in particular Jay Leyda, the disciple and one-time assistant of the great Russian director Sergei Eisenstein, who was at home with Russian and Chinese film as much as he was with Herman Melville and Emily Dickinson. His acts of kindness and concern were to come my way unbidden, and yet as if he had heard a silent call for help. I felt the warmth of a friendship in the willingness of the film historian Arthur Knight to share with me his enthusiasms and knowledge of just about every phase of American culture." Nevertheless, Ernst's mail-room boss felt that he was "too chummy with those brainy jerks" and "Dick Abbott's secretary period-ically communicated the director's warnings to me to 'stay in your place'" (159).

"For joviality," Ernst recalled, "there were sometimes after-hours sessions of music and reminiscences with the two pianists, Ted Huff and Arthur Kleiner, who accompanied the Museum's screenings of silent films, and D. W. Griffith's favorite cameraman, Billy Bitzer. Big, fat, nervous, Huff loved Chaplin and lived in that adoration. His pudgy fingers running across the piano keys evoked, besides his idol, Mabel Normand, Theda Bara and Buster Keaton. This was the sound first heard in the converted storefronts as Mack Sennett's cops upended fire hydrants in their flickering chases. When Kleiner played the score for *Broken Blossoms*, one could almost hear Lillian Gish's cries for help as she floated on the ice.[2]

"Billy Bitzer's job at the Film Library, as camera repairman, had been cre-ated for him by Iris Barry, in order to put a few dollars in the pocket of a movie pioneer who had seen several fortunes disappear. Alcohol had done a good job on him. With the air of a somewhat bloated leprechaun, he relived for us the days of *Birth of a Nation* and *Intolerance*. His animated recreation left little to imagine about the Gish sisters, Erich von Stroheim, Douglas Fairbanks, Mae Marsh, Richard Barthelmess or Lionel Barrymore. He had a rich repertory of old barroom humor and shocked the aristocratic Kleiner with his salacious ver-sion of *The One-Armed Violinist*" (159–60).

After the transition to the new and more capacious Museum facility, "Abbott," Ernst recalled, "now, was really the executive; he no longer had to

share an office with his secretary, who, in turn, from her new empire, could act out all the prerogatives of 'secretary to the director'" (161).

"A few weeks after all the names were on the doors," Ernst recalled, "the Museum opened with a large survey exhibition, 'Art in Our Time.' It was preceded by galas and parties. One in particular took place a day or so before in the penthouse on the sixth floor for the Museum's trustees. Cleaning up on the following morning, I could not help but notice that each of the many empty champagne bottles had cost more than I earned in a week. There was also gossip that one of the topics under discussion had been a report by a team of efficiency experts, strangely somber men who had mysteriously wafted in and out of the offices for several weeks. It was the first time that I heard the term 'pink slip.'

"I circumvented the fact that, as a servant, I was, of course, not invited to the opening, by staying late at the office and sneaking down to the galleries later in the evening. After all, three of my father's works were in the exhibition: *Two Children Are Threatened by a Nightingale, Woman, Old Man, and Flower*, and *Lunar Asparagus*, not to mention works by many artists who had held me on their laps. The only person who seemed openly annoyed by my unbidden presence was Abbott, who whispered out of the side of his mouth, 'Who the hell invited you?' Allen Porter, an old friend of Julien Levy and Iris Barry, later to be assistant secretary of the Museum, winked at me and grinned as if to say, 'Don't pay any attention to him.' Abbott looked very flushed, I think he was drunk" (161–62).

Abbott's snobbery aside, Ernst felt the Museum as a whole was egalitarian. "I enjoyed the evening immensely," Ernst recalled. "I observed Fiorello LaGuardia, who audibly remarked that the Seurats, so far, were the only things that made any sense to him. I squeezed into the downstairs auditorium to hear Franklin Delano Roosevelt characterize the Museum, on a closed-circuit broadcast, as a 'citadel of democracy.' In that description he was absolutely right because class distinction in this auditorium was out. The mighty Nelson Rockefeller was there, as was one of his office boys."

The bonhomie did not last long, however, since "the efficiency ax began to fall not long after the opening. Among the dismissed were many of the guards and janitorial staff." To ease the pain, Ernst found himself the purveyor of some good news. "Within a few days of the opening of 'Art of Our Time,' I distributed an envelope to each staff member on the forth floor that brought smiles and surprised expressions of pleasure to them. It was a letter from Abby Rockefeller, Nelson Rockefeller and Stephen C. Clark, thanking everyone for his or her work in the past. Particular attention was paid to the success in opening the new building and the big exhibition. Each letter contained a bonus of a month's

salary. When I got through with all the envelopes, I was the only one who had not received one. Maybe I had not been in the job long enough or, could it be ... Dick Abbott was punishing me for my unauthorized appearance at the opening? I was lucky to have the job and decided not to inquire if there had been an oversight. A week or so later Allen Porter, who had successfully showed me how to knot a bow tie, noticed that I was wearing a new one and guessed aloud that this was an intelligent way to spend my bonus. When I told him that there had been none, he seemed visibly embarrassed. On a subsequent morning there was a letter for me with $60 in cash, without the written message. Porter told me: 'Oh, that ... it must have gotten lost in the shuffle.' It took me a long time to discover that he and Iris Barry had put their heads together and had made a collection from the staff on the fourth floor" (162).

Also at this transitional time, near the end of 1939 as war in Europe spread menacingly, Iris found herself revisited by two men from her past. In 1939 and before America's entry into the war, Ezra Pound made a trip to the United States and, according to his biographer Charles Norman, "went often to the Museum of Modern Art, sometimes accompanied by Wyndham Lewis. He saw Iris Barry, now curator of the Museum's film library. He was critical of the Museum's collection; after all, Lewis was not represented, neither was Gaudier-Brzeska. The collection was a good representation 'of what was left over after the Europeans had got the best.' Miss Barry was not glad to see him. She told me that she had last heard from him in 1934 when, she said, 'he hoped I might be able to start a magazine or get millionaires to buy some Gaudier-Brzeska, or the American government to accept his own peculiar economic-political ideas—all three of which, as you may imagine, lay far beyond my powers. I had had no contact with him at all until that time since 1918, and when I say contact I mean not correspondence or any sort of communication: relations were severely severed and I hope we don't have to go into *that*.' She added: 'I do not mean that I have in any way changed my gratitude to him for his help to me when young nor my admiration for his constant and splendid generosity and aid to so many. I just simply had reasons and some of them extremely personal for not wanting to see him.'"[3]

Despite her reservations, Iris and Abbott invited Pound to meet the Barrs for tea.[4] Having relieved himself of his ill opinion of the museum, Pound soon returned to Italy, where he resumed his supportive role to the Mussolini government and began his pro-Fascist broadcasts to the allied troops. Lewis's appearance in North America was another matter. Like the man who came to dinner, he did not return to London until the end of the war.

Curiously, his unexpectedly prolonged visit was facilitated by Iris's brother-in-law, Charles Abbott.

W. K. Rose, editor of *The Letters of Wyndham Lewis*, recounts that, in Lewis's opinion, England during World War II was "no place for him. He was especially worried as to how he could paint and write profitably in a situation where the arts would be mobilized in service of the state. He knew his chances for official employment were minimal. In America, he assumed, life would be easier. As a well-known painter and writer he should be able to secure commissions and contracts sufficient to support himself and his wife until a time when England would again be possible. The day before Britain declared war, the Lewises, with a small dog, a certain amount of cash and a few prospects of work, sailed for Canada."[5]

Lewis brought with him a reputation for troublemaking. His unfortunate political views developed on a visit to Germany in November 1930 and were expressed in an article in *Time and Tide*. He described Adolf Hitler as a "very typical German 'man of the people'—'Mann aus dem Volke,' just as his movement is a *Volksbewegung*. As even his appearance suggests, there is nothing whatever eccentric about him. He is not only satisfied with, but enthusiastically embraces, his typicalness. So you get in him, cut out in the massive and simple lines of the peasant art, the core of the Teutonic character. And his 'doctrine' is essentially just a set of rather primitive laws, promulgated in the interest of that particular stock or type, in order to satisfy its especial requirements and ambitions, and to ensure its vigorous survival, intact and true to its racial traditions. Hitler is The German Man—and now he has become the Man of Destiny, as well." He was also, Lewis noted, "a Man of Peace."[6]

Adorned with swastikas, Lewis's book, *Hitler*, was published on March 26, 1931. The book sealed his fate as a pariah. As his biographer Paul O'Keefe put it: "*Hitler* has done more lasting harm to Lewis' reputation than anything else he produced and, several decades after his death, that positive evaluation of National Socialism continues to be brandished against him."[7] For years people were known to spit at it in bookstore windows.

As if driven by perversity, Lewis also took an affirmative position on the Spanish dictator Francisco Franco. His melodramatically titled 1937 book, *Count Your Dead: They Are Alive!*, favored Franco as "'an ordinary, old-fashioned, anti-monarchical Spanish *liberal*'" who was "'no more a Fascist than you are, but a Catholic soldier who didn't like seeing priests and nuns killed . . . didn't want to see all his friends murdered for no better reason than that they all went to mass and to the more expensive cafes and usually were able to scrape enough money together to have a haircut and a shave.'"[8]

Although O'Keefe frames Lewis's pro-Fascist and anti-Soviet sentiments as a desperate attempt on his part to encourage England to keep out of the impending conflict, the antiwar books were, "by his own [Lewis's] admission, 'futile performances—ill-judged, redundant, harmful to [him] personally and of no value to anybody else'" (365). These writings, combined with his reprehensibly titled 1939 book, *The Jews Are They Human?*, contributed to Lewis's motivation to leave England the moment the country entered the war.

Although Lewis later claimed to have booked berths for his wife and himself three months in advance of the declaration of war, O'Keefe points out that this was untrue, because "less than a month before, he had still not finalised his travelling plans. 'I hope to get out of here very soon,' he told Pound on 10 August, 'will let you know when'" (400).

On September 2, 1939, the Lewises set sail on the *Empress of Britain* for Quebec. This was the day after the Wehrmacht and the Luftwaffe swept into Poland and one day before England declared war on Germany. Lewis later enjoyed regaling listeners with tales of blackouts and submarine threats during his Atlantic crossing. In fact, Hitler had given an order not to attack civilian ships after German subs sank the liner *Athenia* in the Atlantic on the first day of Lewis' trip (400).

According to W. K. Rose, in the United States Lewis first went to Buffalo "because of his acquaintance with Charles D. Abbott (b. 1903), Professor of English and director of the Lockwood Memorial Library at the University of Buffalo. He had met Abbott when he [Abbott] was abroad gathering material for the collection of modern manuscripts, which he founded at the university. Hearing of his visit to America, Abbott asked Lewis to come to Buffalo, where he would do what he could to obtain some portrait commissions for him. Abbott then arranged for the painting of [university] Chancellor Capen, but he had to leave on a western trip not long after Lewis' arrival."[9]

Lewis found Buffalo an unpromising place to work. He complained to Abbott that "the cocktail parties you foresaw me frequenting have not materialized," and surmised that "the likelihood therefore of the portrait of Dr. Capen leading to other portraits appears to be slender. That is rather disappointing as I had hoped to make Buffalo my headquarters for a further month or two. Still, we shall see. If by next Thursday nothing happens I shall know that without your magic wand the Buffalo is an animal inaccessible to artistic stimulus."[10]

Although Iris was not anxious to entertain Pound, she did seem curious to see Lewis. Despite all the difficulties he brought to her, she was attached to him and wanted to offer him help. She wrote him that she had secured

what she called "a rather pleasant job at the Museum of Modern Art—which is more or less under the Rockefeller wing—doing things about the movies."[11] She added temptingly that "Alfred Barr, the director of the whole outfit would, I know, be particularly glad of a chance to talk to you but whether about some of your earlier paintings he has tried unsuccessfully to trace or a coming show of contemporary portraits I'm not sure. Anyway perhaps you will let me know when you arrive (in New York) and if there's anything I can do usefully I will."[12]

Lewis decided to enlist Iris's assistance with a publication problem:

Buffalo—1939

Dear I.B.,

From Abbott you will have heard of my presence in the states. I'm painting a man up here, and as it is a big thing it occupies me very fully and has prevented me from getting to New York. I hope I shall not be asking you too much, but I have a mss. at Random House and was asked to contact Mr. [Bennett] Cerf. It is the mss. of a book Dents are publishing in a week or so called The Hitler-cult, and How It Will End. *I doubt if Random House will publish it, as they may think that a good deal of it has been dated by the outbreak of war. But two parts of it at least are extremely to the point and should be highly serializable just now.*

Would it be asking you too much to 'contact' Random House, inquire if they are taking the book or, if not, if they will be so good as to send it round to you?—so much should be easy, and I know you will do that. What would require a little time and attention—though it might not be so difficult—would be this. You know the book and newspaper world of New York pretty well, I expect, and you might be able to 'contact' somebody else, of importance, who would serialize the parts that lend themselves to that. . . . Don't of course send it to anyone but an extremely honorable and important person, otherwise he would lift the arguments and return me the mss.[13]

Lewis and his wife, whom he called Froanna,[14] had obtained one-year permits to visit the United States ("a wife in a thousand," as he described her, supporting the accolade with the observation that "We have no children. She is a blonde, she tends to put on fat, her mother was German, her father a good British farmer and as straight as a gun barrel, she has ridden all over the Atlas on a mule and is a great reader of my books").[15]

Things didn't go as Lewis wished. By August he was complaining to Charles Abbott that he was "quite sure that some day New York will say that it has been

very kind to me. But the fact is that the means of livelihood have not been put in my way there during the last nine months" (273).

It was during these disappointing days in Buffalo that Lewis attempted to blackmail Charles Abbott over his own earlier connections to Abbott's sister-in-law, Iris Barry. Paul O'Keefe relates that the American literary critic, Stephen Spender, told him that in the late forties, when he was staying with Charles Abbott while on a lecture tour, he learned that Lewis "tried to blackmail him [Abbott] on the subject of his brother's marriage. The wider Abbott family, it seemed, had no idea that John's wife had two illegitimate children. 'It would be to your interest,' Lewis is alleged to have told Charles Abbott, 'if I did not publicise the fact that those children were mine.' He even suggested certain sums of money could be placed in a bank account to insure his continued silence. Spender was not certain how serious Lewis had been in making the suggestion, nor how seriously Abbott had received it" (404).

Overall, as O'Keefe put it, in Buffalo Lewis "offended even those people who did extend social invitations, ensuring they would not be repeated" (406). He did not fare better in the environs of New York City, where he moved in December 1939. There he assiduously made contact with all who might prove useful, attending the literary salon of Mabel Dodge Luhan, looking up the literary editor of the *New Republic*, Edmund Wilson, visiting H. L. Mencken, co-editor of the *American Mercury*, and socializing with the poet, e. e. cummings, whom he found a "jumpy, peppery little creature."[16]

Lewis complained in a letter to Iris,

> *I have now been for nearly two months in New York and its neighborhood and I have made every conceivable effort to make a living. Except for one friend's efforts to help me to that end, all my approaches to papers, with a view to obtaining reviewing, or to sell articles or stories have met refusal and rejection. Lectures in New York were unobtainable, which has not been for lack of trying on my part. After some months I got two articles to do for the* New Republic: *these called down a torrent of abuse on my head.[17] As to painting or drawing, all my efforts to get work through galleries have failed. As to my attempts to persuade Mr. Barr to help me privately, you are aware of the outcome. . . . Now this has come to the last straw: a novel I have been working on for the last three months has been twice refused. The second refusal was probably my best bet, as the young man who had a say in the office in question was well disposed and liked my work very much indeed. You may say that I should never have come to the United States of America—that I should have realized that I could not make a living here. But how could I possibly have realized that I could make absolutely <u>nothing</u>?[18]*

During their last summer in the United States, the Lewises were given the use of a house in Sag Harbor on Long Island belonging to the literary agent, John Jermain Slocum. Lewis wrote to Iris, "we have been leading a fairly idyllic life for some time, with thank goodness no rent to pay."[19] Despite having written and sold his book, *America, I Presume,* during this time, and finishing the novel he had begun in England before departure (*The Vulgar Streak,* eventually published in 1985), Lewis ran out of options when his visa expired. He was forced to retreat to Canada in November. Before departing Lewis was invited by Nelson Rockefeller to advise him on his contemporary art collection. He visited the Rockefeller home near Dobbs Ferry, New York, at a time when Iris happened to be there as a guest. Iris later told her daughter Maisie that she came downstairs for dinner and found Lewis sitting in the drawing room. "Iris said, 'Hello, what are you doing here?'" Maisie recalled. "Lewis looked mortally troubled. He explained what he was up to and she said something about Robin and I, something about 'our children.' Lewis said, 'Oh, did we have two?' That really wounded her."[20]

Before he left the United States for Canada, Lewis tried to raise what capital he could by enlisting Iris to facilitate the purchase of several of his drawings by the Museum. This possibility would provide a slim—and ironic—lifeline for Lewis. Iris wrote Lewis of hearing that "Alfred Barr had spoken to you and will by all means attempt to get the purchase of one or more drawings through the [MoMA] acquisitions committee.... We enclose $100 and hope that this alleviates the immediate stress which I regret extremely—though as I said, having in my much more obscure way suffered a similar setback here for two years on my arrival. If we can recover some of the money by the sale of the drawings we shall, as you suggest, do just that for we rather need to, but I will let you have an accounting. It is hard to sell anything I believe just now with all these committees pressing everyone daily for British relief of various kinds—and you ought to be an American to catch any benefit of the current nationalistic trend here."[21]

Lewis wrote Iris on the same day:

Dear Barry,

You will have heard that Mr. Barr telephoned me today. (When I came to the Museum his secretary was not very sanguine of the possibility of my seeing him.) Mr. Barr impressed himself as extremely willing to consider the proposal of acquiring a few of the drawings you have for his collection. But apparently it will involve a delay of anyway some days.

However, Mr. Barr seemed so very cordial and willing that I feel sure, unless some unexpected obstacle arises, something will happen.

But meanwhile I have to leave the U.S.A. without delay,[22] as I told you in my earlier letter and every hour I spend here is in a rush. In view of the close intimacy in which you all work together in the Museum, it will be possible for you to gage the likelihood of the <u>number</u> of drawings that might be acquired and the sum percolating in Mr. Barr's mind. The three hundred dollars I mentioned for <u>the lot</u> in my earlier letter was dictated by the very great straits in which I find myself. If you thought anything of this sort was fairly certain to come off, could you then—seeing the really enormous and sickening jam I have got into—risk a little more than the fifty dollars [sic]?[23] That you—or anyone—should do <u>anything</u> I am aware is a great act of grace. But if Mr. Barr will really put it up to the people who usually make these purchases, and name a not too economic a figure, <u>then</u> not only shall I be able to have a little but the money you advanced me can be paid back.[24]

Iris replied some two months later, saying she was "sorry that you missed me when you called and that the departure was for you so harassed etc. There are so many things too complex to be written well in a letter but I do think Barr bought a couple of the drawings."[25] Lewis riposted that he found it "irritating that I cannot get an answer out of Mr. Barr . . . ,"[26] but was nonetheless "glad to hear from you that two of the drawings I left with you have been purchased by the Modern Museum. What did Mr. Barr pay for them?" Barry apparently felt the sum, whatever it was, should simply be applied to Lewis's outstanding indebtedness to her. Lewis countered that she should return all his drawings to him, because he felt "pretty sure I can do something about it. If I could not, I would either return them to you, or send you some others."[27]

Lewis tried doggedly to track down the sale of his drawings to the Museum, in order to detect what moneys might be due him. He wrote to Iris, who passed the inquiry on to Alfred Barr. Barr, in turn, attempted to deflect the inquiry by saying that the drawings were the property of the Abbotts and not of the artist; hence, no money at all was due to Lewis. This prompted Lewis to write to "Dear Barry" that "with unwanted, and a little alarming, swiftness Mr. Barr has answered my letter to you. (It is obvious that if one desires a reply from Mr. Barr it is best to write to you.) His reply is in effect this: I (Mr. Lewis) have no right to ask how much the Museum paid for the two drawings it bought, because the drawings do not belong to me, but to Mr. Abbott, who purchased <u>all</u> the drawings you (Miss I.B.) hold of mine. . . . The truth about this is that I never sold either to you or to your husband <u>all</u> the drawings, or <u>any</u> of the drawings. So if <u>any</u> are purchased by the Museum I have a right to know what has been paid for them."[28]

In this querulous manner Lewis spent the war years in Canada, years which, as W. K. Rose put it, were "as a whole the blackest in Lewis's life."[29] He and his wife were confined to a studio apartment in a hotel in Toronto, shunned by local intellectuals and scrabbling for pennies through portrait commissions. During this time Lewis lived literally from hand to mouth, hitting up acquaintances for small sums of money, losing his eyesight, and growling about his life "in some stony desert, full of shadows, in human form. I have never imagined the likes of it," Rose quotes him as saying. From his lair at the Hotel Tudor (". . . 14 bucks a week. One big room, kitchen and bathroom"),[30] Lewis dreaded he would "end my days in a Toronto flophouse."[31] He wrote repeatedly to Iris, pleading for money, passing along artworks to sell, and entreating her to act as agent for his unpublished novel, *The Vulgar Streak*. He took revenge upon Barr by writing in a 1940 essay, "There he is, thinking up some new outrage. . . . I have seen him surrounded by millionaires examining some leering monstrosity upon the walls of his so-called museum. He looks like a defrocked Jesuit."[32] He dreamed of becoming a resident artist in an American college ("Do you know of such a college?" he wrote disingenuously to John Crowe Ransom, then on the faculty of Kenyon College);[33] most urgently, he needed money to survive.

In an ironic reversal of fortune, Barry regularly sent him money, usually about thirty dollars weekly, and made some effort to find a publisher for *The Vulgar Streak*. "This about scrapes the bottom of the pot," she wrote in one letter alluding to her own family's difficulties,

> *but here it is. . . . I have been out of town, feeling fairly all right again.[34] Abbott is not taking care of himself, however, which is silly as he is not quite over the TB yet [Abbott had been diagnosed with tuberculosis in the early 1940s], but his mother and father are <u>both</u> ill, how depressing, and so there has been gloom and trouble and hurried train trips and so forth.*
>
> *You will, I am afraid, be cross but I simply felt unequal to coping with the book further, for I never learned how to get on with publishers and such people. Also, as you had apparently not used an agent, I soon found that some highly personal and not always harmonious relations already existed, which I honestly did not know what to do about or discuss. So I placed it in the hands of a person who, to the best of my judgment, would make an honest and enthusiastic effort to place it and has a most high regard for your authorship. The results have not been very encouraging. On the other hand it was not the best moment in the world. I thought it best to tell you of this, not to add to your worries. . . . I am afraid I am not doing much to help. I am sorry for this. It is a pity I didn't manage to become a big shot—but it is you who wrote, 'This is a time to be small, said the flea.'[35]*

Iris complained that she and Abbott "have only what we earn, the government is now going to take half of that and there is still my miserable mother in England who has to be wholly supported now—I felt it would seem friendlier to explain this."[36] She hoped it was warmer in Toronto than in New York.

Even further miseries plagued Lewis. "Dear Barry," he wrote her in October 1941, "my left eye was injured when I was around fifteen years old and has never been very good. Recently it has got worse. The other day I went to an eye specialist here to get some glasses, the first real ones I have ever had. He declared that I probably had <u>glaucoma</u>. Further, he said that if that were the case, within six months I should lose my eyesight altogether." Lewis said the diagnosis was not definitive, although he suspected the worst. He hoped Iris would sell *The Vulgar Streak*, retaining the first two hundred dollars as repayment for moneys advanced by her. "Once more," he concluded, "I am sorry to be such a nuisance. When I crossed the ocean, in search of what I laughingly call business advantage, I could hardly foresee all the array of contretemps. Even if I could attain the necessary eight hundred dollars fare to return to England with, I do not suppose there is much to do there but work in some ministry. But this eye-business weighs on me heavily. Having burdened you enough with all my problems I will terminate this letter, with an expression of the hope that it finds you better than it finds me."[37]

Their fortunes reversed, Lewis survived on Iris's support. "Your money is being eked out," he wrote her in November 1941,

> but I'm damned if I know where else I can get any money from. To say that I am <u>worried</u> would give no idea of the incessant misery induced by these conditions. While I still had a little money left the threat of the eye doctor overshadowed everything else. But now I am unable to think of anything else than what will happen to me next week! . . . I want, and am in the extremest need, of some kind of job.
>
> You for instance have great ability, but you have to take, over here, an administrative job. I am not so stupid as to think that I could get just for the asking so well paid a job as that of yourself or your husband—for which you had to work and to contrive for a long time, naturally. Also my business ability is nil. But I have certain knowledge and aptitudes. Do you think that it would be possible for me to get for <u>two months</u>—for the months of November and December—some minor temporary job at the Modern Museum? I could classify things, help out with prospectuses—I don't know exactly what. . . . <u>Please</u> do not neglect to answer this letter. I am in a very very serious plight. Just an ounce of good will at this juncture—or at least, not hatred, scorn and derision—and I should be able to reconstruct myself modestly . . . and be quit of my present miseries.[38]

Before Iris could reply, Lewis drafted, and perhaps did not send, another letter to her: "My letters probably seem just a lot of words to you," he scrawled, "Hard-up—hell, aren't we all hard up. Eyes! Damn his eyes, does he think I haven't got a liver—an ulcer or fallen arches!"[39] But with protean speed he transformed himself again into a supplicant: "If you can manage to send me another twenty-five dollars," he begged, "it will pay two weeks back rent now, and I can scrape along in other ways until some relief comes."[40]

Iris replied to Lewis's job inquiry that menial work at the Museum might not be a good fit for him. She assured him she understood his plight, that she had been in "truly desperate circumstances, more than once, and so [I] know just what it means to need money immediately for immediate basic necessities and how in such a case one can do nothing else for the lack of it. Please believe that I do realize the situation and let me be honest, as I must if I am to be of any help. I do not think that the Museum idea will work and I do not want to propose it merely to be refused: it is not that you would not 'do' but that no one with creative talent would 'do,' there is a special kind of animal that works in offices. Also there is nothing that you would find as horrible if the thing were feasible which I am positive it is not."[41]

Lewis retorted: "What you say about offices and museums not being for people of my type is no doubt true up to a point, but it would not apply to a month or two's job, which is all I asked for. I could spend a month or two in a lightship or a coal-mine easily."[42]

As the end of 1941 approached, Lewis clung to Iris as if to a buoy. He had found a young person in Toronto willing to peddle his drawings. "The cheque for thirty dollars reached me last week, for which tremendous thanks," he wrote Iris. "The young man I spoke about still has my drawings: so far he has not done any selling, but is showing them to a big shot in a day or so.... Could you manage to get me by Saturday morning the same amount as last week? I can only pray the situation will speedily change for the better."[43]

Lewis's situation did not change. It only got worse. As Christmas approached he wrote Iris: "On Monday morning (yesterday) I had seven cents left—my friend was away for the weekend up in Preston, so the few dollars I could get from him were not forthcoming. Five of the seven cents I had to keep for the telephone, to reach him when he gets back.... I have had two years of this sort of thing, off and on, and I am pretty well worn out."[44]

It is unclear how much longer Iris continued her support. In mid-January 1942, Lewis acknowledged to her that "what you have sent me has filled in the gaps, and without it I should not have been able to continue."[45] The move to

America had proven disastrous. As he put it: "It seems extremely ludicrous that no means can be devised for me to earn a cent in America, which is a fairly big place. But there it is. I am helpless in this icebox."[46]

Even as his miseries worsened, Lewis was still capable of hauteur. Having despaired of finding a publisher for his novel, Iris returned the manuscript to Lewis. Unlike his dismissive reply to her earlier plea to help with the promotion of her own novel, *Here Is Thy Victory?*, Iris had actually made some effort to help Lewis before giving up on his book. Nonetheless, on July 18, 1942, Lewis wrote to her:

Dear Barry,

You did not answer my letter; instead you return me the book. But I have several copies of the book. It is not that I want, nor is it that I asked for. What I must ask you to do is to tell me who the agent is who has been sending the novel round for you. What conceivable objection can there be to my knowing this—leaving aside the fact that it is my book after all that is in question and I have some right to know what has happened to it.

What is behind all this I find it impossible even to guess, except that you prefer to be as unpleasant as possible and of course this is a good way of insulting and annoying me, so adding to the general discomfort of my situation.

If you don't answer pretty soon I shall write to the Author's Society—You know the secretary? (you seem to know most people, worse luck!) Oh well, then I shall do something else. But remember, I will show up your bad behavior. You are a very bad old girl and a fearful _____.

W. Lewis[47]

The irony of this episode is that Iris provided critically needed support for Lewis at this time, disguising it as payment for art works she was supposedly passing on to Alfred Barr to be acquired by the Museum. In fact, there is no record of MoMA's having acquired any Wyndham Lewis work at this time. This situation did not change until the 1970s, when two collectors donated a few Lewis drawings to the Museum. Without telling him, it is clear that Iris pretended to pass on to Lewis money of her own disguised as payments for his works of art. It proved to be a lifeline for Lewis and a silent reminder of her enduring esteem.

Although his miseries would not end for years,[48] until he and his wife took the first boat from Canada to England at the close of the war,[49] Lewis managed

to transform his misfortune into fiction in the novel, *Self-Condemned*. In a chapter titled "Twenty-Five Feet by Twelve," he recounted his experiences confined to the Toronto hotel.

Representing himself and his wife as the characters Rene and Hester, Lewis wrote that

> this prison has been theirs for more than three years. . . . For a period of four months Hester had not gone out at all because she had no shoes to wear. All the shopping had to be done by him; and when the meat famine had come to Momaco [Lewis's word for Toronto], he had to go as far as the downtown market. This took up half the day, while she sat at home, at the mercy of her miserable fancies, counting the hours of this senseless captivity.
>
> At last Hester could buy a pair of shoes. A New York friend had unexpectedly sent a present of thirty dollars. She cried a little. It was like a cripple recovering the use of her legs![50]

In Lewis's mind Iris's extraordinarily faithful assistance could be reduced to a single unattributed and unsolicited gift to his wife.

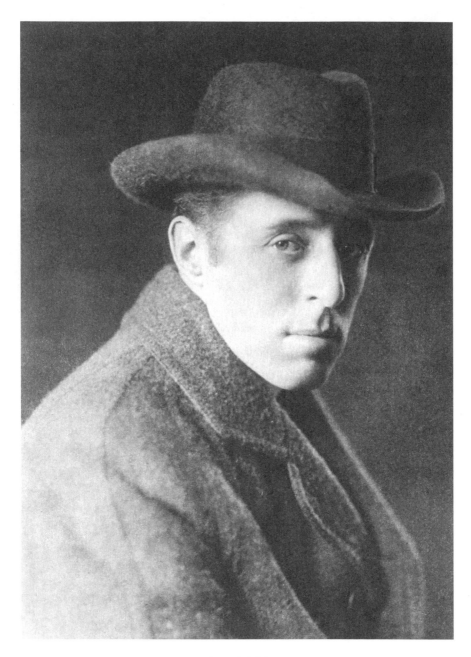

D. W. Griffith

(IBP, MoMA Dept. of Film Archives, NY)

25

"THE MASTER" AND HIS MINIONS

WYNDHAM LEWIS WAS only one of the difficult men Iris had to contend with in the early forties. Also at this time came a trying episode with D. W. Griffith, one of the filmmakers she most admired and for whose reputation she would do inestimable good.

Griffith had riled the film world with his *Birth of a Nation* in 1915, a magnificent cinematic achievement that was morally and politically repugnant. Drawing upon folklore about the Civil War passed on to him by his Confederate veteran father, Jacob Griffith, known as "Roaring Jake" for his ability to be heard above the din of battle, Griffith fashioned a tale of the war that advanced all the arguments some southerners still hold dear: that carpetbaggers and scalawags exploited the South after the war, that the postwar federal government manipulated freed slaves to vote for quisling candidates, and that blacks posed a threat to civil order and southern womanhood answerable only by the Ku Klux Klan. Despite being described by President Woodrow Wilson, himself a historian, as "like writing history in lightning," *The Birth of a Nation* provided the nascent NAACP with its first cause célèbre.

Though its script was deplorable, the film also contained scores of basic film techniques that, although not necessarily invented by Griffith, found in his work their first use as elements of cinematic narrative. Iris appreciated these achievements and felt a strong obligation to conserve, study, and make known the work of the man she dubbed an "American Film Master."

It is widely assumed that Iris Barry and the Museum of Modern Art bear responsibility for the argument that D. W. Griffith was the "father of film," that he alone invented the close-up, flashback, fade-out and fade-in, mobile camera, screen masking, iris shots, and countless other techniques fundamental to film art. Few historical figures have provoked more debate among film historians. But the story is more complicated. Prior to the publication of Barry's *D. W.*

Griffith: American Film Master in 1940, for example, respected histories by Terry Ramsaye (*A Million and One Nights*, 1926) and Lewis Jacobs (*The Rise of the American Film*, 1939) had positioned Griffith as the inventor of modern cinema.

Many have traced the Griffith myth to the Master himself, alleging, as do film historians Kristin Thompson and Richard Bordwell, that Griffith "ran a newspaper advertisement claiming to have created the close-up, intercutting, fade-outs, and restrained acting."[1] If this indeed was the Master's own invented self-portrayal, it is easy to imagine Iris falling under his spell when she visited him at his home near Louisville, Kentucky, in preparation for her book and a retrospective celebrating the receipt of the Griffith collection at MoMA.[2] Indeed, in her book Iris refers to Griffith's use of "brief, enormous close-ups not only of faces but of hands and objects; the 'eye-opener' focus to introduce vast panoramas; the use of only part of the screen's area for certain shots; camera angles and tracking shots such as are commonly supposed to have been introduced by German producers years later; and rapid crosscutting the like of which was not seen again until *Potemkin*."[3]

Barry was grateful to have received the Griffith estate with its enormous film trove, and as a sympathetic reporter her objective was to document the views of her interviewee. Iris identified with Griffith's tale of an impoverished childhood, and if Griffith was deluded about his self-importance, Barry seemed willing to reflect it in her book. In her subsequent publications at the Museum, however, she made it clear that Griffith "did not, of course, invent the close-up, nor cross-cutting, nor flashbacks. What he did was to *use these devices to humanize his characters and give vitality to his stories*."[4] Hence the more accurate view is that in Barry's writings Griffith can be credited with the dramatic and narrative development of major film techniques, although in some form they may appear in earlier films by others.[5]

It is also clear that, as the home of the enormous Griffith estate, it was inevitable that the Museum of Modern art would become identified with the Griffith legend. After all, MoMA held the primary study materials and published educational aids about them. In truth D. W. Griffith brought Iris Barry more trouble than she could have anticipated, and she might not have landed the Griffith estate had it not been for the help of Lillian Gish, who had starred in many of Griffith's films and was unswervingly devoted to him. Gish helped secure the D. W. Griffith deposit at MoMA in the late thirties. In all these maneuverings, Iris Barry saw nothing of D. W. Griffith.

At one point in 1940, before her visit to interview him for her book, Iris had an encounter with the Master. It was the first time she had seen him since the

Pickfair party in 1936. He arrived unannounced at an exhibition of Van Gogh's paintings at the Museum. "Not as tall as I had imagined," Iris recalled of the encounter,

> he walked through the distinguished throng looking like <u>somebody</u>—there was a bearing, a stance—Southern gentleman, actor, ex-millionaire now bankrupt but certainly <u>somebody</u>. It seemed appropriate to introduce him with pride to his host of the evening, Nelson Rockefeller.
>
> Griffith reared back and said, affably enough, 'Ah, young Rockefeller, eh? I knew your grandfather. There was a son of a bitch!' The floor did not open though I wished it would. Nelson took it well—a rapier thrust from an elderly fencing opponent—and replied, smiling, 'Yes, he was a tough one.' The two of them exchanged a brief and amiable chat about the orchard land that Griffith had purchased to stage the ride of the Ku Klux Klan in *The Birth of a Nation* and afterwards sold; the site had become a Kettleman oil field. If I did not register this exactly, it gave me time to overcome a wish to sink into the earth, but it would be hard to say which of the two I admired more.[6]

Griffith's cantankerousness that evening came in the midst of Barry's unprecedented effort to establish his place in film history. As Mary Lea Bandy, who headed the Film Department at MoMA from 1980 to 2006, put it: "Barry was vitally concerned with placing D. W. Griffith within the museum context in the early days of the Film Library's exhibition program, having finally persuaded the director in December, 1937, with invaluable assistance from Lillian Gish, to donate his papers, which included production records, letters, scrapbooks, scripts, and music scores as well as negatives and prints of his features. In 1939 the Film Library acquired some 400 Griffith films, mostly one reel in length, made for the American Mutoscope and Biograph Company in 1908–13, a portion of a large collection found in a warehouse. Barry conceived a project to study the prints firsthand, then to show the films and publish a monograph on Griffith's career, even if the filmmaker distrusted such an appraisal."[7]

Rudely, D. W. Griffith ignored both the retrospective of his films Iris prepared and the publication of the first serious study of his work. "The opening of the retrospective was intended as a celebratory event," Bandy wrote. "On November 12, 1940, Jock Whitney hosted a black-tie dinner at his Fifth Avenue home. Neither Griffith nor the Gish sisters attended. Whitney sent a telegram to Griffith, then in Las Vegas, congratulating him on 'AN EXCITING SUCCESS AND AN IMPORTANT EVENT IN THE HISTORY OF

MOVIE MAKING. WE ONLY WISH YOU COULD HAVE BEEN WITH US TO ENJOY PERSONALLY THE TRIUMPH YOU SO OBVIOUSLY DESERVE.'"[8]

The Griffith retrospective was joined at the Museum by an exhibition celebrating the architecture of Frank Lloyd Wright, a juxtaposition the critic Edward Alden Jewell called "in line with the museum's long-standing policy to direct its attention not to one or two of the arts alone, such as painting and sculpture, but instead to all the arts."[9] A statement issued by the Museum called these two "America's greatest film director and America's greatest architect," as attested to by their "immense influence on European motion pictures and architecture" and as witnessed by artists who "openly acknowledged their debt to Wright and Griffith."[10]

Not known publicly at the time, however, was the fact that the Griffith tribute had gone ahead over the objections of the Master himself. In an act of stunning ingratitude, Griffith tried to wrest curatorial control of the project from Iris, whom he regarded as unsympathetic to American films, and place it in the hands of people of his own choosing. On August 27, 1940, two months before the retrospective was scheduled to open, he sent a letter marked "*Personal and Confidential*" to Museum president Nelson Rockefeller:

Dear Mr. Rockefeller,

I have been very much troubled concerning the special exhibit of my films that the Museum of Modern Arts [sic] is giving next October. I do not imagine that you worry much about the museum or my pictures either and I don't blame you. Oh, boy, if I had your dough I wouldn't worry about anything. But recently I happened to run into a Mr. and Mrs. Spencer, New Yorkers who, with a small group of friends, were visiting San Francisco. The Spencers and their friends had seen several of my pictures at the Museum of Modern Arts. They also witnessed the running of several of the Soviet, German and French pictures. They all seemed to be of the opinion that Miss Barry did a wonderful job on the foreign films, the Soviet films in particular. They said that she was most enthusiastic over these films and seemed to believe that her enthusiasm over these particular films would have a great effect on the audience. However, they felt that my films were not presented with understanding or sympathy. Of course, I personally believe Miss Barry to be a brilliant and most capable woman and as for her enthusiasm for the foreign films, this is easily understood as she, herself, is a foreigner.

The Spencers and others whom I have met later, have expressed the opinion that they thought it regrettable that Miss Barry did not possess the same enthusiasm for

the American films. Now I don't pretend to be damned brilliant or dipped deeply in the wine of sophistication but I, as an American, made pictures mostly for the Americans and I believe that on the whole the American people have liked my pictures very well. The receipts at the box office should be proof enough of this. No picture yet produced has earned as much as The Birth of a Nation. Way Down East *and* Broken Blossoms *didn't do so badly either and the American press as a whole has given all these works great praise.*

Now, I have an idea which I think will be not only a benefit for myself but for the Museum of Modern Arts. Let us put in charge of this coming exhibition, due for October, a man who not only understands what I was getting at in making these pictures but also understands how to present them properly to the public. Now, let me pause to say I don't desire for anything in the world to cause friction between you and Miss Barry and certainly not between Miss Barry and myself, but my brother, Albert Griffith Grey, not only handled the road shows for my Way Down East *and other companies, but also was paid a salary of $500 a week by the Paramount Pictures Company for handling* Wings *and other pictures.* Wings, *as you know, was a great success. Since most of the companies have given up the idea of road shows, my brother is at present out of a job. You could, if you so desire, lay the blame on me after this fashion. You could tell Miss Barry that I wanted to give my brother a job, not only because he understands the business, but as you strongly suspect, it would be a financial help to one of my family. I assure you that on this job he will be satisfied with nothing above $50 a week. Let him have full charge of my productions, then let him have the responsibility of selecting a man to play the music accompanying the picture. I would recommend to my brother that he engage for this purpose Mr. Theodore Huff. Mr. Huff understands the business thoroughly and is a most excellent enhancer of motion pictures by the proper manner of playing the accompanying music. The man you have there now is doubtless an excellent musician but he plays the score for the sake of the music instead of making the music talk for the picture and the picture's sake alone.*

I would also like to have Mr. Seymour Stern write the literature for the pamphlets or other information to be given out to the public. He has been a student of my work for the past ten years, is a brilliant writer and also has entree to the press and magazines and, right or wrong, he has a great enthusiasm for my work. I believe Mr. Stern is splendidly equipped for this job, partly due to his long years of study of my poor endeavors, that he would give out information and propaganda to sway the audience favorably towards the pictures instead of subtly putting ideas into their minds that something was wrong with them. I am quite sure Mr. Huff can be procured for around $35 a week, Mr. Stern for about $40. By putting my brother in complete charge of these showings, he can engage these men and as I mentioned before take the blame off us.

If something after this manner is not done, I personally would very much prefer not to have the films shown at all.

Sorry to make all this trouble for you but you are young, good looking and have all that dough and on the other hand, I am an old and fading weed and don't want to work no more. So, on the whole, I think it is only right that I should give you at least a little trouble.

With best regards believe me, I am, as ever,
 Most insincerely yours,
 D.W. Griffith[11]

In a memo marked "CONFIDENTIAL," Rockefeller passed on a précis of Griffith's letter to Dick Abbott. "Here's a hot one for you!" he wrote. "I would appreciate your drafting a letter which I could send to Mr. Griffith. It looks to me as though the trouble was caused by his wife and probably by friends and relatives who are looking for a job."[12]

The upshot of Abbott's deliberations, which no doubt included Iris, was a letter from Rockefeller to Griffith sent on September 18, 1940, bearing the earmarks of Iris's writing style: "I have been greatly concerned about your letter of August twenty-seventh," the letter began,

saying you would prefer the Museum of Modern Art not show your films at the forthcoming Griffith Festival, unless your brother has charge of the exhibition, unless Mr. Seymour Stern writes the catalogue, and unless Mr. Theodore Huff plays the piano. I am also very distressed to hear that your friends have told you that Miss Iris Barry, the Curator of the Film Library, is not likely to do justice to you and your work, although you yourself believe her to be "a brilliant and most capable woman."

I think you have stated your own feelings very clearly, and now I would like to set forth, as well as I can, the point of view of the Museum.

Running a museum is an enterprise not unlike another; we employ people whom we believe to be well qualified, and as long as both the public and competent critics approve of their work we do not interfere with them. The director of any undertaking, I am sure you will be the first to appreciate, must be given certain freedom in his actions, and we cannot easily introduce new personalities into an organization which has been functioning smoothly for many years. The Museum staff has been working for two years on this particular exhibition; the work is practically complete, and we feel it would be unwise to introduce any new personalities at this time.

In regard to what may seem to you a disproportionate attention to foreign films, I should, perhaps, remind you that the Film Library is international in its scope. It was founded to provide a permanent archive for the significant films of all nations. It is true that it has collected and shown many foreign films, but this has been because there was a definite demand on the part of the public to know and understand what has been done in this field abroad, and whereas good American films have been widely circulated, good foreign films were often difficult to see. Even so, the Museum programs have shown 124 American films while the work of eleven foreign countries was covered in 81 films.[13]

After reassuring Griffith that the aims of the Museum were purely felicitous, and saying that his own work will be presented via "an extensive gallery exhibition of innumerable still photographs, some of them enlarged almost to screen size, documents relative to the making of the films, many pictures of yourself and the actors and assistants you trained, of the studios where you worked, etc.," the letter declared that "Miss Barry believes you to be the greatest creative spirit in the entire history of the film . . . and I can safely assure you that the only desire of Miss Barry and the entire Museum staff is to see that your great work is fully appreciated by the millions of young people who attend films today but do not realize how great a role you played in their development. Whether we show paintings, or architecture, or films, our public expects them to be accompanied by critical evaluations, and in the matter of factual data I am sure that Miss Barry will take pains to verify every detail. But I know that, given her sincerity and her immense admiration for all you have done, any misinterpretation of your work is quite out of the question." Rockefeller concluded by saying that if Griffith were indeed withdrawing his blessing, "we shall have to abandon the exhibition."[14] The withdrawal failed to materialize and the exhibition went on as planned without Griffith's brother.

As it turns out, Griffith's assault upon Iris was an act of piling on begun earlier in the year by film scholar Seymour Stern. The same Russian film retrospective that caught the eye of Griffith's society friends also drew fire from Stern, a notorious anti-leftist and disgruntled critic of the Film Library. In the March 23, 1940, issue of the *New Leader*, Stern nitpicked the program notes written for the series by Jay Leyda, the Soviet film scholar and former aid to Eisenstein then working for Iris. Stern claimed that by naming Kharkov, not Kiev, as the location for an early Bolshevik rally, Leyda was guilty of departing from "accepted canons of cinematic criticism" and of substituting instead "outright political propaganda."[15] Stern denounced Leyda as a "Communist Party partisan, 1940 model," and warned that Leyda, "by his tendentious writings and

Soviet apologetics is not furthering the laudable purposes of the Museum of Modern Art Film Library in its avowed 'scientific study' of the history of film." Stern claimed that it was "highly pertinent" in this connection that "Mr. Leyda is one of the signatories to the now infamous 'Letter of the 400' [*Daily Worker*, August 14, 1939], which hailed Stalin's Russia as the great protagonist of peace, culture, and democracy, and denounced as fascists all lovers of freedom who protested against the regimentation of Russian arts and science."[16] Stern concluded on the ominous note that he "may be mistaken; it may be that Mr. Leyda is doing no more than his duty by and for the Film Library when he gives out political propaganda and typical Communist Party misinterpretation of history in the guise of 'scientific' program notes. . . . Yet the question persists: does the Library really support his line?"[17]

Stern apparently tried to find out. He sent a copy of his article to Nelson Rockefeller, asking at the same time that he himself not be viewed as "in any sense a professional red-baiter," and protesting that he was merely "interested in the MMAFL" and disliked seeing "such an influential public institution used as a springboard for political rather than artistic ideas."[18] Stern followed with another letter to Rockefeller on June 1, enclosing a column by right-winger Victor Riesel in the May 11 issue of the *New Leader* in which Riesel called on "Mr. Rockefeller of the oil millions" to "look sharply into his Museum of Modern Art," since "he'll find that his assistant curator of the Film Library—one Jay Leyda—was formerly an important propaganda commissar in Moscow, where he worked on documentary films under the aegis of the International Bureau of Revolutionary Literature," where "one of his functions was to spread international propaganda boosting Soviet movies."[19]

On April 9 Rockefeller sent a polite reply to Stern's rant, noting "how strongly you disagree, and on what basis, with facts or opinions stated in Mr. Leyda's program note on the film, *Arsenal*, but I am glad to find that your interest in the Film Library is at once so critical and so lively."[20]

This *Sturm und Drang* necessitated Iris asking Leyda for an explanation, which he made in a memorandum dated May 29, 1940: "It would be futile to answer the *New Leader* item in detail," Leyda's memo began, "because it does not contain one true fact." He went on to recall what Iris already knew of his associations in the Soviet Union, that he had worked as a student with Sergei Eisenstein, Dziga Vertov, and Joris Ivens, but that he "was never connected with any International Bureau of Revolutionary Literature."[21]

Iris had already reassured Rockefeller that she was aware of "the articles about the Film Library being the prey of Communistic machinations," but

ventured that she was "personally of the opinion that we should pay no atten-
tion to this at all," since, as far as she could tell, Leyda drew "the bulk of his
information" from the *Encyclopedia Britannica*.[22]

The contretemps with Griffith and Stern, despite its nettlesomeness, was
only one incident in a broader controversy plaguing the Museum. Set squarely
in the supreme American metropolis, the Museum of Modern Art was often
suspected of not being "American" enough. Although Griffith did not know
and would have little appreciated the fact, given the nationality of the reviewer
involved, in early 1940 Iris had asked the émigré British writer Alistair Cooke
to prepare a confidential report regarding the operations of the Film Library.
After observing the staff for three months, Cooke basically reaffirmed Iris's
populist inclinations, urging only that the Film Library pay more attention to
American films. Over all he felt that "we go a little too far in aligning ourselves
(not by intention but by implication) with the people who want to make the
movies an esoteric art. We are primarily historians of a popular art, and we
must not shrink from any connotation of the word 'popular.'"[23] Iris would not
have disagreed.

The year 1940 was also one in which Iris felt other pressures to align herself
and the Film Library with American films and do what she could to coun-
ter the impression that she was too friendly to foreign films, especially Soviet
ones. The long dark night of American politics—later labeled the "McCarthy
era"—had been under way since the late 1930s in the form of the congressional
committee (HUAC) headed by Congressman J. Parnell Thomas dedicated to
rooting out "Un-American" elements in domestic society. Stern's attack on the
Film Library, however, can be attributed at least in part to a personal vendetta.
Stern was a friend of Theodore Huff, a film collector and silent film accom-
panist serving as a curatorial assistant to Iris. Huff's eccentric personality and
suspiciousness of intellectuals put him in conflict with his fellow curatorial
assistant, Jay Leyda. Huff felt Leyda was too influential in having Soviet films
included in the Film Library's programs, and that, commensurately, American
silent films were receiving short shrift.[24]

Iris found herself forced to choose between Huff and Leyda. At first, before
he was let go later that year, she chose Leyda, dismissing Huff with a promise to
help him find a job. Huff apparently went out fighting. Soon after his departure
the *New Leader*, which had published Stern's original attacks on Leyda, pub-
lished a letter to the editor claiming that Huff's dismissal was a victory for "the
Stalinist element in control of the Film Library" and saying that Leyda, whom
the writer called a "Soviet trained propaganda commissar" (quoting columnist

Victor Riesel), had "set himself the task of getting rid of Huff at the earliest opportunity."[25]

Despite his skepticism of critics such as Stern, Rockefeller was not suf-ficiently supportive of Leyda to allow him to keep his job. Margaret Barr believed that Iris did not stand firm for Leyda, and, as Leyda's later colleague at New York University, Annette Michaelson, said at a posthumous tribute to Leyda, "his eventual resignation [in 1940] from the post [at MoMA] was forced after a political attack mounted against him did not elicit support for him on the part of the Museum's board of directors or the trustees of the Rockefeller Foundation."[26]

All this rocking of the Film Library boat must have irritated Iris considerably. No sooner had she gotten rid of Huff than his name appeared in the letter from D. W. Griffith threatening to withdraw his films from her planned retrospective tribute if Huff were not rehired by the Museum. Iris endured these pressures, but could not have failed to understand that she had a public relations job to do to deflect the impression that she and the library were pro-Soviet.

It may not be coincidental, therefore, that Iris's 1940–41 exhibition program featured a history of the animated cartoon.[27] Lest the more high-minded among her audiences conclude that she had gone Hollywood, she followed the anima-tion series with one dedicated to the abstract film, featuring the work of Hans Richter, Mary Ellen Bute, and Theodore Nemeth.[28] Finally, just for fun, there was a retrospective look at American film comedy.[29]

The charge of Eurocentrism was not confined to the film program of the Museum. In the spring of 1940, American Abstract Artists (AAA), headed by George L. K. Morris and his wife Suzy Frelinghuysen, confronted the Museum on the issue of defining modernism. The organization felt the Museum ignored the achievements of American abstractionists. A thousand invited artists attend-ing a preview at the Museum in mid-April were presented with a handbill from the AAA challenging the identity of the Museum. The handbill, which asked, "How modern is the Museum of Modern Art?" was signed by fifty-two artists, eighteen of whom had been collected by the Museum.[30]

These criticisms of the Museum coincided with the final years of Barr's directorship. It is not clear, however, that Barr himself is to blame for the perceived neglect of American abstractionists by the Museum. Jimmy Ernst believed the situation ran deeper, beyond Barr to Nelson Rockefeller and the Abbott regime. Ernst became friendly with many members of the American Abstract Artists in the late thirties and early forties.

"The fact that I worked at the Museum of Modern Art did not bother any of my friends," he recalled in his autobiography, "even though they were very critical of its favoritism toward European, and now also Latin American, art. [The Museum's] permanent collection of American avant-garde work was growing only slowly. What there was of it owed its presence to the embattled prescience of Alfred Barr and Dorothy Miller. There were, after all, other, earlier neglected Americans deserving prior consideration. The Museum owned four superb Edward Hoppers, for example. His haunting *House by the Railroad* had been chosen as one of the large color reproductions for the front desk, where its sales were second only to Picasso's *Woman in White.* Some of the other Americans [in the collection] were Maurice Prendergast, John Marin, Charles Sheeler, Charles Demuth, Charles Burchfield, Alexander Calder, John Flanagan, Walt Kuhn and Loren McIver. There was doubt at the time that the growing institution was ready to look at the experiments of younger Americans more than peripherally. In the opinions of these artists [the AAA], the Museum had stepped backward in opening its doors to Botticelli's *Birth of Venus* and a rich treasure of other Italian early masterpieces in a 1940 special exhibition. There had been ... in succession, a large show of Mexican art and the uninspiring presentation of the Brazilian painter Portinari. The latter two exhibitions made it clear that the Museum was going to be an arm of the Coordinator of Latin American Affairs, Nelson Rockefeller."[31]

The impressive size and scope of the Museum's film activities also made it a convenient target, such as that seen in the Griffith coup attempt. However, Iris's film program pursued its own middle course while Barr's exhibition and collecting program unabashedly acknowledged its European roots. Ironically, the widespread perception of the Museum's Eurocentrism would provide a kind of cover for the strongly pro-American role it played during World War II.

Near the end of 1940, the last year before American entry into the war and a profound change in the nature of Iris's work, she enjoyed a brief moment of relief. In November she wrote her brother-in-law that "Chaplin came in to the Museum two days running so I am very happy as we had quite extensive talks and you know how I worship him. This makes up a little for the nuisance of Mr. Griffith."[32]

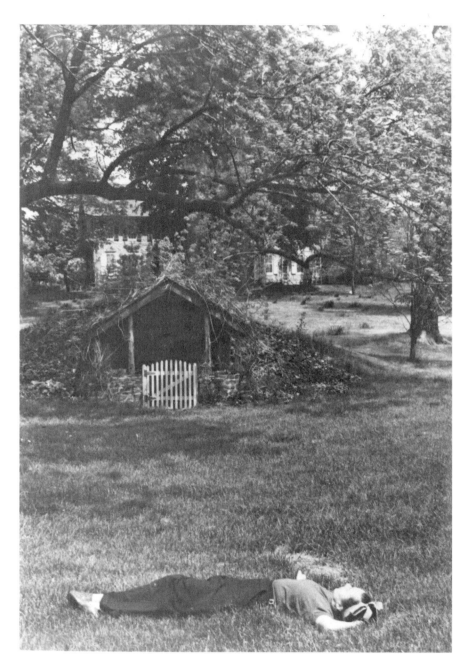

Iris relaxing at Temora Farm (1941)

26

TEMORA FARM

ELL BEFORE PEARL Harbor and the American entry into the conflict, the Museum of Modern Art was gearing up for war. By war's end few American cultural institutions had become more deeply involved in the war effort than MoMA.

In July 1940, Margaret Barr was pressed into the service of the Museum by her husband to coordinate requests to provide asylum for artists fleeing occupied France. The task involved extensive correspondence, for which the understaffed museum was ill-equipped, as well as identifying sponsors who would pay a refugee's passage and sign an affidavit guaranteeing that the incoming person would not become a burden to the state. Additionally, it was necessary to prove "incontrovertibly that the applicant is not, and never was, a Communist or leftist sympathizer."[1]

Margaret Barr worked through Ingrid Warburg and Varian Fry of the Emergency Rescue Committee (later the International Rescue Committee), based in a villa outside Marseilles. Between August of 1940 and the following August, when Fry was expelled by the Vichy government, Fry and his contacts were responsible for spiriting out of France through Lisbon such endangered figures as Heinrich Mann, Marc Chagall, André Masson, Jacques Lipchitz, and Franz Werfel.[2] Eleanor Roosevelt assisted this effort by prevailing upon the State Department to speed up the processing of visas. Frances Perkins, head of the Department of Labor, also played a key role, since immigration at that time was a responsibility of her office.[3] Joining such other émigré artists as Marcel Duchamp, Piet Mondrian, Fernand Leger, Matta, André Breton, and Leonora Carrington, and architects Mies Van der Rohe and Walter Gropius, these newcomers added greatly to the wartime art scene in New York.

Also in August of 1940, Nelson Rockefeller was named head of the Office of the Coordinator of Commercial and Cultural Relations Between the American

Republics (his title later was changed to Coordinator of the Office of Inter-American Affairs), and moved to Washington. Rockefeller had been replaced as board president by John Hay Whitney. Although Whitney told the *New York Times* upon assuming the role that he would not "diminish my interest in the film library but hope rather to participate increasingly in all the museum's other activities,"[4] at the same time he was substituting for Rockefeller at the Museum he was also heading up the motion picture activities of Rockefeller's Office of Inter-American Affairs. These demands resulted in more reliance for the day-to-day management of the Museum on Stephen Clark as board chairman and John Abbott as Executive Vice President.

"Clark's right-hand man was John ('Dick') Abbott," Russell Lynes affirms. "Because of his experience as a broker in Wall Street he was regarded as a 'money man' and a practical operator, and so he was named the Executive, whose function was to keep the Museum's daily operations running smoothly and its purse plump. It was he who was also supposed to be the calm center in a storm of temperaments, and as Clark liked him and trusted him and looked upon him, it is repeatedly said, 'as sort of a son,' his influence in the Museum was exceedingly important for a time—a time, indeed of troubles."[5]

As to Abbott's administrative style, Lynes reports that Henry Allen Moe, former director of the Guggenheim Foundation and a MoMA trustee, remembered Abbott as "a most useful fellow," adding that he was "a good enough administrator, and he was so sensitive to the winds of change that he was a good listening device for all the board members" (225). Indeed, in Lynes's view, "It is likely that it was because he was known to the staff as a 'listening device' that he was so heartily disliked and distrusted by so many of them. 'He treated the staff terribly,' one says, and another: 'I used to lie awake nights worrying about him. He was the menace of the Museum. Am I the only one who thought of him as Hitler? . . . You always felt this very scheming thing going on. You never knew what he was up to, and he had a habit of insisting that you write a memorandum to him, and he would never answer a single memorandum except by telephone, and then if you would quote him, he'd say he never said that. . . . It was a very slippery period indeed.' These statements were made by two of the Museum's most devoted and efficient staff members, an associate curator and the director of a department, Dorothy Miller and Elodie Courter" (225).

As Abbott's status at the Museum rose, so did his lifestyle with Iris. In 1940 they took possession of a townhouse located at 221 East 49th Street, a four-story residence with a small apartment on its top floor in the fashionable Turtle Bay area of Manhattan. The couple attempted to relieve their professional stresses

by buying a place in the country. Ever since her childhood on a farm in England, Iris had harbored dreams of escaping city life, a predilection apparently shared by Abbott, who had fantasized in their prenuptial days about moving with Iris to a ranch in the Southwest. She and Abbott took possession of a historic eighteenth-century manor house in Bucks County, Pennsylvania, called Temora Farm, a sumptuous place and quite beyond their means. Set on 132 acres leased by its owners for over two hundred years to Bucks County farmers, the graceful old house had all the comforts. It was described by the real estate company that handled its sale as having "never been altered or tampered with." The company assured interested buyers that "the architectural details of the house are in themselves museum pieces and have been insured for Fine Arts coverage."[6]

Iris had grown up on a farm, and now she owned one. Enthusiastically, she set about becoming a weekend farmer.

> As we had about an acre of lawn in front of the house, we bought two fat young lambs and put them in a sort of large, moveable pen, so that they ate one square of grass and then were moved to another, leaving their valuable little dots of manure behind. At the proper time we wormed them and had them killed for the price of the two good fleeces, popping their meat in the quick freeze, which had just been set up in nearby Newtown. . . . Down to the quick freeze went most of the Muscovy ducks, the dear ridiculous dumb ducks, so ungainly, so fertile, so good to eat and so friendly with their absurd great yellow feet and smart eyes. . . . We took up baskets of fresh vegetables, eggs, ducks to New York every Monday.[7]

Iris and Abbott had a "pig palace" constructed, in honor of Iris's grandfather's practice of keeping pigs, and thus managed during wartime food shortages to have "sausages galore," sending some to the in-laws "and draped others over the bathroom pipes and of course ate them with mashed potatoes and pancakes and mustard," the pig having been slaughtered by Iris's Hungarian maid, who came to the country for the task wearing a sealskin coat and many rings on her fingers.[6]

"Some lingering childhood memory sent me out, last January," Iris recalled at the end of her first year at Temora,

> to proposition the farmer with a view to obtaining manure. I offered to buy some. The farmer gave me a long, penetrating glance and replied that the farm furnished manure and that I could take what I wanted of it. This decent

and unexpected response gave me a flush of confidence. The farmer added that maybe he could allow us a team to plow the half-acre.

This is the first time that I had ever heard of plowing a vegetable garden. Where I come from, in England, vegetable gardens are mostly hedged neatly about, even the plots being edged with box or lavender. All is dug by hand: the land grows ancient men who have young grand-nephews or connections who will 'oblige' by laboriously and earnestly turning the soil over. As the gardening books tell me, this is the best way. It does not suit conditions here. . . . I gratefully accepted the tacit offer of a horse and plough along with a most grateful acceptance of fine half-rotted stable manure spread generously and turned in.

Meanwhile we were studying seed catalogs and reading gardening books. Reliable guidance was furnished conspicuously from two sources—one from the *Eastern States Cooperator's Seed Catalog*, which proffers not merely seeds and fertilizer and spraying or dusting materials, but practical information on the culture of each vegetable and—most important to the novice—the amount of seed needed for each unit of 100 feet row or acre, how deep to sow, how far apart, the requirements for thinning, how to treat vegetables for winter use, and provides, moreover, a highly practical planting chart.

Came the spring. One weekend it was distinctly winter; the next the air smelled different, birds were acting up in and around all the trees and we decided it was time to go out and *do* something. We ran around like mad with tape measures, mapped out a plan of the garden and decided—most arbitrarily—where to put what. I know now that, though we did not admit it, we actually expected nothing whatever to come up and reach edible maturity.

Also, there was friction. We were very interested in eating, and in eating well. I therefore banned cabbage, brussels sprouts and cauliflower on the grounds that, from what I remembered from a childhood spent on an English farm, they were greatly beset by insect pests and we did not, as a family, greatly care for them. My husband, on the other hand, wanted to grow everything, including difficult critters like egg-plant, artichoke and peppers.

Looking back now I realize how generously Providence, which sent us a season which was at once early and gentle, and Lady Luck, who presumably favors the ignorant, and our critical but truly helpful neighbors, the farmer and his wife, were to us. It is true that we tried very hard. We not merely measured the garden, and drew careful charts of what should go where, and be replaced by what, and given which kinds of insecticide or fertilizer—we ardently bedewed the ground with our own sweat. I personally held the

suspicion that ploughing and harrowing was not enough, that it was best to get down on one's hunkers and crumb the soil up fine by hand before setting the seed according to the instructions.

It was an early and warm spring. We ventured everything, planting peas on April 13 and 14 on the theory that if frost came, we would replant. No frost came: we ate peas generously for Decoration Day. Turnips, beets, onions, carrots, chicory and lettuce went in on April 15 and 16, and salsify, parsnips, mustard were duly sown on the 19th and 20th. For fear that this sounds like part-time labor, I should explain that the patch is a long somewhat irregular rectangle, sloping slightly southwards, roughly 100 feet wide and 230 feet long with an extra wedge off eastwards. We planted in 50-foot rows: a long distance on hands and knees, crumbling the earth by hand around the seed. By the 20th of April borage and fennel and parsley had gone in and, long before this, the collapsing cold frames had been pulled together and early lettuce and parsley well-started therein. We were, as I said, chiefly interested in eating and we had already observed, somewhat grimly, that in the stores in our local town the only lettuce available was rock-hard iceberg and that parsley was unobtainable.

All the gardening books said that amateurs should not attempt to grow tomatoes. There was, however, the remains of an excellent hotbed frame on the place and there were also horses. Some impulse or other compelled me to attempt rising tomatoes, cabbage and peppers—both the gentle green and the fiery cayenne—and much to my own surprise and everyone's admiration, all flourished. It was no trouble at all and a weekend visitor and I set out the young plants in two days—April 10 and 11—without too much trouble, though I admit that, what with wetting the soil down about them and all the rest of it, we were both moaning of pains in ankle, loin and shoulder by nightfall. But all of the plants prospered and by August we were being inundated by tomatoes, which seemed to be rising about us like a red tide although only 75 plants were set out and only a dozen of them properly staked and at sufficient distance from one another and the later shoots suitably pinched off. We _had_ tomatoes.

In May we were rewarded by the tenderest of beets (which we like at that season to pull very small, thus thinning the rows and still having the great delicacy of young beets cooked with their tops) and of young carrots, also pulled to thin the rows but providing one of the vegetable kingdom's greatest treats, while we luxuriated in baby lettuce from the cold frames (no labor here) wilted dandelion tops made tenderer by merely throwing old burlap

bags or rotted planks down upon the ground. The garden gave, and gave generously, despite our ignorance and despite the lack of labor. The weeds, however, were terrifying and, in places where we had let them have their way, grew to dimensions where the only remedy was far beyond any cultivator, so that we had to pull them by hand and cart them away by the hundredweight. For people unused to this kind of work, as we were, this is a killing task and I remember with pride mingled with horror the pains that shot through me when, exhausted, I tumbled into bed at nine every night each weekend and found it impossible to sleep because my swollen feet ached and throbbed so abominably. But it was enormously worth it: there was a moment when the chicory was so immersed in weeds that we almost gave up. Now, in January, when we eat it and its very different friend, salsify, and turnips broadcast where in August we daily culled more melons than we could eat, we feel a sense of pride and satisfaction which no gardening book could suggest."[9]

Temora Farm was the first serious attempt on Iris's part to get back to the land, and although Iris and Abbott did not hold title to Temora for long, the farm provided Iris with a rare sanctuary. It was there that the reality of war came to them.

The morning of Sunday, December 7th, 1941 was fine and sunny. As usual we were in the country for the weekend . . . and much occupied with the garden, the house and rustic delights generally. My husband, whom the doctors had found tubercular, was established on a chaise lounge on the lawn, but connected by endless loops of black cord to the telephone. A portable radio as well as a quart of milk were at hand.

At about eleven the farmer, dear Mr. Ulmer, in very clean brown overalls and carrying a pitchfork, came round the corner of the house in a calm and dignified manner and stood by the chair. 'Is it true,' he asked, 'what we hear on the wireless, that the Japanese have attacked us?'

Abbott answered that, yes, it seemed to be so. The farmer took a goodly time to respond, and then in a way that took our breath away, he asked, in his own deliberate way, 'Are they heathen?'

'Well, yes, they are not Christians,' Abbott replied.

'So, good: now I must get on with my milking,' the farmer sighed. And that for us was how the war began in Pennsylvania.

As things had begun to look so ominous long before that, I had already invited my mother to come over from England and take care of the country

place, where indeed she would have been invaluable. She replied, amiably, no: where, she said, would she be buried in America, whereas at home there awaited her a place for her coffin in the family vault, and moreover with whom, at her age, could she make friends or play bridge?

This reply in a way relieved me, as I had done the dutiful thing, and besides I had never really liked my mother very much. She had the last word, however, when I went down to Bognor Regis to see her in 1946. She had put on a lunch at the local hotel, but after lunch where I had met several of her cronies and been inspected by them, she said gently, 'You know, the best train back to London is at four o'clock.' So I trotted humbly away to the station.[10]

27

THE MUSEUM ENLISTS

EVEN MORE THAN the decline in Barr's authority between 1939 and 1943, it was World War II that transformed the culture of the Museum of Modern Art and its Film Library. As a MoMA board memorandum to Nelson Rockefeller put it in 1942, "with the advent of War the Museum was faced with the question of whether it should go forward with its normal activities or devote itself exclusively to the defense effort. The ultimate decision was to do as much as it could for defense and at the same time maintain insofar as possible a normal program."[1] Programs and services of the Museum were placed on a wartime footing, from the film series, *Britain at War*, to the Edward Steichen photo exhibit, "The Road to Victory," and the poster exhibition the Museum organized for the Army Air Corps.

As top Museum trustees became high-level wartime functionaries, leaving Dick Abbott behind to carry out their agendas, Abbott began his reign at the Museum by waving the annual report before newspaper reporters, trumpeting the gains on his watch. The Executive Vice President brandished statistics to the *New York Times* having to do with the operations of the Museum: "585,303 total attendance—'in spite of the fact that there was an admission fee of 25 cents at all times'—and an increase in membership from 4,075 in 1939 to 7,309 in 1940." Alfred Barr was limited to brief comments on gifts and purchases of art (Mrs. Simon Guggenheim gave Henri Rousseau's *Sleeping Gypsy*—later judged the Museum's most popular painting—and Mrs. John D. Rockefeller donated four unspecified collections of American art).[2]

On another level Abbott was also working with Whitney and Rockefeller to put the Museum firmly in the service of the Roosevelt administration's "Good Neighbor" policy on Latin America. Intelligence gathered by the government pointed to the possibility that areas of Latin America were vulnerable to German propaganda, thus threatening the hegemony of the United States

over its southern neighbors. To counter this perceived threat, the Roosevelt administration undertook a policy of actively courting favor in Latin America, emphasizing the protective role of the United States in exchange for Latin American fealty.

Two weeks after Abbott's annual report, Whitney announced a new role for the Museum. On the first of March 1941, nine months before Pearl Harbor, he told a group attending the First International Conference of the School of the Air of the Americas at the Museum that he was "happy to announce that in cooperation with the government this museum is embarking upon a new program to speed the interchange of art and culture of this hemisphere among all the twenty-one American republics."[3] After an introduction by Abbott, Whitney declared to the assembled crowd that "we conceive of the function of a modern museum as something quite different from that of a static peepshow of antiquity." He announced that the Museum's programming "was to be viewed as a weapon of national defense, particularly in relation to the Western Hemisphere."[4]

The *Times* reported that, in this new liaison between the Museum and the government, "the first medium to be used is the motion picture, and the facilities of the museum's film library will be utilized. . . . Every non-theatrical motion picture available in the United States—private as well as public—will be reviewed and graded for suitability for recording in Spanish and Portuguese. Plans are also being worked out to prepare several travelling exhibitions of paintings by North American artists to send to the South," which Whitney hoped would justify his conviction that the program would do much to counteract the work of "certain elements" in Latin America which are "trying to prove that there can be no common ground on which the people of the Western Hemisphere can meet."[5]

Well before war was officially declared, therefore, the Museum and its Film Library was at the end of a chain of command extending upward from Iris's husband to Whitney, Rockefeller, and the Roosevelt administration. This resulted in a reversal of Iris's established inclination to separate nationalism from critical practice.

Iris took the opportunity of this shift in the Film Library's role to inform the Museum's members that the Film Library was thoroughly pro-American. In the June–July 1941 issue of the Museum's *Bulletin* she extended her campaign against the rumors that the Film Library was anti-American, an impression she attributed to the library's considerable holdings of foreign films. She told the members that "the acquisition of foreign material of this kind gave rise

to a whispering campaign (originating, it seemed, among small groups of film enthusiasts with axes to grind) that the Film Library or the Museum as a whole, or perhaps even the Board of Trustees (!) was infiltrated with Nazi principles (this was in 1937 and 1938) or with Communist principles (this was in 1940) or at best with some 'un-American' spirit." These charges she was now taking the opportunity to emphatically deny. In the broad scope of its programs, from the retrospective of American films that proved so popular in the Jeu-de-Paume exhibition in 1938 to the many programs of American films the library had exhibited and circulated, she declared, "the Film Library [has] affirmed its unwavering faith in the film as the liveliest as well as the most popular of the contemporary arts and one in which the United States is supreme." Lest her audience doubt the continuance of this dedication, Iris revealed that the next undertaking of the Film Library would be to house "a project under the Office of the Coordinator of Cultural and Commercial Relations Between the American Republics for the provision of educational and documentary films in Spanish and Portuguese to the twenty sister nations of the hemisphere. With the growing recognition of the film as a major social and cultural force in our time the Film Library's horizon becomes unlimited."[6] Iris's decision to highlight American films, as these initiatives clearly show, was not altogether her own and was motivated by larger institutional and national interests. At the same time, she no doubt hoped her MoMA *Bulletin* article might put to rest any lingering suspicions that she was not a hundred percent American.

As if to prove it, she became a naturalized American citizen.[7]

To implement the Good Neighbor policy in film, Whitney hired Kenneth Macgowan, a former film critic, amateur archaeologist, and an associate producer with the Zanuck organization, the Hollywood production firm owned jointly by Darryl F. Zanuck and Jock Whitney. Macgowan was installed at the Museum and, according to a *New York Times* report on his hiring, charged with "viewing much of the large body of documentary material already available. That which is considered suitable will be taken, dubbed with Spanish or Portuguese narration (if the subject concerns North America) and dispatched southward after approval of the State Department."[8] The subject matter of the documentaries, the purpose of which were to show "how North American democracy works and plays," would "cover a wide swath—our natural resources, spectacular industry, transportation, rural electrification, efforts at city planning, methods of education, even our amusement parks."[9] To support the project, Whitney would travel to South America to find out what aspects of local culture the various governments wanted to highlight in films to be distributed in the United

States. To assure the broadest distribution of the films, all would be made in 16 millimeter and shown in nontheatrical settings. Although an estimated 15,000 16mm projectors existed in the United States at the time, practically none were available in Latin America. "To remedy this lack," the *Times* reported, "the [Rockefeller] committee intends to dispatch shortly to our embassies in South America a number of 16mm projectors. These in turn will be loaned to schools and sundry organizations for exhibition of films. There, it is to be hoped, Latin Americans will meet a friendlier gringo than the fellow with a big stick."[10]

To pay for all this, the *Times* noted, it is "possible that the government out-lay may be augmented by funds from private or semi-private foundations."[11] How much money Rockefeller and Whitney interests poured into what was then officially known as the "Office of the Coordinator of Commercial and Cultural Relations Between the American Republics Under the Council of National Defense" remains to be determined, but it is clear that the "Rockefeller Museum"—the Museum of Modern Art—played a leading role in the effort.

On the same day Macgowan's appointment was publicized, the Film Library announced the dedication of much of the coming summer to a joint exhibition on the art and cinema of wartime England. Iris's past connections were coming into play to support the Allied cause. She also mentioned to her brother-in-law, Charles Abbott, that "Dick has thought up a lot more government contracts for us and we are practically members of the armed forces by now."[12]

Iris and Abbott had influential allies. In June of 1940 Iris's longtime friend Sidney Bernstein had been appointed Films Adviser to Duff Cooper, head of the British Ministry of Information, Britain's top spy agency. According to Bernstein's biographer Caroline Moorehead, Cooper offered Bernstein the job because of his "links not only with every facet of the British film industry but with overseas and particularly American film companies and distributors."[13] To secure his appointment Cooper had to override a top-secret report that Bernstein might be subversive, since he was "known to visit the Russian Embassy every week" (117). Moorehead claims that Bernstein "had never set foot inside the Russian Embassy, nor voted for anything but the Labour Party and had never been a member of the Communist Party" (117). He came to be entrusted with highly sensitive missions for the British war cause and called upon Barry's help. This relationship helped bring about a significant change in the role of the MoMA Film Library and the nature of Iris's work.

The immediate result was a series of films promoting the British war effort to a United States not yet willing to enter the war. Acknowledging public indif-ference to the conflict raging in Europe, Bosley Crowther of the *New York*

Times gave favorable notice to the efforts of Whitney's business partner Darryl Zanuck, who "was commissioned to supervise production of some army training shorts," and called his readers' attention to the admirable documentaries about British war life being shown at the Museum of Modern Art. "Here is a collection of pictures made since the war began by the G.P.O. Film Unit, a government agency," Crowther wrote, "and by various producers for the Ministry of Information which shows a great variety of aspects of a nation fighting grimly for its life. Not one of them classifies as an out-and-out flag-waver; not one of them goes overboard to make out a preposterous case. Most of them were filmed with the real McCoys, not actors, in the leading roles, and what you see on the screen is a literal representation of fact. They are, to use a term, documentary films of the purest sort."[14]

The films shown included such titles as *The Village School*, which focused on the activities of a schoolteacher in Buckinghamshire teaching pupils who had been evacuated to escape the London air raids, while *Spring Offensive* detailed the activities of British farmers growing crops on previously disused land to aid the war effort, and *Squadron 992* showed how Britons were trained to deal with a possible attack via balloon. Crowther found these films inspiring. Yet another, *They Also Serve*, he found a "homely and inspiring tribute to the plain, everyday housewives of England who do their chores cheerfully and bravely, get their husbands off to work on time, and their children off to their tasks, without grumbling or losing heart."[15] As grateful as she may have been for this publicity, Iris must have noticed how Crowther's views contrasted with the more skeptical view of "inspiring" wartime films she had expressed in her earlier writings. Then she was a film critic; now she headed a major institution positioning itself to support a world war.

Having facilitated through Iris the exhibition of Ministry of Information films at the Museum, Bernstein followed with a clandestine trip to the United States. "On 18 August 1941 Sidney left for America," Caroline Moorehead recounts. "He was to be away for five weeks. His journey was made in total secrecy: Sidney traveled in an American Liberator bomber from Prestwick to Newfoundland, huddled along a bomb rack. Having remembered his Russian literature, he had sensibly taken the precaution of wrapping himself in a layer of newspapers to keep out the intense cold. According to a brief diary he kept of the trip, he 'slept a night under canvas' in Newfoundland, then flew on to Washington, to talk to Lord Halifax, who had replaced Lord Lothian as British Ambassador in December, and then to New York. His sister Beryl came to meet him, and [Alfred] Hitchcock was there, and so was Iris Barry, by

now Film Curator at the Museum of Modern Art and married to its Director, Dick Abbott" (131). Bernstein's mission was to coordinate British propaganda with the U.S. Office of War Information (141). Iris assisted him by exhibiting the documentaries about British war life throughout the fall and winter of 1941. Bernstein played a reciprocal role in pressuring John Grierson of the Canadian Film Board to release to Iris copies of two Canadian-captured German propaganda films, *Victory in the West* (*Sieg im Westen*) and *Feldzug im Poland* (*The Campaign in Poland*), then influencing opinion in Germany and some parts of the Americas.[16] Two weeks after the Japanese attack on Pearl Harbor and the U.S. entry into the war, Iris showed a series of civil defense films titled *Safety for the Citizen* in the Museum auditorium. The six short films, made in England, would be reshown "through the period of their usefulness to the public" as an adjunct to the Film Library's regular programs.[17] Even the Museum's theater would be placed at the disposal of the war effort. The *Times* reported that "the Museum will use as an air raid shelter for its own personnel and visitors, the auditorium floor on the sub-basement level. The entire staff has been organized into squads for an emergency."[18]

When war came to America, the counterattack had already begun at the Museum of Modern Art.

Brett Gary, in his incisive study of wartime propaganda, *The Nervous Liberals*,[19] describes a larger context in which the war work of Iris and the Museum might be understood. Having witnessed the deleterious impact of German propaganda during World War I, and ruing since the early thirties the impact of Nazi propaganda on German society, many American intellectuals were faced with a dilemma: how could America be prepared for entry into World War II without compromising civil liberties or engaging in unseemly counterpropaganda? Should the influx of German propaganda in the United States and Latin America be countered by limitations on free speech? While debating, everyone recognized the growing Nazi threat.

American writers such as the newspaper columnist Walter Lippmann and the poet Archibald MacLeish were early advocates of "preparedness."[20] Both had called for a shift to a war footing of American libraries and cultural institutions. MacLeish was a member of the Board of Trustees of the Museum of Modern Art, and because he tagged politically reluctant writers as "The Irresponsibles," he gained favor with President Franklin Roosevelt, who felt war was inevitable. Roosevelt referred to MacLeish as his "Minister of Culture."[21] MacLeish joined Rockefeller and Whitney in enlisting the Museum in the war effort.

In the face of congressional reluctance to fund war preparedness, Roosevelt worked within the private sector to do what he could. He appointed MacLeish Librarian of Congress in 1939 and, in 1942, head of the Office of Facts and Figures, the purpose of which was to provide factual information to the public to counter Nazi propaganda. This placed the Roosevelt effort squarely in the camp of free-speech liberals, as opposed to those who would limit free-speech rights in defense of freedom. MacLeish was the principal spokesman for the free-speech camp. He labeled those who would limit speech rights, the "Nervous Liberals." The Rockefeller Foundation took the same view. Under the leadership of John Marshall, the foundation funded many projects seeking to analyze and anticipate the effects of Nazi propaganda, among them the Princeton and Stanford University Listening Centers, which monitored German shortwave radio broadcasts, the Totalitarian Communication Research Project at the New School for Social Research, and the Library of Congress Experimental Division. There MacLeish employed the talents of the noted propaganda analyst Harold Lasswell, whose many publications on the nature of German World War I propaganda made him the leader in the field. Gary reports that "of the twenty-three governmental and public entities engaged in propaganda intelligence work" surrounding the war, "nine were financed wholly or in part by the Rockefeller Foundation."[22]

The point man on film for the Rockefeller Foundation, John Marshall, believed film could be analyzed as a cultural document and he regarded media as an index of social, political, and economic trends. As historian David Culbert put it, Marshall "found the study of film as a cultural force absolutely compelling" and "believed that film as propaganda should be the subject of serious historical enquiry, and felt Iris Barry was doing an outstanding job."[23] Almost immediately upon his arrival in New York in 1941, Marshall put film critic Siegfried Kracauer to work with Ernst Kris and Hans Speier, German émigré intellectuals involved in analyzing enemy propaganda radio broadcasts at the New School for Social Research. Marshall went on to recommend Kracauer for a Guggenheim grant, which funded the writing of *From Caligari to Hitler*, a pioneering work in which film is analyzed as an indicator of cultural change.[24]

When Iris Barry found herself called upon to lend support and staff to the war effort, it was her principal funder, the Rockefeller Foundation, who summoned her to duty. In this campaign she enthusiastically joined forces with John Marshall, Nelson Rockefeller, Jock Whitney, and her Museum's trustee, Archibald MacLeish.

Nelson Rockefeller in Rio de Janeiro (1942)

(Courtesy the Rockefeller Archive Center)

28

MR. ROCKEFELLER'S OFFICE

NELSON ROCKEFELLER'S ROLE as the government's Coordinator of Inter-American Affairs was most conspicuous at the outset of the war, when mobilization fever was widespread and political enmities were set aside for the common good. The war effort meant increased contact between the Museum and Washington, where Iris often stayed with the Rockefellers. "They put me up, as they did so many others, until their probably infinite sheets were out and one slept there grandly, gladly in shreds of sheets," she recalled, "for the only things that lacked in America during the war were sugar, cigarettes, silver and sheets."[1]

In true "Good Neighbor" style, after a buffet supper at the Rockefellers, Iris recalled

the phonograph with Spanish songs . . . and NAR and all the entourage were obediently learning Spanish, so with papers in our hands we were supposed to sing *Mi Corazon*. I thought I was back at home again in 1908–10 at the piano or the harmonium singing hymns and yearning to go out into the great high world and here I was in it and it was just the same as before at home.

Another time I was (but only once) invited to the John Hay Whitney's in Washington for the weekend. He was always much grander than Nelson Rockefeller, though less approachable. The invitation was kind, for indeed I was working for him. There was some sort of protocol, funny, perhaps in retrospect, but it worked out nicely. The Whitneys were never like the Rockefellers. [They were] more English than American, with more servants and formality.[2]

Washington was not unknown to Barry and Abbott. As Iris recalled, in 1937

one of our maecenas overlords Eddie Warburg told us that we were going to be invited to the [Roosevelt] White House to show what we were doing. This naturally pleased us immensely. We prepared a perhaps rather inept little program of strictly American films—the necessary *Great Train Robbery*, a short early William S. Hart <u>with</u> Indians, and I forget what else, probably Mary Pickford in *The New York Hat*—and piano music to go with it. I bought a special dinner dress for the occasion, black crepe de chine down to my insteps, white cuffs to the short sleeves and a white bib to the modest décolleté. I did allow myself rather snappy and very expensive evening shoes, which I already of course had.

So off we went to Washington on the eve of the grand occasion and took an elegant bed and bathroom in I forgot what hotel, almost certainly the Willard, and telephoned my parents-in-law in Delaware to give them the glad news.

Before we set off in a taxi for our rendezvous I said, half-jokingly to Dick: 'Now, when we go in, let's put our best foot foremost and above all <u>relax</u>, because you are certain to be frisked, so don't seem surprised or turn a hair.'

He told me how ridiculous I was, that I didn't understand that I was in <u>America</u> (the land of the free) and it was time I got rid of my old-world ideas and so forth.

The taxi delivered us to the White House. The door opened as or before we went in. Negro servants in livery helped us off with our overcoats <u>and frisked Abbott skillfully</u> while doing so. We were put into a blue salon to wait and after a while Mrs. R. came somewhat hastening in, sat poised a moment and then motioned to conduct us into the private dining room. Here several people were already waiting behind their chairs—two sons, an elderly aunt, Missie Hands—around an oval table.

Then the President came in, wheeled in a cane-seated armchair by another Negro servant. He heaved himself up bodily on his powerful arms into a chair which his attendant deftly pushed into place. From a swinging side door now more liveried Negroes marched, the foremost bearing a huge oval serving dish loaded with lobsters, and to my astonishment bore it to the President first. To my delight, he pawed them over and drew out the plumpest one. Then to Madame. Then to me, seated on the President's right hand, and then all around.

At about this moment two red setters joined us and pawed everybody, making me very nervous for my best stockings. The President, after grappling valiantly with his lobster, began a conversation (cryptic to me) about

'Charlie the Baptist' and what he had done and said that day. The meal continued, iced water was abundant in our glasses, and the President teasingly asked Madame R. what it was that had happened to her on the highway coming in and hadn't there been some trouble with the highway police—all this very good humoredly with great flashing of teeth in smiles.

Now he turned to address his two sons, Eliot and James, and hadn't they sped excessively, too? He gave them quite a lecture to which they responded (to my amazement) by making rather violent gestures as of one shoveling something away—obviously manure. There was great general laughter, but premonitory signs from the papa-President as ices or some kind of desert was served. I suddenly realized that no one, including the President or a rigid aunt seated to my right, or indeed anyone had so far addressed a single syllable to me, although Mrs. R. seemed to be talking a little to my husband on her right on the far side of the table. No one spoke a word to me, except the younger of the two sons, for a moment and with evident effort at kindness.

The President heaved himself up again and lopped back into his wheelchair and set off like a bat out of hell. We followed in order of precedence and went via elevator to a big and rather vague room where chairs were arranged in rows before a movie screen and a grand piano was at the back. It was a relief to see ready by this piano our colleague, Theodore Huff, because at least we already knew from experience that old—or any—silent films were intolerable without at least a minimum of musical accompaniment.[3]

And so the first direct encounter between Iris and the head of the Roosevelt administration ended with little personal contact and a quiet evening in the theater. This event, however, was typical of the Museum-government collaboration, which was powered more by Nelson Rockefeller's aspirations than by a reciprocal interest on the part of members of the Roosevelt administration. Roosevelt brought Rockefeller's Office of Inter-American Affairs into existence by executive order,[4] permitting it great leeway in its activities and making it independent of other government functions as long as it proved viable. Rockefeller had high connections, but it was only a matter of time before such a rich and powerful man would begin to draw adverse attention.

According to Stanton Catlin, who had served as Abbott's chief aide in coordinating the Latin American art exchanges carried out by MoMA through the Rockefeller office, Rockefeller often felt pressure from conservative Congressmen. While mounting an exhibition, Catlin was visited in Chile by a committee headed by Michigan Congressman Louis Rabout, Chairman of the House

Committee on Appropriations and a devout Catholic. Rabout objected to numerous nudes in the show, saying they should not be "carrying the American name around the South American continent."[5] Catlin defended their inclusion, but to no avail, and the Rockefeller effort often came to be dogged by conservative disapproval.

At the end of January 1942, Rockefeller prepared for an appearance before congressional committees overseeing his Office of Inter-American Affairs. John Hay Whitney provided him with a memo anticipating some of the questions he might be asked and the answers he might give. One of the complaints Whitney anticipated about the Museum's involvement in the work of the Rockefeller office was that the Museum "spends $15,000 per month to make films for the Rockefeller agency." To this Whitney offered the potential answer that "actually, under its contract with us the Museum of Modern Art gets approximately $10,000 per month" to offset those costs. Anticipating the objection that "Mr. Nelson Rockefeller and Mr. John Hay Whitney hold personal interests in the Museum of Modern Art," Whitney suggested that Rockefeller reply that "the Museum is a non-profit organization and can receive no benefit from the contract under which they operate. As a matter of fact, the Museum donated their facilities and equipment and floor space, and the Museum of Modern Art officers and chief technicians work for us without pay. Sums paid the Museum are used only to satisfy obligations and costs actually incurred in carrying out the contract." The memo points out that Mr. Whitney "at his own expense" had traveled to South America "consulting the authorities of each government as to their film desires" and that "the only films we have made so far are *Better Dresses, Fifth Floor, A Child Went Forth, The City,* and *Power and the Land.*" Although none of these films had yet been sent to South America, such was the intention of the Rockefeller office, and others would be sent as well, along with "12 films on public health subjects since the South American mortality rate from disease is several times higher than ours."[6]

Whitney's memorandum makes it clear that more than the making of educational films was intended by the Rockefeller office. The memo speaks also of "new films to be produced by Walt Disney and Orson Welles," who would work under Mr. Whitney, identified as director of the Motion Picture Section of the Office of the Coordinator of Inter-American Affairs.

Arrangements have been completed for Disney to give, entirely without charge, up to half of his time to the creation of films designed to have a special appeal in the other American Republics. The artist also will finish a project

now underway and known as *Walt Disney Looks at South America*, an animated, three-reel color record of his recent popular tour there. Welles will leave early in February to produce in Brazil a feature length motion picture in color. He also will write the script and act in the film. One of the principal episodes of the production, tentatively entitled *It All Came True*, will, at the suggestion of many Brazilians, be enacted against the background of the celebrated Rio de Janeiro carnival held annually on the weekend preceding Ash Wednesday.[7]

The memo uses wartime language urging Rockefeller to tell the Congressmen that "the stimulation of the motion picture industry's cooperation in providing films of particular interest to the Southern Republics is only one phase of the work of the professional staff Whitney now has in action." In addition, the memo states that Hollywood studios, through the influence of Walter Wanger, head of the Motion Picture Society of the Americas, were producing twenty-four short subjects of interest to our southern neighbors in addition to a number of films about travel in the Western Hemisphere. Whitney alluded to Kenneth Macgowan's work at MoMA to provide 16mm informational films to Latin American countries and place scores of 16mm projectors to carry the American message to the Southern Hemisphere. On the "other side of the exchange the Motion Picture Section has prepared 25 reels of sixteen millimeter film designed better to acquaint the United States with her southern neighbors. These are being made available for non-theatrical exhibition in this country by educational, civic, and similar organizations. A typical subject is *Americans All*, produced and narrated by Julien Bryan, dealing with the youth of the Americas. An additional fifty reels of selected subjects is either being 'shot' or edited.[8]

"Two other phases of movie activity" to be emphasized by Rockefeller "were the successful exclusion of Axis-produced films from the theaters of the Americas and the marked improvement in the newsreel coverage of events in the United States now being supplied to the other American Republics and vice-versa." In a cover letter to this memo Whitney notes that "we do not mention the fact that Jack FitzPatrick, the well-known travel photographer, is now touring through Central America. He is concentrating for his theme on the natural resources and raw material of all these countries, which will be available to us for our common war effort. This is a series to be released through Metro-Goldwyn-Mayer's regular short subjects program." Rockefeller jotted on the memo, "Take up on Hill with me 10:00."[9]

It is clear from this document that in its broadest aspects the Office of the Coordinator of Inter-American Affairs envisioned multifaceted involvement

in film production, distribution, and control during the war. The role played within the office by Iris Barry and the Museum's Film Library was essential. In a brief 1943 report on the first year of operation by the Film Library under its contract with the Rockefeller office, Iris noted that the contract "was originally outlined in Washington by the Coordinator and John Abbott of the Museum of Modern Art, under circumstances of which I have not-full knowledge, but I understand that Mr. Abbott saw Colonel Donovan at the time the contract was being drawn up and obtained his approval for the Coordinator's office undertaking this work although the material to be studied originated in Europe, yet the effects of Axis propaganda in film were keenly felt in Latin-America. It was agreed, I understand, that all findings or results of work done under the contract would be available to the office of the Coordinator of Information, and this I assumed still held good after the reorganization of that office as O.S.S. [Office of Strategic Services]."[10] The involvement of the Museum and the Rockefeller office, therefore, had been authorized by the founder of the Office of Strategic Services, Colonel William Donovan, whose office was kept apprised of the library's work. The OSS later evolved into the Central Intelligence Agency.

In retrospect, as historian Gisela Cramer noted in the Rockefeller Archive Center's *Reports*, "the OIAA [Office of Inter-American Affairs] never reached the institutional standing for which Rockefeller and his crew were striving. After some acrimonious and time-consuming feuds, the OIAA was institutionally subordinated to the Department of State and consequently had to clear major policy initiatives with the State Department in Washington or with U.S. embassies in the respective countries."[11]

Rockefeller's appearance before the House Appropriations Committee ended unsatisfactorily. The same Congressman Rabout who had grilled Stanton Catlin in Chile delivered a severe blow to government funding of Rockefeller's program when Rockefeller appeared before his committee. After excoriating the nudity depicted in some of the paintings the Museum had included in a Latin American exhibition, according to Catlin, "the chairman interviewed him [Rockefeller] and other members of the [Rockefeller] committee on what the reason for this exhibition was ... and it got very tense and in the end, Nelson said, 'Well, I guess we won't do this again.' And that was the end of this [exhibition] program."[12]

It would not be the end of the influence of Rockefeller operatives, however. Stanton Catlin was granted a draft deferment through Rockefeller's influence so he could be installed as a professor of art at the University of Chile, a position from which he was expected to spy on Japanese and German activities, his

Iris Barry (*center*), Luis Buñuel (at projector), and others at work for
the Office of the Coordinator of Inter-American Affairs (1940s).

(IBP, MoMA Dept. of Film Archives, NY)

salary paid by Rockefeller.[13] "After the war," as art historian Eva Cockcroft wrote
in an influential 1974 article in *Artforum*, "staff from the Inter-American Affairs
Office were transferred to MoMA's foreign activities. Rene d'Harnoncourt,
who had proven himself an expert in the organization and installation of art
exhibits when he helped American Ambassador Dwight Morrow cultivate
the Mexican muralists at the time Mexico's oil nationalism threatened Rock-
efeller's oil interests, was appointed head of the art section of Nelson's Office
of Inter-American Affairs in 1943. A year later he was brought to MoMA as
vice-president in charge of foreign activities. In 1949 d'Harnoncourt became
MoMA's director. The man who was to direct MoMA's international programs
in the 1950s, Porter A. McCray, also worked in the Office of Inter-American
Affairs during the war."[14]

With these appointments, Rockefeller's influence continued into the Cold War era. MoMA's International Council, funded by Rockefeller, stepped in to fill the void created when State Department exchange programs were cut back due to virulent disapproval by the congressional right. As art historian Serge Guilbaut has argued, the Museum of Modern Art and its leadership, including Barr, d'Harnoncourt, and Soby, actively participated in the appropriation of postwar Abstract Expressionism as a symbol of American freedom during the Cold War. As Guilbaut puts it, "avant-garde radicalism did not really 'sell out,' it was borrowed for the anti-Communist cause." It became "a symbol of the fragility of freedom in the battle waged by the liberals to protect the vital center from the authoritarianism of the left and the right."[15]

Rockefeller's and the Museum's role in the Cold War has been extensively examined and debated by U.S. and British art historians. Research for this book, however, reveals that Rockefeller's principal influence was felt earlier, during World War II. Early in the war, Iris recalls that Siegfried Kracauer, "whose [report] *Propaganda and the Nazi War Film* had been prepared for the Museum under a grant from the Rockefeller Foundation, and distributed without cost to personnel of government agencies requesting it," had donated his services as an advisor to those working on her Film Library project. The report later became a chapter in Kracauer's *From Caligari to Hitler*. Other workers were engaged in analyzing the many thousands of feet of Nazi propaganda film already in the Museum's possession, footage Iris stated to be "available nowhere else in this country."[16] The workers included Hanna Angel, former film critic of *Lichtbild-buhne*, and Hugh Block, a German film scholar Iris deemed trustworthy. They pored over films seized from the enemy and brought in through England or Canada and also analyzed propaganda films in the hands of small American distributors and collectors.

The work of the Film Library attracted the interest of the film director Frank Capra, then a colonel in the Special Services Division, Film Production Section of the U.S. War Department (now Department of Defense). Iris recalled that Capra and his staff had been among "some 200 members of the various government informational services, Army, Navy, etc." attending a showing of Leni Riefenstahl's *Triumph of the Will* and other German propaganda films Barry presented at the National Archives Building in Washington in the spring of 1942. Capra had independently acquired considerable Axis propaganda film, which Iris attempted to persuade him to give to the Museum. "This he proved unwilling or unable to do," she said. "Nevertheless, I kept closely in touch with him and have from time to time made considerable quantities of

film and information available to him." Finally, in July of 1942, Capra made his holdings available to Iris's analysts, "but only on condition that the work was done on the premises he occupied in Washington, in the Cooling Tower of the Interior Building. There seemed no alternative but to agree to Capra's offer, especially as the material in question constituted the bulk of recent German film,"[17] including the holdings of the New York offices of Ufa, the major German production company.

The work in Washington was directly supervised by the top U.S. spy agency, the Office of Strategic Services. "With reference to the original understanding with Colonel Donovan," Iris recalled, "Dr. Scofield of C.O.I.[18] (now O.S.S.) was closely in touch with myself and the reviewers at the time of their removal to Washington. He or his assistants have since frequently been in touch with the reviewers, and the form used for the reviews was devised in order to incorporate specific information desired by O.S.S., and also Colonel Capra, as well as that needed by C.I.A.A [the Rockefeller committee] on the total propaganda content of each film." For her help to him, Iris added, "Colonel Capra is putting on record his appreciation of the practical use to which the films and the reports on them have been to him." In all, 10,000 feet of film processed by the Film Library's reviewers were made available without charge to Colonel Capra "for incorporation in his Army orientation films."[19] This footage became part of *Why We Fight*, a series of seven documentaries commissioned by the U.S. Government to explain to potential recruits the stake America had in the war. The films were directed by major filmmakers and shown to great effect in theaters nationwide. Iris recalled that during the making of the series, uniformed men "picturesquely exuded into our [Museum] office wearing trousers the color of the underside of freshly picked mushrooms. None of them had ever been there before, nor had indeed practically any Hollywood personality unless to see the paintings in downstairs galleries."[20] Thus assembled after office hours "in our comfortable blue leather armchairs and before our movie screen: Colonel Frank Capra, Major John Huston, Colonel Anatole Litvak, Captain Leonard Spiegelglass—not to mention a 'real' colonel from the 'real' Army," all of whom were intent upon "giving . . . heed to the other and unremunerative side of filmmaking, the factual one."[21]

To prepare her distinguished guests, Iris showed them "everything from Lumiere's *Arrival of a Train* through *Nanook* and the still vivid English documentary productions, the French three-minute 'idea' shorts, [Joris] Ivens' *Spanish Earth*, the New Deal [Pare] Lorentz films," and Nazi footage of the Nuremberg rallies and "such wartime Nazi weekly newsreels as were available

either in our or in government hands. What came of all this . . . was . . . *Why We Fight*, quite widely if belatedly seen by the public, and more valuably, I think, the deeply felt and nobly discreet short made in Italy by John Huston [*Let There Be Light*]—the best war film as it was the best anti-war film, but sabotaged by who knows what censorship, supposedly by American moms who found the sequences showing dead American soldiers unacceptable."[22]

Houston's and Capra's films were being prepared for domestic distribution, exhibited without rental fee in theaters throughout America. Military enlistments, which had peaked after Pearl Harbor, began to wane as the war wore on. The OSS through the Rockefeller office thus used the Museum as a production facility to address this problem, and the upshot, the *Why We Fight* series, is widely regarded as among the most effective propaganda efforts ever made.

On the Southern front, the Rockefeller office brought its resources to bear by blocking Axis propaganda and increasing access to American informational films. According to Gisella Cramer's report, the formation of the Rockefeller Office of Inter-American Affairs allowed, among other things, for "an effective 'blacklisting' in the media and communication field. Motion Picture subcommittees, comprised of OIAA officials, local distributors of movie pictures and representatives of companies providing equipment and spare parts, worked closely with U.S. embassies and were able to screen the programs of movie theaters even in remote areas. Theaters [in Latin America] exhibiting Axis-produced newsreels and movies faced being 'blacklisted' and thus denied access to U.S. movies, equipment and spare parts. Since Hollywood productions tended to be the most successful commercially and since U.S. companies were by and large the only source of equipment during the war years, 'blacklisting' proved to be a highly efficient instrument."[23] The strategy was, however, a nod in the direction of the "nervous liberals" who advocated placing limits on free speech.

The OIAA presented films in remote areas using portable projectors, installed battery-operated radios in public spaces, inserted anti-Fascist cartoon leaflets in cigarette packages, and coordinated with the Roman Catholic Church to include film materials in religious festivities showing persecution of the church in Nazi Germany. Overall, says Cramer, "the 'Rockefeller shop' developed a massive presence in Latin America that has not been fully appreciated as yet."[24]

Dick Abbott's role as administrative factotum for Rockefeller at the Museum extended to his service as chairman of the committee on art of the Office of the Coordinator of Inter-American Affairs. In this capacity he oversaw the assemblage and tour of a group of 300 contemporary oil paintings and watercolors that,

under Rockefeller's auspices, traveled over 50,000 miles in ten Latin American countries in 1942.[25] Upon its completion, the ever-quantitative Abbott boasted to the *New York Times* that the exhibition "was a success in most of the countries where it was shown," having been "seen by 218,089 people in ten of the most important cultural centers in Latin America. It received an enthusiastic reception by the Latin-American press, which gave it an unprecedented amount of space: thirty-three editorials and 454 news and feature articles were devoted to the exhibition, and sixty-three talks were given on the subject."[26] Abbott does not mention that the same show drew opprobrium from Congressman Rabout.

Abbott's statistical prowess was irrepressible. "In six of the ten countries," he told the *Times*, "the President of the Republic was present at the inauguration of the exhibition, and the list of distinguished visitors included thirty Cabinet Ministers, forty high government officials and many of the people prominent in the social and artistic circles of each country."[27] These pronouncements were printed beside a businesslike picture of Abbott himself.

While Abbott publicized the Museum's successes and Iris led the Film Library into the war effort, she also continued to worry about the children she had left behind in war-torn England, children who did not know of each other's existence. Iris decided to put them in touch with one another.

This effort was complicated by the ambiguous role Iris had played in the children's upbringing. Her son Robin recalled that he had lived with his grandmother "probably from when I was born to about four years old, and then between when I was 11, I suppose, until about 17." In between, he said, "there was this boarding school for unwanted children. I was left there, and I think it's almost bloody certain that Sidney Bernstein paid for it, because Iris certainly couldn't afford it and I don't think anybody else would have either wanted to or would have paid for me there."

Iris's mother, Robin recalls, had made a living telling fortunes, "with a crystal ball, teacups and cards and called herself Madame Pandora." However, he "never even knew my grandmother as my grandmother, she never even told me she was my grandmother . . . she always told me she was my guardian . . . she never even told me who my mother and father were, until after the age of 17 when I left and came to London." Iris "occasionally appeared as my guardian's daughter, that's all."[28]

By the end of 1942, her son recalled, Iris "wanted to be all lovey-dovey and motherly, when I was about 20. She did a very stupid thing, very stupid indeed. I was in the Army in a place called Berliac, near Burnley, where, though I didn't know it, my sister had been adopted. And the silly cow Iris writes to me and

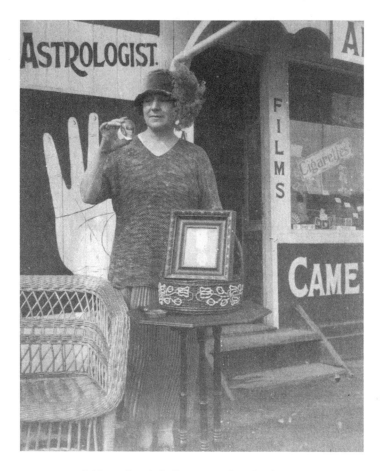

Iris's mother, Acie Crump, on the Isle of Man.

(IBP, MoMA Dept. of Film Archives, NY)

says, 'Son, you may be interested to know that you happen to have a sister.'—
I'd not heard of a sister from anybody before—'and you may wish to go and
see her.' This was bloody stupid, of course, for several reasons. I sent this letter
to this lady whom I am *told* is my sister by this lady and it upset her—Maisie
had been adopted by these two very nice Lancashire people, and it upset the
mother of this couple enormously, because she wanted to have a boy, and had
she known that Iris had had a boy and a girl to be adopted, she would have taken
the boy, but Iris said she *hadn't* a boy . . . the woman was *bloody* annoyed."[29]

For her part, when Maisie was 16 or 17 she had a row with her "adoptive"
mother, who suggested that she move out. She did, into an apartment across

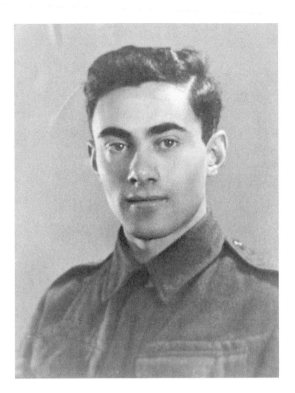

Robin Barry during World War II.

(IBP, MoMA Dept. of Film Archives, NY)

town. She visited Mrs. Spencer twice a week "because the war was on and there wasn't much to do," Maisie recalled. "One day she said there was a letter come for me. It bore a Bolton postmark. I knew nobody in Bolton. I opened it and I couldn't make sense of it. It said 'Dear Miss Spencer. Iris Barry tells me I have a sister in Lancashire and perhaps we might meet, if you're available.' I said to my mother, 'What's it all about?' As far as I knew I was an only child. Mother recognized at once who Iris Barry was and exclaimed, 'so . . . she had a son all the time!' Iris had told them she only had me, because they wanted a boy. My mother was very cross. She said 'I wanted a boy, and I got you!' She got fobbed off with me. And I found myself with a brother I knew nothing about!"[30]

Once again Sidney Bernstein came to Iris's aid, allowing her to feel that someone was caring for her children. Sidney invited Robin and Maisie to stay at his country home, Long Barn, where they became friends. In February 1943 he wrote to Iris,

Robin and Maisie spent a week here together. They are young, virile and completely disorganized the household. Needless to say I left them to it—but had a graphic account of their stay from our long-suffering maid of all work, Yvonne. I imagine a good time must have been had by all.

They took it into their heads to set the world to rights (theoretically) each evening before the log fire, and most sessions continued throughout the night and were still in progress when Yvonne was astir in the morning. On the settee by the still burning fire she would find them, still reorganizing the Universe, and surrounded by the remains of two or three meals, the outcome of organized raids on the larder through the watches of the night. And whilst they made up their loss of sleep during the day, the beauties of the winter countryside slipped by unnoticed.[31]

Back in America, Iris was passing the first years of the war in government service, tending her new farm, and helping to support Wyndham Lewis while relying on Sidney Bernstein yet again to see to the welfare of their children.

Maisie and Robin on the day of Maisie's wedding in 1950.

(Courtesy of Robin Barry)

Luis Buñuel visiting Iris at Temora Farm (1941).

29

L'AFFAIR BUÑUEL

To IRIS, ROCKEFELLER'S Office of Inter-American Affairs (OIAA) and its effort to disseminate the Good Neighbor policy by an exchange of films was "a difficult enterprise in view of the suspicion, hostility and misunderstanding seemingly prevalent in Washington, which is to say on the part of many major and minor bureaucrats, congressmen, etc., directed towards or engendered by this project. It is hard to say if Rockefeller himself were the target or whether the setting up of a contract with the Museum of Modern Art to prepare and furnish these informational films seemed more outrageous and alarming to these critics. The Museum was no doubt to many of them an utterly detestable place where abominations by Picasso, Dali and other frightful creatures were on view and open to admiration: this they had gathered presumably from *Time* or other publications but certainly not from a visit to the place itself."[1]

Iris's assignment from Rockefeller to find experts capable of translating informational film soundtracks led her to be alert for filmmakers fluent in Spanish and Portuguese.

As Luis Buñuel was by now in New York and, one gathered, was evidently at leisure, his was the first name one thought of. He appeared available, indeed he was the successor to [documentarian and film montagist] Pare Lorentz in the small flat on the top floor of our New York house. It was quite private and separate and we hardly ever saw him, though our Hungarian cook Elizabeth immediately took him under her wing and I hope he was not too miserable there.

Before definitely hiring him for the job, our particular patron among the trustees of the Museum of Modern Art, John Hay Whitney, seemed to think it advisable to meet Buñuel on some sort of non-official occasion, and so it

was arranged that we give a small cocktail party at [our] 49th street house in order that Whitney might talk to him. I ran this up in quick order, hiring a white-coated barman, who brought a white-coated trestle table. I invited a few suitable people at short notice, including a General Gustavo Duran, whom I had earmarked already as a suitable member of the team to undertake the Inter-American film project. This worked out splendidly. Within a very short time Whitney discovered that General Duran was practically a relative, as he had recently married a cousin of Whitney's in England.... The party worked out pleasantly and Buñuel, Duran, another friend of theirs, the composer [Gustavo] Pittaluga, and two other chaps came to work at the Museum on the project. They had a not very large office near mine, but of course were frequently in the projection room or the cutting and recording rooms at the [DuArt] laboratory on 10th Avenue. We communicated chiefly in broken French but Spanish was heard around too.[2]

Buñuel's infamy as codirector of *L'Age d'Or* was confined primarily to the small coterie who had seen the film in its premiere New York screening, arranged by Iris for the New York Film Society in 1933,[3] but as a general wartime mentality set in, Buñuel's iconoclasm proved a liability. According to Buñuel's biographer John Baxter, "most of his [Buñuel's] team at the Museum of Modern Art in New York between 1941 and 1943 were Communists."[4] Buñuel himself never explicitly admitted to Party membership, but Baxter suggests that during the 1926–27 conversion of the main Surrealist group in Paris to the Communist cause, Buñuel's dues were included in the group's subscription.[5]

Buñuel's friend Gustavo Duran, to whom Jock Whitney took so readily, also carried political liabilities. "Blond, blue-eyed and handsome," in Baxter's estimation, "the Catalan impressed even Buñuel with his bizarre biography, and they became friends. When he [Duran] was ten, his womanizing father and neurasthenic mother left home, dressed for the opera. His father returned alone, having committed his wife to a mental asylum. A week later his mistress moved in. Duran fled to Paris, studied composition under Paul Dukas and Nadia Boulanger, tutored Yehudi Menuhin's children, and befriended Hemingway and André Malraux, who wrote him into *Man's Fate* as 'Manuel' and asked him to score the film version" (128.) Duran had worked with Buñuel in the early 1930s at Paramount's Joinville facility in France, where they rewrote Hollywood dialogue for foreign export. He rejoined Buñuel in New York, along with other Spanish intellectuals in flight from the Franco regime, translating and reediting films at MoMA for Latin American distribution. Others in the group included

Eduardo and Paolo Ugarte, Paul Duarte, and Francisco Garcia Lorca, younger brother of the martyred poet.

Duran, according to Baxter, was anti-Franco and "had commanded a division in Spain, been wounded twice and captured, only to be released by an old friend and smuggled to Marseilles. Hearing of his arrest and assumed death, his father cut his throat. Bitter at having lost his family, musical career, country, language and culture, Duran refused to talk about the war. He never returned to Spain. After six months with Buñuel he joined Rockefeller's OIAA staff, then spent the rest of the war in Havana running Ernest Hemingway's bumbling private espionage service, the 'Crook Factory.' After the war he became a U.S. Presidential adviser on Latin American affairs, at the price of informing on his old Communist colleagues" (180–81). When they met later in Mexico, Buñuel accused Duran of informing on him to the U.S. government. "Yes, old man, I denounced you," Baxter quotes Duran as saying, "You have no idea. . . . The hours I spent with those CIA types. Six months. I told them everything they wanted" (236).

Duran's denunciation was rendered superfluous, however, by a concerted attack on the Museum and its Film Library by forces within and without the film community during 1942 and 1943. The $125,000 grant the Museum received from the Office of the Coordinator of Inter-American Affairs seemed extravagant and rankled many outside the Museum's circle and some in faraway Washington and Hollywood. Baxter speculates that MoMA's role in creating films for the Latin American market might have appeared to film industry insiders as a form of unfair competition cooked up by a nefarious combination of Rockefeller and big government forces, although it is difficult to see how a few documentary and propaganda films could have displaced Hollywood in Latin American affections.[6]

There was, nevertheless, in Baxter's estimation a "campaign . . . to destroy the MoMA film unit. The first salvoes were fired early in 1942 in the pages of the *Motion Picture Herald*, the industry's most prestigious trade paper. Since it was edited in New York, only a few blocks from MoMA, editor Terry Ramsaye could easily keep an eye on what was happening there. Slighting references to 'the Nelson Rockefeller–John Hay Whitney Museum of Modern Art' began to appear. In February 1942, Ramsaye sneered that MoMA, 'engaged in spreading things cultural, has started a campaign of its own to furnish our soldiers in camp with books—on ART!' In June the *Herald* mentioned Leyda's [previous] presence on the staff, describing him as 'among the editors of the leftist quarterly *films*, and technical consultant on the staff of Artkino, motion picture outlet for the U.S. of Russia's pictures-of-message.'"[7]

All this heavy breathing brought out the fight in Iris. She decided to try to raise support for her team's efforts by screening their work in Hollywood. On January 30, 1943, she and Abbott hosted "Two Evenings of German Propaganda Films 1934–41" at the Film Arts Cinema in Hollywood for an invited audience of celebrities. On the program were *Feldzug in Polen*, by Hans Bertram, a series of war documentaries that had been seized by the U.S. government, and a Buñuel-compiled shorter and more intense version of Leni Riefenstahl's *Triumph of the Will*. "Although Chaplin giggled so much at the posturing of Hitler and his minions that he fell out of his seat," Baxter relates, "most of the 900 guests—many more waited outside—were shocked. René Clair spoke for most of Hollywood when he urged Barry never to let the American public see the films. 'If you do, we're lost.' The MoMA film unit won a brief reprieve."[8]

Buñuel was comfortable enough at MoMA in 1942 to apply for U.S. citizenship. On June 18 he was cleared, according to Baxter, to file preliminary papers by "a tribunal of representatives from the Departments of State, Labor and Justice, and the Navy, Army and FBI."[9] But by early 1943 the drumbeat against MoMA intensified. "The *Motion Picture Herald* urged that all OIAA films henceforth be made in Hollywood. It even nominated two experienced producers to supervise: [film director] Mervyn LeRoy, who had his own reasons for disliking Barry,[10] and Jack Chertok, head of MGM's short subject department. The same month, Jock Whitney discreetly resigned from the OIAA to become Public Relations Director of the 8th Army Air Force, with the rank of Lieutenant Colonel and an office in London. In May the Office of War Information took control of all raw film stock, with the right to limit supplies to those who might waste it. Ramsaye headlined the report 'SENATE TO WEED OUT MEDDLERS IN US FILMS'. Nobody was in any doubt that Barry's operation was doomed.

"Her enemies seized any pretext to attack MoMA," Baxter observed. "*The Secret Life of Salvador Dali*, published by Dali late in 1942, was a gift in this respect. Salvador's confession of incestuous longings, homosexual leanings, masturbatory fantasies and excremental transports of delight left reviewers goggling. Tired of badgering Luis for shared credit on the film, Dali used the book to disown *L'Age d'Or*, which was, he said, 'no more than a caricature of my ideas'. Accusing Buñuel of having 'attacked Catholicism in a primitive manner', he described one of the more anti-clerical scenes, adding piously: 'I accepted the responsibility for the sacrilege, even though it was not my intention.'[11] He went on, with even more damage, to charge that, by creating the shortened version

of *In the Icy Waters of Egoist Calculation*, 'Buñuel expunged the most frenetic passages ... with the goal of adapting it to Marxist ideology.' [*In the Icy Waters of Egoist Calculation*, a term from the Communist Manifesto, was the original title of *L'Age d'Or*.] This might have passed without comment, but some Hollywood PR man, aware of the premium on anti-MMA items, picked it up. A Catholic lobbyist named Prendergast protested to the State Department, and New York's Cardinal Francis Spellman supposedly visited Barry and demanded to know why she was harboring the Anti-Christ. The tale relates that Barry, in tears, called Buñuel in and fired him. This is mostly invention. Barry seldom wept, at least not when sober, and Spellman never made house calls, although Monsignor John J. McClafferty, editor of the *Catholic Herald*, did convey His Eminence's displeasure."[12]

Baxter's account concludes with a coup de grace delivered by the *Motion Picture Herald* in June 1943:

On June 26 a *Motion Picture Herald* article, 'MUSEUM'S PACT WITH COORDINATOR PENDS,' announced that henceforth Hollywood would produce part of the OIAA's film needs. MoMA's film budget was cut by 66 percent. When even the truncated contract had not been signed late in June, the MPH made it clear that the problem lay with MoMA's staff. Their particular target was Buñuel, although forty people would eventually leave the OIAA and MoMA in this covert political purge....

On 30 June 1943 Buñuel wrote to Barry: 'In view of the continued references made in the *Motion Picture Herald* of a prejudicial nature to me, and in consequence of my conversation with you of this date, I feel I have no alternative but to resign. ... It seems evident to me that some person or a group of persons is determined to stir up trouble about me, presumably with the intention of embarrassing or discrediting the Coordinator [of Inter-American Affairs] and the work of his film division, using for that purpose the tendencies represented in one of my pictures, made in 1930 in Paris, and entitled *The Golden Age*.

'As you are one of the few persons in this country who have seen this film, you will understand, no doubt, that it could never be regarded as an anti-religious picture. Certainly, are in it symbolized the obstacles which religion, as well as society, oppose to the attainment of love. The film was a surrealistic poem.' To counter the accusations of 'left-wing feelings,' Luis quoted the tribunal who had approved him for the first level of citizenship the previous June....

Barry's reply on June 30 left no doubt where the real blame lay. 'That your resignation, too, is a consequence of your interest in the success of the Coordinator's film work I also realize, and I can only say that I deplore the existence of a situation which made it seem advisable.' Margareta Akermark and the rest of his staff scribbled their best wishes on the back of a publicity photograph of Buñuel posed with them on the Museum roof in happier times, but Luis was off the premises before the ink was dry. His departure was so hurried that carbons of screenplay treatments remained in his desk.[13]

In retrospect it is difficult to precisely assess Iris's role in the firing of Buñuel. Clearly she was caught up in a fusillade against him and, although she respected him as an artist, she may have felt helpless to protect him. It is unlikely that Iris alone could have shielded Buñuel in any case. It seems clear that Buñuel, along with the Rockefeller project he worked for, suffered overwhelming animosity from the far right, and the ultimate head of her project, Nelson Rockefeller, regarded Buñuel as a liability.

Margaret Barr, for one, later faulted Iris for Buñuel's departure. "Iris told Buñuel to leave," Mrs. Barr recalled in 1985. "She felt helpless to oppose the will of the Catholic church (Prendergast was archdeacon or some other impressive title).

"In 1942 my husband was still director of the Museum and all that Iris needed to do was to turn to him and let him decide whether or not Buñuel should go. Alfred was very pugnacious in those days and came out instantly against the censorship of the Catholic church at the time of *The Miracle*, with Anna Magnani.

"The case was similar to that of Jay Leyda: She did not stand up for him."[14] If he, too, went unprotected by Iris, their firings suggest an instability in the Museum's leadership during a period of Barr's declining influence, when conservative film-industry insiders successfully redefined MoMA as the "Nelson Rockefeller–John Hay Whitney Museum of Modern Art."

Remembering these events, Margaret Barr concluded that Iris "was not great, not generous, not magnanimous- -brilliant but not cultivated."[15]

30

THE OTHER LIBRARY

O NE OF THE abiding ambitions of the American film community has been the development of a national film collection at the Library of Congress, a repository in which outstanding films of each year could be collected and preserved for posterity. Efforts to achieve this have been ongoing, if fitful. A significant boost to the cause came with the founding of the Motion Picture Project in 1942. According to Mary Lea Bandy's overview of MoMA's Film Department, "the Rockefeller Foundation funded the Motion Picture Project, a joint program of the Film Library and the Library of Congress. Barry and a team of experts selected fiction and nonfiction films released in those years (1942–45); the Film Library acquired and stored the films for the Library of Congress, which handled copyright and other arrangements. Poet Archibald MacLeish had been appointed Librarian of Congress in October 1939 and he oversaw the creation and expansion of the Library's Motion Picture Division before resigning in December 1944 to become Assistant Secretary of State. The Library of Congress had a splendid collection of film materials before 1912, when 'paper prints' [contact prints made on photographic paper instead of film stock] were accepted in lieu of films, as visual records of the objects to be copyrighted; since then, it had returned films submitted for copyright because it could not store nitrate film stock. The immediate goal of the Motion Picture Project was to reestablish the national collection. By May 1943, Barry had drafted a list of 104 titles of films made in 1942, and by the end of April, 1945, the Film Library had acquired for the Library of Congress a group of features, newsreels, documentaries, and short subjects."[1] Once more the Film Library, funded by the Rockefeller Foundation, was at work for the U.S. government.

Barry was not the only film scholar MacLeish consulted. He also turned to his old friend and former *Fortune* magazine colleague, James Agee, at the time the film critic for the *Nation*. Agee had been associated with Barry in the

formation of the short-lived New York Film Society, and according to his biographer Laurence Bergreen "loathed" Barry "beyond all reason"—perhaps for her lukewarm support of the Film Society—and made the appalling comment that she "badly needs" raping.[2] Asking Agee to work as an unpaid, anonymous consultant, MacLeish knew that Agee's contempt of Barry alone would spur him to overcome his various procrastinations and work hard to rival her views. "Tightening the screws a notch," Bergreen wrote, "MacLeish sent Agee Barry's list of films to preserve. Agee's reaction can be imagined. He was apoplectic and worked day and night to correct what he considered to be her grievous errors. MacLeish's ploy worked, and Agee got his list in on time, but the strain involved robbed him of sleep and drove him to rely ever more heavily on alcohol" (278). It remains to be determined how Agee's views, or those of others MacLeish might have consulted, differed from those of Iris Barry.

Reviewing the development of the film collection of the Library of Congress, Doug Herrick also makes note of a strategic connection between the Library and the Museum of Modern Art. Toward the end of the 1930's, Herrick writes, "the MoMA film library was beginning to face serious problems. The films acquired were nitrate prints . . . [and] it was developing storage problems. But the MoMA did not intend to be limited by its own facilities in the fulfillment of its charter. It had powerful friends in Washington, Wall Street and most importantly, the Rockefeller Foundation. The three-year operating grant for MoMA's film library had run out in 1938. . . . Among other institutions it looked to for support was the Library of Congress, for in 1939 LC [the Library of Congress] had a new Librarian, a man that MoMA and the Rockefeller Foundation could do business with."[3]

That man, of course, was Archibald MacLeish, whose appointment, says Herrick, "occasioned some opposition from the library profession, but also won wide support. Arrangements were made among MoMA, LC, and the Rockefeller Foundation to revive the original conditions of the motion picture copyright deposit and let MoMA do the selecting and storing of all the films released during 1942 that it felt should be retained."[4]

"The cost to the Rockefeller Foundation was $25,000," Herrick notes, "paid to the MoMA for staff and storage expenses" (12–13). Although this project began on May 1, 1942, and was supposed to last one year, a subsequent grant by the Rockefeller Foundation of $40,000 permitted the project to continue for two more years. By May of 1943, MoMA had finished its first year of selecting films, although MoMA's aesthetic criteria differed from the broader cultural-significance collecting policies of the Library of Congress. "It was inevitable," Herrick

writes, "that there would be disagreements over the choices. For eight years, MoMA had been collecting films in terms of their aesthetic, formal, and artistic contributions to the history of the medium. LC, however, was interested in film as a medium of visual information and wanted those works 'which most faithfully record in one way or another the contemporary life and tastes and preferences of the American people.' The war years were a period in the history of film in which functionalism reigned and art was postponed until peace" (14).

This effort came to a halt, Herrick says, when "the 1946 elections resulted in a Republican Congress hungry for post-war budget cuts and a reduction in the size of the bloated war-time government. As a result, the Motion Picture Division of the Library of Congress was liquidated on July 31, 1947" (15).

The Museum's wartime activity, including the Library of Congress Motion Picture Project, was nothing but successful, at least according to Executive Director John Abbott. Eagerly toting up the Museum's wartime involvement with the U.S. Government, Abbott reported to the Museum's trustees on November 15, 1945, that "during the war the Museum executed 38 contracts for the Office of the Coordinator of Inter-American Affairs, the Library of Congress, the Office of War Information, and other governmental agencies. The aggregate value of these contracts was $1,590,234 and included such varied activities as 19 exhibitions of Contemporary American Painting exhibited in South America; an Industrial Design competition; documentary motion pictures adapted in Spanish and Portuguese; a Hemisphere Poster competition; analyzing enemy propaganda film; architecture and photographic exhibitions for London, Cairo, Stockholm, Rio de Janeiro, Mexico City, etc.; educational exhibits and 20,000 maps for Latin America."[5] The Museum also held over thirty war-connected exhibitions and conducted an extensive outreach program for service personnel under the leadership of James Thrall Soby. As a result, the Museum was voted a favorite New York destination for service personnel, bested only by the Statue of Liberty, the observation deck of the Empire State Building, and Rockefeller Center, in that order.

To Iris, however, much of the period of the war between 1941 and 1945 brought endless red tape. It also involved invasive security surveillance by the U.S. government. Although anticommunism was downplayed to a degree during the war, since the Soviet Union was nominally an ally of the United States, Iris, who often slept poorly during the war, recalled that she

would have rested worse had I been a prophet or dreamed of the McCarthyism to come. For the moment the F.B.I. occasionally dropped into the New

York office to check up on members of my little groups, or friends and associates in the documentary film field, or even myself: but this was not disturbing; the young men who came in were pleasant enough even if it is disagreeable to be asked leading questions as to the political opinions or affiliations of other people—as if one knew!

A great trial, however, was one's contact with government officials, most of them temporary wartime chaps, very 'new broom,' whose business was to brood over what we were doing, and to check and endorse the necessarily innumerable bills submitted by us to Washington. I disliked them intensely and often failed to understand what they were talking about, given the peculiar lingo that accountants and bureaucrats employ. I felt absurdly indignant that they or anyone should seem to suspect anything to do with the Museum, and I thought their attitude as unwarrantably arrogant as it was suspicious. This rankled as well because I was not being paid at all for the very considerable work these wartime projects entailed, and I resented being treated like a delinquent office boy by these upstart godlings. The most obnoxious of these inquisitors telephoned one day [in 1943] and bade me over to his office. As pleasantly as possible I asked if he wouldn't for once come to me instead, as at that moment I had my left leg in a plaster cast from ankle to hip, which makes getting around quite awkward. 'In a pig's eye,' he replied, 'you just come right over.' To get to his rather superb office one had to traverse a vast area crowded with dozens of clerks, desk, typewriters, files. Many eyes watched my stumping progress to his door. What joy, once inside his sanctum, to see the enemy turn crimson, spring forward, attempt practically to carry me to a settee . . . the s.o.b. had actually thought I had been making a crude schoolboyish joke about the plaster cast, an impudent excuse for getting him to lose face by coming to see me—as if any civilized adult would even dream of such vulgar nonsense. Well, he came bounding over, installed me on the settee and cried, 'Let's make a gentleman's agreement,' thrusting out a hand and grasping mine vigorously. This got him over an awkward moment, perhaps, but had no meaning to me and indeed no change for the better was visible thereafter.[6]

The collaboration between MoMA's film activity and the federal government continued warily. Adding insult to injury, Iris's bureaucratic troubles were compounded by the fact that the injured leg she dragged about was associated with a major change in her marital status.

31

DIVORCE

"DICK ABBOTT DIVORCED her in a very cruel way," Iris's daughter Maisie recalled. "She and Dick and two of their friends were all going to Switzerland to ski for a holiday and at the last minute Dick said he couldn't come because he had some business to attend to and he would follow along. The three went off, she and this married couple, and she broke her leg and she very quickly came back to New York and came to their house with her leg in plaster. He wasn't there. He was elsewhere on business, ostensibly, and out of the blue she got these divorce papers served on her. She thought it wicked and mean. He had seemed so devoted to her. He was devoted to the point of almost being a nuisance. Iris wouldn't accept any money but she did ask him for help for her mother."[1]

Dick Abbott had found someone else.

Shortly after this disastrous homecoming, in May of 1943 Iris wrote her brother-in-law, Charles Abbott: "Is there any chance of your being in New York or even of coming up? I very much want to talk to you, though I know how busy you are." she asked. Referring to the plaster cast on her leg, she explained that she had "thrown a cartilage" and was writing from the Gladstone Hotel instead of her residence with his brother at 221 East 49th Street, because Dick himself was sick and had been told by his doctor to rest for a month and gain some weight. He was doing this in her room while she removed to a hotel. These contorted circumstances amounted to a "perplexity I am in," and she solicited Charles's assistance. "You once said to call on you if I ever wanted anything and so I do," she wrote, and even offered to pay his train fare.[2]

Charles Abbott responded cordially but not immediately. Three weeks later, still at the hotel, Iris was anticipating his arrival and suggesting he stay with his brother and not with her. "In that way it won't seem so much as if you were especially <u>my</u> 'ally,' not that there is, really, any dispute at all but

I think he would feel nicer if you were there with him and not here, so to speak, with me."[3]

Charles did not come after all. Iris was on her own with her new domestic crisis. She was out of a residence and losing her connection to the man now in charge of the Museum. She looked for a place to stay but did not find proper housing until the fall, when the Askews lent her their guest apartment at 32 Beekman Place. From there in November she wrote to Charles again, acknowledging her divorce and the fact that Abbott had quickly remarried:

> *I am only just getting around to doing something about a change of address as I am only really just now settled in view of all the present attendant difficulties of getting anything done, but here I am for the next two years, I trust, and I'd like to think that if you and T [Charles's wife, Teresa] come to town you'll let me know so that we may meet. It would be awfully sad if it were to be otherwise as I grew very fond of you both during these years and that, somehow, [divorce in] Reno can't quite cope with.*
>
> *But otherwise all is well that ends well and didn't I tell you that Dick would marry again soon? Perhaps even I didn't quite think it would be this soon, but I can hardly tell you how glad I am or how much it solves the naturally somewhat awkward transitional situation at the Museum.*
>
> *The bride and groom are making their first public appearance this afternoon when the Museum opens its new photography center on 54th St. I don't know how much news you have on the subject but she is quite young and Dick seems rather touchingly happy and it looks as though it promises very well.*[4]

And so it did. The following February Iris told Charles that Dick was "blooming (in fact I must admit he seems to be benefiting greatly by the change!) and seems immensely happy and I am happy too so you see we don't any of us have to feel anything but peace of mind generally."[5]

For Mother Nan Iris put another spin on the divorce. "You can blame me for the change," she wrote. "I felt very strongly that we needed a change and perhaps that is all it will turn out to be, but for the moment I can't see the future at all, obviously neither of us are very happy about the thing."[6]

Details of the Abbott / Barry split are lacking. Theirs seemed a marriage of convenience and they were not especially faithful to one another. Their alliance had been bound up with their work at the Film Library, and now with Alfred Barr's demotion and Abbott's assumption of control over the entire Museum staff, a new dynamic was introduced to their relationship. Despite their much-improved housing situation and more sumptuous lifestyle, Iris may have sensed that her association with Abbott had become a liability in the long run and

been glad to be rid of him. In any case the decision to separate came from Abbott. After the breakup, Iris wrote her Bucks County friend, the novelist Edmund Schiddel, alluding to the time of the separation as "that grim weekend when I had to move out and had nowhere to move into," and describing it as "a gruesome moment now happily long past." Still, her life alone left much to be desired, including proper furniture for her new apartment. "Occasionally I weave around looking for a small grate under eighteen inches wide, or try to get some curtains from Constance [Askew], who promised them but hasn't unearthed them yet . . . but while the place is pleasant and orderly it is still a little bleak."[7]

She told Schiddel about the circumstances of Abbott's prompt remarriage. "I daresay you have heard that Dick got married again, for which I was glad, not only because it was exactly as I predicted, to the first suitable young lady he met. All the details, which you also may have heard, were picturesque and improbable. It is odd, but when I met him the other day I didn't at first recognize him . . . but he is well . . . and seems very pleased with himself." Meanwhile, "the Museum continues, and rather more so: I am supposed to be writing a lot: I am doggedly being psychoanalysed but without much optimism although it is not uninteresting at times. . . . I don't have a cat, or intend to get one."[8] Iris had asked Abbott only to help support her mother as a condition of their divorce. Abbott complied, and faithfully sent money to Iris's mother for the rest of her life.

Meanwhile, Abbott continued to run the Museum, a period of rule in which, as Jimmy Ernst put it, "firings and changes seemed capricious or smelt of empire-building by some newly arrived power figure. 'Better and Better' meant 'Bigger and Bigger,' in spite of the efficiency experts. I could not help but sense the tensions in the curatorial departments as I made my daily mail deliveries through the building and I admired these intelligent and sensitive people as they stood their ground successfully more often than not."[9]

As resentment grew among the Museum staff toward Abbott and his management style, many wondered why Iris had allied herself with him in the first place. She may have signed on with him, as Dorothy Miller believed, because she "needed a man,"[10] but after Abbott replaced Barr as the most powerful administrator at the Museum, Iris must have had second thoughts about their liaison. Abbott indeed had been useful to her. Rockefeller and Museum president Stephen C. Clark thought he was just the sort of man they could trust managing a museum, and this left Iris relatively free to pursue her curatorial work without the added burden of defending the Film Library's budget to the trustees. Once she and Abbott were no longer viewed as a team, however, she found herself more personally accountable for the finances of the Film Library.

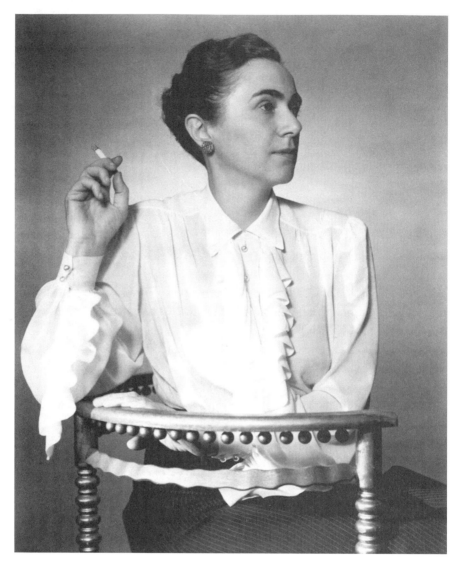

Portrait of Iris Barry by George Platt Lynes (1940s).

32

POSTWAR BLUES

IRIS WAS LIVING alone as the war came to a close in 1945. Although Rockefeller and Whitney returned as board chairman and president, respectively, of the Museum,[1] the funding Abbott had found so plentiful during the government-contract war period was disappearing. Iris found herself confronted with a multitude of new challenges. Her marriage to Abbott had never been ideal. She frequently saw other men and even a person as proper as Margaret Barr believed her to "pick up men at Schrafft's."[2] "I know she had enough lovers," Philip Johnson also recalled, "but they were all taxi drivers or kids in the street. She never had any serious affairs."[3]

A recollection Iris left behind illustrates her extramarital activities while married to Abbott:

> Once I smelled smoke, not imaginary smoke, but real. I cannot say that I leapt to my feet though no doubt I did: and I was not alone; there was with me one of those young men, well, he was a youngish man with a rather heavy backside and I would not have presented him to my worst friend. But the evenings are long and I had a house and there were drinks and so there in the early hours of a morning my mattress was on fire.
>
> I said, 'Fred, the mattress is on fire. I shall have to do something about it.'
>
> All I heard was the rustle of clothes being put on. My Fred did not wait to see what it was; he was gone and far away, a prudent, big-bottomed boy.
>
> The mattress <u>was</u> burning and smelling. I am not a big or a strong woman but I did manage to tease the mattress off the 'sommier' and drag it to the bathroom across my bedroom and did manage to drag it into the bathtub and put on the shower, which I thought would extinguish the glowing fire.

Smoke blinded and choked me. I was coughing like a seal. The water from the shower was pouring down when the whole bloody thing burst into flames, which is not fair or normal.

The flames, which I did not believe in, began to lick the ceiling. So I went to the telephone, to call our handsome neighbors the fire-station boys. I said, 'Here is Mrs. Abbott at 221 East 49th Street and there is a very small fire. Could you please send a very small unit to put it out?'

Before I had put the telephone down on its rack, I heard the tingle tingle tingle coming from the fire station and so I ran like a madwoman down the stairs, only two floors after all, but I had heard stories of firemen who demolished front doors with axes, so I wanted to get there first, and I did. I opened the front door, and a great wave of men rushed in, the first of them hurling me over and the rest of them trampling over me.[4]

After her divorce from Abbott, Iris also welcomed the company of men known and unknown to her. She recalled that

a vastly enjoyable if exhausting wartime duty, though of a most unofficial sort, was a nocturnal one. Every now and then my telephone would ring around midnight, and struggling up out of dog-tired sleep, I would hear dear old Robert Flaherty[5] summoning me pronto to the Coffee House Club, where so frequently he was entertaining foreign VIP's on their way from points unknown and secret to points equally confidential. At times these mysterious birds of passage wanted ardently to go up to Harlem and spend the night there before catching an early plane to an unspecified location. Nothing was too good for them. But white men were then not welcome, or even admitted to the famous Harlem nightspots unless accompanied by at least one white woman. For this duty Flaherty tapped me, no doubt because he considered me nocturnal by habit, knew I was living alone and was fairly familiar with the ropes uptown besides having a number of colored friends mostly in the entertainment world there. With the best will possible it is not easy, after an exhausting day's work, to drag oneself from bed to set out on a spree, but I never regretted those occasional jaunts.

I remember best three Norwegians I chaperoned up there. I had the impression they had something to do with heavy water in Canada. Then there was another time as nice an Englishman as one could hope to run across: he had something improbable to do with salt, it seems, but he most certainly enjoyed his Harlem visit on what he called 'my one night out.'

None of this seemed strange, just one more of those wartime comings and goings and also a characteristic by-product of his [Flaherty's] improbable cohort of travelers, map experts, engineers, younger film men, journalists, et. al.[6]

By day, however, there were constant worries about money. Pressures for funding the Film Library, always stressful, were but part of the peculiar finances of the Museum as a whole. After 1943 Iris could no longer rely upon Abbott to handle the library's finances for her. In its first ten years the Film Library had achieved a great deal. It worked out the legal basis for receiving films on deposit, greatly augmented its European holdings through connections with other members of the International Federation of Film Archives, received major deposits from Douglas Fairbanks, William S. Hart, Walt Disney, and others (including the entire D. W. Griffith estate), and made the film showings at the Museum a major reason people bought admission tickets. Nevertheless, the Museum was not legally a public institution. "The Museum of Modern Art," Iris explained to the readers of the *Hollywood Quarterly*, "unlike most other famous museums, has no endowment and is in receipt of no public funds. Established in 1929, exactly nine days after the stock market crash, it has nevertheless developed steadily through depression and war. In 1939 it acquired its own building, and raised the money to pay for it in full. But its ever-increasing annual budget has never been met by its income from a growing attendance, phenomenal sales of publications, rentals of exhibitions and film programs, and the annual dues from memberships, which now exceed 8,000. Nor have the extremely generous contributions of its trustees and supporters always entirely covered the resulting annual deficit. As one of its largest and costliest departments, the Film Library has therefore, save for the first years, been continually short of funds. No gift of money has ever been made, nor has even one $1,000 life membership ever been subscribed by anyone, and in ten years only two contributions have been received from any film organization."[7]

Iris increasingly saw herself as piloting a sinking ship. The entire Museum, its Film Library included, had long been dependent on too few patrons to be entirely viable. According to a report marked "confidential" from the Committee on Policy to the MoMA Board of Trustees, the Museum ran a deficit of $79,082 for fiscal 1943–44, on an overall budget of $709,999. The report notes that the committee was "appointed by the Board as a result of the Board's dissatisfaction with some phases of the present state of the Museum."[8] Reviewing income for the year, the committee noted that "twenty-six persons made

donations of $500 or more and their contributions total $255,512. Of these 26 donors, seven made contributions which account for 81 percent of the total. In short, the [loss of] contributions of only seven persons, resulting from death or decrease of interest in the Museum, means disaster—and death is sure to come. Clearly the Museum must acquire a broader base of major support than this."[9]

It was supposedly in an effort to achieve such broader support, as well as to trim the sails of the Museum, that Abbott and Stephen C. Clark, both members of the Committee on Policy and, per the report, the "operating heads of the Museum,"[10] announced the curtailment "pro tempore" as of July 1, 1944, of the Museum's Departments of Photography, Dance, and Theatre Design. They nonetheless underlined in their report what they called the "corporate purposes" of the Museum, which in the words of the Museum's charter were "encouraging and developing the study of modern arts and the application of such arts to manufacture and practical life, and furnishing popular instruction."[11] The first obligation of a museum, in their view, was fiscal solvency.[12]

The primary obligation of Iris Barry as head of the Film Library was shifting from curatorship to fundraising, a task she cared little for and was not notably skilled in performing. With Abbott at the controls everyone feared for their jobs. Iris's friend, the novelist Edmund Schiddel, passed on to her an enigmatic postcard he received from Museum employee Elizabeth Trask in February of 1945. "Darling," Trask wrote Schiddel, "Although she probably is aware of it, I thought I should apprise you that there is a plot afoot to unhorse Iris from the Museum and replace her with a shabby little New Directions poet." In parenthesis on the postcard was the notation, "Paul Goodman."[13]

Iris's modus operandi at work may have added to her problems. Describing herself in the third person, she acknowledged that she typically regarded her office desk "with ill-conceived loathing," upon which she could "never find anything" but relied instead upon her "prodigious memory for detail" to get along. On this desk, she recalled,

by mid-afternoon, is deposited a malted milk container and the remains of a sandwich, for she seldom lunches out. Scattered about the debris are various oddments and knick-knacks and among them will be a pair of massive gold chain-rings, which constitute her only articles of jewelry. These, once they are located, she constantly plays with, slipping them on and off her finger as she talks to visitors.[14]

Much of her paper work she manages to ultimately avoid, by a process of simply letting letters go unanswered until the basic situations have either

altered or expired. Business experience has sharpened her on one thing, at any rate, and that is the bulk of correspondence in any office seldom requires an immediate decision. If someone were to inquire what she is going to do about all this, she'd very likely reply she was just going to wait for something to happen. . . .

When displeasing situations confront her, her Irish-blue eyes acquire the hard glitter of diamonds, and the Museum grapevine quickly passes the word that the Queen is in the deep-freeze. The term is apt, for her staff (who in their more jocund moments refer to her simply as I.B.) have come to know that it will be a rare instance that day when any of them will receive more than a frosty monosyllabic reply to their urgent questions.[15]

The Queen's deep-freezes did not last long, however, because "more often than not, at the end of a turbulent day, she will collect her colleagues one by one and ease them into a conveniently located gin-mill on Sixth Avenue where all is forgotten. On one such recent occasion she said to them plaintively, 'I wish I could be back on the fringe of the intellectual world instead of the periphery of business, which I'll never understand anyhow.' Needless to say, they all love her."[16]

But as the cryptic card to Schiddel indicates, this impression of "love" was probably wishful thinking. The postcard was written when Iris was away in Hollywood conducting a study for the Rockefeller Foundation on the use and production of nontheatrical films in wartime. Corresponding from the Hollywood Roosevelt Hotel, she thanked Schiddel for "writing me the bad news about how they want to give me the sack" at the Museum. "So maybe Abbott or (more likely) Mrs. Abbott wants me out of my job?" she speculated, adding resignedly that "I can only feel that they are partly justified. I haven't worked very well for the past two (three?) years." She added that she felt vitalized by being in California, where the weather was balmy and she was very well treated. "In other words," she told her friend, "once more, I believe in life. How really curious and awful."[17]

After her return to the Museum, her prestige continued to deteriorate. As Dorothy Miller put it, at this point "the staff in general hated Iris. They saw through her climb and didn't like it. She was very snobbish. She didn't treat the understaff well, and so she was disliked very much, especially by the small staff because she was so snooty and the upper staff saw through her machinations and so she was very unpopular at the Museum by the time she left."[18]

By the summer of 1945, Iris had also taken a position on avant-garde film that set the Museum in opposition to a new generation of independent filmmakers

emerging from the war. During the war, 16mm film equipment became widely accessible. It was used to make informational films by the Signal Corps and played an important role in military surveillance, since lightweight cameras could easily be suspended from the wings of airplanes. The 16mm JAN (Joint Army-Navy) projector became ubiquitous, and many who had made informational films for the war effort rejoined civilian life with filmmaking skills. Alexander Hammid was among them and, with his wife Maya Deren, filmed *Meshes of the Afternoon* in 1943. Their dreamlike, haunting film, complete with double images of the photogenic Deren, became iconic of the new American avant-garde. Iris detested both the film and Deren, regarding her as indebted to the European avant-garde. As the sole arbiter of Deren's application for support from the Rockefeller Foundation, she rejected the application outright. John Marshall of the Foundation wrote Deren: "I know it appears to you that what you need is a chance to make more films; but after a good deal of thought and some further discussion, Miss Barry and I both feel this would not actually be so advantageous as it seems. Rather, rightly or wrongly, it is our feeling that you can better develop your talent for filmmaking in finding some way in which it can be utilized in filmmaking of various types."[19]

Marshall's letter goes beyond rejecting Deren's grant application, hinting that she should change her style of filmmaking. Deren was incensed. Responding to the rejection, in February 1946 she rented the Provincetown Playhouse in Greenwich Village and staged a multiday run of her own films under the banner, "Three Abandoned Films." The shows were packed. Among those attending were Amos and Marcia Vogel, who followed up by using the Playhouse as the venue of their new film society, Cinema 16, dedicated to the exhibition of avant-garde film. Amos Vogel went on to become the founding director of the New York Film Festival. Subsequent to Vogel's early organization, the New American Cinema Group was founded in 1960 to develop the Filmmaker's Cinematheque and the Filmmaker's Co-operative, leading independent film exhibition and distribution facilities emergent in the 1960s. Jonas Mekas, the guiding spirit behind these efforts, acknowledges that it was the "Provincetown screening which prompted the creation of Cinema 16" and that the New American Cinema Group grew out of these efforts to support avant-garde film.[20] Ironically, Iris's disdain for the postwar avant-garde, which was carried forward by her successor at MoMA, Richard Griffith, provoked the growth of competing institutions such as Anthology Film Archives and the New York Film Festival, and the public ultimately came out the winner. Nonetheless, Iris's attitude ran against a historical tide she seemed totally unaware of.[21] For her part,

Deren gained some recompense by winning a Guggenheim Fellowship in 1946 and an award in the same year from the Cannes Film Festival.

As the war ended, Iris's ultimate departure from New York was five years in the future. Meanwhile, lacking wartime funding, the Film Library needed help. For a time Iris thought her salvation might lie in serving the newly formed film educational community. There were a growing number of film courses and nontheatrical exhibition programs emerging on college campuses. Through the efforts of the Film Library and other institutions, film was becoming an accepted subject of study. Iris took note of this in an article in the *College Art Journal.*

"It was the president of a large eastern college," she wrote, "who, in a moment of discouragement, said not long ago that his new crop of students appeared to be genuinely interested in little but swing music and the movies. He very much welcomed the idea, therefore, of providing them with material for a considered study of motion picture aesthetics and history since, as he put it somewhat wryly, by inducing them first to cerebrate about films he might afterwards more readily induce them to use their native intelligence about other subjects."[22] Iris thought she could appeal to this audience and hoped her income from supplying films and film notes to colleges might keep the Film Library afloat.

To further Iris's film-educational aims, in January of 1946 Dick Abbott passed on to Nelson Rockefeller Iris's proposal for funding the *Film Index*, a publication she proposed to be "an evaluated analysis of the content of all available non-fiction films in the United States."[23] This work would supplement the work done during the 1930s in the "Film in America" project. As Iris put it,

since the war . . . the trend toward visual education has taken on a new vitality. Not only has the projector sold itself as an educator through its success with the troops (it is stated that service men learned three times faster with film than without), but the expectation that large quantities of this equipment will soon be made available at low costs is making educators look at the teaching of film again with new interest. Anything that can be done at the present time to sustain and justify that interest will be a lasting contribution to American education and, it might well be added, the American educational film.

Specifically, what is needed is a group of educators, camera-wise and classroom-wise, a group to devote its entire effort to an examination of all available non-fiction films and report their contents, recommend age level, and relative effectiveness as teaching material. This is not a question of film as art; yet a technically poor film is apt to be a dull one, an ineffective

film—and such ineffective films have too long been the bane of teachers who have wanted to introduce films into their classes. Such a project will involve obtaining and screening all the non-fiction film currently available and now being produced.[24]

To this end a grant request in the amount $59,400 was made to the Rockefeller Foundation.

After successfully securing funding again from Rockefeller, Iris left the day-to-day work on the *Film Index* to others on her staff. She began to take advantage of eased travel restrictions brought on by peacetime. As the war ended, she was approached by Olwen Vaughan, secretary of the London Film Society, about providing films for a retrospective look at film history for the Society. The Society had been largely dormant during the war and needed a theater for its showings and a budget to work with. Vaughn sought the advice of Iris's old friend, Sidney Bernstein, who in turn talked with other Film Society stalwarts and decided they would like Iris to return to London and her Museum to provide the films. They felt the greater impact of the war upon Britain made it more likely that American, rather than British, money would be available for the project.

Thomas Hodge, assistant head of the Film Division of the British Information Services in New York, wrote to Sidney in July of 1945 that "Iris has discussed the matter with Abbott and Whitney, who both agree that it would be a worthwhile journey to make. She cannot leave before September, as she wishes to complete her arrangements for the 1946 documentary film season at the Museum."[25] The 1946 documentary series was indeed ambitious, and a retrospective of its size and complexity would never again be programmed by Iris at the Museum. The series, called "The Film of Fact," involved hundreds of films shown over several months and amounted to a near-definitive retrospective of documentary films. It was a curatorial triumph.

Having arranged the series, Iris turned her attentions from the Museum to other matters. In 1946, the year her title was changed from Curator to Director of the Film Library[26] and she became President for Life of the International Federation of Film Archives (FIAF),[27] she spent nearly five months in Europe, representing the Museum in France, Italy, Switzerland, Belgium, and England. She did the same in 1947. She stepped up her activities for FIAF and sat on several foreign film festival juries. These absences coincided with continuing financial crises at the Museum. The Film Library, despite its popularity, began to be viewed as a drag on the finances of the Museum. In a report to Iris, shared

with Nelson Rockefeller, on the cost of operating the Film Library from its inception until June 30, 1947, Ione Ulrich, the Museum's business manager, summarized the financial plight:

* The Film Library paid for its own housing at 485 Madison Avenue, outside the Museum, from its founding in 1935 until it moved into one-half an office floor of the Museum in 1939, thus becoming a non-paying tenant of the Museum
* By June 30, 1947 $130,881 had been expended on film acquisitions.
* Approximately one in three Museum visitors attend the film programs.
* In its first twelve years the Film Library "has paid about 20% of its way through earnings; the [Rockefeller] Foundation has contributed about 32%, industry about 4%, leaving 44% to be subsidized out of contributions to the Museum of Modern Art in addition to its present contributions of overhead."
* In the four years since the Rockefeller grant ended, "the contributions of the Museum have averaged around 70%."[28]

Ulrich's report ends somewhat ominously:

According to a poll conducted several years ago of the seven curatorial activities of the Museum, the films take second place to painting in public interest. However, in cost, the Film Library is the largest single activity of the Museum, and I might add the only one without support from individuals particularly interested or active in the field.

As brought out in our President's appeal for funds, the Museum in general is in need of financial aid or its programs of activities will be seriously impaired. This comes at a time when we foresee the need for an increased and not a decreased budget for the Film Library—due to rising storage costs, the rising cost of living, and film deteriorations; and also due to the restoration of interest in films on an international basis.[29]

In sum, the Film Library came to be viewed as a sizable liability to the Museum after its eight-year Rockefeller grant ran out in 1943. Overall estimate of the deficit for the period from 1935 to 1947 stood at $368,554. Clearly there was pressure for the Film Library to become more self-sufficient.

In late 1947, Stephen Clark sent a memo marked "confidential" to Henry Allen Moe of the Museum's Coordinating Committee[30] regarding his group's

recommendations about Museum finances. While Mr. Clark found the committee's willingness to exact certain economies "a gratifying change of heart," he also found its members too lenient and at best bent on exacting a temporary expedient. "There is not, so far as I can see, any real disposition to come to grips with the fundamentals of the situation," he said, since the committee seemed "resolutely opposed to the elimination of any department and is apparently living in the hope that by tapping new sources of revenue the good old days will come again. Instead of making a lot of more or less horizontal cuts in department expenses, which may easily result in a deterioration in quality in all of our product," Clark argued, "we should simplify the organization, ruthlessly cut out unproductive departments, and concentrate on those fields of activity which experience has shown produce the greatest results."[31]

To Clark's way of thinking, "the Museum, in recent years, has become more difficult to run than a great industrial corporation, for it has not only entered into a great variety of fields but it is, of necessity, administered largely by people who are wholly impractical and temperamentally difficult to handle. In formulating a policy for the future, we should, therefore, make due allowance for the kind of people we have to use; and so simplify our organization that a reasonably intelligent person can run it in an efficient and business-like manner."[32] Clark felt that of the Museum's various departments only Painting and Sculpture, Publications, the Film Library, and Photography should be retained, asserting that he would "eliminate most of the others," such as Education, Architecture, and Prints and Drawings.[33]

The artistic decision-making involved in curatorship, Clark believed, could be easily farmed out to contract players, while the full-time leadership of the Museum could be left in the hands of business people. "The exhibitions and publications could be taken care of by guest directors and writers, who would be paid for certain specific services but would not be on our pay-roll. In that way we could eliminate a considerable amount of expensive overhead."[34]

Of course there would need to be a sympathetic leader to carry out this regimen, and for this, "more than anything else," Clark concluded, "the Museum needs a first-class over-all director, who is primarily a businessman; but I do not believe that the services of such a person can be secured until we bring some kind of order out of the chaotic administrative set-up that exists at the present time."[35]

Clark's chumminess with Dick Abbott is testimony to his belief that Abbott was this kind of person, but at the same time Clark found the Museum's administration problematical. In the spring of the previous year, at Abbott and the

Rockefellers' request, William Alton of Rockefeller Center, Inc., had done a study of the Museum. In his analysis of Alton's report, Abbott noted, agreeing with Clark, that "the additions of new departments and new functions, whether permanent or temporary, has added greatly to the work and responsibility [of the Museum] without any compensating return."[36] In short, all agreed the Museum and its growing departments were becoming unfunded mandates. With each department having its own spokesperson on the policy committee of the board, a kind of inertia had set in. Talk of cuts was in the air.

Such was the frame of mind of the leadership of the Museum, as Iris stayed away as much as possible in Europe.

Iris's return to Europe after the war coincided with a change in her view of the supremacy of American films. Issuing a "Challenge to Hollywood" in *Harper's Bazaar* in 1947, she accorded supremacy in postwar filmmaking to the Italians, whose pungent neorealism she found preferable to the work being done in France and Scandinavia. "By every standard," she wrote, "the most exciting factor in European cinematography today is the sudden eruption of the new Italy as a source of not one but many pictures of merit." Among these were the works of Roberto Rossellini, whose *Paisan* and *Open City* were the rage of the Cannes Film Festival. Iris sat on the first Cannes jury in 1946. She noted that in Rossellini's films "Italy becomes the vast stage upon which life takes startlingly realistic shape. Since many of the players are real GI's, actual monks, plain people, one has again the impression of witnessing an honest newsreel of breathless and bloody events rather than a contrived movie."[37]

In addition to adjusting her view of American supremacy in film, Iris was also reassessing her personal life. In one fateful episode while traveling after the war, she met the man with whom she would spend the remainder of her days. Wyndham Lewis's biographer Jeffrey Meyers notes that "Iris met Pierre Kerroux at the 1947 Cannes film festival, when a journalist friend broke his leg and gave Kerroux a press card to see the films Iris was judging [*sic*]. Kerroux, a handsome man who was twenty years younger than she, was then smuggling olive oil from Corsica to the coast of France in his boat, which he was forced to sell just before it was confiscated by the police."[38]

Meeting Kerroux, increasing her involvement with the International Federation of Film Archives, and touching base again with friends in England contributed to Iris's growing alienation from New York. As she began to develop new ties in Europe, the old ones in New York continued to fade.

33

ABBOTT'S FALL

S 1947 DREW to a close and Iris was renewing her contacts in Europe, Abbott's health and his position at the Museum deteriorated. He missed work the last half of the year and even with Stephen Clark's qualified support, Abbott could not keep up the pretense that he was in charge. In Russell Lynes's terms, Abbott was "eased out."[1]

On December 22, 1947, Abbott wrote to Nelson Rockefeller: "It is with deep regret that I offer my resignation as Secretary of the Museum effective on January first 1948 or at any subsequent date that might be more convenient to the Board.

"May I say that I am grateful for the years I have spent as an officer of the Museum and that I shall continue to bear it the liveliest affection."[2]

Two days later Rockefeller replied to Abbott, accepting his resignation, saying "it was with great regret that the Executive Committee, at an executive session, accepted your letter of resignation as Secretary of the Museum,[3] effective January 1, 1948. The association with you in connection with the work of the Museum has meant a great deal to all of us and your fellow Trustees have authorized me to express to you our very sincere appreciation of the outstanding contribution which you have made during the last twelve years to the growth and development of the Museum."[4]

This, however, was a more formal version of another letter Rockefeller sent to Abbott at the same time. The second contained allusions to Abbott's health:

I took up your letter of resignation with the Executive Committee at an executive session at which there happened to be a majority of the trustees who were sitting in on the discussion of another matter. They felt very badly indeed to know of your decision and asked me to express their very sincere appreciation for the tremendous contribution which you have made over a

period of years to the growth and development of the Museum. They have all been greatly concerned about your health and quite understood your feeling as to the advisability of withdrawing from the Museum at this time. We appreciate no end your suggestion of staying on, but in view of the fact that you have been out for the last six months, it was felt better to accept your resignation as of January first.

Because of their great personal friendship and admiration for you, a group of the trustees have authorized me to tell you that your salary will be continued until December 31, 1948.

I am attaching a formal letter accepting your resignation. It was felt that perhaps it might be better for all concerned to delay the announcement until you take a job along the lines we were talking the other night, thus announcing your resignation and your new association at the same time.[5] Do let me know how you react to this.[6]

After the Christmas holidays Rockefeller moved to find Abbott a job, writing to William Zeckendorf, whose real estate firm, Webb and Knapp, managed several Rockefeller properties, to urge him to take Abbott on. "When I became President of the Museum in 1939," Rockefeller wrote, "Mr. Abbott was appointed Executive Vice President because of the outstanding job he had done in organizing the Film Library. He did an equally effective job in the management of the various and complex affairs of the Museum, and while in this executive capacity, the Museum grew from an institution with a budget of $400,000 to one with a budget of $1,100,000 with earnings mounting from $125,000 to $640,000. In addition," he continued, "Mr. Abbott carried the responsibility for a very extensive program which the Museum undertook for the Office of the Coordinator of Inter-American Affairs, and for the CIO, which consisted largely of traveling exhibitions prepared for various foreign countries, as well as publications, catalogues, etc., to go with them." Rockefeller concluded by saying that Zeckendorf's "kindness in seeing him [Abbott] is much appreciated."[7]

Rockefeller also successfully solicited Clark, Whitney, Abby Aldrich Rockefeller, and others to contribute to a tax-deductible fund set up at the Museum through which Abbott's salary of $12,000 would be continued for another year.

Zeckendorf did as he was asked and hired Abbott, but the new relationship rapidly deteriorated. By July of 1948 Abbott was already a strain on his new employer. A restaurant property owned by Webb and Knapp, the Monte Carlo, went out of business under Abbott's management and by summer Abbott was busying himself with the landscaping of Webb and Knapp's new offices.

Rockefeller's private secretary, Susan Cable, mentioned in a memo to Rockefeller on July 2 that "for some time" she had "the feeling that Dick's association with Webb and Knapp was perhaps not the happiest." She suggested that Abbott might be put to work renting properties in Rockefeller Center.[8]

Two weeks later Abbott was diagnosed with tuberculosis of the larynx. He had suffered intermittently from tuberculosis since 1941. He left immediately for a facility on Saranac Lake where, according to Cable, he was to keep "absolutely silent and take streptomycin daily." She noted that Abbott "thinks it's the beginning of the end."[9]

Abbott's decline took some time. Zeckendorf agreed to pay his salary for six months, even though he had already consented to a doubling of the salary to $1,000 a month. These funds, presumably, were in addition to Abbott's extended MoMA pay. Zeckendorf also facilitated the loan of an apartment belonging to Nelson Rockefeller to Abbott's wife. He told her that he felt Abbott to be "partly" Nelson Rockefeller's responsibility, and that after a six-month period Rockefeller should step in and help.[10] Zeckendorf apparently did not know that Rockefeller was already helping Abbott financially.

Abbott's ill health persisted. By the spring of 1949 he was out of the Saranac facility and deep into trouble at work. Zeckendorf had asked him to follow his physician's advice and quit drinking. Abbott did not. On April 25, Zeckendorf fired him.

"Dear Dick," he wrote to Abbott at the Hotel Marguery on Park Avenue,

you came to work for Webb & Knapp over a year ago at a salary of $500 a month on a trial basis. After four months you asked for an increase to $1000 a month in order to put you in a position to take care of your cost of living. This request was granted with a statement by me that while you had not as yet proven your value to Webb & Knapp I was both fond of you and had hopes of your becoming an important part of our organization. Unfortunately within a month after your salary was increased you were taken tragically sick with tuberculosis and forced to go away.

Throughout the time of your illness we maintained your salary and gave you a Christmas bonus and all other available benefits to our employees at the higher salary figure. When you returned to New York it was understood you would have to convalesce for a considerable time before you could do full justice to your job.

I took occasion to request of you that you positively cut out drinking and suggested that you also stop smoking, both of which admonitions were but reiterations of your doctor's instructions. It was made clear to you that my interest was inspired by personal concern and for business reasons. Obviously it was unfair to the company for you not

to make every possible effort to restore your health at the earliest possible moment. You agreed and gave me your solemn promise that you would adhere to this regime. To my great regret I have learned from unimpeachable authority that you have not kept your promise. There is but one conclusion we can draw from this action on your part and that is that you are not sufficiently interested in a continuance of your relationship with Webb & Knapp. Therefore I must reluctantly advise you that your employment by our firm is terminated as of the end of this month. I know you will understand how unhappy the entire matter makes me.

You have my best wishes.[11]

This news only compounded Abbott's troubles. He and his third wife were splitting up. She moved out of the Rockefeller apartment on July 1.[12] Abbott's medical problems persisted and he returned again to rehabilitation at Saranac Lake in the spring of 1950. Abbott "went to Saranac on a stretcher which was lifted through the window of the train" in a snowstorm, Susan Cable informed Rockefeller.[13] Abbott had suffered a hemorrhage, brought on, Zeckendorf surmised, by drinking.

As decisive as Zeckendorf may have appeared in his letter of dismissal, he was not yet rid of such a well-connected employee. Abbott managed to linger on at Webb and Knapp. When he again returned for rehabilitation at Lake Saranac, he wrote Rockefeller of his pleasure that "Bill [Zeckendorf] agreed for me to continue at Webb and Knapp during my stay here and 'for several months after my return.' The future to depend on what he will (or won't) have for me to do in his new organization."[14]

Zeckendorf, who seemed unable to get rid of Abbott, was not his only means of support. Even after his one-year salary extension ran out from the Museum, Abbott was still receiving money indirectly from Nelson Rockefeller. From the date of his "dismissal" by Zeckendorf, he received $500 a month in "loans" from Rockefeller. "Since June 1st, 1949," Rockefeller's accountant Philip F. Keebler wrote to his employer,

you have been depositing a monthly check of $500 to the account of John E. Abbott at the Rockefeller Center Branch of the Chase National Bank. These checks have been treated as loans to Mr. Abbott. Up to the end of September [1950] the loans total $8,000 and by the end of the year the loan will be $9,500.

I do not know whether Mr. Abbott will be able to repay part or all of the loans made by you to date. If not, I suggest that you forgive $6,000 of the loan this year and you will have no gift tax to pay on said forgiveness.

Our present instruction is to continue the deposit of $500 each month until advised by you to the contrary.[15]

The evidence is cumulative that Nelson Rockefeller, directly or indirectly, supported John Abbott from his departure of the Museum until his death in 1952.

Rockefeller sought other means of employment for Abbott, and Zeckendorf kept him on the Webb and Knapp payroll. Rockefeller even turned to Abbott's old supporter, Stephen Clark, for help. In October 1950 he asked Clark to take Abbott on at the Baseball Hall of Fame, which Clark had founded in 1939. But Clark demurred. He was "sorry to say there is no job open, at the present time, in the museums at Cooperstown which he could fill," adding that he did not believe Abbott would "fit into the community at Cooperstown and I feel pretty sure that if he should be given a job there he would not last long."[16]

Abbott was clearly out of luck. He lingered on into 1951, appealing to Rockefeller for support. "Nelson," he pleaded in February, "I am still extremely interested in some post with the State Department in Latin America and would appreciate your advice on how to go about it."[17] Divorcing again had been painful and Abbott came to "realize how I have been my own worst enemy."[18] His fate appeared to be sealed. He claimed to have quit drinking as a New Year's resolution for 1951 and he stayed for a time in the Genesee Valley with his brother, Charles, but on February 7, 1952, he died alone in a New York City hotel room, probably under the influence of alcohol.

"Ex-Museum Aide Fatally Injured," the notice ran in the *New York Daily Mirror*:

> John E. Abbott, 43, former secretary of the Museum of Modern Art, was found dead yesterday on the floor of his room at the Sulgrave Hotel, Park Avenue and 67th St. Police said he apparently was fatally injured in a fall.
>
> The body was discovered by Lena Perisano, a maid. There were two bumps on Abbott's head and bloodstains were found in the bathroom. Evidently after he was hurt, he stumbled into the bedroom and collapsed. Cause of death will be established on completion of an autopsy. Abbott was former assistant to the president of Webb & Knapp real estate firm, 383 Madison Ave.[19]

Upon hearing of Abbott's demise, Nelson Rockefeller, in a resolution he wrote on behalf of the Trustees of the Museum, proclaimed that the Museum of Modern Art Film Library "now stands as a living memorial to Mr. Abbott's

outstanding organizing and creative ability." The resolution also stated incorrectly that "during his association with the Museum Mr. Abbott won the respect, confidence and devotion of all who worked with him."[20]

Abbott was ultimately Nelson Rockefeller's man at the "Rockefeller Museum," perhaps even more so than he was Clark's. Clark came to view his leadership as "chaotic" and refused to hire him at Cooperstown. But Abbott did things in the good-for-business manner that Rockefeller admired, and Abbott saw the Museum as an institution properly aligned with the efficiency experts Rockefeller sent in. Although it brought him little but scorn from his fellow employees, Abbott's willingness to do the bidding of Nelson Rockefeller earned him the consistent praise and support of the point man behind the family that created the Museum. Rockefeller was willing to support Abbott until he died and even designate as a "living memorial" to his faithful employee (who had no expertise in film or the film industry before he met Barry) the Film Library Iris Barry built.

34

HOSPITAL

THE END OF the 1940s also brought a major health crisis for Iris. It is unclear exactly what brought her to the hospital in February of 1949. Perhaps, since she alludes to having had a curettage, it was a polyp removal or possibly an abortion, although the latter was unlikely at her age. She was 54. Iris later wrote Charles Abbott that she had had a hysterectomy.[1] Nonetheless, by her account,

a routine check-up at Doctor's Hospital seemed in order at the moment, so off I went with an armload of books and magazines, much looking forward to two or three days' leisure. The doctor who had me in hand was a very bright and kindly refugee and seemed as pleased as punch when on my third day there he came by to say that all seemed well, no adverse report of any kind having come from the lab since my curettage. Slightly later, now more dressed and small suitcase in hand, I was down by the office by the entrance paying my bill, when this Dr. Kulka came scuttling down the hall, looking extremely wan and perturbed and gripped me by the arm and said, 'I must oberate: ve vill do this domorrow.'

Evidently the lab had finally come through, and the verdict was not so good.

It seemed necessary at once to reassure Dr. Kulka and at the same time to get myself a bit of breathing-space—to put things generally in order (make a will, pay up any outstanding bills, see that the office and flat would be taken care of, and so forth). So I said, 'No, not tomorrow. Please give me a day or two. How about operating Monday?'

From extreme solicitude, Dr. Kulka suddenly became indignant.

'Everybody knows I never oberate on Mondays!' he shouted.

'Oh, forgive me. How about Tuesday, and I'll come in on Monday evening?'

'Ja-wohl. Gut!,' Dr. Kulka replied. . . . Come Tuesday, after a rather occu-pied weekend trying to fix things up 'in case,' back I was in Doctors Hospital, being wheeled along a corridor in a beatific state of druggery and semi-coma, looking forward to the anesthetic—than which what can be nicer?

Some time . . . in fact some days later, there I was again in my spacious, sunlit room with Dr. Kulka holding my wrist and smiling delightedly: all, it seemed, had gone very well, and indeed I felt fine if a trifle vague and slightly conscious of bandages and strappings over the belly that made one not want to move.

Flowers in unimaginable quantities began to be brought in, and gift par-cels of heavenly Mary Cross cologne and books and things, which the nurses (minor goddesses in white) seemed to enjoy unwrapping and smelling. There were telephone calls from the office,[2] for I had had, however reluctantly, to say where I should be, if not exactly why.

It was blissful. Lovely druggy sleep and such exquisite whiteness and lit-tle pills and on successive days a lot of visitors, and more flowers. . . . One very intelligent friend sent two frivolous fluffy bed-jackets, most valuable for shoulders and arms, along with scarves to tie around the head and so disguise the sadly disordered hair-do. Another came with an elegant portfolio of blot-ting paper and stiff, large enough to write on.

The most startling and best of visitors, however, was Charles Laughton, who was briefly in New York and who tracked me down. He came blowing in and soon had a small crowd of nurses surrounding him as he perched one chair on another and climbed to sit on the upper one in order to demonstrate the advisability of providing especially high chairs for visitors in nursing homes, so they would be on a level with the patients.

At this point the Head Nurse swam in with grace and power, but to see him and not me. Charles saluted her from his perch. She asked for his autograph, which of course he gave her, and then she bore him away on the pretext that Mae West was on the floor above and was greatly desirous of seeing him.

Things went on splendidly until the tenth day. Up to then, there had been special nurses night and day on an eight-hour shift (and how different they were! Some made one feel happy and well and cared-for, others frankly were grudging and gloomy and one ardently desired their absence). Now no one spent the night on a camp-bed at my bed-foot. I was out of the woods, so to speak. Until it must have been the tenth night when things seemed to have gone wrong and I was greatly incommoded. . . .

It was the drear hour of five, not night, not day, and I was rather ill and realized it . . . I waited and used the receptacles and wondered what a few friends would say when they heard the news of my demise: for indeed I knew that I was on the way out. One knows. I have known it three times near the brink, the animal knows.

Finally it was 7 a.m. and how slowly the minutes marched. At 7 exactly I telephoned my doctor, as I knew that that was his exact hour of rising. In some vague way I trusted in him and when it was what have must have been about 7:20, I dimly saw him in pyjamas with an overcoat over and I felt him take my wrist. There was the wonderful feeling of being able to relax, having done the needful.

Very vaguely I saw shining machines and felt my arms extended as in supreme worship. I realized that needles of sorts had been pushed into my arms and that liquids were dripping into some part of me. Afterwards he said that it was saline injections into one arm and somebody's blood into the other: the bill was fairly steep so no doubt that was what it was.

Dimly, too, I felt a stab in the right buttock and gladly fell unconscious, while equally dimly hearing the doctor in his precise Viennese accent giving somebody hell.

Seemingly I had been about to kick the bucket with a nice little peritonitis.

Convalescence is nice. As I was insured against illness and operations through a sort of group thing emanating from the office, I had been obliged to fill in papers and all that and send them in. Presumably they reached somebody's eye, and the dread word <u>sarcoma</u> was on them. No doubt somebody had telephoned the hospital."[3]

Sarcoma, a malignant cancer arising in connective tissue or bone capable of spreading through the bloodstream, no doubt gave Iris an intense scare, not knowing if an operation would be the end of the problem or the beginning of a period of worrisome uncertainty.

"When I eventually went back to my little flat," she recalled,

rather tottery but feeling all right, the sad thing was that there was a pretty basket swarming with extremely dead black orchids with the usual accompaniments of asparagus fern and so forth and a card attached: from NAR [Nelson Rockefeller]. I sent the usual or indeed perhaps a warmer than usual letter of thanks, but I was dreadfully sad not to have seen and to have been <u>shown</u> such a gorgeous gift.

As I did not of course go back to work at once, various people came by to give me a hand. The best of them was my good friend Virgil Thomson, who proposed himself for dinner by telephone and arrived with more than a meal and cooked and served it and washed up and also rinsed the wash clothes <u>and</u> hung them up square. This amazed and deeply impressed me. It seemed to me what a gentleman would do if he had no servants.[4]

If her health was unstable, her career was receiving a welcome boost. Near the end of her stay at Doctors Hospital, Iris received some unexpected news:

Ambassade de France
aux etats Unis
Washington, le February 16,1949

Dear Miss Barry,

I have the honor to inform you that, by decree signed by the President of the Republic on the 12th of January 1949, you have been nominated 'Chevalier' in our National Order of the Legion of Honor.
I am pleased to congratulate you on this highly deserved distinction which I would like you to accept as a token of gratitude for the imminent services that you render to the cause of French cinematographic art in the United States, thus strengthening, in the most efficient manner, the bonds of friendship between France and the United States.

Sincerely yours,
Henri Bonnet
French Ambassador in the United States[5]

To which Iris replied: "My dear Mr. Ambassador, I am inexpressibly touched and flattered by learning of my nomination as chevalier in the Legion of Honor. Please accept the expression of my deepest gratitude for this distinction and forgive my delay in answering your gracious letter sooner. It only reached me yesterday at Doctors Hospital where I underwent a severe operation last week."[6]

Iris had coordinated with Henri Langlois of the Cinémathèque Française to integrate France into the international film archiving community through the International Federation of Film Archives. Langlois had personally protected many films during the German occupation and made his collection available

to Iris, just as Iris had made MoMA's films available to him. Many of the films coming from America and shown at the Langlois Cinémathèque influenced the generation of French filmmakers of the sixties' New Wave. And many of the titles Iris preserved from France otherwise suffered during the Nazi occupation. By naming her Chevalier of the Legion d'Honneur, France recognized Iris's historical stature. She felt buoyed by this honor, but she knew at the same time it came at a crossroads in her life. She steadily had been losing her enthusiasm for the Museum. Now she faced uncertainty about her health, not knowing if her second operation had been curative. She began to consider how she might choose to spend whatever time she had left.

35

DEPARTURE

"**A**FTER DICK DIVORCED her she remained working at the Museum but then got cancer, I believe of the cervix," Iris's daughter recalled, "and she had a big cancer operation and while lying in hospital she decided she just couldn't be bothered at the Museum any more. I think being divorced and then around fifty, she was tired of the whole thing and she told them. They said, 'Think about it, after an operation you're likely to be depressed. Have a long convalescence.'"[1]

By the spring of 1949, a period, coincidentally, during which her ex-husband was absent from the Museum due to illness, Iris had recovered enough to resume traveling. To move her along, in early April she received an unexpected missive from Nelson Rockefeller. On his personal stationary he told Iris, "I was so glad to learn that you're getting away next week for a little while and I do hope you'll have a real rest. I feel very badly about the long, tough siege you've been through and the added burdens it has placed upon you. The attached is a small evidence of my sincere appreciation for all you've done for the Museum and it brings very best wishes."[2]

Enclosed was a personal check for $4,000.

Iris replied:

Dear Nelson,

What could I say, what could anyone say, in answer to your note with its enclosure? I do say thank you, very very much and with all my heart: but it isn't as simple as that. Because I was so astounded, and then so deeply touched.

It is good of you to speak of what I may have done for the Museum, and I much appreciate it. But then you know better than anyone, too, that the Museum has been my baby and my family and that I love it dearly, so that if I did do anything for

it, that was entirely from pleasure as well as from the sense of devotion everyone there shares.

If it is permissible, I should like to say too that certainly sometimes I have no doubt been a bit of a problem to you, have acted on hunch and on impulse or been too blunt. Yet it was in a way from your Father one day at Tarrytown, as well as from your Mother and yourself on frequent occasions, that I was assured of the importance of seeing and feeling clearly and of the value of honesty. So forgive me some awkward but—in the long run—not necessarily faulty compulsions, and be very deeply assured of my undying regard and fidelity.

Your extraordinarily princely gift it is hardest to speak about. Let me simply say that it comes as the answer to a very real problem, that its very goodness overwhelms me, that it touches and encourages me most deeply, and that I do indeed thank you.[3]

Rockefeller's "princely" gift was an unexpected boon and may have encouraged Iris to think about leaving America. There followed a period in which, as she put it in a letter to Charles Abbott, she "either was foolishly glued to my silly desk or cavorting abroad."[4] The Museum and the Film Library continued to bleed red ink. In December 1949, the playwright and film critic Robert E. Sherwood was invited to introduce a showing of Vittorio De Sica's 1948 *The Bicycle Thief* (now known as *Bicycle Thieves*) at the Museum. Speaking before an invited audience of 500 persons, the *New York Times* reported that Sherwood "stressed the importance of the museum's film library which has 8,000,000 feet of American and foreign films, and urged the support of the museum 'in its many fine functions.'"[5] Sherwood was introduced by William A. M. Burden, a trustee of the Museum, "who noted that while the museum had operating expenses of $1,000,000 a year and was earning 60 percent of its annual budget, it had 'insufficient funds and inadequate space.' With increasing costs, he said, it was necessary for the museum to broaden its base of support from contributors. A plan has been set up, he said, whereby corporations could buy corporate memberships for from $500 to $5,000 and those corporation's employees then could buy for $5 museum memberships that ordinarily cost $12.50."[6] These attempts to broaden the base of support at the Museum highlighted the fact that the institution was still overly dependent upon funds from a few wealthy families, chief among them the Rockefellers.

During her increasingly infrequent appearances at the Museum, Iris continued her efforts to find outside schemes to bring money in. She arranged with New American Library to publish a history of film to be published jointly with the Museum, the Museum taking for sale 10,000 copies of the expected 35,000-copy

first edition.[7] She also negotiated with radio and television producer George Kondolf, who was interested in using Iris and perhaps her assistant Richard Griffith as consultants on a films-for-television project, which he said would bring $1,000 a week as MoMA's half of the profits from the 90-minute weekly programs. Iris thought the offer "well worth considering," provided Kondolf did most of the work as he promised.[8]

At the same time, Iris told the Museum's treasurer, Ione Ulrich, that she intended to attend the annual meeting of the International Federation of Film Archives in Antibes, then travel to Paris in October and to London and the British Film Institute on archival business.[9] No one suspected she might not return.

By the end of October 1949, Iris was living out of a suitcase in Cannes, first in an attic room on the Cours Massena, then on a sailing vessel with Pierre Kerroux, the olive oil smuggler she had met at the 1947 film festival. Ostensibly, she was working with Pablo Picasso on a film he was making about his work. The idea appealed to Alfred Barr, who encouraged Iris to aid in its realization. But mostly she was, as she put it, "cavorting abroad."

"Cavorting" is a polite term for the adventures Iris had. Iris took a male acquaintance to the Musée Grimaldi, a fourteenth-century castle high above Antibes, where Pablo Picasso had a studio. Large works by Picasso were on the museum's walls, and as Iris had been given a key to the studio by Picasso, she took the man into the adjacent museum when it was not officially open. This triggered alarms and an officious raid by French police, who held the couple until the break-in could be cleared up.

On another occasion Iris was with Kerroux in a Riviera nightclub when she was asked to dance by a mysterious man with a Corsican accent. As they danced near the rear door of the crowded room, Iris realized she was being escorted out the door at the point of a revolver. On October 30, using a return address of American Express in Cannes, she narrated these events to Edmund Schiddel:

Indeed I should have written before had I had a reasonably permanent address (the above, however, will work no matter what I decide to do) or had I not had so many adventures. . . . I forget when I last wrote—probably during my little affair with the police and a chap who was arrested with me at the Musée Grimaldi at Antibes . . . all very Simenon. Or had I already been held up by gangsters in the night club. . . . This Corsican affair cost me [my] wrist watch and my lovely ring (which I might maybe get back) but not my life as it perhaps might have. I don't like black revolvers pressed into my tummy on a dance floor, and the chief Corsican was, I think, drugged to the eyebrows too. The

idea seemed to be to take me off to Marseilles. It wasn't too clear and of course at the time I was fascinated and not at all frightened, alas . . . adrenaline to spare . . . anyway all ended when one of the two cars, the first one with Mr. Corsican and me, smashed madly into the mercifully serpentine walls of Antibes at who knows what an hour—Mr. Corsican somewhat shattered I imagine, assistant Corsicans in following car rush to his assistance, and Miss B, to whom a voice said 'this is the time to depart,' trotted quietly away down a handy narrow lane expecting a shot in the back somewhat, but thinking flight the best idea . . . and so back to the night club, I suppose I needed another drink and moral support . . . and so home to my charming attic in the divine empty 18th century house on the Cours Massena or covered market. Henri Langlois and his Indo-Chinese chum (whom you will see in Cocteau's *Orphée*) called on me next morning to go out for le petit dejeuner and were rather astonished to find me covered with dried blood on forehead and back of scalp and knees and quietly turning black in various parts, especially the left ribs at the back and developing a gorgeous black eye . . . you may imagine all this caused quite a little sensation. Picasso (he lives three miles from Cannes and I've seen quite a bit of him, all very good for business as he is making a sixty-minute movie with Kodachrome which I and not the Museum sent him from New York) thinks the whole thing (the original police affair and the Corsican gangsters) is a deep political (municipal) plot . . . and who knows? The charming doctor whom I saw a few times named me *la dernière blesé du festival du film*. I think I was a bit stunned and maybe concussed: the doctor said *'les attaches du foie'* had been torn and certainly my left side is even now a bit tiresome but I'm okay and what are a few ligaments and a bruised liver in contrast to life! They wanted to put leeches on me![10]

Iris continued that

next, I departed by sea for St. Tropez, with French chaps, and had a marvelous ten days on this yacht in port, looking at little farms for sale, walking many miles every day and living on the yacht . . . am still living on the same yacht [with Kerroux] back in the port in Cannes, more or less settled down: it's already colder but except for sudden squalls and showers the weather is divine and I can sit in the sun on deck and write . . . am awaiting the rest of my luggage from Paris and hope to do the movie book right fast. Frankly all I wanted after the automobile affair and the police bothers was to rest . . . and this I've had. Life aboard is new to me and seems very agreeable.[11]

Regarding her relationship with the Museum, she told Schiddel,

I have finally written the MMA, explaining (I hope) my delay in return-
ing, exaggerating my feeble condition due (a) to car smash and (b) another
medical problem which Kulka brought up before I left and (c) the cheap-
ness and excellence of the doctors here and the fact that one specialist can,
he thinks, give me treatments which will obviate the need for an operation,
which frankly I refuse to have.[12]

I haven't quite finished this letter to Rene [d'Harnoncourt, the new direc-
tor of the Museum], but am telling you what, officially, the story is so that
you will please say the same if you run into big shots or gossips. The trick
is, of course, how long the MMA will keep me on salary and how generous
they'll be if they kick me out. I intend to wait and see, as every month is
so much to the good as, now I am settled, I can live here very luxuriously
for less than $3 a day (cigarettes are 6 cents, a bottle of wine 40 cents, a
dozen larks—yes, we had larks for dinner on board the yacht last night at
St. Tropez, I am the cook and have developed amazingly—are $1, and we fed
three . . . for sums I blush to mention and ate like kings. Of course there is
the temptation to go to bars and restaurants sometimes. One blushes to pay
$4 for dinner for three with five bottles of wine! Perhaps my present set up is
too good to last: I'm really awfully happy and busy and so glad to be out of
the MMA you can't imagine. Frankly, as I told you before I left, I very much
doubt if I shall ever return. This does, however, pose certain questions. They
are problems which only you can solve. There is no hurry because I shan't,
if I do decide to stay here, buy a cottage until January or so. But please, I'd
like to put the problems to you.[13]

In any case, should she not return, Iris asked if Schiddel would handle
"the removal my affairs" in New York. She hoped she might be able to sell
the contents of her apartment at auction and use the money to pay the freight
on anything she chose to keep. Schiddel agreed, and ultimately dealt with the
loose ends Iris again left behind.

Among other unfinished business before her departure, Iris had been
consulting two psychiatrists, first an "émigré jewess," the second "a man and
a Frenchman and much more worldly." Iris seemed to shock and annoy the
woman, "herself not very prosperous," by confessing to her a "sense of disap-
pointment" that her father had not "left me a fortune or bought me a hat,"
and instead left her "chiefly with a vision of a miniature scarlet British letter

box into which small silver coins dropped with a reassuring tinkle" and "a desire for money without much hope for it." This analyst "didn't understand the references but said so truly that it was astonishing that I had done so well professionally and so badly sentimentally—emotionally—so true." The second analyst, she recalled, said that she should "choose now to continue with me next autumn or go to Europe for the summer. Which I did and never went back."[14] Iris referred to her analysis as "incomplete."

It seems significant that even Iris herself viewed her relationship with her father, whom she said she hated, as a key to her psychological development. She had written respectfully of dream analysis in her ghostwritten 1932 text, *The Scientific Dream Book*. There she wrote of a dream image of the father: "If you dream of your father . . . you are undoubtedly concerned with the root problems of your whole life. There was a time when your father signified all that was powerful to you. If you are a well-adjusted person, he will no longer be a figure that oppresses you or fills you with fear or dislike. But the mere fact that you dream of him at all suggests this is hardly the case. . . . The father figure also stands, to some extent, for the opposite sex in general, if the dreamer is a woman."[15]

For Iris the image of her father's aggression, the vision of being violated by him in the curious recollection of forcing coins into her miniature letter box, left her puzzled. Her therapists did not explore this image, but had they done so, perhaps Iris might have gained a clearer understanding of the puzzle of how she had achieved so much professionally while often failing in matters of sentiment. Assuming they were orthodox Freudians, the industry standard at the time, they might have surmised that a deep desire for communication with her absent father led Iris to seek intimacy with men, while at the same time expecting it might take the form of violation. Possibly this made male prowess both alluring and intimidating to her, and she transferred these ambivalent feelings to men in her life. Each of them, Lewis, Porter, Abbott, and even Kerroux, had auras of success about them. They promised entrée into masculine worlds Iris sought to enter. When there she succeeded admirably, but eventually became disappointed. She broke barrier after professional barrier over a thirty-year period, yet harbored a persistent desire to leave the world of culture and return to her rural roots. She had farmed enthusiastically at Temora, and as she neared her final days in New York she may have sensed possibilities in France with Kerroux as a man with skills to survive in a rural setting.

Thinking about Iris's relationship to her mother, furthermore, might cast additional light on one of the enigmas of Iris Barry, namely her relationship

with her children. Clearly, Iris was not indifferent to them. She worried from long distances and often tried her best to see to their welfare. Neither child was overly fond of her, but both respected her accomplishments. Nuclear families were not common in Bohemia; Lewis, Pound, and others Iris had admired routinely farmed out their children. But more important than these men and their parental practices may have been the fact that Iris's own mother passed on her maternal responsibilities to Iris's grandmother, a practice Iris was to repeat with her own children. Acie Crump was a liberationist in her own way, taking early to the bicycle and automobile as vehicles of modernity, and going into business for herself as a fortune-teller. Acie took her grandson Robin in tow when the need presented itself, but she went along with Iris's disguise as someone other than the children's mother. Iris's relationship to her mother probably found its way into her own parenting, while the lingering impact of an absent and reviled father may have affected her relationship to men. Iris herself very likely reflected on these possibilities, given her familiarity with psychoanalytic theory and practice. But as she herself noted and her future relationships with Kerroux and her children seem to confirm, her analysis indeed was "incomplete."

Edmund Schiddel was not the only correspondent who learned of Iris's discontent with the Museum. Near the end of her tenure at MoMA she wrote to her old friend from the Askews, John Houseman, producer of Nicholas Ray's first film, *They Live by Night* (1948), which Iris had premiered at the Museum: "Oh, hell! It's so bitchy and narrow at the M.O.M.A these days! How sycophantic, how tactful, how patient can one be?" Houseman interpreted this to mean that "the wild and whirling days of the birth of the Film Department appeared to be over."[16]

And so they were. For a few weeks Iris and Kerroux hung around Cannes, ostensibly working with Picasso on his film. According to Iris's daughter Maisie, Iris said of this adventure: "Picasso was there with a Spanish assistant and he was rattling away and was annoyed that Iris was past fifty and he wanted a younger assistant. Each day they would sit on the yacht and play back the day's film and Picasso really wasn't listening. He ignored her advice as it would be translated into Spanish by his assistant. She meanwhile had taken a fancy to Pierre. So one morning they both walked off the yacht and said good-bye. She packed her bags and walked off with Pierre."[17]

Iris went with Kerroux to look for a country house to buy. She told Schiddel she trusted Kerroux's judgment because he had once managed an antiques shop in Antibes, "so that I've been able to learn a lot about the price of furniture etc.

Also his father is in the wine and grain and fertilizer business, so they know the countryside backwards, values of land, houses etc. I explain in order to assure you I am not without a practical view of things. . . . Obviously I've got to be awfully sharp as, once there is no more salary from MMA, every franc counts and it will be all the rest of my life to pay for."[18]

It is likely that Iris had saved a good deal of the $4,000 Nelson Rockefeller had given her, because on November 27, 1950, she bought La Bonne Font, an old farmhouse with acreage in nearby Fayence, and on December 6 she bought a car.[19] On the same day she finished her letter of resignation to the Museum and the following day mailed it. In a separate letter to her landlord she gave up her New York apartment.

Her decision had been made.

Iris's resignation letter was addressed to the new director of the Museum, Rene d'Harnoncourt, with whom she was on agreeable terms. As the Museum's first professional director since Barr's demotion in 1943, d'Harnoncourt, a large man known by many as the "gentle giant," was not confrontational. Margaret Barr recalled that "Iris did not fear any loss of autonomy because she got along famously with d'Harnoncourt—he could speak her language very well and he never opposed anyone on the staff of the Museum. That was not his way."[20] Although she had no reason to fear being let go, Iris felt she had to justify the passage of so much time since she last checked in with the Museum:

La Bonne Font
Fayence, Var,
France
December 6, 1950

Dear Rene:

I have tried to write before but unsuccessfully. Normally, of course, I should have been on my way back before this: but I have not been well and so I kept waiting to write in case things began to look different. . . . The first part of this trip was most successful. A number of films have already left Paris for New York. Above all I was tremendously lucky that I was able to be with Picasso at Valloris when he was working on the first part of the film he is making—it will be an hour long and consists of a sort of poetic expose of his ideas. I am fairly sure we can get it for the Museum for non-commercial use and I am positive that the very fact he is himself making an original film is something in art history and film history.

Then she turned to the business at hand, in which the encounter with the Corsicans becomes an "automobile accident":

> But personally and subsequently I have had bad luck. You know I was exhausted
> when I left after that incredibly strenuous August. The very nasty automobile accident
> I had at the end of September really shattered me—not so much at first as later. It
> seems silly to go into details but I imagine they'll want to know—briefly, I had quite
> a bit of concussion and two horrid head wounds, but it was apparently the liver, of
> all things, which suffered most as the ligaments that hold it in place were torn, if I
> understand correctly 'les attaches du foie'. Anyway it took ages to become more or less
> normal and I can only just begin to read and write again.
>
> This I hope will in part explain my long silence. I must say, however, too that I have
> had virtually no word from 11 W 53rd St. either except the money for the films which
> Ione [the Museum's treasurer] so kindly sent. I was quite broke as I had had to give
> money to Picasso's young and quite wonderful cameraman and assistant as neither of
> them had a cent . . . and it did seem worthwhile.
>
> Now comes the difficult part. Rene, I am really awfully tired and after trying to feel
> differently for weeks, I just think I won't come back at all. It is perhaps time because I
> simply cannot face television and that awful Harry Brandt and the burden of trying to
> run the office properly and also cope with the money raising thing and those awful men
> like Eric Johnston.[21]
>
> I can hardly make myself write this because I am afraid people at the Museum will
> think me ungrateful and irresponsible, although after eighteen years it is evidently
> hardly the case. Simply I am tired to death. And alas not very young anymore. Please
> try to understand and make my decision understood.
>
> The nightmare aspect of the whole thing is that I have a haunting idea that perhaps
> I am not eligible for an annuity and pension until April 1, 1951. This is absolutely grim.
> What on earth shall I do if this is true? Do you think perhaps the Museum might be
> very generous and not actually dismiss me until April 1? It is not very long and . . . if
> not I shall be in rather an awful plight. Will you let me know . . . what my status is?
> Will you write me, too, how you yourself see the situation?
>
> I write with difficulty: I hope it is at least clear. It would be impossible to say what it
> costs me to say all this.
>
> The address I give is in the country, where I hope I can manage to settle awhile
> and try to recover my lost energy in part and finish the movie book which is alas now
> overdue. It is wonderfully quiet and people seem friendly. I sleep better here than on the
> cote d'azur where I was most of the time until now, getting over my misadventures and
> staying with friends on a yacht, part of the time in St. Tropez and later at Cannes.

The postman doesn't even come regularly let alone ring, which may explain why I have no mail. However, American Express, Cannes, now works equally well as they really do forward mail. The address in Paris is worse than useless.

I can't bear to think that I may never see my office again or all of you . . . but do please try to understand. I shall be frightfully grateful for a word from you soon.[22]

Rene d'Harnoncourt moved to help Iris. On December 15 he replied:

Dear Iris,

This is a note in a great hurry. You can imagine how worried I was about your letter, particularly because I have a hunch that what you say in it is not all there is to say. I just talked to Nelson and got his permission to make you the following suggestion:

The Museum will give you leave-of-absence for six months on a salary corresponding to your pension. This would mean that there would be no loss for you at all and it would give us all time to think things over.

Please believe me that if there is anything I can do to help you, I will do so. So write me again in more detail.

Devotedly,
Rene[23]

Schiddel dutifully handled Iris's New York affairs and saw to the disposition of her effects. They drew a total of $221.46 at auction at Kaliski and Gebay Company. For better or worse, Iris was gone. She had once emigrated from England to America, but now sought to spend the rest of her life in France.

The farmhouse in Fayence (1951).

36

LA BONNE FONT

RAWN AGAIN TO her rural beginnings, Iris settled on a farm, but not one as well-appointed as Temora had been in Pennsylvania. "Try to imagine" she wrote Edmund Schiddel shortly after she bought La Bonne Font,[1] "living in a semi-ruined farmhouse with no light, no plumbing and almost no nothing (you've done it!) in a sudden snap of cold and rain. All the time goes in fetching water from the brook and dragging in wood to try to cook and wash, and hauling out pails. I said no plumbing and I meant it, there is a handy pigsty but when it is not raining there are many merry masons putting in window lintels and mixing cement, etc. all very gay and they sing and chatter like crazy."[2]

The house, she continued, "is at the foot of a wholly impossible precipitous lane that even ox-carts can't traverse . . . there are lots of olive trees and three ruined houses and hundreds of fig trees and a vast walled 'basin' of water big enough to swim in though now choked with bulrushes . . . wild boar, they say: a sweet little river: brambles and neglected land. About five rooms, three fireplaces, lots of cupboards, floors all red tile A sweet house really. Carpenters and the postman and odd dogs pop up and peasants bearing mysterious bundles or heaps of olive branches pass on their way to the old walled town where there is one hotel with neon lights and arctic bedrooms."[3]

The house was in Fayence, the tiny hillside hamlet above Cannes noted for its pottery. Here Iris would settle with Pierre Kerroux, whom she described to Schiddel as "a chap of course, French, the captain of the yacht I was on. Ex soldier sailor antique-dealer etc. etc., very very handy, paints window frames and washes linen and drives a car and is also gay and amusing and about as gypsy as I am—hard to describe or convey: I suppose we are going to farm seriously in the small intensive way they do it here. Certainly I myself am here to stay whatever happens."[4]

Privately Iris felt she had been mistreated by the Museum. "The Museum," she wrote Schiddel, was "without any generosity whatsoever (they stopped my salary as of Dec. 31st but gave me 'leave of absence' for six months." She declared that the Museum was "now a part of my past."[5] To her the separation was at least mutual, although at that time she had no idea how long her relationship with the Museum would last.

As winter turned to spring Iris's living conditions improved somewhat. The house was made habitable by Kerroux and his workers and there was some expectation of success in farming. "We have already had the land ploughed and harrowed," she wrote Schiddel in March,

> by a sweet horse of immense proportions called Bijou and have planted 500 pounds of mint rootlets . . . 25 trees . . . 5 hotbeds full of sage . . . a camellia at the door . . . an aged person very Thomas Hardy clips away at the olive trees (over a hundred and I <u>hope</u> they give oil, which has 'gone up') and the fig trees (also over 100 and what shall we do with the figs?) and is laying low a fine stand of canes quite 10 ft. high—is it a canebrake or is that sugar? (These are for fishing and such). . . .
>
> Tomorrow we go to Cannes to get me I hope a *permis de sejour*, lacking which my things are <u>still</u> stuck in customs at Marseilles, and to sell a boat and go to the coiffeur and buy plates and things and meet Henri Langlois and generally return for two or three days to civilization. . . .
>
> The Museum is being very mysterious about me and won't admit I've gone for good: perhaps I can use this and have them appoint me director emeritus and representative at large in Europe. The Federation of Film Archives is also thinking of making me executive secretary <u>with</u> salary (tiny, but still . . .). On verra.[6]

The following month relationships remained "mysterious" with her former employer. "Lord the poor Museum," she wrote Schiddel, "(you were so right, it <u>was</u> time to go) it is so baffled still. Why did she go? The awful accountant lady says they think there is a man in my life. Really! What do they suppose I was doing up to now? They cannot believe, evidently, that I walked out."[7]

Iris's departure from New York may have been a mystery to her staff, but once she began to settle in Fayence, she did what she could to rekindle her connection to the Museum. In a letter appealing to d'Harnoncourt she asked to become an official representative of the Museum: "I learn today that I am almost certainly about to be offered the post of Executive Secretary of the Federation

of Film Archives with a minuscule salary but also expenses if and when I travel for them. This pleases and flatters me, as I do not want to lose contact . . . moreover it is understood that I really am in semi-retirement and live here and not in Paris. This means of course that once more I shall be attending the Film Festival at Cannes this April and we shall probably hold a meeting of the FIAF at that time. I hope I can get the MMA some extra-special films there also."

She informed d'Harnoncourt of

an idea that popped into my head but—since most flatteringly and touchingly I gathered that you and the MMA were a little sorry to see me go—is it at all possible that you might give me some sort of title, such as director emeritus or thereabouts, and leave me somehow very loosely attached to the Museum—I don't quite see how, but perhaps you will? Obviously I suppose without salary. But there is no doubt that I could be useful to you filmwise, not only in France but in all extra-American and even in American relationships: and if it were desired, of course, in non-film things too. Remember I am only 15 miles from Picasso and Leger and Chagall, and overnight from Paris, and by air from Nice a couple of hours from everywhere. . . .

Dear Rene as I told you I am tired, my goodness I have had a job since the end of World War I, and it was time I relaxed a bit while I can still totter around. But I am not done for: and I see it is inevitable that I go on somehow or other with movies, not to mention the movie book which will get finished eventually. Meanwhile, dear Rene, farewell and all my thoughts and thanks. Let me know if you think this idea of a loose attachment to the MMA is feasible. It would obviously both please and help me enormously.[8]

In reply, d'Harnoncourt told Iris that he was "naturally delighted by the idea of keeping some kind of a relationship between you and the Museum alive and will take the matter up next week when I have a meeting with Nelson."[9]

Rockefeller apparently approved. By April 1951 the Museum had arranged a pension for Iris, affording her the amount of $73.54 per month for life.[10] In return, she wrote Schiddel, the Museum expected her to become "their European representative," an arrangement she found "very good if vague." Meanwhile at the Museum, in Iris's absence the Film Library staff collectively filled in for her. In July of 1951 they decided to recognize the sixtieth anniversary of Edison's invention of the motion picture camera by recycling many of the chestnuts in Iris's collection. Although the *New York Times* welcomed the programs as "a generous lot of good entertainment (as well as good

instruction),"[11] anyone familiar with the programming of the Film Library would have noticed the repetitions.

In 1951 Iris was replaced as director by her assistant, Richard Griffith, who had worked on the *Why We Fight* series. Another film staff member, George Amberg, told Russell Lynes that "Iris was such a powerful personality that all he [Griffith] could do was continue what she had started." When d'Harnoncourt inquired if she would approve of Griffith's succeeding her, Iris did not reply.[12]

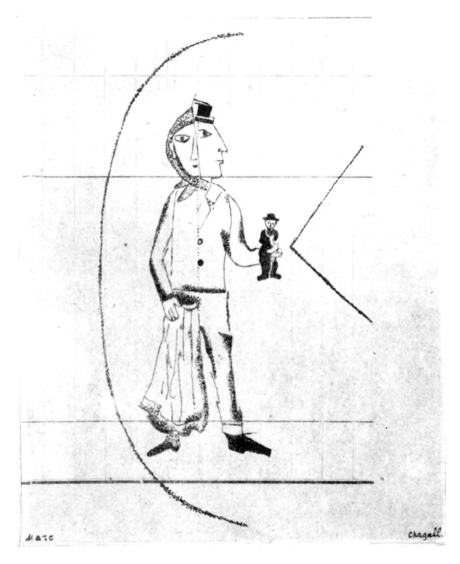

Marc Chagall, Untitled (Portrait of Iris Barry), undated.

37

THINGS PAST

IT SEEMS THAT no matter how far from her old environments Iris traveled, recollections of the past seemed to follow her. She was in Fayence when Dick Abbott died in a hotel in New York on the morning of February 5, 1952. He was buried in the Odd Fellows Cemetery in Milford, Delaware on February 9, 1952, his forty-fourth birthday.[1] Iris was notified of Abbott's death via cable from his brother Charles. The notice came at the same time she heard from her son about her mother's death. The line of support between Abbott and her mother ended with both their deaths.

Iris wrote Charles from La Bonne Font:

> I was grieved beyond words to get your cable and grateful to you for sending it. The Askews have written since, but do not seem to have any very precise information: yet I was touched and pleased, too, really, that they spoke so feelingly and affectionately of Dick and seemed themselves to be truly shocked and sad at this tragic end to his life. I don't know whether I quite believe the news myself: for he had seemed in his own rather reckless way so very full of spirits and confidence when I last saw him, which was several times during the last year I was in New York and particularly the spring and summer of 1950. When you do have time, you know I shall be glad and in a way almost relieved to know exactly what happened, what sort of accident, as one imagines all sorts of things. . . .
>
> Now I am asking myself, which is fruitless but can't be helped, whether I was somehow more to blame for the turn which his life took than usually I had thought until now. . . . I just now had the news that my Mother died suddenly yesterday, and so there is no cause for anxiety as to how financially the situation might affect her. This is a relief to me, naturally, and I am glad to think that at least for the last years of her life she had the security and comfort of that allowance, which meant so much

to her and of course to me, too. Dick was wonderfully good about seeing that she got it
regularly. And indeed it was that which permitted me finally to follow my own strong
desire to leave the Museum and all the heartburning and fret that working for it
made possible to cut loose. Of course I had never dreamed that she would outlive
Dick, even by so little.

I am not going over to England for the funeral, because I cannot afford to do so: I
mean I don't have the fare, not that I wouldn't spend it if I had. But all the necessary
arrangements are being made and, since it is out of my hands, I am glad not to have to
face that too at this moment.[2]

Iris was living quietly in Fayence and growing poorer. She and Pierre made
a number of attempts to wrest a living out of their acreage at La Bonne Font.
In January of 1952 she wrote to John Widdicombe, an American scholar she had
known since the 1920s, that "Pierre is now planting 5,000 rose bushes for per-
fume in 1953. I mean they will not yield until then. Much mud, even snow, very
cold, and we had a difficult if amusing moment around Christmas as there was
no money. We were partly saved by CARE parcels again, thank god, sent by the
strangest people whom I really hardly know, and we also sold a ton of firewood
and a duck so all turned out well in the end. Goodness, what a life."[3]

Marc Chagall lived near Iris in Provence and may have sketched her during
one of their occasional meetings. His drawing astutely captures the two worlds
Iris inhabited: the masculine one of big-city culture in which she excelled in
her profession (holding up a doll-like Charlie Chaplin) and the rural envi-
ronment she was determined to reenter. She committed her resources to La
Bonne Font and decided to make the best of her new life. In July she wrote
Schiddel of her "excitement today as the sweet corn proves to be already ripe,
the first lot of it, so we are going to settle down for a gorge at midday. . . . It is
intolerably hot, I was bitten by a cat, the roses-for-perfume seem to be coming
along, hundred of little asparagus ferns are finally sprouting where we planted
them at Easter. . . .

"We had quite a lot of visitors and expect more—Chick Austin was here
among others, which was extraordinarily nice and we did quite a lot of sightsee-
ing in the neighborhood."[4] She asked if Schiddel knew "anyone who would like
to be a baron, by the way, and it is always nice to be a baron don't you think?
There is a nice castle for sale fairly near here—13th century with every kind of
central courtyard, vaulted this and arched that, turrets and so forth and woods
galore, lots of land, built by Templars and all that: it is true it is $15,000 but still
one could hardly expect to be a baron for less."[5]

Iris mentioned other properties for sale, but concluded that her "favorite is a divine house in Fayence, one I hadn't seen before, really four pleasant apartments one above another with a separate spiral staircase, a truly nice house and in good condition with even electricity and water put in though it is itself of course quite old—for $1,000. We are trying to find someone to buy it and let us have the downstairs part for an antique shop, but I don't suppose it will work."[6] However, this arrangement did work. Chick Austin, Iris's friend from the Askew salon, bought the house in 1954. The property was to become a major preoccupation in Barry's later years. Meanwhile, there was work to be done on La Bonne Font, and an unexpected encounter with her past life in America to be resolved.

Although preoccupied with attempting to make La Bonne Font a source of self-sufficiency, Iris retained many of her professional contacts. In December of 1953 she wrote Edmund Schiddel that she had recently attended a meeting of film archivists in nearby Vence, an event which she "enjoyed immensely, it was fun seeing old colleagues from all over, including Poland etc. and eating royally and not having to do chores. . . . Pierre was invited too and acquitted himself nobly with local politicians—whom he was the only one present to know personally—and visiting Japanese and Jugoslavian delegates and weird French bourgeois persons with sumptuous chateaux, whose wives or rather one of whose wives wore a *decolleté* crimson velvet dress much covered with *paillettes* when receiving for lunch! Quite a change from life at La Bonne Font, as you can imagine."[7]

Otherwise, she reported, "we had fewer visitors this year, partly because of the August strikes: some odd people turned up: [Alexander] Calder is now in the offing: we quarreled rather viciously with my son . . . : my daughter has had another child named oddly I think, Jason: I hear almost nothing from the USA except occasionally from people I hardly know, though Mrs. Askew sends the *New Yorker* regularly and I get now the Paris edition of the *Herald Tribune* daily and thus have some idea of what goes on."[8]

Iris was about to hear from the USA. She was to have her own personal bout with McCarthyism.

James Card, curator at George Eastman House in Rochester, New York, and a self-proclaimed cold warrior, viewed the International Federation of Film Archives (FIAF), the archivist group Iris had cofounded and met with in Vence, as a Communist enclave and "strongly politicized"[9] during the 1950s. Card offered as proof the fact that its director at the time was Jerzy Toeplitz, whom Card claimed was kept in office by a Soviet-controlled Henri Langlois in order

to make it easier for the Soviet Union to join FIAF (the USSR was not yet a member), therefore making available to other archives the extensive holdings of the Russian archive. Toeplitz, head of the film school at Lodz (alma mater of such respected filmmakers as Jerzy Skolimowski, Roman Polanski, and Andrej Wajda), was viewed by Card as a "slick parliamentarian who knew all the tricks to keep a formal meeting going the way he wanted it to proceed" (122).

Sent on a tour of European film archives in 1953 by Gen. Oscar Solbert, a former military intelligence officer and head of Eastman House, Card took it as his mission to "meddle in the political structure of FIAF." Card recalled that his "assignment was a role I relished as an amateur meddler in the murky area of international skullduggery. As a result, some Europeans viewed me as a clumsy McCarthy operator or, even worse, as an incompetent CIA operator" (122). Small wonder, then, that Card was probably disliked by Iris, whom Card remembered as disrupting his screening of King Vidor's *The Crowd* at Vence—a film he claims to have been rejected by Iris in her preservation efforts and salvaged by none other than himself. Card tried to project a 16mm print of the film before a distinguished crowd in the Colombe d'Or restaurant, the meeting of archivists Iris attended. In the audience were the stage designer Gordon Craig, the painter Marc Chagall, filmmakers Lotte Eisner and Nelly Kaplan, and other notables. As the first scene hit the screen in the darkened restaurant, Card says, "Iris shouted out, paraphrasing the famous Nazi storm trooper's comment, 'When I see art, I reach for my revolver!'" Shortly thereafter, "the projector went up in smoke" (125).

It is unclear whether Card named Iris to the State Department as a Communist. Others may have been involved, and the U.S. Government, even in Freedom of Information Act releases, does not name its informants. But Card would be a fit for the shadowy and putatively "unreliable" State Department informant mentioned below as "T-2".

In the summer of 1953, Iris applied for a passport in Nice. She was issued a passport on August 28. Perhaps as a routine inquiry following such applications, a security clearance request made its way through the offices of the U.S. Department of State. It resulted in a curious snag. A March 1, 1954, State Department memorandum, at first confidential but declassified and released through the Freedom of Information Act in 1995, reveals that "The Department is in receipt of information to the effect that MRS. ABBOTT is suspected of being a Communist or a Communist sympathizer." The memo went on to instruct the American Embassy in Paris to interview Iris "in view of obtaining

her views and sympathies toward Communism."[10] An affidavit was to be forwarded to the Department of State in Washington.

What aroused the suspicions of the State Department appears to be contained in a report from the New York FBI office dated August 6, 1953:

In September 1941, T-2 whose reliability is unknown but who is acquainted with the subject advised that virtually everyone affiliated with the Museum of Modern Art Film Library, a Rockefeller Foundation project, was either a Communist Party member or at least strongly communistic in sympathy. T-2 stated further that this project was directed by Iris Barry and that for some time her first assistant was one Jay Leyda. This informant went on to say that in approximately 1940 Leyda allegedly attended a Moscow Propaganda School according to an article published in *The New Leader*, a periodical described by T-2 as 'Socialist'.[11]

It is to be noted that T-3, of known reliability, advised on July 28, 1943 that Jay Leyda, in July 1943, transferred from the New York Section C to the Northwest Section, Branch A of the Los Angeles County Communist Party after having been okayed by the organizational Secretary of the Communist Party in New York. [Leyda was the film scholar and former Eisenstein assistant Iris hired and then let go due to right-wing pressure.]

On December 14, 1944, T-4, of known reliability, advised that the name of Iris Barry, Museum of Modern Art, 53rd Street, New York City, was contained in the personal notebook of George Henri Anton Ivens. [George Henry Anton is the name of Joris Ivens, the pioneering Dutch documentary filmmaker.]

It is to be noted that T-5, of known reliability, advised on March 3, 1943 that George Henri Anton Ivens was known to this informant in Berlin and Moscow as a Communist.

In the winter of 1948, T-5, of known reliability, advised that Iris Barry received a check dated July 29, 1947 for $120.00 drawn on the account of John Grierson.

It is to be noted that this foregoing information is not to be made public except in the usual proceedings following the issuance of a subpoena.

In May 1947, T-7, of known reliability, advised that during the time that John Grierson was Commissioner for the Canadian National Film Board he was a known associate of Communist Party members and Communist Party sympathizers.

Mr. Arthur Krows, Aero Digest, 515 Madison Avenue, New York City, residence 14 Euclid Place, Hastings on the Hudson, New York was interviewed in April 1950, concerning another matter. Mr. Krows advised that he considered Iris Barry, Film Curator, Museum of Modern Art a Communist because of her conversation and the fact that she associated with and hired Helen Van Dongen whom Mr. Krows heard admit to being a Communist. Mr. Krows stated too that Helen Van Dongen was the wife of George Henri Anton Ivens.[12]

This document, obviously a tissue of flimsy accusations, concludes with a caution that Iris may have been tainted by coming into contact with representatives of Sovexportfilm at a FIAF conference at The Hague in November of 1952. It ends with the reassuring notation that

The following Confidential Informants who are familiar with the Communist Party and Communist Party Front Groups in the New York area advised on the dates indicated that they did not know the subject:
T-8 and T-9 contacted on July 3, 1953.
T-10 and T-11 contacted on July 6, 1953.
T-12 and T-14 contacted on July 7, 1953.

The report then proves its own thoroughness by noting that "The files of the New York City Police Department contain no reference identifiable with the subject."[13]

A Foreign Service Dispatch from the American Consulate in Marseilles, dated May 21, 1954, reported to the Department of State in Washington about the affidavit requested from Iris. American Consul J. Roland Jacobs related that Iris had replied "promptly" to her summons and appeared, as promised, on the day of his report and

seemed sincere in her protests against the intimation of being a Communist or a Communist sympathizer. At one point in the interview she said she could not object to Russians being Communists, but that she would never like to live under such a regime. She wondered whether the charge against her came from somebody acquainted with the fact that she had visited Russia. She said that trip had been in line with her job as a journalist and had nothing to do with personal sympathies.

She volunteered the information that the community where she lives contains a proportionately large number of Communists and that she, per force, associates with towns-people who have traditionally leaned far left in their political views, read only Communist newspapers, and talk Communism among themselves all the time. She alleged that she has on occasions been treated by them as a 'capitalist propaganda agent', but said that her only capitalist political pamphlet had been the Sears Roebuck catalogue, which her village friends wag their heads at.

As related in her affidavit, Mrs. Abbott claims to have been director of the Museum of Modern Art in New York City and takes credit for building the film library there. She said her work in this field had brought her into the French Legion of Honor, and displayed on her lapel the ribbon-insignia of that distinction. She also alleges to have been connected with the New York *Herald Tribune.*

The opportunity was taken to request Mrs. Abbott to apply for registration as an American citizen residing in this consular district.

In view of the Department's communication under reference, however, the application is submitted to the Department for approval.[14]

The "Department" replied on October 1, 1954, that Iris's application for registration as an American citizen was approved, but that the Marseilles Consulate was thereby "requested to report to this Department any information that may come to your attention concerning the activities of Mrs. Abbott during her residence in your consular district."[15] Iris was free, but not above suspicion.

She declared to the American Consul:

My name is Iris Sylvia Abbott, but I am known professionally as Iris Barry.

All the time I worked at the Museum of Modern Art in New York City, and also as a journalist with the *Daily Mail* in London and the *Herald Tribune* in New York, I was known as Iris Barry.

I was born in Birmingham, England, on March 25, 1895 and was naturalized an American citizen in New York in about 1941. I have resided in the United States for some twenty years, but no longer maintain a residence there.

I now reside in Fayence (Var), France, where I own a small farm.

I solemnly declare that I am not and never have been a member of the Communist Party in any country.

I do not and have never sympathized with the Communist ideology. I fully recognize that I would find it impossible to live under their system of government.

It makes me very angry to think that anyone could charge me with membership in the Communist party or with sympathies for their ideas or objectives.[16]

Aside from ignorance of Iris's extraordinary service to the war effort, the summons to the Consulate only added insult to injury, coming as it did on the heels of another medical emergency. In March of 1954 Iris suffered an abdominal problem that landed her in the Clinique Notre Dame in Draguignan. On the 16th she wrote to Edmund Schiddel, "here am I, after being rushed up through the night and storm most dramatically, getting over a sudden and rather considerable butchery. Most annoying, not to say ruinous. . . . I am apparently recovering rather well and have had all that modern life could afford in the form of drugs and injections, transfusions, etc. French nurses are infinitely more individualistic and gracious than American ones. The surgeon tries to talk English to me, which creates considerable confusion! . . . I really don't know whether I'm more glad or sorry that everything turned out well. Of course I'm enchanted to be alive and kicking, but the alternative is, after all, a simplification."[17] Iris later explained to Charles Abbott that this episode had been a "catastrophic business with my spleen having to be cut out in the middle of a dark stormy night miles and miles away."[18]

She also reported to Schiddel that Pierre was "earning money by work on Chick Austin's house that he bought in Fayence, and we are also earning a bit with vegetables and things . . . one cheers up so easily, really." Iris closed by saying that she had gone to Marseilles "last week, the local doctor goes there every Friday to take a radiology course and he and his wife drove me in. It was as the result of a request from the American consulate to present myself there. WHAT do you think it was for? My dear Edmund one reads about such things in the papers. It was to investigate me! Some nice kind person had informed the State Department that I was probably a communist, if not a member of the party then a 'sympathiser'. I must say I was pretty angry but happily managed to appear calm and the Consul seemed to be nice (I don't think it was an act to trap one though of course one never knows). And if I <u>had</u> been a commy, what could they do about it? Really, words fail me . . . dragging a convalescent and we might even say respectable elderly woman on a

THINGS PAST • 377

six-hour automobile trip for such nonsense. I don't know if there is more to come of this, we shall see."[19]

The identity of T-2 remains a mystery. James Card? Terry Ramsaye? Iris had known many Communists. Her political sentiments lay somewhere within the U.S. Democratic Party of the time, however, and her wartime service to the allied cause rendered this episode especially absurd.

38

THE AUSTIN HOUSE

THE HOUSE IN Fayence Iris and Pierre admired for its four stories of apartments with connecting spiral staircase and ideal space at street level for an antiques shop became Chick Austin's in late 1954. It is located just under the Mariee, the police station and civic offices spanning the entrance to the heart of Fayence. The structure was built during the medieval period and renovated in the seventeenth century. It lacked central heating and needed extensive repairs. Austin bought the house and one across the street from it for $1,600.[1] Pierre offered to do the work while he and Iris continued to live at La Bonne Font.

In September Iris wrote Schiddel that Austin had been visiting, "mad goings on about his house in Fayence, painter and plumbers, already a Frigidaire and a superb bathroom and so forth, buying lots of furniture, naturally antiques, so we whip around with him a lot sometimes in our dear old car for picking up things and sometimes in his dazzling Mercedes: as he said the other evening as we switched from one car to the other, 'from Mercedes to ox-cart in two seconds.' It is of course marvelous for us as Pierre is sort of the foreman of works and paid daily which has made quite a difference to us already and the job may pay well into and through the winter after Chick has gone five weeks from now, alas. And we shall probably spend the winter up there in comfort, which will be nice and indeed may even open a modest antiques shoppe there. We have lots of little things ourselves and we can sell any of the things Chick is so madly buying. Any profit we split with him, so you can see this is too ideal for words."[2]

The winter proved less than ideal. More work was needed on the Austin house and Chick invited other friends to move in. Iris reported to Schiddel that "In January we are going to begin seriously trying to sell this place [La Bonne Font]. It is much too big for us and we hope to cash in on various

'improvements' before it begins to disintegrate again, and look for something smaller, maybe nearer Nice. I was just offered a charming and amusing half-time job in Paris but the salary with my pitiful pension just isn't enough and I am not sure I <u>would</u> want to be there except for visits anyway. There is also a theory that NBC wants to hire me as an expert and advisor for films for television: a Museum of Modern Art project. Well, we shall see."[3]

In spring 1955, Iris had been "up to Paris every month for a week," she wrote Schiddel, on an assignment for the Cinémathèque Française. "Nature is very demanding at this time," she told him,

> all that to-do with planting and weeding: though I must say, at last, that our artichokes are behaving very nicely and yielding us a bit of income, which is just as well since my various schemes with NBC[4] and the Cinémathèque do indeed provide these outings to Paris but otherwise have brought nothing in. We are also trying to sell the house, the agent brings people. This entails somewhat more housework than otherwise I should deem essential. . . .
>
> The film festival in Cannes is now just beginning and we live in dread of what may come down the path, as people do seem to like to take a few hours off from the Cote d'Azur and come slumming into the country. I may even have to go to Cannes myself next week—that is, if money is sent for me to go there—as the Cinémathèque Française may want me to do a small chore for them. I can't say I want to go there much. I saw a lot of film people in Paris, was even warmly kissed by [Roberto] Rossellini (though not by [Ingrid] Bergman who was busy trying to look <u>incognita</u>) and romped quite a bit with Jean Renoir and Leslie Caron . . . and was even somewhat entangled by [Marc] Chagall. It all seemed remote. And I lost my Hermes gloves. This is a real blow as being the only visible daytime elegance I now possess. However, Bergman was even worse dressed than I, so what the hell?
>
> I also saw Rene d'Harnoncourt and other colleagues from the MMA, which was pleasant but remote, too. Rene wants to take a sabbatical when the various 25th Anniversary activities taper off and might even rent Chick Austin's house here in Fayence, which would be nice for all.
>
> Austin we expect in August. Pierre is about to resume work on his house. We did not open (did you know it was even mooted?) our small antique-junk shop. . . . However, we may have sold a lot of 18th century oil jars in Antibes.[5]

Iris and Pierre continued to live at La Bonne Font while Pierre renovated the Austin house. Iris was again called to Paris to work for the Cinémathèque

Française and to London for the BBC. The work she was asked to do "was a bit depressing," she wrote to Chick, "and also in London as it was mostly seeing old newsreels of 1914–18 in squalid or dreary surroundings. Of course if I get the dollars it will be very nice, but the BBC people are very difficult and I don't think I can go on. London of course was heavenly, so many old chums not to say old sweetie pies, so many flowers and bottles of whiskey sent and costly lunches and things—saw my tiresome funny son and his elegant girl friend several times and also my cute daughter and her husband, very odd. I also saw television as the NBC people had a set sent up to my sumptuous quarters at the Savoy: good God, can anything really be as bad as all that? It seems people <u>love</u> it. The 'old' movies are heaven in comparison. I hear, by the way, that most or many of the gems in the MMA's film library are being taken away and are to go on television—my successor [Richard Griffith] is very upset but kindly recalls that I predicted just that over five years ago. Ah, well."[6]

Iris closed by reassuring Chick that she and Pierre would soon be acquiring a new house of their own.

They never quite managed to find a house. Money problems persisted. Pierre joined Iris for ten days in Paris. "We felt it was really time for him to get 'out,'" she told Schiddel, "and he had—I think—a gorgeous time, seeing all sorts of picturesque chums, such as the celebrated fencing master, Lacaze, and old college pals who've made good and live in incredible circumstances on the Avenue Foch, and others even more picturesque . . . as we have some common friends, I mean friends in common, though I do note that most of <u>his</u> are gentlemen which is more than I can say for many of <u>mine</u>. We whirled about a lot including even with Brazilian embassy folks and such, while I was alternately in the squalor of the Cinémathèque Français or in film vaults, and then whizzing with [Josef von] Sternberg who was briefly here (and met [James] Thurber here for the first time!) and Janet Flanner and old Ester Murphy-Strachey-Arthur . . . and what interested me, really the most, the monstrously odd writer, [Jacques] Audiberti, of whom no one abroad seems to have heard though I should say he is perhaps the most picturesque and one of the most interesting French writers: oldish: weird: from Antibes."[7]

At the same time, the summer of 1955, Iris attempted to renew her passport and found that the charge that she was a Communist somehow persisted. Terms of renewal required her to travel to the United States, unless compelling business arrangements could be cited explaining why she could not, in which case renewal at Nice would be possible. As summer progressed, no such compelling business arrangement had been demonstrated and it appeared that Iris might

lose her passport. She wrote to Rene d'Harnoncourt at the Museum, who in turn, wrote to Nelson Rockefeller that Iris "seems to be in trouble."

"As you know," d'Harnoncourt wrote Rockefeller,

Iris is a naturalized U.S. citizen. She has lived in France ever since she left the Museum as the director of the Museum's Film Library and has done work for us there as the Museum's European Representative. A few weeks ago she wrote me that she had been told she should come to the states to attend to the extension of her passport. She was doing at that time some work for us and I wrote her a letter asking that she be allowed to attend to the renewal of her passport at the American consulate in Nice. The consulate advised her that she may have difficulties obtaining renewal and that charges had been brought against her of having been once either a Communist or a Communist sympathizer. I had heard of these charges before but knew that she had last year testified under oath (at the U.S. consulate in Marseilles) that these allegations were not true. I have known Iris for nearly 25 years and know of course that she had professional contacts with communist members of the film world but I cannot possibly see her as a Party member or Party liner. I always found her conspicuously lacking interest in the political aspects of things but can well imagine that her admiration of Charlie Chaplin or the work of the early Soviet filmmakers may have earned her the reputation of a Communist sympathizer. I also can imagine that she may have made some social comments that strengthened said impression.

I gather from her letter that August 28 is the deadline for her passport renewal and that she believes that there is a danger she may lose both passport and citizenship. One aspect of this problem that worries me considerably is that her prestige and her position as the President of the International Federation of Film Archives could be used by our enemies to turn any incident into another item of anti-American propaganda.

I can't tell you how reluctant I am to bring this problem to you but time is so short I could not even get the necessary data for action from here and I frankly don't know what to do.[8]

The Rockefeller Family Archives do not appear to contain a record of the action taken by Rockefeller, but there is a note to him from a John R. Kennedy on U.S. government stationary dated August 25, 1955:

Passport Director Frances Knight referred me to one of her assistants, Mr. Nicholas, who was handling the passport case of Iris Barry. He told me that some signed statements received from Miss Barry respecting the Communist angle satisfied the Passport Division. As a naturalized citizen she has to return to the United States to renew her passport unless she can show a substantial connection with an American concern and an adequate business reason for remaining in Europe.

On file in the Passport Division was a letter of June 14 to the American Embassy, Paris, from Rene d'Harnoncourt. This letter failed to stipulate Miss Barry's connection with the Museum of Modern Art.

I telephoned Miss Joyce Miller, secretary to Mr. d'Harnoncourt, and told her the type of statements needed by the Passport Division to permit Miss Barry to renew her passport at the American Consulate at Nice. Miss Miller stated that she would have Mr. d'Harnoncourt sign the required letter, dispatch it to me and I agreed to hand-carry it to Miss Knight. This is necessary inasmuch as August 28 is the deadline.

No action by you is necessary at this time: I will follow up on the matter.[9]

The passport was renewed and, having sold and left behind the farm at La Bonne Font, Iris and Pierre began a new phase of their lives, living in close quarters in the Austin house. With the sale of La Bonne Font they were leaving behind their hopes of living off the land. The Austin residence was a townhouse squarely placed at the entrance to downtown, where traffic flowed and people and shops were in close proximity. If Iris and Pierre were to survive, they would have to find new sources of income.

Under these circumstances Iris began a relationship of occupancy of the Austin property that would last until her death in 1969. At first it was not understood to be long-lasting. Iris kept reassuring Austin she and Pierre would buy a house of their own. She wrote of her "hope [that] we can get out now and see some properties or cottages or something: what we have already seen within the bracket possible were madly depressing."[10] She warned that "it seems we are to have a big inflationary thing shortly which doesn't help much or means that we ought to try to find something quick before my francs melt away like the marks of old. . . . But we don't know what we want or mean to do and that really adds to a total confusion. You can't possibly know how grateful and glad we are that we are able to be here. But I didn't want you to think that we were just quietly 'making use' of you. As long as there is the work to be done of course it is all

quite legit in a way but I feel a little embarrassed at times to think that you may fear you have guests who might eventually prove a nuisance."[11]

By Christmastime Iris and Pierre had acquired a "new ruin," which they were "busy as all get out" fixing up. Pierre, she told Chick, "leaves with his little gang at 8 each morning, whips back for lunch, off again until 6, so that I seem all the while to be cooking or preparing sandwiches . . . or washing work clothes."[12] She reported she was "involved also with Christmas preparations," and that she and Pierre "have stolen a small tree from the old railroad near the new ruin at La Banagon: so all in all we shall be as merry as we can, drink some Berry Bros. punch and listen to the lovely Telefunken."[13]

Iris and Pierre were adapting with some difficulty to their new surroundings. They were only a mile or so from their previous farm, but they were in town and living in an apartment made Pierre restless. They spent more and more time in the local bar, owned by Marius Rochemaure, where they "hit the tiles" with some regularity.[14] Iris was now between two worlds in Fayence. The first, like the rural home she once left for the city, recalled a tranquil life gone by. But in the claustrophobia of living with an unpredictable younger man in an apartment in town, she faced a more unsettling reality.

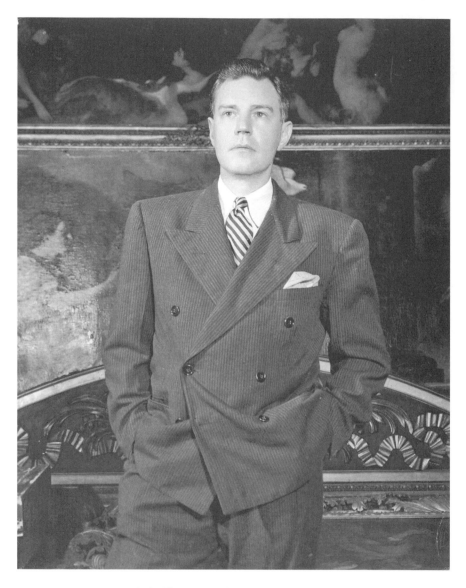

A. E. "Chick" Austin at the Ringling Museum in 1947

(Courtesy the Wadsworth Atheneum)

39

READJUSTMENTS

Aᴏ̄ FTER THE MOVE to town Iris and Pierre survived on her pension and a small income derived from his work fixing up old houses for possible sale. When these prospects dissipated, they turned to work Pierre had done before—selling antiques.

In January of 1957 Iris wrote Schiddel that they were

in the thick . . . of doing over yet another ruin, the third that Pierre has tackled. It is a small house outside Fayence, and very nicely placed but it really was just a shell. Pierre goes off pronto each morning at eight and comes back exhausted at six, whereupon we eat something and whip into bed around eight or eight-thirty—a dog's life, if you like, but a happy dog's.

We hope to be able to sell the [new] house and make a nice bit on it but if the worst comes to the worst we could perhaps and should live there and raise some inoffensive and edible rabbits and ducks and artichokes and so, one hopes, live out another storm. . . .

As this [the Austin] house is big and madly luxurious but virtually uninhabitable in winter, we live in a tiny kitchen on the second floor which can easily be heated by wood in an old cookstove, but of course I do spend lots of time hauling in wood and hauling out ashes and garbage and washing things and cooking things—have become fairly good at this—and mending and also knitting socks, a divine life which gives me no time to write (the hell with it) or even cope with correspondence. . . .

As I can't tell anyone else, I will tell you that early in November I sent Mr. N. Rockefeller a very handsome case of very fine Provencal wine (white, and excellent as a cocktail, like still champagne) which I fancy baffled him a bit. Well, one must have one's little fancies and indeed I __am__ grateful to him for lots of things and wanted to send a remembrance.[1]

Iris added that she and Pierre might come to America, "if various things work out . . . it depends on the MMA and also on the Cinémathèque Française or perhaps, who knows, we might just come and hire ourselves out as a couple of domestics. I should think it might work and it would 'fix' my passport. . . . If not or in any case we plan on going to Brittany again end of March or so. Perhaps we might buy a bit of a house there too, somewhere near St. Malo . . . but not, we hope, breaking our thing here with Austin, so don't put it about that we are dreaming of Brittany. There are many reasons for this, some family one's of Pierre's and also because we really like the people there so much more than the people here."[2]

But 1957 brought news of the death of two men significant in Iris's life. Far from Fayence and unknown to Iris, Wyndham Lewis lay dying. "When he was admitted to Westminster Hospital on the 18th of February," writes Lewis biographer Paul O'Keefe, "he was semi-conscious, moderately dehydrated and anaemic, with extensive bedsores to the small of his back. He was able, from time to time, to respond to questions, but soon lapsed into semi-consciousness again. One question he is alleged to have answered concerned the last occasion he had opened his bowels. The response is credited with containing his final words on this or any other subject, 'Mind your own business.'"[3]

Lewis died of unspecified causes at 8:30 p.m., Thursday, the 7th of March, 1957. O'Keefe says his funeral service was described by Lewis scholar Geoffrey Bridson as "depressingly flat and uninspiring. One could imagine Lewis' disgust at being sent to rest to the strains of 'Going Home' on a Hammond Organ . . . !" (631). O'Keefe also notes that Lewis's autopsy revealed that an operation for diverticulitis in 1935 probably was the occasion for the removal of Lewis's prostate gland (361). The great bull, who once described himself as possessing the energy of a herd of ten bovines, was in all probability sexually dysfunctional for the last twenty-two years of his life.

Another man in Iris's life, without whom her stay in Fayence might have been unsustainable, was himself ill at the time. Helen Austin wrote Iris about her husband's incapacitation with cancer. Iris responded with a letter to Chick: "We were so awfully glad to get Helen's letter, though of course sad that you aren't able to write yourself, for we had been saying and saying—'it is rather a long time since we heard, he is probably back in the thick of the fray in Florida' [where Chick served unsteadily as director of the John and Mable Ringling Museum of Art][4] and so forth. And all the time, there you were, not in Florida at all but stretched Procrustes-like on a bed of pain, poor lamb."[5] Iris wished him a speedy recovery.

Chick did not recover. He died of lung cancer at age 56 on March 29, 1957—
by coincidence, two weeks after Lewis's demise. Like Iris, he was a lifelong
smoker. After Chick's death, there was no assurance of commissions to continue
work on the Austin house. Iris and Pierre decided it was time to build up their
antiques business.

In summer of 1957 Iris wrote Schiddel that she and Pierre were not coming
to America,

> . . . not now. The Museum couldn't find the money. I expect to see d'Harnoncourt over
> here this summer. They will perhaps whiz up something for later on. Meanwhile they
> have fixed up the business of my passport and continued American nationality so that I
> don't lose a third of my pension as was threatened.
>
> Pierre has reconstructed another ruined house. It is angelic. We hope to sell it rather
> profitably. . . . Now we seem to be launched into the antiques business rather madly
> and have just returned from a busy but divine trip to the Spanish frontier with all
> sorts of detours to study prices, see folkloristic museums, and buy things—we have a
> rather elegant friend who has just turned his restaurant near St. Paul de Vence into
> an elegant antiques shop, pretty things which ladies can carry away in their cars, and
> a bar besides. So we have been buying for him. We seem to like this a lot. Heaven help
> us. As everything is going up in price like mad here, you may have seen the auction
> prices recently, it seems the thing to do to acquire things—houses and objets d'art and
> bibelots. We are working like dogs. . . . Most probably Chick Austin's widow and son
> [David] are coming here for August (well, it is their house!) and the spate of summer
> visitors has begun.[6]

After Austin's death, his widow, Helen, turned to settling his affairs. She
looked into the house in Fayence through a local attorney named Marquand,
who was conversant with French property laws. Iris wrote Helen that Mar-
quand was old and addled, but that his assistant, Mlle Marie Rose, could
probably tend to his business adequately. Iris emphasized to Helen that "the
estimated value of the house and contents was very low. . . . Do also tell me,"
she asked, "whether, in principle, this house is David's or yours: I must ask M.
Marquand the same question, no doubt. It was never clear to me and I sup-
pose I ought to know."[7]

As for the "angelic" house Pierre had been restoring, Iris told Helen it had
been sold and the proceeds put into their antiques business. "Anyway," she
continued, "we have put our tiny pittance in the antiques and bibelots, on the
grounds that this is an investment: we sell mostly through a colleague who has a

very smart shop at St. Paul de Vence and also through two other dealers, plus . . . directly from the pretty little shop below here. But things are awfully quiet everywhere at the moment. I don't understand what is happening in France at all. I hope it is good. Incidentally, I was delighted that Nelson Rockefeller got in [as governor] in New York, though I am a rabid Democrat too myself. But he must have enjoyed that a lot."[8]

Iris began her letter to Helen with an apology for failing to deliver on a promised homage to Chick to be included in a tribute exhibition at the Wadsworth Atheneum after his death. "I don't know how to say how badly I feel at not having, after all, been able to write the piece which was to have gone into the Memorial catalogue. After all, it ought to have been easy or at least I thought so: but when I came to do it, all the past came up into my face and my efforts turned out to be nothing but a mess. When I say the past, I don't only mean all that past of movies and the Museum but, especially, the other past which Chick had made so wonderful for all of his friends. I realize that this seems very selfish and that perhaps you won't be able to understand or forgive, for it seems like letting everyone down. It did nevertheless simply prove a task, though only a small one which loyalty ought to have rendered possible, quite beyond my power at the moment. Frankly, I despise myself and, at the same time, I do realize it was a despicable psychological block out of which I didn't manage to extricate myself in the time given."[9]

Upon receiving a copy of the catalogue for the memorial exhibition [*A Director's Taste and Achievement*], Iris wrote Helen that "somehow I felt less badly than before on not having contributed my small piece because now I see that—as Chick had pioneered as usual in showing films in that special way at the Atheneum—there was in reality no need to stress the point that it was his example that pointed the way to what the MMA did later, and it would have been perhaps even a little off-key."[10]

Corresponding with David Austin, Iris reported that "Pierre is still thinking of building over or rather fixing up over the stable-like affair on the other side of the road next to the baker's but so far nothing has been done. For one thing I think you know he had a rather stupid and nasty accident when a mad peasant in a Deux Chevaux dashed into him from behind bushes out of a dirt lane on the main road coming back here from Grasse. . . . Meanwhile of course we had to buy a car, as the dear old one was in mangled shreds. . . . This rather dimmed our dreams of building across the road for the moment but in the end not perhaps so disastrously as all that, as now the idea is, if the town will permit it, he

Pierre Kerroux and Iris Barry in front of their antiques shop in Fayence, 1960s.

(Courtesy of Robin Barry)

will try this autumn to make a two-story upper part over the stable instead of a one-story affair. Well, we shall see."[11]

Iris was informing David Austin about the renovation of his own property across the street, not knowing Pierre would soon occupy the building with another woman and then launch an attempt to make legal claim against Austin to the first two floors of the main Austin house.

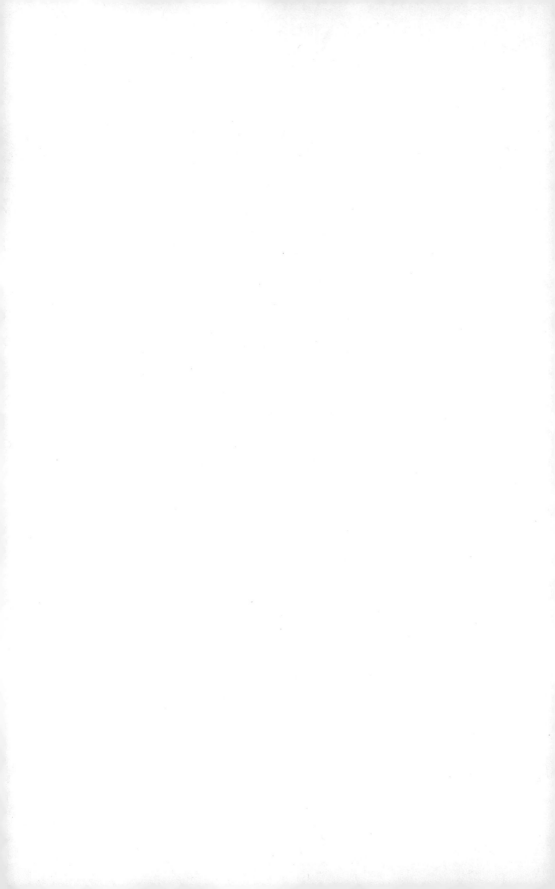

40

NEW YORK AND LONDON

THE NEXT FIVE years of Iris's life saw a steady deterioration of her relationship with Pierre Kerroux. Although she would occasionally be sent on missions abroad by the International Federation of Film Archives (FIAF), she resided mostly in Fayence, warily cohabiting with Kerroux, who continued to drink and chase women. Eventually he became abusive and moved out to take up residence with a younger woman in the stable belonging to the Austins he had renovated across the street. Iris was relieved, but nonetheless remained invested in Kerroux's antiques business and never completely lost her feelings for him. Fortunately, in 1962, an opportunity arose to return to her native England.

Iris's son, Robin, had become a successful architect and author, gaining most of his professional experience while working with firms connected with Sidney Bernstein. When he married Bernstein's former wife, Zoe, he also came into a townhouse on Vincent Square in London. Zoe, the beautiful fashion columnist, had been in Sidney Bernstein's life for many years. It is a curious turn of our story that she became Robin Barry's wife. According to Robin, who had been in love with Zoe since he first saw her riding a horse at Long Barn, Zoe's divorce from Sidney had been amicable and, along with Sidney's townhouse, came other Bernstein properties near Vincent Square. Robin suggested to his mother that he might be able to renovate one of these as an apartment for her.

Iris's journey homeward, motivated by adverse conditions with Pierre and tinged with the uncertainties of assuming the role of mother, began roughly. "Iris didn't phone," her daughter Maisie recalled, "she just sent her trunks to Vincent Square. She intended to stay in London forever." Iris moved into Robin and Zoe's house and immediately there was trouble. "They were having to squeeze past her things in the hall," Maisie said. "They found her impertinent

and demanding. One didn't get much back from her, you know. Zoe thought she might be ousted from her own house."[1] Most of the tension centered on Robin, with Iris and Zoe placing different demands on him. As Robin Barry put it, "they fought over me."[2]

It quickly became clear that alternative quarters were needed for Iris. Iris spent part of the winter house-sitting in the country home of Beatrice Curtis-Brown, her friend from the Curtis-Brown publishing family. Finally moved into Robin's apartment, Iris began to worry about the situation in Fayence, confessing to Schiddel that "as to Fayence, I don't know what goes on there. Pierre swore that the awful Belgian lady would not inhabit the Austin house but who knows and I daresay I'd just as soon not know."[3] She was also thinking about New York, where she had been invited to be the honored guest of the New York Film Festival, to be inaugurated in September 1963. Since the festival was cosponsored by the Museum of Modern Art, it seemed fitting to dedicate the festival to the founder of the MoMA Film Library.

From London in August Iris wrote Schiddel that her trip to the United States would have her in New York at the Sobys' flat on East 54th Street, then on to the Flaherty Film Seminar in Brattleboro, Vermont. Between the 4th and 18th of September she would headquarter at the Museum of Modern Art, but was uncertain of her residence, which turned out to be on Virgil Thomson's couch at the Chelsea Hotel. "Am rather timid of returning after thirteen years," she noted.

"Pierre," she told Schiddel, "telephones from Fayence *se n'est que vous que j'aime*, but what does this really mean? . . . Grave troubles with my nationality business, missing documents, and thus residence in England unsolved as yet."[4]

Returning to London from a short trip to Belgrade for FIAF, Iris had another encounter with immigration authorities, "a most astonishingly not-welcoming reception from the immigration chaps here and assorted police," she wrote her longtime friend, James Thrall Soby. "I had never imagined the British could be so utterly gestapo and beastly. However, I realized later that was all a result of the great Profumo and general spy-scandal and everyone very edgy about 'aliens'. It was quite a shock, nevertheless. However the next day I dashed off to the Home Office where they were quite nice and fatherly and soothed me down and said they wouldn't kick me out (as it really did rather seem on arriving) and that I could under certain conditions remain here indefinitely."[5]

Iris's subsequent visit to New York brought her into touch with friends—the Askews, the Sobys, Virgil Thomson, and others—she had not seen in America since 1950. At the Museum of Modern Art, where she had been lent an office

for the duration of her visit, she struck the staff as aloof and highhanded. Eileen Bowser, a successor to Iris as film curator, recalls that at one point Iris answered a telephone, then turned in her direction while holding out the phone and said, "There is a call for someone named Eileen Bowser!"[6]

Iris was shifted from the quietude of rural France to the bright lights of Lincoln Center. The spotlight was squarely on her. Nineteen feature films were shown at Philharmonic Hall, while at the Museum on West 53rd Street ten programs were presented. *New York Times* critic Bosley Crowther called the new festival "the early fall season's most sensational cultural event,"[7] and seemed impressed that the effort attracted a growing audience of twenty-something film enthusiasts, a group he viewed with some suspicion. For Iris, being surrounded by such hubbub after so many years of relative isolation simply made her nervous. Despite the festival's aim of *not* being another Cannes, of giving no prizes, having no starlets on its selection committee, and minimizing opportunities for paparazzi, Iris found herself rising in her box seat to receive applause from an audience of 2,500 people. Short addresses were given by William Schumann, president of Lincoln Center, and August Heckscher, chair of the festival's sponsoring committee. Then Iris, who was ceremoniously seated

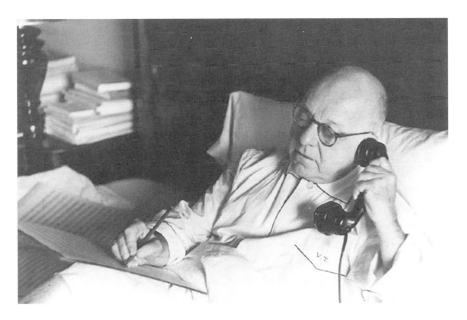

Virgil Thomson at work at the Chelsea Hotel.

(Courtesy of Virgil Thomson)

next to the director of the opening night film, settled warily down in the celebrity box beside her ex-employee, Luis Buñuel, whom she had not seen since she concurred in his ouster from the Museum twenty years earlier. In silence they viewed his film, *The Exterminating Angel*, depicting a group of people caught in a dinner party from which there was no escape.

At the end of her stay, Iris told Virgil Thomson she would have liked to linger in the United States, but the film festival travel money was running out and she needed to return to Fayence to check on Pierre. Iris appreciated Virgil's hospitality, she told him, and later recalled that Thomson had "simply telephoned and said, 'You will come here' and at the fabulous Hotel Chelsea on 23rd St. He gave me a room (who has never seen that hotel knows naught). As I had risked going to America again although I was terrified that it was far beyond my means, although my passage was paid and a per diem granted, I still was afraid and justly so. The nicest people lent me their elegant apartments and I was in luxury and so grateful, but the tips . . . and I had never really understood how to take the subway, unless accompanied . . . and taxis are so necessary and so dear and you can't always catch one when you really need it."[8]

Once again, Iris felt the urge to leave New York.

41

FINAL BREAKS

IRIS'S CURIOSITY ABOUT Pierre turned into a nightmare. When she visited him, not only was he as obstreperous as ever, he also seemed to be working on a scheme to take over parts of the Austin house. The scheme, however, did not become immediately clear. At first Iris sought reconciliation, or at least enough concord to allow the two of them to maintain the house and make it available for vacation visits by the Austins. But Kerroux continued his difficult behavior. Iris retreated again to London.

David Austin announced to Iris that he and his family would be spending part of the summer of 1964 in the Fayence house. Iris welcomed the visit, writing from London that "it seems rather exciting and so very long since an Austin has been visible down there [in Fayence]."[1] But by August plans had changed. Iris wrote to David from her Moreton Terrace apartment in London:

> Well, we seem to have misunderstood one another splendidly and I went down to Fayence on purpose to try to get things ready for your arrival—not with much success, as Pierre seemed to think you would not come (I don't know why). As he has too much 'goods' at present and things suddenly stopped selling, there is a considerable overflow and muddle at the moment—which no doubt will improve when 'business' picks up and Pierre feels in a better mood. At the moment he is rather depressed and difficult. . . .
>
> Perhaps this departure [from Pierre] will not surprise you too much especially if my saying last year that I had had 'considerable differences of opinion' with Pierre conveyed as much as I hoped it would. . . . When I went down there it did really seem that he might have become reasonable and orderly again, but this proved not to be the case, and after <u>truly</u> making very great efforts, it seems useless to attempt the impossible. So I give up. . . .
>
> I hope this won't actually worry you too much. The house is there and your furniture and things too. It just wouldn't have been a very comfortable moment for

you to go there, so no doubt things have turned out for the best with your making other
plans for this summer. . . .

I wish I could say let us turn to pleasanter topics but as you say yourself, the
menace of [U.S. presidential candidate Barry] Goldwater is too dreadful for words:
it is certainly as great a shock in Europe as at home. I hope we can rally even all the
Americans living abroad to vote and to vote the right way, too. This among other jobs
will keep me busy until I go briefly to Leipzig in November.[2]

Unfortunately, along with the precariousness of the situation in Fayence, relations with her son and daughter-in-law in London collapsed. Iris and Zoe could not get along. Their estrangement was never mended. Retreating to Fayence and the Austin house in 1964, Iris wrote to Helen Austin that she was "most grateful to have a roof over my head—you probably don't know that all innocently I got drawn into a savage family quarrel in London and—seemingly it often happens to the innocent bystander—took the rap. This sounds a little colorful, but anyway the result was that it became odious to stay in my ducky little flat where, indeed, I was not so much with my various trips to Russia, and then Yugoslavia, then Belgium but the best of course was the lovely hop to the U.S."[3] Iris's attempts at reconciliation in England having foundered, she saw no alternative but to return to France.

In Fayence she embarked on a final effort to get along with Pierre, at least insofar as he might be useful in maintaining the Austin house. They lingered on together in a loose liaison. In July 1965 she wrote David and Mollie Austin that "personally I am in pretty good form though going rapidly grey at the sides, and very glad to be back here as it does seem to be 'home' by now. The house is okay though of course it needs a bit of doing up after all this time, which we don't get around to doing for lack of either time or money."[4]

It was in this somewhat ambiguous state that Iris passed the final years of her life. She hung on with her tiny pension, the use of the Austin house, and the occasional handyman assist from Kerroux, who became increasingly estranged from her. In January 1968 she wrote David Austin that "as I predicted, Kerroux is no longer living here although he is clinging to the lower part of the house, the 'shoppe', as might be expected. Meanwhile, with the help of Mme. Iampolski [Iris's maid] the upper part is gradually being cleaned up and already begins to look quite civilized. . . . I have had windows made to close, when they didn't, a door put back on its hinges etc. and plan many more improvements when the occasion permits. This is of course nicer for me but especially I hope reassuring to you."[5]

Iris was about to face a final crisis with Pierre. He believed he could use French law to take possession of the first two floors of the Austin house. He invoked a French legalism known as "droit de commerce," by which the operator of a business has prima facie claim to occupancy of business premises.

Iris chose to pass the word along to the Austins via a letter to David's mother, Helen:

My real wish would be of course to send you very nice and cheery greetings, but as you will see, I am having to send you instead a sort of small domestic bombshell.

This situation has been worrying me increasingly for a long time, but I kept hoping David would be here, as he thought, and that things could be worked out then much more effectively by word of mouth and in person than by correspondence.

However I found it necessary to consult a lawyer about several matters, like making a will and other more unpleasant things, and so it seemed only sensible to consult him about this too. I do not think that the letter he has sent or is going to send you makes things as clear as I would have hoped—but no doubt lawyers are like that. I send you a roughish translation of it. I have paid him quite a substantial fee in advance for taking care of things.

Now the situation as I understand it is this. Pierre Kerroux has often and recently declared that he has a legal claim to the occupancy of the two lower floors of this house, which he uses as his shop. This shocked me terribly, for one would think that he would be grateful and not grabby. What seemed to me even more serious, however, is that he has put his own house across the road [the Austin's stable, which Pierre had renovated] up for sale and has at times said that he intends not only selling that house but his 'droit de commerce' with the occupancy of the two floors of this house also. This I thought disgusting. And it is by no means sure that he could actually do it. But supposing he could and did, you would have awful difficulties, I think, in ever getting the new people out of here—lawsuits and goodness knows what. So I thought you ought to be informed, unpleasant as this may be.

I do not know exactly what a 'droit de commerce' is in English, as I have never known anything about shopkeepers, but it is an official permit to exercise a business and is, I believe, saleable or transferable. And it does seem to me that this whole question of the right to occupancy of the two lower floors of your house is really a legal matter and ought to be settled. I consider the lawyer's letter, copy enclosed, as rather cagey for he does not say what could or should be done. Perhaps only a judge or magistrate could decide this, however. Or I have fancied that Pierre could be persuaded to make some arrangement or compromise, such as his agreeing to accept a very short-term lease of the premises on a modest rental basis but one which would terminate with his

departure or at some other specific time. However, French law is doubtless something
we can only surmise now. If the worst comes to the worst, I know a 'top' man who could
doubtless help, if my own little lawyer seems to dither, but he is in Cannes and you
see that it is difficult for me to get to him, as I have no car and don't drive and don't,
at the moment, have any authority from you to take any real action, although I feel so
dreadfully responsible towards you.

Well, all this is very nasty but, in a way, I am relieved that it has to come out into
the open instead of my just having nightmares about it.

Please read all this very carefully, I am trying to be clear. Do you think that David
still might be coming over? If not, would it not be possible for you yourself to come? This
early autumn? I imagine that would be soon enough, although if the situation seemed
more threatening and urgent, I should of course inform you at once. You should just
imagine how it would please me if you could come, in spite of the nasty part, we could
have fun and I would move heaven and earth to make it agreeable.

Perhaps it would make things seem easier if I said that superficially the situation
with Pierre remains civilized in appearance: I mean that we do not snarl at one
another. In fact, I have not really seen him for the past two years, except when going
in and out of the house of a morning to do my bit of shopping, etc. and he lives in his
house across the road. Not, as you will imagine, alone. But all that, you and David will
understand better (and its sinister aspect) when here. Yet I do believe, in spite of all,
that Pierre is not really a bad fellow or a crook, he is just irresponsible. In a way, I even
believe that you could charm him into behaving properly about this house.

Bless you, dear Helen, and forgive me for bringing you this bother.[6]

Iris sent a copy of this letter to David Austin, saying that he "will learn
from Helen, alas, from the copy enclosed of my letter to her, that I have been
compelled to bring up a bit of bother about this house, which concerns Pierre
Kerroux's claim to have a right of occupancy of the two downstairs floors in your
house, which he uses as his shop."[7] In his reply David thanked Iris "for commu-
nicating your fears relative to Pierre's intentions. It seems rather an ungracious
reaction to us who have been so kind and above-board in our dealings with him!
As I have the original title to the house and the documents relating to its trans-
fer at Chick's death, it is hardly imaginable that he has any legal claim to it."[8]

Kerroux's claim in fact proved baseless, but it threatened a relationship with
the Austin family that Iris had come to rely upon. The Austin house had been
her refuge since 1954, and at the moment no alternatives presented themselves.
This dilemma, however, was only followed by a greater one, Iris's final illness.

42

THE END

IRIS HAD BEEN a constant smoker all her life. She also drank to excess. Marius Rochemaure, her bartender and owner of the café she frequented in Fayence, when asked to describe her, extended his forearms in a wrestler's pose and said "dure"—that she was strong. He then tilted his right hand to his mouth with thumb extended in the shape of a bottle and said, "Iris: bois, bois, bois."[1]

Iris indeed was durable and did not drink herself to death. She lived a vital and adventurous life, boldly taking decisions not always wise but constantly in character. Above all she had a lively mind and a rapier wit. In 1924, in a review of a play called *To Have the Honour* by Milne and Philpott, she wrote that "the whole play gave one the sensation of realizing anew what fun it is for us all to be alive and to sharpen our silly little wits on each other."[2] Iris never lost that sentiment.

Iris depended, sometimes excessively, on the generosity of others. She lived in a time when friends meant a great deal, when day-to-day challenges of food and clothing and housing were not mitigated by government safety nets. Yet even in adversity she retained a sense of humor. Toward the end of her life she explained, once again to David Austin, why certain repairs had languished on the house. "If all this sounds rather plaintive" she wrote, "it is no doubt because I really do exist on a very modest level, certainly my own fault at the end of a misspent life, if a most amusing one."[3]

Her "misspent life" ended in a hospital in Marseilles, where she was operated on for cancer of the throat in October 1969. The cancer may have metastasized from her earlier condition, as she had feared upon leaving New York. Russell Lynes recounts that during her last illness, Iris wrote to Margareta Akermark, who worked with her at the Museum, "that she was extremely ill and broke. She was in the terminal phase of the cancer which had threatened her for nearly

twenty years. The hospital, she said, was like a scene out of the once shattering film on the dehumanizing of modern life, *Metropolis*. Miss Akermark turned to James Soby. Soby and [Edward] Warburg, [Jock] Whitney and Philip Johnson and Nelson Rockefeller put together a fund to pay Miss Barry's hospital bills and to give her such comfort as money could provide."[4] This would prove a penultimate gesture of support, the final one being to cover the cost of burial in the cemetery high above Fayence, where Iris lies under a plain marble slab simply bearing her name and dates. There is no mention of her significance to film.

In her last days, in addition to her faithful maid, "Madame" Iampolski, she was looked in on by an Australian architect, Paul Calder. After her death Calder moved to arrange her affairs and answer inquiries about her. He wrote to Iris's friend, Beatrice Curtis-Brown Horton, who asked if Iris had read the letters she sent to her in her last days, that "Iris did receive your letters . . . but could not read for the last two months or so, nor could she barely speak. On my visits I asked if I should read the mail to her, and frankly she was too tired and weary, and really had no interest but to return to Fayence. Iris was being fed intravenously from the date of her operation, October 27th until she died [on December 22, 1969].

"I will not go into the Kerroux situation, only to say that I have restricted him somewhat. He did not attend the funeral nor did he send flowers." Calder also mentions the possibility of sculpture for Iris's grave being made by Isamu Noguchi or Alexander Calder, noting that "there have been given to the Museum some very generous contributions for Iris."[5]

In an addendum to her husband's letter, Calder's Norwegian wife, Bente, gave a memorable description of Iris's last days:

> *I would like to add a few words to my husband's letter. We went away from Fayence for two months during summer, and when we returned Iris was not well. First, she thought it was a cold, then bronchitis, but she would not see a doctor, no matter how much we insisted. During this period she was not happy, because I think she really knew something was seriously wrong. Finally, she was forced to see a doctor—as she could hardly swallow—even drinking hurt her. She had not been to see a doctor for fifteen years!*
>
> *The local doctor sent her to a more qualified one—and photographs were taken. She reluctantly showed these to my husband—the day before she left for Marseilles— upon his insistence—and they were apparently fairly revealing.*
>
> *She told only very few people she was going to Marseilles before the [Calder's] baby was born, though we wrote daily and sent her the things she needed.*

Iris wrote also daily—these days before the 'op'—as she called it. Very amus-
ingly—about the extremely sloppy French system—but seemingly very efficient, all the
same. (It seems she was in the very best possible, French, hands!) She seemed, then, to be
full of courage, and good spirit. She certainly was a handful for the nurses, both before
and after the operation.

Of course, after, there were no more letters. She had strictly forbidden us to come and
see her, until she let us know. But when after a while we heard nothing, we went, and
for us it was a bit of a shock, for we had not realized the operation was so serious.

She was considerably thinner, fed by tubes, and had difficulty talking. And she had
not lost her sense of humor.

However, she was extremely beautiful—and dignified. Even the very last time we
saw her alive (the same day she died), in a coma, her skin was smooth—her colour
wonderful, and because of her bone-structure, her face was lovely, being thinner.

I think—and hope—that she sincerely believed that she would come back to
Fayence and we did all we could to help her believe that. No one, anyway, told her of
her real condition. In fact, she was getting better (though she could still only have lived
for about a year)—when suddenly a blood clot threw her into a coma—and from then
on—for a few days—she was completely unconscious until her death.

Apart from us, there is a woman in the village who knew Iris for all the time she
has stayed in Fayence—she cleaned for Iris and looked after her when ill (she now
cleans for me) who was extremely upset by Iris' death. She also brings flowers every
week—and I think will do so until the day she dies.[6]

The Austin house had lost its principal occupant. David Austin instructed his
attorneys to have their French representative file suit against Kerroux. Mean-
while the house was put up for sale. David Austin wrote Calder that "when we
come up with something firm, I will make a trip to Fayence to arrange about
selling the furniture."[7] The sale was soon completed. The house was purchased
by Iris's bartender, Marius Rochemaure. It is now a series of apartments.

Unlike Iris's gesture for Lady Mary Montague, no one was present to pro-
vide an epitaph for her. In the end perhaps none would be more appropriate
than the one she invented for Lady Mary, but actually intended to be her own:

"It has all been very interesting."

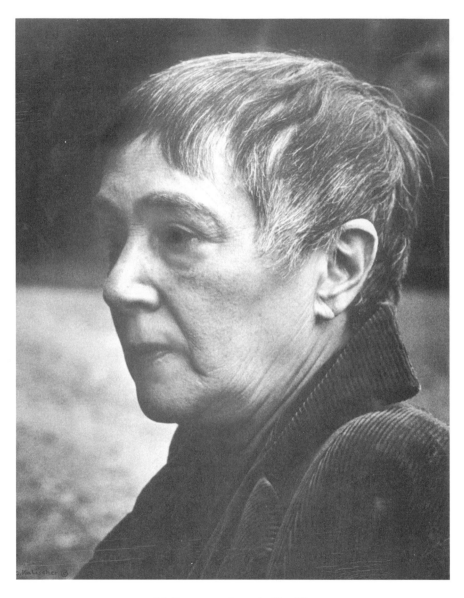

Iris Barry near the end of her life.

SEQUEL

IRIS BARRY WAS an elusive human being. Even those closest to her knew little of her private life, and she lived in an era when privacy was respected. Most likely she determined that it was not in her interest to share her secrets. Inhabitants of the high worlds in which she moved would have looked askance at a self-educated farm girl with illegitimate children. Consequently, Barry lived much of her professional life disguised as a haughty, intellectual aristocrat. She could be charming and funny, then quickly go into her "deep freeze" and be brusque with her underlings.

Maintaining this facade must have been challenging. To go day after day into the courtyards of the rich and hope not to be unmasked must have worn on her. Her slow distancing from her job at the Museum of Modern Art is suggestive of this stress. She wanted both to go away to lead a quieter life and yet retain her ties to professional success in a competitive realm of high culture.

The social spheres in which Barry moved presented her with historic class and gender conflicts. She told John Widdicombe she considered herself both "deeply working class" and "arriviste." She was drawn to the company of powerful men and she proved herself their equal. Her mother had shown her how independent a woman could be, and her imagination was fired by exotic times and places found in movies. Ezra Pound's first letter to her met a receptive mind. She wanted to leave the farm, yet nostalgia for rural simplicity would remain with her throughout her life.

Pound was an unlikely candidate for Iris's affections. Although they may have managed an affair, he was probably too motherly for her. Wyndham Lewis was a better fit. He was the love of her life. Lewis was notoriously manly, handsome, and highly placed in the bohemian fringes of London. In Lewis Iris found her "king."

The depredations Iris suffered at Lewis's hands are appalling, and her responses to them quite touching. She patiently served as his domestic navvy, politely pouring tea, as Herbert Read recalled, while pleading with Lewis to pay attention to the children they had given birth to. Lewis was unresponsive. He repeated this behavior with several other women, probably unknown to her. Nonetheless, Iris remained attached to Lewis for the rest of her life and came faithfully to his aid during his destitute days in Canada. He remained the only man, she said, who never bored her.

Even as she grew older, Iris repeated her mistakes, partnering with competent, but difficult men. She also maintained an ambivalent attitude toward her children. How could a mother drop in and out of her children's lives without identifying herself? How could she introduce her children to one another and not tell them they were related? How could she expect them as adults to welcome her after years of neglect? Men in bohemian London, Lewis and Pound among them, routinely abandoned their children, but their practice does not account for Iris's behavior.

Iris's decision to eschew domesticity and plunge into a career inevitably entangled her in larger forces. In London she was caught up in the social and economic turmoil brought about by the First World War. The massive toll on manpower, both in jobs and lives, had created fault-line shifts in the status of women. The suffrage movement, active since the previous century, was energized by the roles women were called upon to play during wartime. Iris found that, as a single woman, she could find work previously unfamiliar to her sex, such as the new role of film critic. The bohemian world in which she moved was also relatively tolerant of women professionals. Iris saw Hilda Doolittle, May Sinclair, Nancy Cunard, and Edith Sitwell making their marks as writers, and she wanted to join them. She already had published several competent but undistinguished poems in little magazines. The advice Ezra Pound gave her became the core of his later books on writing. Iris tried her hand at plays and short stories, then moved on to novels and biography.

Barry's 1928 biography of Mary Montague is a reminder of how well she could write. Her portrait of this fascinating character, responsible for introducing variolation, a precursor to vaccination, to England, is vivid, well-etched, and breezy. The parallels between the two women's lives are intriguing. Both were careerists and aloof parents. Both distinguished themselves as writers and spent the last years of their lives in exile with problematic men. Iris's earlier and somewhat more successful novel, *Splashing into Society*, a lightweight send-up of Daisy Ashford's *The Young Visiters*, reveals how deeply enmeshed Barry and

Lewis were in British class distinctions. Iris's life, to a considerable degree, is a story of social tensions. She learned to "pass" in upper-class British society, and the veneer she put on became her professional persona. Nevertheless, she disdained hierarchies. She came to America hoping to escape them, and found the most surprising thing about Americans was how conscious of pedigrees they can be.

Another arena of Iris's writing merits note: the local color essay. Although she would have liked her work to be seen in the *New Yorker*, she sent the London *Spectator* entertaining articles about American life that prefigure Alistair Cooke's popular *Letters from America*. The essay on wrestling, containing the memorable beefcake's complaint, "that hoits!," is an engaging example. Iris was an astute reporter, but she was also capable of sentimentality. Her observations about western dawns and California highways, of dude ranch life and swimming in the Catskills, are disarmingly ingenuous. Her descriptions of the ambience in Fayence are vivid.

Two further talents should be mentioned, one for which Iris Barry claimed credit: "talking." She was an excellent conversationalist. This art is becoming endangered in an age of instant communication, as is the art of letter writing, in which she also excelled.

As a writer Iris found her forte in film criticism. There she consistently revealed a sharp and responsive mind and a lively writing style. She wrote fluidly, analyzing the structure and effects of films without invoking a fixed theoretical agenda. She wrote at a time when there were no schools of film criticism to call upon, but her work also shows that a range of justifications for filmic practice can be entertained without conflict. Iris could admire Murnau for reasons we would call auteuristic, then praise Griffith or Eisenstein for their technical expertise. She loved Tom Mix for his showy westerns, but understood that John Ford was seeking a more historically accurate depiction of the West. This flexibility would place Iris Barry today somewhere between the "Paulettes" and the "Sarrisans," the acolytes of film critics Pauline Kael and Andrew Sarris, her successor film critics of the post-sixties film generation. Barry could be as unabashedly populist as Kael, while joining Sarris in applauding the *auteurs*. As a critic perhaps she had most in common with a man who despised her deeply, James Agee.

Inevitably, the question will be asked, "What was Iris Barry's theory of film?" There is no simple answer. In general she took a sociological view, analyzing motion pictures as reflections of the times and places from which they came. Regarding individual films, however, she was an intentionalist: she asked what

the director was trying to achieve and how well he or she achieved it, and evaluated the film accordingly. Above all she venerated the dreamlike qualities of film, which she appreciated unashamedly.

Perhaps one might ask more appropriately: "What did Iris Barry *do* for film?" She helped define it as an art form, through her writings in the *Spectator* and the excellent book, *Let's Go to the Pictures*. Then, despite the happenstance of her disorderly life, she found it possible to build an infrastructure essential to sustaining the study and appreciation of filmic achievements.

Another feature of Iris Barry's life now in diminishing supply is the abiding loyalty of friends. Iris sailed like a meteor through many social settings, yet managed to cultivate sustained, almost philanthropic friendships. The crucible of these loyalties was the Askew salon. There she established relationships with men and women important to her life: Philip Johnson, John Houseman, Virgil Thomson, Alfred Barr, Chick Austin, Constance Askew, Elsa Lanchester, and Esther Murphy, among others. It is remarkable that these people could have been so loyal while knowing her so little. Johnson, who may have recognized in Iris a female counterpart to his insular personality, found Barry fascinating in New York, but disliked her in the more informal environs of Fayence. Thomson revered Iris always, recalling that he could talk to her "like a man." Constance Askew provided her shelter when she was divorced by Dick Abbott. Barr respected her curatorial integrity and never faulted her for the undiplomatic behavior of her husband. And Chick Austin, her true guardian, literally saw to it that she had a roof over her head for the last twenty-five years of her life. Yet none of these friends were as close to Iris as the novelist Edmund Schiddel, the only person Iris seemed to confide in.

Then there was Nelson Rockefeller. Professionally, he was the most influential person in Iris's life. She worked for him for nearly twenty-five years in "mother's museum," supported by his family's foundation. Rockefeller sustained Iris even in her retirement, arranging to keep her on staff until she died and bailing her out of trouble with the immigration authorities. Iris was a faithful executor of Rockefeller's agendas, turning the Film Library into a branch of the Office of Strategic Services during World War II and leading the anti-Fascist propaganda effort for Rockefeller's campaign in Latin America, an area of the world in which he had obvious family interests. This biography shows that the Museum, recognized by scholars as a player in post–Cold War cultural politics, was in fact politically engaged much earlier through its Film Library, both before and during World War II. Iris, who lost her job in England for failing to support British films, became a leading advocate of joining Britain in the

war effort, and even reversed herself on the value of war films. In World War I she thought the films unrealistic. In World War II they became the "film of fact." She was supported by and facilitated a movement of American intellectuals to counter foreign propaganda by truth-telling. To prove her *bona fides* to skeptics of the Museum, she became a U.S. citizen and championed American film superiority. Yet upon leaving the country in 1950, she tossed a challenge back to American filmmakers to equal the postwar accomplishments of the Italians. At the same time, limitations in her tastes inadvertently opened the door to the development of American avant-garde film institutions such as Cinema 16 and the Filmmakers Cinematheque.

Barry's political and social inconsistencies can be seen in the episodes related to the careers of Alfred Barr, Jay Leyda, and Luis Buñuel at the Museum. Barry had no clear connection to the unraveling of Alfred Barr's leadership, but her husband was involved. John Abbott's path from head of the Film Library to Executive Vice President of the Museum remains to be examined in detail by historians. Abbott was only one of several aspirants for Barr's authority, and among them perhaps the least qualified. Nevertheless, it was Abbott who was given administrative control of the Museum from 1943 to 1948. He was on good terms with board chairman Stephen Clark, but it was Rockefeller, above all, who kept tabs on the Museum's administration. Abbott eagerly served Rockefeller, bringing to the Museum countless government contracts and grants from the Rockefeller Foundation. It was Rockefeller who kept Abbott in power beyond the time Clark lost patience with him. After Barr was demoted, curator Dorothy Miller was not the only one to recall that staff hostility toward Abbott spilled over to Iris. But since the Film Library was a separate corporation, Abbott's rise to power was not under the control of Museum personnel and there was little they could do. If Rockefeller stood by him, and he did, Abbott could be plucked out of the Film Library and placed in charge of the Museum and his wife could continue to keep her job. Iris did not alienate everybody during these years her husband "bitched things up," as Allen Porter put it, but many staff members resented her involvement with Abbott.

How noble was Iris in the controversy over the firings of Jay Leyda and Luis Buñuel? Earlier she had finessed the bad behavior of D. W. Griffith, who rewarded her contribution to his legacy by trying to get her fired. In that case Barry stood firm, Rockefeller behind her. Leyda and Buñuel were entrapped in a different and much larger story. Rockefeller had been undercut by right-wingers in Congress, who temporarily neutralized him by placing his Latin American office under the control of the State Department. This setback did

not stop Rockefeller from serving the government; he continued providing foundation support for a national film collection at the Library of Congress, effectively keeping Iris in government service after the war. For Leyda and Buñuel, the virulence of early McCarthyism proved overwhelming. Rockefeller would not defend either of them, and Iris ultimately found herself in no position to be supportive. As Brett Gary points out in *The Nervous Liberals*, it was not until after the war that dissenters were understood to be protected by the First Amendment unless they posed a "clear and present danger" to society.

Was Barry sympathetic to the politics of the Left? In the twenties, when many liberal Britons were flirting with communism, Iris was friendly with leftists. Her first husband, Alan Porter, regarded himself as a Communist; her friend and colleague Ivor Montagu later joined the party, and Sidney Bernstein, though not a party member, was active in leftist causes such as the Loyalists of the Spanish Civil War. On the other hand, Iris was associated with Pound and Lewis, notorious partisans of Mussolini and Hitler, and Philip Johnson, who had a flirtation with the radical politics of Huey Long. There was the nest of leftists in Iris's employ at MoMA, several of whom caused her to be visited by the FBI and attacked by the right-wing press. Like many people after the war, Iris suffered from guilt by association. Because she was so close to many on the Left, she was summoned by the State Department's representative in Nice to prove she was not a Communist. It is ironic that this fate could befall a wartime patriot and Chevalier of the Legion d'Honneur.

Iris was obviously not a Communist. In the United States she was a Democrat, although she found herself appalled by the personal behavior of Franklin Roosevelt the only time she met him. As George Bernard Shaw might have put it, like the dustman in *Pygmalion*, Iris could not afford to be political. It took all she had to keep her job and maintain her facade.

In the midst of all the pressures and scrutiny she endured, Iris managed to set an example at the Museum that has been subsequently emulated by scores of film organizations. She showed through her exhibition, circulating film, publications and preservation programs, the kind of infrastructure film required for sustenance as an art form. She was, in short, a leader, an innovator, and the first woman in her field to achieve such a high level of success.

As the war ended and the fifties approached, Iris was beset by personal and professional trials. The Film Library became a drain on the Museum's budget and Iris found herself in the unaccustomed position of being asked to raise money. She flirted with placing the Museum's films on television, but her antipathy to the new medium got in the way of this pursuit. More consequential,

perhaps, was the lack of enthusiasm she brought to the idea of writing a book on film history for the New American Library. When she failed to deliver on this contract, the assignment defaulted to her employee, Arthur Knight. In 1957 Knight published *The Liveliest Art*, which remains today one of the largest-selling books ever published on the subject of film. Had Barry fulfilled this contract, she might have retired with a proper income and a secure place in film history.

A brush with death in February of 1949 may have provided Iris with a reason to try to live the way she imagined she would like to live. When her doctor shuffled up excitedly as she was checking out after a routine procedure at the hospital, he bore news she was unprepared to assimilate: the prospect of dying. On her way home, thinking about getting her affairs in order, she confronted her own mortality for the first time since her grandmother's death when she was quite young. Perhaps then she began to think seriously of leaving New York. If the cancer operation she faced proved a success, she could start another chapter, move to France and seek a new life. She had met Pierre Kerroux three years earlier at the Cannes Film Festival. With him she might make a new start. Later, when she had survived the operation but did not know if the cancer would recur, she joined Kerroux on the Riviera. She found him enterprising, attractive, and handy around the house. Her mind was apparently made up, but it took time to sort things out. It would be months before she revealed her plans to the new director of the Museum.

Perhaps Iris had outlived her usefulness to MoMA. She was the right person at the right time to start and build the film collection. Her British ties made her prescient in energizing the war effort, a signal achievement of the Museum during a period of true national peril. But Iris was unsuited for what was to come. She was at best reluctantly tolerant of independent and avant-garde film, and her successor, Richard Griffith, followed her example. The postwar period, with its proliferation of 16-millimeter film equipment, saw the rise of a major independent film movement in the United States. Iris's rejection of Maya Deren's Rockefeller Foundation application inadvertently served as a watershed moment in the birth of the American avant-garde. After the Provincetown Playhouse showings of Deren's *Meshes of the Afternoon*, following the rejection of her application, Cinema 16 and later the New American Cinema movement were born. This model—a filmmaker showing her own films and conversing with the audience—gave rise to the development of the independent film movement. The careers of film curators such as Jonas Mekas and Amos Vogel were shaped by this schism. Not until Willard Van Dyke launched the Cineprobe series at MoMA in the late sixties did the Museum pay due

diligence to independent film. Among the programs Van Dyke presented in the 1960s was an evening with Maya Deren and Amos Vogel of Cinema 16. Now we have the Museum of Modern Art Film Department, the New York Film Festival, *and* Anthology Film Archives. We, the public, are the richer for it.

Iris left New York in October of 1950. A vanilla decade followed at the Film Library, when caution became the watchword and the programming carried on as if on autopilot. Had Iris chosen to stay on, she may have seemed out of place. In the sixties Rockefeller's support of the Museum gradually gave way to a multiplicity of funding sources. The government began to support the arts in a new way. Peer panels at the National Endowment for the Arts and the New York State Arts Commission, initiated on Rockefeller's watch as governor, joined individual board members as arbiters of museum programming. Grant writing and fund-raising became the hallmarks of arts administration—tasks that would have bored Iris to death.

Iris retreated to France. The years there with Kerroux became a bittersweet chapter in her life. Twenty years her junior and Gallic-handsome, there was a Breton's roughness about Kerroux. He was restless and querulous and prone to binge drinking. Being with him upped Iris's penchant for wine, and they often "hit the tiles" in Marius Rochemaure's bar in Fayence. Kerroux was dangerous behind the wheel of a car and likely to come home with a criminal in tow. Iris coped, obviously caring for him despite the disapproval of her friends. Were it not for Chick Austin, who opened his house to them, Iris and Pierre could have become homeless. She received occasional accolades, being honored at the first New York Film Festival, sent as an ambassador by FIAF, and feted by old London friends, but life in Fayence did not become the pastoral dream she envisioned. Iris tried reconciling with her children, moving to London for a time, but the reconciliation was a failure. She was stuck with Kerroux, who was abusive and plotting to defraud her benefactor.

Sustaining Iris through these years was the loyalty of Nelson Rockefeller and the leadership of the Museum of Modern Art. The Museum's executives realized that their private sources of funding could be called upon both for personally benevolent and patriotic causes. The result was steadfast fidelity to key employees and major contributions to national issues. The Museum went to war, but it also stood by those who went along with it. It did not pay them handsomely, but it did not abandon them either.

The last years of Iris's life were extraordinary, fraught with a bizarre move by Kerroux to take control of the Austin house through a loophole in French law. Iris found herself in the embarrassing position of explaining to Chick Austin's

widow that Kerroux believed he had a transferrable right to occupy her house and operate an antiques business there. The Austins had been stalwart friends since the days of the Askew salon. This was their reward. Iris even defaulted on her homage for Chick's memorial ceremony at the Atheneum. Soon throat cancer overcame her, possibly due to a recurrence of her earlier sarcoma, possibly the result of years of smoking. Iris wound up in a hospital in Marseilles, where she died in December of 1969.

Iris Barry lies in a nondescript grave in Fayence. James Thrall Soby, Philip Johnson, Jock Whitney, and Nelson Rockefeller covered her funeral and hospital expenses. A plan to have Isamu Noguchi make a monument for her grave went unrealized. In 2010 the village of Fayence dedicated a small film theater in her name. There is a plot of purple irises near the boule court in the middle of town.

I never met Iris Barry. Perhaps we might not have liked one another if I had. Her personal life was not exemplary, but her professional accomplishments endure. In the world of film—in the many centers of exhibition, education, preservation, and distribution inspired by her example—every day there are benefits traceable to her. She, more than her peers in the field, had the good fortune to put her ideas into practice. When she saw the need to justify film as an art form, there was the *Spectator* to write for. When she felt the need to exhibit films to the public, there was the London Film Society to launch. When she came to understand the vulnerability of the film medium, she founded an organization dedicated to archiving film. And when she got the Film Library up and running, she saw that she could distribute films to new and appreciative audiences. These functions have become the hallmarks of modern film organizations. We who have worked in these organizations, formed in 1979 into the National Alliance of Media Arts Centers, are forever in her debt.

NOTES

Codes for correspondence: TLS, typed letter signed; HLS, handwritten letter signed; TLU, typed letter unsigned; HLU, handwritten letter unsigned. (See also "Sources.")

1. EARLY YEARS

1. Certified Copy of an Entry of Birth, given at the General Register Office, Somerset House, London, June 6, 1963. The "informant" listed is Iris's mother, who chose not to give Iris her father's surname. There is no record of why or when Iris changed her name to Barry, although her grandmother's maiden name was Barry. (From a collection of autobiographical notebooks and memorabilia left behind at her death in Fayence, France, now on deposit as the Iris Barry Papers, The Museum of Modern Art Department of Film Special Collections Archives, New York. Cited hereafter as IBP, MoMA Dept. of Film Archives, NY.)

2. See Jeffrey Meyers, *The Enemy* (London; Routledge & Kegan Paul, 1980), 90. John Tytell, in *Ezra Pound: The Solitary Volcano* (New York: Doubleday, 1987), says on 130 that the venereal disease in question was gonorrhea. This allegation probably comes from Iris Barry's son, Robin Barry, who told the author in an interview in September 1988 that his grandmother had two "boasts," one that she was the first person in England granted a divorce on the grounds of having contracted a venereal disease from her spouse (Robin confirmed it to be gonorrhea), the second that she was the first woman bookmaker in Birmingham. Maisie Wyndham Neil, Iris's second child, dismisses this story, complaining that Robin "is always telling that." Robin Barry had been interviewed previously by Jeffrey Meyers, and by that means the story likely first reached print.

3. IBP, MoMA Dept. of Film Archives, NY.

4. Ibid.

5. Ibid.

6. Ibid.

7. Ibid.

8. Ibid.

9. Ivor Montagu, "Birmingham Sparrow: In Memoriam, Iris Barry, 1896–1969," *Sight and Sound* 39.2 (Spring 1970): 106. This account of Iris's missed opportunity to attend Oxford is also mentioned in the notes taken for a biographical sketch proposed for, but unpublished by, the *New Yorker*,

by Edmund Schiddel and in notes for an unpublished biography of Wyndham Lewis by Victor Cassidy (Robin Barry Collection, a collection of papers given the author by Iris Barry's son in 1988. Robin Barry had intended to write a book about his mother, but ceded the task to the author). The material in this book from Edmund Schiddel is courtesy of the Edmund Schiddel Collection (hereafter cited as Schiddel), Howard Gotlieb Archival Research Center at Boston University's Mugar Library.

10. IBP, MoMA Dept. of Film Archives, NY.
11. Iris Barry, "Double" and "The Fledgling," *Poetry* 8.4 (July 1916): 188–89.
12. IBP, MoMA Dept. of Film Archives, NY.
13. Ibid.
14. Iris Barry, "Lost," *The Living Age* 323 (Nov. 1, 1924): 301.

2. "WE ENJOYED THE WAR"

1. According to *Contemporary Authors* 107 (Detroit: Gale Research), Edmund Schiddel (1909–1982) was born January 7, 1909, in Chicago, educated at the College of William and Mary, A.B. 1933, and was a writer best known for his Bucks County Trilogy (*The Devil in Bucks County, Scandal's Child,* and *The Good and Bad Weather*). He befriended Iris when she had a farm in Bucks County, Pennsylvania, during the early years of World War II.
2. Schiddel, unpublished profile of Iris Barry for the *New Yorker* (Schiddel).
3. Iris Barry, "We Enjoyed the War," *Scribner's Magazine* 96.5 (Nov. 1934): 279–83. Subsequent page numbers are given in the main text.

3. "DEAR MISS BARRY"

1. IBP, MoMA Dept. of Film Archives, NY.
2. Ibid.
3. Ibid.
4. Iris wrote John Widdicombe, an American student she had met in London, that although she considered herself "a working class person, which I am very deeply, though arriviste too because you feel so sensitive about background," she nevertheless had "never asked anybody from school to come and see me because of my home being a small old farm tumbling to bits, and my grandmother in print dresses making butter. The fact that she was a grand person I was too silly to see then." HLS from Iris Barry to John Widdicombe, dated Nov. 3, 1930 (Harry Ransom Center, The University of Texas at Austin, hereafter cited as Austin.)
5. Iris Barry, "Grandmother," *The Adelphi* (Aug. 1924): 236–42.
6. IBP, MoMA Dept. of Film Archives, NY.
7. TLS from Ezra Pound to Iris Barry, Apr. 2, 1916, on deposit in the Poetry Collection of the University Libraries, University at Buffalo, The State University of New York (hereafter cited as Buffalo).
8. Schiddel, unpublished *New Yorker* profile of Iris Barry (Schiddel).
9. Ezra Pound, *The Letters of Ezra Pound* (New York: Harcourt, Brace, 1950), 76.

10. Ibid. The magazine apparently agreed, for while rejecting one poem as "simply too hideous," Pound reported to Iris in June that *Poetry* agreed to publish six poems in the Autumn issue, promising payment of nine pounds. Bruce Fogelman, in *Shapes of Power: The Development of Ezra Pound's Poetic Sequences* (Ann Arbor: UMI Research Press, 1988), 200, found in the University of Chicago Library a previously unpublished letter from Pound to Harriet Monroe, editor at *Poetry*, stating, "I enclose 14 brief poems by Iris Barry. I want you to print the lot, and as soon as possible. . . . She certainly has something in her. More grip and sense of inner form tha[n] the generality of late-imagists. I can't see that anything in this group can be omitted. I have had a bunch of about forty poems to go over and have arranged this group out of it with a good deal of care." The letter was sent sometime after April 1916 and conveys to Monroe an impression of Iris's talent somewhat at odds with what Pound told Iris.

11. Pound, *The Letters of Ezra Pound*, 79. Although the letters from Iris Barry to Pound appear to have been lost, and may after all have been mostly cover letters to packets of poems, many from Pound to Barry were deposited by her in the Buffalo collection in the care of her one-time brother-in-law, Charles Abbott, founder of the collection.

12. Pound, *The Letters of Ezra Pound*, letter 102.

13. Ibid., letter 103.

14. Ibid., letter 106.

15. TLS from Iris Barry to Charles Norman, undated (Austin). In 1916, Iris was 21 years old.

16. Iris Barry, "The Ezra Pound Period," *Bookman* (Oct. 1931): 159.

17. Pound, *The Letters of Ezra Pound*, letter 103.

18. Recounted by Charles Norman in *Ezra Pound* (New York: Macmillan, 1960), 194–95.

19. Ibid.

20. TLS from Ezra Pound to Iris Barry, undated (Buffalo). Later, in a notebook written in Fayence during her retirement, Iris wrote that "His [Pound's] idea, an excellent one in theory, was that one should learn to write by concerning oneself solely with the clear expression of known things—the crumb of bread licked up from the table," etc. One should "gain the use of expressive and ultra-simple (denue) terms. The cat sat on the mat. My cat ran up the tree. But it is true that I had already written—on squared exercise paper—the second of these two short reportages at the age of seven, or less. So, wanting to please and also wanting an occupation (hobby, success), I wrote my autobiography at 18 or 19. This may have been a reason why my two attempts at psychoanalysis much later on bored me so extremely—I had been over the ground rather thoroughly before" (IBP, MoMA Dept. of Film Archives, NY).

21. IBP, MoMA Dept of Film Archives, NY (ellipses in original).

4. THE OTHER BLOOMSBURY

1. Doris L. Eder, *Three Writers in Exile: Pound, Eliot and Joyce* (Troy, NY: Whitston, 1984), 29.

2. TLS from Iris Barry to Charles Norman, undated (Austin).

3. Nancy Cunard, *These Were the Hours: Memories of My Hours Press, Reanville and Paris, 1928–1931* (Carbondale: Southern Illinois UP, 1969), 123.

4. Tytell, *Ezra Pound: The Solitary Volcano*, 93.

5. James Wilhelm, *The American Roots of Ezra Pound* (New York and London: Garland, 1985).

6. Ibid., 179.

7. A poem Iris left behind in a notebook she kept in Fayence, where she lived during the last twenty years of her life, hints at this liaison:

The Lovers

He said he would not stay with me.
"All right," I yawned, indifferent-seeming, beginning to undo my plaits.
He said he'd go as soon as he had taken down my hair.

We laughed so when I told him sleepily
how I had stolen the pins from other girls –
some black, some bronze—the color of the hair
that turned about his fingers in their search.

Somehow it took so long to kiss it smooth.

They laughed in the morning
to find the hairpins—long, short,
bronze, black –
strewn all about the place, and him still there.

Unpublished poem (IBP, MoMA Dept. of Film Archives, NY). In a marginal note the author remarks that she prefers this poem to be in "the *first person*, despite Ezra's having taken it for an individual experience and being shocked as well as [finding it] coarse." Pound may have thought the poem to be about him and Iris.

8. TLS from Ezra Pound to Iris Barry, Jan. 25, 1917 (Buffalo).

9. TLS from Ezra Pound to Iris Barry, Jan. 29, 1917 (Buffalo).

10. TLS from Ezra Pound to Iris Barry, Jan. 31, 1917 (Buffalo). Pound told Iris on February 6 that Mrs. Johns "has written some post-Shavian plays" and that "Florence Farr (Mrs. Emery) is the lady with the psaltery in Yeats' *Celtic Twilight* or *Ideas of Good and Evil*, she is now in Celon. She also acted Ibsen with a Beardsley poster, and I think she discovered Shaw. At least she had the theatre, which as G.B.S. says in his preface, 'discovered me at my own suggestion'. She has also written a few books, and talked a great many more." TLS from Ezra Pound to Iris Barry, Feb. 6, 1917 (Buffalo).

11. TLS from Ezra Pound to Iris Barry, Feb. 12, 1917 (Buffalo).

12. See Steven Watson, *Strange Bedfellows: The First American Avant-Garde* (New York: Abbeville Press, 1991), 55.

13. Iris Barry, "The Ezra Pound Period," *Bookman* (Oct. 1931): 165.

14. In 1967 from Fayence Iris wrote to Ford's biographer, Arthur Mizener, that at these meetings Ford "behaved like an old philanderer" and "did seem rather to ogle and drool generically, when not being intelligent and a raconteur about matters literary, or an editor. I never could understand Stella Bowen taking up with him." Rare and Manuscript Collections, Carl A. Kroch Library, Cornell University (hereafter cited as Cornell). Cornell material reprinted by kind permission of the Wyndham Lewis Memorial Trust, a registered charity.

15. May Sinclair was a novelist, biographer, and philosopher (*A Defense of Idealism*, 1917).

16. Douglas Goldring records in *South Lodge: Reminiscences of Violet Hunt, Ford Madox Ford and the English Review Circle* (London: Constable, 1943), 63, that "during the period of Ezra (Pound's)

grandeur in the early 1930's, when he was organizing concerts on the Italian Riviera and was being courted by the Fascists, the bust was sent for by his admirers. Strong men arrived one day, in green baize aprons, yanked it onto a lorry and dispatched it to Rapallo, where it was erected on a plinth immediately opposite Ezra's favorite cafe." The bust was exhibited at the Solomon R. Guggenheim Museum in New York in 1997.

17. In a hand-written note left among papers on deposit at the Museum of Modern Art, Iris recalls that Violet Hunt, the daughter of the Victorian painter Alfred Hunt, was a "successful but now also forgotten novelist of the century into the mid-twenties. I suppose in a way she was a 'modern' woman. H. G. Wells seemed fond of her. She was also the slightly (but most respectably) bigamous wife of Ford Madox Hueffer, i.e. Ford Madox Ford. Her house on Camden Hill was chock-full of (1) her father's water-colors, (2) drawings, photos, paintings, memorabilia and memories of the pre-Raphaelites, including, very naturally, *William Tell's Son*, which was a portrait, I believe, of Ford Madox Hueffer as a small, rosy-cheeked boy. . . . (3) several smoke-colored Persian cats, (4) of course, Ford Madox Hueffer while he was editing the *Poetry Review* (?)—up to and until after his World War I emphatically uniformed patriotic period, i.e. as not a 'German' but almost desperately an English 'gentleman'; (5) various remains of the *Blast* activity, (6) and of the between *Blast* and Vorticism period of intense activity in letters and art in England. Here, for example, were . . . in the drawing-room the large violent Wyndham Lewis canvases on war . . . themes painted before the War. . . . It was a definitely dainty feminine, turn-of-the-century drawing-room violently dominated by these paintings in which red-scarlet and black predominated. I do not know or never heard why scarlet blinds had been also put into this room, which had a fairly wide, triple-paneled bow window. Blinds there had certainly always been, to prevent the sunlight from fading carpets and upholstery, but scarlet they had certainly not originally been. Violet complained in her light, scattery, self-mocking manner that they 'killed' the Lewis paintings. I suppose Ford had something to do with her, or officially their, buying the paintings. One noticed that the blinds were almost always markedly drawn down if the room were to be used, even if they did 'kill' the Lewis paintings, which Violet can hardly really have *liked* as drawing-room ornaments even if they were very advanced and therefore chic. Shades of Marinetti's successful trip to London, of Frieda Strindberg and Amy Lowell. . . .

"Violet Hunt was not an 'important' person, writer or patron. She was very much in and of her own era. She was—though I see it of course much better now—an education or part of an education for me and my lot. . . . In Violet Hunt there was a quality (how I would hate to say a faith, generosity, ebullience) which afterwards I recognized exactly in Abby Aldrich Rockefeller" (IBP, MoMA Dept. of Film Archives, NY).

18. At some time during the war Arthur Waley got Iris a job at the School of Oriental Studies working with Sir E. Dennison Ross as an assistant librarian (IBP, MoMA Dept. of Film Archives, NY).

19. *The Yellow Book* was a leading literary journal in London in the 1890s.

20. Barry, "The Ezra Pound Period," 165–68. Also during this time, "when Maude Gonne and Countess M got arrested in Liverpool," Iris wrote, "Pound arranged for me to room with Iseult [Gonne] and [her brother] Bichon, wildly amusing but didn't last long" (IBP, MoMA Dept. of Film Archives, NY). Iseult Gonne was Maude Gonne's daughter; Maude Gonne was the subject of some of Yeats's poems. She and Countess Markovich "went to Liverpool with flour in their hair and were arrested." During her brief stay with Iseult Gonne in a flat on Kings Road, along with a parrot monkey and a dachshund, Iris said "detectives watched us night and day" (Schiddel).

21. Many have recounted how Pound appended the signature, "H.D., Imagiste," to a draft of a poem by Hilda Doolittle while lunching with her at the British Museum, thus christening the movement and H.D. as a bona fide member of it. An entertaining recounting of the episode is found in Watson, *Strange Bedfellows*, 66.

22. Watson, *Strange Bedfellows*, 58.

23. Quoted by Watson, ibid.

24. See the versions of *Some Imagist Poets* published by Amy Lowell between 1915 and 1917.

25. A maroon was an incendiary device used as a signal.

26. Barry, "We Enjoyed the War," *Scribner's Magazine* 96.5 (Nov. 1934): 281–82.

27. Wyndham Lewis was a gunner in the war.

28. Barry, "We Enjoyed the War," 283.

5. LIFE WITH LEWIS

1. Ezra Pound, *Guide to Kulchur* (New York: New Directions, 1952), 106.

2. Per Lewis's biographer, Paul O'Keefe, in *Some Sort of Genius: A Life of Wyndham Lewis* (London: Jonathan Cape, 2000), 10. O'Keefe notes that Lewis seemed unaware of the source of his name and preferred only the second part of it or, in some cases, merely his last name as an appellation.

3. Lewis, quoted in Humphrey Carpenter, *A Serious Character: The Life of Ezra Pound* (Boston: Houghton Mifflin, 1988), 243.

4. O'Keefe, *Some Sort of Genius*, 21.

5. Carpenter, *A Serious Character*, 243.

6. Wyndham Lewis, "Ezra: The Portrait of a Personality," *Quarterly Review of Literature* 5.2 (1949): 136; subsequent page numbers are given in the main text. Also see E. Fuller Torrey, *The Roots of Treason: Ezra Pound and the Secrets of St. Elizabeths* (New York: McGraw-Hill, 1984).

7. William Wees, *Vorticism and the English Avant-Garde* (Toronto: U of Toronto P), 1972), 147. For a discussion of Lewis's evolving views of Chaplin, see Scott W. Klein, "Modern Times Against Western Man: Wyndham Lewis, Charlie Chaplin and Cinema" in Andrzej Gasiorek, Alice Reeve-Tucker, and Nathan Waddell, eds., *Wyndham Lewis and the Cultures of Modernity* (Farnham: Ashgate, 2011), 201–222.

8. Torrey, *The Roots of Treason*, 78.

9. O'Keefe, *Some Sort of Genius*, 619.

10. Richard Cork, "What Was Vorticism?," in Jane Farrington, *Wyndham Lewis* (London: Lund Humphries, in association with the City of Manchester Art Galleries, 1980).

11. Douglas Goldring, *South Lodge*, 64.

12. Ibid.

13. Ibid., 65.

14. Ibid. Later, even Lewis took a distanced view of Vorticism. In a letter sent to a London editor in 1956, he claimed that the name Vorticism "is an invention of Ezra Pound. When he writes to me from his prison in Washington he addresses me as 'Old Vort'. What does this word mean? I do not know. How anyone can get angry about it, I cannot imagine, but let me say I did not ask for this meaningless word to be revived by the Tate." W. K. Rose, ed., *The Letters of Wyndham Lewis*

(Norfolk, CT: New Directions, 1963), 567. At the time, an exhibition of Lewis's paintings was being presented by the Tate Gallery in London. Pound was incarcerated for treason after World War II at St. Elizabeth's Hospital in Washington, D.C.

15. Swedish playwright August Strindberg's ex-wife, Frieda, opened this avant-garde nightclub in 1912. It became a nexus of artistic personages, including playwright Oscar Wilde, until it closed due to bankruptcy in 1914. "Omega" was the Bloomsbury Group's design studio—19 Fitzroy Street the home and studio of Bloomsbury artist, Duncan Grant, located next door to Lewis's studio.

16. Wees, *Vorticism and the English Avant-Garde*, 147.

17. IBP, MoMA Dept. of Film Archives, NY.

18. Cork, "What Was Vorticism?" 29.

19. Doris L. Eder, *Three Writers in Exile: Pound, Eliot and Joyce*, 31.

20. Quoted in Carpenter, *A Serious Character*, 243.

21. Wyndham Lewis, *Blasting and Bombardiering* (London: Spottiswoode, 1937), 285. Lewis dismissed Pound, after Pound had left London, as a "revolutionary simpleton" (in *Time and Western Man* [London: Chatto and Windus, 1927], 54) and "the most gentlemanly, discriminating parasite I have ever had" (in his *The Enemy: A Review of Art and Literature* [London: Arthur Press, 1927 and 1929; rpt., London: Frank Cass, 1968], pages vary).

22. IBP, MoMA Dept. of Film Archives, NY.

23. Ibid.

24. Jeffrey Meyers, *The Enemy*, 91.

25. In a notebook kept in Fayence toward the end of her life, Iris recalled an earlier time in which she slipped away with a man named Pascoe Hayward for a weekend at the Tour Eifel Restaurant, the haunt of Lewis and Pound and others, which also rented rooms. "Pascoe and I spent a lovely weekend there," she wrote, noting that "I felt quite guilty; that is to say I still feel guilty not to be with Lewis, who was my man" (IBP, MoMA Dept. of Film Archives, NY).

26. Wyndham Lewis, "The War Baby," *Arts and Letters* 2.1 (Winter 1918): 14–41.

27. However, in January 1961, well after Lewis's death, Iris received from Edmund Schiddel a copy of an article in the *New York Herald Tribune* by Edith Sitwell about Wyndham Lewis. Iris wrote Schiddel that she found the article "terribly funny and so true, poor fellow." TLS from Iris Barry to Edmund Schiddel postmarked January 3, 1961 (Schiddel). The Sitwell article originally appeared in the (London) *Observer*, Nov. 27, 1960.

28. John Pearson, *Facades: Edith, Osbert and Sacheverell Sitwell* (London: Macmillan, 1978), 74.

29. Edith Sitwell, *Taken Care Of: The Autobiography of Edith Sitwell* (New York: Atheneum, 1965), 112. Sitwell biographer John Pearson notes that "this annoyed Edith who had always felt her hands her finest feature" (*Facades*, 271).

30. Sitwell, *Taken Care Of*, 113–14.

31. Ibid., 114.

32. Edith Sitwell, *Aspects of Modern Poetry* (London: Duckworth, 1934), 41.

33. John Lehmann and Derek Parker, eds., *Edith Sitwell: Selected Letters, 1919–1964* (New York, Vanguard, 1970), 43.

34. Lewis, *Blasting and Bombardiering*, 96.

35. Sitwell, *Taken Care Of*, 120–21.

36. Unknown letter from Iris Barry to Walter Michel (author of *Wyndham Lewis: Paintings and Drawings* [Berkeley: U of California P, 1971]), sent from Fayence in the 1960s (Robin Barry Collection).

6. CHILDREN

1. According to Maisie Wyndham Neil, her name was chosen by Lewis from a novel he admired by Henry James, *What Maisie Knew*. The novel focuses on the innocent sensibilities of a young girl abandoned by her divorced parents, who knows what is going on when the new spouses of her birth parents become lovers themselves. (Author's interview with Maisie Wyndham Neil, Sept. 1988).

2. Jeffrey Meyers, *The Dictionary of Literary Biography* 15, edited by Bernard Oldsey (Detroit: Gale Research, 1983), 312. That Lewis fathered two children with Iris Barry is also reported by Caroline Moorehead in *Sidney Bernstein: A Biography* (London: Jonathan Cape, 1984), 20. The earlier child is mentioned by Humphrey Carpenter in *A Serious Character: The Life of Ezra Pound*, 243.

3. Iris related this story to her friend Yvonne Kapp in 1925. Kapp, in turn, told the story to Lewis biographer Jeffrey Meyers in 1978 (Meyers notes, Robin Barry Collection). The incident is described in Meyers's *The Enemy*, 92. Nancy Cunard's biographer, Anne Chisholm, acknowledges that Cunard and Lewis had "a brief affair," but notes that Cunard "soon became tired of his boastfulness about his success with women and his habit of making jealous scenes. A few years later, Lewis, according to his widow, included Nancy in his satirical novel *The Roaring Queen* as the teen-age Baby Bucktrout, bent on seducing the gardener at her mother's country home." Anne Chisholm, *Nancy Cunard, a Biography* (New York: Knopf, 1979), 88.

4. HLS from Iris Barry to Wyndham Lewis, undated (Cornell).

5. O'Keefe, *Some Sort of Genius*, 208.

6. Ibid., 212–13. O'Keefe notes that Robin was cared for by his maternal grandmother "until the age of three of four, then placed in a private children's home at Woodford Green until the age of eleven. He was only made aware of the identity of his parents in adulthood."

7. Both Robin and Maisie, Iris's children, expressed to the author their suspicions that Sidney Bernstein might have been Robin's natural father. It is true that Robin resembled Bernstein and Maisie looked like Lewis. Barry, however, recalled that she first met Bernstein shortly before the founding of the London Film Society in 1925, well after the birth of her children.

8. O'Keefe, *Some Sort of Genius*, 220–21.

9. HLS Wyndham Lewis to Iris Barry, Aug. 5, 1920 (Cornell).

10. O'Keefe, *Some Sort of Genius*, 221–22.

11. Ibid.

12. According to Jeffrey Meyers, Lewis "wanted to get away from the pregnant Iris Barry," and T. S. Eliot "wished to escape from his wife," and so they went on holiday together. Meyers, *The Enemy*, 119.

13. HLS from Wyndham Lewis to Iris Barry, Aug. 21, 1920 (Cornell).

14. O'Keefe, *Some Sort of Genius*, 223.

15. TLS from Wyndham Lewis to Iris Barry, Aug. 28, 1920 (Cornell).

16. Ibid.

17. O'Keefe, *Some Sort of Genius*, 225

18. Ibid., 225–26.

19. TLS from Wyndham Lewis to Iris Barry, Sept. 4, 1920 (Cornell).

20. TLS from Wyndham Lewis to Iris Barry, Sept. 9, 1920 (Cornell).

21. HLS from Iris Barry to Wyndham Lewis. Although undated, this letter is placed in the Cornell collection prior to material dated 1920. However, it seems to come from the time of Iris's convalescence with the birth of her daughter in 1920.

22. HLS from Iris Barry to Wyndham Lewis, Dec. 31, 1920 (Cornell).

23. Iris Barry, handwritten memoir from Fayence, date unknown (IBP, MoMA Dept. of Film Archives, NY).

24. Geoffrey Grigson in "Recollections of Wyndham Lewis," *The Listener*, May 16, 1957, 785, recalled that Lewis made a great impression as a defender of the arts. "If art was something which was not merely a game, or merely cooked up by fashion or by the spirit of the age; if art mattered, then here, long before one understood all that he meant by art, was, clearer than a comet in a midnight sky, Art's Champion." Plainly, Iris shared, or would come to share, Lewis's attitude toward art. This affinity of belief figured strongly in her affections for him.

25. Iris Barry, undated letter from Fayence to Walter Michel, who wrote about Lewis as a painter. Iris dated her days with Lewis as "from about the spring of 1918 to about 1922." She acknowledged that she had been the sitter "for the arms and legs of some of his big battle pictures" and that she "indeed" sat for the large oil *Praxitella*, although she did not know to whom it belonged (Robin Barry Collection). The painting was purchased, according to Paul O'Keefe, at the "Tyros and Portraits" exhibition of Lewis's work at the Leicester Galleries in April 1921 for £100 by Edward Wadsworth (O'Keefe, *Some Sort of Genius*, 231) and now is in the collection of the Leeds Art Museum. Barry was also the subject of several drawings and sketches by Lewis in 1919 and 1920, including some in which she is nude and conspicuously pregnant.

26. At 18 Fitzroy Street, "occupying the top flat in which Augustus John had begun his married life years before" (William Roberts, "Wyndham Lewis, the Vorticist," *The Listener* 57.1460 [Mar. 21, 1957], 470). Osbert Sitwell recalled that in his studio Lewis wore

> a Norwegian fishing cap, made apparently on a pudding-basin model (though the material more suggested brawn)—with a short, fat all-round rim, the front of which just afforded shade to his eyes—had long ousted his black sombrero, in the same way that a robust and rather jocose Dutch convexity had replaced the former melancholy and lean Spanish elegance of his appearance. A carefully produced sense of mystery, a feeling of genuine suspiciousness, emanated from him and pervaded all he did, hovered, even, over the most meagre facts of his daily life in the large, rather empty studio. (Caramba! how the haddock arrived, surreptitiously, after this fashion, and wrapped in a copy of last Monday week's *Daily Mail*—his mind reverted darkly to Lady Rothermere, who had been lately to see his pictures: had she any connection with the happening? Why had the washing—he held it up; had it been washed?—returned on a Tuesday, instead of Friday, what were they up to? And wherefore did the sly rat not emerge from its hole, instead of waiting, waiting there, listening. Why?) But he was covered, too, with bohemian bonhomie, worn like an ill-fitting suit, and he could be, and often was, a diverting companion and a brilliant talker. (Osbert Sitwell, *Laughter in the Next Room* [Boston: Little, Brown, 1948], 36–37)

27. Edith Sitwell wrote in her autobiography that Lewis was "prey to the conviction that Roger Fry and Clive Bell roosted, permanently, on the roof of his studio, in order to observe his slightest movement" (Edith Sitwell, *Taken Care Of*, 115). Despite this "persecution mania," Iris wrote Walter Michel, "no one could be a more amusing companion when he was in a genial mood . . . or more sinister when he was gloomy or suspicious." Lewis had a cat called Bennett toward which he was kind and protective, often warding off "tougher toms" who attempted to invade the small garden behind Lewis's Notting Hill Gate studio. Undated letter from Fayence (Robin Barry Collection).

28. Later when she met Nancy Cunard's mother, Lady Emerald Cunard, Iris recalled that "the magnolia smell of [her] gloved, light-crisp handshake lingered on my paw awhile" (IBP, MoMA Dept. of Film Archives, NY).

29. The "heavenly dress," which Lewis purchased for Iris to improve her job prospects, appears in several of Lewis's drawings of Iris, as well as in his painting, *Praxitella*.

30. In his wartime diary Herbert Read wrote of visiting "Lewis's flat—lots of stairs to go up, but a view and fresh air at the top and the jolliest suite of rooms: 1 bedroom, 1 sitting-room, 1 bathroom, 1 kitchen sort of place (very small). But all very jolly and dainty. I fancy they cost about 35 pounds a year. He had a girl there 'to pour out tea'—I did not catch her name, but she is a young poetess who has not yet published. Quite a nice girl." Herbert Read, "A War Diary," in *The Contrary Experience; Autobiographies by Herbert Read* (London; Faber and Faber, 1963), 139.

 In the early 1940s Iris told Edmund Schiddel that "When Lady Ribblesdale and the Sitwells came to see Lewis I sat in the back room not breathing. I can sit anywhere without moving. That's where I learned it." Schiddel's unpublished *New Yorker* profile of Iris Barry (Schiddel).

31. Lewis defined a "Tyro" in the *Daily Express* of April 11, 1921, as "A new type of human animal like Harlequin or Punchinello—a new and sufficiently elastic form or 'mould' into which one can translate the satirical observations that are . . . awakened by one's race. . . . The Tyro is raw and undeveloped; his vitality is immense, but purposeless, and hence sometimes malignant." Reprinted in O'Keefe, *Some Sort of Genius*, 229.

32. Lewis's *Tyro*. This successor magazine to *Blast* survived for only two issues.

33. IBP, MoMA Dept. of Film Archives, NY.

34. Ibid.

35. TLS from Iris Barry to Wyndham Lewis, undated (Robin Barry Collection). "Frieda" was a name Lewis sometimes used for Iris.

36. TLS from Iris Barry to Wyndham Lewis, undated (Robin Barry Collection).

37. Wyndham Lewis, "Ezra: The Portrait of a Personality," *Quarterly Review of Literature* 5.2 (1949): 142.

38. Schiddel, unpublished *New Yorker* profile of Iris Barry (Schiddel).

39. Handwritten transcription by Victor Cassidy of a letter from Iris Barry to Wyndham Lewis (Robin Barry Collection). Paul O'Keefe writes that Lewis, "in an effort to sell work went to Paris" at the same time as Iris, "taking 60 copies of the *Tyro* with him," and there "renewed his acquaintanceship with Joyce, lectured him about Chinese art, and told him that he found life in London very depressing." Lewis and Joyce got drunk, sat in a gutter during a rainstorm, and commiserated about their illegitimate children. O'Keefe, *Some Sort of Genius*, 231–32.

40. Schiddel's unpublished *New Yorker* profile of Iris Barry (Schiddel).

41. Ibid.

42. Rudolf Stulik, proprietor of the Tour Eiffel on Percy Street off Tottenham Court Road, who had given Lewis, and often Lewis's friends, carte blanche for Lewis's having designed the "Vorticist Room" in his restaurant (see chapter 4). "Stulik liked artists," William Roberts, who assisted Lewis in creating the room, recalled in *The Listener*, "especially was he fond of Lewis, repeating to me often, in his Viennese accent, 'I vould to anyting for Mr. Lewis.'" Peter Quennell recalled that "Stulik allowed his needier patrons an almost unlimited degree of credit; and, though I imagine that, while balancing his books, he sometimes over-charged the rich, the habit brought about his ruin." Peter Quennell, *The Wanton Chase: An Autobiography from 1939* (London: Collins, 1980), 120.

43. HLS from Iris Barry to Wyndham Lewis dated Apr. 14, 1921 (Cornell).

44. Handwritten letter from Iris Barry to Wyndham Lewis, undated (Cornell). During this time Iris ran through a number of jobs, from being the receptionist to a West End veterinarian to selling mortuary vaults (unpublished autobiographical typescript, IBP, MoMA Dept. of Film Archives, NY).

45. The Barry book only slightly parodies Daisy Ashford's. Mostly, it takes another tack entirely, being something of a satiric *roman à clef.* Its outstanding features—the infidelity between the two main characters, the obvious comparison between its central character and Iris as ambitious young women placing hope in men for their advancement, the similarities between the Pound faction of "outs" and the Sitwell faction of "ins," the aristocrats' comparability to the clique leaders such as Violet Hunt and Ford Madox Ford, the taxonomy of the schools of poetry of the time, the similarity between the girl's mother and Iris's, the quirkiness of the male protagonist and his similarity to Lewis, the dark comedy of a divorce court as a spectator sport—these position the book both as autobiography and social criticism.

46. Montagu, "Birmingham Sparrow: In Memoriam," *Sight and Sound* 39.2 (Spring 1970): 107. Iris's stint at the wool shop was earlier, in 1921.

47. *New York Times Book Review*, Oct., 21, 1923, 9.

48. In *Blasting and Bombardiering*, 213–14, Lewis recalls that "for a few years after the War I had *some* money," then "I went underground" for "two or three years" [including the time with Iris] and then "at the end of my money, I made a sortie into the portrait-world."

49. TLS from Iris Barry to Wyndham Lewis, undated (Cornell). At this time Lewis's obligation to her was 15 shillings per week.

50. HLS from Iris Barry to Wyndham Lewis, undated (Cornell).

51. Ibid.

52. HLS from Iris Barry to Wyndham Lewis, undated (Cornell).

53. HLS from Iris Barry to Wyndham Lewis, undated (Cornell).

54. O'Keefe, *Some Sort of Genius*, 233. The year likely was 1923.

55. TLS from Wyndham Lewis to Iris Barry, undated (Cornell).

56. O'Keefe, *Some Sort of Genius*, 233.

57. TLS from Iris Barry to Wyndham Lewis, undated (Cornell).

58. Paul O'Keefe relates that Lewis reported to the Income Tax Inspector that his net income for the year preceding September 1921 was £54.6. Despite this, writes O'Keefe,

He had other expenses. Since his mother's death he had Mrs. Prickett to support, together with Olive Johnson's two children who were now in her care. There was also 27/a week for Maisie's keep in the Home in Sudbury. He bought an outfit of clothes for Iris Barry, enabling her to secure a position at Bertry's of New Bond Street, purveyors of silk and woolen haute couture. This investment in her professional future was doubtless intended as a first step towards making her financially independent of him. It should not be forgotten, however, that only the previous year Lewis had received a considerable amount of money from the sale of his father's property in Southport, not to mention the undisclosed sum he realized on the sale of his mother's business in February. What happened to this capital remains a mystery. It is difficult to believe, even with twice the number of illegitimate children to support, he could have so efficiently exhausted his inheritance in such a short time. Be that as it may, in early August, no longer able to pay his rent, he was finally forced to leave Alma Studios. And even the ignominious removal of his furniture into storage was not without expense. 'The little margin that I expected to have went into moving,' he told Barry.

'The men had to come three days running; lots of things had to be settled up of which I had kept no count.' For the time being homeless, he found temporary lodging with a friend, Bernard Rowland, at 16A Craven Road, Paddington." (O'Keefe, *Some Sort of Genius*, 232–33)

59. TLS from Wyndham Lewis to Iris Barry, undated (Cornell).
60. Ibid.
61. TLS from Wyndham Lewis to Iris Barry, Oct. 29, 1921 (Cornell). In another letter in the Robin Barry Collection, an undated handwritten letter to "Olive," apparently his former mistress Olive Johnson, Lewis confesses, after first asking for confidentiality, that as she knows "I was unable to make a living as a painter. I was turned out of my last studio (an eviction order for rent was drawn against me). Since then I have been devoting myself to writing" to relieve what he calls the "crushing burden" of his debts. Lewis, then, was obligated for the support of at least two pairs of children sired out of wedlock. He was nonetheless productive enough in visual art that, as Paul O'Keefe relates, "by April 1921 he had succeeded in producing an impressive body of drawings and canvases for his exhibition at the Leister Galleries. Iris Barry figured in a number of the works" (O'Keefe, *Some Sort of Genius*, 228).
62. An interview with Maisie Wyndham Neil in September 1988 revealed that she believed she was once successfully left for a time in Lewis's care.

7. ALAN PORTER

1. Schiddel, unpublished *New Yorker* profile of Iris Barry (Schiddel).
2. A copy of their marriage certificate among her papers at the Museum of Modern Art indicates that Iris's "condition" was "spinster," Porter's "bachelor," and that Felix Alan Porter's father, Felix Leach Porter, was a "hardware merchant" (IBP, MoMA Dept. of Film Archives, NY).
3. *The Spectator* 131 (Aug. 11, 1923): 198. The unsigned review notes that the book "is a very amusing satire on modern Mayfair, written by a super-civilized and sophisticated adult in the manner of *The Young Visiters*."
4. Jeffrey Meyers notes, Robin Barry Collection. Yvonne Kapp, wife of the graphic designer Edmond Kapp, was a freelance writer noted for the biography of Karl Marx's daughter, Eleanor. In 1936 she joined the Communist Party and later could have been counted by intelligence agencies as among Iris's radical friends.
5. IBP, MoMA Dept. of Film Archives, NY.
6. *John Clare: Poems, Chiefly from Manuscript* (London: Cobden Sanderson, 1922).
7. Schiddel, unpublished *New Yorker* profile of Iris Barry (Schiddel).
8. IBP, MoMA Dept. of Film Archives, NY.
9. Montagu,"Birmingham Sparrow: In Memorium," *Sight and Sound* 39.2 (Spring 1970): 107.
10. IBP, MoMA Dept. of Film Archives, NY.
11. Recounted in Michael Holroyd, *Lytton Strachey: A Biography* (London: Heinemann, 1967), 519.
12. Alan Porter, *The Signature of Pain and Other Poems* (London: Cobden-Sanderson, 1930).
13. HLS from Alan Porter to W. F. Stead dated July 20, 1921, Beinecke Rare Book and Manuscript Library, Yale University (hereafter cited as Yale). The (London) *Morning Post*, a conservative newspaper, gained notoriety in the 1920s for its anti-Semitism.
14. HLS from Alan Porter to W. F. Stead, dated Nov. 25, 1923 (Yale).
15. Ibid. Iris actually lived with Gonne for only a short period.

16. Handwritten letter signed from Peter Quennell to Jeffrey Meyers dated Mar. 9, 1978 (Robin Barry Collection). In a letter dated February 23, Quennell told Meyers: "I saw Wyndham Lewis only once—at the occasion . . . when I was introduced to Edith Sitwell; and I remember thinking that he looked pallid and sour, rather like a pickled cabbage. He remained almost silent, and we had no conversation."

17. Author's interview with Maisie Wyndham Neil, Sept. 1988.

18. Ibid. Apparently the Porters eventually gained access to the upper stories of the Guilford Street house.

19. Ibid.

20. Ibid.

8. *THE SPECTATOR*

1. Iris Barry, untitled article in *The Spectator*, Feb. 2, 1924.

2. Iris Barry, "American Prestige and British Films," *The Spectator* 135.51 (1925): 52.

3. Ibid.

4. Iris Barry, *The Spectator*, Feb. 2, 1924, 707.

5. Ibid., 788.

6. Iris Barry, *The Spectator*, June 7, 1924.

7. Ibid.

8. Iris Barry, *The Spectator*, Aug. 2, 1924, 158.

9. Iris Barry, *The Spectator*, Sept. 13, 1924, 354. The films in question are *The Birth of a Nation* (1915) and *Intolerance* (1916). Subsequently, Griffith's penchant for nineteenth-century melodrama in such films as *Way Down East* (1920) and *Orphans of the Storm* (1921) seemed out of touch with the emerging Jazz Age.

10. Iris Barry, *The Spectator*, Nov. 15, 1924, 734. *Warning Shadows* (1923) was filmed in Germany by Chicago-born Arthur Robison.

11. Ibid.

12. Iris Barry, *The Spectator*, Dec. 20, 1924, 982.

13. Ibid.

14. Iris Barry, *The Spectator*, July 11, 1925, 52.

15. Iris Barry, *The Spectator*, Feb. 14, 1925, 235.

16. Ibid.

17. Iris Barry, *The Spectator*, Mar. 28, 1925, 497.

18. Likely candidates: D. W. Griffith, G. W. Pabst, F. W. Murnau, Erich von Stroheim, Serge Eisenstein, John Ford, Robert Wiene, and V. I. Pudovkin.

19. Iris Barry, *The Spectator*, Mar. 14, 1925, 401.

20. Iris Barry, *The Spectator*, July 11, 1925, 51.

9. SPLASHING INTO FILM SOCIETY

1. IBP, MoMA Dept. of Film Archives, NY.

2. Iris Barry, *The Spectator*, Sept. 5, 1925, 362–63.

3. Ibid., 363.

4. IBP, MoMA Dept. of Film Archives, NY. In a letter to Missy Daniel, who wrote a biographical sketch of Iris Barry in the 1980s, Sidney Bernstein acknowledged that "I first met her [Iris Barry] through a friend [the Shropshire boy] who had been billeted on her mother's farm in the 1914 War." He also said that he "kept in touch with Iris until her death. She was rare, she was special, a superior person for whom I had the greatest affection and respect" (Robin Barry Collection).

5. TLS from Iris Barry to Sidney Bernstein, dated 1927 (Robin Barry Collection). Caroline Moorehead says (*Sidney Bernstein*, 36) that Sidney and Charles Laughton became friends November 16, 1926, the night of Laughton's triumphant debut as the sleepy treasury official in Arnold Bennett's *Mr. Prohack*.

6. IBP, MoMA Dept. of Film Archives, NY. The Theatre Guild, the theatrical model upon which the London Film Society was based, was also referred to as the Stage Society.

7. Ibid.

8. Ivor Montagu, *The Youngest Son* (London: Lawrence and Wishart, 1970), 268.

9. Adrian Brunel, *Nice Work* (London: Forbes Robertson, 1949), 112.

10. Montagu, *The Youngest Son*, 275–76.

11. IBP, MoMA Dept. of Film Archives, NY.

12. Brunel, *Nice Work*, 112–13. *Nju*, subtitled *Eine Unverstandene Frau*, was directed by Paul Zinner in 1924; *The Last Laugh* was directed by F. W. Murnau, also in 1924.

13. Montagu, *The Youngest Son*, 275–76. Adrian Brunel, with whom Montagu was later to collaborate in film production, was prohibited by his employer, Gainsborough Films, from participating in an organization it viewed as "highbrow." Brunel played an important role in the Society, however, by titling and preparing films for exhibition at cost and permitting some of his own comic short films to be exhibited.

14. Ibid., 276.

15. Montagu, "Birmingham Sparrow: In Memoriam," *Sight and Sound* 39.2 (Spring 1970): 106. Adrian Brunel distinguishes between Council members, the inner circle of the Film Society, and its Founding Members, "twenty-nine in all," which included "Lord Ashfield, Anthony Asquith, George A. Atkinson, Lord David Cecil, Edith Craig, Roger Fry, J. B. S. Haldane, Julian Huxley, Professor Jack Isaacs, Augustus John, E. McKnight Kauffer, J. Maynard Keynes, Angus McPhail, H. F. Rubenstein, Christopher St. John, George Bernard Shaw, J. St. Loe Strachey, Lord Swaythling, Dame Ellen Terry, Ben Webster and H. G. Wells." The Council consisted of "Iris Barry (film critic), Sidney Bernstein (film exhibitor), Frank Dobson (sculptor), Hugh Miller (actor), Ivor Montagu (zoologist), Walter Mycroft (film critic), and myself (film). The secretary was Miss J. M. Harvey (concert agent)" (*Nice Work*, 113).

16. Montagu, *The Youngest Son*, 276–77.

17. Ibid., 277.

18. IBP, MoMA Dept. of Film Archives, NY.

19. Montagu, *The Youngest Son*, 277. Subsequent page numbers are given in the main text.

20. The Café Royal, a much-frequented eatery, served as a place-to-be for more than one generation of British intellectuals. Osbert Sitwell wrote of its "smoky acres of painted goddesses and cupids and tarnished gilding, its golden caryatids and garlands, and its filtered, submarine illumination, composed of tobacco smoke, of the flames from chafing dishes and the fumes from food, of the London fog outside and the dim electric light within" (*Laughter in the Next Room*, 34).

21. IBP, MoMA Dept. of Film Archives, NY.

22. Brunel, *Nice Work*, 113. The Film Society audience was later satirized by Stella Gibbons in her popular novel, *Cold Comfort Farm* (1932), who wrote that it "had run to beards and magenta shirts

and original ways of arranging its neckware; and not content with the ravages produced in its over-excitable nervous system by the remorseless workings of its critical intelligence, it had sat through a film of Japanese life called 'Yes' . . . made by a Norwegian film company in 1915 with Japanese actors, which lasted an hour and three-quarters and contained twelve close-ups of water-lilies lying perfectly still on a scummy pond and four suicides, all done extremely slowly. All round . . . people were muttering how lovely were its rhythmic patters and what an exciting quality it had and how abstract was its formal decorative shading." *Cold Comfort Farm* (New York: Penguin, 1938), 93.

23. Moorehead, *Sidney Bernstein*, 23.

24. Moorehead writes that most Film Society insiders knew Atkinson to be accepting gratuities from American film companies in exchange for favorable reviews of their films. Ibid., 26.

25. Montagu, *The Youngest Son*, 324–26.

26. Moorehead, *Sidney Bernstein*, 24.

27. Haidee Wasson notes that the *Daily Mail* had a daily circulation of "almost 2 million," making Iris's "the most widely distributed film writing of its day." Haidee Wasson, "The Woman Film Critic: Newspapers, Cinema and Iris Barry," *Film History: An International Journal* 18.2 (2006): 157.

28. IBP, MoMA Dept. of Film Archives, NY.

29. Mark Glancy, "Temporary American Citizens? British Audiences, Hollywood Films and the Threat of Americanization in the 1920s," *Historical Journal of Film, Radio and Television* 26.4 (Jan. 22, 2007): 462 and 465.

30. Brunel, *Nice Work*, 123–24.

31. For reports on the progress of the Society, see *London Times* articles on Sept. 12, 1928, 10; May 6, 1929, 4; Sept. 20, 1929, 12; Mar. 17, 1930, 14; Sept. 20, 1930, 8; Nov. 12, 1930, 12; and May 13, 1931, 14.

10. CINEMA PARAGONS, HOLLYWOOD, AND LADY MARY

1. Iris Barry, *The Spectator*, Sept. 19, 1925, 444.

2. Iris Barry, in Rickwood and Garman, eds., *The Calendar of Modern Letters* (Mar.–Aug. 1925); rpt., New York: Barnes and Noble, 1966, 130.

3. Iris Barry, *The Spectator*, Sept. 19, 1925, 208.

4. Ibid.

5. In her book on the aesthetics of film, *Let's Go to the Pictures*, Iris wrote: "Every good film must have the impress of one mind and one mind only, upon it." This view conforms to the theory developed among filmmakers in France in the 1960s that cinematic excellence is to be found among films that are written and directed by one person. Iris Barry, *Let's Go to the Pictures* (London: Payson and Clarke, 1926). This book was republished as *Let's Go to the Movies* (New York: Arno Press/New York Times, 1972). This quote is from the Arno Press edition, 170. *Let's Go to the Movies* was edited by George Amberg, Professor of Cinema at New York University, who worked with Barry at the Museum of Modern Art.

6. Iris Barry, *The Spectator*, June 18, 1927, 1062–63.

7. Iris Barry, *The Spectator*, Mar. 6, 1926, 415.

8. HLS, Iris Barry to Sidney Bernstein, dated Friday, Oct. 14, 1927 (Robin Barry Collection).

9. TLS from Iris Barry to Sidney Bernstein, dated Nov. 1, 1927 (Robin Barry Collection).

10. Iris Barry, *Portrait of Lady Mary* (London: Hazell, Watson and Viney, 1928). Iris said of the book: "The only curious thing about it, really, is the death-bed speech of Lady Mary. I felt

she needed one, so gave her the one I'd made up to use myself. It is now quoted in all the authorities as a famous death-bed speech . . . 'It has all been very interesting'" (Schiddel).

11. Robert Halsband, *The Life of Lady Mary Wortley Montague* (Oxford: Clarendon Press, 1957).

12. HLU, Alan Porter to Iris Barry, undated (IBP, MoMA Dept. of Film Archives, NY).

13. Unsigned article, *Times Literary Supplement*, Feb. 2, 1928, 73.

11. *LET'S GO TO THE PICTURES*

1. All quoted material in this chapter is from the Arno Press/New York Times reissue of *Let's Go to the Pictures* in 1972 as *Let's Go to the Movies*, ed. George Amberg.

2. Iris Barry, *Let's Go to the Movies*, vii–viii. Subsequent page numbers are given in the main text.

3. Ibid., 27. Iris refers the reader to Vachel Lindsay's *The Art of the Moving Picture* (New York: Macmillan, 1915–1922) for a discussion of the cinematic significance of natural objects.

4. Barry, *Let's Go to the Movies*, 29.

5. Ibid., 30.

6. Ibid., 31. Barry's account of her moviegoing experience has certain affinities with contemporary surrealist views on cinema and dreams.

7. Ibid., 42–43. After World War II, as a result of the development of more sophisticated lenses for aerial reconnaissance use, the racking focus lens would be developed, enabling the shift in focal length to variable depth within the picture frame. Yet given the fixed-focus lenses in use at the time, Iris's analysis of how film achieves the illusion of three-dimensionality is perceptive.

8. Michelangelo Antonioni, who began his career as a painter, would much later dispute this contention with his own films, many of which derived their colors from pigments sprayed on structures and landscapes he filmed. He believed that differences in color conveyed differences in emotional significance.

9. Peter Decherney, *Hollywood and the Culture Elite* (New York; Columbia UP, 2005), 173. Decherney argues that Iris's rejection of Maya Deren's *Meshes of the Afternoon* represented a new prejudice against the avant-garde on Iris's part. But as her earlier writing testifies, Iris was reluctantly tolerant of avant-garde film all along.

10. Barry, *Let's Go to the Movies*, 71–73. Barry's eclecticism as a critic is also recognized in Leslie Hankins's excellent review of Barry's early writings, "Iris Barry, Writer and Cineaste, Forming Film Culture in London, 1924–26: the *Adelphi*, *The Spectator*, the Film Society and the British *Vogue*," *Modernism/Modernity* 11.3 (Sept. 2004): 488–515. Hankins notes that "Barry's writing ranges from academic prose articulating highbrow aesthetic theory to breezy slang expressing the delight of a film fan. Her inclusive style and chameleon tone are her most apparent characteristics as a critic" (508).

11. Iris Barry, *The Spectator*, Mar. 26, 1927, 540.

12. Iris Barry, *The Spectator*, Apr. 27, 1929, 646.

13. Ibid.

12. VICTORY AND DEFEAT

1. Rudolf Arnheim, *Film as Art* (Berkeley: U of California P, 1957), 5.

2. TLS from Iris Barry to Wyndham Lewis, July 15, 1928 (Robin Barry Collection).

3. TLS from Iris Barry to Wyndham Lewis, Mar. 19, 1930 (Robin Barry Collection).

4. TLS from Iris Barry to Wyndham Lewis, undated (Robin Barry Collection).

5. TLU from Wyndham Lewis to Iris Barry, Apr. 11, 1930 (Robin Barry Collection).

6. In one of the few favorable notices to appear about the book, Oswell Blakeston said, "Everyone will remember; Miss Barry and *The Daily Mail*, Miss Barry and *Let's Go to the Pictures*, Miss Barry and the Film Society. The novel has a Fritz Lang idea; the death of Death. People cannot die, which worries them a lot. Tuberculosis and cancer patients drink Lysol. Young men murder old mothers to get their inheritance. The churches are packed because life without death, people cry, would be too boring. However, there is not much indication that life with death was too exciting. Everyone will want to read Miss Barry's able book." Blakeston, *Close-Up 6.5* (May, 1930): 429.

 Iris herself later pronounced the book "rather pale and touching." Schiddel, unpublished *New Yorker* profile of Iris Barry (Schiddel).

7. O'Keefe, *Some Sort of Genius*, 286–87.

8. Ibid., 288.

9. Montagu, "Birmingham Sparrow: In Memoriam," *Sight and Sound* 39.2 (Spring 1970): 107.

10. IBP, MoMA Dept. of Film Arcives, NY.

11. Ibid.

12. Ibid.

13. Ibid.

14. Mark Glancy notes that Atkinson called for "British films, viewed from a British angle and made especially with a view to advertising British achievements, customs, manners, and history" ("Temporary American Citizens?" *Historical Journal of Film, Radio and Television* 26.4 [Jan. 22, 2007]: 467). As for Atkinson's ability to speak favorably of American films, see ibid., note 268.

15. Ibid.

16. TLS from Iris Barry to Sidney Bernstein, Sept. 13 (1930?) (Robin Barry Collection).

17. TLS from Iris Barry to Sidney Bernstein, undated (Robin Barry Collection).

18. Ibid.

19. IBP, MoMA Dept. of Film Archives, NY.

20. Leslie Hankins, "Iris Barry, Writer and Cineast," *Modernism/Modernity* 11.3 (Sept. 2004): 488.

13. AMERICA

1. TLS from Iris Barry to Sidney Bernstein, Sept. 16, 1930 (Robin Barry Collection).

2. TLS from Iris Barry to Sidney Bernstein, undated (Robin Barry Collection). The "etiquette book" referred to may be Paul Reboux's *Diet for Epicures* (New York: Brentano's, 1932), which Iris translated in 1932. The novel is *Here Is Thy Victory* (see ch. 12, this volume). The letter also speaks of various attempts to supplement Alan's income as a psychological counselor.

3. TLS from Iris Barry to Sidney Bernstein, Oct. 11, 1930 (Robin Barry Collection).

4. TLS from Iris Barry to Sidney Bernstein, undated (Robin Barry Collection). The return address, 334 East 51st St., was her residence in 1931 and 1932. During 1930 she and Alan lived with Joseph Brewer at 229 East 48th Street. From this address she wrote John Widdicombe that she "felt a bit homeless and pauperlike and sordid outwardly," and that "it seems silly to go on pretending to be a lady and wear evening dress when one's future home is a tenement needing the exterminator." The future home was the East 51st Street address, at the time in need of fumigation. HLS from Iris Barry to John Widdicombe, Nov. 3, 1930 (Austin).

5. HLS from Iris Barry to John Widdicombe, Nov. 3, 1930 (Austin).

6. TLS from Iris Barry to Sidney Bernstein, undated (Robin Barry Collection). Iris is referring to the book she ghostwrote under the name of Jonathan Westerfield, *The Scientific Dream Book and Dictionary of Dreams* (New York: Brewer, Warren & Putnam, 1932). The Pound writing became her 1931 *Bookman* article, "The Ezra Pound Period." No record exists of a ghostwriting job on love in the Arctic.

7. TLS from Iris Barry to Sidney Bernstein, Feb. 19, 1931 (Robin Barry Collection).

8. *New York Times* obituary of Alan Porter, Dec. 3, 1942, 25.

9. TLS from Iris Barry to Sidney Bernstein, Feb. 19, 1931 (Robin Barry Collection).

10. Ibid.

11. Iris Barry, *The Spectator*, Dec. 26, 1931, 876–77.

12. Iris Barry, *The Spectator*, July 11, 1931, 45 and 46.

13. TLS from Iris Barry to Wyndham Lewis, Nov. 9, 1931 (Cornell). An autobiographical fragment at MoMA (IBP, MoMA Dept. of Film Archives, NY) indicates that Iris returned to New York from Montreal on December 5, 1931.

14. THE ASKEW SALON

1. Charles Higham, *Charles Laughton, an Intimate Biography* (New York: Doubleday, 1967), 34–35.

2. IBP, MoMA Dept. of Film Archives, NY.

3. Ibid.

4. Julien Levy, *Memoir of an Art Gallery* (New York: Putnam, 1977), 104–106. In a TLS to the author postmarked Sept. 30, 1985, Margaret Barr points out that Kirk Askew "had taken Paul Sachs' famous museum course at Harvard and was selected to represent the London firm of Durlacher Brothers in N.Y. They were dealers and wanted the firm to be represented in N.Y. I think Kirk was appointed around 1930–31. Constance had decided to leave Arthur McComb, whose daughter Pamela Askew is (Kirk adopted her)." Pamela Askew became a professor of art history at Vassar College.

5. Author's interview with Steven Watson, Feb. 1990.

6. See Draper's book, *Music at Midnight* (New York: Harper and Row, 1929). Also Betsy Fahlman, "The Great Draper Woman: Muriel Draper and the Art of the Salon," *Woman's Art Journal* 26.2 (Autumn 2005–Winter 2006): 33–37.

7. Jane Bowles maintained a lesbian affection for Iris Barry for many years. In a letter dated August 1947, she told Paul that during a recent ten-day stay in New York, she had "slept in a different bed every night, including I.B's (of film research fame). You know who I mean. I.B. was pretty annoyed to find me in her place the next morning, I think, which upset me for a good three days." She also told Paul, in 1948: "I have never been so frustrated by anyone in my life as I am being right now—except by Iris Barry, and that lasted eleven years." In a 1949 letter to Katherine Hammil, she wrote: "P.S. I had a letter from Iris Barry, the first in twelve years of my courtship. A friendly note." Apparently Iris did not respond as Jane would have liked. See Millicent Dillon, ed., *Out in the World: Selected Letters of Jane Bowles, 1935–1970* (Santa Barbara: Black Sparrow Press, 1985).

8. Author's interview with Virgil Thomson, Feb. 1990.

9. Gena Dagel Caponi, *Paul Bowles, Romantic Savage* (Carbondale: Southern Illinois UP, 1994), 115. Duchamp was not a surrealist and had been living in New York since 1915.

10. IBP, MoMA Dept. of Film Archives, NY.

11. Ibid.

12. TLS from Iris Barry to Sidney Bernstein, undated, with the return address of 334 East 51st St., Iris's official residence between 1930 and 1932 (Robin Barry Collection).

13. Russell Lynes, *Good Old Modern: An Intimate Portrait of the Museum of Modern Art* (New York: Atheneum, 1973), 109.

14. Author's interview with Philip Johnson, Sept. 1985. Russell Lynes notes that Bernard Karpel, a book librarian at the Museum after Iris, remarked that he "understood Iris went to library school for forty-eight hours," but that it was nevertheless the official position of the Museum that she learned her profession at the Library School of Columbia University. Lynes, *Good Old Modern*, 110.

15. See the correspondence from Iris Barry to John Widdicombe (Austin).

16. Hugh Thomas, *John Strachey* (London: Eyre Methuen, 1973), 70.

17. Ibid. Gerald Murphy is memorialized by Calvin Tomkins in *Living Well Is the Best Revenge* (New York: Modern Library, 1998).

18. Thomas, *John Strachey*, 71.

19. Levy, *Memoir of an Art Gallery* 152.

20. Ibid., 152–55.

21. TLS from Iris Barry to Sidney Bernstein, received Apr. 1933 (Robin Barry Collection).

22. Porter obituary, *New York Times*, Dec. 3, 1942, 25.

23. TLS from Iris Barry to Sidney Bernstein, received Apr. 1933 (Robin Barry Collection).

24. TLS from Iris Barry to Sidney Bernstein, undated but received in Oct. 1933 (Robin Barry Collection).

25. Alice Goldfarb Marquis, *Alfred H. Barr Jr.: Missionary for the Modern* (New York: Contemporary Books, 1989), 93.

26. TLS from Iris Barry, undated but received in Oct. 1933 (Robin Barry Collection).

27. TLS from Ezra Pound to Iris Barry, undated but filed as written in Nov. 1933 (Buffalo).

28. TLS from Ezra Pound to Iris Barry, dated Dec. 8, 1933 (Buffalo).

29. Ibid.

30. TLS from Iris Barry to Sidney Bernstein, Mar. 15, 1934 (Robin Barry Collection).

31. Moorehead, *Sidney Bernstein*, 94. Peter Decherney claims that Montagu "was a socialist when the [film] society began in 1925, and he joined the Communist Party in 1929. Montagu went on to be the president of the Communist Party in Great Britain and a successful Soviet spy." Decherney, *Hollywood and the Culture Elite*, 111.

15. MUSEUM MEN

1. Biographical information is from "Alfred H. Barr, Jr.'s Chronicle of the Years 1902–1929," compiled by Rona Roob of the Museum of Modern Art in collaboration with Margaret Scolari Barr, in *The New Criterion* 5.11 (Special Issue, 1987). Subsequent page numbers are given in the main text.

2. Alice Goldfarb Marquis, *Alfred H. Barr Jr.*, 128.

3. Alfred Barr, Jr., "Notes on Departmental Expansion of the Museum," typescript dated June 24, 1932, Department of Film Archive Records, The Museum of Modern Art Department of Film Special Collections Archives, New York. Curiously, Barr did not recognize jazz as a twentieth-century art form.

4. Author's interview with Dorothy Miller, Sept. 1985.
5. Levy, *Memoir of an Art Gallery*, 137–38. Austin was dismissed from his job as director of the Wadsworth Atheneum in 1944.
6. Ibid., 80–81.

16. REMARRIAGE

1. Barry, *Let's Go to the Movies*, 64. (See ch. 11, note 1, of the present volume.)
2. Ibid., 64–65.
3. TLS from Iris Barry to Sidney Bernstein, Mar. 15, 1934 (Robin Barry Collection).
4. Ibid.
5. Ibid.
6. Moorehead, *Sidney Bernstein*, 73.
7. Ibid.
8. Ibid., 75–76.
9. TLS from Iris Barry to Sidney Bernstein, Aug. 2, 1934 (Robin Barry Collection).
10. Ibid.
11. TLS from Iris Barry to Sidney Bernstein, Aug. 20, 1934 (Robin Barry Collection).
12. TLS from Iris Barry to Annie Gow Abbott, Aug. 6, 1934, collection of Charles Abbott (Buffalo).
13. Ibid. The *Scribner's* article was "We Enjoyed the War" (Nov. 1934). No independent record exists of the Afghanistan book.
14. TLS from Iris Barry to Charles Abbott, undated (Buffalo).
15. IBP, MoMA Dept. of Film Archives, NY.
16. Ibid. Iris recalled that "when Dick and I divorced I kept none of it (the silver) but bought some silver from a good old shop in New York (Altman's) with which I am serving myself today all the days. But I did keep a few nice old tablespoons—coin silver and one grand turkey spoon. Plus a few things I had (but husband by husband, what a loss!)."
17. Ibid.
18. Ibid.
19. Ibid.
20. Ibid.

17. SETTLING IN

1. IBP, MoMA Dept. of Film Archives, NY.
2. Whitney, also known as "Jock," was a constant supporter of the Film Library, although perhaps because of his industry connections he chose to remain in the background. In January of 1937, for example, Conger Goodyear, president of the Museum's Board, wondered in a letter to Nelson Rockefeller whether Jock Whitney would "wish to have it known that the Film Library is so largely supported by him. Of course, the subscription of the Rockefeller Foundation is by far the largest one and I assume there would be no objection to making that known." TLS from Conger Goodyear to Nelson Rockefeller, Rockefeller Family Archives (hereafter cited as Rockefeller), Record Group 4, Series: Projects, box 150, folder 1482.

Whitney had entered Hollywood as an entrepreneur of Technicolor with David O. Selznick in Selznick International Pictures, each holding 42 percent of the Technicolor firm in the early thirties. After producing *Becky Sharp*, the first attempt at the use of Technicolor in a feature-length film, in 1936 he became an equal partner in the business. Among the films the company produced were *Nothing Sacred*, *A Star Is Born*, *Rebecca*, and *Gone With the Wind*. Whitney headed the Board of the Film Library from its inception, led the film division of Nelson Rockefeller's Office of the Coordinator of Inter-American Affairs in the early forties, and served as Chairman of the Board of Trustees of the Museum of Modern Art from 1946 to well after Iris's departure in 1950. See E. J. Kahn, Jr., "Man of Means" (profile of Jock Whitney), *The New Yorker*, Aug. 18, 1951.

3. IBP, MoMA Dept. of Film Archives, NY. This article appears not to have been published by the *Delineator*. *The Delineator* was the name of the Sunday magazine of the *New York Herald Tribune* and may also be the name of another magazine of the period.

4. Raymond J. Haberski, *It's Only a Movie! Films and Critics in American Culture* (Lexington: UP of Kentucky, 2001), 84–85.

5. Haidee Wasson, "The Cinematic Subtext of the Modern Museum: Alfred H. Barr and MoMA's Film Archive," *The Moving Image: Journal of the Association of Moving Image Archivists* 1.1 (Spring, 2001): 19. An account of the founding of the Film Library can also be found in Mary Lea Bandy, "Nothing Sacred: 'Jock Whitney Snares Antiques for the Museum,' the Founding of the Museum of Modern Art Film Library," in *The Museum of Modern Art at Mid-Century: Continuity and Change* (New York: Abrams/MoMA, 1995).

6. Haberski, *It's Only a Movie!*, 85.

7. See Ron Chernow, *Titan: The Life of John D. Rockefeller, Sr.* (London: Warner Books, 1998), 291.

8. Haberski, *It's Only a Movie!*, 86.

9. Lynes, *Good Old Modern*, 112.

10. Milton Bracket in the *New York Times*, July 14, 1935, E10.

11. The Rockefeller Report (Rockefeller, Record Group 4, Series: Projects, box 139, folder 1367). This box also contains a statement of purpose for the Film Library and an enumeration of its functions:

The purpose of the Film Library of the Museum of Modern Art is therefore to trace, catalog, assemble, preserve, exhibit and circulate to museums and colleges single films or programs of all types of films in exactly the same manner in which the Museum traces, catalogs, exhibits and circulates paintings, sculpture, models and photographs of architectural buildings, or reproductions of works of art, so that the film may be studied and enjoyed as any other one of the arts is studied and enjoyed.

The specific activities whereby this purpose would be accomplished were:

1. To compile and annotate a card index of all films of interest or merit of all kinds produced since 1889, both American and foreign.

2. To trace, secure and preserve the important films, both American and foreign, of each period since 1889.

3. To exhibit and assemble these films into programs for exhibitions in New York and throughout the country by colleges, museums and local organizations.

4. To circulate projection machines to colleges and museums lacking this facility until such time as they secure their own equipment.

5. To compose program notes on each exhibition, which would include a critical appraisal of the films and aid the student in appreciation of the medium.

6. To assemble a library of books and periodicals on the film, and of other historical and critical material including the vast amount of unrecorded data which is still in the minds of men who developed the film. If the history of the formative period is to be preserved, it is necessary to secure this information at once for otherwise it will be irrecoverably lost at the death of these men.

7. To assemble and catalogue a collection of film "Stills." (Photographs made during production).

8. To preserve and circulate the musical scores which were originally issued with the silent films and to arrange musical scores (sheet music or phonograph records) to be circulated with the silent programs when needed.

9. To act as a clearing house of information on all aspects of the film, and to maintain contacts with all interested groups, both in America and abroad.

10. To make available the sources of technical information to amateur makers of film.

11. To publish a Bulletin with articles and illustrations to make known the Film Library's activities and to further the appreciation and study of the motion picture.

In order to show that this kind of activity would meet with an appreciative audience, the report cites the successful exhibition, during the previous winter, of ten films at the Wadsworth Atheneum in Hartford and the overwhelming interest shown by college presidents and others responding to the questionnaire about their interest in film.

12. TLS from Iris Barry to Annie Gow Abbott, Apr. 18, 1935 (Buffalo).

13. The art collector Albert Barnes. Barnes, a patent-medicine entrepreneur, amassed the impressive Barnes Collection, which he exhibited beginning in 1922 in Merion, Pennsylvania, a suburb of Philadelphia.

14. TLS from Iris Barry to Charles Abbott, Apr. 18, 1935 (Buffalo).

15. TLS from Iris Barry to Charles Abbott, undated (Buffalo).

16. Ibid.

17. Museum of Modern Art press release dated June 21, 1935 (IBP, MoMA Dept. of Film Archives, NY).

18. William Troy, *The Nation* 141.36 (July 26, 1935): 112.

18. CRACKING HOLLYWOOD

1. IBP, MoMA Dept. of Film Archives, NY.

2. TLS from Iris Barry to Sidney Bernstein, Aug. 1, 1935 (Robin Barry Collection).

3. Barry, *Let's Go to the Movies*, 58–59. (See ch. 11, note 1, of the present volume.) In 1973 Jean Eustache explored this concept in *The Mother and the Whore*.

4. Draft of an article written for the *Delineator*, intended for publication in October 1936 (IBP, MoMA Dept. of Film Archives, NY).

5. Ibid.

6. John E. Abbott, "Pickfair Dinner Speech," Aug. 25, 1935 (John Abbott Speeches, Library of Congress material, box 02-D, DOFA, MoMA Dept. of Film Archives, NY).

7. Iris Barry activity file for 1935–39 (IBP, MoMA Dept. of Film Archives, NY).

8. Haberski, *It's Only A Movie!*, 89.
9. TLS from Iris Barry to Chick Austin, Sept. 6, 1935, Austin materials, Wadsworth Atheneum, Hartford (hereafter cited as Hartford).
10. IBP, MoMA Dept. of Film Archives, NY.
11. TLS from Iris Barry to Sidney Bernstein dated Dec. 12, 1935 (Robin Barry Collection).

19. ART HIGH AND LOW

1. See Haberski, *It's Only a Movie!*, 52–53. The National Board of Review of Motion Pictures was an industry organization formed in 1916 that both promoted outstanding films and assured that they were not offensive.
2. Quoted in ibid., 60.
3. Alfred Barr, "Sergei Mikhailovich Eisenstein" (orig. 1928), reprinted in Amy Newman and Irving Sandler, eds., *Defining Modern Art: Selected Writings of Alfred H. Barr, Jr.* (New York: Abrams, 1986), 146.
4. Haberski, *It's Only a Movie!*, 83.
5. Sandler, "Introduction," in *Defining Modern Art*, 13.
6. The *Kunsthalle/Kunstmuseum* distinction blended well in Barr's years at MoMA, but after his tenure the latter emphasis took effect until, supported by National Endowment for the Arts funding, the "alternative spaces" movement of the sixties drew attention away from traditional museums. Large paintings, conceptual works, and performance art challenged standard museum practices and architecture. MoMA attempted to accommodate these developments, with mixed results, in the redesign of the Museum by Yoshio Taniguchi in 2004.
7. Sandler, "Introduction," in *Defining Modern Art*, 14.
8. John Abbott, "The Motion Picture and the Museum," 1935 (John Abbott Speeches, Library of Congress material, box 02-D, DOFA, MoMA Dept. of Film Archives, NY, 12).
9. Iris Barry, untitled speech, Apr. 1936 (Early Material, box 01-12, DOFA, MoMA Dept. of Film Archives, NY, 4). In this regard Barry prefigured the approach taken later by scholars such as Robert Sklar in his study of film and society, *Movie-Made America* (New York: Random House, 1975).
10. Haidee Wasson, "What's Old Is New Again: Film History's New York Debut," *Continuum: Journal of Media and Cultural Studies* 12.3 (1998): 251.
11. Ibid., 250.

20. ON TO EUROPE

1. Autobiographical typescript (written in the third person), 26 (IBP, MoMA Dept. of Film Archives, NY).
2. TLU from James Clement Dunn, Chief, Division of Western European Affairs of the State Department to John Abbott, Director, the Film Library of the Museum of Modern Art, Apr. 23, 1936 (copy provided the author from the National Archives Reproduction Services in 1994 through the Freedom of Information Act).
3. *Report of the Museum of Modern Art Film Library as of November 6, 1936* (Rockefeller, Record Group 4, Series: Projects, box 250, folder 2984). The language of this report suggests that it was written by Iris and not by Abbott.

4. Ibid., 2–3.
5. IBP, MoMA Dept. of Film Archives, NY.
6. *Report of the Museum of Modern Art Film Library as of November 6, 1936*, 1–2.
7. Ibid.
8. Ibid. This sort of technical exhibition is now the province of the American Museum of the Moving Image (AMMI), located in the old Astoria Studios in Queens. AMMI is modeled after the British Museum of the Moving Image (BMMI), founded in London in 1988.
9. IBP, MoMA Dept. of Film Archives, NY.
10. Ibid.
11. Ibid.
12. Ibid.
13. Ibid.
14. Ibid.
15. Ibid.
16. Ibid.
17. Ibid.
18. Ibid.
19. Ibid.
20. John Abbott, *New York Times*, Sept. 5, 1936, sec. 9, p. 4.
21. *New York Times*, Sept. 27, 1936, sec. 2, p. 4.
22. Robin Barry became an architect and wrote *The Construction of Buildings* (London: Blackwell's, 1958), a five-volume work that went through several editions and came to be widely used by lecturers and students of architecture.
23. TLS from Iris Barry to Sidney Bernstein, Feb. 2, 1937 (Robin Barry Collection). Bernstein had married Zoe Farmer on November 11, 1936. Upon hearing of the marriage, Iris wrote him that she and Dick "were of course delighted with the news and wish you and Zoe all happiness. You had better tell her that several ladies in New York turned pale beneath their makeup on hearing about it all." TLS from Iris Barry to Sidney Bernstein, Jan. 29, 1937 (Robin Barry Collection).

21. GOING PUBLIC

1. *New York Times*, Jan. 8, 1936, 22.
2. *New York Times*, Nov. 16, 1938, 27.
3. TLS from Iris Barry to Richard Cobden-Sanderson, Oct. 26, 1937 (Austin).
4. James Card, *Seductive Cinema* (New York: Knopf, 1994), 108. On the other hand, Card credits Iris and the Museum for sheltering the initial collection of his own archive before it was housed in the home of George Eastman (97).
5. The Film Library at the time was not yet located on 53rd Street.
6. Card, *Seductive Cinema*, 108.
7. TLS from John Abbott to John Marshall (Rockefeller, Record Group 4, Series: Projects, box 250, folder 2985).
8. The *New York Times* of October 2, 1938, reported that five times the number of students who could be admitted were let in. This led to the course's repetition in 1938–39 in association with the Department of Fine Arts of Columbia University.

9. Transcript, "Columbia University—University Extension Film Study—Museum of Modern Art Film Library," reported by Agnes Boyd (IBP, MoMA Dept. of Film Archives, NY).

10. Erwin Panofsky (1892–1968) was a German art historian noted for his work in iconography, the analysis of recurrent symbols in art. His works include *Studies in Iconology* (1939).

11. Transcript, "Columbia University—University Extension Film Study."

12. Arthur Knight, "I Remember MoMA," *The Hollywood Reporter*, Apr. 21, 1978, 19.

13. Thomas Y. Levin, "Iconology at the Movies: Panofsky's Film Theory," *Yale Journal of Criticism* 9.1 (1996): 28. Panofsky reworked his lecture, which he first presented at Princeton in 1936 as "On Movies" as "Style and Medium in the Motion Picture," in *Transition* 26 (1937), his often-anthologized essay on film as art.

14. Erwin Panofsky, "On Movies," *Bulletin of the Department of Art and Archaeology of Princeton University* (June 1936): 5.

15. Bosley Crowther, interview with John Abbott, *New York Times*, Oct. 3, 1937, sec. II, p. 5.

16. Ibid.

17. *New York Times*, Dec. 21, 1937, 27.

22. THE SLOW MARTYRDOM OF ALFRED BARR

1. See Lynes, *Good Old Modern*, 240–63; Marquis, *Alfred H. Barr*, 202; and Serge Guilbaut, *How New York Stole the Idea of Modern Art* (Chicago: U of Chicago P, 1983), 84. Joe Milone was a Sicilian bootblack the young sculptor Louise Nevelson noticed on the street. Impressed by Milone's colorful boot stand, she learned that he had an even more elaborately decorated one installed in his apartment. When she told Barr about this, he went to Milone's home and was so impressed with this work of outsider art that he had it installed at MoMA during the Christmas season. This decision rankled Board President Stephen Clark and others.

2. TLU from Thomas Mabry to Conger Goodyear, June 10, 1937 (Rockefeller, Record Group 4, Projects, box 122, folder "MoMA," 2).

3. TLS from Thomas Mabry to Nelson Rockefeller, undated (Rockefeller, Record Group 4, Projects, box 122, folder "MoMA," 1). In an interview with the author in September 1985, Dorothy Miller, long the curator of American paintings at the Museum, said that Monroe Wheeler "came on strong for years in a bid for Alfred's job," and when he failed, settled in as director of publications, "which he did very well."

4. Ibid.

5. TLU from Thomas Mabry to Conger Goodyear, June 10, 1937 (Rockefeller, Record Group 4, Projects, box 122, folder "MoMA," 3).

6. TLS from Thomas Mabry to Nelson Rockefeller, May 3, 1938 (Rockefeller, Record Group 4, Series: Projects, box 122).

7. Ibid., 2.

8. TLS from Conger Goodyear to Nelson Rockefeller, May 9, 1938 (Rockefeller, Record Group 4, Series: Projects, folder "MoMA").

9. Ibid.

10. Ibid.

11. Copy of letter from Joseph Hudnut to Conger Goodyear, June 20, 1938 (Rockefeller, Record Group 4, Series: Projects, folder "MoMA").

12. TLS from Conger Goodyear to Stephen Clark and Nelson Rockefeller, Sept. 23, 1938 (Rockefeller, Record Group 4, Series: Projects, box 122, folder "MoMA").

13. Margaret Barr, "Our Campaigns," *New Criterion* 5.11 (Special Issue, 1987): 55.

14. Ibid.

15. Oral history interview with Stanton L. Catlin, July 1–Sept. 14, 1989, Archives of American Art, Smithsonian Institution, 33.

16. Margaret Barr, "Our Campaigns," 56.

17. Ibid.

18. Ibid.

19. Marquis, *Alfred H. Barr*, 200.

20. Margaret Barr, "Our Campaigns," 59.

21. Ibid., 56.

22. During lunch with the author in September 1985, Monroe Wheeler refused to comment for the record about his tenure at the Museum.

23. Margaret Barr, "Our Campaigns," 62.

24. Ibid.

25. Catlin, oral history interview, 33.

26. Margaret Barr, "Our Campaigns," 64.

27. Per the author's September 1985 interview with Dorothy Miller, who also recalled that Abbott was among the first on his block to get a television set for watching baseball. Stephen Clark was a principal benefactor of the Baseball Hall of Fame in Cooperstown, N.Y.

28. Margaret Barr, "Our Campaigns," 65.

29. Author's interview with Dorothy Miller, Sept. 1985.

30. Margaret Barr, "Our Campaigns," 68. The fare on the Madison Avenue bus was five cents and a dime on Fifth.

31. Author's interview with Dorothy Miller, Sept. 1985.

32. Margaret Barr, "Our Campaigns," 69.

33. Author's interview with Dorothy Miller, Sept. 1985.

34. Margaret Barr, "Our Campaigns," 69.

35. Ibid.

36. Author's interview with Dorothy Miller, Sept. 1985.

37. James Thrall Soby, "The Changing Stream," in *Studies in Modern Art*, vol. 5, *The Museum of Modern Art at Mid-Century: Continuity and Change* (New York: Museum of Modern Art, 1995), 183–227. Frances Hawkins became Secretary of the Museum, a position for which she was recommended by Lincoln Kirstein. As such she was Abbott's chief aide (Lynes, *Good Old Modern*, 247). Lynes also says that "Others [on the MoMA staff] who are unwilling to exonerate Abbott thought that Wheeler was also at Clark's elbow in this matter, but, whatever the truth may have been, and everyone who played a major role in the Museum's politics at the time is now reluctant to lay blame on anyone except Abbott, who has long been safely dead, it was Clark who made the decision" (ibid.). Margaret Barr incorrectly described Lynes's account of the demotion as "watertight" (interview with the author, Sept. 1985).

38. James Thrall Soby Papers, MoMA Archives, vol. 66a.

39. *Bulletin of the Museum of Modern Art* 11.4 (1944): 20.

40. Emily Genauer, "The Fur-Lined Museum," *Harper's*, July 1944, 129–38.

41. Ibid.

42. Ibid.

43. Ibid., 138.

44. Marquis, *Alfred H. Barr*, 201.

45. Author's interview with Dorothy Miller, Sept. 1985.

46. TLS from Margaret Barr to the author, Oct. 14, 1985. After his rehiring as "Director of the Collections," Alfred Barr's responsibilities were spelled out in a confidential memorandum now in the Rockefeller Family Archive. The memo splits off the responsibilities of a new position called the Director of the Department of Painting and Sculpture, who "shall, within the administrative frame of the Museum, be responsible for the preparation and execution of all loan exhibitions and of publications connected with such exhibitions. He shall conduct the Museum's contacts with artists, art galleries, art scholars, art students, and the public at large on all matters related to painting and sculpture, except those concerned with the Museum Collections which shall be referred to him, with his recommendations, to the Director of the Collections and the Committee."

Barr, as Director of the Collections, "shall be responsible to the Committee on the Museum collections and the Board of Trustees. He will generally be responsible for the planning, organization, care and use of the collections as a whole, including acquisitions and eliminations. Under his general supervision, the heads of the various curatorial departments will assume their responsibility for their respective sections of the Collections and will be expected to initiate and carry on the work related to their fields. In Painting and Sculpture, however, the Director of the Collections will retain the specific responsibilities of conducting the activities of that section of the collections with the understanding that he may delegate responsibility for specific phases of the work. The amount of time to be devoted to the Collections by the various departments shall be established in agreement between the Director of the Collections and the Director of Program Departments [Monroe Wheeler], the Director of Curatorial Departments [Rene d'Harnoncourt], the Business-Manager [Ione Ulrich], and the Secretary of the Museum [John Abbott]."

All authority for acquisitions and eliminations from the collection was to be delegated, one at a time, to Barr by the Committee on the Museum Collections, who set strict limits of the amounts to be spent ("a renewable sum of $5,000 with individual purchases up to $1,000"). Any acquisition must be approved both by Barr and the head of the curatorial department in question, and the department heads were to be allowed to bring any disagreements they had with Barr to the committee. In short, Barr was subject to considerable checks-and-balances. TU memorandum (Rockefeller, Record Group 4, Series: Projects, box 150, folder 1482).

47. Margaret Barr, "Our Campaigns," 70.

48. Ibid., 73.

49. Author's interview with Nellie Soby, Sept. 1985.

50. Author's interview with Dorothy Miller, Sept. 1985.

23. MEANWHILE, BACK AT THE LIBRARY

1. Mary Lea Bandy, "Nothing Sacred," in *The Museum of Modern Art at Mid-Century*, 91.

2. *New York Times*, Jan. 12, 1938, 23.

3. *New York Times*, Mar, 16, 1938, 21.

4. Ibid.

5. *New York Times*, Oct. 28, 1938, 26.

6. Waterston, quoted in "Gender in Libraries and Archives: Iris Barry as a Case Study," undated, 8; see www.ischool.utexas.edu/~gemma/portfolio/projects/gender.

7. Maurice Bardeche and Robert Brasillach, *The History of Motion Pictures* (New York: Norton and the Museum of Modern Art, 1938).

8. *New York Times*, Jan. 16, 1939, 10.

9. *New York Times*, Jan. 29, 1939, sec. 9, p. 4.

10. Ibid.

11. *New York Times*, Apr. 23, 1939, sec. 10, p. 5.

12. *New York Times*, May 10, 1939, 27.

13. Ibid. Also in connection with the 1939 World's Fair and the opening of the Museum building, the popular newsreel series, *The March of Time* (1935–1951), featured the Film Library in a segment titled "The Movies March On."

14. Eileen Bowser, ed., *Film Notes* (New York: The Museum of Modern Art, 1964). Also see "Film Notes. Part 1: The Silent Film," *Bulletin of the Museum of Modern Art* 16.2–3 (1949). The influence of the film notes of the Museum of Modern Art is a promising subject for further study.

15. *New York Times*, Apr. 28, 1939, 21.

16. *New York Times*, May 11, 1939, 29.

17. Ibid.

18. Ibid.

19. *New York Times*, Aug. 13, 1939, sec. 9, p. 3.

20. *New York Times*, Oct. 3. 1939, 21.

21. *New York Times*, Oct. 1, 1939, sec. 2, p. 2. In May of 2013 the Museum announced that it would be open seven days a week.

22. Ibid.

23. *New York Times*, Jan. 7, 1940, sec. 9, p. 5.

24. NEW WORK, OLD ACQUAINTANCES

1. Jimmy Ernst, *A Not-So-Still Life* (New York: St. Martin's, 1984), 155. Subsequent page numbers are given in the main text.

2. Here Ernst is thinking about *Way Down East*.

3. Charles Norman, *Ezra Pound*, 362.

4. Margaret Barr, "Our Campaigns," *New Criterion* 5.11 (Special Issue, 1987): 55.

5. Rose, ed., *The Letters of Wyndham Lewis*, 263.

6. Wyndham Lewis, "Hitler," *Time and Tide*, Jan. 17, 1931, 59.

7. O'Keefe, *Some Sort of Genius*, 303.

8. Quoted in ibid., 365. Subsequent page numbers are given in the main text.

9. Rose, ed., *The Letters of Wyndham Lewis*, 267.

10. Ibid.

11. TLS from Iris Barry to Wyndham Lewis, Oct. 24, 1939 (Cornell).

12. Ibid. Paul O'Keefe notes that in a June 1938 exhibition of Lewis's work in London, Barr purchased the oil study of Lewis's portrait of T. S. Eliot for a Mrs. Resor. Barr promised Lewis he would try to secure a commission for Mr. Resor's portrait for Lewis, but nothing came of it. O'Keefe, *Some Sort of Genius*, 419.

13. HLS from Wyndham Lewis to Iris Barry dated "1939" (Cornell).

14. The nickname, according to W. K. Rose, "began as a humorous corruption of 'Frau Anna.' A German woman friend in London had so addressed Mrs. Lewis, and L., amused, had followed suit." Rose, ed., *Letters of Wyndham Lewis,* 273.

15. O'Keefe, *Some Sort of Genius,* 269. Subsequent page numbers are given in the main text.

16. Jeffrey Meyers, *The Enemy,* 253.

17. In these articles Lewis vilified Picasso on the occasion of his one-man show staged at the Museum of Modern Art by Alfred Barr and announced the "death of abstract art." These imprudent moves, Meyers says, "roused strong feelings against him in the art and literary circles where he had hoped to earn a living." Meyers, *The Enemy,* 254.

18. HLU from Wyndham Lewis to Iris Barry, Oct. 27, 1940 (Cornell).

19. Ibid.

20. Author's interview with Maisie Wyndham Neil, Sept. 1988.

21. HLS dated Oct. 28 (no year) from Iris Barry to Wyndham Lewis (Robin Barry Collection).

22. Lewis and his wife "had already, three months before, applied for and been granted an extension of their temporary stay in the United States, until 9 September. This expiry date approaching, in August Lewis attempted to establish his American citizenship. . . . The Department of State so deemed that Lewis had forfeited his citizenship when he swore allegiance to King and Country on entering military service for the British Empire in 1916." O'Keefe, *Some Sort of Genius,* 422.

23. Apparently Iris had recently sent $50 and was following up with another $100.

24. HLU from Wyndham Lewis to Iris Barry, Oct. 28, 1940 (Cornell).

25. HLS from Iris Barry to Wyndham Lewis, Jan. 3, 1941 (Cornell).

26. HLS from Wyndham Lewis to Iris Barry, January 3, 1941, Cornell.

27. HLS, undated (Cornell).

28. Undated manuscript of letter from Wyndham Lewis to Iris Barry (Robin Barry Collection).

29. Rose, ed., *The Letters of Wyndham Lewis,* 263.

30. Ibid., 281.

31. Ibid., 297.

32. Quoted in Alice Goldfarb Marquis, *Alfred H. Barr,* 186.

33. Rose, ed., *The Letters of Wyndham Lewis* 303. Ransom was Carnegie Professor of Poetry at Kenyon College in Ohio.

34. Barry had written Lewis that she "fell out of an automobile and got a slight concussion." HLS from Iris Barry to Wyndham Lewis, undated (Robin Barry Collection).

35. HLS from Iris Barry to Wyndham Lewis, undated (Robin Barry Collection).

36. HLS from Iris Barry to Wyndham Lewis, Jan. 13, 1940 (Robin Barry Collection). Dick Abbott supported Iris's mother for several years.

37. HLU from Wyndham Lewis to Iris Barry, Oct. 5, 1941 (Cornell).

38. HLS in manuscript form dated Nov. 1, 1941, from Wyndham Lewis to Iris Barry (Robin Barry Collection). It is interesting to note at this juncture that Lewis's biographer, Paul O'Keefe, says Lewis's friendship with Sir Nicholas and Lady Waterhouse, of the accounting firm of Price, Waterhouse, was "one of the very few relationships in Lewis' life that were able to survive his one-sided financial obligation. Sir Nicholas . . . was to support Lewis through illness and financial crisis until the artist's death; thereafter insuring his widow was provided for." O'Keefe, *Some Sort of Genius,* 266.

39. HLU from Wyndham Lewis to Iris Barry, Nov. 5, 1941 (Robin Barry Collection).

40. Ibid.

41. TLS from Iris Barry to Wyndham Lewis, Nov. 7, 1941 (Cornell).

42. HLU from Wyndham Lewis to Iris Barry, Nov. 10, 1941 (Cornell).

43. HLS from Wyndham Lewis to Iris Barry, Nov. 25, 1941 (Robin Barry Collection).

44. HLS from Wyndham Lewis to Iris Barry, Dec. 2, 1941, marked "sent by air mail this day" (Robin Barry Collection).

45. HLU from Wyndham Lewis to Iris Barry, Jan. 16, 1942 (Robin Barry Collection).

46. HLU from Wyndham Lewis to Iris Barry, Feb. 27, 1942 (Robin Barry Collection).

47. HLS from Wyndham Lewis to Iris Barry, July 18, 1942 (Cornell).

48. Lewis faced, among other indignities, ostracism for his relationship with Pound, reviled for his pro-Fascist broadcasts, and the near-destruction by fire of his hotel on February 14, 1944. O'Keefe, *Some Sort of Genius*, 460 and 499.

49. Lewis and his wife sailed from Quebec on August 2, 1945. By August 10, when they reached England, "atomic bombs had devastated two Japanese cities . . . and the world was at peace." O'Keefe, *Some Sort of Genius*, 504.

50. Wyndham Lewis, *Self-Condemned* (London: Methuen, 1954), 177.

25. "THE MASTER" AND HIS MINIONS

1. See Kristin Thompson and Richard Bordwell, *Film History, an Introduction* (New York: Mc-Graw-Hill, 2003), 51.

2. See Richard Griffith's introduction to the 1965 reissue of the book.

3. Iris Barry, *D. W. Griffith, American Film Master* (New York: Doubleday, 1940), 26. Quotes are from the 1965 reissue.

4. "Film Notes. Part 1: The Silent Film," *Bulletin of the Museum of Modern Art* 16.2–3: (1949): 12, emphasis added.

5. For subsequent analyses of Griffith's importance, see Richard Koszarski, *The Rivals of D. W. Griffith*, a monograph published in connection with a Walker Art Center (Minneapolis) exhibition in 1976 and reprinted by Zoetrope in New York in 1980, and the many conferences and publications mentioned by Thompson and Bordwell, *Film History*, 32 and 54.

6. IBP, MoMA Dept. of Film Archives, NY.

7. Bandy, "Nothing Sacred," in *The Museum of Modern Art at Mid-Century*, 93. The Griffith films were acquired in 1938 (see *New York Times*, Mar. 16, 1938, 21). Bandy held the title of Chief Curator in the Film Department (1980–1993), Film and Video (1993–2001), then Film and Media (2001–2006).

8. Ibid., 94.

9. Jewell, *New York Times*, Nov. 13, 1940, 20.

10. Ibid.

11. TLU from D. W. Griffith to Nelson Rockefeller, Aug. 27, 1940 (Rockefeller, Record Group 4, Series: Projects, box 139, folder 1367).

12. TLU from Nelson Rockefeller to John Abbott, Sept. 9, 1940 (Rockefeller, Record Group 4, Series: Projects, box 139, folder 1367).

13. TLU from Nelson Rockefeller to D. W. Griffith, Sept. 18, 1940 (Rockefeller, Record Group 4, Series: Projects, box 139, folder 137).

14. Ibid.

15. Alleged by Victor Riesel in *The New Leader*, May 11, 1940, 8.

16. Seymour Stern, *The New Leader*, Mar. 23, 1940. The letter said no such thing. Signed by 400 American notables, it merely called for unity on the left in opposition to fascism at a time when the left was split over Stalinism. Other signatories included Ernest Hemingway, George S. Kauffman, James Thurber, and the dance impresario and friend of MoMA, Lincoln Kirstein.

17. Ibid.

18. TLS from Seymour Stern to Nelson Rockefeller dated Mar. 30, 1940 (Rockefeller, Record Group 4, Series: Projects, box 139).

19. Stern, *The New Leader*, Mar. 23, 1940.

20. TLU from Nelson Rockefeller to Seymour Stern, Apr. 9, 1940 (Rockefeller, Record Group 4, Series: Projects: box 139).

21. Ibid.

22. TLS from Iris Barry to Nelson Rockefeller dated Mar. 28, 1940 (ibid.).

23. Alistair Cooke, "Report on the Film Library," Mar. 27, 1940 (box A-1/A-3, Dept. of Film, MoMA, 4–5). Quoted in Haberski, *It's Only a Movie*, 98.

24. See Peter Decherney's account of Huff's activities in *Hollywood and the Culture Elite*, 138–40, and the essay on Theodore Huff by Chuck Kleinhans in Jan-Christopher Horak, ed., *Lovers of Cinema: The First American Film Avant-Garde, 1919–1945* (Madison: U of Wisconsin P, 1995).

25. Letter from Jim Waverly, *New Leader*, July 27, 1940, 8.

26. Annette Michaelson, "Jay Leyda: 1910–1988," *Cinema Journal* 28.1 (Autumn 1988): 5.

27. *New York Times*, Mar. 3, 1940, sec. 9, p. 5.

28. *New York Times*, Apr. 14, 1940, sec. 9, p. 5.

29. *New York Times*, July 22, 1940, 20, and July 23, 1940, 18.

30. *New York Times*, Apr. 17, 1940, 25.

31. Ernst, *A Not-So-Still Life*, 194–95.

32. TLS from Iris Barry to Charles Abbott, Nov. 14, 1940 (Buffalo).

26. TEMORA FARM

1. Margaret Barr, "Our Campaigns," *New Criterion* 5.11 (Special Issue, 1987): 60.

2. Ibid.

3. Jimmy Ernst, *A Not-So-Still Life*, 195. Varian Fry recounted his experiences with the rescue effort in Varain Fry, *Surrender on Demand* (New York: Random House, 1945).

4. *New York Times*, Jan. 10, 1941, 21.

5. Lynes, *Good Old Modern*, 224–25. Subsequent page numbers are given in the main text.

6. Advertisement No. 60099 (undated), published by Previews Incorporated—the National Real Estate Clearing House, 345 Madison Ave., New York, N.Y., listed John Abbott as seller when he could not longer afford the property and put it up for sale.

7. IBP, MoMA Dept. of Film Archives, NY.

8. Ibid.

9. IBP, MoMA Dept. of Film Archives, NY.

10. IBP, MoMA Dept. of Film Archives, NY.

27. THE MUSEUM ENLISTS

1. Project Memorandum, unsigned, prepared for Nelson Rockefeller on December 31, 1942 (Rockefeller, Record Group 2, Series E, box 22, folder 219).
2. *New York Times*, Feb. 16, 1941, sec. 7, p. 39.
3. *New York Times*, Mar. 1, 1941, 17.
4. Ibid.
5. Ibid.
6. Iris Barry, *Bulletin of the Museum of Modern Art* (1941): 3–16.
7. See Barry's testimony before the U.S. Consul in chapter 38.
8. *New York Times*, Apr. 13, 1941, sec. 9, p. 5.
9. Ibid.
10. Ibid.
11. Ibid.
12. TLS from Iris Barry to Charles Abbott, Jan. 13, 1942 (Buffalo).
13. Moorehead, *Sidney Bernstein*, 117. Subsequent page numbers are given in the main text.
14. Bosley Crowther, "Pictures Pro Patria," *New York Times*, May 25, 1941, sec. 9, p. 3.
15. Ibid.
16. David Culbert, "The Rockefeller Foundation, the Museum of Modern Art Film Library, and Siegfried Kracauer, 1941," *Historical Journal of Film, Radio and Television* 13 (1993): 4, 502.
17. *New York Times*, December 23, 1941, 9.
18. Ibid.
19. Brett Gary, *The Nervous Liberals* (New York: Columbia UP, 1999).
20. See Walter Lippmann's *Public Opinion* (New York: Macmillan, 1922) and *The Phantom Public* (New York: Harcourt, Brace, 1925), and Archibald MacLeish's "The Irresponsibles" in *The Nation*, May 18, 1940.
21. Gary, *The Nervous Liberals*, 138.
22. Ibid., 126.
23. Culbert, "The Rockefeller Foundation," 496.
24. Ibid., 499 and 504.

28. MR. ROCKEFELLER'S OFFICE

1. IBP, MoMA Dept. of Film Archives, NY.
2. Ibid.
3. Ibid. The date of the Washington visit is unclear, but must have come before Theodore Huff's departure from the Museum in the spring of 1941.
4. See Darlene Rivas, *Missionary Capitalist: Nelson Rockefeller in Venezuela* (Chapel Hill: U of North Carolina P, 2002), 44.
5. Oral history interview with Stanton L. Catlin, July 1–Sept. 14, 1989, Archives of American Art, Smithsonian Institution, 42.
6. Typed memo, unsigned, from John Hay Whitney to Nelson Rockefeller, Jan. 29, 1942 (Rockefeller, Record Group 4, Series: Projects, box 139, folder 1367).
7. Ibid. Also known as *It's All True*, this Welles film was never finished and fell casualty to a change of policy at his studio, RKO, where Robert Wise drastically abbreviated Welles's

The Magnificent Ambersons while Welles was in Rio and Welles's Mercury Theater players were kicked off the studio lot so it could be used for a Tarzan movie.

8. Many of these films were produced by a for-profit corporation set up by Nelson Rockefeller, Hemisphere Films, which he affixed as an arm of the nonprofit Museum of Modern Art until the Internal Revenue Service declared the arrangement illegal (Rockefeller, Record Group 3, box 88, folder 728).

9. Ibid.

10. *Brief Report on Work by the Museum of Modern Art Film Library on Contract OEMcr-112 for the Office of the Coordinator of Inter-American Affairs*, Jan. 4, 1943 (Rockefeller, Record Group 4, Series: Projects, box 139, folder 1367).

11. Gisella Cramer, *Research Reports from the Rockefeller Archive Center* (Fall/Winter 2001): 14.

12. Catlin, oral history interview, 42.

13. Ibid., 48.

14. Eva Cockcroft, "Abstract Expressionism: Weapon of the Cold War," *Artforum* 12.10 (June 1974): 40. Also see Max Kozloff, "American Painting During the Cold War", *Artforum* 11.9 (May 1973): 43–55, and Jane De Hart Matthews, "Art and Politics in Cold War America," *American Historical Review* 81.4 (October 1976): 780.

15. Guilbaut, *How New York Stole the Idea of Modern Art*, 202. See also Irving Sandler's critique of Guilbaut in *Abstract Expressionism and the American Experience* (Lenox, MA: Hard Press Editions, 2009), ch. 5.

16. IBP, MoMA Dept. of Film Archives, NY.

17. Ibid.

18. Colonel Donovan was given the title "Coordinator of Information" by Franklin Roosevelt in 1941. He later headed the Office of Strategic Services.

19. Cramer, *Research Reports*, 14.

20. IBP, MoMA Dept. of Film Archives, NY.

21. Ibid. The *Why We Fight* series included *Prelude to War* (1942), *The Nazis Strike* (1943), *Divide and Conquer* (1943), *The Battle of Britain* (1943), *The Battle of Russia* (1943), *The Battle of China* (1944), and *War Comes to America* (1945). Director Frank Capra received the Distinguished Service Medal from Gen. George C. Marshall in 1945 for his work on the series.

22. John Huston's *Let There Be Light* (1946) was a Signal Corps documentary on posttraumatic stress disorder in the military, then known as "shell-shock." It was withheld from distribution by the government until the 1970s. It was not, however, withheld because it depicted dead American soldiers. Huston's *Battle of San Pietro* (1945) suffered that fate.

23. Cramer, Research Reports, 15.

24. Ibid.

25. *New York Times*, June 28, 1942, 35.

26. Ibid.

27. Ibid.

28. Author's interview with Robin Barry, Sept. 1988.

29. Ibid.

30. Author's interview with Maisie Wyndham Neil, Sept. 1988.

31. TLU from Sidney Bernstein to Iris Barry, dated "Friday" but marked "Feb–1943" (Robin Barry Collection).

29. L'AFFAIR BUÑUEL

1. IBP, MoMA Dept. of Film Archives, NY.

2. Ibid. Buñuel's recollection of being hired at the Museum differs from Iris's. In his version a "huge cocktail party" was thrown at the Museum, where Whitney "held court in one of the exhibition rooms where people were lining up for introductions. 'When I give you the sign,' Iris said to me, busily running from group to group, 'you slip into the line.' I stood around talking to Charles Laughton and his wife, Elsa Lanchester, until Iris signaled, whereupon I joined the line, and after a long wait I finally arrived at His Majesty. 'How long have you been here, Mr. Buñuel?' he asked. 'About six months,' I replied. 'How wonderful.' And that was it, at least for the moment. Later that same day, he and I had a more serious talk at the bar of the Plaza. When he asked if I was a Communist, I told him I was a Republican, and at the end of the conversation, I found myself working for the Museum of Modern Art." Buñuel doesn't explain how he could have been newly hired at a place for which he had worked for half a year, but it's a good story. Luis Buñuel, *My Last Sigh: The Autobiography of Luis Buñuel* (New York: Vintage, 1984), 180.

3. John Baxter, *Buñuel* (London: Fourth Estate, 1994), 177.

4. Ibid., 130–31.

5. Ibid., 131. On the same page Baxter also states that Buñuel told film critic Penelope Gilliatt that he left the Museum of Modern Art "because of Dali's information that I was a member of the French Communist Party."

6. By Baxter's account, "of the forty-two films handled in the first year, the majority were US Air Force training films and promotional shorts for Greyhound and General Electric, plus some newsreels of a US archbishop's Mexican visit and the annual Santa Barbara Spanish-American festival: no masterpieces there, except perhaps Joseph Losey's *A Child Went Forth*, about progressive schools, one of the few independent films Buñuel bought." Ibid., 181.

7. Ibid., 182. Despite Ramsaye's attack, Iris showed professional mettle three years later by praising the reissue of his book, *A Million and One Nights* (originally published in New York: Simon and Schuster, 1926) as "detailed, highly accurate, and spiced with Mr. Ramsaye's own observations of the film great." Iris Barry, *The Motion Picture: A Selected Booklist* (Chicago: American Library Association, 1946).

8. Baxter, *Buñuel*, 182–83.

9. Ibid., 183.

10. According to Baxter (ibid., 177), LeRoy earlier had protested the "abysmal" quality of the print of his *I Am a Fugitive from a Chain Gang* when it was screened at MoMA.

11. On the contrary, Dali wrote to Buñuel while they were working on the film: "Let's have a few blasphematory scenes, if you will, but it must be done with the utmost fanaticism to achieve the grandeur of a true and authentic sacrilege!" Fleur Cowles, *The Case of Salvador Dali* (London: Heinemann, 1959), 212.

12. Baxter, *Buñuel*, 184. Buñuel's own account of his dismissal is more straightforward. Dali, in Buñuel's view, cost him the job. "In his book, *The Secret Life of Salvador Dali*," Buñuel wrote in *My Last Sigh,*

 I was described as an atheist, an accusation that at the time was worse than being called a Communist. Ironically, at the same moment that Dali's book appeared, a man named Prendergast who was part of the Catholic lobby in Washington began using his influence with government officials to get me fired. I knew nothing at all about it, but one day when I arrived at my office, I found my two secretaries in tears. They showed me an article in a

movie magazine called *Motion Picture Herald* about a certain peculiar character named Luis Buñuel, author of the scandalous *L'Age d'Or* and now an editor at the Museum of Modern Art. Slander wasn't exactly new to me, so I shrugged it off, but my secretaries insisted that this was really very serious. When I went into the projection room, the projectionist, who'd also read the piece, greeted me by wagging his finger and smirking, "Bad Boy!"

Finally, I too became concerned and went to see Iris, who was also in tears. I felt as if I'd suddenly been sentenced to the electric chair. She told me that the year before, when Dali's book had appeared, Prendergast had lodged several protests with the State Department, which in turn began to pressure the museum to fire me. They'd managed to keep things quiet for a year; but now, with this article, the scandal had gone public, on the same day that American troops disembarked in Africa.

Although the director of the museum, Alfred Barr, advised me not to give in, I decided to resign, and found myself once again out on the street, forty-three and jobless. (182–83)

The outcome of the Buñuel affair might have been different had not the Abbott regime replaced Barr in the MoMA chain of command.

13. Baxter, *Buñuel*, 185–86.
14. TLS from Margaret Barr to the author, July 17, 1985. But as we have seen, Barr's position was much weaker than his wife believed it to be in 1942. Moreover, *The Miracle* was not released in the United States until 1949, well after Barr's demotion. In 1948 Anna Magnani, directed by Roberto Rossellini, played a peasant woman who believed herself to be an incarnation of the Virgin Mary. Titled *Il Miracolo*, it was a story segment of an episodic film called *L'Amore*, which ran afoul of U.S. censorship.
15. Ibid.

30. THE OTHER LIBRARY

1. Bandy, "Nothing Sacred," in *The Museum of Modern Art at Mid-Century*, 98.
2. Laurence Bergreen, *James Agee: A Life* (New York: Dutton, 1984), 277 and 215.
3. Doug Herrick, "Toward a National Film Collection: Motion Pictures at the Library of Congress," *Film Library Quarterly* 13 (1980): 5.
4. Ibid., 12–13. The "original conditions" Herrick writes about involved the actual deposit of films themselves as evidence of copyright instead of mere documentation of the films such as shooting scripts, stills, etc.
5. John Abbott, quoted in the "Minutes of the 16th Annual Meeting of the Board of Trustees and Members of the Corporation of the Museum of Modern Art," *Bulletin of the Museum of Modern Art* 12.3 (Feb. 1946): 5.
6. IBP, MoMA Dept. of Film Archives, NY.

31. DIVORCE

1. Author's interview with Maisie Wyndham Neil, Sept. 1988.
2. HLS from Iris Barry to Charles Abbott, May 6, 1943 (Buffalo).
3. HLS from Iris Barry to Charles Abbott, May 28, 1943 (Buffalo).

4. TLS from Iris Barry to Charles Abbott, Nov. 3, 1943 (Buffalo). The next day the *New York Times* quoted Abbott as announcing at the Museum that "it is to be the photography center's function to help and encourage both amateur and professional photographers." Like a good corporate executive, he noted that "to reach maximum effectiveness and expansion, the center will need the support of the photographic industry and of photography's vast and devoted following." In that way the new center "can become what its name implies, a focal point for activity in all promising directions open to photography, the most democratic and widely practiced of the arts." *New York Times,* Nov. 4, 1943, 18.

5. TLS from Iris Barry to Charles Abbott, Feb. 2, 1944 (Buffalo).

6. TLS from Iris Barry to Annie Gow Abbott, undated (Buffalo).

7. HLS from Iris Barry to Edmund Schiddel, Nov. 29, 1943 (Schiddel). An autobiographical fragment at MoMA (IBP, MoMA Dept. of Film Archives, NY) indicates that Abbott had remarried on October 25, 1943.

8. HLS from Barry to Schiddel, Nov. 29, 1943 (Schiddel).

9. Ernst, *A Not-So-Still Life,* 182.

10. Author's interview with Dorothy Miller, Sept. 1985.

32. POSTWAR BLUES

1. As reported in the *Bulletin of the Museum of Modern Art* 13.2 (Dec. 1945). Reappointments were effective the previous June.

2. Author's interview with Margaret Barr, Sept. 1985. Schrafft's was a New York restaurant chain popular with women. Although they admired her intelligence, statements by Mrs. Barr and curator Dorothy Miller often indicate their disapproval of Barry's manners in general and her sex life in particular.

3. Author's interview with Philip Johnson, Sept. 1985.

4. IBP, MoMA Dept. of Film Archives, NY.

5. Robert Flaherty, the documentary filmmaker and creator of *Nanook of the North* (1922).

6. IBP, MoMA Dept. of Film Archives, NY.

7. Iris Barry, "Why Wait for Posterity?," *Hollywood Quarterly* 1.2 (1946): 132–33.

8. *Report of the Committee on Policy to the Board of Trustees of the Museum of Modern Art* (Rockefeller, Record Group 4, Series: Projects, box 130, folder 1272). The report is undated.

9. Ibid., 8 [Probably unpaginated]. Apparently many of the Museum's core supporters agreed, as evidenced by a letter to Nelson Rockefeller from John Hay Whitney as late as 1952, in which Whitney concurred with Rockefeller's belief that "the one basic weakness in the [Museum's] situation is the substantial portion in the budget which is contributed annually by a limited number of the trustees." TLS, dated Oct. 24, 1952 (Rockefeller, Record Group 4, Series: Projects, box 132, folder 1290). Rockefeller had decided to make his annual gift of $40,000 to the Museum anonymously that year, noting that "an essential 20 percent of the [Museum's] budget is contributed annually by a limited number of very generous Trustees. In the long run this could turn out to be the Achilles Heel of the Museum." TLS from Nelson Rockefeller to John Hay Whitney, dated Oct. 7, 1952 (Ibid.).

10. TLS, dated Oct. 7, 1952 (ibid.), 2.

11. Ibid.,13.

12. Ibid., 14. The members of the Committee on Policy included Henry Allen Moe (chairman), John E. Abbott, Stephen C. Clark, Adele R. Levy, James T. Soby, James Johnson Sweeney, and Monroe Wheeler.

13. Postcard from Elizabeth Trask, addressed to Edmund Schiddel at 165 East 83rd St., New York 28, N.Y., and stamped Feb. 4, 1945 (Schiddel).

14. She also very likely would be wearing a Lilly Daché hat, which film historian Arthur Knight seldom saw her without (interview with the author, 1977).

15. IBP, MoMA Dept. of Film Archives, NY.

16. Ibid.

17. HLS from Iris Barry to Edmund Schiddel, Feb. 27, 1945 (Schiddel).

18. Author's interview with Dorothy Miller, Sept. 1985.

19. Letter dated July 9, 1945, reproduced in VeVe Clark, Millicent Hodson, and Caterina Neiman, *The Legend of Maya Deren*, vol. 1, part 2 (New York: Anthology Film Archives / Film Culture, 1988), 352.

20. Jonas Mekas, e-mail to the author, Apr. 1, 2010.

21. See Peter Decherney, *Hollywood and the Culture Elite*, 174–75.

22. Iris Barry, "Motion Pictures as a Field of Research," *College Art Journal* 4.4 (May 1945): 206.

23. Proposal for the Educational Film Project dated January 16, 1946 (Rockefeller, Record Group 4, Series: Projects, box 139, folder 1367). *The Film Index* continued the *Film in America* project begun in 1939.

24. Ibid., 1–2.

25. TLS from Thomas Hodge to Sidney Bernstein, July 19, 1945 (Robin Barry Collection).

26. Rockefeller, Record Group 4, Series: Projects, box 150, folder 1482.

27. See Bruce Henson, "Iris Barry: American Film Archive Pioneer," *Katherine Sharp Review* 4 (Winter 1997): 7.

28. TLU from Ione Ulrich to Iris Barry, Mar. 1, 1948 (Rockefeller, Record Group 4, Series: Projects, box 139, folder 1367).

29. Ibid.

30. During Abbott's tenure after the demotion of Barr, policy at the Museum was ostensibly set by a committee of the board, members of which were reported to by the heads of the various Museum departments. This proved inefficient and contributed to the sense of malaise felt among the staff. See Russell Lynes, *Good Old Modern*, 270–71.

31. Memo dated October 7, 1947, from Stephen Clark to Henry Allen Moe in Re. Policy Committee deliberations (Rockefeller, Record Group 4, Series: Projects, box 130, folder 1272).

32. Ibid., 2.

33. Ibid..

34. Ibid., 3

35. Ibid., 4.

36. Memorandum from John Abbott to Nelson Rockefeller, Apr. 30, 1946 (Rockefeller, Record Group 4, Series: Projects, box 251, folder 2993). It was pertinent to this study that the Coordinating Committee was formed to recommend organizational changes at the Museum.

37. Iris Barry, "A Challenge to Hollywood," *Harper's Bazaar*, July 1947, 41 and 87.

38. Meyers, *The Enemy*, 93. The official Cannes Film Festival website indicates that Iris Barry was a juror in 1946.

33. ABBOTT'S FALL

1. Lynes, *Good Old Modern*, 276.

2. TLU from John Abbott to Nelson Rockefeller, Dec. 22, 1947 (Rockefeller, Record Group 4, Series: Projects, box 150, folder 1482).

3. In his capacity of Executive Director of the Museum, Abbott also served as Secretary of the Museum's board.

4. TLU from Nelson Rockefeller to John Abbott, Dec. 14, 1947 (Rockefeller, Record Group 4, Series: Projects, box 150, folder 1482).

5. This sequence of events transpired as Rockefeller suggested. The February 3, 1948, issue of the *New York Times* briefly noted that Abbott "has resigned his post but will remain a trustee, it was announced yesterday by Nelson A. Rockefeller, president of the museum. Mr. Abbott has become assistant to William Zeckendorf, president of Webb and Knapp, the realty firm that assembled the site of the United Nations headquarters." *New York Times*, Feb. 3, 1948, 23.

6. Ibid.

7. TLU from Nelson Rockefeller to William Zeckendorf, Jan. 12, 1948 (Rockefeller, Record Group 4, Series: Projects, Sub-series: Abbott, John E., folder 1).

8. TLU from Susan Cable to Nelson Rockefeller, July 2, 1948 (Rockefeller, Record Group 4, Series: Projects, Sub-series: Abbott, John E., folder 1).

9. Personal memorandum from Susan Cable to Nelson Rockefeller, July 15, 1948 (Rockefeller, Record Group 4, Series: Projects, Sub-series: Abbott, John E., folder 1).

10. Memo from Susan Cable to Nelson Rockefeller, Oct. 7, 1948 (Rockefeller, Record Group 4, Series: Projects, Sub-series: Abbott, John E., folder 10).

11. Copy on file at Rockefeller, Record Group 4, Series: Projects, Sub-series: Abbott, John E., folder 1.

12. According to a signed thank-you note from Kate Abbott to Nelson Rockefeller, May 19, 1949 (Rockefeller, Record Group 4, Series: Projects, Sub-series: Abbott, John E., folder 1).

13. TLS from Susan Cable to Nelson Rockefeller, Apr. 3, 1950 (Rockefeller, Record Group 4, Series: Projects, Sub-series: Abbott, John E., folder 1).

14. TLU from Dick Abbott to Nelson Rockefeller, Mar. 30, 1950 (Rockefeller, Record Group 4, Series: Projects, Sub-series: Abbott, John E., folder 1).

15. TLU from Philip E. Keebler to Nelson Rockefeller, Sept. 25, 1950 (Rockefeller, Record Group 4, Series: Projects, Sub-series: Abbott, John E., folder 1).

16. TLS from Stephen Clark to Nelson Rockefeller, Oct. 10, 1950 (Rockefeller, Record Group 4, Series: Projects, Sub-series: Abbott, John E., folder 1).

17. TLU from Dick Abbott to Nelson Rockefeller, Feb. 5, 1951 (Rockefeller, Record Group 4, Series: Projects, Sub-series: Abbott, John E., folder 1).

18. TLU from Dick Abbott to Nelson Rockefeller, Mar. 22, 1951 (Rockefeller, Record Group 4, Series: Projects, Sub-series: Abbott, John E., folder 1).

19. Clipping from *New York Daily Mirror* of Feb. 7, 1952 (Rockefeller, Record Group 4, Series: Projects, Sub-series: Abbott, John E., folder 1). According to Barry, Abbott "died miserably by falling down blind drunk, cutting his head and bleeding to death in a hotel in New York" (IBP, MoMA Dept. of Film Archives, NY).

20. Resolution of the Trustees of MoMA on the death of John Abbott, undated (Rockefeller, Record Group 4, Series: Projects, Sub-series: Abbott, John E., folder 1).

34. HOSPITAL

1. HLS from Iris Barry to Charles Abbott, Mar. 12, 1949 (Buffalo).
2. Ibid. Among them was one, "very sweetly," from her ex-husband, Dick Abbott.
3. IBP, MoMA Dept. of Film Archives, NY.
4. Ibid.
5. TLS from Henri Bonnet to Iris Barry, Feb. 16, 1949 (IBP, MoMA Dept. of Film Archives, NY).
6. Western Union telegram, Feb. 24, 1949 (IBP, MoMA Dept. of Film Archives, NY).

35. DEPARTURE

1. Author's interview with Maisie Wyndham Neil, Sept. 1988.
2. TLS from Nelson Rockefeller to Iris Barry, Apr. 5, 1949 (IBP, MoMA Dept. of Film Archives, NY).
3. TLU from Iris Barry to Nelson Rockefeller, Apr. 6, 1949 (IBP, MoMA Dept of Film Archives, NY).
4. HLS from Iris Barry to Charles Abbott, Mar. 12, 1949 (Buffalo).
5. *New York Times*, Dec. 27, 1949, 27.
6. Ibid.
7. Unsigned memo from Iris Barry to Ione Ulrich, Aug. 16, 1950 (Roll 2931, Museum of Modern Art materials, Archives of American Art, Smithsonian Institution. The unfulfilled arrangement with New American Library eventually produced Arthur Knight's *The Liveliest Art: A Panoramic History of the Movies* (New York: New American Library, 1957).
8. Ibid. A June 7, 1950, memo from Rene d'Harnoncourt to Nelson Rockefeller's secretary, Susan Cable, reveals that Nelson Rockefeller was the originator of the films-for-television scheme. Jock Whitney also favored the idea and, according to d'Harnoncourt, "felt that this was the first thing that had come along which might prove to be the right approach for the [film] industry for their support." Rockefeller and Whitney worked on this initiative without informing Iris. (Rockefeller, Record Group 3, NAR Personal Projects, box 139, folder 1367.
9. Ibid.
10. HLS from Iris Barry to Edmund Schiddel, Oct. 30, 1950 (Schiddel).
11. Ibid.
12. Iris's datebook indicates that on the 21st of March she again visited Dr. Kulka. One might surmise that, although he may have pronounced her cancer operation a success, there could be no guarantee of nonrecurrence. In France she may have been offered a form of chemotherapy or radiation, although at the time both treatments were in their infancy. IBP, MoMA Dept. of Film Archives.
13. HLS from Iris Barry to Edmund Schiddel, Oct. 30, 1950 (Schiddel).
14. IBP, MoMA Dept. of Film Archives, NY.
15. Jonathan Westerfield, *The Scientific Dream Book*, 230–31. Westerfield was an Iris alias.
16. John Houseman, *Front and Center* (New York: Simon and Schuster, 1979), 323.
17. Author's interview with Maisie Wyndham Neil, Sept. 1988.
18. HLS from Iris Barry to Edmund Schiddel, Oct. 30, 1950 (Schiddel).

19. IBP, MoMA Dept. of Film Archives, NY. Iris spent $1,000 on the house; the car was apparently for Kerroux, since she did not drive.
20. TLS from Margaret Barr to the author, Oct. 14, 1985.
21. Film exhibitor Harry Brandt and Motion Picture Association head Eric Johnston sat on the Film Library's Advisory Committee, overseeing Iris's work.
22. HLS from Iris Barry to Rene d'Harnoncourt, Dec. 6, 1950 (Rene d'Harnoncourt Papers, MoMA Archives, folder 749).
23. TLS from Rene d'Harnoncourt to Iris Barry, Dec. 15, 1950 (Rene d'Harnoncourt Papers, MoMA Archives, folder 749).

36. LA BONNE FONT

1. La Bonne Font came with "another little property about five miles away which is even wilder—two ruined houses in a deserted hamlet and some land with woods and wild boar. It 'went with' this place, but as the whole thing, i.e. both places cost under seven hundred pounds (which, together with repairs etc. was where my annuity went), one can't complain and L'Aumade Haute at least furnishes wood and pinecones and lots of almonds and some olives too." HLS, Iris Barry to Charles and Teresa Abbott, Feb. 1953 (Buffalo).
2. HLS from Iris Barry to Edmund Schiddel, Jan. 6, 1952 (Schiddel).
3. Ibid.
4. Ibid.
5. HLS from Iris Barry to Edmund Schiddel, Feb. 12, 1951 (Schiddel). Iris neglected to mention to Schiddel that the Museum was paying her at a rate commensurate with her future pension, just above $70 a month.
6. HLS from Iris Barry to Edmund Schiddel, Mar. 13, 1951 (Schiddel).
7. HLS from Iris Barry to Edmund Schiddel postmarked Apr. 14, 1951 (Schiddel). The "awful accountant lady" was the Museum's treasurer, Ione Ulrich.
8. HLS from Iris Barry to Rene d'Harnoncourt, undated (Rene d'Harnoncourt Papers, MoMA Archives, folder 749).
9. TLU from Rene d'Harnoncourt to Iris Barry, Mar. 28, 1951 (Rene d'Harnoncourt Papers, MoMA Archives, folder 749).
10. Equitable Life Assurance Society document (IBP, MoMA Dept. of Film Archives, NY).
11. *New York Times*, July 23, 1951, 16.
12. Lynes, *Good Old Modern*, 335–36.

37. THINGS PAST

1. Death certificate (IBP, MoMA Dept. of Film Archives, NY).
2. TLS from Iris Barry to Charles Abbott, Feb. 19, 1952 (Buffalo).
3. TLS from Iris Barry to John Widdicombe, Jan. 29, 1952 (Austin).
4. TLU from Iris Barry to Edmund Schiddel , July 3, 1952 (Schiddel).
5. Ibid.
6. Ibid.
7. TLS from Iris Barry to Edmund Schiddel date-stamped Dec. 22, 1953 (Schiddel).

8. Ibid. In an interview with the author in 1988, Maisie mentioned that she was then divorced from a barrister whose surname was Neil and with him bore two children, a boy and a girl.

9. James Card, *Seductive Cinema*, 122. Subsequent page numbers are given in the main text.

10. Department of State Instruction document A-1054 (Mar. 1, 1954), released January 25, 1995, by Department of State Office of Freedom of Information, Privacy and Classification Review.

11. T-2 could also have been Terry Ramsaye of the *Motion Picture Herald* or anyone who had read his articles complaining of Communists at the "Rockefeller Museum."

12. United States Government Office Memorandum, Sept. 11, 1953, released, as above in note 10, by the Freedom of Information Act. Helen Von Dongen, a film editor who was briefly married to Ivens in the 1940s, reflected later in an interview that "I didn't have enough time to get involved in politics." (Interview by Abe Mark Nornes, n.d., Documentary Box 17, www.yamagata.yamagata.jp/yidff/docbox/docbox-e.html.)

13. Ibid.

14. Confidential Foreign Service Dispatch #85, May 21, 1954, declassified and released as above through the Freedom of Information Act.

15. Confidential Department of State Instruction #A-8, Oct. 1, 1954, declassified and released as above.

16. Statement containing a handwritten note by Iris Barry that it "was typed by the U.S. Consul at Marseilles more or less at my dictation" (IBP, MoMA Dept. of Film Archives, NY). A copy of the typed original was released to the author by the Freedom of Information Act Office in April of 1994.

17. HLS from Iris Barry to Edmund Schiddel dated "March 16?" and received April 2, 1954 (Schiddel).

18. TLS from Iris Barry to Charles Abbott, Mar. 23, 1959 (Buffalo).

19. TLS from Iris Barry to Edmund Schiddel, undated (Schiddel).

38. THE AUSTIN HOUSE

1. Eugene Gaddis, *Magician of the Modern* (New York: Knopf, 2000), 408.

2. TLS from Iris Barry to Edmund Schiddel, date-stamped Sept. 8, 1954 (Schiddel).

3. HLS from Iris Barry to Edmund Schiddel, Dec. 23, 1954 (Schiddel).

4. Barry was hired by NBC to help locate footage for their documentary series about naval warfare in World War II, *Victory at Sea*.

5. TLS from Iris Barry to Edmund Schiddel, Apr. 26, 1955 (Schiddel).

6. HLS from Iris Barry to Chick Austin, undated (Hartford).

7. TLS from Iris Barry to Edmund Schiddel dated (by Schiddel) "August 10, 1955" (Schiddel).

8. HLS from Rene D'Harnoncourt to Nelson Rockefeller, postmarked Aug. 12, 1955 (Rockefeller, Record Group 4, Series: Projects, box 150, folder 1482).

9. TLU (initialed) from John R. Kennedy to Nelson A. Rockefeller (Rockefeller, Record Group 4, Series: Projects, box 150, folder 1482).

10. TLS from Iris Barry to Chick Austin, undated (Hartford).

11. Ibid. The "francs" alluded to are likely to have come from the sale of La Bonne Font.

12. TLS from Iris Barry to Chick Austin, undated (Hartford).

13. Ibid. The Telefunken radio-phonograph was a gift from Austin.

14. Author's interview with Marius Rochemaure, Sept. 1988.

39. READJUSTMENTS

1. TLS from Iris Barry to Edmund Schiddel, dated by Schiddel as postmarked, Jan. 12, 1957 (Schiddel). In November of 1956 Iris sent Nelson Rockefeller a case of wine, thanking him for his "goodness in having fixed the renewal of my passport last year with the State Department lady" and assuring him that "From here [Fayence] I haven't really felt too far away, since many friends like Alfred [Barr] and Rene [d'Harnoncourt] have been here more than once." TLS from Iris Barry to Nelson Rockefeller, Nov. 14, 1956 (Rockefeller, Record Group 4, Series: Projects, box 150, folder 1482). Barry also met resistance in renewing her passport in 1957 and 1959.

2. TLS from Iris Barry to Edmund Schiddel, dated by Schiddel as postmarked, Jan. 12, 1957 (Schiddel).

3. O'Keefe, *Some Sort of Genius*, 631. Westminster was the same hospital in which Lewis's son, Peter, had died of lymphatic cancer at the age of 34 (510).

4. Austin ran afoul of his Board of Directors over, among other issues, his acquisitions policy, which they considered too costly and adventurous. He was fired from the Wadsworth Atheneum in 1944. He left his family in Hartford and became director of the John and Mable Ringling Museum in Sarasota, Florida, in 1946. His tenure there (1946–1956) was also controversial, and he was no doubt preoccupied with his own difficulties during the years he owned the Fayence house. He contracted cancer in 1956 and returned to his family in Hartford, where he died in 1957. See Eugene Gaddis, *Magician of the Modern*.

5. TLU from Iris Barry to Chick Austin, undated (Hartford).

6. TLS from Iris Barry to Edmund Schiddel stamped "received July 8, 1957" (Schiddel).

7. TLS from Iris Barry to Helen Austin, undated (Hartford).

8. Ibid.

9. Ibid.

10. TLS from Iris Barry to Helen Austin, undated (Hartford).

11. TLU from Iris Barry to David Austin, undated (Hartford).

40. NEW YORK AND LONDON

1. Author's interview with Maisie Wyndham Neil, Sept. 1988.

2. Author's interview with Robin Barry, Sept. 1988.

3. TLS from Iris Barry to Edmund Schiddel marked "Rec'd Cannes, 6/8" (Schiddel).

4. HLS from Iris Barry to Edmund Schiddel marked "Received 8/15/63" (Schiddel).

5. TLS from Iris Barry to James Thrall Soby, undated (James Thrall Soby Papers, MoMA Archives). With the Cold War in full swing, the Profumo Affair became topic A in British tabloids in 1962 and 1963. U.K. Secretary of State for War, John Profumo, attempted unsuccessfully to cover up his relationship with aspiring actress Christine Keeler, who was also revealed to be the mistress of a Russian spy. No state secrets seemed to have been passed, but the scandal nevertheless brought down the Macmillan regime.

6. Author's interview with Eileen Bowser, Sept. 1989.

7. Bosley Crowther, *New York Times*, Sept. 14, 1963, 43.

8. IBP, MoMA Dept. of Film Archives, NY.

41. FINAL BREAKS

1. TLS from Iris Barry to David Austin, July 1964 (Hartford).
2. HLS from Iris Barry to David Austin, Aug. 8, 1964 (Hartford).
3. HLS from Iris Barry to Helen Austin, undated (Hartford).
4. HLS from Iris Barry to David and Mollie (his sister), July 1965 (Hartford).
5. HLS from Iris Barry to David Austin, Jan. 1968 (Hartford).
6. TLU from Iris Barry to Helen Austin, undated (Hartford). No copy of the lawyer's letter seems to exist.
7. TLS from Iris Barry to David Austin, undated (Hartford).
8. TLU from David Austin to Iris Barry, June 24, 1969 (Hartford).

42. THE END

1. Author's interview with Marius Rochemaure, Sept. 1988.
2. Iris Barry, *The Adelphi* (June 1924): 67.
3. TLS from Iris Barry to David Austin, undated (Hartford).
4. Lynes, *Good Old Modern*, 334–35.
5. TLU from Calder to Beatrice Horton (Curtis-Brown), Jan. 27, 1970 (Robin Barry Collection).
6. Ibid. The allusion is to "Madame" Iampolsky, Iris's housekeeper.
7. HLS from David Austin to Paul Calder, undated (Hartford).

SOURCES

Sources designated IBP (Iris Barry Papers), include a variety of materials on deposit at the Museum of Modern Art Film Archives, including notebooks Iris Barry kept late in her life in Fayence, France, an unpublished autobiographical typescript, photographs, datebooks, correspondence, memorabilia, and incidental records. The bulk of these materials came from a lot sold at Sotheby's in 1985, purchased for the Museum through funds donated in memory of Iris's successor, Richard Griffith. The Robin Barry Collection is an assemblage of biographical materials put together by Iris Barry's son, Robin Barry, when he began to write a book about his mother. Mr. Barry gave copies of this collection to me in 1988 and expressed the wish that I should write the book. The Schiddel Collection includes correspondence and unpublished writings about Iris Barry deposited at the Mugar Library, Boston University, by the novelist Edmund Schiddel, a long-term friend of Iris Barry's. The material marked "Hartford" comes from the A. E. "Chick" Austin Papers at the Wadsworth Atheneum in Hartford.

* * *

Archives cited in the notes and their abbreviations:

Beinecke Rare Book and Manuscript Library, Yale University (Yale)
Mugar Library, Boston University (Boston)
Museum of Modern Art Film Archives (IBP)
Poetry Collection of the State University of New York at Buffalo (Buffalo)
Harry Ransom Center, University of Texas at Austin (Austin)
Rockefeller Family Archives (Rockefeller)
Rare and Manuscript Collections, Carl A. Kroch Library, Cornell University (Cornell)
The Wadsworth Atheneum (Hartford)

Materials from these archives are quoted with their kind permission.

* * *

Principal research was conducted in the libraries of the University of Washington, Seattle, with additional research at the British Library, Library of Congress, British Film Institute, Cinémathèque

Française, Archives of the Legion d'Honneur, Archives of American Art, and the Academy of Motion Picture Arts and Sciences.

Codes for correspondence: TLS, typed letter signed; HLS, handwritten letter signed; TLU, typed letter unsigned; HLU, handwritten letter unsigned.

INDEX